Turner in Germany

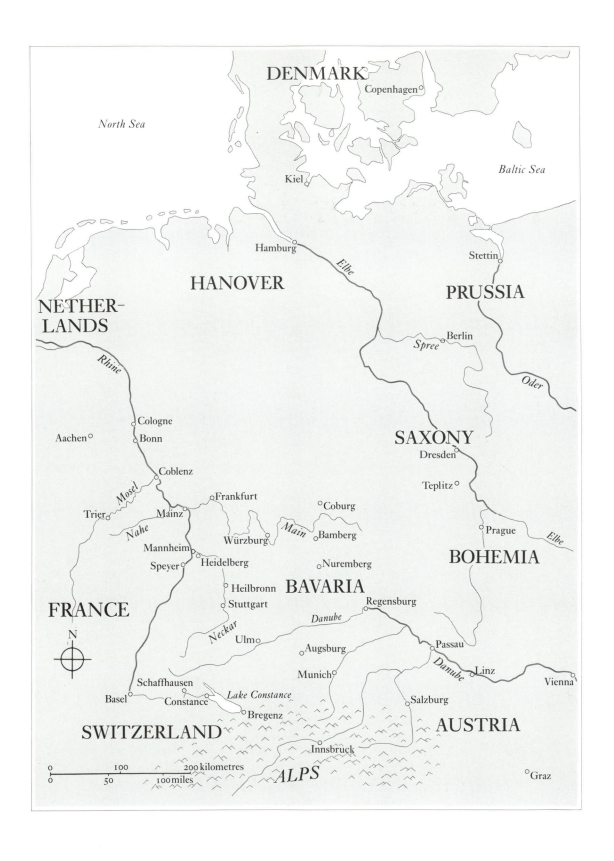

CECILIA POWELL

Turner in Germany

TATE GALLERY PUBLICATIONS

front cover:
'The Enderttor and Alte Thorschenke, Cochem'
*c.*1839 (cat.no.54)

back cover:
'Burg Hals on the Ilz' 1840 (cat.no.88)

ISBN 1 85437 160 6

A catalogue record for this publication is available from the British Library

Published by order of the Trustees 1995
on the occasion of the exhibition at the Tate Gallery, London
23 May – 10 September 1995
Also shown at:
Städtische Kunsthalle Mannheim
26 September 1995 – 14 January 1996
Hamburger Kunsthalle
25 January – 31 March 1996

Designed and typeset by Caroline Johnston
Maps on pp.2, 22, 32, 37, 47, 62, 67, 118, 205, 215 by John Flower
Published by Tate Gallery Publications, Millbank, London, SW1P 4RG
© Tate Gallery and the author 1995 All rights reserved
Printed and bound in Great Britain by Balding + Mansell,
Peterborough, Cambridgeshire

Contents

Foreword

Following the successful exhibition *Turner's Rivers of Europe: The Rhine, Meuse and Mosel* (1991–2), Cecilia Powell has pursued a further three years' research at the Clore Gallery, completing her study of Turner's travels through Germany. This exhibition and publication now present the fruits of this study, carried out largely among the material in the Turner Bequest but also in many parts of Germany itself.

Between 1817 and 1844 Turner travelled far more extensively in Germany than has previously been realised, visiting virtually all of its major cities and diverse areas of outstanding beauty. Many of his continental tours have hitherto defied investigation but Cecilia Powell has now disentangled the complex and fascinating journeys the artist made through Germany in 1833, 1835 and 1840, on which he explored Munich, Heidelberg, Hamburg, Berlin and Dresden, the Danube and the Elbe, and recorded them indefatigably in his sketchbooks. All these tours are described in detail for the very first time in this publication, accompanied by illustrations of many of Turner's sketches.

The tour of 1840 was of particular significance to Turner. It was undertaken in the summer immediately following the marriage of Queen Victoria to her cousin Albert of Saxe-Coburg-Gotha, with the aim of attracting royal patronage. Around forty of Turner's many fine coloured sketches, inspired by this tour and hitherto unidentified and undated in the Turner Bequest, are included in the exhibition.

This publication unites Cecilia Powell's new findings with those of her earlier research, thus becoming the first study to cover the subject of Turner's German tours in all their richness and variety. It amply demonstrates the strength and continuity of his interest, underpinned by the very close relationship which existed between Britain and Germany in Turner's own lifetime.

As in *Turner's Rivers of Europe*, an appendix to the present catalogue identifies the subject matter of all the German sketches drawn on the newly studied tours, thus making a further valuable contribution to the work in progress on the revision of A.J. Finberg's *Inventory* of the Turner Bequest.

In addition to the works in the Turner Bequest, a number of significant works of German subjects are now held in collections elsewhere. I should like to thank the private collectors and museums who have so generously allowed us to include these important loans, enabling us to present such a complete picture of Turner's travels in Germany.

I would also like to thank Cecilia Powell for her enthusiastic and meticulous work. Her discoveries and re-identifications again contribute enormously to our knowledge of Turner and his work.

The exhibition has been organised in collaboration with the Städtische Kunsthalle Mannheim and we have particularly welcomed the opportunity to work with colleagues in Germany on this project. The exhibition will be shown in Mannheim after the Tate Gallery exhibition and will have a final showing at the Kunsthalle in Hamburg. We are delighted that this last venue has proved possible in view of Cecilia Powell's discovery that Turner visited Hamburg in 1835.

Nicholas Serota
Director

Preface and Acknowledgments

This catalogue tells the full story of Turner's travels in Germany for the first time in any publication on the artist. The exhibition grew out of *Turner's Rivers of Europe: The Rhine, Meuse and Mosel* (Tate Gallery 1991–2; Brussels and Bonn 1992) and I am immensely grateful for the collaboration between the Tate Gallery and the Städtische Kunsthalle Mannheim, and their two directors Nicholas Serota and Manfred Fath, which has made the new venture possible.

In my earlier catalogue I traced Turner's tours of 1817, 1824 and 1839. During my further research I have investigated those of 1833, 1835, 1840 and 1844. In bringing all this material together in the present catalogue there is, inevitably, some degree of overlap, but it is vital to consider all Turner's German experiences together. Only in this way can we, at last, come to appreciate the important role which Germany played in his life and work.

In the mid-1990s art history is a subject which takes many different forms. In researching and organising this exhibition I have regarded my role as the traditional one of the art historian. I set out to find, identify, date and classify all the German drawings in the Turner Bequest so as to establish the pattern of the artist's movements about which there has been much ignorance and confusion. The emphasis in this catalogue is therefore biographical and topographical. I have sought to show Turner against the appropriate historical background and to relate works in the Bequest to those outside it. There are plenty of new interpretations, but readers in search of fashionable late twentieth-century art historical theories will not find them here. Several women writers are quoted and Karl Marx receives a brief mention, but there is neither feminism nor Marxism in my approach to my subject.

Turner visited so many places in Germany, over the course of twenty-eight years, that I – in a mere three – could not hope to explore them all as thoroughly as he did. However, I hope that the lists of his sketches in the Appendix will encourage local historians to make further investigations of his visits to their regions.

I have been greatly helped by many members of the Tate Gallery staff: in the Library, the British Collection and the Conservation, Exhibitions, Photographic and Registrar's Departments. I am grateful to them all but particularly to Ruth Rattenbury for her commitment to the project from its inception and Andrew Wilton, David Blayney Brown, Ian Warrell and Ann Chumbley for much valuable guidance and assistance. I should also like to thank the staff of Tate Gallery Publications for their unfailing support and assistance in the production of this catalogue.

I am very much indebted to all the following for their help, advice and information which has often been of far more value to me than they can have realised: Herbert Appeltshauser (Coburg); Fred Bachrach; Marian Barker; Tine Bennett; Christoph Bultmann (University of Göttingen); Ulrike Büsch (Spitz an der Donau); Franz Duschl (Stadtarchiv Regensburg); Judy Egerton; Ernst Englisch (Krems an der Donau); Derek Foreman; Gillian Forrester; Rein Gerretsen (Nijmegen); Emmerich Gmeiner (Stadtarchiv Bregenz); Heiner Henke (Passau); Luke Herrmann; Franz-Heinz Hye (Stadtarchiv Innsbruck); Evelyn Joll; Caroline Johnston; Bjarne Jørnaes (Thorvaldsen Museum, Copenhagen); Bettina Kann (Österreichische Nationalbibliothek Wien); Michael Kitson; Herr Kleber (Stadtbibliothek Koblenz); Petra Kuhlmann-Hodick (Kupferstich-Kabinett, Staatliche Kunstsammlungen Dresden); Gerard Lemmens (Commanderie van St Jan, Nijmegen); Erich Marx (Archiv der Stadt Salzburg); Rodney Merrington; Herbert Muth (Mainfränkisches Museum Würzburg); Kathy Newstead; Constance Parrish; Bruno Heinrich Pauwels; Vivien Perutz; Heidi Peters (Hotel Altstadt, Salzburg); Jan Piggott; Louis Pironet (Waterloo); Ceri Powell; Frau Rabe (Staatsarchiv Hamburg); Hans-Jürgen Sarholz (Stadtarchiv Bad Ems); Reinhold Schommers (Kulturabteilung KVHS Cochem-Zell); Eberhard Schönberger (Bernkasteler Ring); Ejvind Slottved (University of Copenhagen); Jørgen Thorning Sørensen (Royal Library, Copenhagen); Jean Toussaint (Bibliothèque Communale de Spa); Herbert Tschulk (Wiener Stadt- und Landesarchiv); Rosalind Turner; David Wallace-Hadrill; Henry Wemyss; Guido de Werd (Haus Koekkoek, Kleve); Karen Widdicombe; Andrew Wyld.

Many other curators, archivists and librarians have dealt patiently with my queries and played an important part in

my research. I am most grateful to staff at the British Library, London Library, Royal Academy Library, Department of Prints and Drawings at the British Museum, and the Print Room, Windsor Castle; and at the following institutions: Öffentliche Bibliothek Aachen; Stadtarchiv Bamberg; Landesarchiv Berlin; Geheimes Staatsarchiv PK Berlin; Staats- und Universitätsbibliothek Bremen; Institut für Zeitungsforschung Dortmund; Sächsische Landesbibliothek Dresden; Stadtarchiv Dresden; Stadt- und Universitätsbibliothek Frankfurt; Stadtarchiv Graz; Stadtarchiv Heidelberg; Stadtarchiv Heilbronn; Universitäts- und Stadtbibliothek Köln; Staatsarchiv Ludwigsburg; Bayerische Staatsbibliothek München; Stadtarchiv München; Stadtarchiv Nürnberg; Oberhausmuseum Passau; Stadtarchiv Passau; Archiv hlavního města Prahy; Fürst Thurn und Taxis Zentralarchiv Regensburg; Stadtarchiv Stuttgart; Hauptstaatsarchiv Stuttgart; Książnica Szczecińska; Státní okresní archiv v Teplicích; Stadtarchiv Trier; Goethe-Nationalmuseum Weimar; Bundespolizeidirektion Wien; Wiener Stadt- und Landesarchiv; Stadtarchiv Würzburg.

I should like to thank the many individuals and museums who have lent material to the exhibition, especially where the loans are for more than one venue. Their generosity in sharing their treasures will be felt by all those who visit the exhibition.

Finally, my thanks go to people who have made very special contributions. Peter Bower's extensive knowledge of Turner's papers has been of immense value to this project and he has shared it with me on many occasions. Pia Müller-Tamm's enthusiasm was a critical factor in the evolution of the collaboration between Mannheim and London which made it all possible. She has now left the Städtische Kunsthalle Mannheim for a post in Düsseldorf but has contributed an important essay to the German edition of this catalogue. I, too, have benefited from her studies and investigations and have enjoyed our partnership. Ursula Seibold-Bultmann has helped me in so many different ways over the past few years that it would be embarrassing for us both were I to catalogue them. I can only say how very much I have appreciated her knowledge, help and kindness.

As the great German novelist Thomas Mann remarked, 'A writer is somebody for whom writing is more difficult than it is for other people'. Fortunately my husband Nick has provided me with constant support and friendly criticism, cheerfully taking second place to Turner on countless occasions both at home and abroad. Few spouses would tolerate such a *ménage à trois* and I am eternally grateful.

Cecilia Powell

Turner and Germany

There is a story told of Turner meeting a well-known watercolour painter on the Mosel, and fraternising with him. He even went so far as to invite him to rather a handsome dinner, whereat the wine passed freely as the comrades discussed the scenery with enthusiasm. At last it was time to separate, and Turner and his guest exchanged friendly farewells. The next morning the weaker vessel arose late. His first enquiry was if Monsieur Turner had gone out sketching yet. 'Left for good at five o'clock this morning, and said you would settle both bills,' was the petrifying answer.

Turner's first biographer, Walter Thornbury, recounted the above story light-heartedly, as the incident deserved.[1] The artist enjoyed such practical jokes and would have laughed just as heartily if he had been on the receiving end. However, the glimpse it affords of Turner is totally convincing at a serious level. Throughout the tours described in this catalogue, Turner must have risen early and sketched incessantly day after day, week after week. He must have discussed the scenery with enthusiasm, indeed passion, over a glass of wine on many occasions after his day's travelling and sketching were completed. And he was always elusive. When he arrived at Vienna in 1840 he was registered by the authorities as two English noblemen, Herr 'Joseph Mallard' and Herr 'William Turner',[2] and from his own day to the present his many visits to Germany have defied investigation. Yet the country played a very important part in his working life for nearly thirty years, from his first visit to the Rhineland in 1817 at the age of forty-two (cat.nos.8–18) to the publication of the fine large engravings of 'Ehrenbreitstein' and 'Heidelberg' in 1846 (cat.nos.110, 128) just five years before his death. His visits took place at a period in European history when relations between Britain and Germany were exceptionally close, and his depictions of German scenery – some of them now exhibited for the first time – display again and again all the mastery for which he is famous. The story of Turner in Germany must elude us no longer.

Between 1817 and 1844 Turner travelled the length and breadth of Germany, from the Baltic to the Alps, from Aachen in the west to Dresden in the east. During this period, as for centuries before it, Germany consisted of scores of different independent states, principalities and kingdoms. Some, like Bavaria or Prussia, consisted of huge territories, while others were quite tiny, and each had its own ruling family, systems and traditions. In his attempt to dominate Europe Napoleon had defeated one state after another, instituting French law, language and customs, destroying historic ecclesiastical foundations, imposing trade restrictions, exchanging strategically useless territories for ones that would enable his armies to march unhindered across great stretches of Europe. In June 1806 he abolished the Holy Roman Empire which dated from the Middle Ages, and in July of that year he forced sixteen German states, including Bavaria, into a new entity, the Confederation of the Rhine. Through this he was able to control Germany up to three hundred miles east of the Rhine. Some eight million Germans became to all intents and purposes French subjects and tens of thousands were conscripted into the French army. It was not until after Napoleon's retreat from Moscow in 1812–13 that the tide was turned and the French were gradually driven out of German territory, thanks above all to the determination and power of the Prussians. The turning-point was the 'Battle of the Nations' fought at Leipzig on 16–19 October 1813. Here the combined forces of Austria, Prussia and Russia inflicted a serious defeat on Napoleon who was forced to retreat to the Rhine. The decisive moment in the battle, 18 October, became a date with great emotional significance throughout Germany in the period of Turner's visits.

During the years of war it was difficult for Britons to visit the Continent, though Turner did manage to snatch a quick visit to France and Switzerland in 1802. His first contact with Germany was therefore through prints and paintings rather than travel. As a student at the Royal Academy in the 1790s, however, he would probably have learned little of German art. In the lectures of its first President, Sir Joshua Reynolds, published as the *Discourses on Art* (1769–90) and virtually a policy statement of the Academy in its early years, the art of northern Europe was of minor significance compared to that of Italy, and early

painters such as Dürer were regarded not as pioneers and masters in their own right but simply as predecessors of the greatest period of European art, the Italian High Renaissance.[3] Reynolds never mentioned Grünewald, Cranach or Altdorfer at all and judged Dürer solely by Italian standards: 'Albert Dürer, as Vasari has justly remarked, would, probably, have been one of the first painters of his age ... had he been initiated into those great principles of the art, which were so well understood and practised by his contemporaries in Italy.'[4] With the President of the Royal Academy uttering sentiments such as these, it is no wonder that British artists were slow to appreciate Dürer's genius. William Blake, however, was outraged by Reynolds's 'Condemnation & Contempt' of Dürer, as by much else in the *Discourses*, angrily annotating the above sentence in his copy, 'What does this mean, *"Would have been"* one of the first Painters of his Age? Albert Durer *Is*, Not would have been'.[5]

When Turner became Professor of Perspective at the Royal Academy in 1807, he made an intensive study of the subject, considering not only its theory and practice but also its history. This brought Dürer's own study of perspective to his attention, and Turner's preparatory notes in his sketchbooks, the large diagrams used in his lectures and the lecture manuscripts themselves all reflect interest in the ideas of his German predecessor.[6] In his first lecture (7 January 1811) he sought to demonstrate the importance of his subject by linking it with anatomy, sculpture, architecture and painting, and in pursuance of this he illustrated Dürer's depiction of the human body as a series of super-

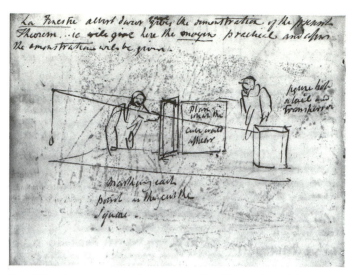

fig.2 Dürer's perspective window, copied by Turner from Salomon de Caus, *La Perspective avec la raison des ombres et miroirs* (1612) (TB CVIII 3v). Pen and ink, c.1809

imposed cross-sections from his *Vier Bücher von menschlicher Proportion* (*Four Books on Human Proportion*) of 1528 (fig.1). He also gave his listeners an outline of the early history of perspective, noting that Dürer was normally credited with 'adducing the art to some fixed method or rules of geometric proportions ... yet it cannot be inferred that all the painters prior to that period ... [were] ... so deficient of vision as to be blind to the obliquity of lines'. He pointed out that earlier artists' 'discoveries probably furnished the means to ... Durer', mentioning Jan van Eyck and Paolo Uccello amongst others, though curiously not Alberti, with whose ideas Dürer was certainly familiar. In his second lecture Turner referred to Dürer's 'famed fenestre'. In this, a window-like drawing frame, together with threads and a weight, is used to provide a theoretical perspective from a single fixed position, the frame intersecting the 'cone of vision' of the artist. This idea had been propounded in Alberti's *De Pictura* of 1435 but Turner was evidently more familiar with Dürer's work than Alberti's, copying both a diagram of Dürer's frame (fig.2) and a discussion of his ideas from a seventeenth-century French treatise, Salomon de Caus's *La Perspective avec la raison des ombres et miroirs* (1612). Turner recognised Dürer's contribution to the study and exposition of perspective and his mastery of it in his own work, but his appreciation was never whole-hearted. Having studied Dürer's perspective through such secondary sources as de Caus, he was uncertain of which innovations were truly Dürer's own; and, himself mistrusting the theoretical validity of parallel perspective and standard perspective in general, he felt that Dürer had obeyed it too rigorously and too conspicuously.

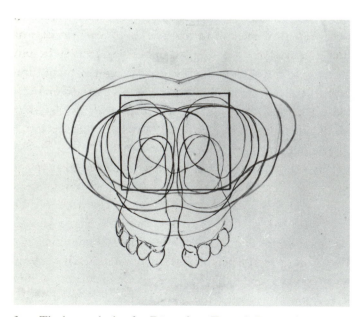

fig.1 The human body, after Dürer, from Turner's Perspective Lectures (TB CXCV 164). Watercolour, c.1810

Since Turner never refers to specific works by Dürer, it is hard to know what he studied in 1807–11. In Rome and Florence in 1819, however, he seems to have been impressed with his work, especially with one painting in the Corsini gallery in Rome which was then universally accepted as a Dürer.[7] This was the large portrait of a hare in a setting of wild plants and insects, now known to be the work of Hans Hoffmann (c.1530–1591/2) and just one of several elaborations of the 'Hare' by Dürer himself in the Albertina in Vienna.[8] Study of this may well underlie Turner's depiction of a large white rabbit, surrounded by flowers and plants, in the foreground of 'The Bay of Baiae', painted soon after this visit to Italy.[9] Overall, Turner's attitude to Dürer seems to have been one of interest rather than admiration and his opinions on Dürer's German contemporaries (if, indeed, he ever studied their work) are not recorded. When he eventually visited Dürer's home town of Nuremberg in 1835 he stood right outside the artist's house to sketch the castle, including part of the house itself on the left and scribbling Dürer's name opposite (see fig.45, p.59). He did not single out the house for special treatment. To Nuremberg as a whole he devoted close attention, but, alas, he may well not have recognised that, in the history of art itself, he was standing upon a piece of genuinely classic ground.[10]

Turner's gradual discovery of the different parts of Germany in the 1820s and 1830s ran parallel with the country's own increasing prosperity and confidence. Time after time on his first visit in 1817 he was confronted with different aspects of the seizure and long occupation of the Rhineland by Napoleonic troops. As a traveller he personally felt the

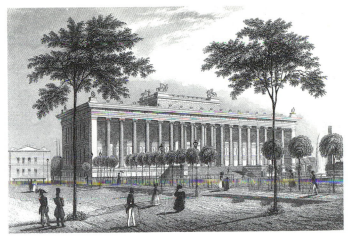

fig.4 Finden after K.F.W. Klose, 'Das Museum', engraving from S.H. Spiker, *Berlin und seine Umgebungen* (1833). *By permission of The British Library*

benefit of the *route Napoléon* built along the west bank of the Rhine – not only by French troops but for the use of French troops in their conquest of Europe. But at almost every turn of the river he saw yet another medieval castle, already wrecked during the wars of the seventeenth century, freshly devastated and blackened with smoke. He saw the fortress of Ehrenbreitstein being rebuilt by the Prussians to guard once more the confluence of the Rhine and the Mosel at Coblenz. He knew Mainz (and, later, the Mosel, Trier and Regensburg) by the French names imposed on them: Mayence, Moselle, Trèves, Ratisbon. He sketched modern ruins such as Mainz cathedral, its eastern dome a victim of the onslaughts of the early 1790s. Not surprisingly, the watercolours resulting from this tour are infused with solemn grandeur and clouds often hang heavy over the river that has been the scene of so many wars.

As Turner explored further afield, however, in Bavaria and Prussia over the next two decades and more, he saw many different faces of Germany and a lighter mood prevailed. There were, of course, obvious regional differences: the diversity of Germany's countryside and the richness of its architectural heritage provide a wealth of subjects for an artist. But many contemporary developments in a variety of spheres are reflected in Turner's sketches. Under the guidance of Ludwig I of Bavaria and Friedrich Wilhelm III of Prussia, both Munich and Berlin were transformed into magnificent new cities, filled with fine neo-classical architecture. The contrast with Germany's many medieval towns, such as Nuremberg (fig.3), could not have been greater. Civic and religious buildings sprang up, as did new museums and galleries (fig.4), designed to house both historic art collections and ones still in the course of being formed. An even greater monument in neo-classical style

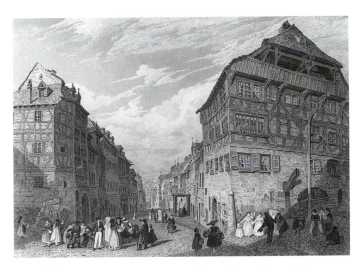

fig.3 W.R. Smith after George Lewis, 'Albert Durer Street, Nuremberg', engraving from T.F. Dibdin, *A Bibliographical, Antiquarian and Picturesque Tour in France and Germany* (1821). *By permission of The British Library*

was constructed in the same decade of the 1830s, the temple of the Walhalla overlooking the Danube, built for Ludwig of Bavaria but honouring all the great Germans of the past. Turner made this the subject of an oil painting (see cat.no.109).

Turner first discovered the Danube in 1833 and explored it further in 1840 but it was not destined to play such an important role in his work as the Rhine or the Mosel. Although it is even longer than the Rhine, reaching from the Black Forest to the Black Sea, the Danube has never been a major trade route for western Europeans. It was used only occasionally by British travellers before Turner's day, unlike the Rhine which had for centuries been the standard route both for merchandise of all kinds and for travellers, especially those returning from the Grand Tour of Italy in the eighteenth century.[11] In the late 1820s, however, Britons started to explore the Danube more seriously, given that 'the tour of the Rhine is now almost as well known as the voyage to Margate'.[12] Comparisons were inevitable and travel writers debated the relative aesthetic merits of the two rivers in different ways. One saw the Danube and the Rhine as the perfect embodiments of the Sublime and the Beautiful as laid down in Burke's *Philosophical Enquiry into the Origin of our Ideas of the Sublime and Beautiful*, with the Danube and its scenery being 'vast in their dimensions', 'rugged and negligent', 'dark and gloomy' 'solid and even massive' compared to the tamer beauties of the Rhine (fig.5).[13] Another claimed to have conducted a vigorous verbal battle with a fellow-passenger from the Rhine itself while on a Danube steamer: 'I cannot enter into a minute detail of every round we fought: I remember only, that at last, as he already staggered under

my blows, he took up a vineyard, and I smothered him with a forest; he flung a ruin at my head, and I floored him with a great living castle; he made a last desperate attack with a hill, and I fairly crushed him with a mountain. My victory was great and complete.'[14] Turner, it must be surmised from his drawings, would have sided with the Rhinelander on this occasion. He recorded many of the famous sights of the Danube in small pencil sketches, but it was only around Passau and Regensburg that he was moved to get out his colours and try to capture atmosphere as well as topography (see cat.nos.85–96).

The arrival of the age of steam on both the Rhine (1827) and the Danube (1837) made Turner's journeys through Germany increasingly easy. In August 1840, he could have travelled by steamer from Cologne up to Mainz in a single day, leaving early but arriving well before midnight.[15] On both rivers, however, there was still a paucity of permanent bridges, whether in stone as at Regensburg or in wood as at Linz, and travellers were dependent on flying bridges, bridges of boats and ferries. At the time of Turner's first visit to Germany, both Cologne and Coblenz had a flying bridge across the Rhine which operated in a somewhat cumbersome fashion: a large floating railed-in platform was attached by a long chain to boats moored higher up in mid-river and it was guided across the river by boatmen, swinging to and fro like the pendulum of a clock. These were replaced at Coblenz in 1819 and at Cologne in 1822 by bridges of wooden pontoons, which would have speeded travellers on their way much more efficiently, except when they needed to be opened to allow the passage of rivercraft or when, as frequently happened in winter, they were damaged by storms or ice floes. Turner used and recorded all these methods of crossing Germany's great rivers and often included them in both sketches and finished works (see cat.nos.23, 27, 95). For him they were not picturesque but the stuff of everyday life. The mighty stone bridges that had survived the centuries, however, were more laden with significance: the Mosel bridge at Coblenz, the bridges at Dresden, Prague, Würzburg and Regensburg were impressive examples of man's achievement in the face of nature, and a stone bridge that had withstood the repeated onslaught of floods and gales was as powerful a symbol as a castle that had survived centuries of war.

There were also many improvements on the roads during Germany's years of economic recovery. Turner would have felt the benefit of road-building on a vast scale (between 1816 and 1831 the length of made-up roads maintained by Prussia more than doubled, for instance[16]). Even more significant, perhaps, was the introduction in the early

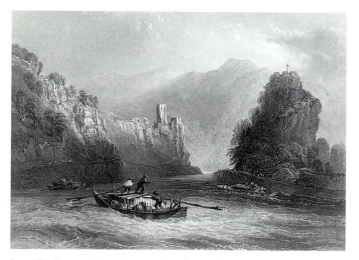

fig.5 C. Cousen after W.H. Bartlett, 'The Strudel', engraving from W. Beattie, *The Danube* (1844)

1820s of the *Schnellpost*, known as the *Eilwagen* in southern Germany: a comprehensive road-transport system linking all the disparate parts of the country together in a network of carriage routes which operated far more quickly and efficiently than the old system of travelling on the post routes. Like so much else in these years, the new system owed its inception to the period of occupation by Napoleon, but its benefits were felt far and wide, by visitors as well as by the Germans themselves.[17]

Thanks to the new, more flexible systems of travelling, Turner was able to make speedy progress through Germany when he wanted and to linger where and when he chose. Thus in 1835 his close study of the celebrated artistic capitals of Denmark, Prussia, Saxony and Bohemia – all within a mere three weeks – was greatly assisted by the fact that by now it took only twenty-four hours to travel from Kiel to Copenhagen, twenty-four hours from Berlin to Dresden and slightly less than that from Dresden to Prague.[18] However, although – at this practical level – Germany was now becoming more unified, in other respects regional independence was as strong as ever. Individual towns and states had their own separate daily newspapers which often listed the arrivals of strangers (and sometimes their departures) in regular 'Fremden-Anzeige' columns. The appearance of Turner's name in these frequently corroborates the evidence of his own sketchbooks and once his exact timetables are known his industry and indefatigability become even more remarkable.

Turner's sketches are a visual diary of his experiences in Germany but, like all diaries, they only tell part of the story. A sketch proves that he saw a given sight and was pleased or interested by it; but the absence of a sketch may be attributed to any number of causes. Why, for instance, did Turner not sketch any of the Old Master paintings in Berlin and why did he ignore the most famous Correggio in Dresden, 'La Notte', when he made tiny copies of all the others (see cat.no.32)? He may have regarded it as in exceptionally poor condition, as several other British visitors did at this time; he may have been prevented from seeing it by the crowd of visitors, by fading light, by lack of time, by sheer carelessness. It is fruitless to speculate on these questions when there is so much positive evidence of what Turner actually did. However, many notes, comments and sketches represent, one suspects, merely the tip of the iceberg as far as his knowledge of Germany was concerned. Who, for example, was the 'German Bookseller in Paris' whom Turner, engaged in illustrating Scott's *Life of Napoleon* in 1832, desired to obtain prints or sketches of the battlefields of Austerlitz, Wagram and Friedland?[19] What was Turner thinking of in 1847 when he exhibited his painting 'The Hero of a Hundred Fights' accompanied by a reference to 'the German invocation upon casting the bell: in England called tapping the furnace'?[20] Reverting to his own German tours, one may well wonder how it came about that in 1833 Turner made his quick sketches of one of the antique statues in the Glyptothek in Munich, a museum where copying was expressly forbidden.[21] Did he make them from memory afterwards or surreptitiously in the gallery itself? Or was he the honoured and indulged guest of its director, Johann Georg Dillis, who personally conducted another British painter, David Wilkie, round the Munich galleries? Again, when Turner sketched St Peter's church in Munich from exactly the same position as the etching in Domenico Quaglio's celebrated series of Munich views, published twenty years earlier, where and in what circumstances had he seen the prototype?[22] In Vienna in 1840 he made tiny sketch copies of several of the lithographs in Jakob Alt's famous series of views on the Danube and of other prints as well (see cat.no.64). He must surely have met members of the artistic community in these and other cities, given the strong ties between Britain and Germany during his lifetime.[23] The links should not be underestimated by twentieth-century lovers of his art.

* * *

When Turner was born in London in 1775, King George III, descendant of the Electors of Hanover, had been on the throne for fifteen years. George III was the first of the Hanoverian kings to 'speak English like an Englishman' but German remained the natural language of the royal family. Indeed, until 1837, when Turner was sixty-two, the king of England was also king of Hanover. Royal links with numerous German states were formed as a matter of course, largely because Germany provided an enormous pool of suitable, that is Protestant, marriage partners: George III's children married into the princely families of Brunswick, Prussia, Saxe-Meiningen, Württemberg, Saxe-Coburg, Hesse-Homburg and Hesse-Cassel. During some of the most formative years of Turner's life, Britain and Germany were engaged in a common struggle against the threat of a Europe dominated by France. After more than twenty years of a war which reached every corner of continental Europe, it was the combined forces of Britain and Prussia, led by the Duke of Wellington and General Blücher, that finally put paid to the ambitions of Napoleon on the Field of Waterloo on 18 June 1815. When both of George III's eldest sons, George IV and William IV, died without legal

heirs, the British throne passed in 1837 to the eighteen-year-old Victoria, sole surviving grandchild of George III and, literally, born to be queen: she was the only child of the marriage between the Duke of Kent (1767–1820) and Princess Victoria of Saxe-Coburg-Saalfeld, hastily arranged in 1818 in order to secure the Hanoverian succession. The ties with Germany were reinforced once again when Victoria married her first cousin, Albert of Saxe-Coburg-Gotha, at the beginning of 1840.

There were close links between Britain and German states in every area of science, commerce and the arts and at every level from the greatest to the least. British firms were involved in developing the steamships on major German rivers which Turner was so often to use from the 1820s onwards. After the great fire that devastated Hamburg in May 1842 (and thus came to be both reported and illustrated on the front page of the very first copy issued of the *Illustrated London News*), British engineers and architects were closely involved in its rebuilding and a British architect, Sir George Gilbert Scott, designed its new cathedral.[24] On the other side of the sea, new life was brought into the print-selling activities of London by Rudolph Ackermann who had arrived from Saxony in the late eighteenth century and set up a fine-art publishing business in the Strand. Amongst his many other activities, in the 1820s Ackermann introduced into England from Germany the 'annuals', the little new year's gift books containing stories, poems and engravings. These were soon copied by other booksellers. They were quite distinct from the earlier British 'pocket-book' annuals, filled with useful information, and became immensely popular from the 1820s to the 1840s, Turner himself being a regular contributor, especially to the *Keepsake*.

Letterpress printing had, of course, been invented in Germany in the fifteenth century (see cat.no.37) and at the very end of the eighteenth century a new printing process which was to revolutionise the reproduction of paintings and drawings was also invented there. Lithography, or the art of drawing on stone, involves no engraving process but is based on the antipathy of grease and water, and was invented by the Bavarian Alois Senefelder. The new method was immediately taken up in England and was used to particularly brilliant effect by Samuel Prout in several series of plates, published in the 1820s and 1830s, which contained magnificent depictions of German architecture. Pre-eminent among them was the *Facsimiles of Sketches Made in Flanders and Germany* of 1833 which certainly inspired the fourteen-year-old Ruskin's continental tour with his parents of that year, may also have influenced

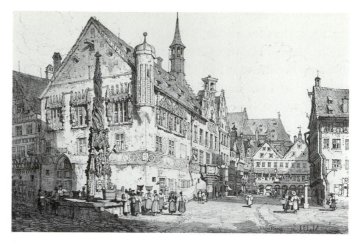

fig.6 C. Hullmandel after Samuel Prout, 'Ulm: The Rathaus', lithograph from *Facsimiles of Sketches Made in Flanders and Germany* (1833). *By permission of The British Library*

Turner's though the two artists' visions of Germany were always wholly different, and received handsome praise from Ruskin in *Modern Painters* ten years later (fig.6).[25] Another fine series of lithographed views, which was to have an important catalytic effect upon Turner, was Clarkson Stanfield's *Views on the Moselle, the Rhine, & the Meuse* of 1838. Turner himself seems never to have practised the art of lithography although he was keenly interested in engraving techniques. However, he did own a copy of Senefelder's *A Complete Course of Lithography*, published by Ackermann in 1819. One of Turner's watercolours was reproduced as a lithograph in the early 1820s and several more plates were issued soon after his death, presumably with his approval.[26]

In other areas of the arts there were many further examples of co-operation and liaison. In the mid-1820s the celebrated Prussian architect Karl Friedrich Schinkel paid a visit to England during which he studied everything from factories, warehouses, docks and the achievements of Thomas Telford and Isambard Kingdom Brunel through to the arrangements in the National Gallery in London, opened in 1824.[27] A decade later, when the Institute of British Architects was inaugurated, both Schinkel and the leading architect in Munich, Leo von Klenze, were among its Honorary Members and Correspondents. Many British writers, including Wordsworth and Coleridge, spent considerable periods in Germany in order to learn the language, meet the great German writers and thinkers of the age and read the works of Goethe, Schiller, Herder, Klopstock, Lessing and Bürger in the original. As is well known, Wordsworth was far less successful in this endeavour than Coleridge, his lonely winter in Goslar in 1798–9 being redeemed only by thoughts of home and thus leading

directly to the composition of *The Prelude*. However, other British writers forged very strong ties with Germany, chief among them two who were personally known to Turner through his illustration of their collected works in the 1830s: Scott and Campbell.

The art of Sir Walter Scott (1771–1832) was largely shaped by his early study – and translation – of German literature in the 1790s. His first published translation was of Bürger's *Lenore* and *Der Wilde Jäger* (*The Wild Huntsman*) in 1796, his second of Goethe's *Götz von Berlichingen* in 1799, and the impact upon him of these ballads and Goethe's play cannot be overemphasised. As his son-in-law and biographer J.G. Lockhart was later to observe:[28]

> with what double delight must he have seen Goethe seizing for the noblest purposes of art, men and modes of life, scenes, incidents, and transactions, all claiming near kindred with those that had from boyhood formed the chosen theme of his own sympathy and reflection! In the baronial robbers of the Rhine, stern, bloody, and rapacious, but frank, generous, and, after their fashion, courteous … Scott had before him a vivid image of the life of his own and the rival Border clans, familiarised to him by a hundred nameless minstrels … [Reading Goethe, he realised that] he had been unconsciously assembling materials for more works of high art than the longest life could serve him to elaborate.

Scott's works became enormously popular in Germany – so much so that when it was heard that *Redgauntlet* would not be ready in time for the Leipzig Book Fair of 1824, an unscrupulous German printer simply wrote and published a substitute, *Walladmor*.[29] Fashionable young ladies could be seen on Rhine steamers with tartan silk parasols 'à la Sir Walter Scott', and when a party including Scott himself entered a Frankfurt bookshop in 1832 they were immediately offered a lithograph of his own home, Abbotsford, not because he had been recognised but simply because they were British.[30] If Turner had ever mentioned, in a small town in Germany in the course of one of his tours, that he knew Scott well through illustrating his works (fig.7) and had stayed with him at Abbotsford, he would have been an instant celebrity for that alone.

Thomas Campbell (1777–1844), also a Scot by birth but largely resident in London, developed his German connections in a very different fashion. He went to Hamburg in 1800 where he became acquainted with Klopstock, visited other cities including Munich, Regensburg and Leipzig during that year and only returned to England when the

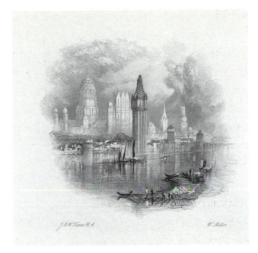

fig.7 William Miller after J.M.W. Turner, 'Mayence' (R 533). Engraving from Scott's *Prose Works* (1835)

British fleet arrived in the Baltic, early in 1801, intent on punishing Denmark for her conciliatory attitude towards Napoleon. Two of his poems with German connections later illustrated by Turner, 'The Battle of the Baltic' and 'Hohenlinden' (cat.no.36), were inspired by events around this time. Later he returned to Germany in more pleasant circumstances, spending several months there in 1820 when he was entertained by both the Schlegel brothers, attended lectures at Bonn University and was inspired by the beauties of the Rhine beneath the Drachenfels to compose 'The Brave Roland'.[31] It was not until 1832, however, that he composed his 'Ode to the Germans', after the democratic revolution in the short-lived Kingdom of Poland, a creation of the Vienna Settlement of 1815, had been brutally suppressed by the Russians (see cat.no.37).

Bloodshed and heroism, in both ancient and modern times, also infused the Rhineland portrayed by Lord Byron (1788–1824) whose posthumous collected works were published in 1832–4 with numerous illustrations after drawings by Turner (see cat.nos.24–6).[32] These scenes typify the places viewed by Don Juan and by Byron's other wandering hero, his own *alter ego*, in *Childe Harold's Pilgrimage*, with Turner responding sensitively both to Byron's wit and to his sense of melancholy. On many occasions Turner appended quotations from Byron to his exhibits at the Royal Academy and did so in 1835 for 'The Bright Stone of Honour (Ehrenbreitstein), and Tomb of Marceau, from Byron's *Childe Harold*'. This was painted in order to be engraved (see cat.no.110), and thus to reach a far greater audience than the visitors at the Royal Academy, and a conspicuously Byronic theme will have been no hindrance to its marketing.

The seventeen-volume edition of Byron illustrated by

Turner was published by John Murray, a firm also renowned for its books of travel and topography. Turner had begun producing illustrations for engraving in some of their books around 1814 and was on friendly terms with members of the family and its circle for over thirty years. In 1836 the firm began publishing their *Handbooks for Travellers on the Continent*, of which the first two, devoted to northern Germany (1836) and southern Germany (1837), were the work of John Murray III himself. He reputedly met Turner in the Tyrol in the 1840s but this meeting, unlike those they had in London, was evidently accidental and they were not, in fact, travelling companions.[33] There is clear evidence in Turner's sketchbooks that he consulted the first edition of the *Handbook* for northern Germany on at least one occasion, in 1839 (see cat.no.63), though his library at his death did not include a copy. Furthermore, he used some of the routes suggested in that book a year before it was published: a salutary reminder that Murray's guidebooks reflected what British travellers were already doing rather than making radical suggestions.

Of Turner's close friends, three had particularly deep and long-lasting connections with Germany. One was David Wilkie (1785–1841), the Scottish genre painter; the second, the landscape painter Augustus Wall Callcott (1779–1844); and the third, Charles Lock Eastlake (1793–1865), a scholar as well as a painter, who eventually became both President of the Royal Academy and Director of the National Gallery. All three would have fostered Turner's interest in travelling in Germany and in German art both past and present, though their individual concerns were rather different.

Wilkie acquired a considerable reputation on the Continent, and particularly in Germany, through the dissemination of engravings of his genre scenes, depictions of Scottish life in the tradition of the Dutch masters of earlier centuries. As one notable German remarked, he shared with Sir Walter Scott a 'genuine, refined delineation of character which extends to the minutest particulars … they show us man in his manifold weaknesses, errors, afflictions, and distresses, yet their humour is of such a kind that it never revolts our feelings'.[34] In 1819 Wilkie was commissioned by the King of Bavaria to produce a work for the royal collection in Munich and he painted 'Reading the Will' (fig.8). George IV saw this at the Royal Academy in 1820 and would dearly like to have bought it; Wilkie was thus in the unusual position of having two monarchs contending for his work and had regretfully to decline the offer of his own sovereign (Turner may have recalled this episode with some bitterness later on when he himself

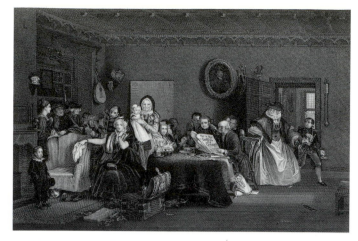

fig.8 David Wilkie, 'Reading the Will', engraving from Payne's *Book of Art with the Celebrated Galleries of Munich* (1850). *By permission of The British Library*

failed to make any impression on Queen Victoria and Prince Albert).[35] From then on Wilkie enjoyed a close relationship with the art establishment in Munich, being on friendly terms with its chief administrator, Johann Georg Dillis, and having contact there with other painters including Peter Cornelius and Julius Schnorr von Carolsfeld.[36] He also loved the German countryside and its people, constantly remarking on their similarity to his native land and fellow-countrymen.[37] Turner's affection for Wilkie and his grief at his death are well known through his remark to Stanfield that he could not make the sails in 'Peace – Burial at Sea' black enough to express his sorrow.[38] It is inconceivable that the two friends had not discussed Wilkie's experiences in Dresden, Teplitz and Prague in 1826 before Turner's visits to the same places in 1835, especially when Wilkie had specifically written home declaring that Prague and Turner were ideally suited to each other.[39] Wilkie's last journey eastwards through Europe in 1840 took him for the first time to places Turner had admired in 1833 – Salzburg and the Danube below Linz with its wild and beautiful scenery. Perhaps the friends had discussed this part of Europe also.

Callcott, too, travelled widely in Germany and much is known of his experiences there, thanks to the journal kept by his wife Maria whom he had married some three months before their long European tour of 1827–8.[40] They sought out connoisseurs and collectors, early German paintings and the works of modern artists, with an enthusiasm and single-mindedness that makes their tour unique and gives it a dimension very different from Turner's. Indeed, they were sometimes so engrossed in works of art that they had to restrict their exploration of fine scenery – a sacrifice which Turner himself would rarely, if ever, have made.

None the less, he would have learned much from their experiences, and certain aspects of his tours of 1833 and 1835 echo theirs. Like Wilkie and Eastlake, they enjoyed conversations on painting and architecture with many figures in the art establishments of Germany and could have offered Turner both advice and introductions.

With Eastlake, Turner would have had an equally wide range of German topics to discuss. When the two shared lodgings and a studio in Rome in 1828–9, Eastlake – who had been living in Rome since 1816 – was on close terms with the German community of artists there and Turner would undoubtedly have met some of them and seen examples of their work. Indeed, he may have done so in 1819 when he made a list of names of foreign artists working in Rome which includes three eminent Germans: Johann Christian Reinhart, Joseph Anton Koch, Wilhelm Friedrich Gmelin.[41] In 1828, Eastlake himself had only just returned from a month in Germany during which he studied both the work of the Old Masters and that of his contemporaries in Cologne, Berlin, Dresden, Munich and elsewhere. He discussed art with the curator Gustav Waagen in Berlin and with the Nazarene Peter Cornelius in Munich, watching the latter work on his mural decorations in the rooms of the new Glyptothek.[42] All this he would doubtless have recounted to Turner. When Eastlake translated Goethe's *Farbenlehre* (*Theory of Colours*) into English in 1840, Turner was soon the possessor of a copy, reading it avidly and filling it with marginalia, not all of which were complimentary to its distinguished author (cat.no.4). In 1843 he exhibited two paintings at the Royal Academy which were his own form of reply to Goethe's theories: 'Shade and Darkness – the Evening of the Deluge' and 'Light and Colour (Goethe's Theory) – the Morning after

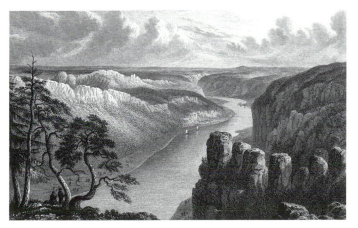

fig.9 Robert Wallis after Robert Batty, 'Banks of the Elbe from the Bastei Rock', engraving from *Hanoverian and Saxon Scenery*, Pt III (1827). *By permission of The British Library*

the Deluge – Moses Writing the Book of Genesis',[43] the two paintings which were stolen in 1994 whilst on loan to the Schirn Kunsthalle in Frankfurt, host to an exhibition celebrating the subject of Goethe and the visual arts.

Turner's relationships with poets and with other painters who had deep and varied interests in Germany contributed much to his vision of the country as well as to his knowledge and exploration of it. While his pencil sketches were, necessarily, factual memoranda, his coloured drawings were never mere topographical statements, unlike the work of so many of his contemporaries. German scenes were plentiful in publications such as Captain Robert Batty's *German Scenery* (1823), *Scenery of the Rhine* (1826) and *Hanoverian and Saxon Scenery* (1829) (fig.9) and in *Tombleson's Views of the Rhine* (1832). Turner sometimes copied their subjects and viewpoints but enriched them with perceptive glimpses of everyday life, historical or allegorical references, dazzling atmospheric effects and, always, with the sheer brilliance of his technique in both oils and watercolours.

* * *

Turner's paintings have not always been as popular with audiences in Germany as they are today. German painters and critics alike have consistently found his work too vague and too extravagant for their liking, even at a surprisingly early date. Part of the reason lay in the traditional German love of drawing, clarity and truth to nature, exemplified in Old Masters such as Dürer and Cranach and pursued in the early nineteenth century by the Nazarene painters in Rome, forerunners of the British Pre-Raphaelites in turning to the masters of the early Renaissance for their inspiration. A contributory cause was that many nineteenth-century Germans were familiar with Turner's work through the medium of small steel engravings. These often transformed comparatively freely painted works into models of delicacy and precision, so that the shock of seeing a large, real painting by Turner was often considerable.

The first German to comment on his paintings was the art historian Johann Dominicus Fiorillo, writing in 1808, who described him as one of the most respectable artists of the British school whose style had, however, become too loose in his most recent works.[44] Twenty years later, by which time his style could, indeed, be described as 'loose', Turner exhibited three paintings in a studio in Rome ('View of Orvieto', 'Vision of Medea' and 'Regulus').[45] These attracted strong criticism from the Nazarene

painters there, including a scurrilous cartoon and an attack by the acknowledged master of the German artists in Rome, Joseph Anton Koch, for their combination of accident and fantasy.[46] The paintings could, he said, have been produced by a person wearing a blindfold who drew the first thing that came into his head, and it made no difference to what could be seen in the 'Vision of Medea' whether it was the right way up, on its side or upside down.

Carl Blechen, working in Rome at the time, seems to have appreciated the beauty of Turner's fluid and expressive handling which can probably be seen reflected in his own oil studies of skies and luminous landscapes, but his reaction was exceptional.[47] Johann David Passavant, the artist and critic who had earlier championed the Nazarenes in Rome, visited England in 1831. When he saw Turner's exhibits at the Royal Academy he was both disappointed and horrified at what he found:[48]

This artist is decidedly the most talented of all the living landscape painters; but such is his extravagance of effect, and total neglect of all form, that the English, although great admirers of his genius, are seldom found willing to purchase his works. Generally speaking, his oil pictures are finished off in the most hurried manner, and only just in time to be admitted into the exhibition … [In the works seen] a straining after extraordinary effects is too apparent, united, it must be owned, to great power of imagination, but so utterly defying all the usual rules of art, as only to afford satisfaction when viewed from a distance: on coming near, the eye seems to lose all power of discrimination … we find ourselves at once launched into the realms of impossibility – drawing, colouring, light and shade, all in such glorious confusion, that even the first rough sketch of a picture would be easier deciphered. To what purpose is talent, when unrestrained by rules?

Passavant published these remarks in his influential *Kunstreise durch England und Belgien* (1833) which was translated by Elizabeth Rigby (the future Lady Eastlake) and published in England in 1836 as *Tour of a German Artist in England*. By that date, however, an even more important personage from the German art world had paid a visit to London. This was Gustav Waagen, now the director of the Royal Gallery in Berlin, who devoted six months to a close study of art and artists in England, culminating in a description published in Berlin in 1837–8. This was closely followed by its publication in English in three volumes by John Murray in 1838. Waagen, too, criticised

Turner for his lack of precise drawing, vagueness of form, bad colour and absence of truth. When he visited the Bridgewater Gallery and saw Turner's 'Dutch Boats in a Gale' alongside the Van de Velde it had been painted to accompany, he found it inferior in almost every respect to the earlier work and hardly classifiable as art at all: 'inferior … in the truth and clearness of the clouds and waves, in feeling and detail of the execution, and compared with it, appears like a successful piece of scene-painting'.[49] His remarks on the Royal Academy exhibition of 1835, which included works today regarded as among Turner's most glorious achievements, were equally unfavourable:[50]

I made a point of looking for the landscape of the favourite painter Turner, who is known throughout Europe, by his numerous, often very clever compositions for annuals, and other books, where they appear in beautiful steel engravings. But I could scarcely trust my eyes, when, in a view of Ehrenbreitstein, and another of the burning of the two Houses of Parliament, I found such a looseness of treatment, such a total want of truth, as I had never before met with. He has here succeeded in combining a crude, painted medley, with a general foggy appearance. Many Englishmen are very sensible of this total running wild of a great talent; but many admire such pictures as remarkably bold and spirited.

Waagen was not alone in reacting to Turner's paintings in this way; many British critics shared his views. It was only a year later, when Turner exhibited 'Juliet and her Nurse' and two other paintings at the Academy, that a particularly vicious review appeared in *Blackwood's Magazine*, attacking Turner's 'higgledy-piggledy' composition, 'unpleasant mixture' of colour, daubed together 'with childish execution', and 'strange jumble' of materials all flung together in 'confusion worse confounded'. This inspired Ruskin to take up his pen for the very first time in defence of Turner.[51] When the young Ruskin wrote to the elderly Turner, enclosing a copy of his proposed riposte to the editor of *Blackwood's*, Turner thanked him for his 'zeal, kindness, and the trouble you have taken' but declared that 'I never move in these matters'.[52] It was perhaps partly in the same spirit of quiet defiance that in 1845 Turner decided to send one of his paintings to an international exhibition in Munich. The result, alas, was not a success.

'The Opening of the Wallhalla, 1842' (cat.no.109) had enjoyed a moderately favourable reception when it was exhibited at the Royal Academy in London in 1843 but no

purchaser was forthcoming and Turner was left with the painting on his hands. In 1845 he heard of the proposed Exhibition of Fine Arts to be held in Munich at the brand new exhibition building expressly built for this purpose (the Neue Kunstaustellungs-Gebäude, on the south side of the Königsplatz facing the Glyptothek), and it seemed an ideal opportunity to promote his unsold painting with its Bavarian subject matter. Mrs Owen, wife of the celebrated naturalist and anatomist Richard Owen, who knew Turner well, wrote in her diary for 8 August: 'I translated part of the programme of the Munich Exhibition for 1845 for Turner, as he is thinking of sending them a picture.'[53] The exhibition was opened on 25 August[54] and Turner's painting arrived in Munich about a month later, having been despatched from London probably in mid-August.[55] It was not appreciated and the correspondent of the *Athenaeum* soon reported:[56]

> Of our countrymen, Mr Turner, unfortunately, of all the English artists invited, is the only one who has contributed. His picture is 'The Opening of the Walhalla,' exhibited at the Royal Academy a year or two since. When it arrived it created no small surprise among the natives, and various were the suppositions afloat concerning it. It was by some considered a practical joke, of rather a heavy character, as the Academy had to pay the carriage, and could not refuse or return it. One paper asserted that the only question was, whether it was painted *in* Bedlam or *for* Bedlam? But, concerning the subject of the painting, there could be no doubt – for, in addition to the title in the catalogue, there might be read, on two little pieces of paper (apparently stuck on the foreground) certain inscriptions in bad French, to the effect that it was in honour of the '*Roi Bayern,*' and was a representation of the '*Triomphe de Walhalla.*' We English, I can assure you, had no little to bear in the way of banter; and our only defence was, that in former times the artist *did* paint fine pictures, but now he was an old man, and that age should have its privileges.

The German papers told a similar tale:[57]

> The painting caused a sensation because it was seen as a pure satire on this kind of celebration. One knew Turner from the lovely steel engravings after his drawings and imagined, therefore, that one had been honoured with a lampoon by him. If the later works of this master show the same kind of treat-

ment, they could be taken as proof of the worst and most ludicrous kind of confusion into which art can get. When looking at this picture, it was impossible to comprehend that the artist had once painted good pictures and knew how to produce beautiful effects of light and colour. Pictures of the above-mentioned kind show neither sense nor understanding. One would like to see these productions as a cheerful satire if only they were not, unfortunately, so patently meant to be taken seriously. For his contribution to the Munich art exhibition he goes down in history on page 198 of the Kunstblatt 1846, as a dauber. At the same time we note that in England too, the degeneration of such an outstanding talent is regretted. Some of his works are seen only as curiosities of the art of painting.

Turner's attempt to attract a German buyer failed utterly and the painting was duly returned to him. The episode has a curiously touching conclusion. On 20 May 1846 Elizabeth Rigby and Turner's friend H.A.J. Munro called on the artist in Queen Anne Street where they surveyed row upon row of unsold cherished masterpieces. Elizabeth Rigby wrote in her journal:[58]

> Then up into the gallery; a fine room – indeed, one of the best in London, but in a dilapidated state; his pictures the same. The great 'Rise of Carthage' all mildewed and flaking off … There was a picture in Wilkie's line – a harvest feast – painted the same year as Wilkie's 'Rent Day', and showing most astonishing powers and truth; but he was disgusted at some remarks, and never finished it … Then he uncovered a few matchless creatures, fresh and dewy, like pearls just set – the mere colours grateful to the eye without reference to the subjects. The 'Téméraire' a grand sunset effect. The old gentleman was great fun: his splendid picture of 'Walhalla' had been sent to Munich, there ridiculed as might be expected, and returned to him with 7*l.* to pay, and sundry spots upon it: on these Turner laid his odd misshapen thumb in a pathetic way. Mr. Munro suggested they would rub out, and I offered my cambric handkerchief; but the old man edged us away, and stood before his picture like a hen in a fury.

How pleased he would surely have been to know that, a hundred and fifty years later, his work was to find such favour in Germany.

The First Visit to the Rhine, 1817

The English flocked to the Continent after 1815, eager to travel once more. High on everybody's list were the Field of Waterloo and the Rhineland, both so memorably treated by Byron in canto III of *Childe Harold's Pilgrimage* published in November 1816. In heading for these two destinations in the summer of 1817, Turner was simply following the crowd, but the impact of this tour on his own career should not be underestimated. Although he had visited France and Switzerland in 1802, this had been with a companion.[1] The tour of 1817 was his first attempt at foreign travel alone and unaccompanied, and it might well have been a personal and professional disaster, resulting in a disinclination to leave the shores of Britain ever again. As it was, he found that he could cope with all the multifarious travelling arrangements: the difficulties of language and the intricacies of currency, not to mention the interminable delays and seemingly endless harassment from customs officials at Europe's plethora of borders and the constant nightmare of alien food and drink. For many insular Britons these were too much to endure, but for Turner it became clear, from very early on, that the benefits of foreign travel easily outweighed its problems. In 1817 he was enormously stimulated by what he saw, making vast numbers of pencil drawings, and when he returned he immediately transformed some of his Rhine sketches into a series of watercolour and gouache scenes which instantly sold to a friend and patron for the same price as a large oil painting.[2] His 1817 tour was thus a triumph both personally and professionally. It gave him the confidence to make a far more ambitious continental tour two years later, in which he visited Venice, Rome, Naples and Florence, and the pattern of his life was set thereafter. He used part of each summer for travel, usually spending a month or two abroad and collecting data in his sketchbooks. His winters in London were devoted to transforming his hoard of material into the watercolours and oil paintings that led to his fame and fortune. Some of these were simply sold to individual patrons and collectors. Others reached a much wider audience, being executed for publishers or printsellers who launched Turner's scenes on the public as prints, usually at this date as steel engravings. Either way, Turner received a sufficient return on his work for the

annual cycle to continue right up to the summer of 1845 when he was seventy.

Turner prepared himself for his 1817 tour with as much care as he had done for his earlier British tours and was later to prepare for Italy and other parts of Germany itself. He bought three leather-bound sketchbooks of different sizes, the two larger ones containing the high quality Whatman paper which he preferred to any other, and the most up-to-date English guidebook available, *The Traveller's Complete Guide through Belgium and Holland ... with a Sketch of a Tour in Germany* (2nd ed., 1817) by Charles Campbell. It may also have been about now that he acquired another new but more discursive book on some of the areas he was about to explore, *A Picturesque Tour through France, Switzerland, on the Banks of the Rhine, and through Part of the Netherlands* (1817) by J. Mawman. In the smallest of his sketchbooks (TB CLIX, *Itinerary Rhine Tour*) he made copious notes covering sights and distances, inns and currencies, useful foreign phrases and transport in all the regions he was about to visit. Some derive from Campbell's book but most are copied from two large illustrated volumes he could certainly have neither afforded nor carried with him: *Sketches in Flanders and Holland; with some Account of a Tour through Parts of those Countries, shortly after the Battle of Waterloo; in a Series of Letters to a Friend* (1816) by the watercolour painter Robert Hills and *Views Taken on and near the River Rhine, at Aix la Chapelle, and on the River Maese* by the Revd John Gardnor, first published between 1788 and 1791 and then reissued in a smaller format in 1792.[3]

Turner's many notes from the 'Hints of Occurrences in the Tour' accompanying Gardnor's Rhine scenes (fig.10) reveal that artist as a dominant force in his attitude to the Rhineland. Just as Turner was embarking on his artistic career in the 1790s, that of Gardnor (1729–1808), a frequent exhibitor at the Royal Academy, was coming to an end, with his last scenes appearing in 1796. His landscapes were dictated by the taste of the time, showing views in Wales, the Lake District and the Isle of Wight. He also made one important foreign tour, travelling to the Rhine in 1787. For the next few years his exhibits consisted almost exclusively of large watercolours of Rhine subjects and

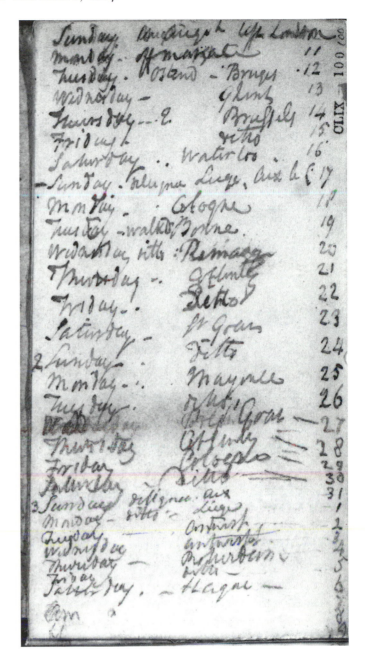

fig.10 Turner's notes on St Goar, copied from John Gardnor's *Views Taken on and near the River Rhine* (TB CLIX 24r). Pen and ink, 1817

during the same period these were published as thirty-two folio-size aquatints in the eight parts of the *Views on the Rhine*. Gardnor's influence upon Turner can thus be dated to two distinct periods, the 1790s and 1817. The young Turner was avidly studying the work of established artists around 1790 – the year in which the Royal Academy first accepted one of his works, the watercolour 'The Archbishop's Palace, Lambeth'. He must surely have noticed Gardnor's six large Rhine watercolours in 1790. They were close to Turner's own watercolour in the Academy's printed catalogue and they were, in any case, exactly the sort of works to which he would naturally have been drawn.[4] By the middle or late 1790s Turner could have handled Gardnor's book in the libraries of his new-found friends and patrons; the Academician Joseph Farington, for instance, was one of the subscribers to the sets of prints. At this date Turner's interest would have focused on Gardnor's aquatints, but in 1817 his text was of paramount importance; it not only described the highlights to be sought but also suggested the best viewing spots for sketching them. On the 1817 tour Turner often took heed of Gardnor's recommendations and followed closely in his footsteps (see fig.12).

He also benefited greatly from the 1817 edition of Campbell's *Guide through Belgium and Holland*, following the itinerary described from Margate to Brussels and the Field of Waterloo, across Belgium to Cologne, along the Middle Rhine, and finally through Holland.[5] In his first edition (1815), Campbell's tour had begun in Holland, but he rearranged his material radically in the second edition to accommodate and give prominence to its most important new feature, the chapter on the Field of Waterloo. Turner kept a record of his own movements in the same small sketchbook that he had used for his notes from Hills, Gardnor and Campbell, making this tour one of the best

fig.11 Turner's timetable of his 1817 tour (TB CLIX 100r). Pen and ink followed by pencil, 1817

documented of his entire career (fig.11). He provides dates and places from his departure from London on Sunday 10 August through to his arrival in The Hague nearly four weeks later, on Saturday 6 September.

Turner's days in Belgium and Holland lie beyond the scope of the present catalogue and they have, in any case, already been discussed elsewhere.[6] However, his visit to the Field of Waterloo deserves more than a cursory mention for it was here, on 18 June 1815, that the British forces under the Duke of Wellington and the Prussian forces under General Blücher had finally defeated the armies of

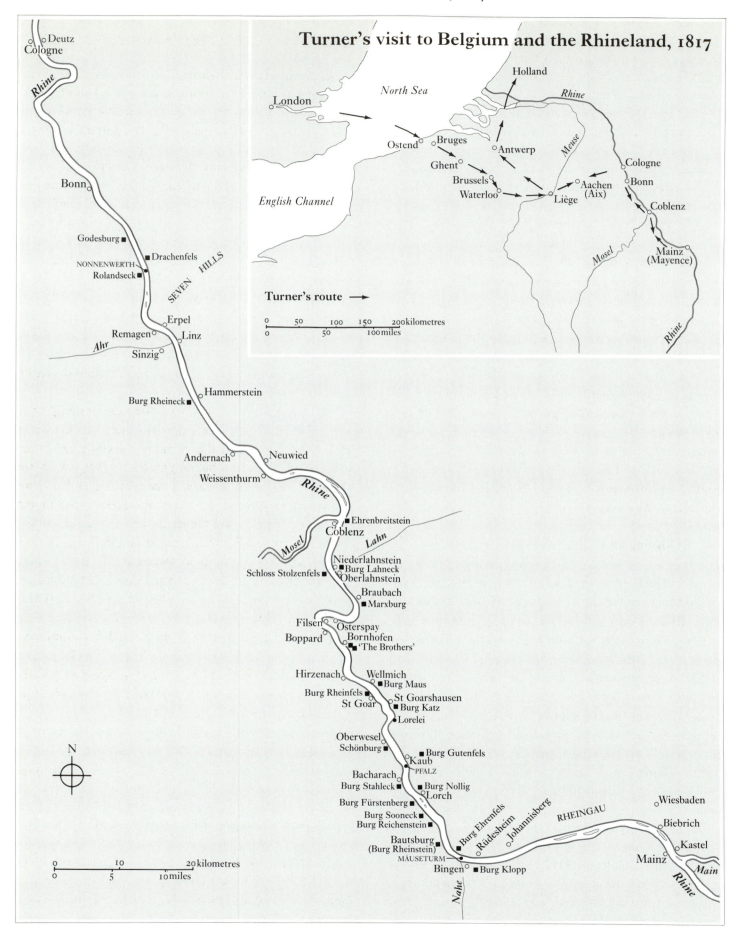

Turner's visit to Belgium and the Rhineland, 1817

Deutz
Cologne

Rhine

North Sea

London

Holland

Rhine

Ostend

Bruges

Antwerp

Meuse

Cologne

Ghent

Bonn

English Channel

Brussels

Waterloo

Liège

Aachen
(Aix)

Coblenz

Mosel

Mainz
(Mayence)

Turner's route →

0 50 100 150 200 kilometres
0 50 100 miles

Rhine

Bonn

Godesburg
Drachenfels
NONNENWERTH
Rolandseck
SEVEN HILLS

Erpel
Remagen
Linz
Ahr
Sinzig

Hammerstein
Burg Rheineck

Andernach
Neuwied
Weissenthurm

Rhine

Ehrenbreitstein
Coblenz
Mosel
Lahn

Niederlahnstein
Burg Lahneck
Schloss Stolzenfels
Oberlahnstein

Braubach
Marxburg

Filsen
Osterspay
Bornhofen
'The Brothers'
Boppard

Hirzenach
Wellmich
Burg Maus
Burg Rheinfels
St Goarshausen
St Goar
Burg Katz
Lorelei

Oberwesel
Schönburg
Burg Gutenfels
Kaub
PFALZ

Bacharach
Burg Stahleck
Burg Nollig
Lorch
Burg Fürstenberg
Burg Sooneck
Burg Reichenstein
Burg Ehrenfels
Johannisberg
RHEINGAU
Bautsburg
(Burg Rheinstein)
Rüdesheim
MÄUSETURM
Bingen
Burg Klopp
Nahe

Wiesbaden
Biebrich
Kastel
Mainz
Main
Rhine

N

0 10 20 kilometres
0 5 10 miles

Napoleon. Turner was intensely interested in the battle. He drew seventeen pages of pencil sketches, often accompanying them with notes about the numbers of casualties, which forces had been deployed in which positions and where particular commanders had fallen.[7] He toured the battlefield in the sequence recommended in Campbell's *Guide through Belgium and Holland* but he was obviously accompanied by a human guide as well, who gave him a great deal of extra information which was not in that book. Such guides were a regular feature of visits to Waterloo at this date and Turner would have been glad of every piece of information he could gather at first hand from such a source. He was later to paint several watercolours connected with the Battle of Waterloo when illustrating the works of Byron and Scott in the 1830s, but the most important result of his visit was the large oil painting exhibited at the Royal Academy in 1818 and now hanging in the Tate Gallery. This shows not the battle itself but its aftermath: night has fallen, carcasses of buildings are smouldering in the background and in the foreground women are desperately searching by torchlight for the bodies of their loved ones. Turner had seen the large, bare, empty field on which the battle had been fought and the ruined buildings which were the centre of the action. He must have imagined the noise and heat and suffering of the day itself but he had no desire to paint a battle picture. Instead he depicted the tragic consequences of war, the pain that results from 'man's inhumanity to man'.[8]

After visiting the Field of Waterloo itself in August 1817 Turner travelled on through Belgium to Aachen and then Cologne which he reached on Monday 18 August. From then until the end of the month, when he returned by diligence from Cologne to Aachen, he devoted himself to an intensive study of the Middle Rhine, making pencil sketches from morning till night and accumulating thousands of images of its towns and villages, hills and ruined castles, both in his sketchbooks and in his mind. He himself wrote 'walked' against his entry for 19 August and 'ditto' for 20 August; and he marked several of the entries for the ensuing week with dots or dashes also signifying 'ditto'. By nineteenth-century standards Turner's tour was not an unusually energetic one for an active man in his early forties.[9] His route was over flat ground, along an excellent road, the recently constructed *route Napoléon* on the west bank of the Rhine. The days were long, and by constantly stopping to sketch the scenery he broke his walk at frequent intervals. He did not attempt long distances each and every day. After spending one day walking, he would sometimes spend the whole of the next exploring a town and its envi-

rons. The last part of his journey upstream was made by boat and this was true also for the greater part of his return downstream.

As a pedestrian Turner naturally travelled light, carrying a 'wallet', the nineteenth-century equivalent of a backpack, 'a kind of long bag closed at each end but with a slit in the centre for the insertion of things'; it would have been of modest size and capacity and carried slung over one shoulder.[10] Unfortunately, Turner managed to mislay his wallet in the course of his travels, but his loss became posterity's gain since he recorded its contents in a sketchbook: 'a Book with Leaves [probably an interleaved guidebook], ditto Cambell's Belgium, 3 Shirts, 1 Night ditto, a Razor, a Ferrele for Umbrella, a pair of Stockings, a Wais Coat, ½ Doz of Pencils, 6 Cravats, 1 Large ditto, 1 Box of Colors.'[11] If this is a comprehensive list of all Turner's equipment for a month's tour, apart from the pencils and sketchbooks he was carrying in his pockets, it is certainly a very basic collection of necessities. If he had to change his boots or outer garments, he would have needed to rely on local resources.

The Rhine from Cologne up to Mainz is far more varied than is commonly supposed, and this was even more true in Turner's day before the spread of the larger towns and the advent of modern buildings. On his first day by the Rhine, 19 August, he made just one careful sketch of some of the historic riverside buildings of Cologne – the church of Great St Martin and the Rhine Gate[12] – before setting off on his day's walk which brought him to Bonn. On that day he had no good views of spectacular scenery, though the distant towers of Bonn merited quick sketches as did also the even more distant Siebengebirge or Seven Hills.[13] On the next, however, soon after leaving Bonn he had wonderful views across the river of the Seven Hills, dominated by the Drachenfels. He also came close to the Godesburg, his first Rhine castle, and he stopped many times to make pencil sketches of all these sights and of the Hochkreuz, an elaborate Gothic cross by the roadside.[14]

Until he reached the Drachenfels Turner had made all his pencil sketches either in his tiny *Itinerary Rhine Tour* sketchbook (TB CLIX) or in the pocket-sized *Waterloo and Rhine* sketchbook (cat.no.6). Confronted by the Drachenfels, he brought out a much larger sketchbook for the first time,[15] the *Rhine* sketchbook (cat.no.7) and thereafter often used this for his most complex views of the river. He balanced this by frequently dividing the pages of the *Waterloo and Rhine* sketchbook into small rectangles or boxes as he went along, so that his sketches of the Rhine are immensely varied in size: a double-page spread in the

Rhine book might carry a single image measuring *c.* 8 × 20 inches, while some of the boxed-in sketches in the *Waterloo and Rhine* book are as small as *c.* 1 × 1½ inches. He did not make sketches in watercolours as he travelled – his timetable could not have accommodated the delay these would have involved – but many of his pencil sketches of particularly memorable sights were used as the basis for watercolours soon afterwards: the Rhine Gate at Cologne, the Drachenfels and the Godesburg and Hochkreuz near Bonn were all subjects in the series discussed later in this essay (see pp.26–8 and cat.nos.8–18).

Turner's walk on 20 August brought him to Remagen, shortly after he had sketched an impressive prospect showing the towns on both sides of the river: Erpel, Linz, Remagen and St Martin's chapel on the Apollinarisberg. This was not drawn, as might be expected, in his *Rhine* sketchbook but on four successive pages of his *Waterloo and Rhine* book.[16] Turner's sketching practice, like so much else about his art, was never wholly consistent or predictable. On the following day he drew many sketches of the huge Hammerstein cliff and castle on the further bank of the river and studied with much interest the notable ancient buildings of Andernach which make such an impression on Rhine travellers.[17] By the evening he had reached Coblenz, the Rhine town he was to revisit so many times between 1817 and 1844 and whose great fortress of Ehrenbreitstein was to inspire some of his most outstanding German scenes. On this first visit he stayed two nights in the town (21 and 22 August) which allowed him plenty of time to cross the Rhine on the flying bridge and make many sketches of Ehrenbreitstein from numerous widely scattered viewpoints on the east side of the river: in the village of Ehrenbreitstein at the base of its great rock; behind the fortress in the valley; and on the road going south. For these views Turner used single pages in his *Waterloo and Rhine* sketchbook, reserving the large spreads of the *Rhine* sketchbook for his grandest sketches of Coblenz, showing both Ehrenbreitstein and the Mosel bridge and waterfront.[18] This was a view that Turner was to sketch again and again in slightly different ways over the years, culminating in his shimmering watercolour of 1842 (cat.nos.122–3). In 1817 he recorded all the architectural ingredients of the view in careful detail, both from the bridge itself and from the Mosel shore just above and below it. He made detailed studies of the façade of the fortress facing the confluence with the Mosel which it guards and of the magnificent old buildings at the mouth of the Mosel. However, on his first visit to Coblenz – unlike his later ones – he seems to have spent little time on the Rhine waterfront[19] and evidently

did not stay at one of the hotels there looking directly out at Ehrenbreitstein.

The Rhine valley south of Coblenz and Ehrenbreitstein is rich in picturesque views. As Turner walked upstream along the west bank on Saturday 23 August, he stopped several times to look back at the town and fortress he had left behind, drawing three large sketches from some miles away to the south-west.[20] In these Ehrenbreitstein and its rock are virtually one, the work not of military engineers but of nature itself. Soon afterwards he reached the junction of the Lahn with the Rhine where the castle of Stolzenfels stands high above the village of Kapellen, and the Lahn is flanked by Niederlahnstein and Oberlahnstein and guarded by Burg Lahneck. Turner drew all these subjects, some on a large scale, others in a small compass.[21] Schloss Stolzenfels was the subject of his first real castle 'portrait' on the Rhine. This records it with the scrupulous care that was typical of late eighteenth-century topographical artists, but if Turner's sketch is somewhat lacking in vitality, the exercise must at least have provided him with a grounding in the architecture of Rhine castles. His depiction of Burg Lahneck, on the other hand, not only affords a more dynamic composition and a more revealing glimpse of river life, with men and horses using the ferry beneath the castle, but it looks forward to Turner's later concerns as well. It will be seen throughout this exhibition and catalogue that, even where a castle is the ostensible subject of Turner's scene, it often occupies only a small proportion of his paper or canvas. The castle provides a focus of attention, a resting-place, but it is the prospect as a whole that resounds upon the eye and the imagination of the viewer, like the slowly changing prospects of the Rhine that revealed themselves to Turner himself as he walked upstream in 1817.

At the junction of the Lahn Turner crossed the Rhine by ferry in order to gain better views of all the fine buildings and castles. He then walked a short way south to Braubach to study the Marxburg, the only castle on the entire Middle Rhine which had never been captured and wrecked. He recorded it in three large sketches which show it from very different viewpoints: from the fields to the north; from the shore at the Braubach landing-place; and finally from back across the river on the west bank.[22] Throughout Turner's career, it was often his first glimpse of a subject that lived on in his mind and provided the germ for a finished painting or watercolour, and this was true of the Marxburg. His first view of the impregnable stronghold and its placid rural setting corresponded closely to that which Gardnor had used and extolled (fig.12).[23] Besides his

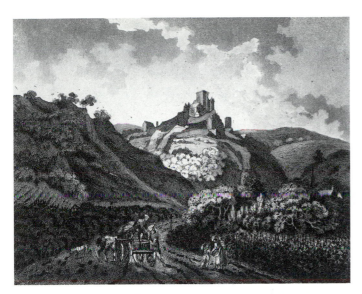

fig.12 John Gardnor and Richard Gardnor junior after John Gardnor, 'The Second View of Marxburg Castle', aquatint from the second edition of *Views Taken on and near the River Rhine* (1792)

detailed sketch of the Marxburg from this viewpoint, Turner also drew several tiny studies, adjusting his composition until he felt it was exactly right. Later he returned to this composition, using it as the basis for two watercolours.

Above the Marxburg Turner had quite a long walk before he came to any other castles, as the Rhine winds lazily in a huge double bend fringed only with villages and vineyards. He drew several sketches of the busy little town of Boppard on the west side of the river and then of the pilgrimage church at Bornhofen, just upstream on the opposite bank beneath Burg Sterrenberg and Burg Liebenstein, the pair of castles traditionally associated with two hostile brothers.[24] After this, his sketches became small and hasty as he reached the final stages of his walk. Burg Thurnberg (usually known by its nickname, 'Maus'), one of the most beautiful castles along the Middle Rhine which stands in an incomparable setting, was sketched in a very cursory fashion.[25] It must have been with a sense of relief that Turner at last caught sight of his day's destination, the town of St Goar, which countless Rhine tourists over the centuries have made their base.

He spent the whole of Sunday 24 August exploring not only St Goar and its environs but also those of St Goarshausen opposite and making many fine sketches across complete spreads of the *Rhine* sketchbook showing the towns and their castles, Burg Rheinfels and Burg Neukatzenelnbogen ('Katz') (see cat.no.7). At St Goar he began by going to the waterfront and recording the views downstream to Wellmich and Burg Maus and upstream to

St Goarshausen and Burg Katz.[26] Gardnor had enjoyed both these prospects from his room at the inn, the Bois Vert,[27] but Turner's two sketches were drawn from the very edge of the river and from two distinct viewpoints: each uses part of Burg Rheinfels as a framing device. Turner sketched a third and even larger face of Burg Rheinfels when he climbed a little way up the valley beneath it, the Grundbachtal, and he then walked along the Rhine front at St Goar, recording road and river views with equal enthusiasm.[28]

The latter part of the day was spent across the Rhine near St Goarshausen. He looked upstream and caught his first sight of the Lorelei, the most celebrated cliff on the Middle Rhine.[29] He climbed the hillside to Burg Katz and sketched the view across to St Goar, Burg Rheinfels and the hills beyond them.[30] From here the mighty Rhine seems to thread its way peacefully in its narrow channel far below, while high above it rich countryside and fertile fields extend as far as the eye can see. One of Turner's sketches shows the evening sun descending in a trail of vaporous cloud towards the hills beyond Burg Rheinfels; he probably remained up on the hillside as long as the light lasted.

On the following day Turner travelled from St Goar up to Mainz, a distance of around thirty-five miles. For the first stage of his journey he continued to walk, as the Rhine remains highly picturesque with winding curves, ruined castles, brooding rocks and fertile vineyards constantly crowding upon the eye. As soon as Turner had finished recording the Lorelei, he caught sight of the Schönburg and Oberwesel,[31] and shortly afterwards Kaub, poised between the hillside castle of Burg Gutenfels and the Pfalz on its island. His walk continued, past castles and landing-stages, cows drinking and peasants gathering wood, and the sketches poured forth in an apparently never-ending stream.[32]

At Bingen the river assumes an entirely different aspect, characterised by tranquillity and calm. It is two or three times wider than in the gorge below Bingen and it is bordered by low-lying land rising gently above the eastern shore to the famous vineyards of the Rheingau. Its banks are dotted not with castles but with villages and the river is broad enough to contain numerous islands. This is no country for a pedestrian in search of the picturesque, so at Bingen Turner, like so many others, took a boat for the rest of the journey to Mainz. This was almost certainly the regular passage boat drawn by horses. His sketches from this slowly moving boat are entirely different from his earlier ones drawn from the riverside road and there are far fewer of them. He divided the pages of the *Waterloo and*

Rhine sketchbook into minute boxes and strips, some less than an inch high but often as much as seven inches wide. The sketches show distant shores with backdrops of hills, almost identical but given individuality by a carefully drawn tower or spire, or a hastily scribbled name.[33] The breadth and tranquillity of the Rhine in this area, with its distant views of Rüdesheim and the Johannisberg, Biebrich Palace and the city of Mainz, were a novel experience for Turner after the previous few days but they made a strong and lasting impression upon him (see cat.nos.16–17).

At Mainz all Turner's sketching was done from the Rhine or very close to it: from a quay or from its bridge of forty boats across the vast expanse of water to Kastel on the opposite bank. From here Mainz is seen at its most attractive, as many artists have discovered. Ornate medieval and baroque buildings crowd its waterfront, with the cathedral rising above them. Turner would not have been disappointed when here, as elsewhere in the Rhineland, he followed closely in Gardnor's footsteps.[34]

After two nights at Mainz, 25 and 26 August, Turner began his journey downstream back to Cologne during which he stopped overnight, as before, only at St Goar and Coblenz. A large part of the journey was made by boat and now it only took him three days as opposed to the earlier seven. This enabled him to see the celebrated sights of the Rhine from fresh angles and viewpoints, so he continued to sketch avidly, though he could no longer choose his own viewpoints or linger over his sketches. On 27 August he made a few sketches in the large *Rhine* sketchbook, while he waited to change boats at Bingen.[35] In the *Waterloo and Rhine* sketchbook he recorded several views that can only be experienced from a boat in midstream: the Rhine gorge at Bingen, bounded by Burg Klopp to the west and Burg Ehrenfels to the east, with the Mäuseturm in the centre of the river and the Rhine appearing like a vast lake; the Pfalz, Kaub and Burg Gutenfels, drawn as the boat passed between the Pfalz and the eastern bank; the Lorelei with Burg Katz and the watchtower south of St Goarshausen.[36] On the next morning, Turner thoroughly explored the ruins of Burg Rheinfels, making many large sketches of the castle before a day which included both walking and sketching on the road along the west bank.[37] His journey by boat on the following day, 29 August, continued to present him with fresh views of familiar sights including one of the most celebrated of all Rhine views: Rolandseck, with the convent island of Nonnenwerth below and the Drachenfels opposite. The Rhine itself provides a much finer view of these than the road on the west bank;[38] it was a view that Turner recorded again and again in subsequent years when

journeying on the river and was later to depict in no less than three watercolours.[39]

Turner's final day on the Rhine was a long one, taking him all the way from Coblenz down to Cologne. Here he stayed two nights, 29 and 30 August, which enabled him to make many large sketches, some from the waterfront and some depicting the great unfinished cathedral and town hall.[40] These reflect his early training as a copyist of architectural drawings, the complicated details being drawn with a sure hand but also with spirit. Thus, when Turner left the Rhineland on the last day of August 1817, he took with him a record not only of its landscape but also of some of its finest buildings.

The importance of this tour in Turner's career cannot be overemphasised. It instantly inspired a series of watercolours that would have gained Turner a worldwide reputation even if he had died in 1818 and painted no others. These drawings, showing nearly all the famous sights on the river between Mainz and Cologne, were bought by Walter Fawkes – for about £500 – almost as soon as they were ready. From early on, they were regarded as a series of fifty-one drawings, but the family owned many works by Turner and the Rhine series should more properly be regarded as consisting of fifty scenes (see cat.no.17).[41] They remained in the Fawkes family home of Farnley Hall, Yorkshire, for many decades, largely unseen except by family, friends and connoisseurs. They were subsequently sold by Walter Fawkes's descendants, thirty-five of them as early as 1890, so that today they are dispersed in museums and private collections throughout the world. The series is not only one of the most beautiful that Turner ever painted (see cat.nos.8–18) but also the forerunner of outstanding works to come. In the 1830s he was to work up his small pencil sketches of the Loire and the Seine into the seventy-five coloured drawings that were engraved as his famous three-volume series of the *Rivers of France*. At the end of that decade he was to paint a similar number of scenes in his glorious Meuse and Mosel series, based on the sketches made on his 1839 tour (see cat.nos.42–63).

One of the extraordinary things about the 1817 series is that, although Turner had used a large sketchbook for much of his time on the Rhine, only six of his coloured drawings are based on the material in that book and, even in those cases, often only in part.[42] His larger drawings were valuable for their meticulous records of the architecture of Cologne, Coblenz and Ehrenbreitstein, but for the Rhine itself, its landscape scenery and its smaller towns and villages, the vivid little sketches in the *Waterloo and Rhine* sketchbook gave him all the information he needed.[43] It was

widely supposed in the past that the series was painted on the spot, in the course of Turner's first Rhine journey itself. This view was propounded by Ruskin,[44] reinforced by Turner's first biographer and is, of course, understandable in view of the superlatively evocative light effects and fluid handling of the works themselves. However, the fact is that each and every drawing in the series can be matched with a preparatory sketch or sketches in a sketchbook – sometimes even down to such details as the cows standing on the shore, a boat landing or linen spread out to dry on a grassy bank (see cat.nos.8–18).

According to the tradition recorded by Thornbury in 1862, when Turner arrived at Farnley Hall in the autumn of 1817, 'Before he had even taken off his great-coat he produced these drawings rolled up slovenly and anyhow, from his breast-pocket'.[45] However, the painter had not gone directly from his continental tour up to Yorkshire. During the two months since his return to England he had been hard at work, partly in London and partly at Raby Castle in County Durham. Here he was making sketches for an oil painting of the house for the 3rd Earl of Darlington which was exhibited at the Royal Academy in 1818 along with the 'Field of Waterloo'.[46] It may well have been partly at Raby that Turner worked on his Rhine drawings, for he still had his Rhine sketchbooks with him and drew Raby itself in one of them.[47] A sojourn in an English stately home would have been a perfect opportunity for developing his sketches into watercolours: searching through his sketchbooks for details of remembered sights, brushing in broad sweeps of coloured washes over swift pencil outlines on the new and larger pages, adding flurries of gouache here, pressing down the paint with his fingers there, and elaborating the boats, birds or figures that enliven their foregrounds.

The paper on which Turner's Rhine scenes were painted was not, as might be supposed, paper from a sketchbook. Most of them are on a very lightweight, heavily sized writing paper which in at least one instance bears a Whatman watermark of 1816. He would have bought this in a quire of twenty-four foolscap sheets (i.e. $17 \times 13\frac{1}{2}$ inches) which he then folded and cut in order to provide himself with forty-eight sheets, each measuring $13\frac{1}{2} \times 8\frac{1}{2}$ inches.[48] The later river series devoted to the Loire and Seine, Meuse and Mosel were similarly executed on paper that Turner folded and cut to his own desired size, though for all those scenes he chose to work on a much smaller scale, each drawing only measuring c. $5\frac{1}{2} \times 7\frac{1}{2}$ inches.

The drawings in the Rhine series of 1817 are not only larger but also more sombre than those of the later river series since, with one exception (cat.no.17), they were painted on paper which Turner had previously prepared with a wash of grey. This provided a neutral but sombre starting-point for the sky, hills and river of each scene, which could be intensified or transformed by sources of light as Turner wished. For the later river series he used blue paper which provided a much more dynamic base for his drawings; areas of blue could be left untouched for both sky and water, and an increased lightness and brightness in his palette counteracted the effect of their smaller size. However, Turner continued to use grey paper or white paper prepared with washes of grey well after 1817. He made a great many pencil and coloured sketches on the latter in Rome in 1819.[49] In 1824 he used such paper for both types of sketch during his first journey along the Mosel from Trier to Coblenz (cat.no.22). However, a few years later he abandoned grey-washed paper in favour of manufactured grey papers which he evidently bought in large quantities. Much of this carries an 1829 watermark and was used from at least 1833 onwards right into the 1840s. As will become apparent later in this catalogue, Turner made use of such paper for depictions of Rhine, Mosel and Danube scenery in 1840 (see cat.nos.67–96), so that there is a real sense of continuity between his earliest drawings of Germany and those of many years later.

A further characteristic of Turner's German river series is that they reflect his own preferences rather than being dictated by outside forces. In 1817 he chose to paint what some might regard as an unnecessarily large number of depictions of the Lorelei (seven in all) and two of his drawings of Burg Katz with St Goarshausen are practically identical in composition (see cat.nos.12–13). His series omits the highly picturesque Burg Maus and relegates other castles such as Burg Lahneck and Schloss Stolzenfels to the distance (cat.no.11), but it includes bends of the river that simply caught his eye and imagination. Had he been at the beck and call of a patron or publisher at this point, such idiosyncrasies would not have occurred; this series might have been more balanced and comprehensive but it would have lacked some of its spontaneity and would be less of a record of what Turner had truly enjoyed.

The 1817 Rhine scenes are often somewhat smaller than the original size of the paper they were painted on, $8\frac{1}{2} \times 13\frac{1}{2}$ inches, and were clearly shaped by the artist himself and not by subsequent owners, since their measurements were recorded as early as 1889 when they were lent by the Revd Ayscough Fawkes to the Royal Academy's *Exhibition of Works by the Old Masters, and by Deceased Masters of the British School*. In some he reduced the height to stress the width of the river, as when he was depicting distant scenery

and following the narrow strip-like sketches of Mainz and the Rheingau. In other drawings he reduced the width to obtain a more compact format, as in those of the Drachenfels which had been sketched from just across the Rhine where the river is much narrower. When Turner came to paint his Mosel series over twenty years later he had to handle a similar variety of compositions (compare 'The Ruined Monastery at Wolf', cat.no.46, with 'Distant View of Coblenz and Ehrenbreitstein', cat.no.62, for example). On that occasion, however, he stuck far more strictly to a consistent page size and any variations in proportions are probably either accidental or attributable to later owners.[50]

Soon after the Rhine drawings had been acquired by Walter Fawkes, Turner repeated several of the scenes in the series, some for private purchasers, others as a publishing venture with the printseller W.B. Cooke which was abandoned, probably within months of its inception. Had Cooke's project proceeded, the total number of Turner's watercolours of the Rhine inspired by his first visit would have been well over ninety. Among the handful painted for individual patrons, 'Biebrich Palace' and 'The Marxburg' were both made for the Swinburne family, friends of the Fawkeses, living at Capheaton in Northumberland.[51] These were executed with far greater precision and detail than their 1817 equivalents, on a much grander scale and in watercolour alone on white paper, and they were commissioned either by the 6th Baronet, Sir John Swinburne, or his son Edward. Turner was already on very friendly terms with the Swinburnes whom he had known for some time, for he had taught painting to Lady Swinburne's sister Julia

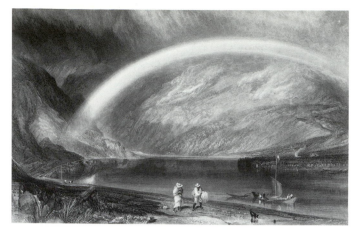

fig.14 William Miller after J.M.W. Turner, 'Osterspey and Feltzen' (R 669). Engraving, 1852. *Trustees of the British Museum*

in the 1790s. He remained in touch with her and, later on, her husband Sir James Willoughby Gordon for the next thirty years, painting three oil paintings specifically for the couple, while Sir John Swinburne had bought an oil painting from Turner in 1813.[52] Of Turner's other Rhine scenes, one version of 'Cologne from the River' was painted for his patron Thomas Tomkinson and a second for his friend James Rivington Wheeler who bought it some time between 1818 and 1820 for 30 guineas. This scene was immediately made the subject of a large engraving (see cat.no.20).[53] The earliest owner of 'Burg Sooneck', however, remains unknown.[54]

According to the original plan for the publishing project, Turner was to have produced a series of thirty-six views of the Rhine between Mainz and Cologne for engraving in a book to be published by John Murray in conjunction with W.B. Cooke. The manuscript contract for this, between Turner, Cooke and the engraver J.C. Allen, once belonged to Ruskin who took great pride in owning it, since it had been signed on 9 February 1819, the day after that on which he himself had been born.[55]

The collapse of the project was undoubtedly caused by the appearance of another series of engraved Rhine views in 1819–20, the English version of a book that had already appeared in Germany in 1818 by Baron Johann von Gerning. *A Picturesque Tour along the Rhine, from Mentz to Cologne*, consisting of twenty-four engravings, chiefly by Thomas Sutherland after drawings by C.G. Schütz, and von Gerning's text translated by John Black, appeared in six monthly parts from October 1819 to March 1820, over the imprint of Rudolph Ackermann's publishing house in the Strand. On hearing news of this – probably well before Turner's own departure for six months in Italy on 31 July

fig.13 Thomas Sutherland after C.G. Schütz, 'Cologne', engraving from J. von Gerning, *A Picturesque Tour along the Rhine, from Mentz to Cologne* (1820). *By permission of The British Library*

1819 and the first advertisements in the press in August[56] – Cooke and Turner met in order to discuss how Ackermann could be bought off and prevented from going ahead with von Gerning's book.[57] This plan failed to work, if indeed it was ever discussed with Ackermann. The rival monthly parts duly appeared and received much critical acclaim (Turner himself acquired at least one of the engravings, fig.13), while Turner's own publishing project came to nothing.[58] He abandoned his work on a watercolour of Boppard[59] and the few he had completed began to be dispersed. Cooke bought three of them in 1822 for 27 guineas each,[60] including 'Osterspey and Feltzen' (fig.14) and 'Neuwied

and Weissenthurm', which he exhibited at his Soho Square gallery in 1823, by which time they were owned by James Slegg. The third must have been the similarly sized 'Ehrenbreitstein' which was the only Turner Rhine scene J.C. Allen would come to engrave, albeit not until 1824 (cat.no.19).

Turner's new-found interest in the Rhineland was in no way affected by this setback. Early in the 1820s, perhaps about 1824, he painted one of the most dazzling of his Rhine watercolours, 'Kaub and the Castle of Gutenfels' (fig.15)[61] and in August 1824 he was off on his travels again, eager to see more of northern Europe.

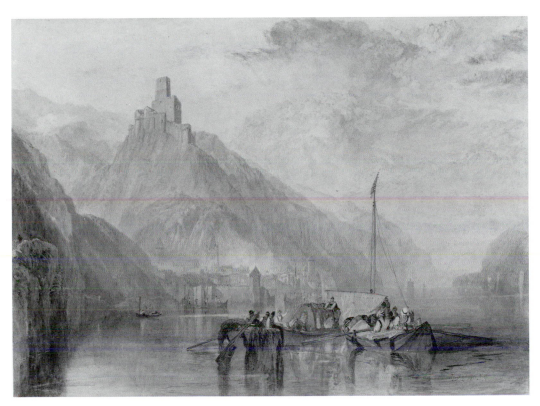

fig.15 'Kaub and the Castle of Gutenfels' (w 1378). Watercolour, *c.*1824. *Private Collection*

The First Meuse-Mosel Tour, 1824

In 1824 Turner discovered two very beautiful stretches of river scenery to the west of the Middle Rhine: the Meuse valley between Liège in Belgium and Verdun in France, and that of the Rhine's most important tributary, the Mosel, on its final and most celebrated section between Trier and Coblenz. Here the Mosel is essentially a miniature Rhine, with the latter's breadth and sublimity transformed into grace and charm. Vineyards grow on steep banks, the river winds its way in serpentine curves under ruined castles, but the scaling-down of everything in the landscape makes the experience of the Mosel quite different from that of the Rhine. It was to become a particularly attractive subject for Turner, luring him away from the Rhine on several occasions.

The 1824 tour was, for many years, mistakenly believed by Turner scholars to have taken place in 1826, but it was redated by the present writer in 1991 on the evidence of Turner's own notes and sketches. One of the sketchbooks used on the Mosel and elsewhere contains many sketches made in Dieppe at the very end of the tour. These were to become the basis for Turner's oil painting 'Harbour of Dieppe (Changement de Domicile)', painted in the winter of 1824–5 and exhibited at the Royal Academy in the spring of 1825.[1]

The sketchbook containing this vital piece of evidence, *Rivers Meuse and Moselle* (cat.no.21), was used for at least a thousand tiny sketches during Turner's tour.[2] It also holds two other important clues to the artist's interests and movements: his preparatory notes for the tour and the actual dates in August and September when he reached his various destinations. Here, as in the *Itinerary Rhine Tour* sketchbook of 1817, he wrote several pages of notes before he left England, providing himself with useful data for the Mosel, not only on distances and inns but also on a wide variety of sights. Between Burgen and Trarbach, for instance (fig.16), he noted that there were market towns and churches, a collection of paintings, a Roman camp, no less than six castles, three convents, a prison and a hermitage, many in exceptionally fine settings ('on a high Rock', 'Wild Situation', 'on a Steep Rock', 'A great bend of Moselle').[3] Here, too, he drew himself tiny sketch maps of both the Meuse and the Mosel, squeezing the names of

towns and villages into the bends of the rivers as best he could (fig.17). The source for Turner's notes on the Mosel between Trier and Coblenz and his maps of the same area was Alois Schreiber's guidebook, *The Traveller's Guide down the Rhine*, of which he owned a copy of the first English edition of 1818 (cat.no.1).[4] This had not been available in English at the time of his first visit to the Rhineland, although he was certainly aware of its existence in French and German.[5] Now, thanks to the translation of Schreiber's book, his maps copied from its frontispiece and his notes taken from its 'Third Excursion', Turner was well equipped for his travels down the Mosel.

The *Rivers Meuse and Moselle* sketchbook also contains Turner's own timetable of his tour.[6] He set out on 10 August, reached the Meuse at Liège on the thirteenth and then travelled up that river as far as Verdun where he was on the twenty-third. From here he went eastwards to the French part of the Mosel, the Moselle, south of Metz, then north to Metz itself and Thionville, both situated on the Moselle. He then travelled away from that river to Luxembourg but returned to it just south of Trier which he reached on 27 August. He carried on down the Mosel, arriving at Coblenz on 1 September, down the Rhine to Cologne and back across Belgium to northern France where he spent several days before sailing home from Calais. He was home, or at any rate in England, on 15 September.

Turner's travels on the Meuse in Belgium and France, recorded partly in the *Rivers Meuse and Moselle* sketchbook, partly in the slightly larger *Huy and Dinant* one (TB CCXVII) lie outside the scope of the present catalogue and have already been described elsewhere,[7] but they provided an important prelude to his first sight of the Mosel in the last days of August. Along the Meuse he saw several towns dominated by great forts: Huy, Namur and Dinant. These three, like Ehrenbreitstein, guarded points of special strategic significance, had a long history, and had recently been – or were in the process of being – rebuilt after the Napoleonic wars as a precaution against any future aggression by the French. However, the valley is not enlivened by the succession of villages and vineyards sheltering beneath the ruins of ancient castles that are such a constant and

fig.16 Turner's notes on the Mosel between Moselkern and the Starkenburg, copied from A. Schreiber, *The Traveller's Guide down the Rhine* (TB CCXVI 7r). Pencil with red pencil underlining, 1824

fig.17 Turner's sketch map of the Mosel between the Starkenburg and Müden, copied from A. Schreiber, *The Traveller's Guide down the Rhine* (TB CCXVI 9r). Pencil with red pencil underlining, 1824

picturesque feature of the Mosel. Furthermore, his passage upriver was quite slow, being made in a boat or barge towed by horses, and lasting some ten days with the most attractive scenery of the Meuse – its famous limestone cliffs and its abundant woods and groves – occurring during the early days.

Turner reached Trier on 27 August, exactly halfway through his tour. His timetable shows that he spent two nights here and his sketches show that he revelled in the city and its situation. His pencil sketches in the *Rivers Meuse and Moselle* book ceased being the scribbles and jottings they had become in recent days and were once more the tiny miracles of subtlety and precision they had been in Belgium.[8] He drew a few pencil sketches of Trier in the *Huy and Dinant* sketchbook and then put that book aside.[9] In its place he brought out a new, larger sketchbook, also of

horizontal format but with pages already tinted with a grey wash like the paper used for his Rhine drawings of 1817, and he started to work in it in both pencil and watercolours (*Trèves and Rhine*; cat.no.22). Thus, in Turner's work at Trier there is a sense not only of arrival, fulfilment and enjoyment but also of continuity with his earlier visit to the Rhineland. No doubt it was not merely the new scenery that brought about this new mood: Turner had arrived again in Germany and the language, the streets and houses and all around him would have reminded him of his happy time on the Rhine in 1817.

The same pleasure in his surroundings is evident in the sketches made over the following four days during which he travelled by boat down the Mosel to Coblenz, stopping overnight at Neumagen (29 August), Trarbach (30 August) and Cochem (31 August). Sailing, being rowed or drifting

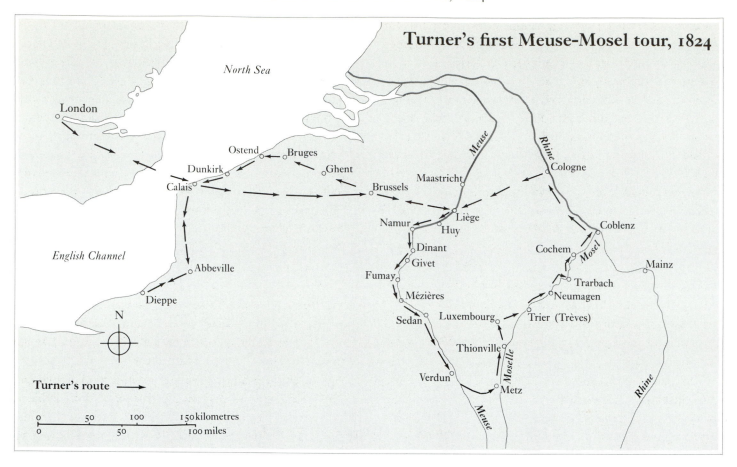

Turner's first Meuse-Mosel tour, 1824

North Sea

London

Ostend
Bruges
Dunkirk
Ghent
Calais
Brussels
Maastricht
Cologne

English Channel

Namur
Liège
Huy
Coblenz

Abbeville

Dinant
Cochem
Mosel
Mainz

Dieppe

N

Fumay
Givet
Trarbach
Neumagen

Mézières
Luxembourg
Trier (Trèves)

Sedan

Turner's route

Thionville

Moselle

Verdun
Metz

Meuse
Rhine

0 50 100 150 kilometres
0 50 100 miles

down the Mosel with its current over a period of three or four days was the standard means of seeing the river at this period, for the land route was tediously long, the roads poor and it was to be seventeen years before a steamer service could take passengers from Trier to Coblenz in a matter of hours. In the 1820s and 1830s travellers would either take the regular public passage boat or hire a boat and boatmen to convey them down the river. A Mosel voyage very comparable to Turner's was enjoyed by Mary Shelley, widow of the poet, in June 1840, and she later described both its delights and its drawbacks: the ravishing scenery and the miserable inns; the golden evenings with their sense of peace and the 'chill, white, and dank' misty mornings when they passed many barges being 'towed up the stream by horses up to their middles in the cold foggy river'.[10] She and her companions hired a boat with an awning, directed by an old man who steered and two youths at the oars and, by dint of early rising, they travelled all the way from Trier to Coblenz with only two overnight stops on land. Turner's journey took a whole day longer, giving him more opportunities for sketching and study.

As Mary Shelley remarked, 'The finest scenery of the Moselle occurs after leaving Trarbach',[11] so Turner's third

day on the Mosel would undoubtedly have been its high point. Along the stretch he saw on the first day, between Trier and Neumagen, the Mosel winds its way placidly in huge curves through low vine-clad hills dotted with villages, each with its own small church and huddle of houses. Turner recorded everything he could, dividing up the small pages of the *Rivers Meuse and Moselle* sketchbook into tiny rectangles – even smaller than those he had created for his 1817 Rhine sketches – and sometimes getting as many as nine sketches on a single page.[12] He turned his head constantly in order to catch the views both upstream and downstream before they changed and disappeared, and sometimes he not only numbered his sketches but also took compass bearings so that he himself at a later date would be able to recall in complete detail his experiences of the river (cat.no.21). This meticulous practice, however, was largely abandoned after the first day. From then on, as the course of the Mosel became more tortuous, its hills and villages more spectacular, Turner was far too occupied in recording castles and churches, ferries and flying bridges to keep an eye on the compass. Simply naming the villages on his sketches was both easier and potentially more useful.

Travelling as he did, Turner had few opportunities for

exploring the villages of the Mosel valley and none for climbing the hills that line it in order to gain a different perspective on the scenery (both these deficiencies were to be remedied on his second major Meuse–Mosel tour, making his return to this territory a very different experience). However, the boat did occasionally pause at villages and Turner took as much advantage of this as he could. On the second day he started using his last sketchbook of the tour, *Moselle (or Rhine)* (TB CCXIX), similar to the *Trèves and Rhine* sketchbook. Here he made about thirty pencil drawings on pages previously prepared with a grey-tinted wash. These swift but beautiful sketches, in many of which the pencil work is now barely discernible against its grey background, cannot have taken long to draw. They record a number of places passed on the second and third days of his journey, including Bernkastel and Kues, Traben and Trarbach, the Marienburg and Beilstein, all of which cried out for depiction on larger pages than those of the *Rivers Meuse and Moselle* book.

That sketchbook, however, remained in constant use until the end of Turner's tour. His third overnight stop on the Mosel, at Trarbach, enabled him to make a few full-page sketches in it, not only of the river front but also of gabled medieval houses at a street corner in the town and of a butcher's shop where he recorded 'Dogs and Cats' prowling around beneath the carcasses.[13] At his last stop, at Cochem, he also made careful full-page sketches, this time only of views along its river front, which was and remains the most densely and most picturesquely built up of any town on this stretch of the river.[14] His activity was prodigious: during his final day on the Mosel, he drew nearly a hundred and fifty minuscule outlines of hills, castles and villages as his boat glided past them.

When Turner reached Coblenz on 1 September he still had a fortnight to go before crossing the Channel back to England, but only a small part of that time was devoted to Germany. During his two-night stay at Coblenz he returned to some of his favourite subjects of 1817, sketching the fortress of Ehrenbreitstein and going along the east bank of the Rhine as far as its junction with the Lahn.[15] Travelling down the Rhine to Cologne he sketched Andernach and Hammerstein, the Seven Hills and Cologne itself, but only very cursorily.[16] He then carried on by diligence to Liège, Brussels and Ghent and by canal boat from Ghent through Bruges to Ostend.[17] Finally, he headed south into France and spent six days in Calais, Abbeville and Dieppe before catching the boat home from Calais.

Turner's first visit to the Meuse and Mosel was very productive in terms of pencil sketches but it did not lead immediately to a series of coloured works on paper like the visits in 1839 and 1840 or to oil paintings directly related to these rivers. It inspired just one watercolour, 'Bernkastel' (cat.no.23). The most important product of the tour was his 1825 oil painting 'Harbour of Dieppe (Changement de Domicile)', commissioned by a Mr John Broadhurst before Turner's departure from London and the product of two days of intensive study there on 11 and 12 September. However, Turner would not have responded so sensitively to the harbour of Dieppe, and depicted it with such magical intensity, if he himself had not spent the preceding five weeks travelling up and down rivers on a variety of craft, observing sunshine and reflections on water, tying up endlessly at one landing-stage after another, watching cargoes being loaded and unloaded each day and sleeping in a different town or village nearly every night. By grafting his experiences of the Meuse and the Mosel with his own constant 'changements de domicile' onto the sight of Dieppe itself, he produced a masterpiece.

Broadhurst also commissioned a companion to 'Dieppe' which was Turner's first oil painting of a Rhine subject: 'Cologne, The Arrival of a Packet Boat, Evening', exhibited exactly a year later, in 1826. This, too, was inspired by very recent experiences. In the summer of 1825 Turner made a tour of Holland[18] after which he journeyed up the Rhine as far as Cologne, across country westwards to Aachen and Liège and then briefly down the Meuse to Maastricht before he travelled on once more to Ostend. He had found his method of data collection in 1824 so convenient that in 1825 he copied it very closely. He simultaneously used a small fat upright sketchbook for quick records, sometimes in minuscule compartments (*Holland*, TB CCXIV), and a slightly larger book of horizontal format for more expansive sketches, usually stretching over two pages at once (*Holland, Meuse, and Cologne*, TB CCXV). He did not, however, use any larger sketchbooks comparable to

fig.18 Aachen: the imperial chapel (TB CCXIV 152v). Pencil, 1825

Trèves and Rhine and *Moselle (or Rhine)* used in 1824. This was the first year that Turner travelled along the Rhine north of Cologne and he duly recorded parts of Düsseldorf in both his sketchbooks.[19] It was, however, the third year that he was passing through Cologne and Aachen. His sketches suggest that he deliberately paid careful attention to Cologne, as though compensating for having neglected it in 1824.[20] However, there was, as usual, not enough time for Turner to do justice to Aachen (fig.18).[21]

His tour cannot have lasted very long, since he left London only on 28 August and would not have stayed abroad far into October. Its primary purpose was to study Holland, but – as in 1824 – he ended up by painting an entirely different subject, seen in the very last days of his tour, almost incidentally in the course of travelling. Mr Broadhurst may have specified a Dutch type of subject for his picture and Turner may have gone to Holland to find a suitable one, but no painting of Holland was executed.[22] Instead Turner painted 'Cologne' and – as in the case of 'Dieppe' – it drew

on all his recent experiences. 'Cologne' (fig.19) is chiefly based – both in general plan and in specific details – upon Turner's most recent sketches of that city.[23] It does not show Cologne's most famous building, the cathedral, but a landing-stage that could be at almost any large town on a sizeable river in northern Europe. The inspiration behind it is not the picturesque Middle Rhine but the sights Turner had seen earlier on his tour: the skies and water and boats of Holland so magical in themselves, so dear to Aelbert Cuyp and the other seventeenth-century Dutch painters whom he admired, and which he had already celebrated in his 'Dort, or Dordrecht' of 1818, painted soon after his visit to the Low Countries in 1817. Nothing could show the breadth of Turner's vision more clearly than his 'Cologne', painted according to one of the great traditions of European art but transformed by his own sense of light and colour. It was to savour such sights and recreate them in his own language that he returned to the Continent year after year.

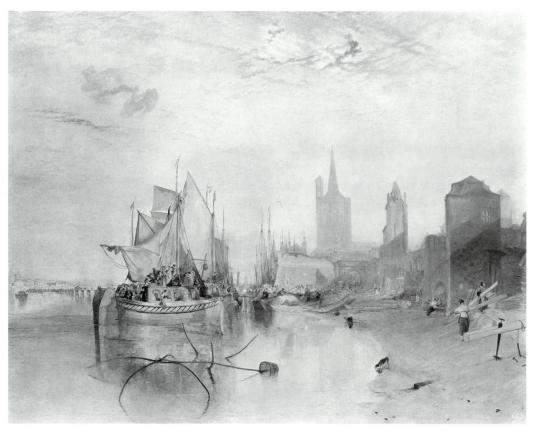

fig.19 'Cologne, The Arrival of a Packet Boat, Evening' (B&J 232). Oil on canvas, RA 1826. *The Frick Collection, New York*

Down the Danube to Vienna, 1833

Turner's discovery of Germany and Austria in the 1830s is a part of his life that has been sadly misunderstood. For decades after the publication of Finberg's biography of the artist in 1939, it was believed that Turner made his second tour of the Meuse and Mosel in 1834 and visited Berlin, Dresden, Prague and Vienna on his way to Venice in 1835.[1] Both these ideas have had to be radically revised. The second Meuse–Mosel tour was reassigned to 1839 by the present writer in 1991,[2] while the other tour has been subjected to various speculations in recent years.[3] It is, however, now clear that Turner paid two substantial visits to Germany and Austria in the mid-1830s. The first, with Venice as its ultimate goal, took place in 1833, while the other, which took Turner only as far as Prague, occurred in 1835. Their routes were quite distinct, with repetition only along the great scenic highway of northern Europe, the Rhine between Mainz and Cologne. In each case Turner's tour can be followed in a small group of sketchbooks forming a pictorial diary of his experiences; consistent sketching styles and slight overlaps of subject matter produce an entirely coherent itinerary. Turner himself very rarely dated his sketches or drew up lists of dates and places as in 1817 and 1824, but his arrival in foreign towns in 1833 and 1835 was sometimes recorded in local newspapers. These records confirm the evidence of the artist's own sketchbooks.

Turner's decision to revisit Venice in the summer of 1833 is usually attributed to the fact that he exhibited his first Venetian oil paintings at the Royal Academy in the spring of that year, partly in emulation of Richard Parkes Bonington's success with such subjects and partly in friendly competition with Clarkson Stanfield. His only previous visit to Venice had taken place as long ago as 1819, when he spent four or five days there on his way to Rome during his first tour of Italy; and it was on the basis of his 1819 sketches and memories that he produced his famous 'Bridge of Sighs, Ducal Palace and Custom-House, Venice: Canaletti Painting' and another Venetian painting, now untraced, 'Ducal Palace, Venice', in 1833.[4] The act of painting these would have prompted a desire to revisit Venice itself, whilst the prospect of taking advantage of an existing market for Venetian paintings cannot have been unattractive (Bonington himself had died in 1828). However, the real catalyst for the tour was the patronage of H.A.J. Munro of Novar, one of Turner's closest friends and supporters. Munro had begun buying Turner's work about 1830 and by the time of his death in 1865 had built up a large collection of both oil paintings and watercolours.[5] In 1833 he bought Turner's 'Rotterdam Ferry Boat' at the time of its exhibition at the Royal Academy[6] and he then proceeded to send him to Venice in the hope of acquiring a watercolour of that city, an intention that was, in the event, frustrated.[7] At Turner's insistence, Munro agreed to take care of all his friend's travelling expenses, a circumstance which played its part in shaping Turner's subsequent itinerary.

In 1819 Turner had reached Venice via France, crossing the Alps to the west of Turin and visiting Milan and Lake Como on his way. In 1833 he chose an entirely different route which took him through Belgium, Germany and Austria. This enabled him to make a short detour to revisit part of the Meuse before travelling on up the Middle Rhine. It also provided him with experiences of many notable cities including Mannheim, Heidelberg, Munich, Salzburg and Innsbruck. What is at first sight surprising is that he made a deviation from the direct route, turning north-east from Salzburg rather than south-west towards the Alps. This gave him his first experience of the highly picturesque stretch of the Danube below Linz and also introduced him to the splendours of Vienna and its imperial picture gallery. He then doubled back to Salzburg and headed for Innsbruck and the Brenner Pass, followed by Verona, Padua and Venice. Turner's choice of route must have been influenced by the illustrations in Batty's *German Scenery* (1823) and Prout's *Facsimiles of Sketches Made in Flanders and Germany* (1833) and, especially, by hearing from the Callcotts about their visit to Germany in 1827 and from Eastlake about his visit to Munich in 1828. However, it must surely have also owed much to Munro's financial support for the tour. Turner would not have found a ready market for German views, other than ones of the Rhineland, at this date.[8]

The first sketchbook Turner used in 1833 was an English one of horizontal format which he himself labelled

Brussels up to Mannheim – Rhine (TB CCXCVI; cat.no.27), but those which lie at the heart of his German and Austrian experiences are three upright books of continental origin. Of these, the very similar pair *Heidelberg up to Salzburg* (TB CCXCVIII; cat.no.28) and *Salzburg and Danube* (TB CCC; cat.no.29), were probably both bought in the same shop in Heidelberg and both were inscribed with their titles by Turner himself in similar fashion to *Brussels up to Mannheim – Rhine*. The second contains just one sketch of Heidelberg, with a view of Salzburg on its verso, providing further proof of the relationship between the books: this was the only time Turner visited Salzburg.[9] He used the *Salzburg and Danube* sketchbook right up to his arrival in Vienna where he bought and started sketching in the book here renamed *Vienna up to Venice* (TB CCCXI; cat.no.30). All three upright books were scored in ink by Turner across their fore-edges, like the group of five he was to use in 1839.[10] This was his own memorandum that the three belonged together. Turner's arrivals in Vienna, Innsbruck and Venice were all recorded in local newspapers in August and September 1833. Furthermore, in 1834 two of his sketches in the *Vienna up to Venice* sketchbook showing the Roman amphitheatre at Verona were developed into a watercolour which was engraved and published in Volume XI of the *Prose Works* of Sir Walter Scott early in 1835 (fig.20).[11]

Two further factors may have affected the planning of this journey. At the 1833 Royal Academy Turner's depiction of Venice with Canaletto painting was hung immediately next to one of Ghent by his friend George Jones with whom he proceeded to indulge in a typical piece of amiable one-upmanship. Jones's 'Ghent' had a brilliant blue sky which Turner put down by working up the 'magical contrasts' in his own. Jones then added a lot more white to his, making Turner's sky look excessively blue – as it remains today. According to Jones, Turner thoroughly enjoyed the episode, laughing heartily and slapping him on the back.[12] It may not be a coincidence that he paid particular attention to Ghent a short while afterwards, drawing fine pencil sketches of its principal sights.

Turner's detour to the Danube is easily understood within the context of 1833. December 1832 had seen the publication of the first volume of *Turner's Annual Tour; or, The River Scenery of Europe*, a Christmas and New Year gift book devised by Charles Heath and published by Longman.[13] The first volume, with engraved plates after twenty-one gouache scenes by Turner and a text by Leitch Ritchie, was devoted to the Loire and in May 1833, five months after its appearance, the publishers announced that they

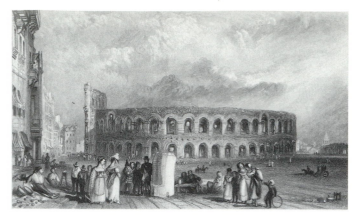

fig.20 William Miller after J.M.W. Turner, 'Verona' (R 530). Engraving from Scott's *Prose Works* (1835)

proposed to issue a whole series of volumes covering all the 'Great Rivers of Europe'.[14] Clearly Turner would have wanted to use part of his next summer tour to collect material on at least one of these rivers. He can easily be imagined on the eve of his tour. On 3 July 1833, during an exhibition of eighty of his drawings for the *Picturesque Views in England and Wales* and for Scott's *Poetical Works*, one observer found Turner's appearance somewhat anomalous: 'his coarse, stout person, heavy look, and homely manners contrasting strangely with the marvellous beauty and grace of the surrounding creations of his pencil.'[15] Behind the exquisite drawings there lay months of arduous travelling, and with the arrival of the summer it was time to leave London again.

Turner's tour began at Ostend and he then spent time in both Bruges and Ghent, drawing pencil sketches of all their most popular sights. After travelling on to Brussels and Liège, he made a detour of around thirty miles westwards, up the Meuse, to revisit Huy and Namur. He had seen these fortress towns on his 1824 tour and he now ranged extensively not only within the towns themselves but also in their environs. It was, in fact, only after several days in Belgium that he headed for Cologne and the Rhine. He had the whole summer before him and was clearly not in a hurry.[16]

Many of the Belgian sketches of 1833 are careful drawings, occupying an entire page or even two, but along the Rhine his behaviour was quite different. He was almost certainly travelling on the steamer service introduced on this stretch of the river in 1827, and his sketching had to keep pace with his boat. As usual, he divided his pages up into sections, to cram in as much as possible without having to keep turning the pages. In any case, his sketchbook – the only British one used on this tour – had to last him until

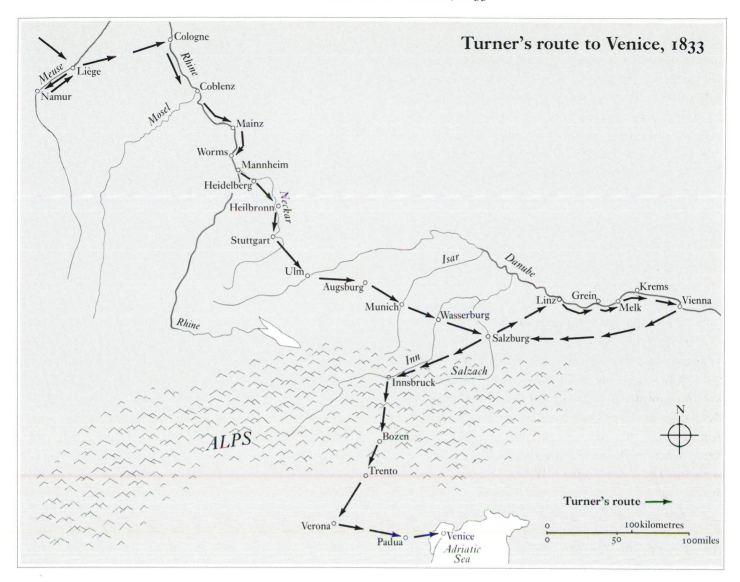

Turner's route to Venice, 1833

he was at leisure to buy another in a sizeable town with a stationer's. By sheer ingenuity he contrived to make its ninety-odd pages last from Ostend right up to Mannheim. Some time on this journey – and while still drawing on a large scale, rather than squeezing his sketches into corners – he made two studies of reclining female nudes. Subsequently he needed to use the spaces surrounding them for small sketches and notes on travelling arrangements but they remain fine sketches in themselves, a useful reminder that Turner had a private life as well as a public persona as an artist (fig.21). Similar drawings were made later on the same tour[17] and, indeed, on other tours but most were destroyed by Ruskin.

After drawing a few quick sketches of Mannheim (cat.no.27) Turner left the Rhine and travelled by road up the Neckar valley to Heidelberg. Here at last he had a break from his relentless travelling, buying himself fresh sketch-

fig.21 Reclining female nude, with German travel memoranda (TB CCXCVI 90v). Pencil, 1833

books, and he plainly delighted in everything he saw. Like all other tourists of his day, he explored its celebrated castle and walked up to the high terrace in its gardens to admire the prospect of the castle and town with the Neckar flowing westwards to join the Rhine. He walked along many parts of the Neckar shore itself, looking at terrace and hillside, castle and bridge, and filled over fifty pages of his new sketchbook with pencil sketches.[18] What he did not do, however, was explore the enchanting stretch of the Neckar valley nearby, which was largely unknown to British travellers at this date and Turner himself was not to discover until 1844.[19] Instead, he headed south for Stuttgart, at first travelling cross-country by road from Neckargemünd to Heilbronn through Meckesheim, Zuzenhausen and Sinsheim, and then carrying on, without a pause, on the road which more or less follows the Neckar valley to Lauffen, Kirchheim, Bietigheim and Stuttgart.[20] Here he did stop in the centre of the town and sketched some of its principal buildings (cat.no.28) as well as walking out to the most noted viewpoints in the hills to the east in order to depict the town as a whole, prettily situated amid vine-covered slopes with a backdrop of gently rising hills.[21] Stuttgart lay off the beaten track as far as most nineteenth-century travellers were concerned, inspiring few paintings from visiting artists.[22] Turner's pencil sketches have therefore something of a rarity value besides their innate attractiveness (fig.22). It is also a nice historical accident that he viewed with pleasure the city that was, a hundred and fifty years later, to house James Stirling's Neue Staatsgalerie (1977–84), probably the most outstanding building designed by the architect of the Clore Gallery for the Turner Collection.

From Stuttgart Turner travelled by road to Ulm, the route initially following the course of the Neckar through Esslingen and then going south-eastwards to the Danube.[23] He made many quick sketches of the walls and towers of Ulm from the carriage and several others, showing the vast unfinished cathedral and town hall, during a walk round the city, probably while waiting for the next *Eilwagen*.[24] One, overlooking the Münsterplatz, was taken from a window in the Cafe Tröglen, established earlier in the century and still functioning today, which provides a fine view of the cathedral façade.[25] Prout had sketched a similar view ten years earlier, one of half-a-dozen Ulm sketches which were later developed into larger drawings, watercolours and lithographs.[26]

Ulm provided Turner with his first sight of the Danube and was the furthest upstream that he ever sketched it, although he was fairly close to its upper reaches on several

fig.22 Stuttgart: figure studies and the tower of the Stiftskirche (TB CCXCVIII 46r). Pencil, 1833

of his European tours, for example at Schaffhausen in 1802 and the 1840s and at Lake Constance in 1840. In 1833 he moved swiftly on from Ulm through Bavaria to Munich.[27] Here, not surprisingly, he paused.[28]

The 1830s were very important years in the development of Munich which was soon to become not only one of the handsomest towns in Germany but also, to at least one foreign observer, 'the most interesting capital in Europe'.[29] King Ludwig I, an ardent admirer of the art and architecture of classical antiquity, had succeeded his father in 1825 and during the next decade, under his guidance and patronage, architects, painters and sculptors embellished the city with many fine buildings and monuments in neoclassical style. Turner would have heard from the Callcotts about the paintings and galleries they had seen in 1827, the artists and collectors they had met and the grand new buildings of the city. One of these, sketched twice by Turner, was the Glyptothek, the sculpture gallery designed by Leo von Klenze (1816–30), the façade of which incorporates a pedimented Ionic porch like that of a Greek temple.[30] This was built to house a superb collection of classical sculptures acquired for Bavaria at his own expense by Ludwig whilst Crown Prince. Although no one was allowed to sketch in the gallery without special permission from the king, Turner managed to draw one of its most famous exhibits, quickly recording it from four different viewpoints.[31] This was the kneeling figure of a youth, then

fig.23 Munich: the statue 'Ilioneus' in the Glyptothek (TB CCXCVIII 37r). Pencil, 1833

known as the 'Ilioneus' and thought to be part of a celebrated marble group of the children of Niobe being slain by Apollo (fig.23). It was one of the most highly regarded statues of antiquity at this date, receiving a long eulogy from the pen of the art critic Mrs Anna Jameson who surveyed it some two months after the painter himself.[32]

Although the Glyptothek was already completed and functioning as a public museum at the time of Turner's visit, this was not the case with the Pinakothek (1826–36), the art gallery created by Ludwig I to display the paintings collected and commissioned by the leading family of Bavaria, the House of Wittelsbach, from the early sixteenth century onwards. This, too, was designed by Leo von Klenze but in an Italian Renaissance style. Turner sketched its unfinished exterior (fig.24), making a careful study of one bay and noting that there were '24' of them,[33] but to see the paintings themselves he had to make his way to the palace of Schleissheim, some eight miles to the north of Munich. He duly sketched the palace itself – a summary outline with memoranda about the number of its bays.[34]

Just two British artists were represented in the Bavarian royal collection at this date: Stubbs, by a painting of a sporting dog, and Wilkie, by 'Reading the Will', painted for Ludwig's father, King Maximilian I, in 1819–20 (see fig.8, p.16).[35] However, the collection was rich in Old Master paintings, over 1,000 works of high quality providing almost a surfeit of interest. One British visitor actually complained: 'It is not as in the exhibition of our Royal Academy, where the visitor at once walks up to Turner, or Wilkie, or Sir Thomas Lawrence, without troubling himself to cast his eyes to the right or left.'[36] Turner must undoubtedly have been impressed by the quality of the collection as Munich was destined to be the only continental

capital to which he sent one of his own paintings, 'The Opening of the Wallhalla' (cat.no.109), from London for exhibition. He did not, however, succeed in this venture and it was not until 1976 that a Turner painting entered the Munich collection. This was his 'Ostend' (1844),[37] which, appropriately enough, was inspired by experiences at the very end of the important tour of Germany on which he had studied the Walhalla.

As Turner walked northwards in Munich in 1833 to the gleaming new classical buildings dedicated to the arts, he must have passed the equally new obelisk in the Karolinenplatz, also designed by Klenze and due to be unveiled by Ludwig himself some two months later on 18 October, the anniversary of the battle of Leipzig which was also used for both the formal inauguration and the opening of the Walhalla.[38] This 100-foot obelisk, which is shown in the background of two of his sketches (see fig.24),[39] was cast almost entirely from the metal of captured guns and commemorates the thirty thousand Bavarian conscripts who had perished in the Russian campaign of 1812–13 – forced to fight for, rather than against, Napoleon. Its purpose was to show that these soldiers had not died in vain but had, in their own way, contributed to the deliverance of their country. The same all-embracing humanity inspired the Walhalla itself, dedicated to the memory of all great Germans, not just Bavarians. Turner must surely have already heard of the project for the Walhalla from the Callcotts who had been shown Klenze's design for it by the architect himself in 1827.[40] Now he learned more. Its foundation stone had been laid in 1830 and, although it was being built many miles away, near Regensburg, it was much talked of in Munich at the time of his visit.[41]

Besides making swift pencil sketches of the modern buildings of Munich and more careful ones of its historic

fig.24 Munich: Klenze's Pinakothek (TB CCXCVIII 57r). Pencil, 1833

gates and churches and town hall, Turner also surveyed the city from afar, using the viewpoints across the river Isar to the north favoured by his German contemporaries.[42] However, there is nothing to suggest that he travelled out to Hohenlinden, depicted in a small vignette a few years later (see cat.no.36). The distant view of Munich shown in its background is very schematic and without any basis in Turner's own sketches.

In the 1830s it took the best part of a week to travel from Munich to Vienna, communications between the Bavarian and Austrian capitals being poor and inns scarce. Many preferred to travel entirely by boat, going north down the Isar to join the Danube near Deggendorf and thence down the Danube itself; some joined the Danube at Passau.[43] Turner followed neither of these options, choosing instead to travel by road to Salzburg. This was not the most obvious course of action in pursuit of either Vienna or the Alps and Italy. It can only have been a deliberate choice, prompted by a desire to see Salzburg itself, a city which had received very favourable reports from recent British travellers, some of them belonging to the same circles as Turner. Captain Robert Batty included five engravings of Salzburg and its environs in his *German Scenery* of 1823, remarking that no inland city in Europe could probably rival it for the picturesqueness of its situation, a sentiment echoed in the published account of Sir Humphry Davy's last tour on the Continent in 1828–9.[44] The antiquarian T.F. Dibdin, accompanied on his tour of 1818 by the watercolourist G.R. Lewis, went even further, declaring that: 'I hardly know where I could pass the summer and autumn months more completely to my satisfaction than at Salzburg. What might not the pencils of Turner and Calcott here accomplish, during the mellow lights and golden tints of autumn?'[45] Another British visitor to Salzburg shortly after Turner himself was Wilkie who, in 1840, paid the city the highest compliment of which a Scot is capable when he compared it to all the beauties of Scotland rolled into one: 'Edinburgh Castle and the old town brought within the cliffs of the Trosachs, watered by a river like the Tay, and having for an entrance a tunnel through a rock. These, with the snow-covered Alps of the Tyrol in the distance, make a combination no where else to be met with.'[46]

Turner's route from Munich to Salzburg took him past Steinhöring, the very scenic town of Wasserburg, almost entirely encircled by the river Inn, Stein an der Traun and the Waginger See.[47] From Munich onwards the Alps were constantly in sight and Turner sketched them from time to time from the carriage as jagged outlines that grew ever nearer and more dramatic. It must have been around mid-

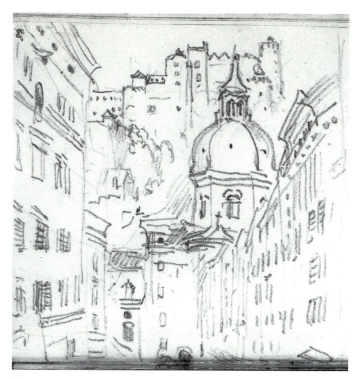

fig.25 Salzburg: the cathedral and fortress from the Höllbräu (TB CCXCVIII 88r). Pencil, 1833

August that he simultaneously reached Salzburg and came to the end of the blank pages in his sketchbook, wedging in a few sketches of the city probably on the day of his arrival.[48] The two most accomplished of these were drawn, as might be expected, from inns. One shows the view across the Salzach to the Kapuzinerkloster and the old houses lining the river and was drawn from the inn named Zum Mohren. The other depicts the cathedral and fortress of Hohensalzburg from an upper window in another hotel, the historic Höllbräu (fig.25).[49]

In Salzburg Turner brought out his third sketchbook, later inscribed 'Saltzburg and Danube'. Here he made over ninety pages of pencil sketches which reveal an enthusiastic and systematic exploration of all the best viewpoints in and around Salzburg. Dibdin had been right: Salzburg and Turner were perfectly suited to each other. He may have learned of the viewpoints through books or conversations, by glancing into printshop windows or simply by following his instincts to climb hills and follow rivers. In any event, he found his way to all the localities beloved by generations of German and Austrian artists and particularly dear to those of the early nineteenth century. Again and again Turner's sketches show sights recorded by Ferdinand Olivier, Johann Adam Klein, the Reinhold brothers, Johann Christoph Erhard, Ludwig Richter, Julius Schnorr von Carolsfeld and numerous others.[50] He may have heard

of their interest in Salzburg when he was in Rome in 1828, or even on his recent visit to Munich.

Turner's first sequence of sketches was made when he climbed the Kapuzinerberg, above the new town on the east side of the Salzach, pausing at some of the Stations of the Cross on the way and then surveying the old town and the fortress spread out across the river with the morning light on it.[51] He then walked about three miles southwards along the Salzach, as far as Schloss Goldenstein, constantly stopping to sketch the views in both directions (cat.no.29). To the north, the city gradually disappeared behind the great bulk of the fortress, while to the south rose the massive Hoher Göll and the peaks of the Watzmann and Untersberg, and he only turned back after crossing the river and noting the 'Avenue of very fine trees' at Schloss Hellbrunn.[52]

It was probably in the evening that Turner made another three-mile walk to a notable viewpoint in the opposite direction: the pilgrimage church of Maria Plain which houses the miraculous image of the Virgin honoured in Mozart's Coronation Mass. On this excursion, too, he made many sketches of the magnificent views both in front and behind. When he reached his destination, he still had energy enough to climb to the organ loft of the church to gain an extra bit of height for his sketch of Salzburg dominated by the Untersberg.[53]

Finally, he climbed the Mönchsberg, the great crag on the southern tip of which the fortress of Salzburg is situated. This, like the Kapuzinerberg, afforded Turner splendid views of the old town with its many domes and towers and of the fortress itself.[54] He did not neglect the town itself, exploring streets and squares to discover good views of Salzburg's famous sights and noting points of detail in pencil memoranda (the inscription 'Te Saxa Loquuntur' on the Neutor and its 'Medusa Head', for instance).[55] However, it was, above all, the picturesque situation of Salzburg rather than any individual buildings that inspired the concentrated sequences of sketches that seem to record each step of his walks. His activity would have passed entirely unremarked in this locality at this date. The numerous sketches, drawings and paintings of the German and Austrian Romantics in and around Salzburg between 1815 and 1840 frequently include the artists themselves: sketching in books or painting at easels out of doors in front of the very same motifs that caught Turner's eye; standing laden with equipment discussing views or seated on rustic benches simply enjoying them; perched on camp-stools and protected by sun-shades or umbrellas.[56] Many passersby, indeed many native artists, must have seen Turner at

work around Salzburg in 1833 without having the slightest idea of who he was.

After exploring the environs of Salzburg Turner went north-east by road to Linz on the Danube and then spent the next few days travelling by boat down to Vienna. This was a considerable detour from his journey to Venice – the Danube stretch alone is nearly a hundred and thirty miles long and probably took him two or three days, while the cross-country journeys from Salzburg to Linz and from Vienna back to Salzburg would have occupied several more. But Turner was keen to collect sketches of European rivers with future volumes of *Turner's Annual Tour* very much in mind at just this moment and the Danube was, in any case, an appealing subject and one that was comparatively little known in Britain. The wild and romantic scenery between Linz and Vienna is, as one of his contemporaries remarked, somewhat similar to that on the Rhine between Mainz and Coblenz; a second had recently published an account which bemoaned the fact that the magnificent Danube was so neglected by English artists and praised its countless sublime views 'which might task the united pencils of a Claude and a Salvator Rosa'; whilst a third observed that during a voyage in these parts, gliding 'swiftly and silently … with heaven's breath upon one's face, may be enjoyed morning and evening views, sunsets with castles and mountains that Claude might have painted'.[57] It was thus a natural theme for Turner to pursue in mid-career, especially since the boat brought the traveller to the Austrian capital with its famous buildings and art collections.

In Linz Turner wandered through the town itself, sketching a very distinctive view along the Landstrasse with three church façades in a row stretching away from him, as well as many river views showing the castle and the long wooden bridge.[58] He certainly stopped at an inn for refreshment, and probably the night too, before making an early start in the Danube boat. He recorded the interior of the inn in a spirited sketch, on which he scribbled 'De Hooge' – the Dutch painter Pieter de Hooch, of whose seventeenth-century interiors this real-life nineteenth-century Austrian one reminded him (fig.26).[59] On his European travels Turner often found that nature reminded him of particular continental painters: in Germany there were landscapes reminiscent of the paintings of Claude Lorrain or Gaspar Dughet and light effects that recalled those of Aelbert Cuyp.[60] On more than one occasion in German lands, taverns called de Hooch to his mind and prompted quick sketches.[61] He seems to have felt thoroughly at home in such an environment. Moreover, in Turner's day Linz

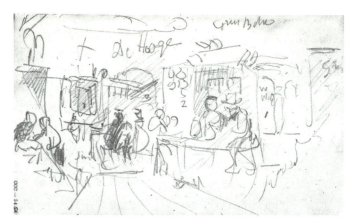

fig.26 An inn scene at Linz on the Danube (TB CCC 54r). Pencil, 1833

was famed for the beauty of its women, and travellers noted that although the voyage down the Danube involved two nights' indifferent sleeping and two days' meagre food, a stay in Linz did not require mortification of the flesh in either respect.[62] Turner, it must be hoped, enjoyed himself at Linz while he could.

Turner's most famous British predecessors on the Danube were Lady Mary Wortley Montagu who greatly savoured her experiences in 1716 and Dr Charles Burney who detested his in 1772.[63] Whether he travelled on a gigantic raft like the former or in an 'Ulm box' like the latter, the conditions on board will certainly have been primitive, but either craft provided views of great interest and beauty. Between Linz and Klosterneuburg on the outskirts of Vienna Turner covered over sixty pages of his sketchbook with small pencil drawings, using each page for many separate sketches just as he had done when discovering the Middle Rhine in 1817 and the Mosel in 1824 and, indeed, had been doing earlier on the 1833 tour itself.[64] To begin with, he used the pages lengthwise to give himself shallow, wide compartments since the Danube after Linz is comparatively broad and meandering with several islands and the valley is spacious. Soon, however, he began using the pages crosswise to fit in more sketches per page as he recorded buildings and scenery closer at hand. On the first lap of his voyage the chief objects of interest were the ruined tower of Spielberg on its island and the fine castle of Wallsee, both of which he drew many times from different directions as he passed them, just as he had done with the castles on the Rhine and Mosel.

The pace of his sketching intensified once he reached the most famous scenery on this part of the Danube, between the towns of Grein and Krems, with its celebrated – and, in the eighteenth and nineteenth centuries, danger-

ous – passages past the whirlpools of the Strudel and the Wirbel. In 1772 Burney declared that the scenery around the Strudel was wilder than any he had seen while crossing the Alps.[65] This was a gross exaggeration but the passage was still attended with difficulties in Turner's day, while the craggy scenery and historic buildings and ruins all around had lost none of their excitement for travellers. The great baroque monastery towering above the river at Melk (fig.27), the castle of Schönbühel lapped by the water, that of Aggstein sharp against the sky, the gentle hills of the Wachau clothed with vines and firs, the jagged great ruins of the castle in which Richard Coeur de Lion was imprisoned at Dürnstein – all these retained their visual appeal long after the Danube became easier to navigate and regular steamships started to travel up and down it.

Turner did his best to record all the passing sights, but he was hampered by his mode of transport. He could not choose his viewpoints or linger over his sketches; he could not leave the boat to walk along the river banks, since there was no assurance of a decent inn or riverside road or of catching another craft later. He remained on board, sketching valiantly on, so that the pages of his sketchbook give an unbroken hour-by-hour sequence of the sights he passed, often annotated with place-names learned from his fellow-passengers. From them he must have heard of the guidebook *Reise auf der Donau Ulm bis Wien* whose title he noted, perhaps already planning a return to this area.[66] Sadly, Turner did not follow up his preliminary glimpses of the Danube with a more careful and prolonged study on his own terms, as he was to do with the Mosel. He did not return until 1840, when he used the river for part of his journey home from Venice. On that occasion he saw even less of the Danube between Vienna and Linz than he had in 1833 and paid it less attention. He travelled by steamer, passing some of the best scenery by moonlight, and concentrated instead on different areas of the river which were new to him, notably Passau and Regensburg.[67] British artists and writers continued to neglect the Danube during the 1830s, no volume appearing in the 'Great Rivers of Europe' series, and it was not until the 1840s – with the engravings after W.H. Bartlett and the narratives of Robert Snow, William Beattie and J.P. Simpson – that it became at all widely known.[68] Turner was ahead of his time. Lacking an existing market for Danube scenes, he made no attempt to convert his numerous pencil sketches into watercolours or oil paintings, but painted the scenes and subjects his patrons and publishers demanded: in the mid-1830s this meant France and Venice and sometimes the Rhineland, but not Austria.

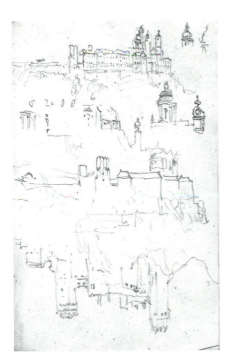

fig.27 Melk abbey and Weitenegg castle on the Danube
(TB CCC 72v). Pencil, 1833

As it approaches Vienna, the Danube is a broad meandering stream flowing in a wide valley, with many islands and sometimes several channels, so that the last fifty miles, after Krems, have much less scenic interest than the previous fifty. Here Turner reverted to using his sketchbook pages lengthwise in order to draw the simplest of sketches showing distant hills enlivened only by occasional towers, such as those of Tulln, or a place name. The 'Wagram' he noted in the distance was not the site of the battlefield where the French had defeated the Austrians on 5 and 6 July 1809; his fellow-passengers would have told him that this took place at a different Wagram altogether, on the opposite side of Vienna. The final stretch of the Danube provided more of interest, the castle of Greifenstein and the huge monastic complex of Klosterneuburg being impressive sights before travellers disembarked at Nüssdorf on the outskirts of the capital.[69]

Turner is recorded as arriving in Vienna on 25 August and staying at the Golden Lamb (Zum Goldenen Lamm).[70] This hotel was in the Leopoldstadt, just over a small branch of the Danube from the inner city, at the very start of Praterstrasse. It may have been less good and less central than the one he was to stay at in Vienna when he returned in 1840, but it was perfectly reliable and much cheaper and well patronised by English visitors.[71] To reach the centre of Vienna Turner would have crossed the northern branch of the Danube, as yet not canalised and liable to cause

disastrous flooding in the Leopoldstadt.[72] He used this knowledge ten years later in his verses on his one great oil painting depicting the Danube, 'The Opening of the Wallhalla, 1842' (cat.no.109). Here he refers to the tide of war as pouring on 'Like the swollen Danube to the gates of Wien'. Staying in the Leopoldstadt, he would have heard of notorious episodes of flooding, and perhaps seen depictions of them as well.

The first thing Turner needed to do in Vienna was buy a new sketchbook and this he did in Rothgasse, just north of the Stefansdom, on his walk into the city centre (*Vienna up to Venice*; cat.no.30). He was then ready for work and set about visiting the Upper Belvedere which had housed the imperial art collection since the 1770s and also provides superb views of the city itself, as many artists visiting both palace and gardens over the centuries have discovered. The collection of Old Masters in the Belvedere was very highly regarded in Turner's day, among those in Germany second only to that of Dresden, being exceptionally rich both in Italian art and in works by northern masters. Copying was encouraged and Turner himself made a few notes and sketches, though these are neither as careful nor as thoughtful as those made two years later in Dresden.[73] He noted down artists' names and dates, presumably from labels or frames; he made tiny rough copies of a handful of paintings, including Francesco Furini's 'Penitent Magdalene' and an 'Ecce Homo' of the Venetian School, believing it to be the work of Mantegna whose biographical details he noted nearby. Both this work and another reminded him of similar paintings by Titian. His largest sketch – but still a very small one – shows a work by a master extremely well represented in the Viennese gallery, though never a great favourite with Turner himself, Rubens. Writing in one of his Perspective Lectures in about 1811, Turner had disparaged the Flemish painter for too much variety in his colour schemes – '[he] threw around his tints like a bunch of flowers' – and was quite violent in denouncing his landscapes in 1830.[74] However, in 1833 he was clearly interested by the painting of 'Hélène Fourment in a Fur Wrap' – possibly for its subject matter or perhaps for its simple but effective composition and colour scheme.

Apart from recording the fine views of Vienna from the Belvedere gardens and making a few perfunctory drawings of the Stefansdom, Turner did little sketching in the Austrian capital. He did, however, take pleasure in the wooded heights just north-west of the city, the Wienerwald or Vienna Woods, with the village of Grinzing and the hills of Leopoldsberg and Kahlenberg. These were – and, indeed, still are – immensely popular both with the Viennese them-

selves and with visitors to the city since they command extensive views over the winding Danube. He recorded these many times in pencil sketches, sometimes with notes on light and shade.[75]

After his stay in Vienna, Turner returned to Salzburg, not by following the Danube but by road. He probably sketched little until he was quite close to his destination, when he passed through Vöcklabruck and Frankenmarkt.[76] He made several rough sketches of Salzburg before carrying on to Innsbruck (cat.no.30) which he is recorded as reaching on Monday 3 September.[77] It was not a very productive time as far as his art was concerned, but he may have been hindered by poor health or poor weather or simply by being confined to the carriage. Alternatively, he may well have been diverted by agreeable company. There are life drawings of reclining female nudes both in the *Vienna up to Venice* sketchbook and on small pieces of grey paper such as Turner was certainly using during his return journey in September 1833.[78] Like the similar drawings made in the *Brussels up to Mannheim – Rhine* and *Heidelberg up to Salzburg* sketchbooks, these serve as a reminder that his continental excursions were not exclusively devoted to work.

The most distant part of Turner's 1833 tour is the best documented in local records of his whole summer. Having travelled south from Innsbruck via Bolzano and Trento to Verona and Padua, he reached Venice on 9 September.[79] He cannot have spent more than a week there, since an Austrian newspaper recorded him as arriving back in Innsbruck on 23 September.[80] During his days in Venice he made pencil sketches in two nearly identical sketchbooks of upright format (slightly larger than, and with different origins from, those just used in Germany and Austria). *Venice* (TB CCCXIV) was used in the city itself and the one Turner later named *Venice up to Trento* (TB CCCXII) actually records his return journey well into Bavaria.[81] Several of the themes in the first of these books were later developed into oil paintings from the mid-1830s to 1840, so that his brief stay in Venice was, in that sense, extremely fruitful. It did not, however, lead him to make watercolours and Munro of Novar, who had sent him there for that purpose, received an oil painting of Venice instead.[82] As will be seen later in this catalogue, many of the coloured sketches of Venice previously associated with an 1830s visit can now be confidently assigned to his final visit there in 1840.[83]

By the time that Turner reached Innsbruck on 23 September he had started making pencil sketches on small loose sheets of torn grey paper as well as in his sketchbook, which makes his return journey somewhat hard to recon-

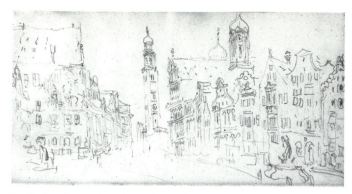

fig.28 Augsburg: view along Maximilianstrasse towards the Perlachturm and town hall (TB CCCXII 65v). Pencil, 1833

struct. The Turner Bequest contains over 500 such pieces of grey paper and, although one group of sixteen can be reassembled into its original sheet and contains the scribbled date '23 of Sep 1833',[84] other pieces or groups bear depictions of entirely different regions from that visited in 1833 and can be assigned to several other, identifiable, tours of the 1830s and 1840s. In late September 1833 Turner probably headed straight for home from Innsbruck, returning down the Rhine. He certainly passed through Augsburg, making a few very fine sketches of its remarkable buildings (fig.28).[85] He was back in London by 20 October when he wrote to his friend J.H. Maw about some 'Drawings and your Copies' but made no reference to his recent experiences on the Continent.[86]

Turner's 1833 tour – the existence of which was once doubted and which has, until now, never been properly described – was curious not only in design but also in outcome. Although his goal was Venice, the tour gave him his first sight of the great artistic capital of Munich and took him to the most easterly point of all his European travels, Vienna. The excitement of seeing the Old Master paintings in Vienna and the new museum buildings of Munich must have encouraged him to visit Berlin and Dresden two years later, but it was not until 1840 that he made any further study of the Danube. In the meantime, he returned to his *French Rivers* project, the second and third volumes of engravings appearing in the autumn of 1833 and 1834 and both being devoted to the Seine. However, the influence of the Danube, Germany and Italy can surely be felt in Turner's oil painting exhibited in 1834, 'The Fountain of Indolence' (fig.29). This allegorical landscape, inspired by James Thomson's poem *The Castle of Indolence* (1748), unites many of the ingredients recorded along the Danube in 1833: rounded wooded hills crowned with half-glimpsed castles, watermills and wooden bridges, range upon range

of higher hills and snow-covered mountains. On the right are two fine classical buildings possibly inspired by the sight of the new museums in Munich or Palladian villas near Venice: a gleaming white pedimented building and a grand stone portico, seen sideways on, in the manner of Claude. The scenery described by Thomson himself contained all the most attractive features depicted by the landscape artists most admired in eighteenth-century Britain:[87]

Sometimes the pencil, in cool airy halls,
Bade the gay bloom of vernal landskips rise,

Or Autumn's varied shades imbrown the walls:
Now the black tempest strikes the astonished eyes;
Now down the steep the flashing torrent flies;
The trembling sun now plays o'er ocean blue,
And now rude mountains frown amid the skies;
Whate'er Lorrain light-touched with softening hue,
Or savage Rosa dashed, or learnèd Poussin drew.

So, too, Turner's painting brings together many of his most recent concerns in a brilliant composition filled with cross-references and allusions.

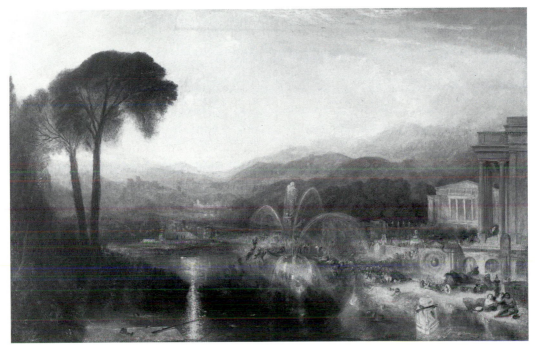

fig.29 'The Fountain of Indolence' (B&J 354).
Oil on canvas, RA 1834. *The Beaverbrook Foundation.*
The Beaverbrook Art Gallery, Fredericton, N.B., Canada

Northern Germany, the Elbe and Prague, 1835

In 1835 Turner made the most original of all his German tours. Much of it has never previously been studied, the sketchbooks having been misunderstood as representing parts of other journeys or else ignored.[1] Six small sketchbooks now in the Turner Bequest were used on this tour, of which the first five are here given revised titles: *Hamburg and Copenhagen* (cat.no.31), *Copenhagen to Dresden* (cat.no.32), *Dresden and Saxon Switzerland* (cat.no.33), *Dresden, Teplitz and Prague* (cat.no.34), *Prague, Nuremberg, Frankfurt and Rhine* (cat.no.35) and *Rotterdam* (TB CCCXXI). They all measure about 6 × 4 inches, are of upright format and continental origin and they contain hundreds of pencil sketches, the subject matter of which overlaps slightly from book to book providing a continuous thread. Turner's itinerary took him on a wide circuit embracing not only Germany but also Denmark, Bohemia and Holland and it provided him with his only visits to Hamburg, Copenhagen, both Germany's North Sea and Baltic coasts, Berlin, Dresden, Prague and Frankfurt. It was not until the final few days of the tour, in which he travelled down the Rhine from Mainz to Rotterdam, that he was on familiar territory. For a man of sixty, travelling on his own, speaking very little German and none of the other languages needed, and crossing many frontiers, this was no mean feat. Why did he do it?

It looks as though a series of separate influences drew his attention to northern Germany at this time. He would certainly have been curious to study the famous picture collections in Berlin and Dresden, especially in view of the recent visit to London of the director of the Berlin Museum, Dr Gustav Waagen.[2] Copenhagen, too, was an important artistic centre where many German artists of the day were trained. He may have learned of the singular nature of the Elbe valley above Dresden through Captain Robert Batty's *Hanoverian and Saxon Scenery* (1826–9), of which he owned at least one instalment (see fig.9, p.17) and which also featured Hamburg and Copenhagen, while the beauty of Prague was renowned. Many British travellers had by this date made the journey from Dresden to Teplitz and Prague, including Henry Crabb Robinson in 1801, David Wilkie in 1826 and the Callcotts in 1827.[3] Turner would have heard first-hand accounts of his friends' expe-

riences and he may also have been interested in seeing Germany's coasts as a result of hearing that they were to feature in the recently inaugurated *Coast Scenery* series by Clarkson Stanfield.[4] A further but less obvious catalyst was the publication in Germany in 1833 of a book of over a hundred engravings with descriptive letterpress, *Berlin und seine Umgebungen*, by the librarian at the Prussian court, Samuel Heinrich Spiker. German artists, including the most celebrated painter of Berlin views at this period, Eduard Gaertner, had supplied the scenes to be reproduced, but many of the engravings had been made in England, by the Finden brothers or in their workshop (see fig.4, p.11). In the early 1830s Turner's relationship with the Findens was at its closest, with the *Works of Lord Byron* project (1832–4), and it cannot be a coincidence that several of Turner's sketches of Berlin echo those engraved by the Findens.[5]

Whatever Turner's reasons, four of his exhibits in the spring of 1835 curiously foreshadow important features of his summer tour.[6] Leaving aside its industrial aspects, 'Keelmen Heaving in Coals by Night', with its ghostly tall ships and moonlit waters, could almost be a depiction of what Turner actually experienced in the busy ports of Hamburg and Copenhagen. After the great fire of October 1834 depicted in the two versions of 'The Burning of the Houses of Lords and Commons', a new Westminster was about to be designed and created, just as a new Berlin designed by Karl Friedrich Schinkel was in the process of creation after destruction and fire. Turner was to make many sketches of the brand new buildings of the Prussian capital, which are all the more poignant today after the events of the last fifty years during which Schinkel's buildings have been destroyed and then recreated in all their former glory. 'The Bright Stone of Honour (Ehrenbreitstein)' depicts not only Turner's beloved Rhineland but also a hero's grave, and in both Berlin and Dresden he was to record further monuments to heroism in the struggle with Napoleon, though in very different styles and in very different settings.

'Keelmen Heaving in Coals by Night' was painted expressly for the Manchester textile manufacturer Henry McConnell. On 23 July, soon after the exhibition ended, Turner wrote to him saying, 'I have received the Picture of

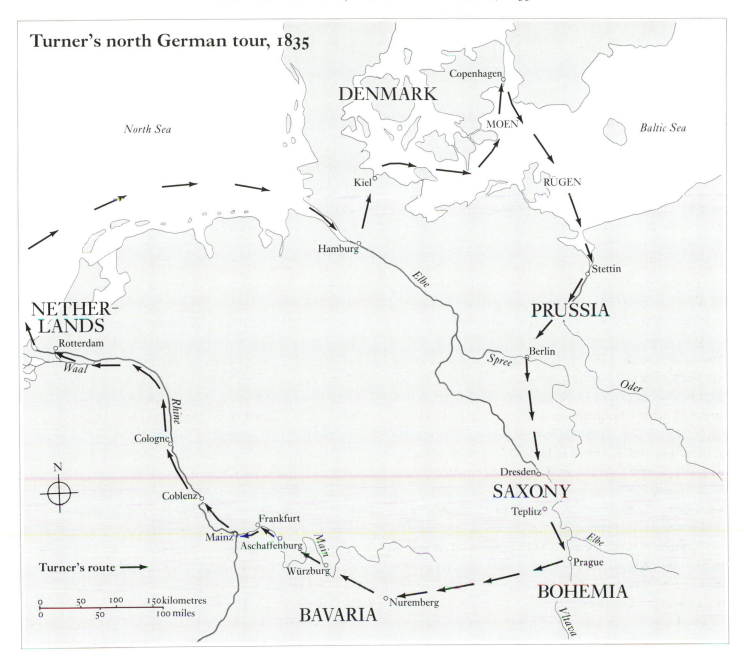

Turner's north German tour, 1835

the Moonlight from the Academy Exhibition. Have the goodness to say what you wish me to do with it before I leave Town for the summer months'.[7] However, he did not go abroad until nearly the end of August, delayed perhaps by McConnell, perhaps by John Pye who was about to start engraving 'The Bright Stone of Honour' (cat.no.110) and was still settling the terms of their agreement when he wrote to Turner on 19 August.[8] Turner's reply – if any – is not preserved.

The first new city Turner explored in 1835 was Hamburg, where his arrival was announced in that city's *Privilegirte Nachrichten* for Thursday 3 September.[9] The

General Steam Navigation Company ran a regular steam packet service to Hamburg at this date, with a boat leaving the Custom House quay, close to the Tower of London, twice a week on Wednesday and Saturday, very early in the morning, carrying His Majesty's Mails.[10] Passengers were advised to embark the evening before and the journey was advertised as taking only fifty hours though in practice it sometimes took as many as seventy.[11] The cost was £5 (first class) or £4 (second class).[12] Turner's choice of route and means of travel was already very popular at this date. The following year, the first edition of Murray's *Handbook for Northern Germany* was merely codifying existing practice

when it declared that the shortest way from London to the centre of the Continent was by steamboat to Hamburg and then by road to Berlin, Dresden, Teplitz and Prague.[13]

Turner would have gone aboard late on Friday 28 August,[14] sailed early the following day and probably reached Hamburg itself by Tuesday 1 September.[15] Here there were few formalities for the arriving traveller, since it was a Free Town, but contemporaries recorded that their names and hotel destinations were taken down at the Baumhaus, a custom-house on piles close to the entrance to the Binnenhafen (fig.30); this was the source for the information later published in the *Priviligerte Nachrichten*.[16] Turner's destination was the Hotel Belvedere, an imposing building situated at the southern corner of the Binnenalster, the beautiful man-made lake at the heart of Hamburg. As its name implies, the hotel commanded an enjoyable view: the Binnenalster itself and the fashionable promenade of the Jungfernstieg. It was, at this date, the city's premier hotel (figs.31–2).[17]

Hamburg was – and remains – one of the most important ports in Europe; a great trading centre, rather than a cathedral city. Travellers of Turner's generation were advised not to expect fine architecture or valuable art collections here but simply to enjoy the city itself: to stroll along the four or five miles of boulevards and gardens newly laid out on the site of the city's erstwhile fortifications, to savour the views of the river Elbe, the city and its great harbours from the high ground of the 'Stintfang', and to admire the prospect of the numerous church spires across the waters of the Binnenalster and the other, even larger, lake, the Aussenalster.[18] Turner evidently took heed of such advice, for his pencil sketches of the city in his *Hamburg and Copenhagen* sketchbook are essentially of three types: those made on and near the 'Stintfang'; those made around the Binnenalster, Esplanade and Jungfernstieg; and those depicting the port.[19] In 1799 the shipping at Hamburg had reminded the political economist T.R. Malthus of that on the Thames, though the Elbe was 'much wider and finer',[20] so it is easy to see its attraction for Turner, together with the many baroque and Gothic spires, huddles of gabled houses, narrow streets, shops, warehouses and close alleys similar to those of the City of London. A Scottish writer in 1836 longed to have 'the pencil of Canaletti' to give his readers an idea of the beauty of Hamburg, and it may well have been Canaletto's Thames views rather than his Venetian ones that prompted this remark.[21] Turner enjoyed the sight of all the church spires of Hamburg soaring into the sky beyond the glassy surface of the Binnenalster (cat.no.31), but he did not record their

fig.30 Hamburg: the Baumhaus (TB CCCV 31v). Pencil, 1835

fig.31 Hamburg: the Hotel Belvedere (TB CCCV 22v). Pencil, 1835

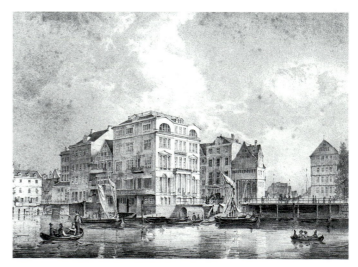

fig.32 Hamburg: the Hotel Belvedere, as seen in the lithograph by J.W. Vos, 'Die Jungfernstiegsbrücke in Hamburg'. *Staatsarchiv Hamburg*

architecture in much detail, being more concerned with ensembles as seen from different viewpoints.

In 1772 Dr Charles Burney had visited Hamburg, the city of Telemann, C.P.E. Bach and Handel, on his research tour of Germany for his *General History of Music*, and he found 'an air of cheerfulness, industry, plenty, and liberty, in the inhabitants of this place, seldom to be seen in other parts of Germany'.[22] One of its notable inhabitants, with whom he spent an agreeable evening, was Johann Georg Büsch (1728–1800), professor of mathematics and economics and (in 1768) founder of an international academy of commerce.[23] In 1835 Turner's attention was caught by the large granite obelisk with a portrait medallion and classical reliefs erected to Büsch in 1802 by the grateful citizens of Hamburg. It was the only monument he sketched here, recording it in both a general and a more detailed view (fig.33).[24]

The cheerfulness and plenty of Hamburg, which Turner must have experienced as well as Burney, were not to last long after his visit, however.[25] A great fire destroyed a third of the city in four days, from 5 to 8 May 1842, bringing down nearly all of its spires. In the years that followed, Britain – which has always had a very close relationship with Hamburg – played a considerable part in the rebuilding of the city: the civil engineer William Lindley was largely responsible for transforming the ancient Hanseatic port into a modern commercial centre, while the architect Sir George Gilbert Scott designed and supervised the building of the new Nikolaikirche. How pleasing it is, therefore, to discover that Turner enjoyed a visit to this most English of German cities, and recorded its great views and noble prospects, before the devastation of the fire.

After this, instead of making the short journey southeast to Berlin, Turner headed north. He chose the road to Kiel in preference to the notoriously bad one to the other possible port, Lübeck,[26] and drew three quick pencil sketches of the church and castle at Kiel in his sketchbook.[27] He is recorded in a Copenhagen newspaper as arriving there from Kiel on Sunday 6 September with a number of merchants on the steamship *Frederik den Siette* and he carried on sketching Copenhagen in all the spare pages and empty spaces of his book that had not been used in Hamburg or on his latest journey.[28] The ship had left Kiel at 7.30 p.m. on the Saturday and it reached Copenhagen just over twenty-four hours later. This means that it must have been around dawn when it passed close to the eastern side of the island of Moen and Turner drew his series of sketches of its dramatic white chalk cliffs, one of the most spectacular sights of the Baltic. At dawn, on a fine

fig.33 Hamburg: the Büsch monument (TB CCCV 16v). Pencil, 1835

September morning, they must have been as magnificent as those of Rügen and Arkona nearby which were such an inspiration to Caspar David Friedrich.[29]

Turner recorded Copenhagen's principal square, Kongens Nytorv, in four instalments of which two, well wedged in between earlier sketches, look over the square eastwards and down on to its statue of Christian V from a high viewpoint.[30] This strongly suggests that he stayed in the renowned Hôtel d'Angleterre, which still functions on this site today. He would have had neither a guidebook nor much knowledge of the city, but Copenhagen is small enough for the visitor to wander round and enjoy its fine sights even without assistance. Not surprisingly, Turner sketched its three very different but equally imposing royal palaces: the Dutch Renaissance style Rosenborg (then widely attributed by English writers to Inigo Jones), the rococo Amalienborg and the early nineteenth-century Christiansborg.[31] He recorded the Nicholas Tower and the Round Tower, copying down a date on the former and the arresting and curious rebus inscription on the latter.[32] But perhaps his most intriguing and unusual sketches are those of the Church of Our Lady, a neo-classical building only completed in 1829, which is nowadays the city's cathedral. Turner's exterior view of the church is surrounded by details of parts of the adjacent university building which was begun in 1831 and not completed until 1836, whilst his interior view shows the setting of one of the most celebrated works of Denmark's greatest sculptor, Thorvaldsen's 'Risen Christ' and his 'Twelve Apostles' (figs.34–5).[33] The apostles Turner saw, over-life-size figures standing against the main walls of the church, six on each side, were not, however, the marble versions there today, which were not installed until 1839. What he saw, recorded with a few flicks

fig.34 Copenhagen: the interior of the Church of Our Lady
(TB CCCV 32r). Pencil, 1835

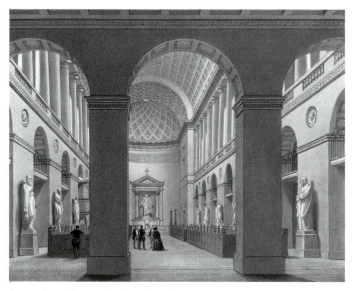

fig.35 Copenhagen: the interior of the Church of Our Lady, as seen in
the lithograph by I.W. Tegner and J.A. Kittendorff after H. Hansen

of the pencil, but, interestingly, attempted to name individually, were the full-size plaster versions modelled by Thorvaldsen in Rome in the 1820s and placed in the church in 1829.[34] Turner's sketches thus capture a building and its environs in a period of change, and may even be a unique record of how things stood in September 1835.

But is there any more to it than this? When Turner indicated Thorvaldsen's statues with such economy and speed, did he know what he was recording or might he have been oblivious of their quality? What links, in fact, exist between the two men? Thorvaldsen (1770–1844) lived and worked in Rome for virtually all of his career, from 1797 to 1842, but he was absent from that city for the whole of Turner's 1819 visit. This, however, would not have prevented Turn-

er from hearing about his work, and even perhaps from seeing his studio. By the time of Turner's second visit to Rome, in 1828, Thorvaldsen was President of the Academy of St Luke, the artists' academy of which Turner had been made an honorary member in 1819.[35] That autumn Thorvaldsen was 'closely engaged on the late Pope's (Pius VII) monument', as Turner reported from Rome in a letter to his friend the sculptor Francis Chantrey.[36] He must have seen this for himself, given the extent to which he socialised with other artists in Rome on this visit. Thorvaldsen had many visitors to his studio and a considerable British clientele in Rome, including the collector and writer Thomas Hope, Lord Byron and Sir Walter Scott; the last sat for him in 1832, less than a year after Turner's visit to the poet's home at Abbotsford.[37] In 1839 Turner was to make a pencil sketch showing Thorvaldsen's statue of Gutenberg, erected in Mainz in August 1837 (see fig.48, p.61).[38]

Another English admirer of Thorvaldsen, who was able to study his work in Copenhagen itself, was Elizabeth Rigby, later to marry Charles Lock Eastlake, Turner's companion in Rome in 1828. She lingered for as long as she could in the Church of Our Lady on her visit of 1838, remarking that the statues of the apostles were 'of such grandeur of design and matchless beauty as alone to repay a journey from England'.[39] Later pilgrims who visit Copenhagen in search of Thorvaldsen have more to look forward to than just one church; they have the Thorvaldsen Museum which contains the sculptor's own gift of his work to his native city. In conception, this was not dissimilar to Turner's vision of a 'Turner Gallery' in his native city, London (except that Thorvaldsen's gift was treated with the respect it deserved), so it is worth considering its possible influence on the painter. The entire process, from the sculptor's decision to make the gift through to the official opening of the purpose-built museum, took just eleven years, from 1837 to 1848. The land for the site was donated by the King himself, Frederik VI; a public subscription was launched to meet the building costs; the sculptor was involved with progress on the site up to his death in 1844; and his coffin was ultimately placed in a burial chamber in its courtyard, just before the museum opened to the public. Meanwhile, in London, Turner was constantly changing his mind about how to dispose of his works and keep them together after his death. His original intention, to have a privately run gallery built adjacent to almshouses in Twickenham (1829) was developed into a grander plan for such a gallery to be attached to his own house in the West End, in Queen Anne Street (1832). By the summer of 1848, however, Turner's ambition had risen

much higher: his finished pictures were to be bequeathed to the National Gallery, provided that rooms called 'Turner's Gallery' were built to house them within five years (in 1849 extended to ten years). There were, of course, many influences on Turner in these years, including the successful foundation of Sir John Soane's Museum in 1833 and the inefficient handling of the Robert Vernon Gift to the National Gallery in 1848. But international influences on Turner should not be overlooked. The progress of the Thorvaldsen Museum was well reported in the British press from 1838 onwards and it – unlike the Soane Museum and the Vernon Gift – consisted primarily of an artist's oeuvre rather than a collector's collection.[40]

Turner cannot have spent more than a day or two in Copenhagen in 1835. As he left the city he drew many quick pencil sketches in the Sound, using the second sketchbook of the tour, *Copenhagen to Dresden*, and capturing all the wonderful sights he had not managed to sketch on his arrival. First there were the impressive buildings of Christianshavn, including the guard-house, the rigging shears and the twisting spire of the Church of the Redeemer. Then there were the tall ships of the Baltic, sometimes carrying the Swedish flag, and the great fort of Trekroner which lies across the neck of the Sound, protecting Copenhagen. Looking back, there were the multifarious green, red-brick and gilded spires and towers of the city itself, looking like a Venice of the North.[41] It was on these sketches and memories that Turner was to rely when he painted his tiny watercolour 'The Battle of the Baltic' for engraving in *The Poetical Works of Thomas Campbell* (1837), but the vignette is extremely generalised and there can be no question of Turner's having gone all the way to Copenhagen in order to compose it.[42]

From Copenhagen Turner sailed across the Baltic – presumably by steam packet – to the capital of Pomerania, then part of Prussia and known as Stettin (today it is part of Poland and named Szczecin). This journey was equivalent in length to that from Hamburg to Copenhagen and took him past the island of Rügen and the Greifswalder Bodden, the homeland of Caspar David Friedrich. Turner did not have a chance to study any of the places which inspired Friedrich, but caught glimpses of them in the distance over the sea, annotating his sketches with names heard from his fellow-passengers: Rügen, Arkona, Greifswald, Pomerania, Swinemünde.[43] Although Stettin has long been important as a port, it is not actually on the Baltic, but lies some forty miles from the coast, up the river Oder. Turner made several pencil sketches of the hilly banks of the Oder near Stettin and many of the town itself

with its ancient churches, its conspicuous castle crowning its hill, and its busy harbour.[44]

By now he was halfway through the *Copenhagen to Dresden* sketchbook. At the back of this he made a fresh start, creating with the assistance of a native of these parts a personal German phrase book, over six pages long, to help him in the weeks to come.[45] This ranged from very specific statements and questions such as 'I want to go to Berlin' and 'How far is it to …?' to essential words like 'baggage', 'money', 'linen', 'buy' and 'lost'. It also included material of more theoretical than practical interest (the perfect tense of the German verb 'to be' for all persons) and has the peculiar feature that in nearly every instance the German versions are given not only in Latin cursive script – which Turner could have read out when necessary – but also in German script (*deutsche Kurrent*) which he could not possibly have read, there being few similarities between the two and no transliteration guide provided. Perhaps Turner asked a chance acquaintance for a little information and, trapped in an inn on a rainy evening, got rather more than he had bargained for.

But he did at least succeed in his desire to go to Berlin, which he must have reached by the middle of September, entering the city through the Oranienburg Gate.[46] He seems to have made no sketches on this part of his journey, a sign that he travelled on the coach which left Stettin each afternoon, arriving in Berlin at 8.30 the next morning.[47] But he certainly made up for this once in the Prussian capital where he drew thirty-eight pages of sketches immediately following those of Stettin. It was always Turner's practice to walk extensively in and around any city he visited and Berlin in 1835 was no exception. As well as walking the length of Unter den Linden (fig.36), 'the most splendid street in Germany',[48] with its imposing classical buildings and five parallel walks divided by double rows of

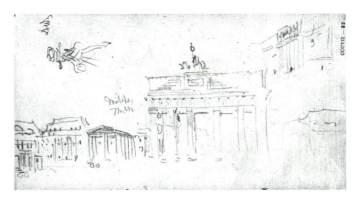

fig.36 Berlin: the Brandenburg Gate at the end of Unter den Linden (TB CCCVII 23r). Pencil, 1835

lime trees and horse-chestnuts, Turner explored much older and less fashionable areas: those around the Waisenhauskirche beyond the Nikolaiviertel.[49] In the 1820s Berlin was described by one British visitor as the 'most straggling, unsymmetrical, discrepant metropolis that I have seen – a jumble of magnificent buildings and ruinous houses'.[50] Turner was used to this state of affairs, for the same could have been said of London. It comes as no surprise to find that the blank spaces left beside his sketches of the royal palace in Berlin, for example, are sometimes filled with sketches of people from a very different level of society from that of a court but whom he found just as worth recording as the city itself.

Turner may well have explored the Spree in the eastern part of Berlin in the hope of coming across good general prospects of the city and its river such as can be found so easily in London, Rome or Paris. Berlin does not possess this attribute, so he walked to the only piece of moderately high ground nearby, the Kreuzberg to the south of the city, to sketch the view from there instead. The Kreuzberg takes its name from the wrought-iron Gothic monument commemorating Prussia's role in the war against Napoleon in 1813–15, designed by Schinkel and erected there in 1821. Turner could not see any fine building or monument without committing a record to paper, so he drew it in some detail in his sketchbook (fig.37), but what he was really after was a good distant view of the whole of Berlin. He soon found the one already much favoured by German painters, by going eastwards from the Kreuzberg so that his view could include the hill and its monument as a framing device for the distant array of domes and towers.[51]

Besides searching for broad prospects across the whole of Berlin, Turner also made many fine sketches of the grand buildings and ensembles that lay – and in most cases still lie – at its heart.[52] He studied the royal palace from every direction – from the Lustgarten, from around the Langebrücke, from the Schlossplatz and from around the Schlossbrücke – so that his sketches constitute a full and remarkable record of this mighty vanished building, parts of which went back to the sixteenth century but which was mostly built around 1700 to the designs of Andreas Schlüter. He also studied Schlüter's masterpiece, its beautiful inner courtyard, automatically noting which columns were of the Doric order and which Corinthian, and Schlüter's celebrated statue of the Great Elector on the Langebrücke, depicting it both on its own and against backgrounds of its surrounding buildings. On the western side he stood close enough to look along to the grandeur of the Eosander portal. He also stood further back, on the

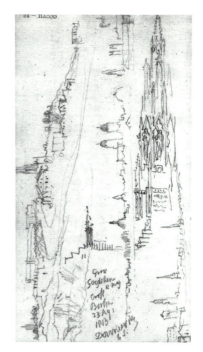

fig.37 Berlin: the Kreuzberg monument
(TB CCCVII 20r). Pencil, 1835

Schlossbrücke, like the great topographical painter of Berlin Eduard Gaertner, to see the picturesque variety of old houses on the Schlossfreiheit with their gables and awnings.[53]

Other buildings that attracted Turner's gaze had a more topical interest. For nearly twenty years Prussia's great neo-classical architect Karl Friedrich Schinkel (1781–1841) had been transforming central Berlin with a succession of monumental buildings, from the Neue Wache (New Guard-house) (1816–18) to the Bauakademie (School of Architecture) (1831–5). Turner's sketches show the Neue Wache and many others of Schinkel's buildings: the Schauspielhaus (theatre) (1818–21) (fig.38), cathedral (1816–21), Schlossbrücke (1819–23), and museum (1823–30).[54] But, above all, they show the open spaces transformed by Schinkel's architecture: the Gendarmenmarkt, the Lustgarten and the eastern end of Unter den Linden. Both men had been deeply influenced by their visits to Rome (Schinkel in 1803–4 and 1824 and Turner in 1819 and 1828) and Turner could hardly fail to appreciate the spirit that lay behind Schinkel's new Berlin: not just a desire to create individual buildings of classical style but a vision of a new classical city with an overall plan, unity and grandeur. When Schinkel had been in Rome, he had tended to sketch with great breadth, preferring – perhaps surprisingly for an architect – to capture complete panoramic environments rather than recording details.[55] When Turn-

er was in Berlin, he approached Schinkel's new buildings in just the same way. He showed the museum, cathedral and Neue Wache as parts of urban ensembles with many different ingredients; he did not make separate studies of them and did not record them in any greater detail than the other buildings he saw. In fact, the reverse was true: the richer decoration on Berlin's baroque and classical buildings – such as the Königskolonnaden (1777–80) or the New and French churches (1701–8) – forced Turner to record them rather precisely whereas the austerity of the Neue Wache called for no such thing.[56] Truth to tell, in Turner's sketches both the Neue Wache and the eighteenth-century opera house opposite play very much second fiddle to the bronze statue of General Blücher by Christian Rauch erected nearby in 1826, which was very fully recorded from every direction (fig.39).[57] Instead, Turner walked to and fro in Schinkel's new urban spaces, experiencing them from every possible angle and testing all their scenic potential in sketch after sketch.

Schinkel's neo-classical vision was shared by many of his contemporaries in Germany, England and elsewhere and by painters and sculptors as well as architects. Turner, too, had already shared in such visions of the ancient world reconstructed or created afresh, as testified by his two paintings of 1816 with Greek subject matter, 'The Temple of Jupiter Panellenius Restored' and 'View of the Temple of Jupiter Panellenius in the Island of Aegina'.[58] It may well be that the experience of Schinkel's Berlin in 1835 played a part in Turner's classical city visions of the later 1830s: the Grecian 'Parting of Hero and Leander' (1837) and the 'ancient' and 'modern' Roman pairs of 1838 and 1839.[59] Obviously the primary inspiration in these latter paintings was the ancient world itself, Rome with its seven hills and the Tiber flowing under them, but the experience of walking around and among the newly built classical architecture

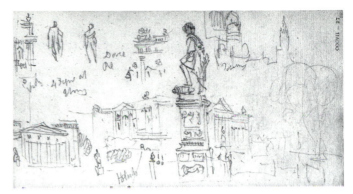

fig.39 Berlin: view across Unter den Linden, with Schinkel's Neue Wache, the Zeughaus and Rauch's statue of Blücher (TB CCCVII 27r). Pencil, 1835

of Berlin must surely have contributed to Turner's imagination of what ancient Rome had actually felt like.

The most curious feature of Turner's sketches of Berlin is that they do not include any of the art treasures in Schinkel's museum or its interiors. He made several quick pencil sketches of the exterior of the building, seen in the distance across the Lustgarten, twice counting up the number of columns across its very broad façade (there are eighteen). Moving closer to the building, he was able to read and copy down the Latin inscription on its façade, and he got as far as the top of the stairs in the upper vestibule, pausing here to sketch the staircase itself with the replica of the Warwick Vase and the view through the colonnade to the cathedral and over the Lustgarten. Indeed, he actually got to the doorway leading to the picture gallery and recorded its inscription, 'Eingang zur GEMÄLDEGALERIE' (fig.40). Whether he entered it or not remains a mystery, which is especially intriguing given that Schinkel himself had visited England in 1826 and studied the National

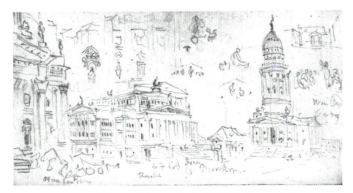

fig.38 Berlin: the Schauspielhaus flanked by the New and French churches (TB CCCVII 21v). Pencil, 1835

fig.40 Berlin: the upper vestibule of Schinkel's museum (TB CCCVII 31r). Pencil, 1835

Gallery in Trafalgar Square which had opened in 1824. His museum in Berlin was much admired by British visitors who praised its splendid exterior, beautiful interiors and superb display. Mary Shelley thought the grand circular hall surpassed in elegance and space anything she had ever seen except in the Vatican, while the arrangement of pictures by schools, the lighting and the lists of pictures and their painters provided in every room also greatly impressed visitors.[60] It is tantalising not to know whether Turner shared their impressions.

In Turner's day it took about twenty-four hours to travel from Berlin, the capital of Prussia, to Dresden, the capital of Saxony.[61] He arrived there on Saturday 19 September, his arrival, together with the name of his hotel, being noted in the *Dresdner Anzeiger* of the following day.[62] The Hôtel de Russie was one of many in Wilsdruffer Gasse which runs westwards from the Altmarkt towards what was then Wilsdruffer Platz (now Postplatz) and the Zwinger, and Turner may simply have found it by chance. It is not mentioned in contemporary English guidebooks or road-books, but is the first Dresden hotel listed in Reichard's *Manuel du Voyageur en Allemagne* (1836); Turner may have been directed to it by a fellow-traveller.[63]

By the 1830s Dresden's nickname of 'Florence on the Elbe' had almost become a cliché, and it is not surprising that Turner, who loved Florence itself, was determined to visit it.[64] Once there, he was enchanted by the famous prospects of river, bridge, churches and palaces and, in contrast to Berlin, made sketches of some of the paintings in its celebrated art gallery. There was much for him to see and study in and around Dresden: so much so, in fact, that the city and its environs feature in three different sketchbooks. However, each has its own special characteristics so that Turner's priorities and the order of events during his visit are quite clear.[65]

Arriving in Dresden from Berlin, the first famous sight Turner saw was the market place in the Neustadt, with the 'Golden Rider', the equestrian statue of Augustus the Strong made of gilded copper.[66] Immediately afterwards he crossed the Elbe on the eighteenth-century bridge, with its segregated system for traffic which so impressed English visitors in the eighteenth and nineteenth centuries.[67] Soon he was in the heart of the city, passing the Hofkirche and glimpsing the Electoral Palace on his way to his hotel. But he was to make several returns to the banks of the Elbe during his time in Dresden, sketching the bridge and city from every direction.[68] Like other visitors, he enjoyed the view popularised by Canaletto's nephew, Bellotto, in his painting in the Dresden gallery and widely disseminated as

an etching, looking westwards along the Brühl terrace to the Hofkirche.[69] The reverse view, from the gardens of the Japanese Palace and beyond, was equally delectable and perhaps even more pleasant to sketch if Turner was seated on the grass like the figures in his own foregrounds.[70] The beauty of the immensely wide stone bridge with its many arches and the grandeur of the adjacent buildings were irresistibly attractive to artists of all nationalities and commonly regarded as 'forming one of the grandest scenes … in any inland city of Europe' – especially when enhanced by the last rays of sun casting their reflections 'in the clear and rapid current beneath'.[71] Many of Turner's contemporaries who were associated with the Dresden Academy of Art – including Carl Gustav Carus (1789–1869) and J.C.C. Dahl (1788–1857) – made superbly expressive paintings showing the city and its river at sunset, by moonlight, at night or with storm clouds rolling round its spires and towers.[72] The swift and atmospheric sketches in Turner's *Dresden, Teplitz and Prague* sketchbook – so very different from his crisp topographical records in the *Copenhagen to Dresden* one – share the same sensibility.

If Dresden's situation and buildings have attracted countless visitors over the centuries since Bellotto's visit of 1747–58, so too has its art collection. In Turner's day this was still housed in the building known as the 'Museum Johanneum', at the north-west corner of the Neumarkt, the Semper Gallery used today not being created until 1847–54. The core of the collection was obtained when Augustus III bought the entire ducal gallery of Modena in 1746, so it was not surprising that Dresden gained the reputation of having the most outstanding gallery north of the Alps. Even Napoleon respected it: these pictures were not, like so many European masterpieces in Italy and elsewhere, carted off to Paris as part of his booty. By Turner's day the gallery contained some 1,200 paintings by around 330 artists, arranged according to nationality: Italian paintings were hung in the inner gallery, many of the most celebrated in the same room, while those of the northern schools were in the outer gallery.[73] At the time of his visit the gallery was open every day of the week, except Sunday, between 9 a.m. and 1 p.m., and admission was free on Saturday, Monday and Tuesday.[74] The rooms attracted a veritable army of copyists – professional and amateur, rich and poor – so we can imagine Turner busily scribbling away, on the last pages left in his little sketchbook, unnoticed among the crowd, which was exactly to his taste (cat.no.32).[75]

There are a few surprises among his choice of paintings and many points of interest.[76] His sketch of Raphael's 'Sis-

tine Madonna', the jewel of the Dresden gallery (which had not, in fact, come from the ducal collection of Modena but from a convent in Piacenza), measures less than three by two inches, is extremely schematic and bears a mere half-dozen elementary, monosyllabic colour notes. The engaging putti in the foreground are no more than a doodle. Even less care was expended on the sketch of Correggio's 'Penitent Magdalene', one of that artist's smallest but most exquisite works and described in Turner's day in the most glowing terms: 'one of the sweetest and most pleasing, as well as the most faultless pictures ever painted'.[77] Nowhere in Europe except for Parma, the scene of his greatest activity, could so many excellent paintings by Correggio be studied as in Dresden. Turner concentrated a fair amount of attention on the complex figure and colour arrangements of his three large altarpieces which show the Madonna with groups of saints headed by St Sebastian, St George and St Francis. However, he did not sketch the most celebrated of all Correggio's altarpieces, 'La Notte', universally acclaimed as his masterpiece. Given Turner's own passionate, lifelong concern with chiaroscuro, the omission is astonishing.

His behaviour in the outer gallery, among the paintings of the northern schools, was equally idiosyncratic. He made himself the most elementary memoranda possible of two paintings by Claude, the painter whom he admired above all others: 'Landscape with the Flight into Egypt' and 'Landscape with Acis and Galatea'; and another very simplified one, but at least with some indications of chiaroscuro, of Ruisdael's famous 'Hunt'.[78] As with the Italian paintings, however, it was eloquent or intricate figure subjects that stimulated him to draw a little less hastily and to sprinkle his sketches with colour notes: a few on Govaert Flinck's 'David giving Uriah the Letter' and a great many on the more complicated groups of Watteau's 'Conversation in a Park'. His sketch of Aert de Gelder's 'Christ before Pilate' conveys, through different intensities of hatching, a good idea of the complex light and shade of the original. It is not what Turner chose to sketch that is odd – all are fine works in themselves and were popular in his own time, soon to be selected for appearance in *Payne's Royal Dresden Gallery* of engravings[79] – but what he chose not to sketch: works by Rembrandt, Rubens and German artists. However, he may perhaps have believed that the works by both Flinck and Gelder were really paintings by their master Rembrandt: the Gelder is similar to a Rembrandt drypoint of the same subject which Turner could have known.[80]

Throughout Turner's life he was intensely interested in

fig.41 Dresden: the Frauenkirche from the Neumarkt, with the Johanneum on the left (TB CCCVII 5v). Pencil, 1835

the work of other artists, past and present, but his sketch copies are rarely more than memoranda. When he visited Paris in 1802 and studied the paintings there, at the age of twenty-seven, he drew a number of careful coloured copies on individual pages in a small sketchbook.[81] He accompanied some of these with a page or two of analytical notes which must have grown naturally out of his conversations with other British artists there at the time, all taking advantage of the Peace of Amiens to travel on the Continent after nine years of war.[82] In later life – as, for example, on his first visit to Italy in 1819 – Turner's copies of paintings were invariably tiny, swift and monochrome.[83] Unpredictable choices of what to sketch are another recurrent feature of Turner's travels. Sometimes he would sketch works by artists in whom he was already deeply interested – as in Dresden with the paintings by Raphael, Ruisdael, Claude and Watteau[84] – but equally he might sketch works by artists of lesser renown that simply caught his eye. Many of the most renowned Old Master paintings were widely available as engravings by Turner's day, so there would have been no need for him to use his precious time abroad in recording compositions already known to him or obtainable in London. As far as Dresden itself was concerned, most of the key works in the collection had been published individually as engravings by the 1830s,[85] and in the very month of Turner's departure, August 1835, the British press was announcing the imminent publication of a hundred of the best paintings in the gallery, 'executed in lithography by the best artists of Paris after drawings by the best Dresden artists'.[86] So the task facing Turner was to record the one element missing from the prints, namely their colours – and this was what he did, scribbling the outlines simply as a framework for his colour notes.

Exploring Dresden itself, Turner found, by instinct or design, many of the viewpoints that other artists have

fig.42 Dresden: the Zwinger (TB CCCVI 6v). Pencil, 1835

chosen both before and since. He drew the Frauenkirche both from the Neumarkt (as Bellotto had done) (fig.41) and from the opposite direction – looking down the Rampischegasse (as Prout had done).[87] He explored the Zwinger and its gardens, recording not only the central courtyard (fig.42) but also the exteriors: the Crown Gate with the long gallery, moat and bridge; the Wall Pavilion with its surrounding trees and basins; and the wonderful views from this part of the garden towards the Elbe, bridge and Japanese Palace which enchanted visitors before the building of the Semper Gallery.[88] In many of these, figures recline under the trees by fountains or basins with statuary and buildings nearby. It is almost as if Turner had stepped into a Watteau scene, such as that he sketched in the Johanneum, and life were imitating art.

A very different experience was provided by Turner's walk out to the hill to the south of the town where he sketched the stark memorial to the French General Jean-Victor Moreau, a vast helmet on a plain granite plinth, with three oak trees planted around it (fig.43).[89] This hero, the victor of Hohenlinden (see cat.no.36), had abandoned the Napoleonic cause and joined the allied forces and was mortally wounded on this very spot at the battle of Dresden on 27 August 1813 at the side of his commander Tsar Alexander. Again and again on this tour of 1835, Turner was reminded of the war effort against Napoleon in 1813–15: by the Blücher statue and the Kreuzberg in Berlin, here in Dresden by the Moreau monument, and soon afterwards by the sight of the battlefields of Kulm and Nollendorf on his way from Dresden to Teplitz. Twentieth-century visitors to the historic centres of Berlin and Dresden are constantly reminded of the suffering and devastation wrought by war, so it is extraordinarily moving to find that Turner had similar experiences. He, too, came face to face with reminders of both tragedy and heroism and he did so in

precisely the same places that move us most profoundly today.

In Turner's day a tour from Dresden to 'Saxon Switzerland' was *de rigueur* for all visitors to the city. This bears little resemblance to Switzerland itself, but was so named in about 1790 by two Swiss visitors, both painters at the Dresden Academy of Art,[90] and it is a spectacular area, unique among the hilly and mountainous regions of Europe. About seven miles south-east of Dresden, as the Elbe runs from Bohemia into Saxony, its valley is dominated for some twenty to thirty miles by sheer cliffs and vast fingers of coarse grey sandstone, curiously marked into layers with deep horizontal grooves, which have been created by millennia of erosion. Some are no more than solitary pillars of bizarre shape standing in the landscape, some are massive enough to have a small village or an impregnable fortress miraculously built upon their tabletops. Many pillars and groups stand in splendid isolation, towering above untamed countryside and themselves untouched by man, but this is not true of the most famous German group, and the nearest to Dresden, the Bastei. The unrivalled position of the Bastei rocks, striding (as it were) to meet the Elbe itself at the start of a magnificent double bend of the river, made it a natural destination for tourists in Dresden. It was easily accessible and provided breathtaking views in every direction of flowing water, hemmed in now by grassy meadows, now by untamed rocks and dense forests, with an incalculable number of hills, peaks and rocks in the middle and far distance.[91] Soon after the two Swiss painters, Adrian Zingg (1734–1816) and Anton Graff (1736–1813), discovered the area, it was taken up by artists and tourists alike, including Caspar David Friedrich and Ludwig Richter. Some walked, taking several days over their tours, others used boats and carriages or a form of sedan-chair where appropriate, and with the advent of steamboats on the Elbe (1837) and the railway close to its margins the tour became even more popular.

fig.43 Dresden: the Moreau monument (TB CCCVII 8r). Pencil, 1835

By 1835 the tour of Saxon Switzerland had refined itself into an established pattern, providing visitors with a sequence of experiences to interest, delight and excite and to suit both old and young, ladies and gentlemen, energetic and sedentary. It normally occupied about three days. Turner probably set off on his tour on Monday 21 or Tuesday 22 September since he is recorded as arriving back in Dresden, and returning to the same hotel, on Thursday 24 September.[92] He devoted most of a small sketchbook to recording his tour (TB CCCVI; cat.no.33) and it is clear that he did exactly what everybody else did, with a guide and probably with companions too.[93] Thanks to this circumstance, he was able to explore a demanding terrain and to annotate his pencil sketches with occasional names or other information such as the height of a rock; and it is possible to match Turner's experiences exactly with those of his contemporaries.

Turner's party would have left Dresden very early in the morning and travelled up the Elbe past the village of Loschwitz and the Chinese-style summer palace of Augustus the Strong at Pillnitz, after which they turned inland for the village of Lohmen.[94] Beyond the gentle countryside here, the vast rocky forms start announcing themselves in the distance with the great flat-topped mass of Lilienstein, but soon after the next village, Uttewalde, travellers are taken by surprise. Rather than starting to climb, they plunge into what appears to be a subterranean wooded valley threaded with ravines – cool, damp, dark, walled in by sheer grey sandstone rocks, with mosses and ferns and dripping water – which at times scarcely leave room for a person to squeeze between them. The peculiarity of passing through the Uttewalder Grund was well described by Mary Shelley after her visit in 1842:[95]

Generally, when you see mountains, they seem (as they are) upraised above the plains which are the abodes of men; lifting their mighty heads towards heaven. In Saxony, the impression is as if the tops of the hills were the outer circumference of the globe, strangely fissured and worn away by the action of water … As we proceeded through the narrow ravine, the rocks rose perpendicularly on each hand and shut us in as with walls … The precipices are broken into a thousand fantastic shapes, and formed into rough columns, pillars, and peaks numberless; with huge caverns, mighty portals, and towering archways; the whole clothed with pines, verdant with a luxuriant growth of various shrubs … the stream … ripples murmuring in its rocky channel.

The path, ascending and descending over the rocks, winds at its side … Various ravines branch off from the main one, and become numerous and intricate, varied by huge caverns of strange shapes; some open to the sky, some dark and deep.

Turner recorded this mysterious and thrillingly novel area in a handful of scribbled sketches, snatched hastily since he had to remain with the rest of his party. Thanks to his guide, he could also scribble down some of the names – 'Teufelsküche' (Devil's Kitchen), 'Höllergrund' (Hell-bottom).[96] At length, travellers left the ravine and entered a forest of broad-leaved trees and conifers, occasionally glimpsing distant country dotted with great outcrops of rock. And then, as if by magic (as Mary Shelley says), they found themselves standing high over the Elbe upon the Bastei. Here Turner was able to make plenty of sketches: of the prospects both up and down the Elbe; of the Bastei viewing platform which seemingly hangs right over the river; of the group of the Bastei itself with its triumph of engineering – a wooden bridge providing a long high-level link between an entire group of close but separate pinnacles (cat.no.33).[97] This bridge led to the remains of an ancient stronghold whose name, Neurathen, he also recorded. Situated on a huge curve of the Elbe and well over 600 feet above it (Turner noted the height as 630 feet), on a clear day the Bastei affords superlative views both upstream and downstream. Turner was able to see not only the rock formations of the immediate neighbourhood – Lilienstein, Pfaffenstein and Königstein – very distinctly but also the shapes of the hills on the distant horizon to the south, including the Winterberg and Zschirnstein on the fringes of Bohemia.

Another British visitor to the Bastei a few years earlier had enjoyed views of equal splendour which he doubted that even Turner could capture with his paintbrush:[98]

At the celebrated station of the Bastey, when we turned our eyes to the north, the scenery surpassed description. We stood, as it were, in an amphitheatre of split and riven rocks, shooting up into the sky in all possible shapes and forms, and conveying to the mind the idea of the ruins of some mighty giant-city … to give you any idea of this scene by description, is impossible. Sir Walter Scott himself, the greatest of all painters after Nature, would fail in the attempt; and as little could Turner, the most poetical of all colourists, convey to the mind a just notion of the splendour which an evening sun throws over the singular scenery about the Bastey.

Even before this letter was published, in 1836, Turner had actually recorded as much as he could, with his pencil and sketchbook, but, alas, he lacked either the time or the inclination to transfer his experiences into colour.

After lingering at the Bastei – and undoubtedly patronising its inn – Turner's party headed north, away from the Elbe by carriage, to Rathewalde and Hohnstein and thence to the small town of Schandau, further upriver.[99] To judge from Turner's increasingly erratic sketches, the party arrived there after nightfall.[100] At no stage could Turner linger over his sketches, but one swift annotation shows that this wild and rocky terrain reminded him of the work of Gaspar Dughet.[101]

The following day the journey from Schandau back to Dresden, at first crossing the Elbe by ferry and then on the road, afforded Turner numerous fine views and he sketched constantly. Sometimes he looked back to the rugged group of the Schrammsteine, which forms such a distinctive backdrop to Schandau, sometimes ahead to the towering masses of the rocky Lilienstein and the huge impregnable fortress of Königstein, nearly two miles in circumference, which even Napoleon had failed to capture.[102] To neither of these could travellers ascend (Königstein was at this date used as a state prison) – they could merely marvel at a distance – but Turner made many sketches of them both together and separately.[103] After Königstein he did not follow the Elbe back to Dresden; the road cut off the loop on which the Bastei is situated, bringing travellers back to the river at Pirna. This small town, painted by Bellotto in the eighteenth century and many subsequent painters, is dominated by the huge building of the Sonnenstein. Turner depicted it too, in a variety of pencil sketches, some drawn in the market square, some along the river.[104] The final grand sight of Turner's tour of the environs of Dresden was, however, neither a rock formation nor situated on the river Elbe, but a work of man. This was Schloss Weesenstein, a country seat of the Saxon kings in the Müglitzthal south of Dresden, whose Italianate garden wing and formal gardens provided him with very different aesthetic pleasures from those of Saxon Switzerland.[105]

Soon after returning to Dresden Turner was off on his travels again, using a fresh sketchbook (TB CCCI; cat.no.34). His journey again took him south, but this time he travelled entirely on the road which lies west of the Elbe, heading first for Teplitz and later for Prague. Neither journey afforded him much opportunity for sketching, but he did manage to catch glimpses of two notable battlefields of 1813: Kulm and Nollendorf.[106] Teplitz (nowadays named Teplice and lying in the Czech Republic) was at this time

fig.44 Teplitz: the Schlossplatz (TB CCCI 19r). Pencil, 1835

the most fashionable spa town in all Germany. It boasted warm springs with a high reputation for curing ailments, fine buildings, numerous hotels, an abundance of amusements and the opportunity to make excursions into the beautiful hills around with their ruined castles and citadels. It was resorted to at all times of the year by distinguished visitors and crowned heads, not only from German states but from all over Europe.[107] Its location should have made it an ideal stopping-place for Turner on his way to Prague, as it had been for Wilkie and the Callcotts, but his visit unfortunately coincided with an international conference of some significance. All the available rooms in Teplitz were engaged by the government for these visitors and their entourages, who were no less than the Austrian Emperor Franz Josef I, the Russian Tsar Nicholas I, King Friedrich Wilhelm III of Prussia and King Anthony of Saxony. The leaders of the three great powers convened at Teplitz for the inauguration of the Russian monument commemorating the battle of Kulm (now Chlumec), some eight or nine miles north-east of the town. Here their combined forces had gained an important victory over those of Napoleon in August 1813, the three leaders themselves observing the battle from the Schlossberg at Teplitz, and here the Austrians and Prussians had already erected their monuments somewhat earlier.[108] The planned meeting of the leaders had already featured in the British press before Turner's departure, where it was hailed as a renewal of the alliance which had defeated Napoleon. But he could hardly have predicted that he would come as close to them as he did in far-away Bohemia.

Since Turner could not stay in Teplitz itself, it is not surprising that only a couple of his pencil sketches show the centre of the town (fig.44), while nearly twenty were drawn in its environs.[109] Many look down on Teplitz and its

neighbour Schönau from the hills that hem them in and many were drawn close to the spectacular ruined castles on nearby heights.

From Teplitz Turner travelled on to Prague, a distance of some sixty miles, passing through Bilin and Laun on the river Eger (now known as Bilina and Louny).[110] His intensive study of Prague, which inspired over twenty pages of pencil sketches in one sketchbook and a further forty in a second, shows the interest which he felt in its magnificent situation and the richness of its buildings.[111] In 1826 Wilkie had declared that Prague was 'such a place as our friends, Callcott and Turner, might find excellent subject to work upon: it is romantic and picturesque in the highest degree'[112] and he would certainly have recommended it personally to Turner once he reached home. For Wilkie, Turner and their contemporaries Prague was another German capital, on a par with Munich, Weimar, Berlin, Vienna, Dresden, Frankfurt and Hanover. As the capital of Bohemia, 'which had anciently had for its queen the Princess Elizabeth, the daughter of James I', it had important links with Great Britain and Turner may have shared the romantic notions Wilkie had entertained about the city from his earliest youth.[113] He was certainly interested in Elizabeth, the 'Winter Queen', by the early 1840s when he painted his oil painting of Heidelberg castle, where she resided as the wife of the Elector Palatine, Friedrich V, from 1613 to 1619 (cat.no.131).

In Prague, as in so many other European cities, it was the grandeur of the ensemble that pleased Turner most. He made several sketches of historic buildings in the Old Town, such as its town hall and the Tyn church (cat.no.34) and some showing the Little Quarter. However, these are greatly outnumbered by those taken from the elevated viewpoints of the Belvedere, north-east of the castle, and the Petřín hill to the south of it. He drew many sketches close to the celebrated bridge over the Vltava with its statues and imposing gate-towers and many on the right bank further north looking towards the castle. Prague was just the city to appeal to Turner's taste, with its many high viewpoints, grand castle complex and cathedral on a lofty hill, impressive river and multiplicity of domes and towers. He responded to it enthusiastically, making many sequences of pencil sketches that sometimes provided an almost panoramic record of what he had seen.

From Prague Turner made his way homewards by a far more direct route than that of his outward journey. The first part took him south of Carlsbad, past Buchau, Engelhaus and Elbogen, with their picturesquely sited castles.[114] He then carried on south-westwards through Sulzbach to

fig.45 Nuremberg: the castle from Albrecht-Dürer-Strasse, with Dürer's house on the left (TB CCCIV 46v). Pencil, 1835

Nuremberg which he is recorded as reaching on 2 October.[115] Here he lodged at the Hotel Strauss in Karolinenstrasse, admirably situated in the centre of the town so that he could explore in every direction.[116] It must surely have been on Turner's first evening that he made the group of quick and expressive sketches depicting the various bridges over the Pegnitz around the Trödelmarkt island, including Germany's oldest suspension bridge, erected in 1824. Next morning he was at work early, making very different sketches which are a model of precision, filled with detail and drawn with a newly sharpened pencil. He drew the Herdegenhaus just across Karolinenstrasse from his hotel, several sketches of the St Lorenz church, the market place dominated by the Schöner Brunnen and Frauenkirche (cat.no.35), the town hall and St Sebaldus. All the buildings are crisp and clear in the morning light, the streets empty except for the town's other early risers – country people on their way to market. Later in the day he walked further north to explore the castle complex both inside and out, west to the Spittlertor and south to the Königstor. He was clearly impressed by the city's fine Gothic architecture and the multiplicity of picturesque views provided by a walk encircling the many historic buildings that comprise its castle. However, it is not clear from Turner's sketches whether he visited Dürer's house which lies close under the castle opposite the Tiergärtnertor. He scribbled Dürer's name on the sketch he drew in the road outside it (fig.45), but whether he went indoors and saw Dürer's own painting room, as many tourists did, including the Callcotts in 1827 and Wilkie in 1840, remains a mystery.[117]

Turner may have left Nuremberg in the afternoon of Saturday 3 October and reached Frankfurt early on Monday 5 October.[118] This journey went largely unrecorded, much of it being made by night, save for one sketch which

fig.46 Frankfurt: the Römerberg and Nikolaikirche (TB CCCIV 37r).
Pencil, 1835

may show Würzburg glimpsed through driving rain and
two quick but unmistakeable sketches of the castle at
Aschaffenburg on the Main close to Frankfurt.[119] In Frank-
furt he concentrated on the cathedral and river, which he
crossed so as to gain views of the city as a complete entity
with all its towers. He sketched the Katharinenkirche and
the Römerberg with the Nikolaikirche (fig.46) and the fine
buildings on the riverside close to the cathedral and bridge
but his wanderings seem not to have brought him close to
Goethe's house in the Grosse Hirschgraben.[120] He proba-
bly spent very little time in Frankfurt, no more than a few
hours, before he was heading for home. For this he used the
convenient route of the Middle Rhine on which steamers
now left Mainz for Cologne every day at 6 a.m. Soon he was
once more sketching all the towns and castles which were
now extremely familiar to him.

However, the conclusion to the 1835 tour was as novel as
its opening. Instead of leaving the Rhine at Cologne and
travelling overland to Calais or Ostend, as he had done in
the past, Turner stayed on the river right down to Rotter-
dam. Probably this was simply because there were by now
excellent co-ordinated steamer services linking Cologne to
Rotterdam and Rotterdam to London and he was anxious
to reach home. The sketchbook he had started using in
Prague contains drawings of places on the Rhine as far
north as the castle at Loevenstein and the church at
Gorinchen, showing that, once he was past Nijmegen, he
travelled along the Waal branch of the Rhine.[121] Shortly
afterwards, he started sketching in the final book of the
tour, the *Rotterdam* sketchbook (TB CCCXXI).[122] The
sketches in this book are almost entirely devoted to that city
and include depictions of two very recently constructed
buildings: the new town hall (1827–35) and St Dominicus's
church, completed in 1836.[123] Just as in Copenhagen, at the

start of his tour, Turner had sketched the university before
its total completion, so in Rotterdam, the fact that St
Dominicus's church lacked a few final touches did not
deter him from sketching it. Two of the sketches in which
it appears show the fish market on the Leuvehaven.[124] Soon
after his visit Turner painted a watercolour of this scene,
based on one of these sketches.[125] In 1836 this was pub-
lished as an engraving by W. Floyd in the second volume of
the *Gallery of Modern British Artists* (fig.47), an occurrence
establishing beyond doubt the dating of the *Rotterdam*
sketchbook. Thus the events of the mid-1830s were a curi-
ous repetition of those of the mid-1820s when Turner's
visit to the Meuse and Mosel in 1824 culminated in an oil
painting of Dieppe and his visit to Holland in 1825 led to a
painting of Cologne. In each case he made many pencil
sketches and immediately after the tour was over just one
sight, which was only incidental to it, was transformed into
a painting.

Turner was back in London by mid-October and was
soon at work on his exhibits for the next year's Royal
Academy and his illustrations for engraving projects. Only
one of the latter had any connection with Germany, the
vignettes for *The Poetical Works of Thomas Campbell*
(cat.nos.36–7). He must surely have discussed his tour with
Campbell, who was so keenly interested in Germany, and
also with Wilkie and the Callcotts, in whose footsteps he
had recently trodden. Sadly, however, his opinions went
unrecorded and Turner's numerous pencil sketches, an
engraving of Rotterdam and some sightings in continental
newspapers are all that remains of one of his most original
and spectacular tours.

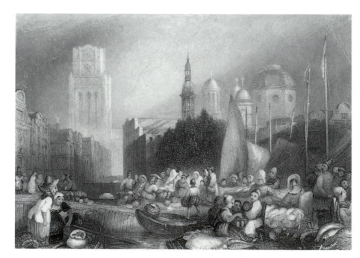

fig.47 William Floyd after J.M.W. Turner, 'Fish Market, Rotterdam'
(R 570). Engraving from the *Gallery of Modern British Artists* (1836)

The Second Meuse-Mosel Tour, 1839

After the novelty of Turner's extensive tour of 1835, it was to be four years before he made a further tour in Germany, but the country cannot have been absent from his thoughts. The first Murray *Handbooks*, describing northern and southern Germany, appeared in 1836 and 1837 and the following year saw an unprecedented number of Rhineland subjects at London art exhibitions, a trend that was to continue well into the 1840s.[1] Turner himself visited northern Italy and Switzerland in 1836 with Munro of Novar who had funded his 1833 tour through Germany and Austria to Venice. By now Turner was already at work creating his twenty watercolour vignettes which appeared in *The Poetical Works of Thomas Campbell* published in 1837. Campbell was particularly interested in Germany, its culture, literature and landscape, and three of the vignettes showed German subjects. 'Rolandseck' illustrated 'The Brave Roland', a retelling of the tragic story of the 'Chanson de Roland' in the Rhineland setting of Rolandseck, the Drachenfels and Nonnenwerth;[2] 'Hohenlinden' illustrated the famous poem on the battle fought at that site in 1800 (cat.no.36); and 'Ehrenbreitstein' (cat.no.37) illustrated the 'Ode to the Germans', composed as recently as 1832.

The year 1838 saw the publication of a book that was to be an important catalyst in Turner's career. This was *Sketches on the Moselle, the Rhine & the Meuse* by Clarkson Stanfield. Just as in 1833 Stanfield's paintings of Venice had spurred Turner on towards that city, now at the end of the decade the appearance of his book with its thirty large lithographs of Belgium and Germany made Turner long to revisit those countries. He therefore made a second Meuse–Mosel tour, very similar in route to that of 1824, but in which he studied the rivers and their neighbourhoods far more closely than he had done earlier; this intensive work was to lead to an enchanting series of gouaches on his return to England (cat.nos.42–63). Stanfield himself lent Turner a map of the Mosel to help him in his wanderings and Turner often echoed Stanfield's views and subjects in his pencil sketches, just as he had echoed those of the Revd John Gardnor's depictions of the Rhine over twenty years earlier.

Turner's second Meuse–Mosel tour, like the first, was for many years wrongly dated by writers on Turner, all of whom followed the suggestions in Finberg's *Inventory* of the Turner Bequest (1909) and the same author's *Life* of the artist (1939, 2nd ed. 1961) that it had taken place in 1834.[3] It was, however, redated by the present writer in 1991, thanks to the evidence of Turner himself.[4] Having reached Mainz, the most distant German city of this tour, he paused to explore it a little, away from the riverside. His sketches include an unmistakeable depiction of Thorvaldsen's statue of Johannes Gutenberg (*c*.1397–1468), the inventor of printing and Mainz's most famous son. The bronze statue was designed in 1834, cast in Paris in 1835 and unveiled on 14 August 1837 amidst great celebrations and festivities and it stands to this very day exactly where Turner sketched it, just north-west of the cathedral (fig.48).

The 1839 tour did not take Turner as far afield as those of 1833, 1835 or 1840 but it occupied him for the best part of two months, which is a measure of its importance to him and the thoroughness with which he explored both the rivers. He left London on Saturday 3 August, soon after writing to the portrait painter H.W. Pickersgill, declining an invitation because, 'I am on the Wing for the continent (Belge) this morning'.[5] He was probably only just home on 30 September when he attended a meeting of the General Assembly of the Royal Academy, expecting to meet Stanfield there and hoping to give him a new map of the Mosel in place of the old one he had borrowed. When Stanfield

fig.48 Mainz: the cathedral and Thorvaldsen's statue of Gutenberg (TB CCXC 69r). Pencil, 1839

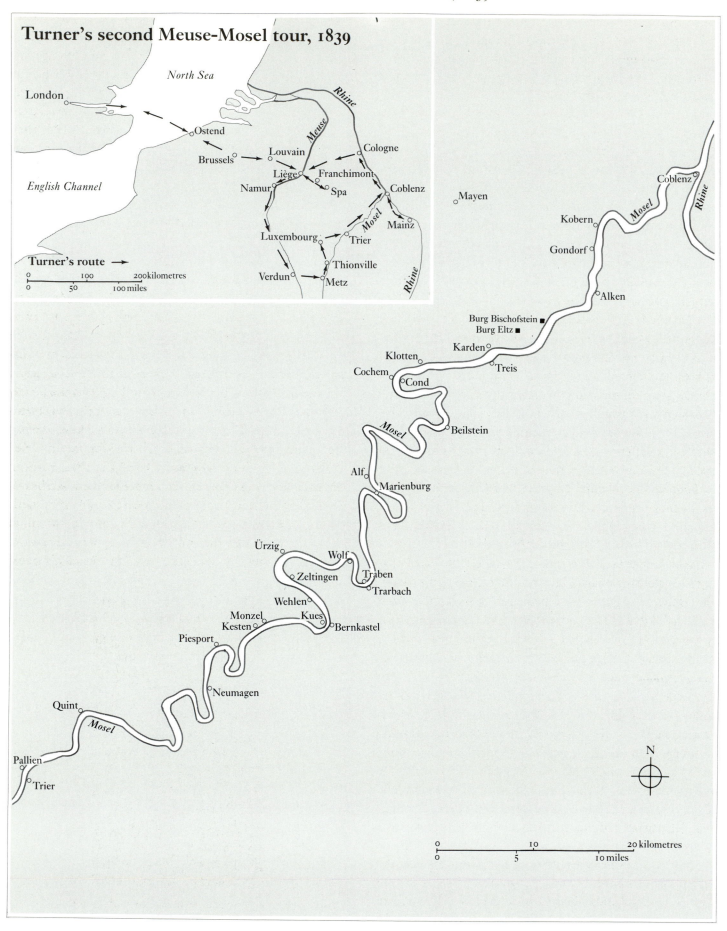

Turner's second Meuse-Mosel tour, 1839

North Sea

London

Ostend

English Channel

Rhine

Meuse

Louvain

Cologne

Brussels

Liège
Franchimont

Namur
Spa

Coblenz

Mosel

Mainz

Luxembourg
Trier

Rhine

Verdun
Thionville

Metz

Turner's route →

0 100 200 kilometres
0 50 100 miles

Mayen

Coblenz

Kobern

Mosel

Rhine

Gondorf

Alken

Burg Bischofstein ■
Burg Eltz ■

Karden

Klotten

Treis

Cochem
Cond

Beilstein

Mosel

Alf
Marienburg

Ürzig

Wolf

Zeltingen
Traben

Trarbach

Wehlen

Monzel
Kues

Kesten
Bernkastel

Piesport

Neumagen

Quint

Mosel

Pallien

Trier

N

0 10 20 kilometres
0 5 10 miles

failed to appear, Turner wrote to him explaining that the old map had been '*worn out* in the Campaign' and enclosing its replacement.[6] He could hardly have chosen a better word than 'Campaign' to describe his recent tour, since the five sketchbooks which he filled with pencil sketches are evidence of extremely tough work: day after day spent tramping up hill and down dale in search of good viewpoints and interesting subjects.

Although the year of Turner's tour was for a long time elusive, there has never been any doubt about the five sketchbooks which record all the key destinations on his travels. He himself listed and named all five on a paper label affixed to the front of one of them.[7] Furthermore, he scored the fore-edge of each book with black ink lines, a practice he had adopted earlier, with his German and Austrian sketchbooks, in 1833.[8] In that year the sketchbooks had been marked only roughly, but in 1839 Turner was more systematic: the first book was marked with one line, the second with two, and so on through to the fifth. In addition to these sketchbooks, he also used loose sheets of two kinds of blue paper for sketching. He made pencil sketches on the firm blue paper which was used for his gouache scenes.[9] He also drew in both pencil and watercolour on darker blue sheets of a different paper which seems only to have been used on this one occasion (see cat.nos.38–41).

Four of the sketchbooks were small upright books of continental origin and almost identical dimensions (*c.* 6 × 4 inches). The first – which Turner himself referred to as 'Brussels up to Givet' on the paper label referred to earlier – was bought at a stationer's shop in Brussels and used during the whole of Turner's travels along the Belgian part of the Meuse and the excursion to Spa, near Liège, which preceded it (TB CCLXXXVII, nowadays known by its *Inventory* title, *Spa, Dinant, and Namur*). After reaching the French part of the Meuse, he started using the *Givet, Mézières, Verdun, Metz, Luxemburg and Trèves* book (TB CCLXXXVIII). This, as its title shows, contains sketches not only of French towns on the Meuse but also ones drawn when he crossed the small section of France between the Meuse and the Moselle and visited the capital of Luxembourg before rejoining the German Mosel at Trier.[10] The travels recorded in these two sketchbooks and the gouache scenes they inspired have been described elsewhere,[11] but the German part of this tour deserves a repeated analysis and attention here.

At Trier, Turner spent most of his time sketching the city from across the Mosel, just as he had in 1824 (see cat.nos.22, 42),[12] and then descended the river by boat as he had also done previously. This journey is recorded in the

sketchbook Turner's paper label refers to as *First Mossel and Oxford* (TB CCLXXXIX), as a reminder that it contained his first Mosel sketches of this tour as distinct from those made shortly afterwards in his two other sketchbooks. In *First Mossel and Oxford* the sketches are flung helter-skelter into the nooks and crannies left by some earlier Oxford ones; their lines are often jerky and uncontrolled, their viewpoints consistently low and in mid-river, and sequences of sketches show recognisable towns coming closer and closer as Turner was carried downstream towards them.[13] There is only one full-size German subject in the entire book: a fine and detailed view of Ehrenbreitstein (see p.104).[14]

After this voyage down to Coblenz Turner doubled back up the Mosel to study it from the land and sketch its scenery at leisure from a multiplicity of viewpoints of his own choosing in the *Trèves to Cochem and Coblenz to Mayence* and *Cochem to Coblenz – Home* sketchbooks (TB CCXC and CCXCI). Unfortunately, the first of these was dismembered in the nineteenth century and some of its pages reassembled in the wrong order, and its *Inventory* title, given above, completely contradicts Turner's movements on the Mosel. He based himself at Cochem, where he had stayed in 1824, and travelled slowly back up to Trier, sketching everything very carefully.[15] As in 1824, many of his sketchbook pages contain numerous tiny studies of the same or adjacent scenery from slightly different viewpoints, thus comprising a minute-by-minute record of the artist's journey (fig.49). From Trier he returned to Cochem, possibly by boat, after which he turned his atten-

fig.49 Three sketches of the ruins of Wolf and the Gockelsberg (TB CCXC 27r). Pencil, 1839

tion to the lowest part of the river, recording it in an equally detailed fashion.[16] However, in the *Cochem to Coblenz – Home* sketchbook many of Turner's sketches are not so much notes as carefully planned compositions, occupying an entire page (fig.50), which suggests a far more leisurely journey along this part of the Mosel, as though Turner were unwilling to leave it.

These two sketchbooks contain not only the dozens of pencil sketches of the Mosel that were soon to be developed into gouaches (cat.nos.42–63) but also – in the first – sketches of many sights on the Middle Rhine south of Coblenz. Besides the pages devoted to Mainz, which led to the redating of this tour, there are several sketches of Oberwesel from the hillside downstream of the town and on the ascent up to the Schönburg.[17] This was a particularly enchanting area, but it seems to have been only in this one year that Turner explored it. Along the Rhine, as along the Meuse and the Mosel, he sought out high viewpoints that gave him more wide-ranging views than he had enjoyed on previous visits, and the watercolour 'Oberwesel' of 1840 was undoubtedly inspired by his experiences high on this hillside in the summer of 1839 (see cat.no.108).

As a result of this tour Turner painted a series of over a hundred small gouache scenes not only of the Meuse and Mosel but also of other notable sights in Belgium, Luxembourg and Germany. Forty-three depict German subjects. Had all these scenes been engraved and published, they would have totally outclassed Stanfield's lithographs, but sadly this was never to happen. The individual drawings which make up this outstanding series remained largely ignored in the literature on Turner, unidentified and virtually unknown to the public until the series as a whole was catalogued and shown in *Turner's Rivers of Europe: The Rhine, Meuse and Mosel* in 1991–2.[18] Such is its beauty and importance, however, that a large selection of the finest German scenes is also included in the present exhibition (cat.nos.42–63).

These were not drawn on the spot, directly from nature, but at Turner's leisure, like the Rhine series of 1817 (see cat.nos.8–18), being based on the pencil sketches gathered in his sketchbooks. They were executed on small pieces of blue paper, measuring *c.* $5\frac{1}{2} \times 7\frac{1}{2}$ inches, which he had created by first folding large sheets and then tearing or cutting them into sixteen. They are thus only about half the size of the 1817 Rhine drawings and their blue backgrounds give them a warmth and brightness – indeed a joyful visionary quality – that is very much their own, but there is a strong sense of continuity between the two groups. There is an equally important sense of continuity between the 1839

fig.50 Burg Treis (TB CCXCI 10r). Pencil, 1839

group and the depictions of some of the same scenes along the Mosel on small pieces of grey paper, painted less than a year later, on Turner's tour of 1840 (see cat.nos.67–81).

Turner's gouaches of the Mosel have been less widely known in the past than the celebrated series of the late 1820s showing Petworth or those of the early 1830s depicting the Loire and the Seine, but they are equally stunning in their beauty. Not surprisingly in view of their later date, they are freer in execution, bolder in colouring and less filled with narrative incidents. Some are vaporous and feathery in touch, others sturdy in their handling. Some contain dramatic contrasts of light and shade, with a startling use of black, while others hint at chiaroscuro by more subtle means, relying on the opposition between golden radiance and shadows of lilac and mauve.

Turner probably worked on the series over the autumn and winter of 1839, following his usual practice of developing several scenes at once. Stylistic traits run clean across their subject matter, so that the same colour schemes or light effects are used for both Meuse and Mosel scenes. For example, the twilight colouring used for a view of Namur is also found in that of Trier (cat.no.42). The strong colouring of some of the Belgian and Luxembourg scenes reappears in the Mosel group in the depictions of Beilstein (cat.no.51) and Wolf (cat.no.46). The swift and rather spikey pen and ink work found in the right foreground of 'Distant View of Cochem' (cat.no.56) is a standard feature of the French, Belgian and Luxembourg scenes but less common in the German ones. Turner evidently painted all these scenes with great gusto and enjoyment, which twentieth-century viewers can easily understand. It is also easy to see why, soon after the start of his long summer tour through Europe the following year, he felt impelled to make a special detour along the Mosel as far as Cochem, to revisit some of his favourite places and have the pleasure of seeing them and painting them all over again.

Austria and Southern Germany, 1840

In 1840 Turner paid his last visit to Venice. During a stay there of just two weeks, he produced an extraordinary quantity and variety of work: so many drawings that there has been much discussion in the past as to whether they can all really be dated to this single visit.[1] However, it is now clear that a large number of watercolour sketches of Venice on white, grey and brown papers can indeed be securely dated to this summer, through their stylistic similarities to depictions of parts of Germany which Turner visited only in 1840.[2] Moreover, his output immediately before and after his time in Venice was equally prodigious. The tour itself probably lasted even longer than that of 1839 as well as taking him much further afield. In 1840 British interest in Germany rose to new heights following the marriage of Queen Victoria to Prince Albert of Saxe-Coburg-Gotha on 10 February. From early in the year an abundance of paintings, books and prints appeared, relating both to the young couple and to Germany itself. Among these there were new editions of both Murray *Handbooks* to Germany; Bulwer-Lytton's *Pilgrims of the Rhine* (1834), containing folk tales and legends, was reprinted, while Thomas Hood's satire on contemporary travel *Up the Rhine* was an instant best-seller. Eastlake's translation of *Goethe's Theory of Colours* (cat.no.4) was ready by the summer. Albert's reputation as a lover of the arts had preceded him to England and writers and artists now strove to attract his attention by dedicating their works to him. Not surprisingly, Turner combined his 1840 visit to Venice with new routes through German lands. His outward journey through Holland, Germany and Austria inspired many fine works including cat.nos.67–84. His return journey, using an entirely different route through Austria, Germany and Belgium for most of its five weeks, was even more stimulating. His experiences of Germany prompted a wide variety of pencil and watercolour sketches (cat.nos.85–104, 106) and eventually led him to produce two very ambitious and splendid oil paintings (cat.nos.107, 109).[3]

Turner obtained his passport on 14 July, having made the second of only two such applications listed in the Public Record Office in London.[4] However, he cannot have left immediately, for he attended a General Assembly of the Royal Academy on 28 July.[5] The route of his journey to Venice can be glimpsed in his pencil sketches in the small *Rotterdam to Venice* sketchbook (TB CCCXX). This was bought in Rotterdam and used briefly there.[6] In Heidelberg Turner drew one sketch from the window of his room at the Prinz Carl hotel, showing the Kornmarkt and the castle.[7] He subsequently used this sketchbook several times near Bregenz at the eastern end of Lake Constance, and much more intensively thereafter.[8] From Bregenz he struck south-east to Landeck and Innsbruck and then crossed the Brenner Pass to Venice through Bozen (now in Italy and known as Bolzano) and Belluno.[9] For some of the most northerly part of his journey he was accompanied by a married couple, Mr and Mrs 'E.H.', whose existence is known solely because when Mr H. reached Rome he wrote a long letter to Turner in Venice.[10] From the date of this letter, 24 August, they must have parted company in Bregenz about a fortnight earlier and they reached their respective destinations on 20 August.[11]

Turner's outward journey is intriguing for being recorded in only one sketchbook, contrary to his usual practice, with large parts of the journey apparently not being recorded at all. However, he was not idle. One of the recurring features of this tour is that he made sketches on loose pieces of paper of different sizes and colours as well as in sketchbooks. Some are in pencil, some in watercolour and gouache (cat.nos.67–101, 106).[12] A sequence of around twenty small coloured scenes on grey paper depicting views on or near the Mosel shows that Turner lingered a little while between Coblenz and Cochem, indulging his lifelong habit of returning to favourite viewpoints (compare cat.nos.67–81 with 52–62). He also ventured away from the Mosel itself, making a detour within a detour in order to see the celebrated castle of Burg Eltz (cat.nos.76–7), which he had not visited in 1839.

At Bregenz and, about a week later, at Bozen Turner again made pencil sketches on loose sheets of paper – blue at Bregenz (cat.no.82) and grey at Bozen (cat.nos.83–4). He coloured these at convenient moments in his lodgings, some in haste, some with much greater care, just as he was to do in the similar drawings executed in Venice and Germany. In fact, Turner's rooftop views of Bozen were both drawn and coloured in his lodgings, for these provided him

with as fine a view of the town itself and the Dolomites as any artist could desire. In Bregenz, on the other hand, he ranged around seeking good views of the town and lake and his much less finished views may well not have been coloured until after he had left the area they depict.[13] Both the blue and the grey papers on which these scenes were drawn had been brought by Turner from England, several large sheets having been folded and torn either into eight sheets measuring *c.* 7½ × 11 inches each or sixteen sheets measuring *c.* 5½ × 7½ inches. He used the smaller size chiefly in the Middle Rhine and Mosel regions, thus echoing the dimensions as well as many of the motifs of the 1839 series on blue paper. The larger size was used for more extensive views, new subjects and grand sights at Bregenz and Bozen, in Venice itself and at several places in Germany on his homeward journey.

Besides his coloured sheets Turner had also brought with him from England two medium-sized 'roll' sketchbooks of white paper. One of these he used for coloured sketches in Venice (TB CCCXV), the other not until his return journey through Germany (TB CCCXL; see cat.nos.85–6, 88, 93). However, he seems to have set out without any smaller sketchbooks at all. It was probably near Bozen that he bought three of the four small sketchbooks of upright format (*c.* 8 × 5 inches) which he was to use for pencil sketches from about 20 August until he reached Ostend at the end of his tour: *Venice and Bozen* (TB CCCXIII, largely used in Venice itself), and the books now renamed *Venice; Passau to Würzburg* (cat.no.65), *Trieste, Graz and Danube* (cat.no.64), and *Würzburg, Rhine and Ostend* (cat.no.66).[14] The first three are composed of paper with fake Whatman watermarks, which was manufactured only in Austria, and must have been bought by Turner in Austrian territory.[15] Between them, cat.nos.64–6 provide not only a very clear picture of Turner's weeks in Austria and Germany in September 1840, but also the context for a number of other works in the Turner Bequest, some of them executed in watercolours and in most instances hitherto unidentified and undated (cat.nos.85–104).

Turner's homeward journey may be dated precisely. He left Venice for Trieste on Thursday 3 September and reached London on Wednesday 7 October,[16] when he immediately wrote to his solicitor George Cobb, apologising for not having replied to a letter sooner, 'but have only arrived from Venice a few hours'.[17] The earliest pages of the *Trieste, Graz and Danube* sketchbook (cat.no.64) contain sketch after sketch, often several to a page, of the gulf of Trieste seen in the distance from Turner's boat. Gradually buildings and the lighthouse are discernible, then boats and

the harbour, then the great mass of the town itself with its castle and fort, warehouses and quays, mole and the thirteenth-century church of San Giusto.[18] Many travellers to and from Venice in the nineteenth century used the route via Trieste, since they thus avoided the ordeal of crossing the Alps and with the coming of steam-boats the journey across the gulf took only a few hours. Wilkie had used this route in 1826.[19] Turner probably chose it in 1840 in order to enjoy what was for him a novel experience. Moreover, he cannot have been unaware that further down the coast from Trieste lay the important town of Pola (now Pula) in Istria. Although he had never visited this area before, some twenty years earlier he had depicted the outstanding Roman remains at Pola – an amphitheatre, arch and temple – in a watercolour based on sketches by the architect Thomas Allason.[20] Although his timetable in 1840 did not permit a detour to Pola itself, he would undoubtedly have been interested in seeing for himself the coastline on which these ruins are situated.

From Trieste Turner travelled by road directly northeast to Graz and Vienna, a total distance of some three hundred miles, using a major trade route of the period which carried a prodigious amount of traffic in both directions.[21] Graz itself was more peaceful: a fine old town on the river Mur with Italianate buildings. Turner made it the subject of more careful pencil sketches than Trieste, usually devoting entire pages to single views of the town with its fortress-crowned hill, its distinctive clock-tower, its churches and riverfront. He climbed the Schlossberg to look down on the town and he walked along the river banks, sketching picturesque old houses and different aspects of the fortress.[22] After the war with Napoleon many of the defence works on the Schlossberg had actually been removed, leaving a rather gaunt and rubble-strewn hill below the fortress itself, which was planted with trees between 1839 and 1842. What Turner saw was enormously impressive at a distance. One of his contemporaries noted its similarity to Castle Hill in Edinburgh and went on to claim that the 'Acropolis of Athens appears much less imperial than the citadel of Styria's capital'.[23]

By contrast to Graz, Turner spent very little time sketching Vienna which he reached on 7 September; he had, in any case, already explored it in 1833.[24] He is recorded as staying at the Stadt Frankfurt, a substantial hotel in Seilergasse, just off the Graben, which Murray's *Handbook* described as 'very good, clean, and comfortable, with excellent restaurant'.[25] Not surprisingly, he stepped outside and drew a few sketches of the Stefansdom including one from the Stock-im-Eisen Platz.[26] It was almost certainly in

Turner's homeward journey from Venice, 1840

Vienna – and perhaps from examples hanging in the rooms of his own hotel – that he made minute sketch copies of fifteen prints of famous views on the Danube, mostly from Adolf Kunike and Jakob Alt's *Donau-Ansichten vom Ursprunge bis zum Ausflusse ins Meer*.[27] These were just a mere handful out of the 264 which had been published in Vienna in monthly parts by subscription, from 1819 to the mid-1820s, just like so many of his own topographical views in the 1820s and 1830s. However, unlike Turner's *England and Wales* series or his *French Rivers* scenes, these were not engravings but lithographs and, indeed, among the earliest and most celebrated works in this medium. Turner, himself about to follow the course of the Danube for part of his homeward journey, refreshed his memory of

several of its notable sights such as the Wirbel and Strudel, the castle of Wallsee and that of Weitenegg which lies opposite the abbey of Melk. He also copied some scenes that he was not destined to visit himself, including the castle and cathedral at Pressburg, today's Bratislava, and – in the opposite direction – two castles in Germany near the source of the Danube (see cat.no.64).[28] Inevitably, some of the picturesque sights along the river had changed considerably since the time when Jakob Alt (1789–1872) had sketched them. Turner's sketch copy of Alt's view of the ruined castle of Spielberg, east of Linz, shows a far better preserved building than the one he himself drew from nature in both 1833 and 1840; and when, in 1840, he reached the tiny village of Donaustauf near Regensburg he

found Alt's pastoral prospect transformed by the building of the Walhalla (cat.no.109).[29]

Turner's Danube journey of 1840 carried him the 280 miles upstream from Vienna to Regensburg itself and – with its diversions – took him the best part of a week. On the first part of this journey he travelled along the same celebrated stretches of river between Vienna and Linz that he had recorded so assiduously when sailing in the opposite direction in 1833: its dramatically situated castles and churches, its wild slopes clothed with trees and vines, its watchtowers and abbeys and dangerous rocks and whirlpools were irresistibly attractive. However, his sketches in the *Trieste, Graz and Danube* sketchbook (cat.no.64) are never as finely drawn as those in his earlier *Salzburg and Danube* book (cat.no.29). Sometimes the cause is accounted for by Turner himself, as in the group of sketches of the Wachau which he annotated 'begun in the moonlight at St Michael's'; the adjacent pages full of rugged silhouettes of Spitz and the Hinterhaus have an eerie quality wholly consistent with night-time on the river.[30] But the underlying reason for the variable quality and topographical patchiness of Turner's sketches is that he was travelling by steamer, a regular service between Regensburg and the Black Sea having been established in 1837.[31] Turner's most intensive sequence of sketches, occupying fourteen pages, was made during the steamer's cautious passage upstream from St Nikola to Grein, past the Wirbel and the Strudel (fig.51), whereas other, highly scenic, spots such as Melk or Linz were jotted down only once or twice and in a careless fashion.[32]

On the second stage of his river journey, from Linz to Passau, Turner was faced with scenery that was entirely new to him. Here the Danube runs between high wooded hills, often being joined by small noisy tributaries which add to its depth rather than its width, and for mile after mile there is nothing to be seen but woods and the occasional castle or fishing hut. The wildness of the whole reminded one English writer in Turner's day of the scenery near Keswick and provoked another to reflect that whatever entertainment the area provided for strangers, it provided nothing except firewood for its own inhabitants.[33] Many of Turner's contemporaries were unable to enjoy such scenery for long: one traveller noticed that some of his fellow passengers were deep in twopenny editions of Scott's romances, while others fished.[34] Turner, however, kept his eyes on the passing scenery, even though, at first sight, he seems to have done so rather intermittently. One sequence of sketches shows changing views of Burg Neuhaus perched high on its wooded hill, and there are other

fig.51 The Strudel (TB CCXCIX 34v). Pencil, 1840

sequences recording the ruined castles of Kerschbaum, Marsbach, Rannariedl and Krampelstein in similar fashion, with Turner looking quickly now upstream, now downstream.[35] The reasons for his behaviour are not hard to find. Between Linz and Passau the Danube pursues its course by means of several spectacular bends so that many a lofty ruin 'presents its northern side to the eye in apparently the same situation that it did its southern side scarcely ten minutes before'. At times perpendicular rocks appear to bar all further progress, but then the river, 'suddenly and rapidly wheeling, completely doubles itself, and enters a narrow defile, the romantic, and ... awful beauty of which surpasses all description ... The pencil of a Salvator Rosa could alone do justice to these wondrous scenes'.[36] The author of these sentiments, writing in 1828, was inspired by this particular stretch of the Danube to make his comparison between that river and the Rhine: the Danube, he claimed, personified Burke's ideal of the Sublime, the Rhine his ideal of the Beautiful.[37] Turner was undoubtedly impressed by the Danube's magnificence. In his sketches the river is as wild and deserted as it was held in popular estimation, inhabited only by gaunt and distant ruins high on the horizon. Finally, at Engelhartszell the steamer had to stop at the Austrian custom-house and he was able to sketch a group of local people at the water's edge,[38] but such sketches are otherwise absent from this record of his Danube travels. Very probably these were the only people Turner observed on shore during the whole of his journey up the Danube from Linz to Passau.

At Passau the mood is entirely different. From the moment the city first comes into sight, its spires and domes impossibly clustered on what seems to be an island site, dark woods and tortuous bends are quite forgotten.[39] Here, instead, is an enchanting city located at the confluence of

three rivers, the Danube, the Inn and the Ilz, and seeming, with its colourful Italianate buildings and multiplicity of river façades, like a Bavarian Venice. The Italian appearance of Passau was not lost on Turner's contemporaries who were unanimous in regarding it as the gem of the whole Danube, leaving easily the strongest impression on the mind and memory of any scene on that river.[40] With its confluence of three rivers, it was also held to be vastly superior in picturesque beauty and prospects to Coblenz where two rivers only, the Rhine and the Mosel, are united.[41] Turner found his way to all the best local viewpoints, some right over the confluence itself. He also wandered a few miles up the valley of the Ilz, to see the ruins of Burg Hals and Burg Reschenstein perched high above the winding river. In Passau – as in Venice – he was inspired by the effects of light and colour to bring out a 'roll' sketchbook of white paper in order to make larger pencil and watercolour sketches (cat.nos.85–6, 88, 93). He also unearthed from his baggage a small sketchbook which he had already begun using in Venice (*Venice; Passau to Würzburg*; cat.no.65), similar in format to that used along the Danube; and he brought out again his stock of brown and grey papers. These were used to depict Passau itself, Burg Hals and also the nearest of the castles on the Danube, Burg Krampelstein (cat.nos.87, 89–92).[42] In the days that followed, as Turner travelled homewards through Germany, he was to sketch numerous sites with interest and attention. But in his watercolours of Passau there is a sense of true intoxication at the city and its mingling waters that places them in a very special category. They are as magical as his most iridescent depictions of Italy and Switzerland, while the drawings of the castles of this area have, with their delicate, limpid colouring, an ethereal feeling rarely found in his earlier drawings of Germany's other castles.

From Passau Turner travelled up the Danube valley to the cathedral city of Regensburg, but details of his journey are largely absent from his sketchbooks and he probably travelled by road, possibly at night. Here he is recorded in a newspaper of Monday 14 September as recently arrived and staying at the historic Drei Helmen (Three Helms) hotel in the Neupfarrplatz.[43] This was a first-class hotel conveniently situated in the centre of the city, looking out at the Neupfarrkirche ('new' parish church, built in the early sixteenth century) (fig.52) and only a stone's throw from the celebrated Gothic cathedral and the Danube itself.[44] Turner made pencil sketches of each of these (that of the cathedral shows its west façade) but his interest was chiefly focused on the Danube which is here spanned in a highly impressive manner by a stone bridge over a thou-

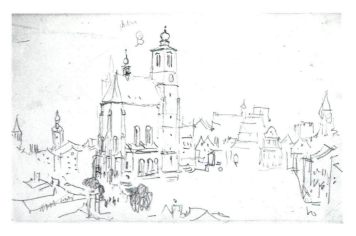

fig.52 Regensburg: the Neupfarrkirche from an upper floor of the Drei Helmen hotel (TB CCCX 41v). Pencil, 1840

sand feet long dating back to the twelfth century.[45] Despite its wealth of ancient buildings, including a Roman gate-tower and numerous medieval towers on patrician family houses, comparable to those at San Gimignano in central Italy, Regensburg was not admired by British visitors in the early nineteenth century. Samuel Prout was fascinated by the rich sculptural decoration on the main portal in the west front of the cathedral, but others simply found the building 'grand but gloomy' and many were struck by the prevailing 'antique gloom' of the whole city.[46] An authority on the Danube in the 1840s summed it up nicely by comparing the modern traveller who was unwilling to bestow any lingering attention upon Regensburg itself 'with its tall battlemented heavy towers, its antique sculptured and painted houses, its fine Gothic cathedral of a gloomy beauty, so full of severe harmony, its saintly cloisters, and its dark old town-house' to 'the modern novel reader [who is unwilling] to wade through a preface'.[47] Travellers of Turner's day seem to have felt the same sense of physical oppression among the narrow lanes and tall heavy buildings of Regensburg as they did in many parts of Florence.[48] Moreover, the city's air of gravity reflected the many disasters it had suffered in the past. As one writer said in 1828, 'The Roman, the Vandal, the Frank and the Hun, the Bohemian, the Austrian, and the Swede, the ancient and the modern Gaul, have, by turns, besieged, stormed, plundered, and burnt thee'.[49] When the French succeeded in taking it, after a desperate conflict, on 21 April 1809, it was the fourteenth time in nine centuries that it had been 'visited by the united horrors of war'.[50] Only on the further bank of the Danube, surveying its long bridge and looking back at the city as a whole from a safe distance could tourists admire the grandeur of its vast cathedral and the

extraordinary array of dark towers. Besides the many pencil sketches of Regensburg which Turner made in his small sketchbook, he also recorded it in several larger drawings (see cat.nos.94–6). For these he chose to use grey paper and sombre colours, sometimes articulated by dark penwork. The gravity of cat.nos.94–6 compared to the airy lightness of his coloured drawings of Passau, exactly reflects the prevailing mood of Regensburg itself.

Cat.nos.94–6 were drawn (though not coloured) in the course of the excursion which Turner made a few miles back down the Danube and which was to inspire one of his largest and most important German oil paintings, 'The Opening of the Wallhalla, 1842' (cat.no.109). Indeed, he was among the very first Englishmen to make this pilgrimage which was to become such a standard feature of visits to the Danube in years to come.[51] The Walhalla (fig.53) is an immense Hall of Fame honouring the great German men and women of history. The idea of such a building was conceived early in 1807 by the twenty-year-old Crown Prince Ludwig of Bavaria following the crushing defeats inflicted on Prussia by the Napoleonic forces at the battles of Jena and Auerstedt and the setting up of the Confederation of the Rhine which brought so many German states, including Bavaria, under the control of Napoleon. He consulted the historian Johannes von Müller, describing his vision of a colossal building combining dignity and simplicity, and it was Müller who suggested its name: Walhalla, the dwelling-place of the gods in ancient German mythology, into which only those chosen by the Walkyrie may be admitted. For the nineteenth-century Walhalla it was Ludwig himself, advised by Müller, who chose which outstanding figures to include. While Napoleon was still dominating Europe, the Prince commissioned the greatest sculptors of the age (Schadow, Rauch, Tieck and Dannecker) to depict rulers and poets, musicians and philosophers, and by the time he became King in 1825, sixty busts out of the final ninety-six had already been completed. After Napoleon's downfall Ludwig invited German architects to submit suitable designs for the temple itself and when none was found to be satisfactory he turned to the neo-classical architect Leo von Klenze (1784–1864). Gradually the exact site of the building and its nature evolved. The original idea of constructing it in Munich, the Bavarian capital, was abandoned. In 1826, the hillside site above the Danube village of Donaustauf was chosen, the land being donated by Prince Karl Alexander von Thurn und Taxis. Leo von Klenze drew up plans for a Doric temple closely resembling the Parthenon at Athens but supported on a massive substructure because of its huge size and the

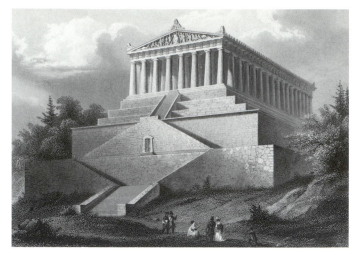

fig.53 The Walhalla, as seen in a nineteenth-century engraving published by G.J. Manz, Regensburg

gentle slope of its hilltop situation. Plans were completed by 1829 and the foundation stone was laid by the man who had conceived it, now King Ludwig I of Bavaria, on 18 October 1830, the anniversary of the Battle of Leipzig. The opening ceremony took place on the same symbolic day twelve years later, in 1842.[52]

Turner's many sketches show that he was extremely interested in both the Walhalla itself and its setting. He made pencil sketches from near and far, noting also many subsidiary features of the scene including boats on the Danube, a praying figure at a roadside crucifix, a distance that reminded him of Claude. He recorded the number of columns on its façades (eight and seventeen, like the Parthenon itself), drew parts of its entablature and substructure and ground-plans of both the building as a whole and its prostyle porch.[53] He made a large quick sketch of its unfinished interior (fig.54). Whether he already contemplated painting it as early as the autumn of 1840 must be an open question, but there can be no doubt that, when he learned of its completion and ceremonial opening from the London press in 1842, he had all the materials ready to hand to start planning a painting there and then (see cat.no.97), ready for the Royal Academy exhibition of 1843.

From Regensburg Turner could simply have travelled to Nuremberg and then headed westwards for home as he had done from there in 1835.[54] However, he still had an important visit to make before returning to London, and that was to Coburg, the home town of Prince Albert. Accordingly he spent a very brief time in Nuremberg, drawing a mere half-dozen pages of sketches compared to the many pages he had drawn in 1835.[55] From there he went

fig.54 The interior of the Walhalla (TB CCCXLI 363). Pencil and white chalk, 1840

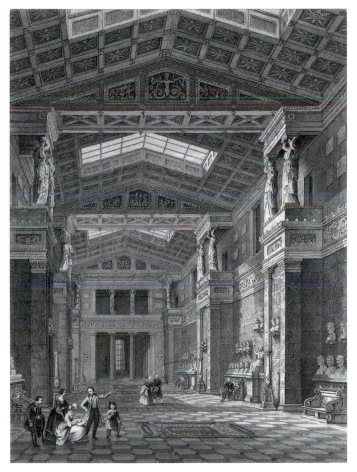

fig.55 The interior of the Walhalla, as seen in a nineteenth-century engraving published by G.J. Manz, Regensburg

north to Bamberg, almost certainly on the *Eilwagen* which was advertised as arriving from Nuremberg at 8 p.m. on Wednesday 16 September,[56] and he was recorded as spending the night of 16–17 September at the Drei Kronen (Three Crowns) hotel in Langegasse.[57]

Bamberg was – and remains – exceptionally rich in fine views, and Turner made full use of his short visit for sketching. His pencil drawings range from thumbnail records of picturesque corners (cat.no.65) to expansive views of the entire city with its forest of church towers and spires, and he also drew close-up studies of the impressive Altenburg, the hilltop residence of the Bamberg bishops, and the cathedral complex.[58] Here, even more than in Regensburg and Nuremberg, he was following in the footsteps of Samuel Prout, who had published two lithographs of Bamberg in 1833, while most English travellers to Germany remained ignorant of its splendours. However, nothing could illustrate the difference between these two artists more clearly than their views of the cathedral and Alte Hofhaltung: Prout's interest lay in the intricate and curiously ornamented gateway to the Old Court, while the cathedral just happened to be adjacent to it. For Turner, it was the majestic cathedral which merited a sketch and the 'Beautiful Gate' of 1570 was of no more significance than any other gateway.

Turner must have left Bamberg after only one night, for one of his Coburg sketches is annotated '17 Sepr'.[59] On that day he travelled north-eastwards, a complete diversion from his homeward route, to make his pilgrimage to Prince Albert's birthplace and childhood home. This excursion in part followed the course of the river Main, which at one point he made the subject of a sketch, complete with a well-laden ferry-boat,[60] but went largely unrecorded.

There was much for Turner to see and sketch in Coburg, so it is not surprising to find that he was still there on Sunday 20 September, a date inscribed on one of his many views of the town from the beautiful countryside which surrounds it.[61] No records exist locally of his sojourn in Coburg, but two sketches of the houses in Spitalgasse as seen from the first floor of the Weisser Schwan (White Swan) hotel are proof enough that he stayed there (see cat.no.98).[62] For four or more days Turner applied himself strenuously to studying Prince Albert's home town, making many pencil sketches that are of very high quality and watercolour sketches of great charm and vitality, a sure indication of his interest (cat.nos.98–101). He made careful records of its most notable buildings and squares including Schloss Ehrenburg, the palace of the Dukes of Saxe-Coburg-Gotha since 1547, the fifteenth-century church of

St Moriz, and the market place with its imposing municipal buildings.[63] He made long walks to sketch its several outlying castles and residences from as many different viewpoints as possible, most notably the great Gothic fortress of Veste Coburg on its hill, which dominates the landscape for miles around, the more modest Schloss Callenburg and the newly built Schloss Ernsthöhe.[64] Last, but not least, he walked out to Prince Albert's birthplace itself, the gabled and turreted hunting-lodge of Schloss Rosenau, built on a little hill above the Itz valley about four miles north of Coburg. Here he sketched the house in its wooded landscape setting but also approached close enough to study the precise details of its architecture.[65]

Turner was obviously looking out for a subject that would catch the eye of Prince Albert at the next year's exhibition of the Royal Academy. However, he may not have decided to paint Schloss Rosenau itself, in preference to any other Coburg view, until some time after his visit. As well as the watercolour sketch which shows the same view as his pencil sketch of Rosenau and the final oil painting (cat.nos.102, 107), there are other watercolour sketches in the Turner Bequest depicting landscape subjects around Coburg (cat.nos.103–4). For a time Turner may well have toyed with the idea of painting a landscape that embraced the environs of the Prince's home.

The last German city Turner explored in 1840 was Würzburg which he had reached by 23 September. His journey from Coburg went largely unrecorded (like all his coach journeys since Passau), except for two drawings of Dettelbach, a small and highly picturesque old town on the Main just east of Würzburg.[66] A lone depiction of Würzburg in the *Venice; Passau to Würzburg* sketchbook shows the market place, looking eastwards from the Renaissance Casteller Hof building which functioned from 1830 to 1945 as the Wittelsbacher Hof.[67] Turner had consistently used his hotel windows as vantage-points for his sketching throughout this tour, both at the Hotel Europa in Venice and in Austria and Germany (Heidelberg, Bozen, Regensburg and Coburg), and it was, indeed, in this very hotel that he is recorded as staying in Würzburg.[68] From here he looked out at the buttressed side of the Gothic Marienkapelle on the left and over the obelisk fountain to the majestic dome and octagonal bell-tower of the Neumünster, his view closed by the spires of the cathedral.

At Würzburg Turner began a new sketchbook, the final one of this tour, *Würzburg, Rhine and Ostend*, which he very probably acquired there (cat.no.66). No longer cramped for space as he had been at Coburg, he made sketch after sketch, giving a full page to each drawing. The fine situation, sparkling atmosphere and noble buildings of Würzburg – its many churches, the imposing Marienberg fortress overlooking the river Main, the old stone bridge with its wide arches and statuary, the hillside pilgrimage chapel (the Käppele) designed by Balthasar Neumann – inspired him to explore the city very thoroughly and sketch it from every direction. He wandered up and down the river well outside the city's boundaries, and climbed not only the hill of the Marienberg but others also, such as the Steinberg to the north and that of the Käppele to the south, recording ceaselessly, so that by the time he left he had covered some forty pages of his sketchbook with drawings. Unlike today's visitors to Würzburg he seems not to have visited the Residenz of the Prince-Bishops to gaze at the Tiepolo frescoes, but he looked briefly at its exterior. He found it of minimal interest compared to the other attractions of the city and returned to the more inspiring prospects of the riverside.[69] There eventually came a point when Turner could bear the confinement of his small sketchbook no longer, so he started sketching on larger sheets of paper. Six drawings are known, of which two are studies in pencil, four in colours. All show Würzburg from the south, some from viewpoints close to the Käppele, others from much further away (see cat.nos.105–6).

After Würzburg Turner headed for home, using the familiar route of the Rhine between Mainz and Cologne. He almost certainly travelled by steamer, as on the Danube, sketching most of the well-known sights perfunctorily as he passed.[70] At Cologne he must have struck westwards, leaving the Rhine and probably passing through Aachen and Liège. His tour ended at Ostend, recorded in a final burst of sketches,[71] and he reached home on 7 October. It is not known whether he shared any part of his Rhine journey with his companions of the outward journey, Mr and Mrs 'E.H.', as the latter had hoped.[72] He did, however, make contact with an English 'gentleman travelling faster' whom he persuaded to post an urgent letter for him as soon as he reached Dover.[73] It cannot have been hard to find someone making better speed towards England than Turner was in September 1840. He took an exceptionally long time – thirty-five days – to travel from Venice to London through the highways and byways of Austria and Germany. His numerous sketches and his subsequent paintings show just how valued and valuable the experiences were.

Heidelberg and the Neckar, 1844

During the 1840s Turner painted his most complex and visionary paintings of Germany and continued to explore its towns and rivers. Early in the decade he exhibited his evocation of Prince Albert's childhood at Schloss Rosenau (cat.no.107) and his allegorical depiction of the opening of the Walhalla (cat.no.109). His shimmering watercolour of Oberwesel was engraved in 1842 (cat.no.108) and Germany played its part in the series of watercolours executed after 'sample studies' which were circulated among prospective clients by Turner's agent Thomas Griffith (cat.nos.122–5). The year 1846 saw the publication of two particularly large and fine engravings after Turner: the long-awaited 'Ehrenbreitstein', engraved by John Pye after the oil painting 'The Bright Stone of Honour', exhibited in 1835 (cat.no.110); and 'Heidelberg', engraved by Thomas Abel Prior after a newly executed watercolour (cat.nos.127–8). Both works had been conceived as engravings, the oil painting and watercolour being produced specifically with this end in view.[1] Soon after Turner's death in December 1851 two final engravings of German subjects appeared: 'Osterspey and Feltzen' (fig.14, p.28) and 'Neuwied and Weissenthurm'.[2] These looked back to his great Rhine series of 1817, being based upon two of the larger versions of those scenes painted around 1820 and intended for engraving. Now, after a delay of over thirty years, they were a superb and fitting conclusion to Turner's German subjects. The Rhine had dominated his experience of Germany: he had travelled along it more regularly than in any other part of the country and his depictions of the river and its tributaries had inspired the majority of his German paintings and watercolours.

During the first half of the 1840s Turner also visited Germany annually, so that the years 1839 to 1844 represent an unbroken series of summers in which he travelled along the Rhine and elsewhere. His destination in all the tours of 1841–4 was Switzerland. At this stage in his career his pencil sketches in his small sketchbooks were for the most part perfunctory affairs, dashed off at top speed. However, he was by now regularly using larger sketchbooks with soft covers for coloured sketches and also making coloured drawings on loose sheets of paper, and the works thus produced during his last tours are unequalled in their interest

and beauty. Since Turner seems to have been visiting some of the same places year after year and research work still remains to be done into his late Swiss tours, it is not always possible to allocate the sketches of this period to particular tours with complete certainty. However, one group of German subjects, showing Coblenz and Ehrenbreitstein, can undoubtedly be dated to the tour of 1841 (cat.nos.115–21).

This justifiably famous series of drawings showing different light effects upon the same vast rock and fortress and the Rhine flowing beneath them anticipates the work of the Impressionists by over thirty years and shares some common features with it: an interest in the way sunlight changes the appearance of objects minute by minute; a narrow range of colours used at great speed; informal compositions which crop buildings and foreground motifs in unexpected places; a concern with the pictorial potential of modernity, exemplified by the steamers using the landing stage at Coblenz. It is, however, most unlikely that Turner painted them in the open air as the Impressionists would have done. This was rarely his habit, as anecdotes and comments of contemporaries throughout his life make very clear.

Other German works that probably date from the 1841 tour include several depictions of Burg Eltz in a far freer style than those of 1840 (compare cat.nos.111–12 with 76–7). Once Turner had discovered this magical spot, it was comparatively easy for him to approach it from the Rhine or Mosel when he was in the area. He often made very quick sketches of the castles of the Rhine in his notebooks or in his 'roll' sketchbooks or on loose sheets of paper. Characteristically, he seized on the same motifs again and again and his later drawings often parallel those of 1817. There are late watercolours of St Goar and Bacharach that echo those inspired by his very first Rhine tour of all.[3] There are also similar echoes among the drawings of less familiar sights (cat.no.114). Although Turner was frequently travelling in his own footsteps, he also diversified his routes wherever he could and explored new areas. Twenty pencil sketches on small loose sheets in the Turner Bequest depict the most scenic parts of the Ahr valley from Blankenheim, its source in the Eifel, down to Sinzig where it joins the Rhine some fifty-five miles away.[4]

Another small group of sketches, this time partly in a sketchbook and partly on loose sheets, shows that on one occasion he crossed the Rhine from Bingen to Rüdesheim and walked up on the Niederwald, enjoying the superlative views which this commands (cat.no.113). Both his energy and his enthusiasm for exploring remained unaffected by his advancing years.

This can be seen to a truly remarkable degree in the tour of 1844, his last major continental tour and final visit to Switzerland. He was now in his seventieth year. On this tour he broke his journey again and again to explore new areas of Germany and the products of this tour (from 'roll' sketchbooks bearing 1844 watermarks) are among his most spirited depictions of the country.

He probably left London early in August 1844 and he was back home by 7 October when he acknowledged a commission for a new painting of Venice.[5] On 28 December he wrote to Hawkesworth Fawkes, the son of Walter Fawkes who had bought the series of fifty Rhine views inspired by his first visit there in 1817, making a rare comment on his most recent tour:[6]

> The rains came on early so I could not cross the Alps, twice I tried, was set back with a wet jacket and worn-out boots and after getting them heel-tapped I marched up some of the small valleys of the Rhine and found them more interesting than I expected.

The comment about the Alps is mysterious in view of Turner's triumphant proclamation in one of his sketch-books that he had finally managed to cross the Alps with 'W.B.': 'No matter what befell Hannibel – W.B. and J.M.W.T. passed the Alps near Fombey, Sep. 3, 1844'.[7] 'W.B.' was almost certainly William Brockedon (1787–1854), geologist, amateur artist, writer and member of the John Murray circle. Whatever the explanation of this apparent contradiction, Turner clearly did explore and enjoy some 'small valleys of the Rhine'. Understandably it has been traditionally thought that these must have been near the Alps and this is probably correct. However, it is now clear that in this year Turner also devoted much time to exploring German tributaries of the Rhine.

The first of these was probably the Hasenbachtal close to St Goarshausen. Here he made at least twelve sketches of Burg Reichenberg, one of the most impressive castle-fortresses of the Rhineland, in his *Rhine and Rhine Castles* sketchbook (TB CCCLI; cat.no.133). Because of its secluded position Burg Reichenberg escaped the repeated on-

fig.56 The Kornmarkt in Heidelberg, with the Prinz Carl hotel on the right, as seen in an engraving from *Ansichten von dem Schloss und der Stadt Heidelberg* (1843). *By permission of The British Library*

slaughts by foreign armies that have afflicted the castles of the Rhine itself and presented a very attractive subject.

Shortly afterwards Turner explored a very different environment, the valley of the Nahe which becomes unbelievably dramatic a mere ten miles south of Bingen. The porphyry wall of rock which here lines the Nahe is one of Germany's most astonishing sights north of the Alps, and the picturesqueness of the town of Bad Kreuznach has led twentieth-century guidebooks to describe parts of it as a 'little Venice'. Turner responded to these sights with great enthusiasm and his coloured drawings of Kreuznach (as it then was) (cat.no.135) and the rocks and castles on the bend of the Nahe at Münster am Stein (cat.nos.136–7) are the equal of his Swiss drawings of this year in their colouring and intensity.

The third valley which Turner explored in 1844 was that of the Neckar and his visit there can be exactly dated. Towards the end of August a 'Mr Turner' from London is recorded as staying at the Prinz Carl hotel in Heidelberg.[8] This had been J.M.W. Turner's hotel in the town in 1840 so there is every reason to suppose that he would have returned there (fig.56). Furthermore, the residence which is recorded – from 24 to 27 August – would have given him the necessary time for the thorough exploration of Heidelberg and its neighbourhood indicated by his sketchbooks. 'Mr Turner' was recorded as being accompanied by a 'Mr Towner' (or 'Fownes'). The identity of this individual is not known and he may have been merely a chance acquaintance.

The beauties of the Neckar are nowadays so well known

that it is hard to equate that river with the 'small valleys of the Rhine' that Turner found more interesting than he had expected. However, the fact remains that in 1833 and 1840 he had not bothered to explore the Neckar beyond Heidelberg but in 1844 he travelled up its winding valley as far as Heilbronn, recording its rounded hills richly clothed with bushes and trees, its splendid castles of red sandstone and its picturesque towns, villages and riverside chapels. This area was still largely unknown to travellers from England. One who was 'glad to escape from the beaten track of tourists' by following the Neckar as Turner did, a few years later, was reminded by its wildness of the highlands of Scotland.[9] It was apparently still 'virgin soil for the literary pioneer' when the American Mark Twain explored it in 1878 and wrote his brilliant account of it in the ironically titled *A Tramp Abroad*.[10]

The untamed quality of the Neckar valley is reflected – perhaps not always intentionally – in Turner's sketches. He recorded everything he could in the small pencil sketches in the *On the Neckar* sketchbook (TB CCCII; cat.no.132).[11] More significantly, he drew a handful of expressive watercolours showing Heilbronn itself, Zwingenberg, Hirschhorn and Neckarsteinach (cat.nos.145–50). These complement and, indeed, sometimes come from the same sketchbook as an equally beautiful and delicate group portraying Heidelberg itself (cat.nos.138–44). Turner used all the most popular viewpoints of his day, reflecting a close study of what his German contemporaries were doing and of prints and pictures that were on display or for sale locally. However, he brought to the Neckar his own personal sensitivity to light and colour that makes these drawings such a unique and evocative group. Heidelberg itself is depicted sometimes in the pearly grey light of morning, sometimes under the hot afternoon sun which makes its great red castle glow against the hillside. Turner's drawings of the Neckar are quite different from those of the Rhine or Mosel: the river is grand like the Rhine but not sombre; it is colourful like the Mosel but has more dignity and breadth. Its liveliness is captured through juxtapositions of contrasting colours and a generous amount of pen drawing in both soft and bright colours.

Just a year after Turner's discovery of the Neckar he despatched his oil painting 'The Opening of the Wallhalla' (cat.no.109) to Munich for inclusion in the international art exhibition. It is not entirely clear exactly how this came about. Turner was the only British artist represented in the exhibition and his painting was not well received.[12] One of the many adverse criticisms in the German press included a reference to Turner's visit to Munich 'a few years ago'.[13] This cannot refer to his visit of twelve years earlier, in 1833, but almost certainly to a second one in 1843. During that summer Turner travelled in the Tyrol and parts of northern Italy,[14] passing through Innsbruck and Munich and making tiny pencil sketches of both cities on his journey.[15] In 1843, as in 1833, he must have met members of the Munich art establishment and may have heard then of the planned exhibition.

Undaunted by the reception of the 'Wallhalla' in Bavaria, Turner pressed on with the two large engravings of other German subjects, 'Ehrenbreitstein' and 'Heidelberg' (cat.nos.110, 128). These provide a spectacular finale to his German work. With their gleaming rivers and lofty ruins, their fertile landscapes and abundance of human incident, they reflect the Germany which he visited with such regularity and clearly savoured. Much has changed in Germany since Turner's day, as it has in Britain. Many of the views which he recorded have been destroyed and painstakingly rebuilt, others appear scarcely touched by the passage of time. Turner himself confronted images of loss and destruction, change and renewal wherever he travelled in Germany, and his paintings address issues that are alive today. They look back to the vicissitudes of the past; they record the transitory splendour of the present; and, through their sheer beauty, they fill the viewer with hope and determination to strive for a better future.

Turner's works can move us powerfully whatever their subject or setting. Apart from the 1817 series of Rhine views, Turner's German drawings have mostly lain unrecognised among the 'hidden treasures' of the Turner Bequest since his death. The few that were assigned specific titles were usually mislocated as French or Alpine views and the part played by Germany in his life has been consistently underestimated. Turner's German subjects run through his life and work just as the great rivers of the Rhine and the Danube flow across the length and breadth of Europe. They are worthy partners of his *Rivers of France* drawings and his Italian and Swiss watercolours. If these had not existed, the German works by themselves would present in microcosm a complete and true account of his landscape art in the years of his maturity.

Notes

Turner and Germany

1 Thornbury (1877), p.103.
2 See below, p.81 n.24.
3 Sir Joshua Reynolds, *Discourses on Art*, ed. R.R. Wark, New Haven 1975, pp.107–8, 160.
4 Ibid., p.51.
5 Ibid., p.311, 299.
6 For all references in this paragraph see M. Davies, *Turner as Professor: The Artist and Linear Perspective*, exh. cat., Tate Gallery 1992, pp.17, 31–2, 34, 37, 44, 64. See also TB CVIII 4r.
7 'A Hare by Albert Dürer': TB CLXXI 13r and TB CLXXX IV. Notes on the Uffizi: TB CCCLXVII (Turner's guidebook to Italy, Reichard's *Itinerary of Italy*, 1818), pp.58–9.
8 F. Koreny, *Albrecht Dürer und die Tier- und Pflanzenstudien der Renaissance*, Munich 1985, pp.146–7.
9 B&J 230; RA 1823; Tate Gallery, London.
10 See below, p.59.
11 On the appeal of the Rhine in this period see Bonn: Rheinisches Landesmuseum (1992).
12 Holmes (1828), p.37.
13 Planché (1828), pp.105–8.
14 Simpson (1847), pp.44–6.
15 As Wilkie did later the same month (see Cunningham 1843, III, pp.292–3).
16 D. Thompson, *Europe since Napoleon*, 1967, p.161.
17 *Zeit der Postkutschen. Drei Jahrhunderte Reisen 1600–1900*, exh. cat., Deutsches Postmuseum, Frankfurt 1992, pp.189–220.
18 See Reichard (1836), pp.568, 589; below, pp.46–60.
19 Gage (1980), p.149.
20 Tate Gallery, London (B&J 427). It has been suggested that the reference may be to Schiller's *Song of the Bell* but this theory has received little support. See Vaughan (1979), pp.112, 279; N. Alfrey, 'Turner and the Cult of Heroes', *Turner Studies*, vol.8, no.2, 1988, pp.33–44.
21 See below, pp.38–9.
22 TB CCXCVIII 79v; London: British Museum (1994), p.194 (no.129a).
23 For recent appraisals of German art in this period, see the essays in *The Romantic Spirit in German Art 1790–1990*, exh. cat., Edinburgh and London 1994.
24 On Britain's relationship with Hamburg see Vaughan (1979), pp.16–17.
25 Ruskin (1903–12), III, pp.217–18. See also London: Victoria and Albert Museum (1985), pp.61–4.
26 Rawlinson (1913), pp.405–15.
27 See London: Victoria and Albert Museum (1991), pp.172–5.
28 J.G. Lockhart, *Narrative of the Life of Sir Walter Scott, Bart*, Everyman ed. 1922, p.90. See also E. Johnson, *Sir Walter Scott: The Great Unknown*, 1970, I, pp.129, 159, 165.
29 G. Lindop, *The Opium Eater: A Life of Thomas De Quincey*, Oxford 1985, pp.272–5.
30 Brown (1840), p.36; Lockhart, *Walter Scott*, p.630.
31 Beattie (1849), I and III.

32 See Brown (1992) and Piggott (1993) for broader surveys of Turner's work illustrating both poets.
33 Thornbury (1877), p.103.
34 Waagen (1838), I, p.240.
35 Cunningham (1843), II, pp.21–42.
36 Ibid., II, pp.318, 321–2; III, pp.297–9.
37 Ibid., II, pp.316, 317, 322, 324.
38 Tate Gallery, London (B&J 399).
39 See below, p.59.
40 See the microfiche edition of Lloyd and Brown (1981). Turner had got to know Maria (then Mrs Thomas Graham) in Rome in 1819, later describing her as 'a very agreeable Blue Stocking' (Gage 1980, p.103).
41 TB CXCIII 99r: see Gage (1969), p.101.
42 Robertson (1978), pp.31–3.
43 Turner Bequest 47–8; B&J 404–5.
44 Andreas Haus, in Berlin: Nationalgalerie (1972), p.95. J.D. Fiorillo (1748–1821) trained as a painter but subsequently became Professor of Art History at Göttingen University (1799), curator of its art collection and the author of long art-historical surveys.
45 Tate Gallery, London (B&J 292–4).
46 Haus, op. cit., p.98; Gage (1969), pp.104–5; Gage (1987), p.8.
47 London: National Gallery (1994), pp.10, 110.
48 Passavant's remarks appear in the original German in Haus, op. cit., pp.95–6; in English in C. Powell, 'Nineteenth-century Writing on Turner', *Turner Society News*, no.55, Aug. 1990, p.13.
49 B&J 14. Waagen (1838), II, p.80.
50 Haus, op. cit., p.96; Waagen (1838), II, pp.151–2. The exhibits were B&J 360–4 including the 'Ehrenbreitstein' engraved as cat.no.110. Turner was evidently very pleased when Dawson Turner – who was no relation – defended the achievements of the British school against Waagen in 1840 (see Gage 1980, pp.198–9).
51 See the entries for B&J 365–7.
52 Gage (1980), pp.160–1.
53 R. Owen, *The Life of Richard Owen*, 1894, I, p.264.
54 *Athenaeum*, no.903, 15 Feb. 1845, p.173; no.929, 16 Aug. 1845, p.817.
55 On 20 August John James Ruskin wrote to his son: 'Foord says he has packed off 1 Large picture to America [i.e. 'Staffa, Fingal's Cave', B&J 347] & another large one to Munich [i.e. the 'Wallhalla'].' (Bembridge Collection, manuscript letter, reference kindly supplied by Ian Warrell). Foord of Wardour Street, London, was Ruskin's framemaker.
56 *Athenaeum*, no.943, 22 Nov. 1845, p.1126. The pieces of paper stuck on the painting – which have parallels elsewhere in Turner's art, in 'Mortlake Terrace' (1827; B&J 239), 'Childe Harold's Pilgrimage – Italy' (1832; B&J 342) and 'The Golden Bough' (1834; B&J 355) – were also remarked on in the German press, as Pia Müller-Tamm relates in her essay in the German edition of this catalogue.
57 From the entry on Turner in Nagler's *Künstler-Lexicon*, quoted from B&J, p.250.
58 C.E. Smith, ed., *Journals and Correspondence of Lady Eastlake*, 1895, I, p.189.

The First Visit to the Rhine, 1817

1 See Powell (1990), pp.12–15.
2 Walter Fawkes not only bought Turner's Rhine series (W 636–86, but see also p.26, cat.no.17 and n.41 below) late in 1817 for about £500, but also acquired the oil painting 'Dort, or Dordrecht, the Dort Packet-Boat from Rotterdam becalmed' (B&J 137) in 1818, the price of which was recorded at the time as 500 guineas.
3 Notes from Campbell: TB CLIX 13v; from Hills: TB CLIX 1r–15r; from Gardnor: TB CLIX 16r–30r (those from Hills and Gardnor interspersed with later notes and sketches). These notes are transcribed in the Appendix of Powell (1991), which also provides a detailed analysis of the contents of all three sketchbooks used in Germany on this tour.
4 In the RA catalogue for 1790, Turner's water-colour (W 10) was no.644, Gardnor's Rhine scenes nos.419, 530, 540, 582, 652, 653. For a fuller account of Gardnor, see Powell (1991), pp.21–2.
5 In Turner's notes from Campbell on TB CLIX 13v some words are precisely those of the 1817 edition where it differs from the 1815 edition, e.g. 'Haerlem' is described as 'ten' miles from Amsterdam (as in the 1817 edition, p.249) whereas as in the 1815 edition (p.69) 'Harlem' had been given as 'seven' miles from it.
6 See Powell (1991), pp.23–5, and Bachrach (1994).
7 TB CLX 16v, 17v–26r.
8 See also Powell (1991), pp.23–5, 105–6.
9 He would rarely need to have walked more than about thirty-five miles a day and this should be judged against the walks of his contemporaries. When the young Wordsworth visited Switzerland in 1790 with his friend Robert Jones, they frequently walked nearly forty miles a day. When another poet, Robert Southey, was in his sixties, he thought little of walking twenty-five miles over high ground in the English Lake District.
10 R. Jefferies, *Round about a Great Estate*, 1880, p.141. See also *Journals of Dorothy Wordsworth*, ed. M. Moorman, Oxford 1981, pp.28, 129–30, for travellers both young and old carrying wallets.
11 TB CLIX 101r.
12 TB CLX 27v.
13 TB CLIX 86r–84v.
14 TB CLX 28v–38r.
15 TB CLXI 2r, 3r.
16 TB CLX 39v–40r, 40v–41r.
17 Hammerstein: TB CLX 48r, 48v, 92v; Andernach: TB CLX 49v, 50r, 50v–51r.
18 TB CLX 53r, 53v, 54v, 56r; TB CLXI 6v–7r, 7v–8r, 8v–9r.
19 TB CLX 42v, 55r.
20 TB CLXI 10r, 10v–11r, 11v–12r.
21 TB CLIX 81v, 79r; TB CLX 57r, 57v, 93r; TB CLXI 16r; 16v–17r.
22 TB CLXI 17v–18r, 18v–19r, 19v–20r.
23 See Gardnor, pls.XIV and XV and his remarks (1792, p.76).

24 TB CLX 58v, 93v; TB CLXI 20v–21r.

25 TB CLX 60r, 60v.

26 TB CLXI 21v–22r, 22v–23r.

27 See Gardnor, pls.IX and XI and his remarks (1792, p.55).

28 TB CLXI 23v–24r. For further discussion of Turner's sketches of St Goar in TB CLXI, see Powell (1991), p.58 n.36.

29 TB CLX 59v; TB CLXI 25v–26r.

30 TB CLXI 26v, 28r, 28v, 29r, 29v–30r.

31 TB CLX 1v–2r, 90v, 91r.

32 E.g. TB CLX 62v–63r, 63v, 64v (Bacharach); 65r, 65v (the Bautsburg).

33 TB CLX 67v–68r, 70v–71r, 71v–72r.

34 Gardnor (1792), p.25; TB CLIX 18r, 59r, 59v, 60r; TB CLX 68v–69r, 69v–70r.

35 TB CLXI 32v–33r, 33v–34r, 34v–35r, 35v–36r.

36 TB CLX 71v–72r; 73v–74r, 74v–75r, 75v.

37 St Goar and Burg Rheinfels: TB CLXI 37v–38r, 38v–39r, 39v–40r, 41r, 42r. St Goar to Coblenz: TB CLXI 43r–52r.

38 Compare TB CLXI 3r and TB CLX 81v, 82v–83r.

39 W 666 (cat.no.10), 1216 (see cat.no.26), 1285.

40 TB CLXI 53r–58v.

41 W 636–86. This list of fifty-one works includes two accidental duplications (w 640 is the same work as w 683, and w 647 the same as w 686) but it omits two depictions of the Lorelei (see Powell 1991, p.102).

42 'Coblenz: The Quay' (w 658, at present untraced but probably similar to w 687): TB CLXI 8v; 'The Mosel Bridge at Coblenz' (w 659): TB CLXI 6v–7r; 'The Rhine Gate, Cologne' (w 669): TB CLXI 53v–54r, augmented by architectural detail from TB CLX 27v; 'Cologne' (w 670): TB CLX 87v, 88r, and TB CLXI 57v–58r in equal measure; 'Burg Rheinfels' (w 650): TB CLXI 22v–23r (but it brings the castles much closer together); 'Katz Castle and Rheinfels' (w 649): TB CLX 41v (but it includes the evening sun and Burg Rheinfels from TB CLXI 29r).

43 Taking the remaining drawings in topographical order from Mainz to Cologne, they are based on the sketches in TB CLX as follows: 'Mainz' (w 636): 68v–69r; 'Mainz' (w 637): 67v–68r; 'The Palace at Biebrich' (w 638): 67v–68r (centre), augmented by a raft such as that sketched on TB CLIX 58r; 'The Johannisberg' (w 673): 70v–71r (first sketch); 'Rüdesheim' (w 639): 70v–71r (last sketch, for the landscape) and 71v–72r (first sketches, for Rüdesheim itself); 'The Binger Loch and Mäusethurm' (w 679): 71v–72r (centre); 'Bingen from the Nahe' (w 682): 66v–67r (centre); 'The Abbey at Bingen' (w 680): 68r; 'The Bautsburg' (w 640/683): 67v (first sketch); 'Burg Sooneck with Bacharach in the Distance' (w 671): 62r; 'Burg Fürstenberg' (w 641): 64r; 'Bacharach and Burg Stahleck' (w 642): 61v; 'The Pfalz on the Rhine' (w 643): 73v–74r with 62r for Burg Gutenfels; 'Oberwesel and the Schönburg' (w 644): 2r, 90v, 91r; 'The Lorelei' (w 646): 1v (last sketch); 'St Goarshausen and Katz Castle' (w 645 and w 676): 75v; 'The Lorelei with Burg Katz and St Goarshausen' (w 684): 1v (first sketch); 'Hirzenach below St Goar' (w 681): 60r; 'Brüderburgen' (w 651): 90v–91r, 93v; 'Boppard' (w 652): 93v; 'Osterspey and Feltzen' (w 674): 73v–74r; 'The Marxburg' (w 653): 52r; 'Oberlahnstein' (w 654): 93r; 'Abbey near Coblenz' (w 672): 56v; 'Ehrenbreitstein from the Zathel' (a strange title, almost certainly due to an early

misreading of 'Thal' Ehrenbreitstein, the village below the fort) (w 656): 53v; 'View from Ehrenbreitstein' (w 657): 52v; 'Neuwied and Weissenthurm' (w 661): 78v–79r (third sketch); 'Weissenthurm and the Hoche Monument' (w 660): 77v–78r; 'Andernach' (w 662): 50v–51r; 'The Watch Tower at Andernach' (w 663): 92v (second sketch); 'Hammerstein, below Andernach' (w 664): 92v (first sketch); 'Remagen and Linz' (w 665): 39v–40r and 40v–41r; 'Rolandswerth, Nunnery and Drachenfels' (w 666): 83r (last sketch); 'Rolandseck and Drachenfels' (w 667): 38v–39r; 'Drachenfels' (w 675): 36v–37r; 'The Hochkreuz and the Godesburg' (w 668): 31v–32r and 32v–33r.

44 Ruskin (1903–12), XII, pp.376–7.

45 Thornbury (1862), II, p.86.

46 B&J 136. Finberg (1961), pp.249–50.

47 See Powell (1991), p.59 n.55 and Appendix.

48 Bower (1990), pp.102–3. Some of the series exceed these sizes slightly in one dimension or another, but could have been painted on paper cut from whole sheets rather than half-sheets of the same or similar paper. w 682 is watermarked. w 671, 674, 675, 683 are painted on a different paper from the others.

49 See Powell (1987), pp.44–50.

50 Several of those which left Turner's hands are smaller than those in the Turner Bequest (e.g. W 1007, 1023, 1027, 1029) but the measurements of these may be 'sight' ones rather than to the edges of the paper.

51 w 691, 692 (signed and dated 1820). British Museum, Lloyd Bequest (1958-7-12-420 and 1958-7-12-422).

52 B&J 234, 269, 328a; 114.

53 w 690 (Powell 1991, cat.no.21). w 689a, documented in two sketchbooks, Hints River (TB CXLI 35v) and Liber Notes (2) (TB CLIV(a) 58r). See E.H. Yardley, 'The Turner Collector: "That Munificent Gentleman" – James Rivington Wheeler', Turner Studies, vol.6, no.2, 1986, pp.51–60.

54 w 693 (Powell 1991, cat.no.17).

55 Ruskin (1903–12), XXXV, pp.595–6; reprinted in Powell (1991), p.35.

56 See, e.g., Literary Gazette, 16 Aug. 1819, repeated 21 and 28 Aug., 4 and 11 Sept.

57 A memorandum of the meeting and the points discussed occupies three pages of the Aesacus and Hesperie sketchbook (datable by other evidence to 1819), TB CLXIX 7r, 7v, 8r, of which only the last two pages are in Turner's handwriting, the first in W.B. Cooke's. The memorandum is printed in Powell (1991), pp.59–60. On f.35r of the same sketchbook Turner made a list of Rhine subjects for his own book, including Oberwesel, Burg Lahneck, Johannisberg, Remagen, Mainz, the Brothers, Bacharach, the Mouse Tower, Burg Katz and St Goarshausen.

58 A biographical notice of von Gerning appeared in the Literary Gazette no.70, 23 May 1818, pp.321–2; review in ibid., no.146, 6 Nov. 1819, pp.705–6.

59 TB CCLXIII 259 (Powell 1991, cat.no.14).

60 In Cooke's accounts relating to Turner for 1818–22 (Thornbury 1862, II, pp.423–5), £85 1s. appears four times in 1822 against 'Three Drawings of the Rhine' (i.e. w 687–9). Before this (p.423) he had spent £1 4s. on a copy of Gardnor's Views on the Rhine.

61 See Powell (1991), cat.nos.18–20.

The First Meuse-Mosel Tour, 1824

1 B&J 231. For further details, see Powell (1991), pp.38–9.

2 The contents of this sketchbook and all the others used in Germany in 1824 are fully listed in ibid., pp.202–13.

3 Turner's notes on the page illustrated in fig.16 can be transcribed as

Rhon *Kern*
Burgen *Eltz*
one League from Kern Elz & Castle
Raudouin or Baldwin near
Pyrmont a League further Castle and
Fall of the Elz. Carden Mt Town
Church Castle Monr Sontag Pictures
Opposite to Carden Hermitage of Zilles
berg on a high Rock fine View of M
Treis Mt T
Pommern Wine Roman Camp on Mt
1 L Rosenthal Convent Wild Situation
Klotten Klottenberg Castle
Kochen Anchor and Roman King
3 L baths of Bertrich
Bieltein Castle Prison Convent
Marienberg Convent on a Steep Rock
A great bend of Moselle to Zell Mt T
Merl Inn Monr Koch
Enkirchen St
Starkenbourg Castle Mt Stephanberg

4 TB CCXVI 1r–9v, transcribed in Powell (1991), pp.202–3. Twelve pages relating to the Meuse (ff.1r–6r) are followed by seven on the Mosel (ff.6v–9v). Apart from errors, Turner's use of red pencil underlining, a circle and a jagged circle on his maps of the Mosel (ff.8v, 9r, 9v) corresponds exactly to the usage in Schreiber's map of bold type for important places, a circle for 'Walled or open towns' and a similar jagged circle for 'Fortified towns'.

5 A note on TB CLIX 98r gives its French title, another on TB CLX 90v its German one.

6 TB CCXVI 270r.

7 See Powell (1991), pp.40–2.

8 TB CCXVI 90v–97v.

9 TB CCXVII 5r, 17v, 21r.

10 Shelley (1844), I, pp.20–6.

11 Ibid., p.23.

12 E.g. TB CCXVI 98r–102r. The sketches on ff.102v–111r must have been drawn on Turner's second day on the Mosel; those on ff.111v–121r on the third; and those on ff.121v–137r on the fourth. Clearly, however, one cannot tell which sketches at Turner's overnight stops belong to the evening, which to the morning. Other sketches were later inserted by Turner on pages used on the Mosel; plainly these are not covered by the break-down above.

13 TB CCXVI 110v–111r.

14 TB CCXVI 121r–123r.

15 TB CCXVI 136r–142r.

16 TB CCXVI 143r–147r.

17 TB CCXVI 147v–180r.

18 For this tour see Bachrach (1974); Cologne (1980), pp.68–9; Bachrach (1994).

19 TB CCXIV 140r, 140v; TB CCXV 35v–36r, 36v–37r.

20 TB CCXIV 141r–150r, 164v; TB CCXV 31v–32r, 32v–33r, 34v–35r, 65v–66r, 66v–67r.

21 TB CCXIV 152r–154r. Turner's other sketches of Aachen from other tours are equally schematic

(see, e.g., TB CCXCI(a) 50v, 51r, 56r, 56v, 57r, which include tiny depictions of the former abbey of St John the Baptist, Burtscheid, the imperial chapel and town hall at Aachen and one of its massive town gates).

22 For more details of Mr John Broadhurst see Powell (1991), p.61 n.37.

23 The sketches in the *Holland* sketchbook (TB CCXIV, especially ff.142v–143r and 164v) show both the general scene and individual motifs; they do not, however, include such a detailed depiction of the buildings on the far right as one of Turner's large sketches of 1817 (TB CLXI 54r), which he must surely have consulted.

Down the Danube to Vienna, 1833

1 Finberg (1961), pp.348, 355.

2 Powell (1991), pp.45–54.

3 E.g. George (1984) redated Finberg's 1835 tour to 1833, assigning numerous sketchbooks to it; Lyles (1992, pp.19–22, 76–7) demonstrated conclusively that Turner's Berlin, Dresden and Prague visits must have taken place after 1834, probably in 1835, and rightly postulated that this tour did not extend as far as Venice.

4 B&J 349, Tate Gallery, London; B&J 352, present whereabouts unknown. See also Stainton (1985), pp.13–16, 19–21.

5 See Thornbury (1862), II, pp.396–7, 400.

6 B&J 348, National Gallery of Art, Washington DC.

7 Thornbury (1877), p.105.

8 See Vaughan (1979), p.265, for a table demonstrating the dominance of Rhineland subjects throughout the period of Turner's visits.

9 TB CCC 2r (Heidelberg castle, bridge and Heiliggeistkirche); 2v (views on the Kapuzinerberg at Salzburg).

10 See below, p.63.

11 W 1107, based on TB CCCXI 67r, 67v, was engraved as R 530 by William Miller.

12 Jones's account is reprinted in Gage (1980), p.5.

13 *Athenaeum*, I, 8, 22 Dec. 1832, pp.780, 798, 800, 831; *New Monthly Magazine*, Dec. 1832, pp.526, 528; *Gentleman's Magazine*, Dec. 1832, pp.549–50.

14 *Athenaeum*, 25 May 1833, p.336; *Gentleman's Magazine*, May 1833, p.448.

15 Quoted in Gage (1980), p.270.

16 TB CCXCVI 2r–4v (Ostend); 5v–8v (Bruges); 1v, 9v–11v (Ghent); 37v, 38r, 39v (Liège); 29r–32r, 33r, 33v, 90r, 91v (Huy); 12v–14r, 16v–30r, 79v–8or (Namur).

17 TB CCXCVI 90v, 91r; TB CCXCVIII 78r; TB CCCXI 38v, 77r.

18 TB CCXCVIII 1r–26r.

19 See below, pp.74–5 and cat.nos.145–50.

20 TB CCXCVIII 26v–35r, 48v. Turner's route from Mannheim to Munich was that used by the Callcotts in 1827 (see Lloyd and Brown 1981, p.7). The route from Heidelberg to Heilbronn was also followed by the British scientist Sir Humphry Davy in 1828, on his last visit to the Continent (Tobin 1832, p.24).

21 TB CCXCVIII 37v–41v, 45v, 46r, 47r.

22 See Münster: Westfälisches Landesmuseum (1987), nos.31–2, which show in contemporary paintings how very attractive the views sketched by Turner were in the 1830s.

23 TB CCXCVIII 42v–43r, 49r–50r.

24 TB CCXCVIII 51v–67r, interspersed with sketches of other subjects (see Appendix).

25 TB CCXCVIII 65v.

26 See London: Victoria and Albert Museum (1985), pp.134, 141.

27 His route took him through Leipheim, Günzburg, Zusmarshausen and Augsburg (TB CCXCVIII 70r, 69r, 53v, 62v, 59r).

28 Following Finberg (1961, p.381), many modern books and catalogues on Turner state that he visited Munich during his return journey from Venice in 1840. This, however, was not the case (see below, pp.66–72).

29 Baxter (1850), pp.15–16.

30 TB CCXCVIII 56v, 81r.

31 Murray (1837), p.32. TB CCXCVIII 37r, 52r, 53r. Of these the first sketch on f.53r is the frontal position usually illustrated in books, showing the torso at its most expressive. All four sketches are drawn in corners of pages already used on Turner's journey.

32 Jameson (1839), I, pp.228–30.

33 TB CCXCVIII 57r.

34 TB CCXCVIII 56r.

35 *Payne's Book of Art*, 1849–54, I, p.vii; II, p.vii.

36 Holmes (1828), p.77.

37 B&J 407, Bayerische Staatsgemäldesammlung, Neue Pinakothek, Munich.

38 Jameson (1839), II, pp.15–22, gives a full account of the inauguration of the obelisk.

39 TB CCXCVIII 56r, 57r.

40 Lloyd and Brown (1981), Notebook 1, p.93.

41 Jameson (1839), II, pp.58–61.

42 E.g. TB CCXCVIII 54r, 54v, 57v, 58r, 58v, 67v, 73v, 79v (city centre); 55r, 55v (across the Isar). Compare Münster: Westfälisches Landesmuseum (1987), nos.40, 42.

43 See Glover (1927), pp.132–6; Frye (1908), p.364; Holmes (1828), pp.87–8.

44 Batty (1823), pls.12–16; Tobin (1832), p.124.

45 Dibdin (1821), III, p.358.

46 Cunningham (1843), III, p.302.

47 TB CCXCVIII 97v, 77r, 77v, 79r, 94r, 89r.

48 TB CCXCVIII 76v, 80r, 83r.

49 TB CCXCVIII 78v–79r. Compare *Das Salzkammergut, Berchtesgaden und Salzburg*, Anton Schroll, Vienna, n.d., pl.54. TB CCXCVIII 88r. On this hotel (now the Radisson Hotel Altstadt) see *Das 'Höllbräu' zu Salzburg*, Salzburg 1992.

50 *Das Salzkammergut …*, passim. See also London: British Museum (1994), pp.208–28.

51 TB CCC 2v–5v.

52 TB CCC 6v–19v.

53 TB CCC 23v–31r.

54 TB CCC 43v–45r.

55 TB CCC 46r, 46v.

56 *Das Salzkammergut …*, pls.52, 56–7, 72, 81, 86, 113, 117.

57 Frye (1908), p.368; Planché (1828), pp.v, 246 and passim; Holmes (1828), p.99.

58 TB CCC 50v–53v.

59 TB CCC 54v.

60 See below, pp.70, 58, 168.

61 See also TB CCXCI(a) 2v.

62 Frye (1908), p.367; Planché (1828), p.145; Holmes (1828), p.113.

63 See Halsband (1965–7), I, p.259; Glover (1927), pp.132–47.

64 TB CCC 50v–82r. For details see Appendix.

65 Glover (1927), p.142.

66 TB CCC 69r.

67 See below, pp.68–70.

68 Snow (1842); Beattie (1844), with Bartlett's engravings; Simpson (1847). Turner's own library reputedly included a volume which is listed as *Views on the Danube* by 'Jeremias Wolffius' (1822) (see Wilton 1987, p.247). This work is, however, unrecorded in available nineteenth-century book catalogues. The author must have been Jeremias Wolff (1663–1724 or 1730) whose sixty-two engravings of the Danube were published as *Prospekte von Schlössern, Kirchen und Klöstern von Augsburg bis Wien an der Donau*.

69 TB CCC 79v–82v.

70 *Wiener Zeitung*, no.197, 28 Aug. 1833, p.793: 'Hr. Turner, Mitglied der königl. Akademie zu London … von London.' In the nineteenth century Vienna used a continuous numbering system for its buildings, rather than numbering them along each street. Turner is therefore actually recorded as staying at 'Leopoldstadt, Nr. 581', the identity of which is easily ascertained through the *Häuser-Schema* of C. Schwab, Vienna 1843, p.57 and R. Messner, *Die Leopoldstadt im Vormärz*, Vienna 1962, p.136. The hotel also numbered Helmuth von Moltke and Bismarck among its nineteenth-century guests.

71 Reichard (1836), p.139; Murray (1837), p.127.

72 The Viennese branch of the Danube was converted into the Donau-kanal in 1869–73; the main branch, lying some two or three miles further north, was canalised later in the 1870s. In Turner's day both goods and passengers could be brought by river into the heart of Vienna.

73 TB CCCXI inside front cover, 1r, 94v (for details see Appendix). Copying and facilities for artists in the Belvedere are referred to in Batty (1823), note to pl.34; Murray (1837), p.146. For Turner in Dresden, see below, pp.54–6.

74 See Finberg (1961), pp.314–15.

75 TB CCCXI 10r–17v.

76 TB CCCXI 24r, 27v, 29r. He also sketched Melk on the Danube (as seen from the road, f.23v) and there are many unidentified sketches in TB CCCXI which may be places seen along this part of his route.

77 *Intelligenz-Blatt zum K.K. priv. Bothen von und für Tirol und Vorarlberg*, no.72, 9 Sept. 1833, p.441: 'Angekommene Fremde in Innsbruck. Den 3 Sept. Hr. Turner-Mallord, Privat aus England und Mitglied der Akademie in London, von Wien.' Whilst this reference is unquestionably to Turner, there must be some uncertainty over whether he is the 'Mallord' referred to in a group of Englishmen recorded in the *Salzburger Zeitung* for 5 Sept. as arriving in Salzburg from Vienna. However, a belated registration is by no means impossible and, if Turner did travel in the company of Messrs Pierker, Batteman, Hayes and Wekeman (as they are described), this would certainly account for the paucity of sketches.

78 TB CCCXI 38v, 77r; TB CCCXLI 231r, 231v, 232a.

79 George (1971), pp.84–5. The journey is recorded in TB CCCXI.

80 *Intelligenz-Blatt zum K.K. priv. Bothen von und für Tirol und Vorarlberg*, no.77, 26 Sept. 1833, p.474: 'Angekommene Fremde in Innsbruck … Den 23 Sept. … Hr. Turner, Rentier und

Mitglied der Akademie der Wissenschaften in London, von Venedig.'

81 One sketch (f.17r) bears the date '22 Sept' as well as the note 'Botzen'. See Finberg (1930), pp.169–70, where he suggested renaming this sketchbook *Venice up to Innsbruck*. However, Finberg himself subsequently identified the sketches of Augsburg in this book referred to in the next paragraph.

82 'Venice, from the Porch of Madonna della Salute', B&J 362, Metropolitan Museum, New York.

83 See below, pp.65 and 81 n.2.

84 Starting at top left, the sheet consisted of TB CCCXLI 167, 164, 115, 155v, 169, 170, 157, 156v, 168, 18 (dated), 159, 158, 165, 166, 160v, 161. It bears the watermark 'B E & S/1829'.

85 TB CCCXII 65r–66r.

86 Gage (1980), pp.150–1.

87 *The Castle of Indolence*, canto I, stanza xxxviii.

Northern Germany, the Elbe and Prague, 1835

1 See Finberg (1961) pp.355–6; Bachrach (1974) and George (1984). No author has yet – to the present writer's knowledge – given consideration to TB CCCV, though Vaughan (1979, p.101) included Hamburg among Turner's destinations. Turner's visit to Berlin was definitively recognised as having taken place after 1834, thanks to the research of Anne Lyles (1992, pp.19–22).

2 Waagen (1838), passim.

3 Sadler (1869), I, pp.96–104; Cunningham (1843), II, pp.325–59; Lloyd and Brown (1981), Notebooks 1–2. The Callcotts had been unable to explore Saxon Switzerland as much as they would have liked and must surely have encouraged Turner to do so fully.

4 *Gentleman's Magazine*, Aug. 1835, p.179.

5 E.g. those of the Waisenhauskirche, Königs-brücke and Münze (TB CCCVII 18r, 18v, 16r).

6 B&J 360, 359, 364, 361.

7 Gage (1980), p.156.

8 Ibid., pp.157–8. For the text of this letter, from Pye's own draft in the Victoria and Albert Museum, see cat.no.110.

9 No.209, p.4, under 'Angekommene Fremde'. The announcement describes Turner as a 'Particulier' (private individual) from London, and also names his hotel.

10 See the advertisements in the *Times* for this year, e.g. 25 July 1835, p.1, col.1; Murray (1836), p.267.

11 Ibid.

12 Reichard (1836), p.532.

13 Murray (1836), p.xxv. In fact Turner's 1835 tour consisted of part of Murray's 'Skeleton Tour D', followed by 'Skeleton Tour C' in reverse, before Murray had constructed them.

14 The date '27 Aug 1835' is inscribed in Turner's hand on one of the small folded sheets, making a miniature home-made sketchbook, in the Turner Bequest (TB CCCXLIV 214–26). It does not date any particular sketch and probably relates to a financial calculation made just before his journey. However, the rough sketches of boats and coastlines on these pages can certainly be related to Turner's outward journey of 1835, since they carry a number of English and German phrases, in a mixture of Turner's and German hands, after the fashion of the phrases in the sketchbook TB CCCVII.

15 A journey very comparable to Turner's is described by Wilkey (1839, pp.1–3). He went on board the *John Bull* at the Custom House about 10 p.m. on Friday 28 July 1837. It sailed around 1 a.m. on Saturday and reached the mouth of the Elbe about 10 p.m. on Sunday. At 2 a.m. on the Monday the boat started travelling the seventy-five miles up the Elbe to Hamburg which was reached by 7 a.m.

16 Barrow (1834), pp.3–7; Strang (1836), I, p.11; Murray (1836), p.268.

17 Ibid.; Reichard (1836), p.242.

18 Murray (1836), pp.269–70. See also Neale (1818), pp.16–27; Hodgskin (1820), I, pp.195 et seq.

19 TB CCCV passim. For details see Appendix.

20 P. James (ed.), *The Travel Diaries of Thomas Robert Malthus*, 1966, p.32.

21 Strang (1836), I, p.9.

22 Glover (1927), p.233.

23 Ibid., pp.234–5.

24 TB CCCV 16v, 17r. The position of the obelisk has been changed since Turner saw it on the Lombardsbrücke. It now stands on the Moorweide west of the Rothenbaumchaussee. For details and an illustration of the relief sketched by Turner on TB CCCV 16v, see Hermann Hipp, *Frei- und Hansestadt Hamburg*, Cologne 1989, p.368. Even more details about the monument, together with a rapturous account of the walk round the Binnenalster on which Turner would have seen it, are given by Louis de Boisgelin, *Travels through Denmark and Sweden. To which is prefixed, a Journal of a Voyage down the Elbe from Dresden to Hamburg*, 1810, I, pp.29–31. The Büsch monument is drawn to travellers' attention in Domeier (1830), p.133, and inspired moral precepts in Hodgskin (1820), I, pp.213–14.

25 The 'bustle of business' and well-being of Hamburg at the time of Turner's visit are also described by Johnson (1841), pp.273–4.

26 For the Hamburg–Lübeck road, see Barrow (1834), pp.19–20; Murray (1836), p.271.

27 TB CCCV 10r, 10v, 11r.

28 *Berlingske Tidende*, 8 Sept. 1835; TB CCCV passim (see Appendix). Photographs of all the subjects of Turner's sketches of Copenhagen can be found in S. Aakjaer, M. Lebech and O. Norn, *Kobenhavn før og nu*, Copenhagen 1949–50, 6 vols.

29 TB CCCV 5v, 6r, 6v. For a comparable Friedrich view, see, e.g. London: National Gallery (1994), p.83.

30 TB CCCV 23v–24r, 27r. For details see Appendix.

31 TB CCCV 7r; TB CCCVII 59r–58r; TB CCCV 2r. Rosenborg is attributed to Inigo Jones by Carr (1805), p.73; Batty (1829), text next to the vignette of the castle.

32 TB CCCV 5r, 21r, 31r.

33 TB CCCV 20r, 32r. The archivist of the University of Copenhagen was surprised to learn of Turner's transcription (f.20r) of the first part of the inscription on the façade of their building, 'Fredericus Sextus Instauravit', since this continues with 'Aº MDCCCXXXVI' and had been presumed not to have been put up until that year!

34 See Bjarne Jørnaes and Anne Sophie Urne, *The Thorvaldsen Museum*, Copenhagen 1985, pp.15, 17, 26–7.

35 See Powell (1987), pp.61, 71.

36 Gage (1980), p.121.

37 Thorvaldsen's marble bust of Scott has only recently reappeared and was acquired in 1993 by the Scottish National Portrait Gallery. His statue of Byron is in the Wren Library at Trinity College, Cambridge.

38 See below, p.61 and Powell (1991), p.47.

39 [Lady Eastlake], *A Residence on the Shores of the Baltic*, 1841, I, pp.28–9.

40 Events surrounding the creation of Thorvaldsen's museum were reported in, e.g., the *Athenaeum*, 22 Dec. 1838, p.915.

41 TB CCCVII 57v–51r.

42 W 1278; R 620. Piggott (1993), no.128.

43 TB CCCVII 49v–47r.

44 TB CCCVII 45r–42r; 41v–32v.

45 TB CCCVII 1r–4r.

46 TB CCCVII 32r.

47 Reichard (1836), p.572.

48 Russell (1825), II, p.22.

49 TB CCCVII 17r, 18r, 22r, 31r.

50 Holmes (1828), p.216.

51 TB CCCVII 19v, 20r, 21r, 22r. Compare the oil painting of the same view by J.H. Hintze in the Schinkel Pavilion, Schloss Charlottenburg, Berlin. The level and uninteresting situation of Berlin was adversely commented on by Turner's contemporaries (see Wilkey 1839, p.29; Forbes 1856, p.32). Forbes had a very positive attitude towards the Kreuzberg monument itself, however, likening it to the Scott Monument in Edinburgh and the Martyrs' Memorial in Oxford (p.39).

52 Of the buildings sketched by Turner in Berlin, only the Oranienburg Gate (taken down 1871), the Domkirche (destroyed 1893 to make way for the present building of 1894–1905), the Waisenhauskirche (destroyed 1905), the royal palace (badly damaged by bombing in 1945 and destroyed by the GDR in 1950) and the Langebrücke are absent today. Most of the others have been superlatively restored after the bomb damage (the Opera had already been rebuilt after a fire in 1843). The Königskolonnaden were relocated in the Kleist Park in 1910 and the statue of Blücher has been moved some yards further back from its original location, away from the traffic of Unter den Linden.

53 TB CCCVII 13v, 14r, 24r, 27v, 28r, 28v, 29r, 29v, 30r. The statue of the Great Elector: 24v, 29r, 29v. Gaertner's oil painting of the Schlossfreiheit in 1855 was recently acquired by the Staatliche Museen zu Berlin Preussicher Kulturbesitz and is on show in the Alte Nationalgalerie.

54 See Appendix entries for TB CCCVII 13v–31r.

55 Pundt (1972), pp.78–105.

56 TB CCCVII 18v, 19r, 21v.

57 TB CCCVII 25v, 26r, 27r.

58 B&J 133, 134.

59 B&J 370; 'Ancient Italy – Ovid Banished from Rome' and 'Modern Italy – the Pifferari' (B&J 375, 374); 'Ancient Rome; Agrippina Landing with the Ashes of Germanicus' and 'Modern Rome – Campo Vaccino' (B&J 378, 379).

60 Shelley (1844), I, pp.219–20; Forbes (1856),

pp.41–4; Wilkey (1839), pp.21–2.

61 Murray (1836), p.xxv. Reichard (1836), p.568.

62 *Dresdner Anzeiger*, no.263, 20 Sept. 1835, Extra-blatt (p.5): 'Hôtel de Russie: Hr Partic. Turner a London.'

63 Reichard (1836), p.163. Turner had used another of Reichard's many famous guidebooks, his *Itinerary of Italy* (1818) during his 1819 tour of that country (see Powell 1987). Reichard's road-book of Germany, originally published in 1820, was for a decade the only such work in English (Domeier 1830, preface) and was therefore much used by English visitors as well as by other nationalities (the present author has, however, only had access to a French edition of 1836). Domeier's own book sought to remedy the situation, but was soon overshadowed by Murray's guides.

64 According to Murray (1836), p.356, the phrase originated by Herder was 'the German Florence', but other variants included 'the Florence of Germany' (Frye 1908, p.400). Turner's 1819 visit to Florence, which is described in Powell (1987), chap.7, has numerous points in common with his visit to Dresden.

65 Some sketches of Dresden were drawn in TB CCCVII which he had been using since leaving Copenhagen; some in the same book as those depicting his tour of Saxon Switzerland, after which he returned to Dresden (TB CCCVI); and some in that used for the subsequent journey to Prague and in Prague itself (TB CCCI).

66 Neale (1818), p.66. TB CCCVII 11r.

67 E.g. James Boswell in 1764 (F.A. Pottle, ed., *Boswell on the Grand Tour: Germany and Switzerland 1764*, 1953, p.129); Dr Burney in 1772 (Glover 1927, p.192); Frye in 1818 (1908, p.390). Needless to say, both pedestrians and carriages were expected to keep to the right!

68 See especially TB CCCI 2r–5v and TB CCCVII 9v, 10r, 10v.

69 Some of Turner's sketches from the Brühl terrace (TB CCCVII 8v, 9r; TB CCCVI 9r, continued on 12r) are very close to Bellotto's.

70 TB CCCI 2v–4r.

71 Neale (1818), p.67; compare Forbes (1856), p.47.

72 See, for instance, Neidhardt (1983), pls.60–8.

73 See Russell (1825), I, pp.268–70; Neale (1818), pp.70–1; Shelley (1844), I, pp.235–9.

74 See the announcements in the *Dresdner Anzeiger* for September 1835. Permission for visits at other hours was, however, obtainable at a price (see Shelley 1844, I, p.239, and the *Dresdner Anzeiger* announcements for 1835).

75 On the copyists, see Russell (1825), I, pp.286–8; Johnson (1841), p.262; Neale (1818), pp.70–1.

76 TB CCCVII 6r–7v. For details, see Appendix. For illustrations of all the paintings (except the 'Magdalene' of Correggio, which is now lost), see *Gemäldegalerie Dresden. Alte Meister. Katalog der ausgestellten Werke*, Leipzig 1992.

77 Murray (1836), p.362; see also Russell (1825), I, p.282.

78 Both Russell (1825, I, p.273) and Murray (1836, p.363) considered Ruisdael's 'Hunt' to be of outstanding quality and one of the best pictures he had ever painted. Russell did not mention the Claudes, Murray merely listed them (p.364). For the influence of the Ruisdael on Friedrich, see London: National Gallery (1994), p.80.

79 As well as the inevitable Italian and Dutch

masterpieces of the collection, *Payne's Royal Dresden Gallery*, 1845–50, included Claude's 'Flight into Egypt' (I, p.121), the Watteau sketched by Turner (II, p.135), and 'David giving Uriah the Letter', which it attributed to Ferdinand Bol (II, p.157).

80 For the engraving, see B. Haak, *Rembrandt: His Life, Work and Times*, 1969, pp.258–9.

81 TB LXXII, *Studies in the Louvre*.

82 This environment is well caught by the diary entries of Joseph Farington RA whose visit to Paris overlapped with Turner's. See *The Diary of Joseph Farington*, ed. K. Garlick and A. Macintyre, V, 1979.

83 See Powell (1987), chaps.5 and 7.

84 For Turner's interest in these painters see Powell (1987), passim, on Raphael; Bachrach (1994), pp.19–20, on Ruisdael; M. Kitson, 'Turner and Claude', *Turner Studies*, vol.2, no.2, 1983, pp.2–15; S. Whittingham, 'What You Will; or Some Notes Regarding the Influence of Watteau on Turner', *Turner Studies*, vol.5, no.1, 1985, pp.2–24; vol.5, no.2, 1985, pp.28–48.

85 In 1842 Mary Shelley, seeing the Dresden collection for the first time, weighed up the merits of some of the paintings against those of prints and copies already known to her (1844, I, pp.236–8).

86 *Gentleman's Magazine*, Aug. 1835, p.183. This was to be a part-work, with four subjects in each part, five parts a year, to be completed in five years.

87 TB CCCVII 5r, 5v, 11v, 4r; TB CCCI 1r, 1v. Compare the lithograph in Prout's *Facsimiles of Sketches made in Flanders and Germany*, 1833, and the oil painting by Fritz Beckert (1917) illustrated in Neidhart (1983), pl.139.

88 TB CCCVI 7v–6v; TB CCCI 5v–7r. Compare Frye (1908), p.38. Two of Prout's views of the Zwinger in his *Facsimiles* volume (see n.87, above) were also taken from beyond the Wall Pavilion and looking down from the balustrade next to its upper storey.

89 TB CCCVII 9r, 8r.

90 *Sächsische Schweiz*, Berlin (Kümmerly & Frey), n.d., pp.6–7. The area was previously known as the Meissner Highlands (Forbes 1856, p.55).

91 Russell (1825), I, pp.259–66 described Saxon Switzerland in terms that can hardly be improved on and will have drawn many British visitors to the area. Domeier (1830) included an account abridged from a German source (Appendix III, pp.425–8). Murray (1836), pp.374–80 quoted Russell's descriptions, adding practical directions.

92 *Dresdner Anzeiger*, no.268, 25 Sept. 1835, Extra-blatt (p.5): 'Hôtel de Russie: Hr Edelm. Turner a London' (*Edelmann*: nobleman, gentleman).

93 Turner's tour may usefully be compared with those carried out by Strang (1836), pp.135–63; Shelley (1844), I, pp.259–76; Forbes (1856), pp.54–67 (whose two-day tour in 1855 included journeys by train and steamer, neither of which was possible for Turner in 1835). A wonderful contrast is provided by Dr Burney's account of his 1772 journey from Prague to Dresden which was decidedly not that of a Picturesque tourist (Glover 1927, pp.185–91).

94 TB CCCVI 67v–63v.

95 Shelley (1844), I, pp.261–3.

96 TB CCCVI 62v–60r.

97 TB CCCVI 59r–48v.

98 Strang (1836), II, pp.145–6.

99 This option is suggested by Murray (1836), p.378, who notes the existence of good accommodation at the Baths, a quarter of a mile from the town of Schandau.

100 TB CCCVI 44r–37v.

101 TB CCCVI 39v.

102 TB CCCVI 39r–32r. Murray (1836), p.380.

103 TB CCCVI 31v–24v.

104 TB CCCVI 24r–19r.

105 TB CCCVI 17r–9v.

106 The notes on TB CCCI 40v and inside back cover include the useful phrase 'Ich will ein Platz bis Teplitz' (I want a seat for Teplitz). The earlier part of the carriage journey from Dresden to Teplitz is recorded on ff.7v–10r, one sketch being labelled 'Hellendorf', the site of the Saxon customs house. The latter part, which took him past the battlefields of both Kulm and Nollendorf, is recorded on ff.37v–40r.

107 See Neale (1818), pp.81–2; Domeier (1830), pp.341–3; C.V. Riedel, *Teplitz et ses charmes*, Prague 1834; Reichard (1836), pp.426–31; Wilkey (1839), pp.86–7; Johnson (1841), pp.232–8. The luxury of the bathing arrangements in contrast to those of other German spas was noted with pleasure by Mary Shelley (1844, I, p.278).

108 See the *Times*, 3 and 18 Aug., 15, 19 and 23 Sept. 1835. Information supplied by the Státní okresní archiv of Teplice which holds records of visitors to the town: Turner's name is not among them. On Kulm and its monuments, see Wilkey (1839), p.85; Johnson (1841), pp.237–8.

109 TB CCCI 10v–20v. For details see Appendix.

110 TB CCCI 21r–24v.

111 TB CCCI 25r–37r; TB CCCIV 102r–68r (interspersed with sketches of other places).

112 Cunningham (1843), II, p.359.

113 Ibid., p.358.

114 TB CCCIV, 67r, 66v, 65v, 60r, 59v.

115 *Allgemeine Zeitung von und für Bayern*, no.277, 4 Oct. 1835, p.1112.

116 TB CCCIV 57v–40v. For details see Appendix.

117 Lloyd and Brown (1981), Notebook 1, p.107. Cunningham (1843), III, p.294.

118 This would correspond to the schedule in Reichard (1836), p.594.

119 TB CCCIV 47r, 44v, 54v.

120 TB CCCIV 39v–26v. For details see Appendix.

121 TB CCCIV 4v, 5r.

122 According to Peter Bower, the origin of this sketchbook is probably German. Its construction, marbled paper covers and garish yellow edge-painting all point to a German origin. It is also very similar to TB CCCV, CCCVII and CCCI, all used in 1835.

123 See Bachrach (1974) in which many of the sketches in TB CCCXXI are identified and reproduced. The sketchbook itself is, however, dated to 1841.

124 TB CCCXXI 5v, 6v.

125 The watercolour (present whereabouts unknown) is not listed in Wilton but was referred to in the letterpress of the *Gallery of Modern British Artists*. It must have been based on TB CCCXXI 5v.

The Second Meuse-Mosel Tour, 1839

1 See Vaughan (1979), p.265.
2 See Powell (1991), cat.no.29.
3 Finberg (1909), entries for TB CCLXXXVII–CCXCI; Finberg (1961), p.348.
4 Powell (1991), pp.46–8.
5 Gage (1980), no.227. He thus missed a meeting on 3 August at the Royal Academy (General Assembly Minutes Book, IV, 1826–41).
6 Ibid., minutes for 30 September 1839, showing that Turner was present at this meeting but Stanfield absent. For Turner's letter, written from the Royal Academy, see J. Gage, 'Further Correspondence of J.M.W. Turner', *Turner Studies*, vol.6, no.1, 1986, no.201a.
7 TB CCXC (see Powell 1991, p.220). However, Finberg mistakenly attached several further sketchbooks to this group (see 1909, II, p.1254). These have been excluded from the discussion here.
8 See above, p.36.
9 TB CCXXIV 18–23, 25, 33–4, 54, 87, 91, 100, 108, 110, 111, 138, 209. See Powell (1991), p.62 nn.27–8, for identifications.
10 The *Trierische Zeitung* included two individuals named 'Turnes' (*sic*) in its 'Fremden-Liste' for 17 August 1839. Both are described as from London, one being specified as a military man, and both stayed at the Trier'scher Hof. One of these may have been J.M.W. Turner, but this is by no means certain.
11 See Powell (1991), pp.49–52, 127–8, 151–83, 213–18.
12 TB CCLXXXVIII 10v, 19r, 20v, 21r, 43v, 44r, 45v, 46r, 47v–48r, 49v–55r (see Powell 1991, p.217).
13 The contents of this sketchbook and the other two used in Germany in 1839, TB CCXC and CCXCI, are fully listed in Powell (1991), pp.218–25.
14 See Powell (1991), cat.no.44.
15 TB CCXC 5r–40v. Turner obviously returned from Coblenz to the Mosel on one of the roads through the Eifel described in Murray's *Handbook for Northern Germany* of 1836; this accounts for his sketches of Mayen on the misplaced pages ff.42v–43r (see cat.no.63) and for the distant views of Cochem from the hills on ff.4r–4v.
16 TB CCXCI 2r–34v.
17 TB CCXC 55r–60r, 61v.
18 See Powell (1991), pp.130–83.

Austria and Southern Germany, 1840

1 See especially Stainton (1985), pp.23–7, and Lyles (1992), pp.22–3, 67–71, 81–3.
2 This catalogue is obviously not the proper place to discuss Turner's Venetian drawings in detail, but there are striking links between those in the 'roll' sketchbook of white paper watermarked 1834 (TB CCCXV) and the coloured drawings in the *Passau and Burg Hals* 'roll' sketchbook (see cat.nos.85, 86, 88, 93); between some of those on grey paper (TB CCCXVII) and views of both Regensburg and Coburg (see cat.nos.94–6, 98–101); and between some of those on brown paper (TB CCCXIX) and three depictions of Burg Hals (see cat.no.89). Three sketches of castles near Bozen on grey paper (TB CCCLXIV 297–9) must also be dated to 1840.
3 This tour and its associated works have stimulated several articles in German periodicals, notably Appeltshauser (1976), von Freeden (1977) and Muth (1983). Appeltshauser's important work was later presented in the form of a book (1991).
4 PRO FO 610/2, no.6232. Turner's other passport application was made in July 1802 (see Powell 1990).
5 General Assembly Minutes Book, Royal Academy, London, IV (1826–41), p.354.
6 TB CCCXX 1r, 2r. Bachrach (1994, map on p.10) believes that Turner then travelled by road from Rotterdam to Cologne through Holland. However, there are no sketches recording such a journey and Turner may equally well have travelled quickly up the Rhine by steamer.
7 TB CCCXX 3r.
8 TB CCCXX 2v, 3v–6v.
9 TB CCCXX 23r–77r.
10 Gage (1980), pp.178–9, reprinted from Finberg (1930), pp.119–21, the letter itself now being lost. 'E.H.' cannot have been Edward Hakewill, as Gage suggests, since he did not marry until 1853.
11 Turner's arrival in Venice was recorded in the *Gazzetta Privilegiata di Venezia* (see George 1971, p.84). Mr E.H.'s arrival in Rome can be dated by means of his letter.
12 The pencil drawings include those of the Walhalla and Regensburg referred to below (see cat.no.96).
13 Some of these are reproduced and discussed in O. Sandner, *Bregenz*, Vienna and Munich, 1983, pp.60–1.
14 Finberg (1909) assigned cat.no.65 correctly to 1840; and described cat.nos. 64 and 66 merely as '*c*.1837–41', as was the case with most of the other 1830–40 sketchbooks discussed in the present catalogue. More recent writers have mostly followed his rough estimates. Stainton (1985) correctly assigned TB CCCXIII to 1840.
15 Information kindly supplied by Peter Bower.
16 His departure was recorded in the *Gazzetta Privilegiata di Venezia* (see George 1971, p.86).
17 Gage (1980), p.180.
18 TB CCXCIX 67r–57r. For details see Appendix.
19 Cunningham (1843), II, pp.366–7.
20 See C. Powell, 'Turner's "Antiquities at Pola": "the art of construction practically arranged"', *Turner Studies*, vol.4, no.1, 1984, pp.39–43.
21 Baxter (1850), p.192; Brown (1840), p.47. For Turner's probable route from Trieste to Graz, see Reichard (1836), p.321.

22 TB CCXCIX 48v–41v.
23 Baxter (1850), p.189.
24 Turner's only sketches of Vienna in 1840 are on TB CCXCIX 4r, 5r, 5v, 9v, 40r and 40v. His arrival was recorded in the 'Angekommen' column of the *Wiener Zeitung*, no.251, 10 Sept. 1840, p.1730, in a particularly engaging fashion: 'Hr. Joseph Mallard, und Hr. William Turner, Englische Edelleute (St. Nr. 1086), von Venedig'. On his journey from Venice Turner had become two English noblemen!
25 Turner's address is actually recorded as 'St. Nr. 1086', using the address system of nineteenth-century Vienna. Both numbers 1086 and 1087 in the city centre were the Stadt Frankfurt: see K.A. Schimmer, *Ausführliche Häuser-Chronik der Innern Stadt Wien …*, Vienna 1849, p.209; R. Messner, *Wien vor dem Fall der Basteien: Häuserverzeichnis und Plan der Inneren Stadt vom Jahre 1857*, Vienna and Munich, p.156. Murray (1840), p.144.
26 TB CCXCIX 40r, 40v, 9r.
27 TB CCXCIX 13v–10r. For details see Appendix.
28 Besides Pressburg, Turner did not visit Schloss Wildenstein, Schloss Sigmaringen, Abbach (near Regensburg) or Theben (at the Hungarian frontier) (TB CCXCIX 10r, 13v).
29 Compare Alt, *Donau-Ansichten*, pl.61, copied on TB CCXCIX 11r, with Turner's sketches on TB CCXCIX 24v and CCC 56r–57r; and pl.39 with TB CCCX 38r, 42r, 43r.
30 TB CCXCIX 14v–16r.
31 See Duller (1849), pp.402–5.
32 TB CCXCIX 31v–38r (St Nikola to Grein); 25v (Melk); 26r (Linz).
33 Snow (1842), p.15; Burney in Glover (1927), p.140.
34 Holmes (1828), p.103.
35 TB CCXCIX 23v, 24r, 26v (Burg Neuhaus); 21r, 21v, 22r (Kerschbaum); 21r (Marsbach); 20v, 21r (Rannariedl); 17r, 17v, 19r (Krampelstein).
36 Planché (1828), pp.103, 109, 103, 105.
37 Ibid., pp.105–6. See above, p.12.
38 TB CCXCIX 20r.
39 Turner's quick pencil records of his first view of Passau are on TB CCXCIX 18r.
40 Burney in Glover (1927), p.138; Beattie (1844), p.72; Simpson (1847), I, pp.34–6.
41 Snow (1842), p.15; Beattie (1844), p.73.
42 Apart from the very few sketches in TB CCXCIX, drawn on Turner's arrival, his sketches of Passau on white paper occur in TB CCCX and CCCXL. The brown paper was used only for Burg Hals (see cat.no.89). The grey paper was used for both Passau and Burg Hals (see cat.nos.87, 90, 92–3). Turner's extremely fragile depiction of Burg Krampelstein, TB CCXCII 24, is reproduced in Wilkinson (1975), p.96. Sadly, Turner's largest watercolour of Passau (W 1317) was not available for this exhibition, owing to the terms of the Vaughan Bequest to the National Gallery of Ireland.
43 *Regensburger Zeitung*, 14 Sept. 1840.
44 This celebrated old hotel lasted until 1881 and was pulled down in 1972. The site is now occupied by the Horten department store. It is listed first among Regensburg's hotels in Reichard (1836), p.113.
45 TB CCCX 18v, 41v, 46v–47r; 32r–47r. For details see Appendix.
46 On Prout's scene of 1832, see London: Victoria and Albert Museum, (1985), pp.144–5; Planché

(1828), p.9; Snow (1842), p.14.

47 Simpson (1847), I, pp.6–7.

48 See Powell (1987), pp.90–2.

49 Planché (1828), p.20.

50 Ibid., p.9.

51 For later British reactions to the Walhalla, which were not always adulatory, see, e.g., Simpson (1847), I, pp.7–27.

52 See also *The Romantic Spirit in German Art 1790–1990*, exh. cat., Edinburgh and London 1994, pp.303–6.

53 TB CCCX inside front cover, 33v–38r, 41r, 42r, 43r, 43v, 44r, 67v, 68r, 69r, 70r, 70v, inside back cover. For details see Appendix. He also sketched it on larger sheets of grey paper (TB CCCXLI 363, 364, 371).

54 See above, pp.59–60.

55 TB CCCX 29r–31v, 32r, 45r.

56 *Tagblatt der Stadt Bamberg*, no.253, 15 Sept. 1840.

57 *Tagblatt der Stadt Bamberg*, no.255, 17 Sept. 1840, under the heading 'Fremden-Anzeige von gestern auf heute' where he was listed as 'Sir Jurner, Rentier von London'. The Drei Kronen was situated at 12–14 Langegasse, a spot occupied at the time of the present writer's visit by the small Tengelmann supermarket in Langestrasse.

58 TB CCCX 19v, 26v–28v, 46r, 48r, 65v–67r.

59 TB CCCX 1r.

60 TB CCCX 44v.

61 TB CCCX 62r.

62 See also Appeltshauser (1991), pp.70, 76–7. The Swan is the second Coburg hotel listed in Reichard (1836), p.288.

63 TB CCCX 1v, 10v, 16v, 21r.

64 TB CCCX 2v, 3v, 4v, 5v, 10v, 20v, 21v, 22v, 23r–26r, 27v, 60r, 61r, 62r, 63r.

65 TB CCCX 22r, 62v–63r, 64r.

66 TB CCCX 51r, 68v.

67 TB CCCX 51r.

68 *Neue Würzburger Zeitung*, no.265, 23 Sept. 1840, 'Fremden-Anzeige' column: 'Wittelsb. H. … Turner, Rent. von London.'

69 TB CCCIII 88r–69v. For details see Appendix.

70 TB CCCIII 68v–20v; 11r. For details see Appendix.

71 TB CCCIII 6v–1v.

72 See n.10 above.

73 Gage (1980), pp.178–80. The letter, addressed to William Finden and concerned with stopping payment of a draft upon a bank, was eventually posted on 27 September.

Heidelberg and the Neckar, 1844

1 On these works see also Herrmann (1990), pp.233–7, where they are discussed in the context of other large late Turner prints.

2 R 669 and 670, engraved after W 688 and 689. See above, pp.28–9.

3 Powell (1991), pp.54–5.

4 The Ahr sketches are TB CCCXLIV 39r, 39v, 43r, 43v, 44v, 45r, 46r, 46v, 97r, 97v, 98r, 98v, 99–106. For details see Powell (1991), p.62 n.3. These were first identified as Ahr scenes in Stader (1981), pp.43–5 and ill.16.

5 He was present at the meeting of the General Assembly of the Royal Academy on 30 July 1844; Gage (1980), p.200.

6 Ibid., p.203.

7 TB CCCXLVIII 17r.

8 *Heidelberger Journal*, nos. 235–7, 26–8 Aug. 1844, pp.992, 996, 1000. These references were kindly supplied by Pia Müller-Tamm.

9 Baxter (1850), p.5. See also Mrs Boddington, *Slight Reminiscences of the Rhine …*, 1834, I, pp.131–2.

10 M. Twain, *A Tramp Abroad*, 1880, 1982 Century ed., pp.60–120.

11 A similar sketching style is found in the *Spires and Heidelberg* sketchbook (TB CCXCVII) which can therefore also be regarded as datable to 1844. Heidelberg itself is depicted from viewpoints similar to those in the *Heidelberg* sketchbook (TB CCCLII) to which cat.nos.138–44 belong; Speyer is sketched only at a distance, as seen from the Rhine; and the book also contains sketches of Lucerne. Some German sketches (e.g. that of Speyer on f.3r) are drawn on pages already containing Swiss ones, which suggests that Turner's outward and homeward routes through Germany in 1844 were very similar.

12 See *Augsburger Allgemeine Zeitung*, Beilagen (supplements) for 6 and 25 Sept., 1 Oct. 1845.

13 Ibid., 1 Oct. 1845 ('Turner, der vor einigen Jahren auch unsere Stadt besuchte').

14 See Gage (1980), p.192.

15 See the *Dover, Rhine and Innsbruck* sketchbook (TB CCCIX). Innsbruck is depicted on ff.22v and 23r. Munich is sketched on ff.14v (one of the towers of the Frauenkirche), 15r (the Sendlinger Tor and Kreuzkirche) and 26v (the Heiliggeistkirche, Peterskirche, town hall and Frauenkirche from Im Tal). The book also contains many small sketches of castles on the Middle Rhine and elsewhere and of mountain scenery. The book may more correctly be termed *Innsbruck, Rhine and Dover* (see Finberg 1930, p.170).

Select Bibliography

All books published in London unless otherwise stated.

Appeltshauser, H. (1976), 'Ein Gemälde von Schloss Rosenau von J.M. William Turner', *Jahrbuch der Coburger Landesstiftung*, 21, pp.13–20

Appeltshauser, H. (1991), *William Turner Fränkisches Skizzenbuch von 1840*, Fränkische Bibliophilengesellschaft

Bachrach, A.G.H. (1974), *Turner and Rotterdam, 1817, 1825, 1841*

Bachrach, A.G.H. (1994), *Turner's Holland*, exh. cat., Tate Gallery

Barrow, J. (1834), *Excursions in the North of Europe*

Barrow, J. (1841), *Tour in Austrian Lombardy, the Northern Tyrol, and Bavaria, in 1840*

Batty, R. (1823), *German Scenery: From Drawings Made in 1820, By Captain Batty, of the Grenadier Guards, F.R.S.*

Batty, R. (1829), *Hanoverian and Saxon Scenery, from Drawings by Lieut. Colonel Batty, F.R.S.*

Baxter, W.E. (1850), *Impressions of Central and Southern Europe*

Beattie, W. (1844), *The Danube, Illustrated in a Series of Views Taken expressly for this Work by W. Henry Bartlett*

Beattie, W. (1849), *Life and Letters of Thomas Campbell*, 3 vols.

Berlin: Nationalgalerie (1972), *J.M.W. Turner: Gemälde, Aquarelle*, exh. cat.

Bonn: Rheinisches Landesmuseum (1992), *Vom Zauber des Rheins ergriffen …*, exh. cat.

Bower, P. (1990), *Turner's Papers 1787–1820: A Study of the Manufacture, Selection and Use of his Drawing Papers*, exh. cat., Tate Gallery

Brown, David Blayney (1992), *Turner and Byron*, exh. cat., Tate Gallery

Brown, T. (1840), *The Reminiscences of an Old Traveller*, 3rd ed.

Carr, J. (1805), *A Northern Summer*

Cologne: Wallraf-Richartz-Museum (1980), *J.M. William Turner: Köln und der Rhein*, exh. cat.

Cunningham, A. (1843), *The Life of Sir David Wilkie*, 3 vols.

Dibdin, T.F. (1821), *A Bibliographical, Antiquarian and Picturesque Tour in France and Germany*, 3 vols.

Domeier, E.A. (1830), *A Descriptive Road-book of Germany*

Duller, Eduard (1849), *Die malerischen und romantischen Donauländer*, Leipzig

Finberg, A.J. (1909), *A Complete Inventory of the Drawings of the Turner Bequest*, 2 vols.

Finberg, A.J. (1930), *In Venice with Turner*

Finberg, A.J. (1961), *The Life of J.M.W. Turner, R.A.*, 2nd ed., Oxford

Forbes, Sir J. (1856), *Sight-seeing in Germany and the Tyrol in the Autumn of 1855*

von Freeden, M.H. (1977), 'William Turner in Franken', *Altfränkische Bilder*, 76, pp.8–13

Freiberg, S. (1955), 'Turner zeichnete in Österreich', *Alte und neue Kunst. Wiener kunstwissenschaftliche Blätter*, vol.4, no.3/4, pp.133–9

Frye, W.E. (1908), *After Waterloo*

Gage, J. (1969), *Colour in Turner*

Gage, J. (1980), *Collected Correspondence of J.M.W. Turner*, Oxford

Gage, J. (1987), *J.M.W. Turner: 'A Wonderful Range of Mind'*

Gardnor, J. (1792), *Views Taken on and near the River Rhine, at Aix la Chapelle, and on the River Maese*, 2nd ed.

George, H. (1971), 'Turner in Venice', *Art Bulletin*, vol.13, pp.84–7

George, H. (1984), 'Turner in Europe in 1833', *Turner Studies*, vol.4, no.1, pp.2–21

Glover, C.H. (ed.) (1927), *Dr Charles Burney's Continental Travels 1770–1772*, London and Glasgow

Halsband, R. (ed.) (1965–7), *The Complete Letters of Lady Mary Wortley Montagu*, 3 vols.

Herrmann, L. (1990), *Turner Prints*

Hodgskin, T. (1820), *Travels in the North of Germany*, Edinburgh, 2 vols.

Holmes, E. (1828), *A Ramble among the Musicians of Germany … by a Musical Professor*

Jameson, Mrs (1839), *Visits and Sketches at Home and Abroad*, 2 vols., 3rd ed.

Johnson, J. (1841), *Pilgrimages to the Spas*

Lloyd, C., and Brown, D. (eds.) (1981), *The Journal of Maria, Lady Callcott, 1827–8*, Oxford

London: British Museum (1994), *German Printmaking in the Age of Goethe*, exh. cat.

London: National Gallery (1994), *Caspar David Friedrich to Ferdinand Hodler: A Romantic Tradition*, exh. cat.

London: Victoria and Albert Museum (1985), *Samuel Prout 1783–1852*, exh. cat.

London: Victoria and Albert Museum (1991), *Karl Friedrich Schinkel: A Universal Man*, exh. cat.

Luxembourg: Musée de l'Etat (1984), *J.M.W. Turner in Luxembourg and its Neighbourhood*, exh. cat.

Lyles, A. (1992), *Turner: The Fifth Decade. Watercolours 1830–1840*, exh. cat., Tate Gallery

Münster: Westfälisches Landesmuseum (1987), *Einblicke und Anblicke des 19. Jahrhunderts. Glimpses of a Forgotten Germany*, exh. cat.

Murray, J. (1836), *A Handbook for Travellers on the Continent: Being a Guide through Holland, Belgium, Prussia, and Northern Germany*

Murray, J. (1837), *A Handbook for Travellers in Southern Germany*

Murray, J. (1840), *A Handbook for Travellers in Southern Germany*, 2nd ed.

Muth, H. (1983), 'Eine Würzburg-Ansicht von William Turner', *Altfränkische Bilder*, 82, pp.10–11, 13–14

Neale, A. (1818), *Travels through Some Parts of Germany …*

Neidhardt, H.J. (1983), *Dresden, wie es Maler sahen*, Leipzig

Piggott, J.R. (1993), *Turner's Vignettes*, exh. cat., Tate Gallery

Planché, J.R. (1828), *Descent of the Danube, from Ratisbon to Vienna, during the Autumn of 1827*

Powell, C. (1987), *Turner in the South: Rome, Naples, Florence*, New Haven and London

Powell, C. (1990), 'Turner's Travelling Companion of 1802: A Mystery Resolved?', *Turner Society News*, no.54, pp.12–15

Powell, C. (1991), *Turner's Rivers of Europe. The Rhine, Meuse and Mosel*, exh. cat., Tate Gallery

Pundt, H.G. (1972), *Schinkel's Berlin: A Study in Environmental Planning*, Cambridge, Mass.

Rawlinson, W.G. (1908, 1913), *The Engraved Work of J.M.W. Turner, R.A.*, 2 vols.

Reichard, H.A.O. (1836), *Manuel du Voyageur en Allemagne. Itinéraire de l'artiste, du négociant, de l'amateur*, Paris

Robertson, D. (1978), *Sir Charles Eastlake and the Victorian Art World*, Princeton

Ruskin, J. (1903–12), *The Works of John Ruskin*, ed. E.T. Cook and A. Wedderburn, 39 vols.

Russell, J. (1825), *A Tour in Germany … in the Years 1820, 1821, 1822*, 2 vols., 2nd ed.

Sadler, T. (ed.) (1869), *Diary, Reminiscences, and Correspondence of Henry Crabb Robinson*, 3 vols.

Schefold, M. (1968), 'William Turner in Heidelberg und am Neckar', *Jahrbuch der Staatlichen Kunstsammlungen in Baden-Württemberg*, 5, pp.131–50

Schreiber, A.W. (1818), *The Traveller's Guide down the Rhine*

Shelley, Mrs (1844), *Rambles in Germany and Italy, in 1840, 1842, and 1843*, 2 vols.

Simpson, J.P. (1847), *Letters from the Danube*, 2 vols.

Snow, R. (1842), *Journal of a Steam Voyage down the Danube to Constantinople*

Stader, K.H. (1981), *William Turner und der Rhein*, Bonn

Stainton, L. (1985), *Turner's Venice*

Strang, J. (1836), *Germany in MDCCCXXXI*, 2 vols.

Thornbury, W. (1862), *The Life of J.M.W. Turner, R.A.*, 2 vols.

Thornbury, W.G. (1877), *The Life of J.M.W. Turner, R.A.*, 2nd ed.

Tobin, J.J. (1832), *Journal of a Tour made in the Years 1828–1829, through Styria, Carniola, and Italy, whilst Accompanying the late Sir Humphry Davy*

Trollope, Mrs (1834), *Belgium and Western Germany in 1833*, 2 vols.

Vaughan, W. (1979), *German Romanticism and English Art*, New Haven and London

Waagen, G.F. (1838), *Works of Art and Artists in England*, 3 vols.

Warrell, I. (1995), *Through Switzerland with Turner*, exh. cat., Tate Gallery

Wilkey, E. (1839), *Wanderings in Germany; with Moonlight Walks on the Banks of the Elbe, the Danube, the Neckar, and the Rhine*

Wilkinson, G. (1975), *Turner's Colour Sketches 1820–34*

Wilton, A. (1982), *Turner Abroad*

Wilton, A. (1987), *Turner in his Time*

Zink, F. (1954), 'William Turner in Heilbronn am Neckar', *Zeitschrift für Kunstwissenschaft*, vol.8, no.3/4, pp.225–8

Catalogue

Abbreviations

B&J Martin Butlin and Evelyn Joll, *The Paintings of J.M.W. Turner*, 2 vols., revised ed. 1984

R W.G. Rawlinson, *The Engraved Work of J.M.W. Turner, R.A.*, 2 vols., 1908 and 1913

TB A.J. Finberg, *A Complete Inventory of the Drawings of the Turner Bequest*, 2 vols., 1909

W Andrew Wilton, *The Life and Work of J.M.W. Turner*, 1979 (catalogue of watercolours)

RA Exhibited at the Royal Academy

Catalogue Note

Unless otherwise stated, all works are by J.M.W. Turner.

All measurements are given in millimetres (followed by inches), height before width. Except where common English usage demands otherwise (e.g. Cologne, Copenhagen, Vienna), place names are generally given in their German form. French forms in use in Turner's day (e.g. Moselle, Trèves) have, however, been retained in the familiar titles of Turner's own sketchbooks and works. The watermarks recorded in the blue and grey papers were read by Peter Bower using a fibre-optic light source and are not visible under normal lighting conditions.

cat.no.110 (detail)

1 Turner's Copy of Alois Schreiber,
The Traveller's Guide down the Rhine
London, 1818

140 × 88 (5½ × 3½)
Inscribed in pencil inside the front cover: 'J M W Turner'
Private Collection
[Exhibited in London only]

This important and very detailed guide to the Rhine went through numerous editions in German, French and finally English during the period in which Turner explored the river and its tributaries. The first English edition was published too late for him to use it on his first Rhine tour, but he probably acquired it soon after publication, realising that he would be returning to its territories before long.

In preparation for his first Meuse–Mosel tour in 1824, Turner took copious notes on the Mosel between Trier and Coblenz from Schreiber's 'Third Excursion' (pp.173–95); he also made a sketch copy of the same stretch from one of Schreiber's maps, extending over three pages of his sketchbook (*Rivers Meuse and Moselle*, ff.6v–8r and 8v–9v) (see figs.16–17 on p.31). He was thus well equipped with necessary information about notable sights such as castles, galleries and antiquities and also on practical matters like distances and inns and the flying bridges and bends of the river itself.

2 Turner's Copy of Madame de Genlis,
Manuel du Voyageur, or, The Traveller's Pocket Companion; Consisting of Familiar Conversations in English and German
London, new edition [1829]

90 × 135 (3½ × 5¼)
Private Collection
[Exhibited in London only]

3 Turner's Copy of Dr F. Ahn, *Handbuch der englischen Umgangssprache*
Cologne, 1834

170 × 108 (6¾ × 4¼)
Private Collection
[Exhibited in London only]

Several of Turner's sketchbooks contain German, French, Dutch or Italian words and phrases he had copied out of books or obtained in the course of conversations

(see, e.g., p.51). German was the only language for which he decided it was necessary to buy a phrase book, and he in fact owned two, presumably buying Mme de Genlis's one in London and Dr Ahn's in Germany itself. The publisher of Genlis, Samuel Leigh of 18 Strand, London, published a large number of guidebooks and other aids to travel in the early nineteenth century, of which Turner owned Reichard's *Itinerary of Italy* (1818; now TB CCCLXVII) and Schreiber's *Traveller's Guide down the Rhine* (1818; cat.no.1). Both of these were bought and used by Turner soon after their publication (Reichard's book was used in 1819, Schreiber's in 1824). He probably bought Genlis's phrase book for use on his 1833 tour through Germany and Austria; it is scored with small lines in black ink across its fore-edge, in exactly the manner of three of the sketchbooks used on that tour (cat.nos.28–30). He could have bought Ahn's book on any of his tours from 1835 onwards.

Imaginary conversations between travellers and native inhabitants form the basis of both these books, that by Ahn also containing lists of words relating to particular themes (e.g. food and drink, clothing, trades and occupations) and many other lists of words or phrases under different classifications. Mme de Genlis devoted far more of her book to conversations, providing no independent vocabulary lists, but she usefully included a selection of sample letters and notes, both formal and informal, and an account of the many different coinages operating in the German states and their relative values in English money. There must have been many occasions when both books were invaluable to Turner, when he sought transport, accommodation, information about his surroundings or just a meal.

Both books contain a number of manuscript notes by Turner, sometimes in ink but mostly in pencil. These occur on the title-page of Genlis and in both books on the blank endpapers and in the margins of the text, proving that they were actually consulted by Turner from time to time. Sometimes his notes can be deciphered (e.g. 'Ve fel – (Combien – how much) Was costet' and 'Machen – faire (to make)', Genlis, inside back cover) but often they are illegible and have no apparent connection to the adjacent text. On p.31 of Ahn Turner practised writing a Gothic capital 'T', copying it from 'Trinken' nearby, which suggests that he was not over-familiar with Gothic printing. More revealing notes about his lifestyle are found on pp.32–3. On his travels through Germany he must constantly have been asked the first question of 'Gehen und Kommen' (Conversation 14): 'Wohin gehen Sie?',

'Whither are you going?' He made two attempts at 'Wohin' nearby and at the top of the opposite page he had two shots at 'spazieren', 'to walk', which is used in the printed text towards the bottom of p.33.

4 Turner's Copy of *Goethe's Theory of Colours; Translated from the German with Notes by Charles Lock Eastlake, R.A., F.R.S.*

London, 1840

230 × 160 (9 × 6¼)
Private Collection
[Exhibited in London only]

Johann Wolfgang von Goethe's *Farbenlehre* was first published in German in 1810 and its first English translation was that by Turner's close friend C.L. Eastlake, which appeared in 1840. Not surprisingly, it was published by the firm of John Murray who had recently launched their famous series of *Handbooks for Travellers* with volumes devoted to northern Germany (1836) and southern Germany (1837). They published many travel accounts, books on the fine arts and illustrated books; and both the Murray family and their circle were intensely interested in Germany. When Gustav Waagen, the Director of the Royal Gallery in Berlin, visited London in 1835, he was extremely gratified to discover how knowledgeable John Murray himself was with regard to Germany.

As well as practising as a painter and eventually becoming President of the Royal Academy (1850–65), Eastlake was, throughout his life, very concerned with the theory and history of painting. This was nourished by his long residence in Rome between 1816 and 1830 where he soon became acquainted with the Nazarenes, the German colony of artists who were seeking to revive the art of fresco painting. He studied their works and became aware of contemporary German interest in the art of the past and theories of art. He translated Goethe's *Farbenlehre* not because he believed in its conclusions but because he approved of its general experimental approach to its subject and wished to make German works on art better known in England.

The issues raised by Goethe's treatise and the numerous marginal comments scribbled by Turner in his copy lie well outside the remit of the present, topographically oriented, exhibition. Both have been lucidly discussed and the notes themselves transcribed by John Gage in his book *Colour in Turner* (1969, chap.11), and his article 'Turner's Annotated Books: "Goethe's Theory of Colours"' (*Turner Studies*, vol.4, no.2, 1984, pp.34–52) and the ideas of both Goethe and Turner are discussed in his *Colour and Culture* (1993). Goethe's book is exhibited here because it represents an aspect of Turner's interest in Germany that ran parallel to his topographical work. Shortly after Turner had read Goethe's book, of which he was decidedly critical, he composed his formal reply to it

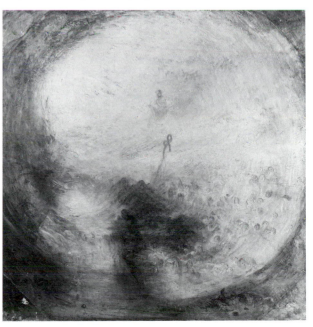

'Shade and Darkness – the Evening of the Deluge'
(Turner Bequest 47; B&J 404). Oil on canvas, RA 1843

'Light and Colour (Goethe's Theory) – the Morning after the Deluge – Moses Writing the Book of Genesis'
(Turner Bequest 48; B&J 405). Oil on canvas, RA 1843

in two oil paintings, 'Shade and Darkness – the Evening of the Deluge' and 'Light and Colour (Goethe's Theory) – the Morning after the Deluge – Moses Writing the Book of Genesis' (B&J 404–5, RA 1843). Sadly, these works were stolen in July 1994 whilst on loan from the Tate Gallery to the Schirn Kunsthalle in Frankfurt for *Goethe und die Kunst*, an exhibition focusing on the great Romantic writer and thinker (1749–1832) and his attitudes towards the visual arts.

5

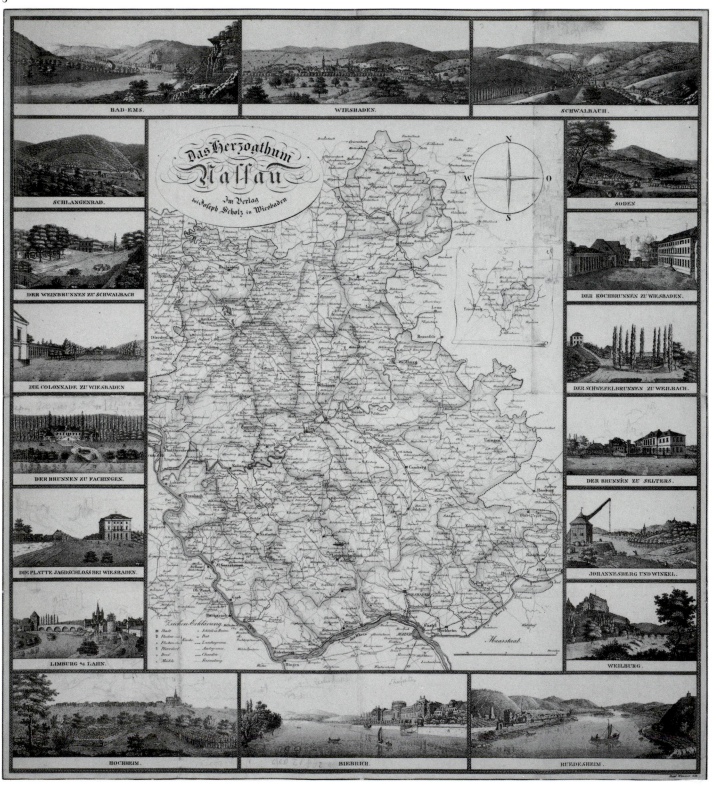

5 Turner's Map of the Duchy of Nassau:
Das Herzogthum Nassau

Engraved by Friedrich Wimmer, published by Joseph Scholz, Wiesbaden
585 × 533 (23 × 21)
Bearing many pencil sketches and calculations on both recto and verso and some underlining, etc., on place-names north of Eltville on the Rhine
TB CCCXLIV 425
D34920
[Exhibited in Germany only]

It is not known when Turner acquired this map though he could have done so when he visited Wiesbaden in 1839. On that occasion, he sketched the town and the nearby Sonnenburg (TB CCXC 63v, 64v–66v, 68v) but probably did not explore far afield. On a different tour he visited and made a few pencil sketches of Bad Ems on the river Lahn (TB CCXCI(a) 15v–16r, 21v–22r, 57v) as well as re-visiting the Sonnenburg and presumably Wiesbaden itself (ff.23r, 54r).

Turner's sketches do not necessarily relate to the scenery illustrated in the engravings next to them, or indeed to Nassau. He folded up the map and treated it as a sketching block, exactly like any other large piece of paper. If this is how he treated the map of the Mosel which Clarkson Stanfield lent him in 1839 (see pp.61–3), it is not surprising that Turner had to buy him a substitute!

Waterloo and Rhine sketchbook 1817

6 Six Sketches of the Rhine and the Rheingau

Pencil
Page size: 150 × 94 (5⅞ × 3¹¹⁄₁₆)
White wove paper
Watermarked: J WHATMAN/1816
Inscribed: 'Edrich'; 'Johannisberg'; 'Vines' (f.70v); 'Elfeldt'; 'Clouds' (f.71)
TB CLX ff.70 verso, 71
D12838, D12839

This sketchbook contains Turner's earliest sketches of Germany. He started using it in Belgium at the beginning of his 1817 tour, most notably at the Field of Waterloo, and he continued using it during his exploration of the Rhine between Cologne and Mainz. He arrived at Cologne on 18 August, spent a week going upstream, chiefly on foot, and then returned downstream to Cologne which he reached for the second time on 29 August. During this period he sketched incessantly, sometimes on a generous scale (see cat.no.7), sometimes (as here) on an incredibly minute one. Many of the sketches in this book were used as the basis for works in the series of fifty watercolour scenes executed immediately after the tour (cat.nos.8–18). Others were developed into watercolours of the Rhine well into the 1830s.

These six sketches, each of which extends right across ff.70v–71r, were drawn as Turner travelled by boat from Mainz back to Bingen along the very wide and peaceful stretch of the Rhine which is bordered on the north by the Rheingau. In the far distance he could glimpse churches and cranes such as those of Oestrich and Winkel, the castles at Hattenheim and Eltville, wooded islands in mid-river and hills covered with vines such as the slopes of the Johannisberg. He was surrounded by sky and water, the banks of the Rhine appearing as no more than a thin strip of land between them, so he divided up his sketchbook page in correspondingly strip-like fashion. As he approached Bingen and Rüdesheim, however, the hills began closing in on either side and the final sketch on these pages provided the basis for a scene of considerable drama (cat.no.16).

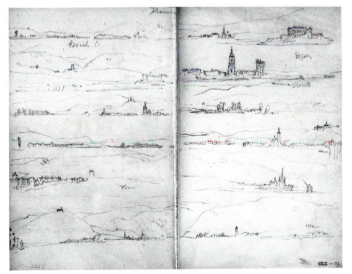

6

Rhine sketchbook 1817

7 The Riverside at St Goar and Burg Katz from the Forstbachtal

Pencil
Page size: 202 × 265 (7¹⁵⁄₁₆ × 10⁷⁄₁₆)
Contains two different white wove papers
Watermarked: J WHATMAN/1816 and J WHATMAN/1817
Inscribed: 'Two Boats lashed together making one'; 'Children fishing' (f.27v); 'W'; 'W' (i.e. Wood) (f.28r)
TB CLXI ff.27 verso, 28
D12932, D12933

Turner used this sketchbook alongside cat.no.6 to record the same or similar subjects in greater detail on its much larger pages. He did not start using it, however, until his travels had brought him to the Drachenfels south of Bonn on 20 August. Because of its size it was obviously less handy to use on his journeys, whether on foot or by boat, but it proved invaluable at the towns where he stayed overnight – Coblenz, St Goar and, at the end of his visit to the Rhine, Cologne. In each of these places Turner

drew immensely fine and detailed pencil studies, recording their notable buildings and prospects with infinite pains but the drawings played a surprisingly minor role when he came to paint his series of Rhine watercolours after his tour.

These two pages are almost certainly not in their true places in the sketchbook (see Powell 1991, p.58 n.36) but together they show the two small towns and three ruined castles which lie at the heart of every traveller's experiences of the Middle Rhine. In the sketch on f.27v Turner was standing on the riverbank at St Goar from where he could look up at Burg Rheinfels and down the river to Wellmich and Burg Maus. In that on f.28r he is on the opposite side of the Rhine and has walked up behind St Goarshausen, to the side of Burg Katz which looms massively against the sky. It was to savour Picturesque scenery such as this – with rugged cliffs and dramatic ruins towering over the windings of the great river itself – that artists and tourists flocked to the Rhine in Turner's day.

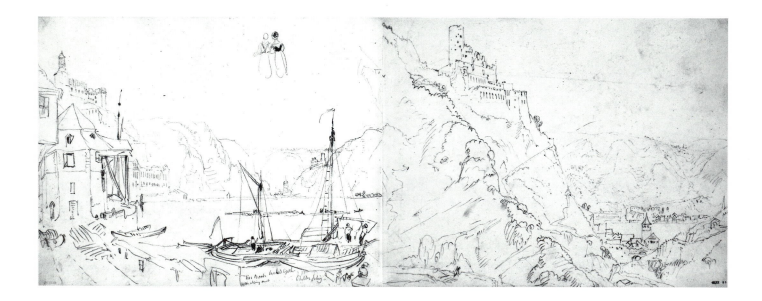

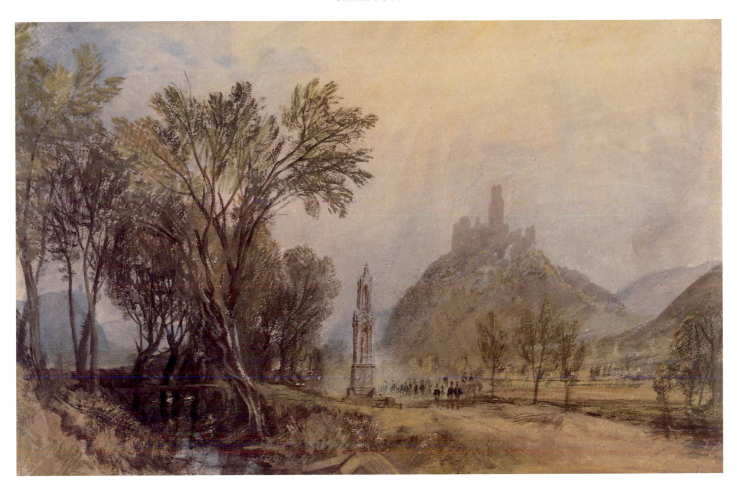

8 The Hochkreuz and the Godesburg 1817

Gouache and watercolour, with scratching out, on white paper
prepared with a grey wash
195 × 305 (7¹¹/₁₆ × 12)
Rheinisches Landesmuseum, Bonn
w 668

Soon after Turner reached England after his first Rhine tour, he painted a series of views depicting many of the most famous scenes between Mainz and Cologne. Fifty-one watercolours have traditionally been regarded as constituting this series, but there were more probably just fifty (see cat.no.17). These he sold immediately to his friend and patron Walter Fawkes at whose Yorkshire home, Farnley Hall, they all remained for over seventy years, unseen except by family and friends. The collection began to be dispersed in 1890, however, and the drawings are now widely scattered, very well known and generally regarded as one of the most important and beautiful series of Turner's career.

The spontaneity of execution, the limited range of colours employed, and the vitality and freshness of vision that are such striking features of 'The Hochkreuz and the Godesburg' are characteristic of the entire series and led, for a long while, to the supposition that Turner had actually painted all his scenes in the open air. This was not the case, however, for every scene can be matched with preliminary pencil sketches in Turner's sketchbooks. The coloured scenes may have been begun in his hotels in Germany but must have been largely executed after his return to England.

The Godesburg was the first ruined castle Turner saw as he walked along the west bank of the Rhine in August 1817. Leaving Bonn behind him, he walked southwards between the river and the fields and soon passed the Hochkreuz, the highly decorated medieval wayside cross shown in the foreground, while enjoying good views of the Godesburg itself which lies slightly west of the river. He stopped at frequent intervals to make small pencil sketches (TB CLX 28v–35v) and subsequently transformed two of these (ff.31v–32r and 32v–33r) into cat.no.8. With consummate mastery, he has placed the cross almost at the centre of his scene; allowed a tantalising tiny glimpse of the Drachenfels – one of the most celebrated crags on the Middle Rhine – through the tangle of tall trees on the

The Hochkreuz and Godesburg (TB CLX 31v–32r)

left; and devoted the whole of the right-hand half to a vaporous evocation of the Godesburg on its hill and a band of tiny harvesters trudging along the path beside their field.

The Hochkreuz still stands on the outskirts of Bonn today, hemmed in by houses, roads and railway tracks – a far cry from the scenery depicted by Turner. Happily, however, this version is merely a replica, while the original is safely housed in the Rheinisches Landesmuseum at Bonn, the owner since 1992 of Turner's watercolour itself.

The Drachenfels and Godesburg (TB CLX 32v–33r)

The Drachenfels (TB CLX 38v–39r)

9 The Drachenfels 1817

Gouache and watercolour over pencil, on white paper prepared with a grey wash
209 × 290 (8¼ × 11⅜)
Courtauld Institute Galleries, London (Spooner Bequest)
W 667
[Exhibited in Mannheim only]

The Drachenfels, or Dragon's Rock, is not, as might be supposed, the huge cliff on the left of Turner's scene; it actually hangs over the Rhine on the group of hills seen on the opposite shore, the Seven Hills or Siebengebirge. However, the road seen here, beneath Rolandsberg, part of the *route Napoléon* which Turner followed in 1817, affords several very fine prospects of it, enhanced by the inclusion of both banks of the Rhine. Perhaps not surprisingly, Turner drew a second scene showing the view from near here in his 1817 series and made use of a very similar composition to that of cat.no.9 when he came to portray the Drachenfels as an illustration to Byron in the early 1830s (see cat.nos.10, 26).

This is one of the most sketch-like of Turner's 1817 Rhine series, though it was itself based on a pencil sketch (TB CLX 38v–39r). Its apparent artlessness reflects the taste which fostered Turner's first travels on the Rhine and his earliest depictions of it. Picturesque scenery, with winding rivers, savage rocks, daunting cliffs, ruined castles and dangerous defiles, had become highly fashionable before the turn of the century, with Mrs Ann Radcliffe, the Revd William Gilpin and many others extolling scenery such as that of the Middle Rhine. The extempore quality of cat.no.9 suggests that the travellers in the carriage, and the painter himself, are delighted to gaze on such thrillingly Picturesque scenery but, ever-mindful of brigands and tumbling boulders, have no real inclination to linger.

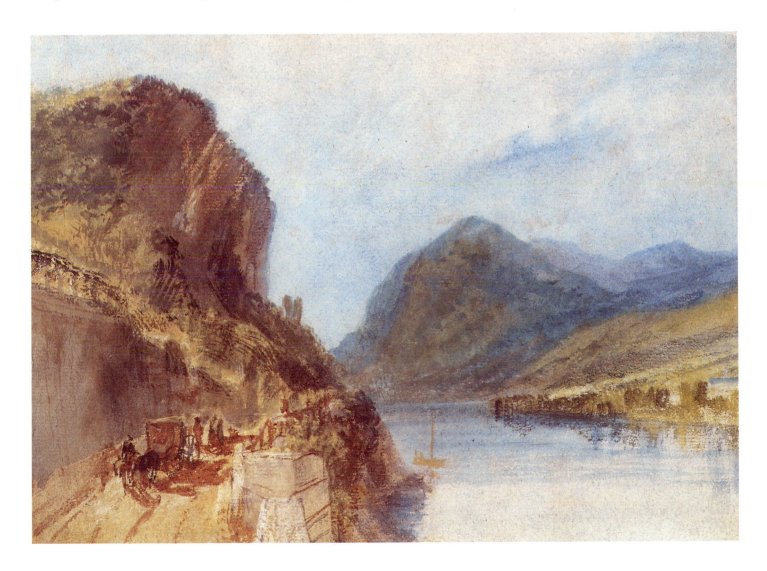

10 Rolandswerth, Nunnery and Drachenfels

1817

*Gouache and watercolour on white paper prepared
with a grey wash*
195 × 303 (7¹¹⁄₁₆ × 11¹⁵⁄₁₆)
Private Collection
W 666

The ingredients in this work are essentially the same as those in cat.no.9, but Turner's viewpoint is now slightly further upstream and past a slight curve in the river, so that a much more open view has been achieved. Partly as a result of this, the two works are very different. In place of the squareish format of cat.no.9, the present work has a more elongated one to suit the breadth of the river; the sombre palette and summary handling of cat.no.9 have been replaced by a lighter, gayer range of colours and passages of delicate painting, and the mood is serene compared to the anxious, brooding note of cat.no.9.

The contrasts between the two works are partly due to the fact that they were based on pencil sketches made under very different circumstances and on different days. The first was drawn during Turner's upstream walk, the second on his downstream voyage over a week later (TB CLX 83r). The wedge of shore at lower left was not, in fact, seen and recorded from his boat in mid-river; it was simply introduced to give balance to the watercolour.

The Rhine presented Turner with an immense variety of experiences and challenges: hills and buildings of every description, huge and ever-changing expanses of sky and water. His own responses were equally diverse.

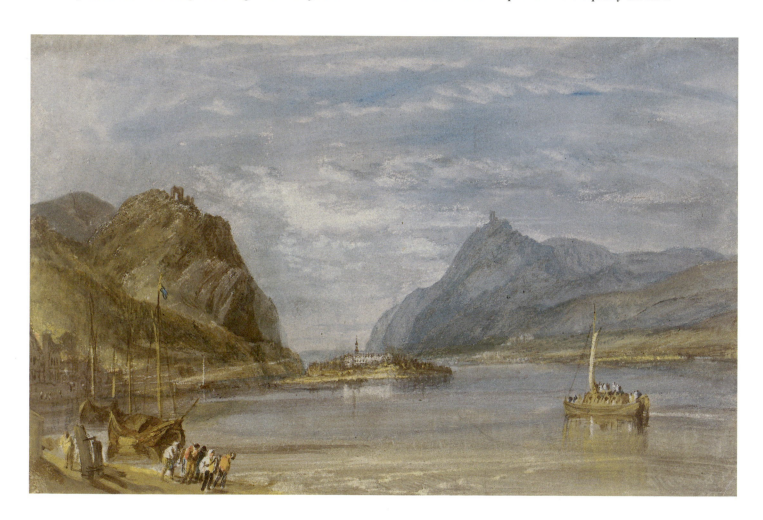

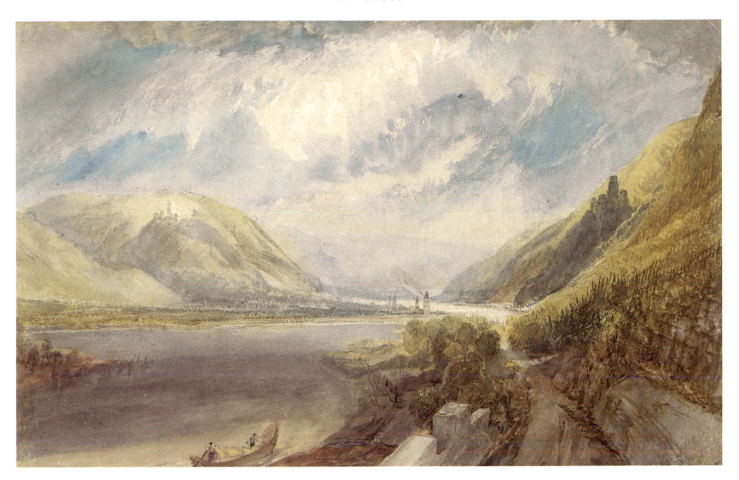

11 Junction of the Lahn 1817

Gouache and watercolour on white paper prepared
with a grey wash
196 × 314 (7¾ × 12⅜)
Private Collection, courtesy of Agnew's
W 655

As Turner walked up the Rhine in August 1817 he
stopped to sketch this majestic prospect in his large *Rhine*
sketchbook (TB CLXI 12v–13r) and it was one of the very
few sketches in that book to be developed into a coloured
drawing. Nothing could convey better the experience of
his Rhine-side walk, with breathtaking views constantly
unfurling themselves beneath the broad sky and a succes-
sion of castles and villages beckoning him on. Here Burg
Lahneck on the left guards the mouth of the Lahn, St
John's church at Niederlahnstein is superbly situated at
the water's edge, and the castle of Stolzenfels stands
darkly against the hillside.

The junction of the Lahn (TB CLXI 13r)

12 St Goarshausen and Katz Castle 1817

Gouache and watercolour, with scratching out, on white
paper prepared with a grey wash
195 × 307 (7⅝ × 12⅛)
*Courtauld Institute Galleries, London (Stephen Courtauld
Bequest)*
W 645
[Exhibited in London only]

This scene is dominated by the medieval castle of
Neukatzenelnbogen – universally known as 'Burg Katz' –
which was built by the same family as Burg Rheinfels on
the opposite bank (see cat.no.7), thereby achieving com-
plete control of the valley in the fourteenth century. By
Turner's day it was a ruin, like virtually all the castles on
this stretch of the Rhine. However, it had not been devas-
tated in some long-distant struggle, but as recently as
1806 when it was blown up by the troops of Napoleon.

There were many such modern ruins in the Rhineland at
the time of Turner's first visit, so that his enjoyment of
fashionably Picturesque views must constantly have been
overshadowed by the consciousness of recent wars.

Cat.no.12 is notable for its richness of colouring in
both the warm, light areas and the cooler, darker ones.
The surface of the paper is more intensively worked than
that of many of the drawings in this series, so that the
winding course of the Rhine and the monumentality of its
separate crags and eminences are exceptionally well
realised. Turner's viewpoint is almost opposite the most
famous of these, the Lorelei, which lies just beyond the
right-hand edge of the paper; the pencil sketch on which
it is based shares a page with a sketch of the Lorelei itself
(TB CLX 75v). Another work in the series (W 676) has an
almost identical composition and may be a trial run for
cat.no.12.

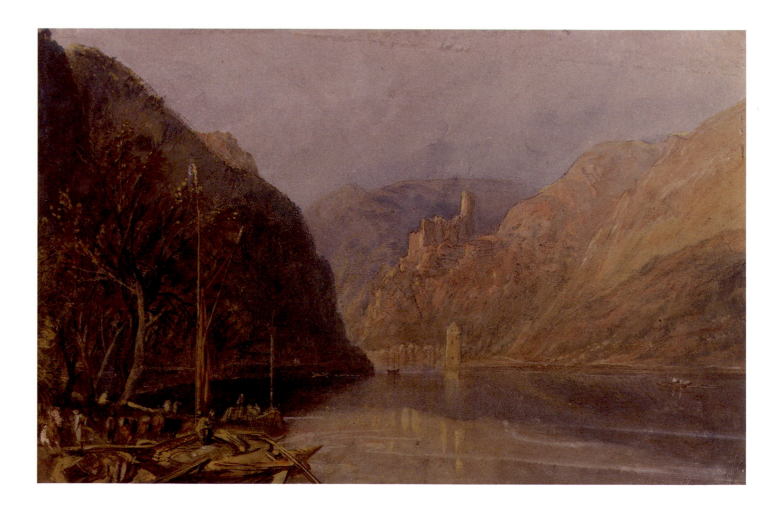

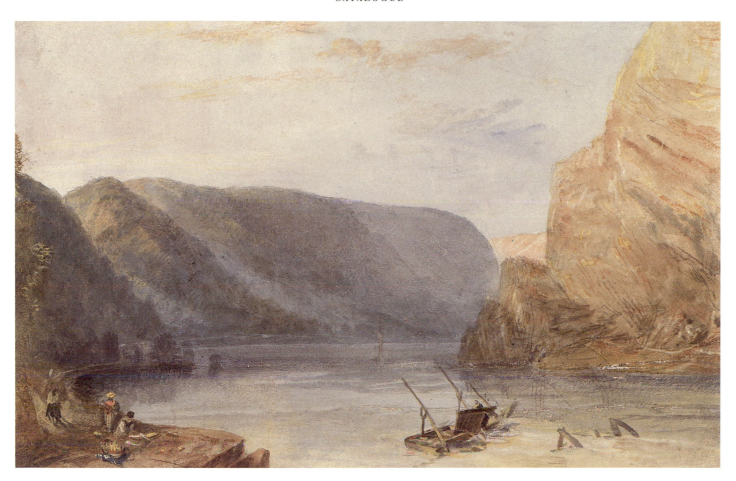

13 The Lorelei 1817

Gouache and watercolour on white paper prepared
with a grey wash
191 × 302 (7½ × 11⅞)
Private Collection
w 685

The Lorelei, seen here on the right, is the most famous
cliff on the Rhine between Mainz and Cologne. It rises
dramatically from the river inside a bend that was excep-
tionally dangerous in Turner's day, with hidden rocks,
whirlpools and currents, and still has to be navigated with
caution today. It is the focal point of a legend about a siren
who lures sailors to their deaths which was actually
invented by Clemens von Brentano in 1802 and inspired a
famous poem by Heinrich Heine. Late eighteenth- and
early nineteenth-century tourists in search of the Pic-
turesque were here entertained by the blowing of horns
and the firing of pistols into the air to create echoes. This
induced a pleasant feeling of terror and the satisfaction of
sampling the Sublime.

Turner painted seven views of the Lorelei in this 1817
Rhine series, showing it from very diverse viewpoints.
Five of these are known today but the whereabouts of two
are unknown (see Powell 1991, under cat.no.8). The view-
point of cat.no.13 is looking downstream from just south
of the Lorelei and only a short way upstream from the
viewpoint of cat.no.12. To give a telling impression of its
size, Turner only shows part of the Lorelei and the viewer
is left to imagine the immensity and grandeur of what is
not actually shown. This was a pictorial stratagem he
often used, not only for cliffs and mountains but also for
such great buildings as the Colosseum in Rome.

14 The Pfalz on the Rhine 1817

Gouache and watercolour on white paper prepared
with a grey wash
190 × 305 (7½ × 12)
Private Collection, courtesy of Agnew's
W 643

This is a scene of great charm and serenity in which viewers can instantly identify themselves with the figures in the tiny boat in the foreground. The rounded hills which enclose the scene have no menace, the sky no threat of storm, and Turner's downstream voyage may be imagined as free from all anxiety. The Pfalz on its island, the town of Kaub and the castle of Gutenfels will all soon be passed and he will reach Oberwesel and the castle of Schönburg, like the tiny boats in the middle distance.

For all its effortless appearance, this scene is actually the result of careful planning; Turner combined the ingredients of several small pencil sketches made on his voyage, including a close-up drawing of the Pfalz itself and more generalised ones of the entire scene (TB CLX 73v–74r, 62r).

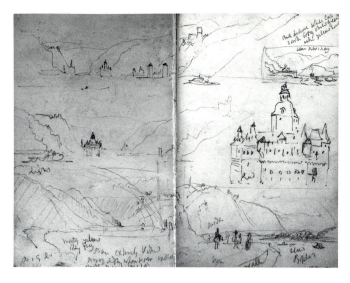

The Pfalz, Kaub and Gutenfels; Osterspay and Feltzen
(TB CLX 73v–74r)

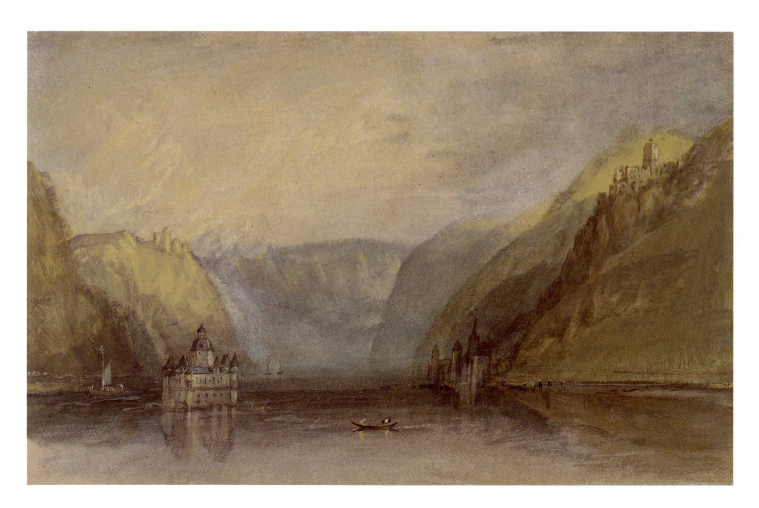

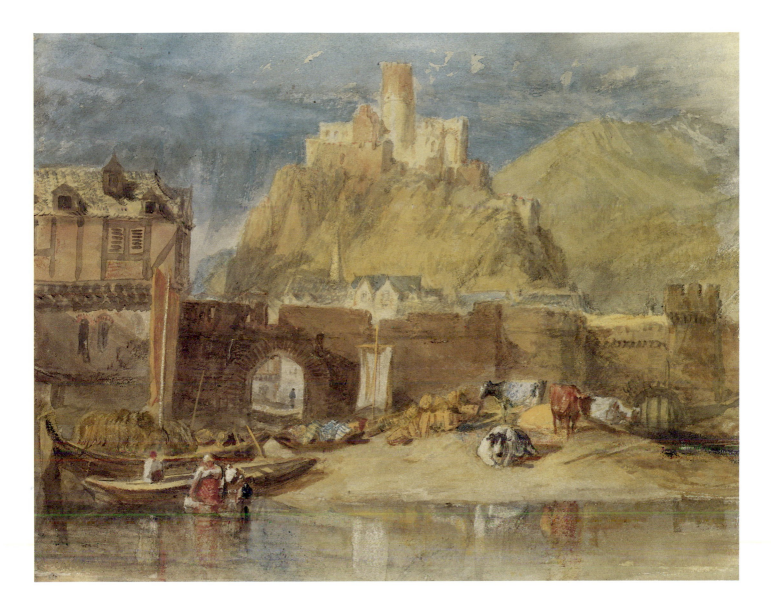

15 Burg Fürstenberg 1817

Gouache and watercolour, with scratching out, on white
paper prepared with a grey wash
235 × 311 (9¼ × 12¼)
Manchester City Art Galleries
W 641
[Exhibited in London only]

Cat.no.15 is one of several drawings in this series to depict
a place which had no particular claim to fame but simply
caught Turner's eye as being worthy of a sketch or two
and then lingered on in his memory. The scene is based
on a very small but detailed sketch in the *Waterloo and
Rhine* sketchbook (TB CLX 64r) which it follows very
closely even down to the cows reclining on the riverbank.

Burg Fürstenberg, seen in the background, dates from
the thirteenth century when it was built as a toll-castle
and to protect the lands of the Archbishop of Cologne.
Like so many other castles on this part of the Rhine, it
was sacked by French troops in 1689, during the wars
against Louis XIV. It was never rebuilt. In the fore-
ground is the village of Rheindiebach with its half-
timbered houses and strong defensive walls.

16 Rüdesheim, Looking towards the Binger Loch 1817

Gouache and watercolour, with scratching out, on white
paper prepared with a grey wash
214 × 347 (8⁷/₁₆ × 13¹¹/₁₆)
National Museum and Gallery, Cardiff
W 639

Cat.no.16 shows the view looking downstream towards the start of the Rhine gorge at Bingen from the broader, calmer part of the river between Bingen and Mainz. Bingen itself is in the distance on the left, overshadowed by Burg Klopp on its hill. In the centre, an isolated white tower on an island site, is the Mäuseturm, where Bishop Hatto was reputedly devoured by rats in the tenth century (see Powell 1991, p.104). On the right lies Rüdesheim, its long line of buildings reflected in the river beneath a steep hillside which Turner has evoked by particularly vigorous scratching out.

The Binger Loch with its currents and rocks was notoriously difficult to navigate in Turner's day, vessels having to keep within a narrow channel to the north of the Mäuseturm (see cat.no.113). Turner's drawing well suggests the dangers ahead. In the placid waters of the foreground, men and boats are at rest beneath motionless tall sails and a limp flag of Prussian blue and white, but over the distant inky gorge loom threatening clouds and the prospect of wind and storm.

Despite its expansive handling, this drawing is based on some of the smallest of Turner's pencil sketches of 1817: the lowest view on the pages exhibited here as cat.no.6 and the tiny views of Rüdesheim on the following pages (TB CLX 71v–72r).

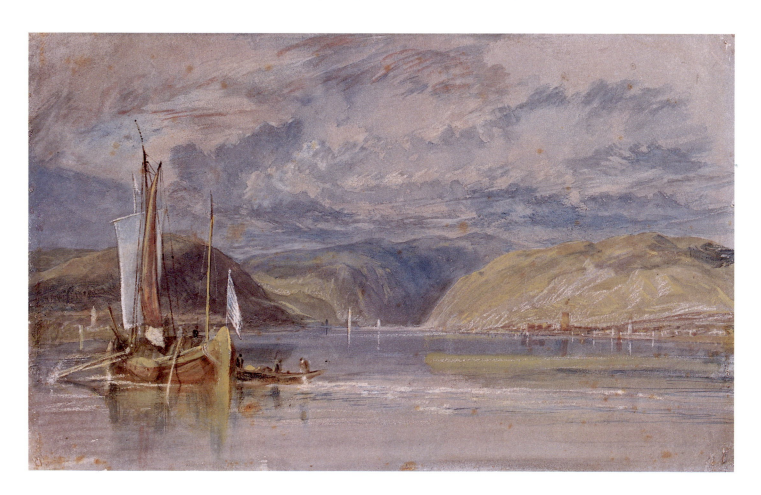

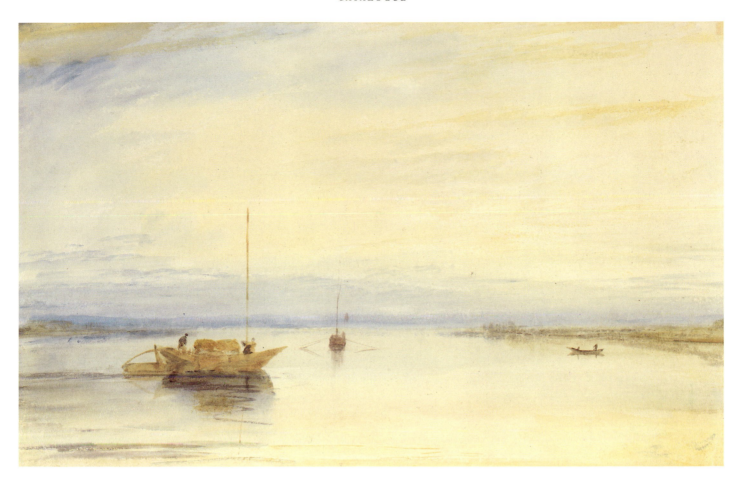

17 Mainz 1817

Watercolour
210 × 340 (8¾ × 13¾)
Private Collection
W 637
[Exhibited in London only]

This view of the Rhine, looking eastwards towards Mainz, is by far the simplest and most peaceful scene in Turner's 1817 series, wonderfully evoking the character of this particular broad stretch of the river. Its colouring, especially the juxtapositions of colours in the left-hand half, is similar to that found in others of the series, but its feeling of space and rendering of light look forward to Turner's watercolours of Venice on white paper painted just two years later. In Italy, in 1819, Turner varied his watercolour practice, using gouache on grey-washed paper to depict the ruins of Rome but pure watercolour on white paper for his evocations of Venice and Naples. For Germany, in 1817, he favoured grey-washed paper as a background for the severe beauties of the Rhine in its most spectacular stretches, but quite naturally regarded this as inappropriate for cat.no.17. At this point, the Rhine is so wide and peaceful that it often resembles a huge lake

'Mainz and Kastel' (w 678). Watercolour, *c.*1820. *Private Collection*

rather than a river, with little in sight save water and sky.

There is, indeed, so little topographical material in Turner's scene that, were it not for its traditional title and its inclusion among the group of Rhine views sold from the Fawkes collection in 1890, there might be some difficulty in recognising its subject matter. However, it can be elucidated by reference to a tiny pencil sketch (TB CLX 67v–68r) and the larger and more complex watercolour 'Mainz and Kastel' (w 678). This has traditionally been

regarded as one of the 1817 series but, as Evelyn Joll has suggested, should really be seen as one of the slightly more elaborate scenes painted a couple of years later (see, e.g., *Agnew's 1982–1992*, 1992, p.162). Just as the second versions of 'The Marxburg' and 'Biebrich Palace' (W 691–2) have many more narrative incidents and a much greater pictorial sophistication than their 1817 pre-decessors, so too 'Mainz and Kastel' develops the motifs of cat.no.17 and, in so doing, renders its topography much clearer. Mainz lies beyond the spit of land to the right, with the twin towers of St Peter's church and the dome of the cathedral just distinguishable to the right of the group of trees and to the right of the boat respectively. Across the centre of the scene a series of minute gradations of light and shade indicates the bridge of forty boats which linked Mainz with Kastel on the opposite bank.

If 'Mainz and Kastel' is redated to *c.*1819–20, the Rhine series of 1817 can be seen as consisting of fifty drawings, a far more likely number than the traditional total of fifty-one.

18 Mainz 1817

Gouache and watercolour, with scratching out, on white paper prepared with a grey wash
190 × 311 (7½ × 12¼)
Landesmuseum Mainz. Graphische Sammlung
W 636
[Exhibited in London and Mannheim only]

Mainz was the furthest city on the Rhine visited by Turner in 1817 and his most distant destination on that tour. He spent seven days travelling up the river from Cologne, chiefly on foot, and recording its scenery in numerous pencil sketches. He then stayed two nights in Mainz (25 and 26 August) before returning northwards along the identical route as far as Liège and concluding his tour with a visit to Holland. Mainz was the natural goal for a traveller in search of the beauties of the Rhine at this date, just as Cologne was the natural starting-point. Turner did not explore further afield on his first visit to the Rhineland, contenting himself instead with studying its most renowned sights very intently.

Cat.no.18 shows Mainz at its most spectacular, looking downstream to a fine array of buildings of differing dates, styles and functions and in varying conditions. Between

18

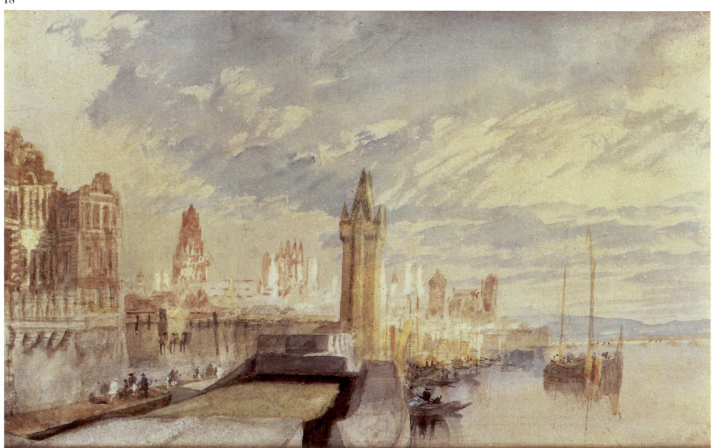

the grand gabled palace on the left and the severely defensive Holzturm at the centre can be seen the huge cathedral of red sandstone, its ornate west dome contrasting strongly with the spikey outline of its eastern counterpart flanked by two white towers. The cathedral had suffered heavy damage during the Napoleonic invasions of the 1790s and subsequent occupation and it was not until 1828 that the east dome was finally rebuilt.

Turner's scene is based on a pencil sketch (TB CLX 68v–69r) which provided him with all his architectural ingredients. Here, as in so many other sketches, his view was too broad for his page opening, so that addenda appear in the sky on both left and right. The buildings of Mainz are realised in cat.no.18 in a narrow but appropriate range of warm colours, enlivened by magical contrasts of black, grey and white. The sky and distant hills of the Rheingau are indicated in the simplest possible manner with very thin washes of watercolour. These stop well short of most of the buildings on the left but cut right across the Holzturm and the churches in the distance, giving this otherwise very serene scene a great sense of liveliness.

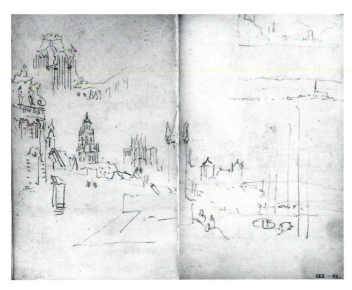

Mainz (TB CLX 68v–69r)

J.C. ALLEN AFTER J.M.W. TURNER

19 Ehrenbreitstein, during the Demolition of the Fortress in 1817, from the Quay at Coblentz 1824

Line engraving on copper, engraver's proof (b)
189 × 289 (7⅜ × 11⅜)
T06067
R 202
[Exhibited in Germany only]

In February 1819 Turner signed an agreement with the publisher John Murray, the printseller W.B. Cooke and the engraver J.C. Allen to produce a series of thirty-six views for engraving in a volume devoted to the Rhine between Mainz and Cologne. He began work on these watercolours and had completed at least three before the project came to an abrupt end, due to the appearance of a rival book, *A Picturesque Tour along the Rhine, from Mentz to Cologne* by a German nobleman, Baron Johann von Gerning. This was illustrated with twenty-four engravings, mostly by Thomas Sutherland after drawings by C.G. Schütz (see fig.13, p.28), and it was published from October 1819 to March 1820 by Rudolph Ackermann. After Turner's Rhine project had been abandoned, J.C. Allen engraved just the one scene from it, this view of Ehrenbreitstein, as a large single plate, presumably so that the work already done would not be entirely wasted.

All Turner's scenes for this project were very similar in composition to those of the 1817 series bought by Walter Fawkes (see, e.g., Powell 1991, cat.no.14). That of Ehrenbreitstein (w 687) was close to 'Coblenz: the Quay' (w 658), both being based on the same pencil sketches. It shows the view from the landing-stage at Coblenz, looking across the Rhine to the fortress of Ehrenbreitstein – a view that Turner was to sketch many times over the next twenty-five years but never with precisely the same ingredients as here. The Napoleonic armies had inflicted severe damage on Ehrenbreitstein which they at last succeeded in capturing in 1799 after five years of repeated sieges. With the return of peace in 1815 the Prussians had begun demolishing it so that it could be rebuilt on an even grander and stronger scale to withstand any further aggression on the part of France. The new fortress was completed in the early 1830s, after fifteen years of work at a cost that has been estimated as equivalent, in today's terms, to around DM 600 million. By the time of Turner's celebrated late visions of the fortress (cat.nos.115–21), it had 400 pieces of heavy ordnance on its ramparts, cisterns with enough fresh water for a three-year siege,

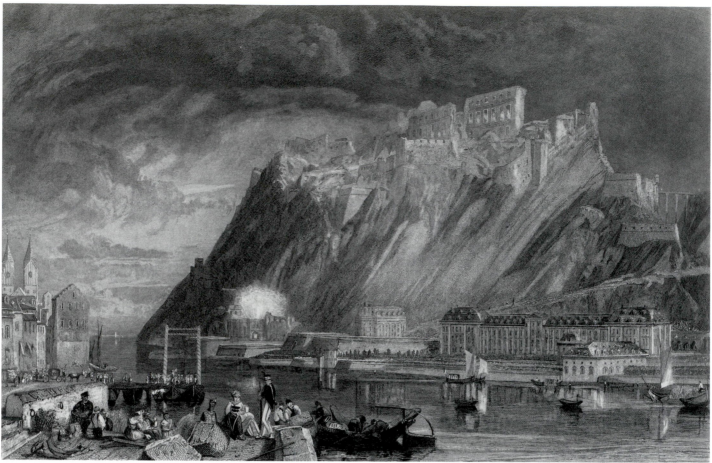

19

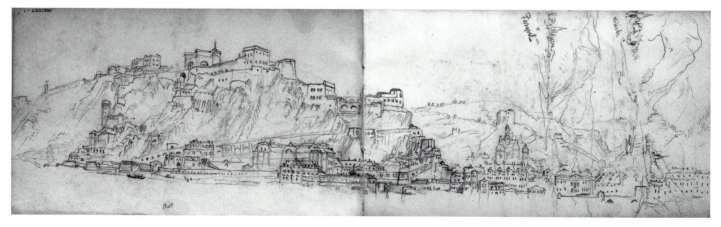

Ehrenbreitstein, after its rebuilding
(TB CCLXXXIX 6v–7r), 1839

stores with sufficient provisions to feed 8,000 men for ten years and it was estimated as capable of housing an army of 100,000. Meanwhile, the flying bridge in the left foreground – made conspicuous by its striped poles, just like the warning signs on the roads of the twentieth century – had been replaced by a bridge of boats in 1819.

In October 1828 a tiny replica of this scene (2¾ × 4¼ inches) was published in one of the annuals, the *Literary Souvenir* (R 317a). It was the work of John Pye who was later to produce the largest and most famous engraving of Ehrenbreitstein (see cat.no.110).

ARTHUR WILLMORE AFTER J.M.W. TURNER

20 Cologne from the River 1859

Line engraving on steel
190 × 265 (7½ × 10⁷⁄₁₆)
T05195
R 712
[Exhibited in Germany only]

This plate was published eight years after Turner's death in *The Turner Gallery*, a series of sixty engravings after some of his best-known works, largely executed by engravers who had earlier worked under Turner himself. It shows a very popular view of Cologne from the Rhine which was sketched by Turner in 1817; worked up into a watercolour in the same year (w 670, recently rediscovered after being untraced for many years); then developed further in 1820 as watercolours for Thomas Tomkinson (w 690) and James Rivington Wheeler (w 689a). In 1824 it was engraved on a large scale by Edward Goodall (R 203; Powell 1991, cat.no.21).

Willmore's engraving follows Goodall's closely, but is much smaller. It nevertheless conveys well both Turner's composition and his details. The view shows the Bayenturm in the left foreground; beyond it is seen the unfinished cathedral, Great St Martin's church and St Cunibert's. Cat.no.20 also testifies to the success of Turner's earlier scene with the public, for it was the only subject in *The Turner Gallery* not derived from an oil painting.

Arthur Willmore (1814–88) does not appear ever to have worked for Turner himself. He probably contributed to *The Turner Gallery* thanks to the influence of his elder brother, the notable James Tibbetts Willmore (1800–63), who had enjoyed an excellent relationship with Turner and engraved some of his finest scenes including 'Oberwesel' (cat.no.108).

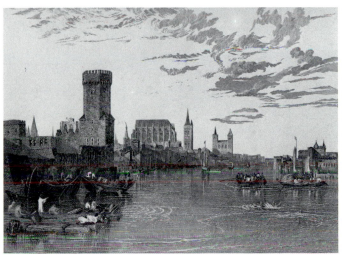

20

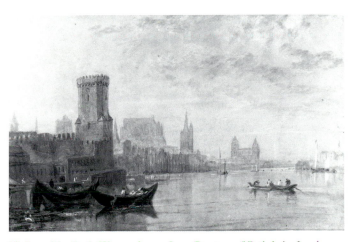

'Cologne' (w 670). Watercolour, 1817. *Courtesy of Sotheby's, London*

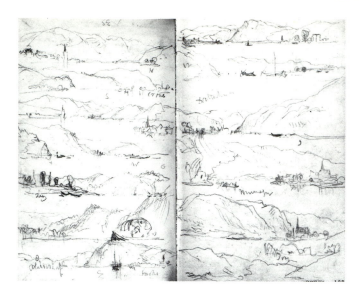

Rivers Meuse and Moselle sketchbook 1824

21 Sixteen Sketches of the Mosel between Ensch and Dhron

Pencil
Page size: 118 × 78 (4⅝ × 3¹⁄₁₆)
Lightweight white wove writing paper
Watermarked: SMITH & ALLNUTT / 1822
Inscribed: 'SE'; 'N'; 'S'; 'Erths' (i.e. Ensch); 'W'; 'Ferry';
'Klukserhof' (i.e. Klusserath); 'Smoke' (f.101v); 'R'
(? Rock); 'Drettenh' (i.e. Trittenheim); 'Misty'; 'Neumagen';
'Tron' (i.e. Dhron) (f.102r)
TB CCXVI ff.101 verso, 102
D19751, D19752

This small fat sketchbook was used throughout Turner's summer tour of 1824 on which he explored the Meuse between Liège and Verdun and the Mosel between Trier and Coblenz for the first time. Three other books were used during the tour (*Huy and Dinant*, TB CCXVII; *Trèves and Rhine*, TB CCXVIII, cat.no.22; *Moselle (or Rhine)*, TB CCXIX) but, even if all those had perished, this one would provide a comprehensive picture of the tour from 10 August through to 15 September. It contains Turner's preparatory notes and sketchmaps, his own brief notes of his itinerary with dates, minute sketches of virtually everywhere he visited and the vital clue that establishes beyond doubt the year of the tour: the sketches on which he based his oil painting of Dieppe, exhibited in 1825.

In the part of this sketchbook devoted to the Mosel Turner usually crammed as many sketches as possible on each page, just as he had done on the Rhine in 1817 (see cat.no.6). Eager to miss none of the delights of the river, he turned his head this way and that, recording upstream and downstream views, minute by minute. Despite their tiny size, the sketches on ff.101v–102r are full of precise information: the shapes of the hills are carefully modelled in fine pencil drawing and the minuscule churches are given dark or light spires as appropriate. A ferry is noted, as are mist and smoke effects and villages are sometimes named. Most fascinating of all, Turner has regularly taken compass bearings, recording (on f.101v) views to the south-east, north, south and west.

The sketches were drawn on 29 August, Turner's first day on the Mosel, during which he travelled from Trier as far as Neumagen. This stretch of the river does not have the succession of ruined castles which characterise its valley north of Bernkastel but it does have very spectacular whiplash bends and it may well have been these that stimulated Turner's use of the compass.

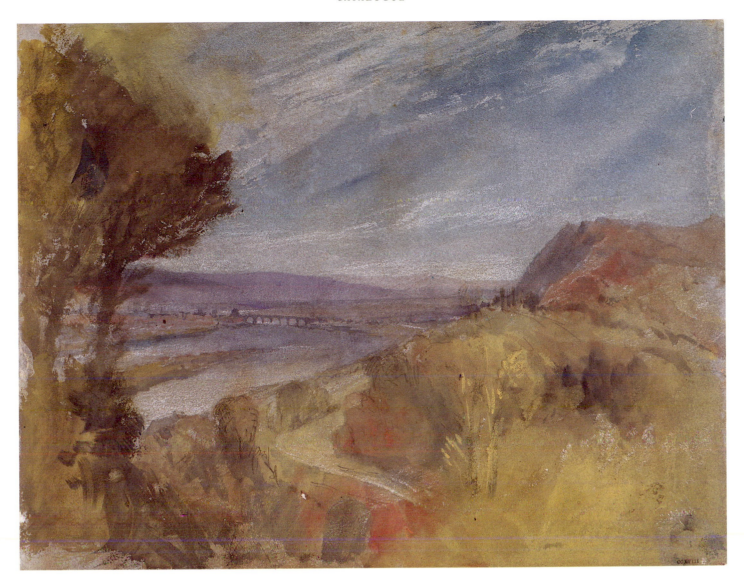

Trèves and Rhine sketchbook 1824

22 Trier from Pallien

Pencil, watercolour, gouache and chalk
Page size: 220 × 291 (8¹¹⁄₁₆ × 11⁷⁄₁₆)
White wove drawing paper prepared with a grey wash
Watermarked: ghost watermarks present on some pages,
J WHATMAN/TURKEY MILLS/1823
TB CCXVIII f.10
D20148

This sketchbook and the second one used along the Mosel in 1824 (TB CCXIX, named *Moselle (or Rhine)* in the *Inventory* of the Turner Bequest but actually used for drawings between Bernkastel and Beilstein) were the first books with soft covers that Turner took with him on a foreign tour. Whereas in cat.no.21 he made many tiny pencil sketches on each page, recording every detail of the scenery as he travelled past it, in these two books with larger pages of horizontal format he was able to make more composed and careful sketches, occupying complete pages, at many of the towns and villages at which he stopped. Their soft covers meant that they were light in weight and could easily be rolled up and carried in his pockets.

Both books contain the same type of paper, a white Whatman one, prepared with a grey wash. This has sometimes marked the facing page, showing that the tinting was done by Turner himself after he had bought the books. The grey wash is variable in tone, some pages in TB CCXIX being almost too dark to show off Turner's pencil drawings, while the lighter pages in the *Trèves and Rhine* sketchbook were an excellent base for both pencil and coloured sketches. The coloured drawings on these pages show a pronounced continuity with the Rhine drawings of 1817 (cat.nos.8–18).

In 1824 Turner stayed two nights in Trier, 27–8 and 28–9 August. He was thus able to follow the recommendation in contemporary guidebooks to cross the Mosel to the village of Pallien and admire the city with the evening light upon it. He evidently savoured this experience, for it inspired two watercolour sketches in this sketchbook (ff.8, 10) and he returned to Pallien on his second Mosel tour of 1839 (see cat.no.42). However, cat.no.22 celebrates Trier and its landscape setting in a very personal way. Turner depicts the city and its long Roman bridge at the distant centre of his drawing, encircled by vigorous trees and bushes, clouds that race across the sky, and warm red cliffs of sandstone, all of which are painted with great liveliness and gusto as though the natural world were Turner's true subject. Amid this scene of perennial change and movement, reposes Trier, seemingly unaltered by the passage of some two thousand years.

23 Bernkastel on the Mosel *c*.1830

Pencil, watercolour and gouache on white paper prepared with a grey wash
290 × 420 (11⅞ × 16⅝)
Stadt Bernkastel-Kues
W 1378a

This work was painted after Turner's first visit to the Mosel in 1824 and can be related to some of the pencil sketches he drew on that tour (TB CCXVI 104v–106r; TB CCXIX 15r–21r), of which those in the last group were drawn on paper prepared with a grey wash like cat.no.23 itself. However, it cannot have been painted until around 1830, since it includes the vivid green which he briefly favoured for the costumes of his foreground figures in the very early 1830s (compare 'Margate, Kent', W 839, 1830–1; 'Flint Castle, North Wales', W 868, *c*.1834; 'Marly', W 1047, *c*.1831).

Bernkastel with the castle of Landshut is seen from the opposite shore, with Kues on the right. There is a great deal of activity on the Mosel: the flying bridge, well laden

23

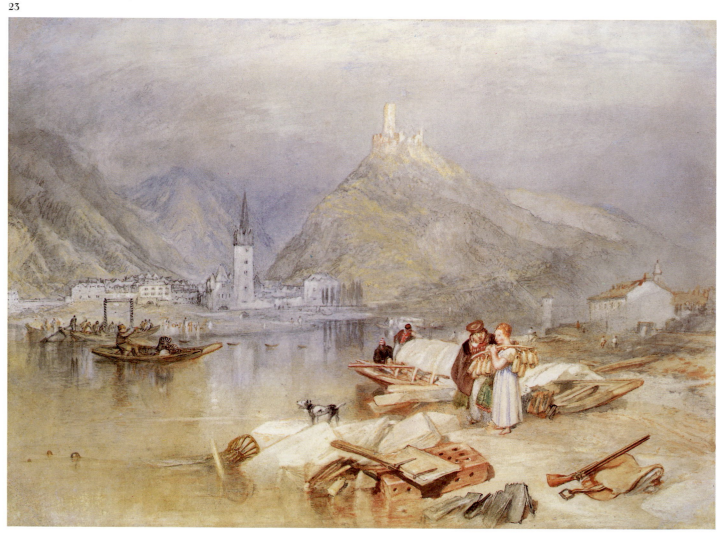

with passengers, is guided by its boatman and a stout, solitary man occupies a separate boat, watched by a dog who barks on the right-hand shore. Here two lounging boatmen and a bucolic-looking couple provide a note of low life, in the Dutch style, which was frequently adopted by Turner from the work of David Teniers the Younger and others for his rustic and marine subjects. There is thus a nicely gauged contrast between the ancient buildings in the background, depicted in an elevated, rather refined style, and the down-to-earth reality of life on the river bank. However, the girl's burden of bottles would not have contained the wine for which this area is famous. Such bottles were, in fact, used to carry water from a nearby spring.

Turner's work around 1830 includes many scenes that are similar to this in their size, style and pictorial and narrative concerns, even down to the guns, rudders, dogs, fishing baskets and other staffage in the foreground (compare, e.g., the rudder in 'Nottingham', w 850, and the gun in 'Castle Upnor, Kent', w 847). None of these, however, has a German theme. They are the hundred or so scenes executed for the engraving project of *Picturesque Views in England and Wales* between 1825 and 1838 and the three Italian ones produced *c.*1827–8 for the intended sequel, the *Picturesque Views in Italy* volume which never came to fruition (w 785–885; 726–31; see E. Shanes, *Turner's Picturesque Views in England and Wales 1825–1838*, 1979, passim, and, for the Italian ones, Powell 1987, pp.126–31). 'Bernkastel on the Mosel' stands alone as a German subject and was perhaps made as a sample for a printseller or publisher, perhaps for Charles Heath himself before he and Turner parted company following the commercial failure of the *England and Wales* series. Like those scenes and the Italian ones, it is full of specific details and human incidents which were essential in an engraved scene. These render it quite different from all Turner's other Mosel watercolours and gouaches (cat.nos.42–62, 67–81). It is sad that it never found its way into the hands of an engraver or those of an editor of an annual or anthology. Mary Shelley could have written a fine short story to accompany it, as she did in the case of Turner's 'Lake Albano' in 1828 when this was published in the *Keepsake for 1829* instead of in the *Picturesque Views in Italy*. However, her visit to the Mosel did not take place until 1840, by which time Heath was financially ruined and the entire stock of the *England and Wales*, together with the copper-plates, had been auctioned.

24 The Castellated Rhine *c.*1832

Watercolour
Vignette 165 × 211 (6½ × 8⁵⁄₁₆)
Beit Collection
W 1235

In the early 1830s the firm of John Murray published a 'pocket' edition of the *Life and Works* of Lord Byron who had died in Greece in 1824. Each of the seventeen volumes contained two vignette engravings – a frontispiece and one on the title page. Of the total of thirty-four scenes Turner was responsible for exactly half (w 1219–35), the other seventeen watercolours being supplied by Clarkson Stanfield, J.D. Harding, William Westall, W. Purser and G. Cattermole.

'The Castellated Rhine' was engraved in 1833 and appeared as the title-page vignette in the final volume (R 431). It takes its name from a line in Byron's comic masterpiece *Don Juan* which, as it happened, occurred near the end of volume XVI rather than in volume XVII. Don Juan's amorous adventures have now brought him right across Europe from his native Spain to Poland and Prussia:

> And thence through Berlin, Dresden, and the like,
> Until he reach'd the castellated Rhine:–
> Ye glorious Gothic scenes! how much ye strike
> All phantasies, not even excepting mine!
> A grey wall, a green ruin, rusty pike,
> Make my soul pass the equinoctial line
> Between the present and past worlds, and hover
> Upon their airy confine, half-seas-over.
>
> But Juan posted on through Mannheim, Bonn,
> Which Drachenfels frowns over like a spectre
> Of the good feudal times for ever gone,
> On which I have not time just now to lecture.
>
> (x: lxi–lxii)

Some of Turner's Byron scenes, such as his 'Bacharach' (w 1222), were directly based on his own sketches (see Powell 1991, cat.no.25); some were based on the sketches of other artists, even when Turner himself was familiar with the sight depicted (see Piggott 1993, pp.44–9). Unlike many of the other vignettes, 'The Castellated Rhine' is not a portrait of any particular place on the river but a distillation of its scenery. It includes elements taken from Kaub, Oberwesel and elsewhere along its most celebrated stretch between Mainz and Cologne (the Pfalz can be seen in the distance). Whereas the mood of his vignette of 'Cologne' (cat.no.25), seems to be delib-

erately directed towards the jesting tone of *Don Juan*, that of 'The Castellated Rhine' is quieter and more serious. It is, in fact, closer to the brooding, contemplative mood of *Childe Harold's Pilgrimage*, canto III, which epitomised the 'Romantic Rhine' for so many nineteenth-century travellers.

In 1833 the art critic Mrs Anna Jameson, admiring Julius Schnorr von Carolsfeld's new *Nibelungen* frescoes in Munich, lamented the fact that English painters had so few opportunities for literary paintings on a grand scale, compared to those of Germany: 'What would some of our English painters … give to have two or three hundred feet of space before them … with us such men as Hilton and Etty illustrate annuals, and the genius of Turner shrinks into a vignette!' (1839, I, p.306). However right she may have been, Turner's vignettes have stood the test of time and given immeasurable pleasure to viewers the world over. The exquisite delicacy of this particular watercolour shows Turner's vignette style of the 1830s at its most refined.

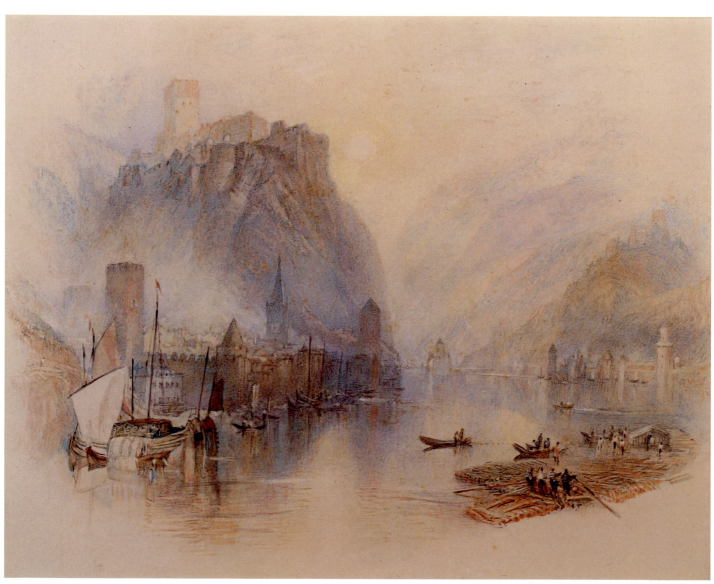

24

EDWARD FINDEN AFTER J.M.W. TURNER

25 Cologne 1833

Line engraving on steel, large paper proof of published state,
on wove paper
Vignette, 81 × 78 (3³/₁₆ × 3⅛)
T06189
R 428

Edward Finden's engraving of 'Cologne' served as the
frontispiece to volume XVI of Byron's *Life and Works* pub-
lished in 1832–3. This volume contained cantos IV–X of
Don Juan, at the very end of which Byron's profligate
hero reached Cologne,

> A city which presents to the inspector
> Eleven thousand maidenheads of bone,
> The greatest number flesh hath ever known.
>
> (X: lxii)

A footnote explained to readers that 'St Ursula and her
eleven thousand virgins were still extant in 1816, and may
be so yet, as much as ever' (p.325). It is more or less
impossible to read these words without being reminded of
the famous catalogue of conquests in Mozart's *Don
Giovanni*, but Byron's reference is, in part at least, to the
celebrated relics housed in the church of St Ursula at
Cologne. According to legend, Ursula and her compan-
ions had set sail from Britain, the destined brides for an
army in Gaul, and mistakenly landed in Cologne where
they were slaughtered by the barbarian Huns whose
advances they had rejected. However, according to late
editions of Murray's *Handbook for Northern Germany*,
'Among these bones Professor Owen, at a glance, detected

numerous remains of lower animals' (1886 ed., p.29).
Turner will certainly have been aware of conflicting
attitudes towards the relics in the early nineteenth century
(he numbered Professor Richard Owen among his
friends); his coy maidens huddled over a trunk in their
boat in the foreground provide a nice touch of wit in his
scene.

Behind the houses lining the Rhine shore, Turner
depicts some of Cologne's most famous buildings. On the
left is the tower of the town hall, in the centre that of
Great St Martin's church. The gigantic cathedral, begun
in the twelfth century but not completed until 1880,
appears in two instalments behind Great St Martin's: the
tower, on which work was abandoned in the fifteenth cen-
tury, is surmounted by a crane while the choir, finished
and consecrated in the 1320s, is shown complete with roof
and buttresses. To compose the scene Turner made use of
some of his 1817 sketches, including those on TB CLX 27v,
and TB CLXI 56r, 58r.

WILLIAM FINDEN AFTER J.M.W. TURNER

26 The Drachenfels 1833

Line engraving on steel, published state
86 × 132 (3⅜ × 5³/₁₆)
T06180
R 412

This scene, based on a watercolour in Manchester City
Art Gallery (W 1216), appeared in *Finden's Landscape
Illustrations to ... The Life and Works of Lord Byron*. This
publication of 1832–4 included not only Turner's
seventeen vignettes from the *Life and Works* itself (e.g.
cat.nos.24, 25) but also nine landscape scenes inspired by

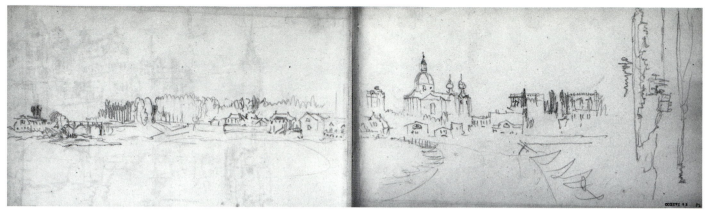

27

<div style="columns:2">

Childe Harold's Pilgrimage (see Brown 1992, pp.99–106). The dominant figure in both publications was Edward Finden, his brother William only engraving 'The Drachenfels' and one other scene.

Cat.no.26 shows the view from the west bank of the Rhine looking downstream to Rolandseck on the left and the Drachenfels in the distance on the right. Turner had included two downstream views from very similar positions in his series of Rhine views bought by Walter Fawkes of Farnley Hall in 1817 (w 666, cat.no.10; w 667, cat.no.9). The viewpoint of cat.no.26 is closer to the second of these, in that the traveller is nearer to Rolandseck and the island of Nonnenwerth appears to the right, but it is closer to the first in its fine rendering of atmosphere, water and distance.

This was one of the most celebrated beauty spots on the Rhine with two of its grandest precipices looming over the convent island below. Turner made sketches of this view on virtually every occasion he travelled along the Rhine, sometimes from the west bank, sometimes from a boat in mid-river. In 1816 Byron described it in *Childe Harold's Pilgrimage* in lines that seem to have engraved themselves on the hearts and minds of all British travellers along the Rhine:

> The castled crag of Drachenfels
> Frowns o'er the wide and winding Rhine,
> Whose breast of waters broadly swells
> Between the banks which bear the vine.
>
> (III: lv.i)

Cat.no.26 comes from the collection of the noted Turner scholar A.J. Finberg (1866–1939); it is inscribed in his hand with references to both the Byron project and Turner's earlier watercolour of the same view.

Brussels up to Mannheim – Rhine sketchbook 1833

27 Mannheim from the Bridge of Boats and Oppenheim from the Rhine

Pencil
Page size: 113 × 185 (4⁷⁄₁₆ × 7¼)
White wove writing paper
Watermarked: J JELLYMAN/1828
Inscribed on f.82r: 'Openheim'
TB CCXCVI ff.81 verso, 82
D29755, D29756

This was the first book Turner used on his 1833 tour and the only one taken with him from London, the others being acquired in Germany and Austria. It is in a format and size much favoured by the artist in the middle part of his career; on his first visit to Italy in 1819 twelve such books were used. The title is Turner's own and is inscribed in pencil on the outside of the back cover. The book contains two distinct types of sketches. First, he recorded Ostend, Bruges, Ghent and Liège and made a detour up the Meuse to the fortress towns of Huy and Namur (which he had first seen in 1824). He then travelled cross-country to Cologne and went up the Rhine as far as Mannheim. In the Belgian towns he made large, full-page studies of famous buildings and views. On the German river he drew very much smaller sketches so as to seize quick records of all the constantly changing views provided by the steamer. Although this was Turner's third visit to this part of the Rhine, he sketched assiduously and by the time he reached Mannheim he was, in fact, extremely short of space.

Turner's sketches of the Rhine record several architectural changes that had taken place since his earlier visits. The eastern dome of Mainz cathedral, which had been devastated by fire whilst under attack from Napoleonic forces in the early 1790s, had been replaced by 1828

</div>

(ff.39r, 41r); Burg Rheinstein had been rebuilt in medieval style for Prince Friedrich of Prussia between 1825 and 1829 (ff.70v, 71r); and the parish church of Wellmich, beneath Burg Maus, had been given a new spire, with a different design, in 1830 (ff.48r, 61v).

Mannheim, which lies some forty-five miles up the Rhine from Mainz, was universally praised by British visitors in the late eighteenth century for its elegance and beauty. It had been devastated during the Wars of the Palatinate Succession and subsequently rebuilt on a grid-plan with grand classical buildings. These were a welcome relief to British eyes after the many German towns in which travellers felt they had stepped back several centuries in time, and its admirers included Boswell, Dr Burney and William Beckford. It is doubtful, however, whether Turner had time to explore its interior in 1833. The principal sketch on ff.81v–82r shows the view across the Rhine to the large domed Jesuit church with part of the Electoral Palace on the right. To its left is the observatory and on the far left, beyond the trees, is the bridge over the canal which links the Rhine to the Neckar. The foreground on f.82r is occupied by the bridge of boats which provided Turner with an excellent viewpoint.

Heidelberg up to Salzburg sketchbook 1833

28 Two Views of Stuttgart

Pencil
Page size: 164 × 101 (6½ × 4)
Contains two different papers. One is a very lightweight cream wove writing paper, watermarked J WHATMAN (ff.1–16 and 85–end). The other is a blue laid writing paper, watermarked BV (ff.17–84)
TB CCXCVIII ff.38 verso, 39
D29889, D29890

Turner himself wrote the name of this sketchbook on the inside front cover, close to the stitching. He probably bought it in Heidelberg itself, since he had finished his previous sketchbook in Mannheim and the Whatman paper this one contains is not the genuine article but a continental forgery. It is, however, quite unlike the fake Whatman paper found in the three sketchbooks bought in Austria in 1840 (see cat.nos.64–5).

Turner drew some fifty pencil sketches of Heidelberg on this, his first visit to that city. These occupy the earliest pages of the book, after which it was used to record his journey directly across Germany by road through Heilbronn, Stuttgart, Ulm and Munich to Salzburg. This was the only occasion on which he used precisely this route to the Alps, though he revisited Heidelberg in 1840, 1841 and 1844; passed through Munich again in 1843; and

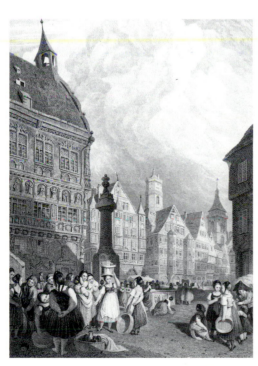

J. Mitan after George Lewis, 'Hôtel de Ville and Market Place, Stuttgart', from T.F. Dibdin, *A Bibliographical, Antiquarian and Picturesque Tour in France and Germany* (1821). *By permission of The British Library*

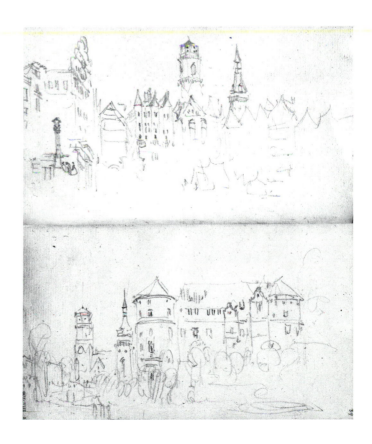

explored the Neckar valley between Heidelberg and Heilbronn in 1844 (see cat.nos.145–50).

Turner drew many pencil sketches of Stuttgart, mostly showing it from the outskirts, charmingly enclosed by fields and hills. These two sketches, however, depict some of the historic buildings in the centre of the town. That on f.38v shows the market place with the town hall on the left and the two towers of the fifteenth-century Stiftskirche, or collegiate church, soaring over the roofs and gables of the houses. That on f.39r was drawn in the Karlsplatz, facing the massive Old Palace which dates from the sixteenth century. The Stiftskirche can be seen again, on its left, but it is now completely dwarfed by its· neighbour.

In 1821 T.F. Dibdin included a depiction of the market place at Stuttgart in his book on France and Germany, engraved after a drawing by the artist who had accompanied him on his tour of 1818. This was George Robert Lewis (1782–1871), one of the celebrated family of topographical artists and engravers descended from Johan Ludwig who fled to England as a political refugee from Hanover (see J.M.H. Lewis, *The Lewis Family*, 1993). Dibdin noted that the upper storeys of the church towers in the distance 'are occupied by people who regularly live there' and that 'just in front of the town hall is a fountain of black marble, where the women come to fetch water, and the cattle to drink' (III, p. 136). The black fountain can be clearly seen on the left of Turner's sketch, though it is not, apparently, in use. Turner has, as usual, risen early.

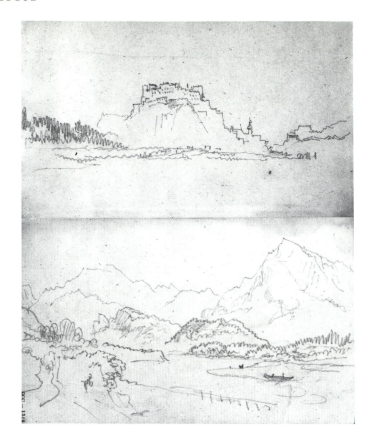

Salzburg and Danube sketchbook 1833

29 Two Views on the Salzach

Pencil
Page size: 160 × 98 (6⁵⁄₁₆ × 3⁷⁄₈)
Contains two papers, possibly from the same mill in southern Germany. One is a cream wove writing paper, watermarked with a Basle Crozier and countermarked LDRO + C. The other is a cream laid writing paper, watermarked with a Basle Crozier and countermarked RCDD + C.
TB CCC ff.12 verso, 13
D30153, D30154

Turner must have bought this book at the same time and from the same stationer as cat.no.28. The distinctive and relatively rare design of the marbled paper used for the cover of this book is the same, though differently

coloured, as that used for the inside paper pocket of cat.no.28, suggesting that the books were made up by the same binder. Turner probably bought them in Heidelberg which was extensively sketched in cat.no.28 and recorded just once in cat.no.29 (f.2r).

Just over half the sketchbook is devoted to Salzburg and its environs, which Turner explored thoroughly on foot, visiting many of the favourite viewpoints of contemporary German and Austrian artists. The second half of the book chronicles his journey by boat down the Danube from Linz to Vienna, with numerous small sketches, often annotated with names, crowded onto each page. The sketches on ff.12v and 13r were drawn in the course of Turner's walk southwards from Salzburg, along the Salzach, as far as Schloss Goldenstein. As usual, he stopped every few minutes in order to record the views both behind and ahead: the fortress of Hohensalzburg on its great rock (f.12v) and the peaks of Hoher Göll and the Untersberg (f.13r). Here, as in many of these drawings, Turner's sketching style is extremely precise, with delicate lines, hatching and varying pressure on the pencil all exploited to produce fine effects of light and shade, perspective and volume.

Vienna up to Venice sketchbook (formerly known as *Lintz, Salzburg, Innsbruck, Verona and Venice*) 1833

30 Two Views of Innsbruck

Pencil
Page size: 184 × 114 (7¼ × 4½)
White laid writing paper
No watermark
TB CCCXI ff.55 verso, 56
D31525, D31526

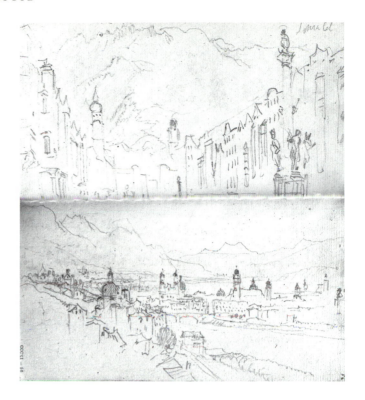

Unlike cat.nos.27–9, Turner did not inscribe this sketchbook with its name and it has hitherto been known by the title given to it in 1909 by A.J. Finberg. However, it contains several sketches of Vienna and its environs and none of Linz, and it has therefore been renamed here, in the style of Turner's own titles for the other books used on this tour. Although Turner did not name this sketchbook, he did mark its fore-edge with inked lines in exactly the same manner as cat.nos.28 and 29, as a reminder to himself that they had been used on the same tour. It chronicles the whole of his long journey through Austria and northern Italy, which can be dated precisely since he was recorded in local newspapers as arriving in Vienna on 25 August 1833, in Innsbruck on 3 September and in Venice on 9 September.

Turner must have bought this book from the shopkeeper whose printed label it bears, Anton Lehenbauer, 'bürgerlicher Buchbinder', whose premises were just north of the cathedral in the Grosses Waghaus in Rothgasse (Stadt, 641 in the nineteenth-century Viennese address system). Turner would have passed this shop on his way to the city centre from his hotel, the Golden Lamb in the Leopoldstadt. At this date Lehenbauer was registered in the Viennese *Adressen-Buch der Handlungs-Gremien und Fabriken* of J.B. Schilling (1834) as a 'Futteral- und Brieftaschenarbeiter' (sheath- and wallet-maker), but this sketchbook proves that he had already started business as a bookbinder as well. In the 1840 *Handlungsalmanach* he is listed as a bookbinder, still in Rothgasse but at Stadt, 487, and he died aged sixty-three on 12

March 1864. Freiberg (1955) followed Finberg in believing that this sketchbook had been used in 1840, but this cannot have been the case. Turner's sketches of Verona on ff.67r and 67v were used as the basis of a watercolour of its Roman amphitheatre, of which an engraving was published in 1835, and in 1840 his travels between Austria and Venice were to take an entirely different form (see cat.nos.64–5).

As in so many places which he simply passed through on a journey, Turner found the time in Innsbruck not only to record the town itself but also to survey it from good viewpoints nearby. His sketch on f.55v shows Maria-Theresien-Strasse with St Anne's column in the right foreground. That on f.56r shows the view from across the Inn, with the old bridge at the centre of the scene, just below the cathedral. The mountains that encircle the town form the backdrop to both sketches.

Hamburg and Copenhagen sketchbook (formerly known as *German(?)*) 1835

31 The Spires of Hamburg across the Binnenalster

Pencil
Page size: 151 × 95 (6¹/₁₆ × 3¹³/₁₆)
Contains two different papers. One is a white laid writing paper, watermarked with an orb ornamented with laurel leaves and *Jordan*. The other, probably from the same mill, is a white laid writing paper, watermarked with a portrait head of Friedrich Wilhelm III of Prussia in a patterned oval and FR.WI.D.III. The book also contains a high glaze white wove card
Inscribed: '1'; [...] (f. 17v); '2'; '3' (f.18)
TB CCCV ff.17 verso, 18
D30854, D30855

This sketchbook is of Prussian origin. It contains paper watermarked with the portrait of Friedrich Wilhelm III (1770–1840) and its outer covers of dark plum-coloured boards are embossed with views of Bad Ems on the Lahn and Bingen on the Rhine. Turner probably bought it in Hamburg soon after his arrival there on 1 or 2 September 1835. He used it chiefly in Hamburg itself and in Copenhagen which he reached on 6 September. However, a few quick sketches also record Kiel and the chalk cliffs of the island of Moen, passed on his twenty-four-hour voyage from Kiel to Copenhagen.

Hamburg abounds in magnificent views, one of the finest being that of the many church spires of the city as seen across the lake of the Binnenalster. So wide and grand is this view that Turner could only get a record of it into his tiny sketchbook by drawing it in numbered instalments, an expedient he had recourse to on many of his tours. His first sketch (on f.17v) shows the Gertrudkirche and Jakobikirche (with separate details of each nearby), the second the Petrikirche and Katharinenkirche, the third the Nikolaikirche and Michaeliskirche. Since Turner's visit this view has twice been almost completely destroyed: in a great fire in 1842 and again in the bombing raids of 1943. Twice Hamburg has risen again like a phoenix and many of the views recorded by Turner in this sketchbook of different parts of the city may still be enjoyed by visitors there today.

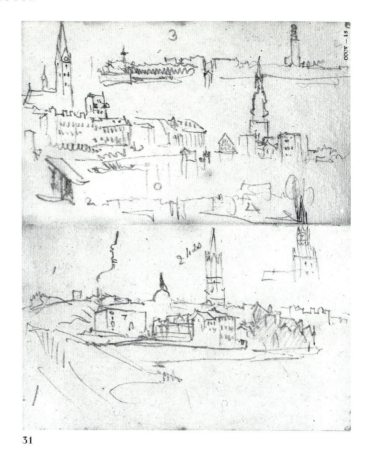

31

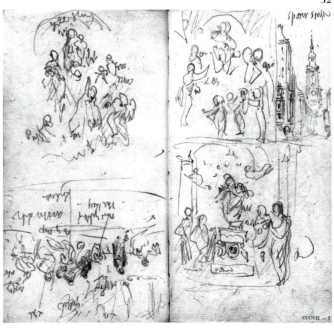

32

Copenhagen to Dresden sketchbook (formerly known as *Dresden*) 1835

32 Studies in the Dresden Picture Gallery

Pencil
Page size: 161 × 85 (6⅜ × 3⅜)
White laid writing paper
Watermarked with a beehive surrounded by a garland and bees
Countermarked with a double x and CFW&S
Inscribed: 'Yell. Glory'; 'Red L'; 'Blue'; 'P[…]Gre'; 'Gold'; 'Or' on Correggio's 'Madonna with St Sebastian' and 'LB'; 'Light'; 'Yellow'; 'L Yel'; 'P'; 'W'; 'W'; 'V'; 'Red Yellow the Key'; 'BY Stripes'; '[…]Lilak' on Watteau's 'Conversation in a Park' (both f.6v); 'B'; 'Or'; 'Red'; 'Red'; 'L'; 'Bl'; 'Red' on Correggio's 'Madonna with St George'; 'Blue'; 'Red'; 'Red' on Correggio's 'Madonna with St Francis'; 'Sporer Strasse' on a sketch of the Kreuzkirche (all f.7r)
TB CCCVII ff.6 verso, 7
D31031, D31032

Turner used this sketchbook for about ten days, from the time he left Copenhagen, recording its silhouette again and again across the water, until he was in Dresden which he reached on 19 September. His journey took him across the Baltic, past the island of Rügen and close to the homeland of Caspar David Friedrich, to the Pomeranian port of Stettin. He then travelled on by road to Berlin and Dresden.

The Dresden Gallery (at this date still housed in the 'Johanneum' in the Neumarkt, close to the Frauenkirche) was regarded in Turner's day as the most outstanding collection of Old Master paintings north of the Alps. Artists and tourists of all nationalities flocked there to admire and to copy and Turner himself was no exception, as is shown by four pages of this sketchbook (ff.6r–7v).

The tiny copies on ff.6v–7r record the compositions, colour schemes and (by means of hatching) light effects of three famous altarpieces by Correggio, each showing the Madonna and Child accompanied by saints, and of a *fête galante* by Watteau. On another page he recorded two other gems of the gallery, Raphael's 'Sistine Madonna' and Correggio's 'Penitent Magdalene' but, rather curiously, he did not sketch an even more famous Correggio, 'La Notte'. These sketches and another (greatly inferior) group recording paintings seen in Vienna in 1833 (in TB CCCXI) are the only drawings Turner made in picture galleries on any of his German tours. The Dresden studies thus have an especially precious quality, out of all proportion to their size.

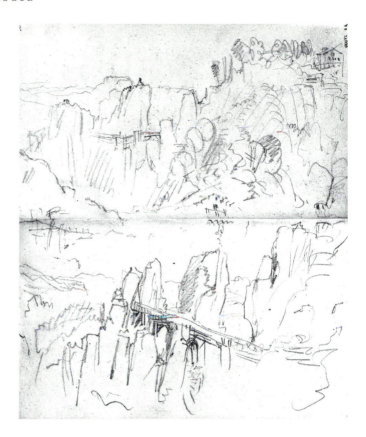

Dresden and Saxon Switzerland sketchbook (formerly known as *Dresden and River Elbe*) 1835

33 Two Views of the Bastei

Pencil
Page size: 170 × 103 (6¾ × 4¹⁄₁₆)
Low-grade blue wove writing paper of unknown origin
No watermark
TB CCCVI ff.49 verso, 50
D30981, D30982

Turner must have acquired this sketchbook in Dresden in late September 1835, when he had completely filled cat.no.32 and was about to set forth on his tour of Saxon Switzerland. It has been renamed here because it was the whole area of Saxon Switzerland, south-east of Dresden, that was the object of Turner's tour rather than simply the Elbe valley itself. This region of huge and curiously shaped fingers and cliffs of grey sandstone, formed by millennia of erosion, had become a favoured destination of artists and tourists alike at the end of the eighteenth century when it was given its name by two Swiss painters working in Dresden. By Turner's day it was an essential feature of any visit to the Saxon capital. A boat would take travellers up the Elbe from the city to the nearest part of the area and the rest of the tour was performed in a carriage and on foot, lasting for anything between a day and a

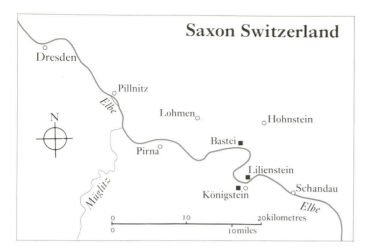

Saxon Switzerland

Dresden, Teplitz and Prague sketchbook (formerly known as *Dresden(?)*) 1835

34 Two Views of Prague

Pencil
Page size: 160 × 98 (6⁵⁄₁₆ × 3⁷⁄₈)
Cream wove writing paper
Watermarked: CF/AF
Inscribed: 'Nine'; 'No Roof here' (f.37)
TB CCCI ff.36 verso, 37
D30365, D30366

week. Turner probably spent about three days over it. His initial arrival in Dresden was on 19 September, and he arrived back there from this tour on 24 September (see pp.56–8).

The rocks of the Bastei are an astonishing series of separate giant pinnacles not far from Dresden itself and one of the most famous sights in Saxon Switzerland. They were linked in Turner's day by a wooden bridge, providing an experience as thrilling as any 'devil's bridge' in the Alps (this was replaced by a stone one in 1851). A viewing station (seen at top right on f.50) and a terrace provided breathtaking views over the Elbe some 600 feet below (see fig.9, p.17) and across to a host of other rock formations in the area. One of the nearest, Lilienstein, can be seen in the distance on f.50, peeping above the head of a much closer rock.

After Turner's tour of Saxon Switzerland (see cat.no.33), he returned to Dresden where he took a coach for the spa town of Teplitz (now the Czech Teplice). This was one of the most fashionable watering-places in Europe, set in beautiful countryside, and Turner made many sketches around the town before travelling on to Prague.

His sketches of the Bohemian capital show that his distant destination lived up to all his expectations. He drew it from many viewpoints both near and far, enjoying the sight of individual buildings and grand prospects. His sketch on f.36v shows the Hradčany, the hilltop complex of Prague castle and cathedral, from the north-east, with the buildings of the Little Quarter clustered at its feet. That on f.37 shows the Old Town Square, looking across to the Tyn church. On its left is the rococo Kinsky Palace, to its right the column dedicated to the Virgin Mary.

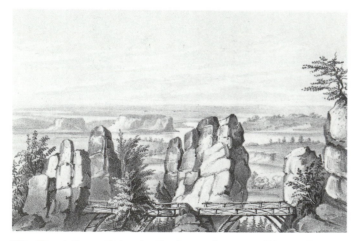

'The Bastei, Saxon Switzerland', nineteenth-century lithograph

Prague, Nuremberg, Frankfurt and Rhine sketchbook (formerly known as *Rhine, Frankfort, Nuremberg, and Prague(?)*) 1835

35 The Hauptmarkt at Nuremberg

Pencil
Page size: 191 × 107 (7½ × 4⅝)
White laid paper
Watermarked with the Seven Provinces lion/JH&Z and
J.HONIG/&/ZOONEN
TB CCCIV f.54
D30732

Although the paper in this sketchbook is Dutch, there is no doubt that Turner started using it in Prague in late September 1835, continuing to do so as he travelled homewards through Nuremberg and Frankfurt and then down the Rhine. The scenery depicted is extremely diverse, ranging from the hills of Bohemia to the banks of the Waal branch of the Rhine only a few miles from Rotterdam.

Turner is recorded as arriving at Nuremberg on 2 October and staying at the Strauss hotel in Karolinenstrasse. This occupied the site of today's Grand Bazar, successor to the Strauss Bazaar department store of the 1870s. The drawing of the Hauptmarkt was probably made the following morning and shows one of Nuremberg's most beautiful ensembles: the ornate façade of the Frauenkirche and, to its left, the richly ornamented Schöner Brunnen (or Beautiful Fountain); both date back to the fourteenth century. In Turner's day part of the Hauptmarkt, the town's chief market place, was occupied by low buildings with open arcades in which trading could take place under cover. These totally hide the main entrance to the Frauenkirche in his sketch, just as they do in early photographs of Nuremberg (see J. Bier, *Das alte Nürnberg*, Nuremberg 1926, pls.49–50).

ROBERT WALLIS AFTER J.M.W. TURNER

36 Hohenlinden 1837

Line engraving on steel
Vignette, 105 × 73 (4⅛ × 2⅞)
T04773
R 621

This vignette appeared in *The Poetical Works of Thomas Campbell*, published in 1837, as the headpiece to a celebrated poem commemorating the battle of Hohenlinden. Here, close to Munich, on 3 December 1800, the Napoleonic army, led by General Moreau, completely defeated the Austrians, already brought low by their defeat at Marengo just six months earlier. By the ensuing treaty of Lunéville, February 1801, France continued to control the left bank of the Rhine and annexed territory in northern Italy while Austria received Salzburg and part of Bavaria.

> On Linden, when the sun was low,
> All bloodless lay th' untrodden snow,
> And dark as winter was the flow
> Of Iser, rolling rapidly.

But Linden saw another sight,
When the drum beat, at dead of night,
Commanding fires of death to light
The darkness of her scenery.

By torch and trumpet fast array'd,
Each horseman drew his battle-blade,
And furious every charger neigh'd,
To join the dreadful revelry.

Then shook the hills with thunder riven,
Then rush'd the steed to battle driven,
And louder than the bolts of heaven,
Far flash'd the red artillery.

But redder yet that light shall glow
On Linden's hills of stained snow,
And bloodier yet the torrent flow
Of Iser, rolling rapidly.

'Tis morn, but scarce yon level sun
Can pierce the war-clouds, rolling dun,
Where furious Frank, and fiery Hun,
Shout in their sulph'rous canopy.

The combat deepens. On, ye brave,
Who rush to glory, or the grave!
Wave, Munich! all thy banners wave,
And charge with all thy chivalry!

Few, few, shall part where many meet!
The snow shall be their winding sheet,
And every turf beneath their feet
Shall be a soldier's sepulchre.

Campbell wrote this poem in London in 1801, soon after his return from ten months in Germany, and it was published anonymously, with his 'Lochiel', in 1802. It was widely believed that he had witnessed the battle itself but this impression was corrected in later editions of the poem and in Beattie's posthumous biography of the poet (1849, I, pp.343–5). At the time of the battle the twenty-three-year-old Campbell was actually in Altona, near Hamburg, but earlier in 1800 he had witnessed fighting at Regensburg and had been devastated by the scenes of 'blood and desolation', 'men strewn dead on the field – or, what was worse – seeing them in the act of dying'. These images continued to haunt him for years.

Turner's scene follows Campbell in providing a vision of the battle rather than a descriptive rendering. The distant city in his vignette bears little real resemblance to Munich or to his own sketches of it drawn in 1833. Both

poem and vignette suggest that Hohenlinden – like Munich itself – lies on the river Isar (which Campbell consistently spelled 'Iser'). It is, however, some twenty miles from that river. British travellers did not make pilgrimages from Munich to the plain of Hohenlinden as they did from Brussels to the Field of Waterloo, but sometimes recollected the battle, alongside that of Blenheim a century earlier, whilst in Bavaria. Murray's *Handbook for Southern Germany* complained about the topographical inaccuracy of Campbell's lines but other travellers found that the poet was right in one respect: 'The Isar … exceeds even the Danube in rapidity, and well may Campbell call it "Isar rolling rapidly"' (Tobin 1832, p.35).

General Moreau subsequently fought on the side of the forces ranged against Napoleon and was mortally wounded at the battle of Dresden in 1813. In 1835 Turner sketched the memorial erected to him there (see fig.43, p.56); and it must have been just a few months later that he painted 'Hohenlinden'.

EDWARD GOODALL AFTER J.M.W. TURNER

37 Ehrenbreitstein 1837

Line engraving on steel
Vignette, 76 × 70 (2⅞ × 2¹³⁄₁₆)
T04784
R 631

Thomas Campbell's 'Ode to the Germans', for which this vignette served as a headpiece in the 1837 edition of his collected works, was written in June 1832 and first published in one of the periodicals of which he himself was editor, the *Metropolitan Magazine*. It was composed in the context of the many revolutions that occurred throughout Europe in 1830 and the general movement towards independence and democracy which in Britain culminated in the Reform Act of 1832.

After the Polish revolt of 1830–1 had been brutally crushed by the army of Tsar Nicholas I, the Russians took ferocious revenge on all those involved; hundreds of Polish intellectuals were exiled and many took refuge in England. Campbell, whose passionate interest in Poland dated back to the 1790s, was deeply troubled by the stories they told him and founded a Polish Association to assist them

were fined or imprisoned. In the following year a party of German students and Polish exiles seized the guardhouse at Frankfurt and tried unsuccessfully to overawe the Diet. The nationalistic 'Young Germany' movement was thus beginning.

ODE TO THE GERMANS

The Spirit of Britannia
 Invokes across the main,
Her sister Allemannia
 To burst the Tyrant's chain:
By our kindred blood, she cries,
Rise, Allemannians, rise,
 And hallowed thrice the band
Of our kindred hearts shall be,
 When your land shall be the land
 Of the free – of the free!

With Freedom's lion-banner
 Britannia rules the waves;
Whilst your BROAD STONE OF HONOUR
 Is still the camp of slaves.
For shame, for glory's sake,
Wake, Allemannians, wake,
 And thy tyrants now that whelm
Half the world shall quail and flee,
 When your realm shall be the realm
 Of the free – of the free!

MARS owes to you his thunder
 That shakes the battle-field,
Yet to break your bonds asunder
 No martial bolt has pealed.
Shall the laurelled land of art
Wear shackles on her heart?
 No! the clock ye framed to tell
By its sound, the march of time;
 Let it clang oppression's knell
 O'er your clime – o'er your clime!

The press's magic letters,
 That blessing ye brought forth, –
Behold! it lies in fetters
 On the soil that gave it birth:
But the trumpet must be heard,
And the charger must be spurred;
 For your father Armin's Sprite
Calls down from heaven, that ye
 Shall gird you for the fight,
 And be free! – and be free!

and promote the cause of Polish independence. On 7 June he wrote, 'I shall write for the next number [of the *Metropolitan*] an "Ode to the Germans," exhorting them to rise and assist the Poles' (Beattie 1849, III, p.124).

Germany itself underwent a number of local revolts against individual rulers at about the same time. Following these, the most powerful states in central Europe, Austria and Prussia, ensured that repressive measures were taken and the Diet at Frankfurt passed the Six Acts in 1832. The powers of aristocratic rulers were strengthened against parliamentary assemblies and the press was censored.

Campbell's Ode was translated into German, set to music and widely circulated in Germany. Many Germans in London hailed him as 'the *first* who had taken up the cause of German liberty in this country' (ibid., p.132). Later in 1832, an address signed by 600 citizens of Frankfurt and Hanau was presented to Campbell by a German deputation in London, declaring that 'millions of their countrymen share their feelings; and that they would loudly declare them before the world, if they were not prevented by brute force' (ibid.). Many of the signatories

Turner's depiction of the fortress of Ehrenbreitstein, the 'broad stone of honour' referred to in the second stanza, shows it from a somewhat unusual angle which owes a lot to his imagination. The foreground, too, is imaginary. However, the spires of St Castor's church in Coblenz on the left bank of the Rhine are faithfully portrayed as is the bridge of boats which replaced the previous flying bridge at this spot in 1819.

In the 1837 edition a footnote to the beginning of the third stanza reminded British readers that 'Germany invented gunpowder, clock-making, and printing'.

38 On the Mosel 1839

Gouache and watercolour on blue laid paper
186 × 232 (7⅜ × 9³⁄₁₆)
Watermarked with the top half of a Basle Crozier in a shield
Inscribed in white on the verso: '5'
TB CCCLXIV 249 ('River scene', possibly the Danube, after *c.*1830)
D36095

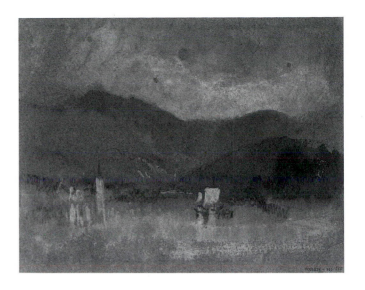

39 On the Mosel 1839

Gouache and watercolour on blue laid paper
184 × 228 (7¼ × 9)
Watermarked: *Richard Bocking/ & / …*
Inscribed in white on the verso: '9'
TB CCCLXIV 253 ('River, with boats', possibly the Danube,
after *c.*1830)
D36099

40 On the Mosel 1839

Gouache and watercolour on blue laid paper
184 × 233 (7¼ × 9⅛)
Watermarked with the top half of a Basle Crozier in a shield
Inscribed in white on the verso: '11'
TB CCCLXIV 255 ('River with church tower and mountains',
possibly the Danube, after *c.*1830)
D36101

41 On the Mosel 1839

Gouache and watercolour on blue laid paper
185 × 226 (7¼ × 8⅞)
Watermarked: *Richard Bocking/ & / …*
Inscribed in white on the verso: '[?12]'
TB CCCLXIV 256 ('River, with town and mountains', possibly
the Danube, after *c.*1830)
D36102

These four studies come from a group of twenty-one
drawings executed on a dark blue handmade Swiss paper
which was not used by Turner for any other works. Nine
of these (TB CCCXLIII 26–34) bear studies in pencil and
white gouache showing places on the Mosel including
Pallien (f.27), Traben and Trarbach (f.29), and possibly
Trier (f.28). The presence of these places suggests a
dating of 1839 for the entire group, since Turner is only
known to have travelled thus far upstream on two occa-
sions, 1824 and 1839. The palette and some aspects of the
style of the twelve coloured drawings in the group
(TB CCCLXIV 246–50, 252–8) are, indeed, similar to those
found in his gouache series of the Mosel, painted on a
paler and quite different type of blue paper and inspired

by his visit there in 1839 (see cat.nos.42–62). An apparently similar sheet, TB CCCLXIV 251, is in fact a different paper.

Since the pencil studies on dark blue paper are all clearly drawings made in the course of a tour, those in colour probably represent a rare example of Turner colouring in the open air. Many of them merely show the river and its surrounding hills, with an occasional boat in the foreground. Turner himself must have been seated in a similar small boat in mid-river and was thus able to sketch at ease, without the encumbrance of onlookers.

Turner has repeatedly characterised the colours and outlines of the hills lining the Mosel, paying attention to their craggy outcrops of rock, the redness of their sandstone, and the presence of occasional clumps of trees or bushes. However, few buildings are included, making firm identifications difficult. Cat.no.41 may well show the view looking downstream towards Piesport with its slender eighteenth-century church situated almost on the river bank, but the church in cat.no.40 is almost certainly elsewhere. It seems unlikely that the sites are lower down the Mosel than Trarbach, the most easterly town included in the pencil sketches (TB CCCXLIII 29).

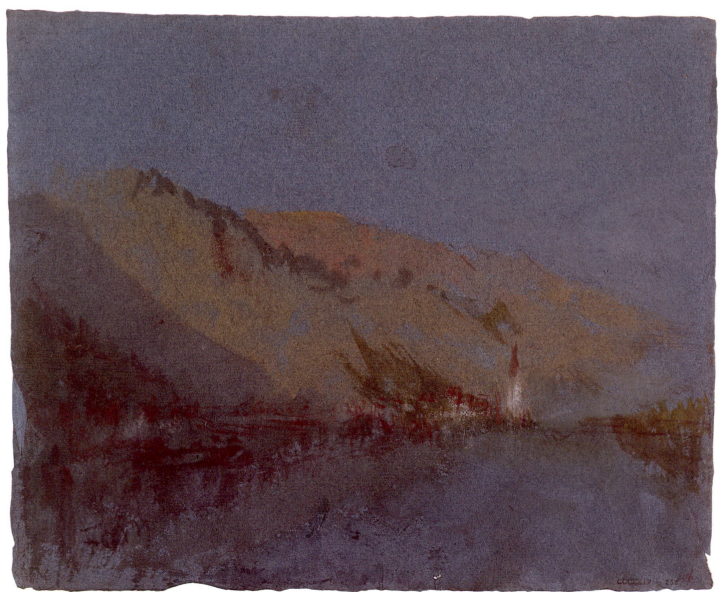

41

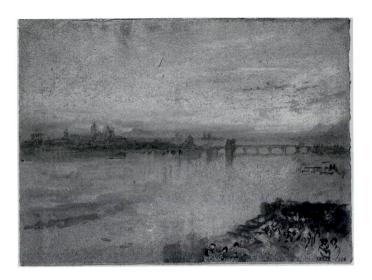

42 Trier from the West c.1839

Gouache and watercolour on blue paper
141 × 188 (5⁹/₁₆ × 7⁷/₁₆)
TB CCLIX 150
D24715
[Exhibited in Germany only]

Cat.no.42 is the most southerly scene of Turner's gouache series of the Mosel, which includes depictions of virtually all the famous sights on the river from Trier down to Coblenz. Most of the forty drawings composing the series were still in Turner's studio at his death and are today part of the Turner Bequest housed at the Tate Gallery, but a few scenes exist elsewhere in private collections and museums. A fuller description of the whole series, with illustrations of most of the currently known works and the pencil sketches on which they were based, was given in Powell (1991), pp.130–49.

On both Turner's visits to Trier, in 1824 and 1839, he followed the recommendation in contemporary guide-books to take an evening walk on the hills above the west bank of the Mosel, so as to enjoy the prospect of the changing light on the river and the buildings of the city. The popularity of this area – around the village of Pallien – can be seen by the numerous figures enjoying them-selves on the hillside in Turner's foreground.

Trier was founded in 16 BC by the Emperor Augustus and is Germany's oldest city. Its notable antiquities include a Roman gate, the Porta Nigra (shown here simply as a square block on the extreme left, but in more detail in cat.no.43) and the Roman bridge across the Mosel protected by a sturdy gate tower (seen on the right). Also prominent on Turner's skyline, and veiled in the same purplish twilight mist, is the cathedral and Liebfrauenkirche complex with its many towers.

Turner made several sketches of this scene (TB CCLXXXVIII 43v–55r) and it was on the basis of these pages, especially ff.51r–52r, that he later composed this gouache.

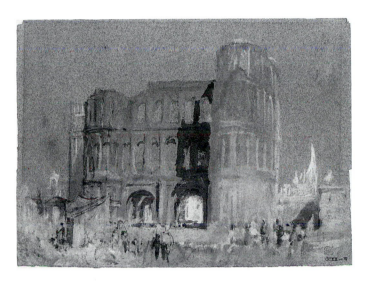

43 The Porta Nigra, Trier c.1839

Gouache and watercolour on blue paper
138 × 190 (5⁷/₁₆ × 7½)
Watermarked: B,E…/18…
TB CCXX W
D20230

The Porta Nigra was built in the second century AD as the north gate of the Roman city of Augusta Trevirorum, and it is the largest extant Roman gateway. Here Turner shows its outer face, designed to keep out the barbarian hordes of the north, which it succeeded well in doing. Although its sandstone soon blackened dramatically (hence its name), the molten lead and iron clamps binding the masonry together rendered it almost impregnable. From the Middle Ages onwards it accommodated two churches, but these had been dismantled by the time of Turner's visits to Trier and from 1822 onwards it func-tioned once more as a city gate.

The gouache is closely based on a careful pencil sketch occupying an entire sketchbook page, with a few useful architectural details tucked away in the corners, as was Turner's habit (TB CCXC 41r). The watermarks on this sheet and elsewhere in the series (see cat.nos.49, 59, 60, 62 and further examples in Powell 1991) are the two halves of the same mark, that of Bally, Ellen and Steart with the date 1828.

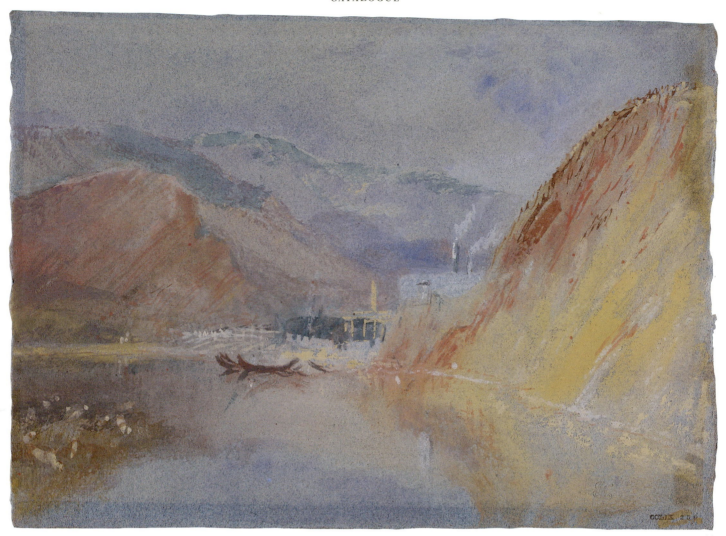

44

44 The Iron Forges of Quint *c.*1839

Gouache and watercolour with pen and ink on blue paper
139 × 191 (5½ × 7½)
TB CCLIX 258
D24823

Quint is so named because both the village and the river
which flows into the Mosel next to it are situated at the
fifth milestone on the Roman road from Trier to Ander-
nach. By Turner's day it was the site of a flourishing iron
industry with numerous forges for the smelting of the
iron that abounded in the hills of this district. The vivid
colours, lively technique and general sense of drama in his
gouache all suggest the heat and activity of this industry,
making the scene a splendid realisation of the spirit of the
place, not simply its outward appearance.

45 Kesten and Monzel *c.*1839

Gouache and watercolour on blue paper
138 × 188 (5⁷⁄₁₆ × 7⅜)
TB CCXXII R
D20277
[Exhibited in Germany only]

When this work was exhibited in *Turner's Rivers of Europe*
in 1991–2 it was captioned simply with the annotation
that appears on Turner's preliminary pencil sketch
(TB CCXC 36r): 'Napoleon passed here'. Following the
exhibition Mr Reinhold Schommers of the Kultur-
abteilung KVHS Cochem-Zell kindly wrote to the organ-
iser, explaining that it depicts Kesten. Here Napoleon's
soldiers crossed the Mosel and Napoleon himself is
known to have spent the night. Napoleon's tour of the
Rhineland in September–October 1804 was occasioned by
his visit to Brussels and Aachen where he visited the tomb
of Charlemagne. His route took him from Cologne to
Coblenz by boat, from Coblenz to Mainz on the new *route
Napoléon* built by his own armies and then on to

45

Mannheim and beyond. He returned home through Trier and Luxembourg.

Turner's scene shows clearly the village of Kesten with its Gothic church lying beneath the dark slope of the Monzeler Hüttenkopf. Monzel itself, with its own church, is shown on the skyline while the hill to the right is part of the well-known Brauneberg, famous for its wine.

46 The Ruined Monastery at Wolf *c.*1839

Gouache and watercolour on blue paper
141 × 190 (5⁹⁄₁₆ × 7½)
TB CCLIX 152
D24717

The isolated ruins of the monastery of Wolf form a dramatically impressive sight high above travellers who approach Traben-Trarbach down the Mosel. As the river winds its way in the loop round the Gockelsberg, the

46

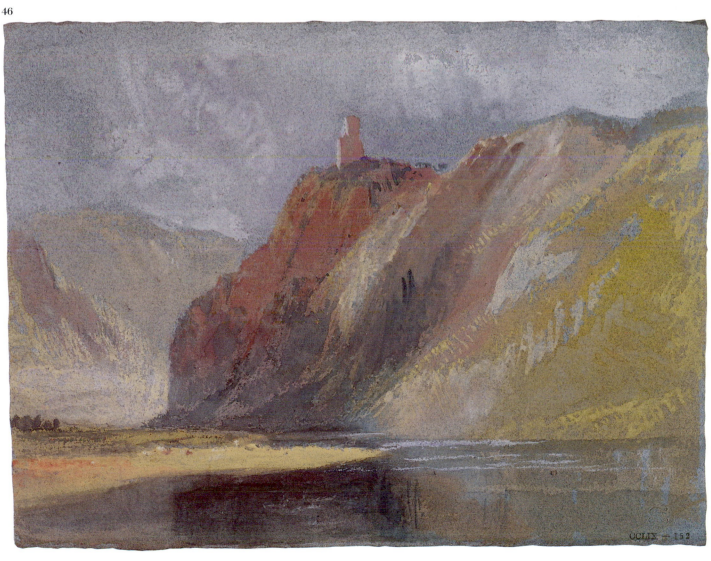

lonely tower is seen in many different guises from a succession of viewpoints: sometimes crowning a hill, at others peeping above a ridge.

Turner drew several small pencil sketches of this subject which later helped him to compose his gouache (TB CCXC 27r; fig.49 on p.63). These are especially noteworthy for their attempts to record light and shade. One includes passages of hatching to indicate the deepest shadows on the hillside (these were translated into rich pinks and deep blues in the painted scene). On another, he simply scribbled 'Beaut[iful] Light', just at the point where the gouache shows a dazzling spit of sand, golden yellow between the inky blues of hill and water.

47

47 Traben, Trarbach and the Grevenburg

*c.*1839

Gouache and watercolour on white wove paper
prepared with a blue wash
138 × 187 (5⁷⁄₁₆ × 7³⁄₈)
TB CCXXII P
D20275
[Exhibited in Germany only]

Although this work undoubtedly belongs to Turner's Mosel series of *c.*1839, it is painted not on blue paper, like the others in the group, but on white paper prepared with a blue wash. Evidently Turner had either temporarily run out of blue paper or else wished to experiment in creating his own.

The scene is based on the pencil sketches Turner drew as he approached Traben and Trarbach, coming down the Mosel, and suddenly saw the ruins of the Grevenburg at their most spectacular (TB CCXC 20v, 21r). Today the two towns are linked by a bridge but in Turner's time their inhabitants were dependent on the flying bridge prominent in the foreground of the sketch. In the finished work this is shown at the end of the spit of sand below Traben.

As a result of the *Turner's Rivers of Europe* exhibition, a work on blue paper resembling cat.no.47 was shown to staff at the Tate Gallery and the present writer. This was obviously a copy of Turner's scene, possibly made when that work formed part of the National Gallery's Sixth Loan Collection (1896–1931, no.41). However, the copyist – unaware of the meaning of the swift little strokes delineating the flying bridge – had simply omitted this notable feature on the Traben riverbank! The work was subsequently auctioned at Academy Auctions in Ealing in west London on 22 March 1994 and fetched several hundred pounds.

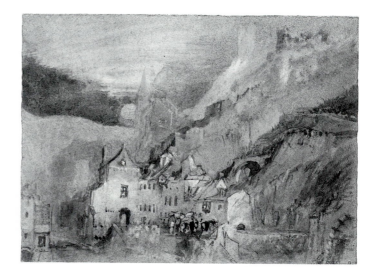

48 The Entrance to Trarbach from Bernkastel

*c.*1839

Gouache and watercolour on blue paper
141 × 191 (5⁹⁄₁₆ × 7½)
TB CCXXI G
D20240

Although most of Turner's Mosel gouaches depict towns and villages from the river itself, there are several which demonstrate that he explored inland as well as following the course of the river. This view shows the square in Trarbach reached by the path over the hill from Bernkastel. Turner may have used this path as one of his routes or he may simply have stayed a night in Trarbach (as he had done in 1824) and taken a stroll which brought him to this

picturesque corner of the town. He recorded this view of the group of houses, St Nicholas's church, the Greven-burg and the steeply ascending town walls in his sketch-book (TB CCXC 22r), adding the motif of the moon when he developed the subject into a gouache. The square takes its name from the gate depicted below the church, the Weihertor. Further to the right can be seen the town mill, the focus of great activity.

49 Trarbach from the South *c.*1839

Gouache and watercolour on blue paper
137 × 190 (5⅜ × 7½)
Watermarked: B,E…/182…
TB CCXX P
D20223

When this work was exhibited in *Turner's Rivers of Europe* in 1991–2 (no.76) it was catalogued as 'Alken and Burg Thurandt from the North' due to a perceived similarity to one of Turner's pencil sketches of that subject. However, Mr Reinhold Schommers of the Kulturabteilung KVHS Cochem–Zell subsequently put forward the suggestion that it actually depicts Trarbach from the hillside path to Bernkastel. Having revisited both locations in 1994, the author gratefully adopts this suggestion. Turner's view-point is thus in the same direction as that of cat.no.48 but higher on the hillside and further away from Trarbach. The irregular profile of the hill on which the Grevenburg stands has been depicted most faithfully as has the steep-ness of the hill in the left foreground. Here Turner shows villagers with huge baskets on their backs, evidently har-vesting the vines that still clothe this very hill today.

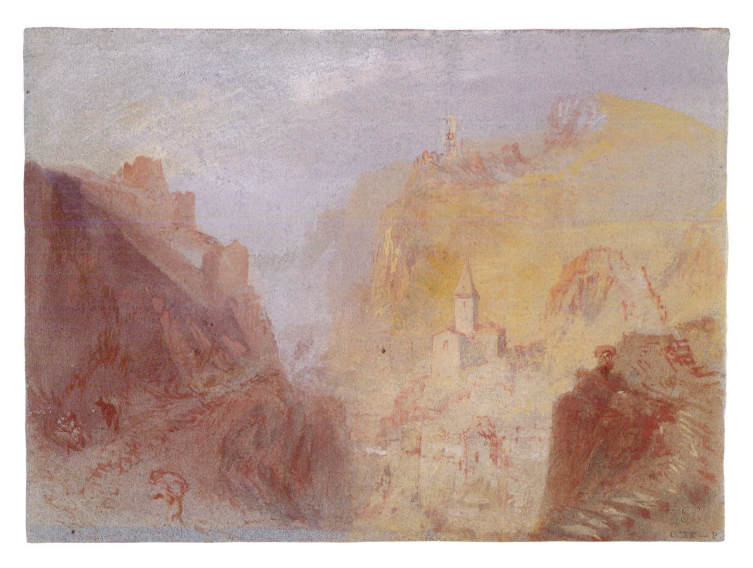

50 Trarbach from the Grevenburg *c.*1839

Gouache and watercolour on blue paper
139 × 190 (5½ × 7½)
TB CCXXI Z
D20259

This scene, like cat.no.49, shows that Turner lingered a while at Trarbach, making sketches away from the riverside and possibly staying overnight. It shows the view he saw (and recorded in a pencil sketch, on TB CCXC 25v) when he walked up to the ruins of the Grevenburg and looked down on the walls and numerous strong towers that enclosed Trarbach.

The handling of this work is much more robust than some of the others in the series, but the same colours are used. Turner may well have chosen to match his style to his subject matter of rugged crags and sturdy fortifications, in contrast to the delicately painted vineyards, men and rivercraft depicted elsewhere in the series (compare cat.nos.51, 55).

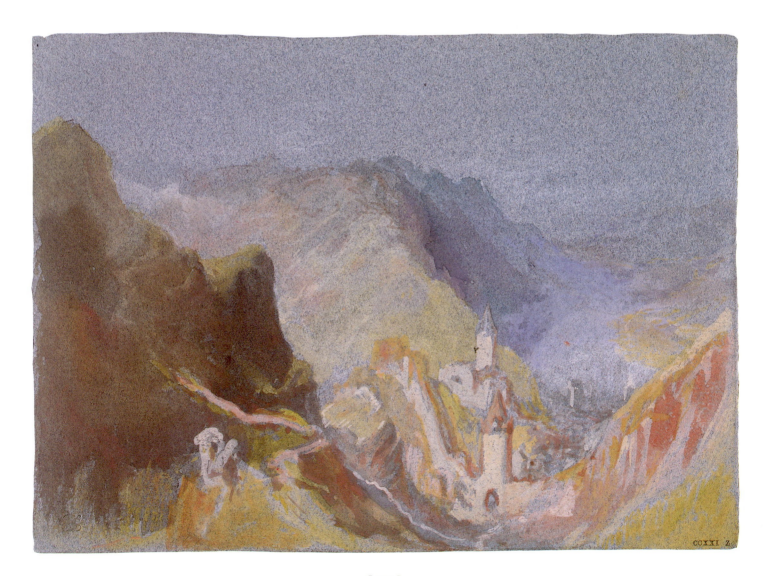

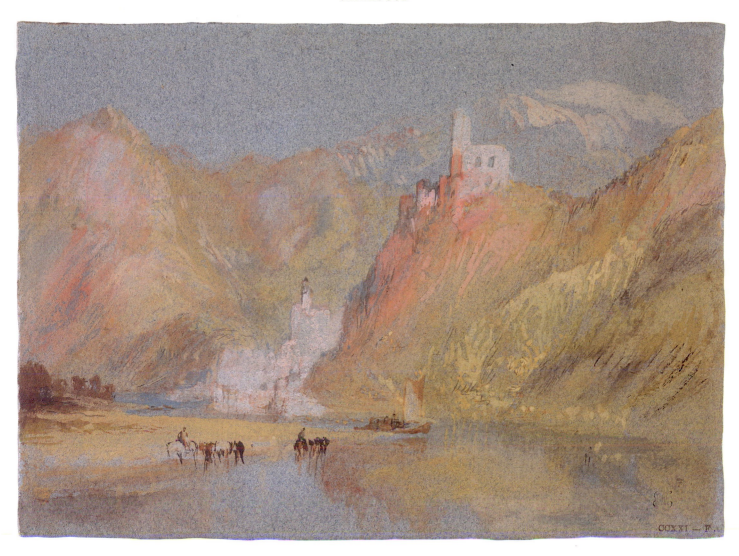

51 Beilstein and Burg Metternich *c.*1839

Gouache and watercolour on blue paper
140 × 192 (5½ × 7⁹⁄₁₆)
TB CCXXI F
D20239

The little town of Beilstein is one of the gems of the
Mosel, standing on one of its most attractive bends and
nestling beneath the spectacular ruins of Burg Metter-
nich. In this scene Turner made use of material in his
own pencil sketches (e.g. TB CCXC 9r), but he chose to
show Beilstein from a very similar viewpoint to that of
Clarkson Stanfield's lithograph in his *Sketches on the
Moselle, the Rhine, & the Meuse*, 1838, the volume that
had inspired him to make his second Meuse–Mosel tour.
Perhaps in deliberate contrast to his friend's monochrome
treatment of the subject, Turner here made use of a daz-
zling array of colours and the most delicate techniques to

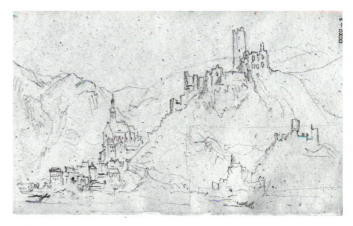

Beilstein (TB CCXC 9r)

capture the effects of light and shade on the rocks, vines
and bushes of the hillside, the river itself and its inhabi-
tants.

52 Cochem from the South *c.*1839

Gouache and watercolour on blue paper
140 × 189 (5½ × 7⁷⁄₁₆)
TB CCXCII 39
D28986

Turner painted more views of Cochem than of any other town or village on the Mosel. This may have been partly because of its size (it was – and still is – the largest town between Trier and Coblenz), which made it an excellent stopping-place and centre for exploration, quite apart from its own intrinsic charms. He is known to have stayed here in 1824 and must have done so also in 1839 and 1840. Several of Turner's coloured views of the Mosel on grey paper of 1840 have very similar viewpoints to those used for the series on blue paper of 1839 and this is particularly noticeable in the views of Cochem (compare cat.nos.52, 55–6, with cat.nos.67–73).

In 1839 Turner painted seven gouaches of Cochem, of which five are included in the present exhibition (cat.nos.52–6). His view from the south (based on the pencil sketch on TB CCXC 5r) is dominated by the main castle in Cochem, the Burg (sometimes referred to as the Reichsburg), beneath which can be seen the small plague chapel, the town walls and one of its gates. The town itself lies in the middle distance, with Cochem's second castle, the Winneburg, just visible in the distance to the right of the parish church.

Although their colour schemes are very different, certain features of cat.no.52 are reminiscent of Turner's view of Beilstein (cat.no.51): for example the tiny dark figures flicked in with the brush on the smooth sandy shore, and the summary treatment of the distant town in contrast to the rich delineation of the landscape.

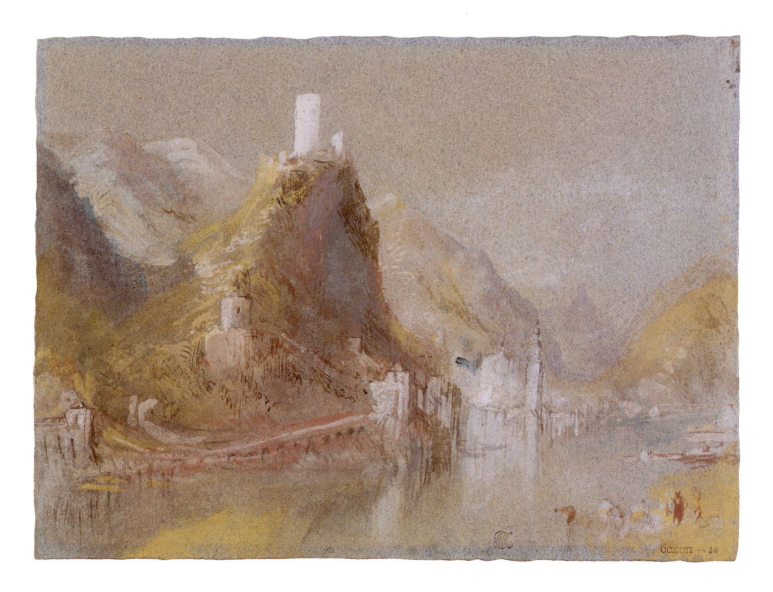

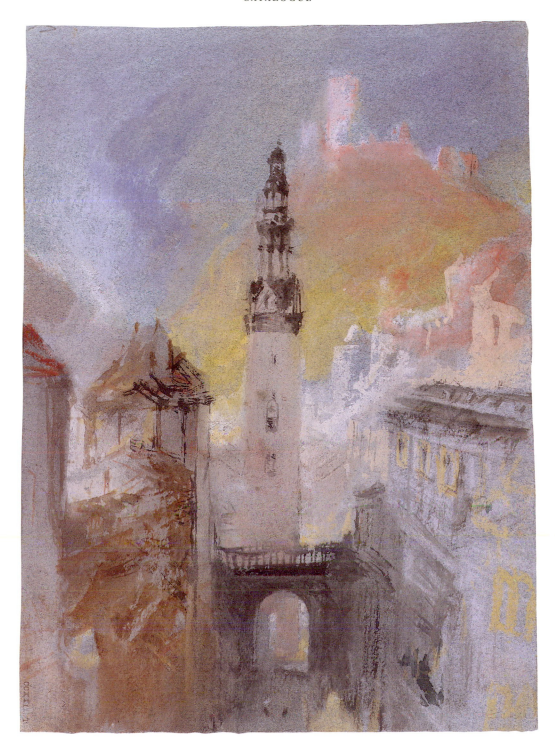

53 St Martin's Church, Cochem *c*.1839

Gouache and watercolour on blue paper
190 × 139 (7½ × 5½)
TB CCXXI T
D20253

While Turner was wandering around Cochem, his attention was caught by the sight of the eighteenth-century steeple of St Martin's church, hemmed in amongst the buildings of the town (TB CCXCI 2r) and he recreated this effect in a dazzlingly theatrical gouache scene. The castle of Cochem is seen high on its hill as a backdrop. Imaginary buildings of contrasting styles and colours – traditional brick-and-timber to the left, eighteenth-century classical stone to the right – appear as side screens linked by a vast black arch. Finally, to emphasise the height of the tower, the viewer's eye is led sharply downwards to two minute figures in the centre foreground, completely dwarfed by their setting.

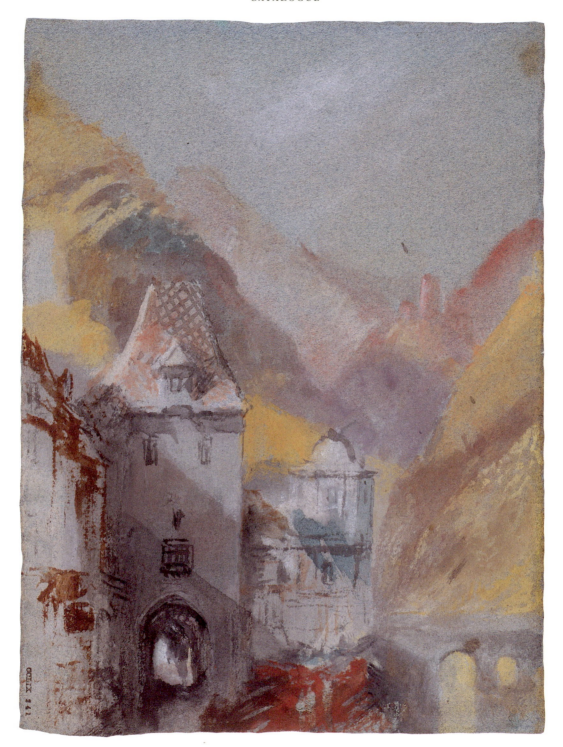

54 The Enderttor and Alte Thorschenke, Cochem *c.*1839

Gouache and watercolour on blue paper
191 × 141 (7½ × 5⁹/₁₆)
TB CCLIX 241
D24806

Vertical scenes are as rare among Turner's gouaches and watercolours as they are among his oil paintings and there can be no doubt that this work was conceived and executed as a companion to cat.no.53. In contrast to the elevated mood of that work, the spirit behind cat.no.54 is decidedly playful, with the stern façade of the fourteenth-century town gate situated by the little river Endert being transformed into a human face with a jaunty expression. The half-timbered building with a round gable immediately to

The Enderttor and Alte Thorschenke, Cochem
(TB CCXCI 2v–3r)

the right of the gate is the Alte Thorschenke, a tavern built into the town walls in 1625. As well as recording it in pencil sketches (TB CCXCI 2v, 3r), Turner must surely have been among its customers, probably on more than one occasion, and may indeed have stayed here.

55 Cochem from the North *c.*1839

Gouache and watercolour on blue paper
140 × 190 (5½ × 7½)
TB CCXXI E
D20238

55

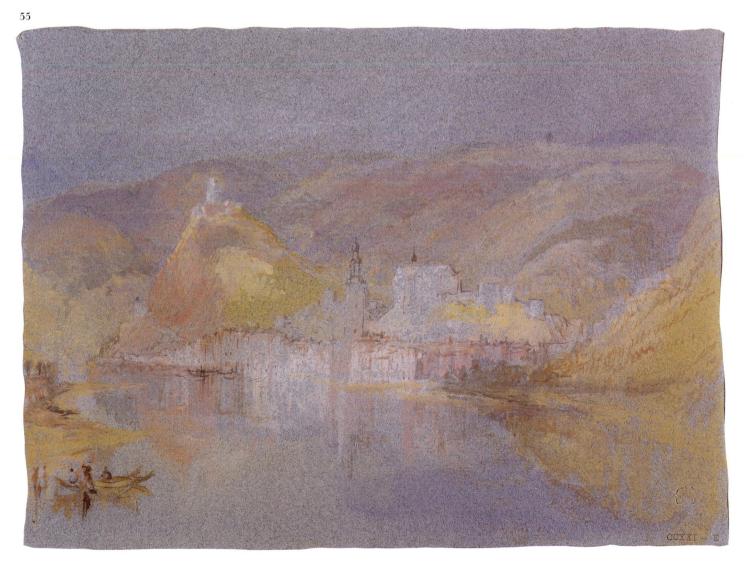

56 Distant View of Cochem c.1839

Gouache and watercolour on blue paper
141 × 190 (5⁹⁄₁₆ × 7½)
TB CCLIX 158
D24723

Cat.nos.55 and 56 record two successive visions of
Cochem seen by travellers leaving the town for Coblenz.
In cat.no.55 the principal buildings are still distinctly
seen, and the town and its surrounding hills are painted
with exquisite delicacy and refinement. In cat.no.56, how-
ever, the distant view of Cochem is merely the starting
point for Turner's study in light and colour and reflec-
tions: his washes of closely related and contrasting colours
are juxtaposed in a very simple manner that is, at the same
time, carefully planned and utterly magical in its effect.

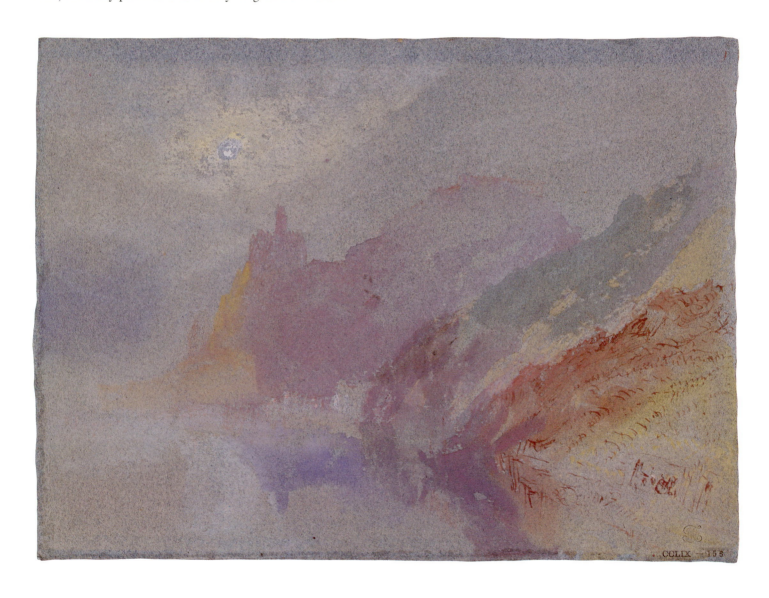

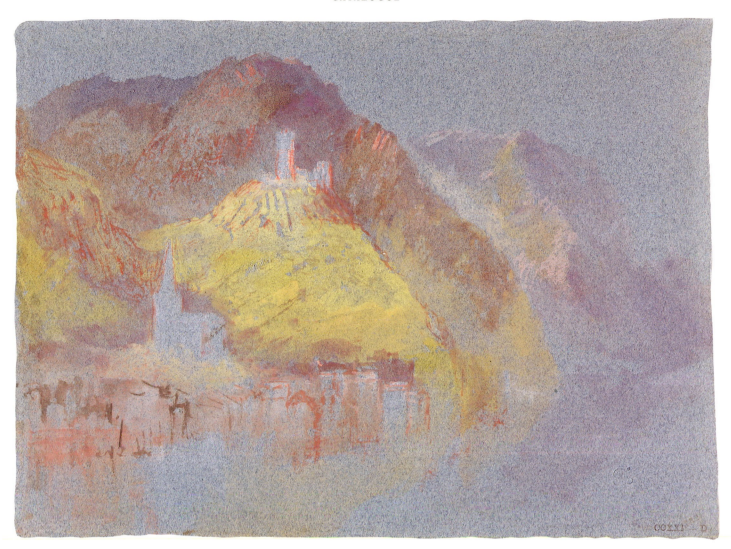

57 Klotten and Burg Coraidelstein from the West *c.*1839

Gouache and watercolour on blue paper
140 × 189 (5½ × 7⁷⁄₁₆)
TB CCXXI D
D20237

This is one of Turner's most dramatic Mosel scenes. The vivid colouring of the central hill is beautifully contrasted with the delicately rendered rocky hillsides surrounding it and areas of blue paper are left untouched to brilliant effect. The scene is that recorded in pencil on TB CCXCI 7v, with the Gothic church of St Maximim seen just to the left of Burg Coraidelstein. Shortly afterwards Turner drew another pencil sketch on f.8r of the same sketchbook, showing the two buildings in a very different relationship to each other and the surrounding scenery. The resulting gouache (TB CCXCII 78; Powell 1991, no.70) was very similar to that painted in 1840 (see cat.no.74).

58 Treis from the North *c.*1839

Gouache and watercolour on blue paper
136 × 190 (5⅜ × 7½)
TB CCXX Z
D20233

Cat.no.58 is based on a pencil sketch recording the view as Turner looked back at Treis as he travelled on, past Karden which lies on the opposite bank, towards Coblenz (TB CCXC 11r). The most prominent feature in the scene is the hill on the left, crowned by the ancient little Zilleskapelle. Treis itself lies on the riverbank in the middle distance, dominated by the elegant white spire of its new church designed by J.C. Lassaulx (1831). The numerous steep hills lying south of Treis are shown by layers of colour washes given aerial perspective by the blue of the paper itself. The smallest hill (no more than a flick of the paintbrush just above the dark bushes on the riverbank) is that on which Burg Treis is situated.

Turner painted the same view from a similar viewpoint in his second Mosel series a year later (cat.no.75).

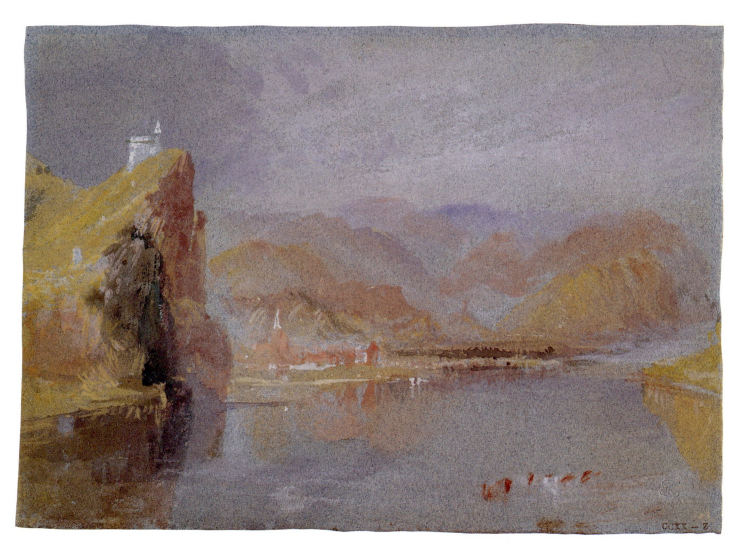

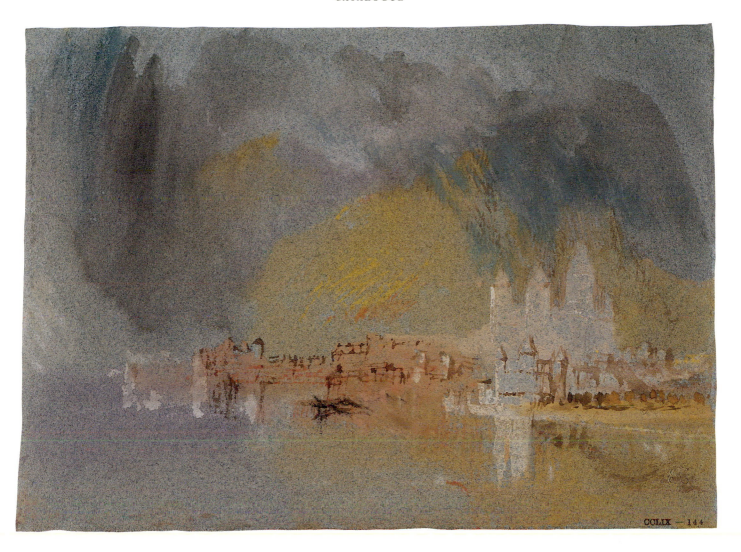

59 Karden from the North *c.*1839

Gouache and watercolour on blue paper
139 × 193 (5½ × 7⁹⁄₁₆)
Watermarked: B,E.../182...
TB CCLIX 144
D24709

Although Karden boasts no ruined medieval castle, it is one of the most striking sights on the lower Mosel, with many notable buildings. Chief amongst them is the large Romanesque church of St Castor with three belfries which dominates Turner's scene, but river travellers are also delighted by the turreted sixteenth-century Burghaus which he shows immediately beneath it. Turner drew two very different pencil sketches of this group of buildings (TB CCXCI 10v, 11r). For his coloured scene he chose the fine view looking upstream from the north, just before the bend in the river hides Karden suddenly from view.

60 Burg Bischofstein *c*.1839

Gouache and watercolour on blue paper
138 × 190 (5⁷⁄₁₆ × 7½)
Watermarked: B,E.../182...
TB CCXCII 70
D29021

Burg Bischofstein is one of the most arresting castle ruins on the entire Mosel. It stands on a rugged ridge of its own, rising steeply from the river, and a tall, cylindrical and very dark tower with a white band near the top is its most prominent feature. The aspect given here is not the most obvious one for an artist to draw (compare Turner's later view, cat.no.78, for a more characteristic view) but it well sums up the essential grandeur and isolation of Burg Bischofstein.

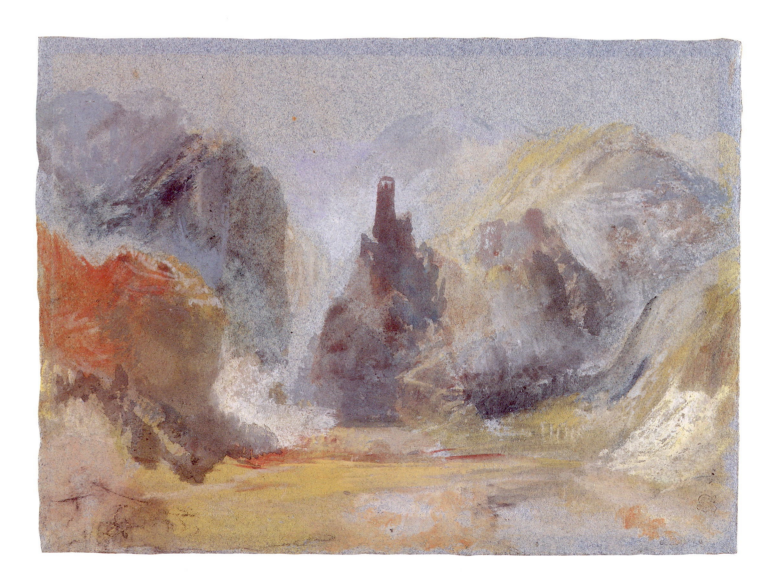

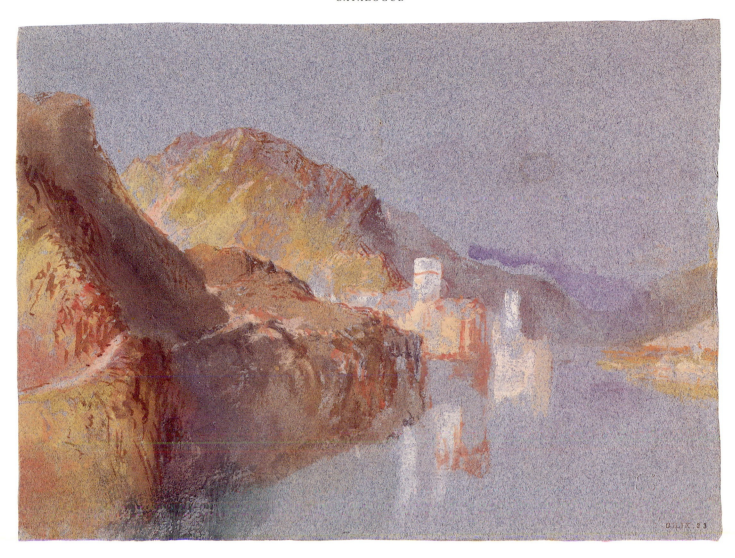

61 The Leyen Burg at Gondorf *c.*1839

Gouache and watercolour on blue paper
138 × 188 (5⁷⁄₁₆ × 7³⁄₈)
TB CCLIX 23
D24588

The Leyen Burg at Gondorf is a spectacular and unusual sight on the lower Mosel. Unlike other Mosel castles, it is situated immediately on the riverbank and it is not a ruin for it was maintained and occupied by the Counts of Leyen until the early nineteenth century. On successive visits to the Mosel Turner made pencil sketches of many of the buildings that make up the complex (TB CCXVI 130V; TB CCXXIV 91, 100; TB CCXCI 24V–27r; W 1330, W 1346). However, for his gouache scene of 1839 he chose the simplest and most dynamic view, when the traveller first catches sight of the castle, poised between the hills and its own reflections.

Some parts of this drawing are quite intensively worked, with successive washes of bright colour, white highlights and final touches with both brush and pen. However, large areas of the blue paper are left blank, so that its natural colour and texture create the impression of a cloudless sparkling sky and a motionless river. The effect is pure magic.

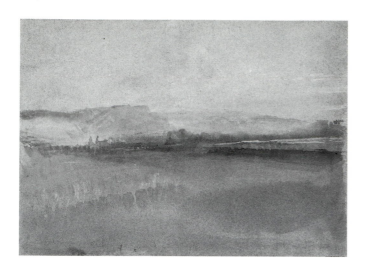

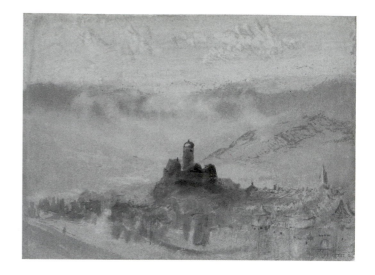

62 Distant View of Coblenz and Ehrenbreitstein *c.*1839

Gouache and watercolour on blue paper
Watermarked: B,E.../182...
139 × 190 (5½ × 7½)
TB CCXXII B
D20261

This view of Ehrenbreitstein, towering above the conflu-ence of the Mosel and the Rhine, is visible for many miles as the traveller approaches Coblenz down the Mosel val-ley. Turner's final gouache of this series (W 1034) shows the view much further down the Mosel, so that the indi-vidual parts of Ehrenbreitstein, the arches of the bridge over the Mosel and the multifarious buildings of Coblenz are all clearly indicated. Sadly, that work can never be shown with the rest of the series, owing to the terms of Henry Vaughan's bequest to the National Gallery of Scot-land in 1900. Turner's series is thus for ever deprived of its grand finale and the more generalised and distant view in the Turner Bequest has to serve as a serene conclusion instead.

63 Mayen in the Eifel *c.*1839

Gouache and watercolour on blue paper
141 × 188 (5⁹⁄₁₆ × 7⅜)
TB CCXXI U
D20254

Besides the gouache scenes depicting the famous sights of the Meuse and the Mosel, Turner also painted an equiva-lent number of others, showing views which had particu-larly impressed him on the same tour and been recorded in pencil sketches. These included Spa and Franchimont in Belgium, the city of Luxembourg and at least four Ger-man scenes: three showing the Rhine with Ehrenbreit-stein from Coblenz (TB CCLIX 244, 268, 239; Powell 1991, nos.80–2) and cat.no.63. Turner had passed Mayen when travelling across the Eifel from Coblenz to Cochem and sketched it in the same sketchbook that was in service along the Mosel from Cochem up to Trier (TB CCXC 42v–43v).

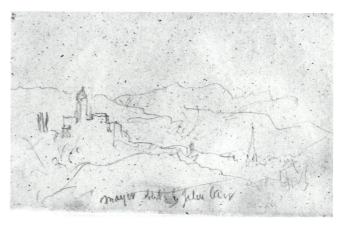

Mayen (TB CCXC 43r)

Turner's scene is dominated by the Genovevaburg, a great castle built between 1280 and 1311 for the Archbishops of Trier. On the right can be seen St Clement's church with its twisted spire and, in the foreground, the town walls and the Brückentor. Today Mayen is greatly changed but late nineteenth-century photographs show it very much as Turner depicted it.

On one of Turner's pencil sketches he noted the impressive fact that Mayen was 'built by Julius Caesar', an opinion not shared (so far as the present writer is aware) by any modern guidebook. There may, however, be a simple explanation of this mysterious note. In Murray's *Handbook for Northern Germany* (1836), the final words on p.251 talk of the 'picturesque and ancient' town of Mayen and the final words on p.253 are 'it may fairly be considered the oldest city in Germany. Julius Caesar'. Turner, leafing briskly through the book whilst actually on his tour, obviously assumed that both comments referred to the same place; in fact, those on p.253 related to Trier!

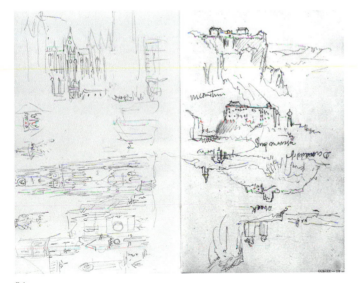

64

Trieste, Graz and Danube sketchbook (formerly known as *Danube and Graz*) 1840

64 Two Sketches of Vienna Cathedral and Four Copies of Jakob Alt's Lithographs of the Danube

Pencil
Page size: 198 × 127 (7^{13}/$_{16}$ × 5)
Cream wove paper
Watermarked: J. WHATMAN
Inscribed: 'Wildenstein'; 'Singmaringen'; 'Danaustof'; 'Aback' (f.10)
TB CCXCIX ff.9 verso, 10
D30019, D30020

This is one of three almost identical sketchbooks which Turner bought in Austria on his way to Venice in August 1840. The full stop after the 'J' in their watermarks shows that their paper is not genuine Whatman but an imitation produced at three Austrian mills and nowhere else in Europe. The other two sketchbooks were cat.no.65 and one used in Venice itself (TB CCCXIII). Cat.no.64 was not brought into service until Turner had left Venice (on 3 September) and was surveying the spectacular gulf of Trieste. It was in use for about a week thereafter, in Trieste itself, Graz, Vienna and while Turner was travelling up the Danube by steamer as far as Passau.

The sketches of Vienna cathedral, the Stefansdom, on f.9v are from a mere handful of quick drawings of the city made on Turner's second visit there on 7 September. He stayed at a hotel just off the Graben and it was probably there that he saw and made the tiny sketch copies of several prints of the Danube which are a notable feature of this sketchbook. All four of the copies on f.10r were drawn from Jakob Alt's famous series of lithographs, *Donau-Ansichten* (1819–26), and record notable sights in Germany: the castles of Wildenstein and Sigmaringen, Donaustauf near Regensburg (which Turner visited about a week later, finding the scenery much altered by the building of the Walhalla), and finally Abbach (Alt, pls.5, 6, 39, 34).

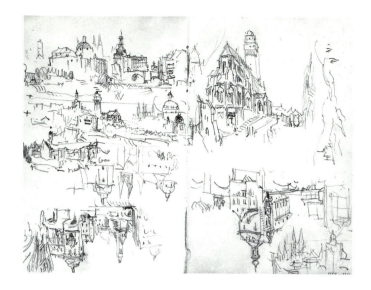

Venice; Passau to Würzburg sketchbook (formerly known as *Coburg, Bamberg, and Venice*) 1840

65 Nine Sketches of Bamberg

Pencil
Page size: 198 × 127 (7¹³⁄₁₆ × 5)
Cream wove paper
Watermarked: J. WHATMAN
Inscribed: 'Back of 3 Crowns' (f.26v)
TB CCCX ff.26 verso, 27
D31327, D31328

Like cat.no.64, this sketchbook is composed of paper with a fake Whatman watermark, manufactured in Austria where it must have been bought. Turner initially used it in Venice, laid it aside while he sketched in cat.no.64, and then brought it out again when he reached Passau in Germany. It provides a very full record of his homeward journey through Regensburg, Nuremberg, Bamberg and Coburg, with one last sketch depicting Würzburg before he began sketching in the final book of the tour (cat.no.66). The pencil sketches include some of the most carefully drawn of all Turner's German studies of this tour with the exception of his Mosel series (cat.nos.67–81). Inspired by the cities through which he was travelling, he recorded many of them on larger sheets of paper as well, often colouring these shortly afterwards (see cat.nos.94–6, 98–101, 105–6).

Turner is recorded as staying at the Three Crowns hotel in Bamberg on 16–17 September. During his brief visit he snatched quick sketches of many of its historic buildings and fine prospects. Among those sketched from different viewpoints on ff.26v–27r are the Obere Pfarr-kirche with its tall square tower and Gothic apse, and the Old Town Hall on its island, a medieval building given a

baroque façade in the mid-eighteenth century. By contrast, one tiny sketch, annotated 'Back of 3 Crowns', in the middle of f.26v, simply shows the view that greeted Turner when he slipped out of his hotel.

Würzburg, Rhine and Ostend sketchbook (formerly known as *Ostend, Rhine, and Würzburg*) 1840

66 The Domstrasse, Würzburg

Pencil
Page size: 172 × 101 (6¾ × 4)
Flecked blue laid paper of south German origin
Watermarked with the Tree of Liberty mark
Countermarked with an indecipherable maker's name
TB CCCIII ff.88 verso, 89
D30631, D30632

This was the final sketchbook to be used on Turner's 1840 tour, not being brought into service (or possibly not even being bought) until Würzburg, the last of the historic German cities which he studied so intently in that

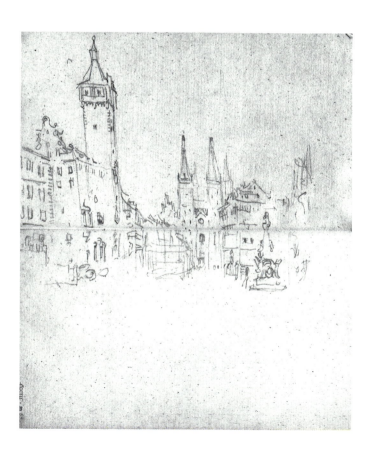

year. Besides some forty pages depicting Würzburg, the book also contains a large number of sketches of sights between Mainz and Cologne, hastily scribbled down as the steamer on which Turner was travelling took him homewards down the Rhine. Finally, he crammed in a number of spirited drawings of Ostend which he reached at the beginning of October. These sketches – and, perhaps more particularly, the experience of departing from Ostend in 1840 – contributed to the lively depiction of that town from the sea which Turner exhibited at the Royal Academy in 1844 ('Ostend', B&J 407, Bayerische Staatsgemäldesammlung, Neue Pinakothek, Munich).

Turner's arrival in Würzburg was noted in a newspaper of 23 September which also names his hotel, the Wittelsbacher Hof in the market place. From here it was a very short walk to the view recorded on ff.88v–89r. The Domstrasse runs directly eastwards from the Main bridge to St Kilian's cathedral, a medieval building with four slender towers. The town hall stands on the left and an ornate fountain of 1765 consisting of an obelisk and statues on the right. Turner would already have been familiar with this fine view through the work of artists such as Samuel Prout and Robert Batty.

67 Distant View of Cochem from the South 1840

Pencil, watercolour and gouache on grey paper
140 × 192 (5½ × 7⁹⁄₁₆)
TB CCXCII 40 ('Visp, Rhône Valley (?)', c.1834)
D28987

In 1840 Turner made many drawings on pieces of grey paper, some measuring c. 5½ × 7½ inches (like cat.nos.67–81), some measuring c. 7½ × 11 inches (like cat.nos.83–4, 94–6, 98–101). All these pieces of paper were created by the artist folding and tearing larger sheets into eight or sixteen and then treating the smaller pieces as a sketching block or pad. The paper is of a consistent type, bearing the watermark of Bally, Ellen and Steart and the date 1829. Some sketches are executed in pencil alone (occasionally with white highlights), others were coloured. The latter were not based on pencil sketches in sketchbooks, but were simply pencil sketches which were

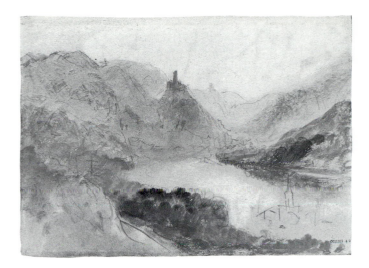

themselves coloured, sometimes only very slightly with pale washes of watercolour, sometimes with much greater richness and density. They were executed as memoranda, not as parts of any programmatic sequence.

Some of these drawings on grey paper have been variously identified and dated in the past, but most have remained ignored in the Turner Bequest since the artist's death. However, a substantial group depicts places in Germany that Turner visited on only one tour – that of 1840: Coburg, Passau and Burg Hals, Regensburg and the Walhalla. These may now be securely dated to that year, and other drawings that share striking similarities of style, colour, technique and vision have here been attributed to 1840 also.

In the group of small coloured drawings depicting the Mosel as far south as Cochem, Turner repeatedly drew the same views that he had recorded in both pencil sketches and his gouache series of 1839. The distant view of Cochem in cat.no.67 was drawn from even further away from the town than the equivalent scene in the 1839 series (cat.no.52). In the 1840 series cat.nos.67–70 all show Cochem from the south, with the same features reasserting themselves in each scene, sometimes in the same or similar colours, sometimes not. The church with the pointed spire, sketched in pencil, apparently in mid-river, in cat.no.67, appears in its proper location on the left bank in cat.nos.68 and 69. This jotting down of details wherever it suited him is a constant feature of Turner's sketching practice and examples can be found in virtually all of his sketchbooks (see also cat.no.71).

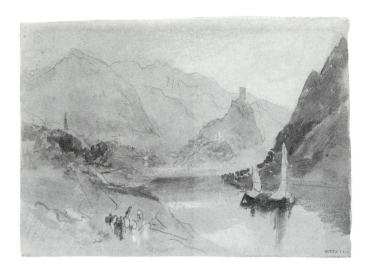

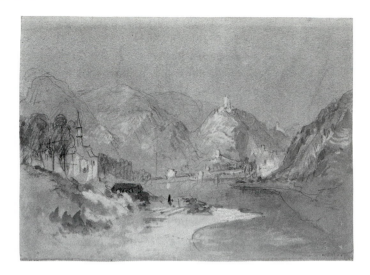

68 Distant View of Cochem from the South 1840

Pencil, watercolour and gouache on grey paper
140 × 190 (5½ × 7½)
TB CCXCII 16 ('River scene, with castle on rock. (Possibly Beilstein.)', *c.*1834)
D28963

Cochem is here slightly closer than in cat.no.67. The Peterskapelle – a small plague chapel built in 1422 – is visible on the mound below the castle, as is the spire of the Antoniuskirche at Sehl, the little church behind the trees on the left bank. Figures are seated nearby and sailing boats glide down the river – both a rare feature in this series.

The subject of this scene was correctly identified as Cochem when it was exhibited in Luxembourg in 1984 (no.42), but the castle was incorrectly described as the Winneburg. It is, of course, the main castle of Cochem, the Burg, sometimes referred to as the Reichsburg.

69 Cochem from the South 1840

Pencil, watercolour and gouache on grey paper
140 × 189 (5½ × 7⁷⁄₁₆)
TB CCXCII 69 ('River scene, with town and fortress', *c.*1834)
D29020

Turner's viewpoint is now close to Cochem. From here its walls and gate towers are clearly visible and the second castle of this neighbourhood, the Winneburg, is now discernible. It stands on a distant blue-grey hill whose limpid colouring echoes that of the river itself.

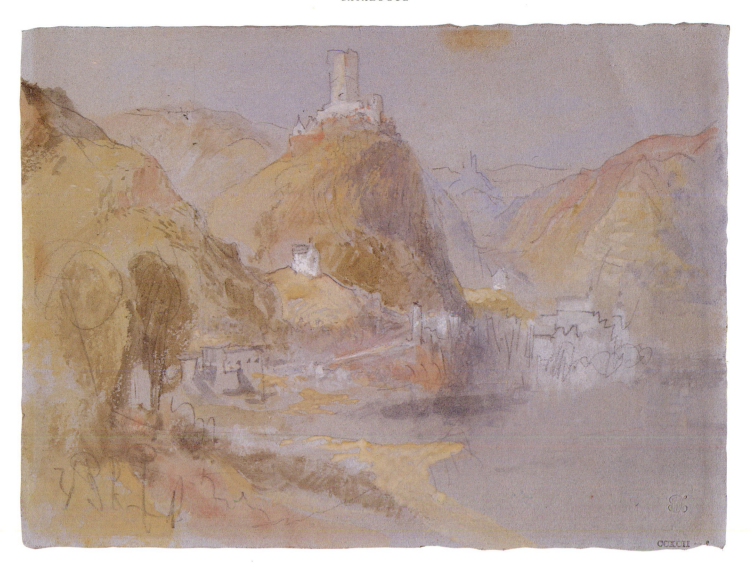

70 Cochem from the South 1840

Pencil, watercolour and gouache on grey paper
140 × 190 (5½ × 7½)
TB CCXCII 3 ('Cochem, on the Moselle', c.1834)
D28950
Verso: a small pencil sketch of a church and cliff,
presumably near Cochem

The composition of this scene is very similar to that of the
corresponding view on blue paper of 1839 (cat.no.52),
though Turner's viewpoint is now on the left bank rather
than in mid-river. As in cat.no.52, the buildings of the
town are largely indicated by judiciously placed white
highlights, while a subtle variety of colours is used for the
landscape.

71 Cochem from above the Enderttal 1840

Pencil, watercolour and gouache on grey paper
140 × 191 (5½ × 7½)
TB CCXCII 45 ('Town on Moselle (?)', *c*.1834)
D28992
Verso: a pencil sketch of Cochem from a similar viewpoint to
that on the recto

This is the only drawing of 1840 to show clearly St Martin's church and the Enderttor which were both depicted in 1839 (see cat.nos.53–4). The tonality and handling of the present work are similar to those in both the earlier scenes, showing that Turner deliberately sought out a favoured viewpoint at the same time of day as on his previous visit. In the foreground he has included a pencil memorandum of the silhouette of the spire of St Martin's church.

72 Cochem from above the Enderttal 1840

Watercolour and gouache on grey paper
140 × 194 (5½ × 7⅝)
TB CCXCII 27 ('Castle on rock', *c*.1834)
D28974
Verso: a slight pencil sketch showing Cochem from a view-
point similar to cat.no.70

Like the final view of Cochem in 1839, looking straight into the sun, this scene is the most dynamic and colourful of the series (compare cat.no.56). The fact that no pencil is visible anywhere in this drawing suggests that some of Turner's colouring at Cochem must have taken place out of doors.

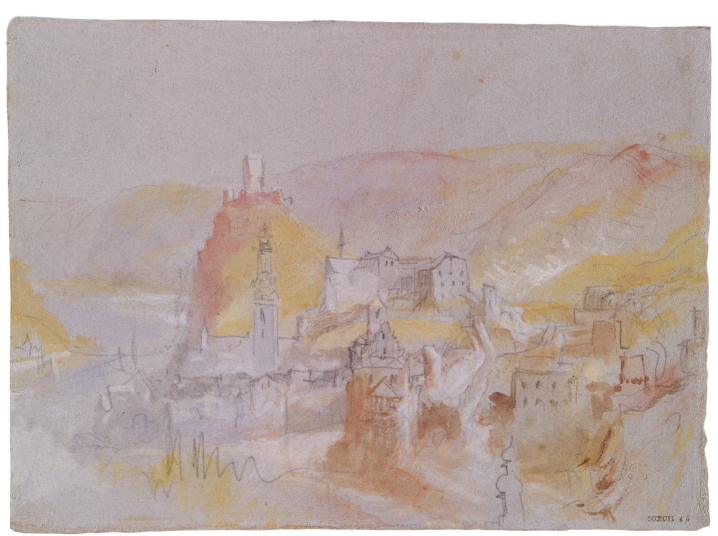

71

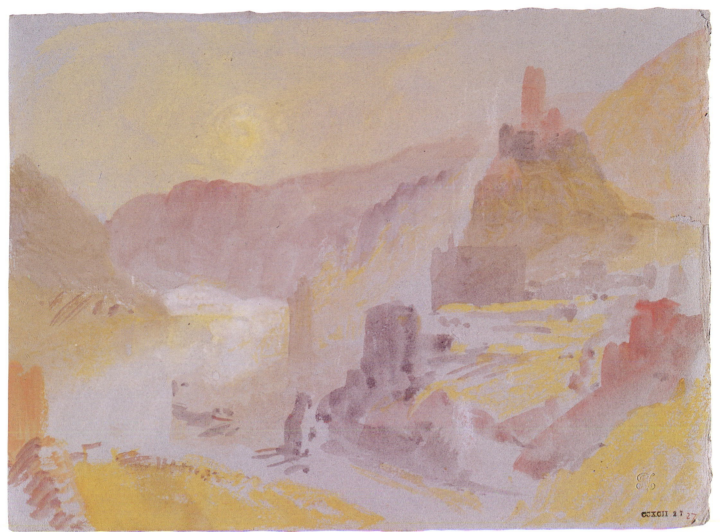

72

73 Cochem from the North 1840

Pencil, watercolour and gouache on grey paper
142 × 191 (5⁹⁄₁₆ × 7½)
TB CCXCII 51 ('Town, with ruined castle, on Moselle',
c.1834)
D29000
Inscribed: 'Mos'

For his last view of Cochem looking upstream from the
river bank, Turner used the same colouring as in his views
from the south (cat.nos.67–70). His distance from the
town is similar to that in two of his 1839 gouache views of
Cochem (cat.nos.55–6) and, as in that series, the hill on
the right of the scene stands in dramatic contrast to the
distant town. In 1839 a fiery red was used, in 1840 a som-
bre black.

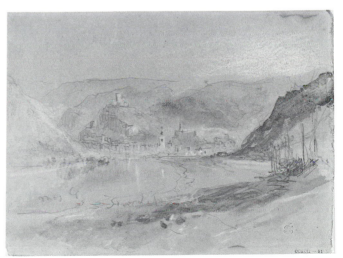

73

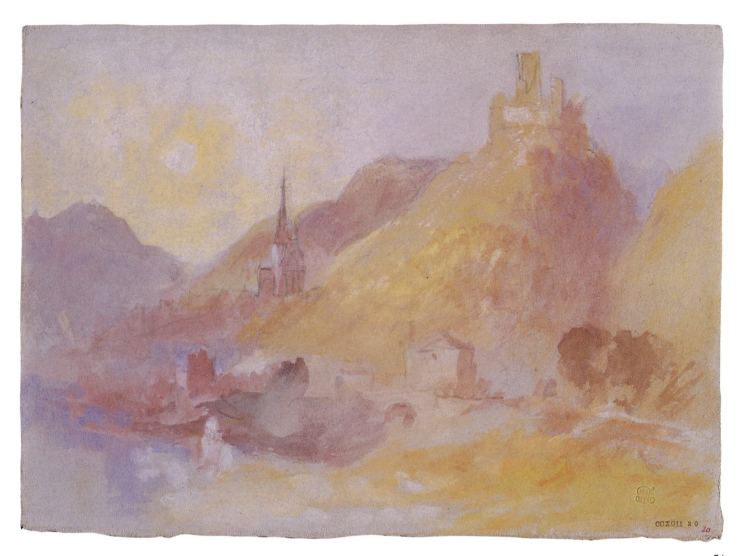

74

74 Klotten and Burg Coraidelstein from the East 1840

Pencil, watercolour and gouache on grey paper
140 × 191 (5½ × 7½)
TB CCXCII 20 ('Town, with castle on rock above. (?Beilstein)',
c.1834)
D28967

In this scene Turner looks straight into the sun from a viewpoint close to that used for a gouache scene in 1839 (TB CCXCII 78; Powell 1991, no.70). The colours of the right-hand half are close to those in the view of Burg Bischofstein (cat.no.78), while those in the left-hand side and the shadowed side of the gorge below the castle echo those used in a view of Ehrenbreitstein (cat.no.81).

75 Treis from the North 1840

Pencil, watercolour and gouache on grey paper
140 × 195 (5½ × 7¹¹⁄₁₆)
TB CCXCII 50 ('River scene, with town and mountains',
c.1834)
D28998
Verso: a pencil sketch, probably of the Leyen Burg at
Gondorf

Turner's viewpoint is looking upstream from Karden and includes the little white Zilleskapelle on its cliff with the town of Treis beyond. In both composition and colouring the scene is very like that of the previous year (cat.no.58), but Turner's handling is far more sketchy, the patches of colour left as abstract shapes rather than being tidied up to represent particular features of the landscape.

This sheet originally formed part of the same sheet as eight others of the same size which bear pencil drawings of the Rhine on both recto and verso. These include views

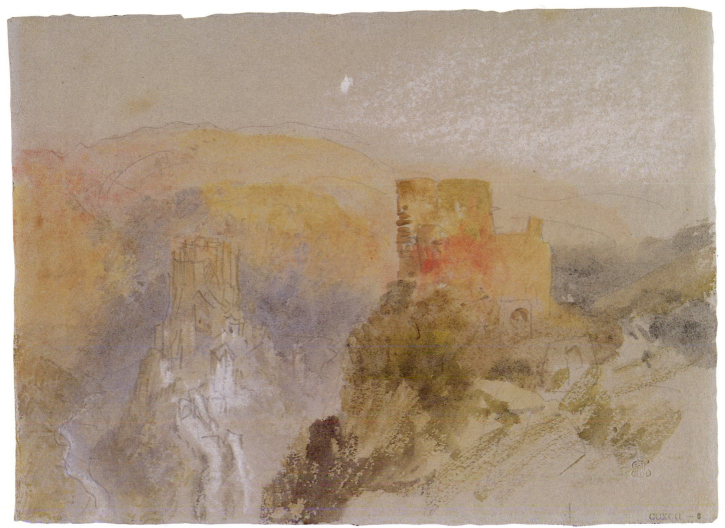

76

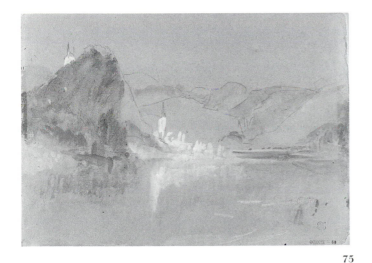

75

of Bonn, the Godesburg, Rolandseck, the Drachenfels, Hammerstein and Burg Rheineck (TB CCCXLI 194–209). The sheet is watermarked BE&S/1829.

76 Burg Eltz and Trutz Eltz from the North

1840

Pencil, watercolour and gouache on grey paper
140 × 192 (5½ × 7⁹⁄₁₆)
TB CCXCII 8 ('Schloss Eltz, on the Moselle', c.1834)
D28955

77 Burg Eltz and Trutz Eltz from the North

1840

Pencil, watercolour and gouache on grey paper
141 × 190 (5⁹⁄₁₆ × 7½)
TB CCXCII 41 ('Ravine, with ruined castles in foreground', c.1834)
D28988

Burg Eltz is a wonderfully preserved castle which lies about four miles from the Mosel in a highly secluded spot

roughly half way as the crow flies between Karden and Burg Bischofstein (cat.nos.59, 78). It crowns an elliptical rock over two hundred feet high overlooking the narrow and tortuous valley of the Eltz, which joins the Mosel at Moselkern, and has remained in the possession of the Counts of Eltz since the twelfth century. Turner did not penetrate this peaceful wooded area either in 1824 or in 1839, but in 1840 he did so at last, recording Burg Eltz in these two works.

In cat.no.76 Turner's viewpoint is close to the ruins of Trutz Eltz or Baldeneltz, a castle built on the hill immediately opposite by Archbishop Baldwin of Trier in 1331. Baldwin carried on a feud with the Counts of Eltz and forced the castle to capitulate after a two year siege. This was the only important conflict in the castle's history and it is one of the few Rhenish castles never to have been destroyed by force.

Burg Eltz was already attracting visitors by Turner's day (see Schreiber 1818, p.176, transcribed by Turner himself in TB CCXVI 7r; cat.no.1 and fig.16, p.31) and a special viewing station had been constructed above Trutz Eltz. Clarkson Stanfield had used this for a lithograph in his *Sketches on the Moselle, the Rhine, & the Meuse* (1838) and Turner drew cat.no.76 from here. It afforded an admirable view of Burg Eltz and its rock at their most slender and of the only approach to the castle, which consisted of a road across a narrow bridge followed by a steep flight of steps. Furthermore it gave the viewer the unexpected experience of looking down upon the numerous turrets and gables of the castle as in a bird's eye view, instead of gazing up at it against the sky as in so many other depictions of castles. The viewing station is itself shown on the left of cat.no.77, which, being drawn from further up the hillside, shows the two castles in far less detail.

Turner evidently did not approach close to Burg Eltz in 1840, but made up for this on a subsequent visit (see cat.nos.111–12).

77

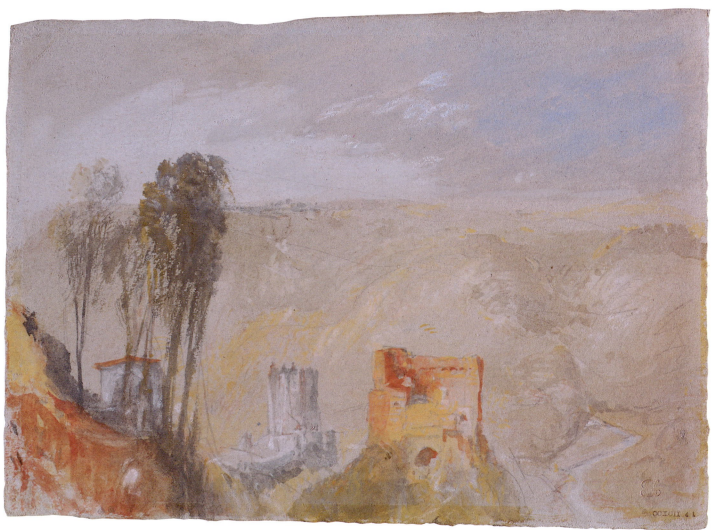

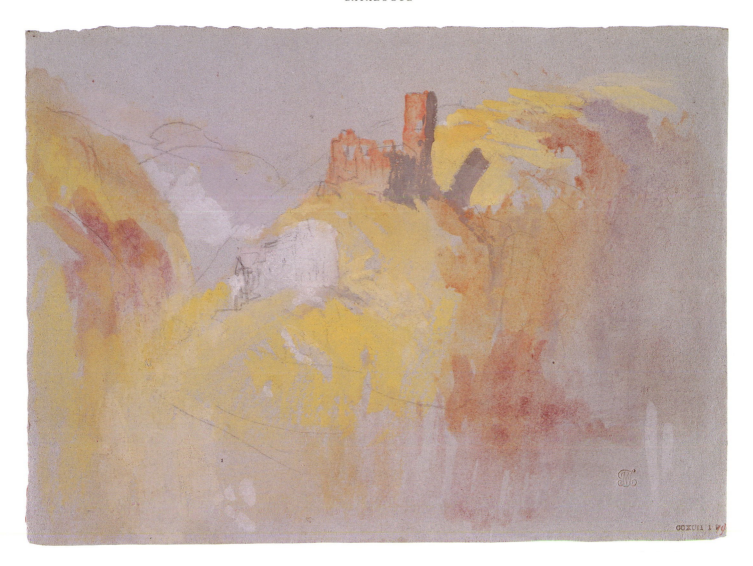

78 Burg Bischofstein 1840

Pencil, watercolour and gouache on grey paper
139 × 190 (5½ × 7½)
TB CCXCII 19 ('Ruined castle. Possibly Clotten', c.1834)
D28966

Turner's 1840 depiction of Burg Bischofstein shows the castle from a totally different viewpoint from that in his 1839 scene (cat.no.60). However, even in 1839 his eye had been caught by the composition exploited here and he had recorded it in two pencil sketches (TB CCXCI 14v, 15r).

The dark gaunt tower of Burg Bischofstein is transformed by the setting sun, but casts a sinister shadow on to the hillside behind it. The paler building of the Pauluskapelle situated lower down the hillside seems insubstantial compared to the blazing hillside itself, celebrated in a sunburst of gold comparable to those in some of Turner's Venetian scenes on grey paper of the same year (e.g. TB CCCXVII 27).

Burg Bischofstein (TB CCXCI 14v), 1839

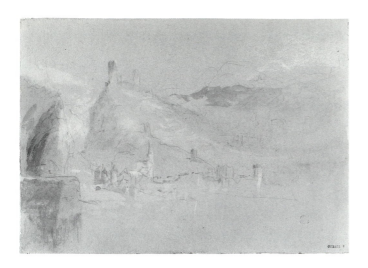

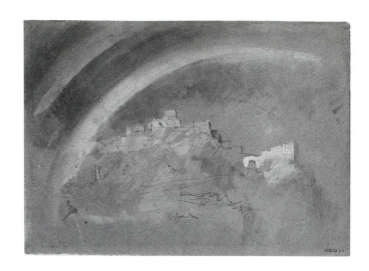

79 Alken and Burg Thurandt 1840

Pencil, watercolour and gouache on grey paper
140 × 195 (5½ × 7¹¹⁄₁₆)
TB CCXCII 2 ('Alken, on the Moselle', *c.*1834)
D28949
Verso: a pencil sketch of the inner face of the Leyen Burg at
Gondorf, a few miles north of Alken (compare TB CCXCI 26r,
drawn in 1839)

In this drawing Turner shows clearly the two towers of
Burg Thurandt, the twelfth-century church of St Michael
and the walls and towers of Alken. He did not include this
view in his gouache series of 1839, but he did record it in
pencil in that year (see TB CCXCI 20v, 21r).

The paper on which cat.no.79 was drawn has very dis-
tinctive mould marks, a characteristic it shares with one of
the drawings of Burg Eltz (cat.no.76), one of Burg Hals
(cat.no.92), one of Coburg (cat.no.99) and one of Venice
(TB CCCXVII 2).

80 Ehrenbreitstein with a Rainbow 1840

Pencil, watercolour and gouache on grey paper
140 × 193 (5½ × 7⁹⁄₁₆)
TB CCXCII 32 ('Ruins, with rainbow', *c.*1834)
D28979
[Exhibited in Germany only]

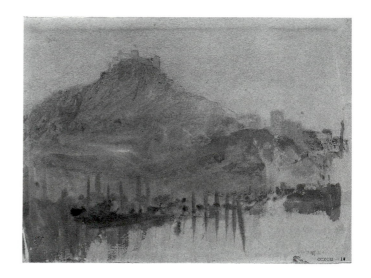

81 Ehrenbreitstein and the Bridge of Boats
 over the Rhine 1840

Watercolour and gouache on grey paper
139 × 190 (5½ × 7½)
TB CCXCII 10 ('Castle on mountain', *c.*1834)
D28957
[Exhibited in Germany only]

This selection of small coloured studies on grey paper
ends with two very different depictions of one of Turner's
favourite Rhine subjects, Ehrenbreitstein. In cat.no.80 the

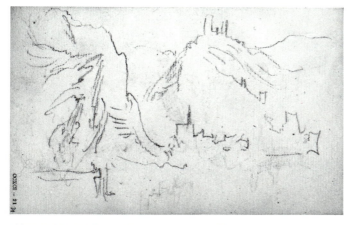

Alken and Burg Thurandt (TB CCXCI 21r), 1839

fortress is quite crisply delineated but is dwarfed by the immense and brilliant rainbow soaring over it. By contrast, cat.no.81 shows a much simpler view of Ehrenbreitstein. The last rays of sun catch its high walls while the lower parts of the east bank of the Rhine are already in shadow (compare these colours with those in cat.no.74) and the masts of the bridge of boats are reflected in the still waters of the foreground.

82 A View of Bregenz 1840

Pencil, chalk, watercolour and gouache on blue paper
191 × 282 (7½ × 11⅛)
Courtauld Institute Galleries, London (Spooner Bequest)
W 1350
[Exhibited in London only]

The Austrian town of Bregenz lies at the easternmost point of Lake Constance, some eight miles from where the Alpine Rhine enters that lake, and in Turner's day was a place of considerable traffic, being on the border of both Bavaria and Switzerland. It was here that he parted from his travelling companions of 1840, Mr and Mrs 'E.H.'; they headed for Rome and Turner himself for Venice.

The situation of Bregenz made it a natural subject for Turner and he drew several quick pencil sketches (TB CCCXX 2v, 3v–6r) and four independent coloured studies (W 1349–51 and another work, not listed in Wilton, in the Cooper Art Gallery, Barnsley; on this see the article by F. H. Yardley in *Turner Studies*, vol.2, no.2, 1983, pp.54–5). Why all four of these sketches should have left Turner's possession is a mystery, unless perhaps he gave or sold them to his companions.

The present work shows the view over the Oberstadt, towards the lake, with the famous landmark of St Martin's tower on the right. On the left, on a hill south of the upper town, stands the parish church of St Gallus. The whole scene is sketched with great vitality and economy but many of the light effects – such as the touches of pink gouache on the buildings – are nevertheless superbly managed.

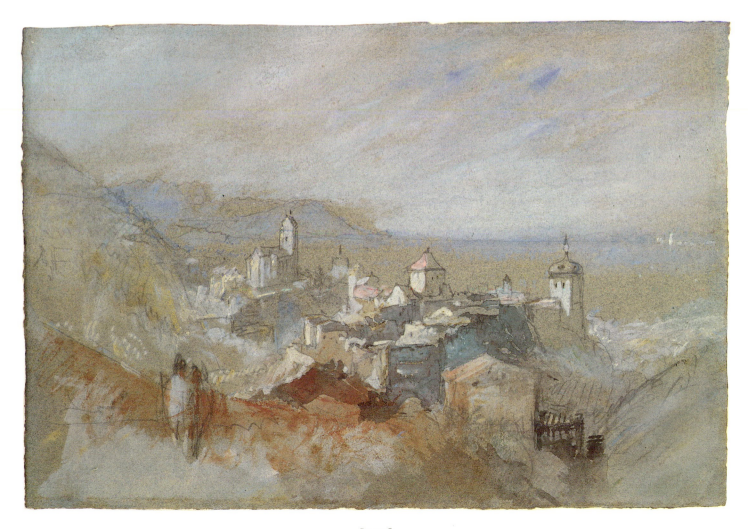

83 Bozen and the Dolomites 1840

Watercolour and gouache on grey paper
196 × 280 (7¹¹⁄₁₆ × 11)
TB CCCXVII 10 ('Mountain pass, with tower', *c.*1839)
D32189

84 Bozen and the Dolomites 1840

Pencil, watercolour and gouache, with pen and ink,
on grey paper
195 × 282 (7¹¹⁄₁₆ × 11⅛)
Watermarked: B[E].../1[8]...
TB CCCLXIV 295 ('Meran', after *c.*1830)
D36152

These two studies were made during Turner's stay in the Austrian town of Bozen in the Tyrol on his way to Venice in August 1840. Bozen (now known as Bolzano and capital of the Italian region of Alto Adige) was one of the most flourishing commercial towns of the area at this date, lying at the junction of roads from Switzerland, Germany and Italy (see Murray 1840, p.266). Its situation is also magnificently picturesque. In both these works Turner's view is identical, looking eastwards towards the Dolomites over the roofs of the town. On the right is the fourteenth-century parish church, with its elegant Gothic spire of 1501–19 rising above a long pitched roof dotted with dormer windows.

The view is almost certainly that from Turner's

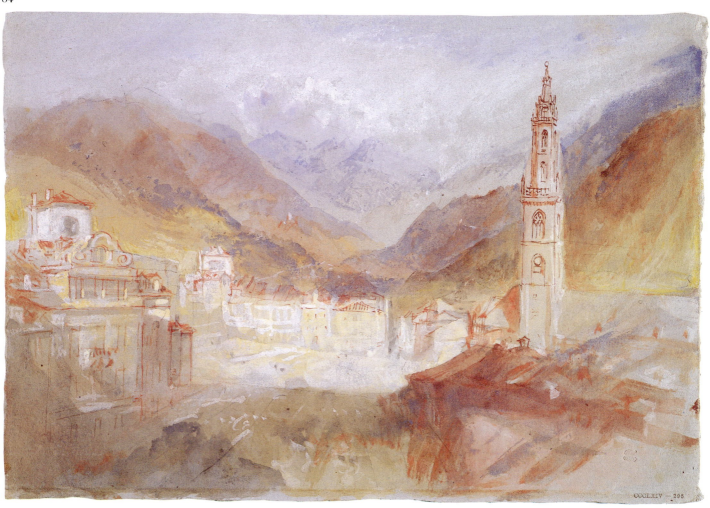

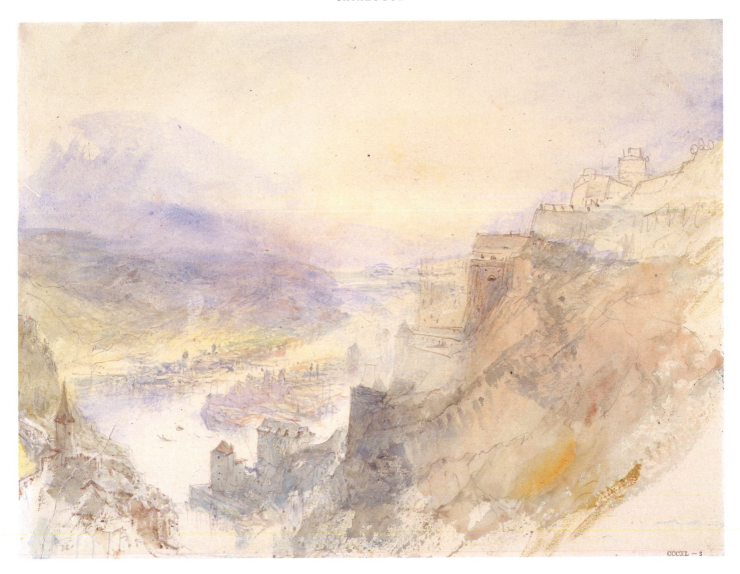

CCCXL — 3

lodgings in Bozen. In cat.no.84 he used pen and red ink to delineate carefully the delicate openwork of the church spire and special features of a number of other buildings he could see from his window, but cat.no.83 is altogether less finished. The blues and plum-pinks used in both are common in Turner's views of Venice on grey paper painted shortly afterwards.

Cat.no.84 originally formed part of the same large sheet as TB CCCLXIV 372, a pencil scene of a mountain valley lightly washed in with similar colours, which bears the other half of the watermark (i.e. …[E]&S/…[8]29).

85 Passau: The Confluence from above the Ilz

1840

Pencil and watercolour
213 × 278 (8⅜ × 10¹⁵⁄₁₆)
Watermarked: R. TURNER
TB CCCXL 3 ('Grenoble (?)', c.1841)
D33668

Ruskin suggested that this drawing depicts Grenoble, but its true subject has long been known. The page comes from a 'roll' sketchbook which is entirely given over to studies of Passau and its environs, sometimes in pencil alone, sometimes – as here – in watercolour (see also cat.nos.86, 88, 93). Turner visited these on only one occasion: in September 1840.

Passau is superbly situated at the confluence of three rivers – the blue Danube, the green Inn and the black Ilz as they are popularly described. From high viewpoints it can be observed that both the first two retain their own

distinctive colouring (if not precisely the hues above) for a considerable distance below the confluence. Passau is not only beautiful in itself but in many ways reminiscent of Venice, especially when its Italianate buildings are seen at dawn or dusk or in brilliant sunlight. Turner's visit to the city took place soon after a sojourn in Venice and, perhaps not surprisingly, there are marked similarities of style, colour and technique between the drawings on white paper made in Passau and those depicting Venice (TB CCCXV).

The viewpoint of cat.no.85 is high above the Ilz valley, looking southward to the meeting of that little river with the Danube and – further away – the Inn. From here Passau seems to be a tiny island city, floating in mist. Most of it is hidden by the numerous fortified buildings on the right, guarding the Danube, including the Oberhaus (at top right) and the Niederhaus (at the water's edge). In the left foreground, to the left of the Ilz, is the suburb of Passau known as the Ilzstadt, with its parish church of St Bartholomew.

86 Passau: View down the Danube 1840

Pencil and watercolour
213 × 278 (8⅜ × 10¹⁵⁄₁₆)
TB CCCXL 9 ('River, with town on island; the rocky banks on either side fortified', c.1841)
D33674
[Exhibited in Germany only]

Like cat.no.85, this is a page from the 'roll' sketchbook formerly known as the *Grenoble(?)* sketchbook which Finberg dated c.1841 and which is here identified as having been used in Bavaria in 1840 and renamed *Passau and Burg Hals*.

In this sketch Turner is looking down the Danube to its confluence with the Inn (visible on the right) and the Ilz (hidden by the buildings on the left). The page was inventoried as f.9r but it must in fact be f.9v since the pencil drawing continues from here on to f.10r. Although much less finished than cat.no.85, this drawing is no less magical, with its simple washes of pure colour set off by the whiteness of the page.

87 Passau from the Ilzstadt 1840

Pencil, watercolour and gouache on grey paper
142 × 188 (5⁹⁄₁₆ × 7⁷⁄₁₆)
TB CCXCII 46 ('Town, with mountains beside lake (or river)', c.1834)
D28993

The viewpoint of this drawing is similar to that of cat.no.85, but Turner is now standing lower down the hill in the Ilzstadt so that the slightly concave spire of St

Passau (TB CCXCII 57)

Bartholomew's church is seen at lower right and the Ilz itself is scarcely visible. Beyond the firm diagonal made by the buildings of the Niederhaus and the Oberhaus, linked by a long wall, much more of Passau can be seen than in cat.no.85: not only the square towers of St Michael's church but also, further right, the domed cathedral with one of its towers. On the far horizon, above the river Inn, stands the pilgrimage church of Mariahilf, built in the seventeenth century.

Turner's style here is far looser than in his depictions of Passau on white paper, but it is consistent with many of the pencil drawings on grey paper which he made in 1840 and did not bother to colour. The fact that he did colour this drawing (and a second one on grey paper, TB CCXCII 57) underlines the special significance he attached to Passau on this tour.

87

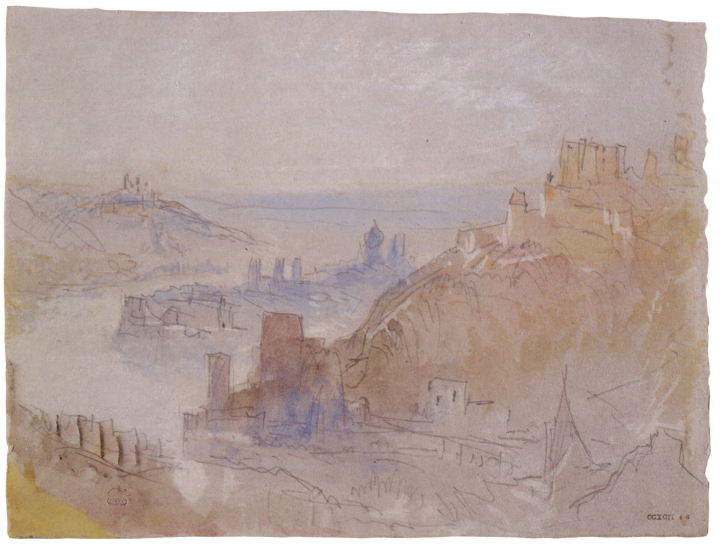

88 Burg Hals on the Ilz 1840

Pencil and watercolour
212 × 275 (8⁵⁄₁₆ × 10¹³⁄₁₆)
TB CCCXL 2 ('Ruined castle on rock', *c*.1841)
D33667

The village of Hals and the ruins of Burg Hals lie some two miles from Passau up the valley of the Ilz, the smallest of the three rivers that unite at that city. In order to reach this spectacularly beautiful spot Turner walked up the Ilz valley after exploring the Ilzstadt at its mouth. At this date an excursion to Hals was routine for visitors to Passau, the ruins often being mentioned or illustrated in books on the Danube even though they strictly lie some way away and cannot be seen from that river (see Beattie, 1844, pp.76–7). The course of Turner's excursion can be traced in the many pencil sketches he made in both TB CCCXL and TB CCCX. Cat.nos.88–92 follow the order of Turner's own experiences.

Burg Hals dates back to at least the twelfth century, its lofty situation and strong walls rendering it extremely secure. It was occupied from the twelfth century to the sixteenth by a number of noble families beginning with the Hals themselves and ending with the Wittelsbachs. In the seventeenth century it was abandoned because of the inconvenience of its site and it gradually fell into ruin. Turner made several pencil sketches of the castle in the *Venice; Passau to Würzburg* sketchbook (TB CCCX; cat.no.65) and both pencil and watercolour studies in the larger *Passau and Burg Hals* sketchbook (TB CCCXL) of which the present work is just one. His pencil sketches show an impressively large complex of walls and towers seemingly growing out of the rock itself in a cluster of jagged outlines which remain today very much as he saw them.

Fine as the view from the river in cat.no.88 is, further beauties still awaited Turner as he continued up the Ilz

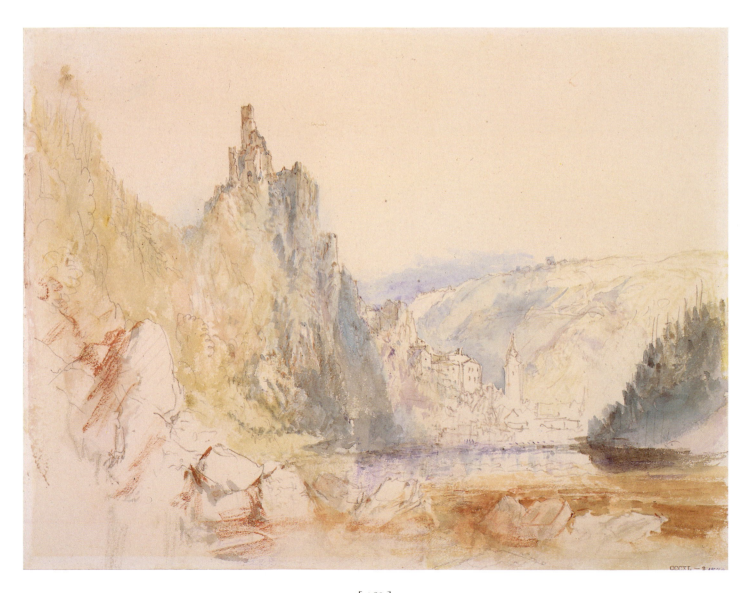

valley since Burg Hals is 'situated on a neck or promontory, formed by an extraordinary bend of the river, which on one side of Hals runs in one direction, and in an exactly opposite direction on the other' (Murray 1837, p.96). To exploit this situation to the full Turner later climbed the nearby hillside to look down on the whole ensemble (see cat.nos.91–2).

89 Hals and Burg Hals 1840

Pencil, watercolour and gouache on brown paper
149 × 226 (5⅞ × 8⅞)
TB CCCLXIV 305 ('On the Rhine', after *c.*1830)
D36162

As well as depicting Burg Hals on both white and grey paper (cat.nos.88, 90–2), Turner also made three coloured sketches of it on brown paper. In the present work his viewpoint on the left bank of the Ilz is very similar to that of one of his pencil sketches (TB CCCX 60v) which reveals that hills rather than clouds loom above the church of St George on the left. The view is the reverse of that depicted in cat.no.88.

'Hals and Burg Hals' was drawn on an Italian brown paper that had been used by Turner in Venice just a few weeks earlier for several coloured drawings of this size including TB CCCXIX 1, 4, 7–10. Two further examples, used for pencil and white chalk drawings, are TB CCCXLII 40, 41. The palette used in cat.no.89 is strikingly similar to that of TB CCCXIX 4, depicting the interior of a church.

The other two depictions of Burg Hals on brown paper (TB CCXCII 60, 61) also have strong similarities of style and palette to some of the Venetian drawings of TB CCCXIX. One of the torn edges of TB CCXCII 60 makes a perfect fit with TB CCCXIX 1, depicting the Salute.

90 Burg Hals: Moonlight 1840

Pencil, watercolour and gouache on grey paper
142 × 190 (5⁹⁄₁₆ × 7½)
TB CCLIX 211 ('Ruined castle among hills', *c.*1830)
duplicated as TB CCXCII 4 ('Castle on rock', *c.*1834)
D24776
[Exhibited in Germany only]

This work shows Burg Hals from further up the Ilz and from a much higher viewpoint than cat.no.89. The composition is similar to that of Turner's pencil sketch on TB CCCX 59v. The mood and colouring are much quieter than those of cat.no.89, a crescent moon having replaced the strong light effects.

91 Burg Hals and the Ilz from the Hillside 1840

Pencil, watercolour and gouache on grey paper
142 × 191 (5⁹⁄₁₆ × 7½)
TB CCXCII 13 ('Mountain scene, with fortress. (? Schloss
Eltz.)', c.1834)
D28960

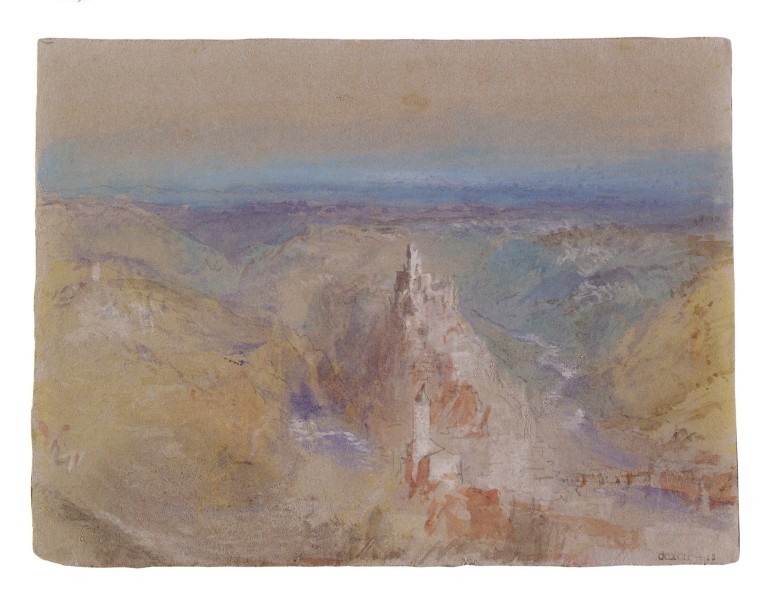

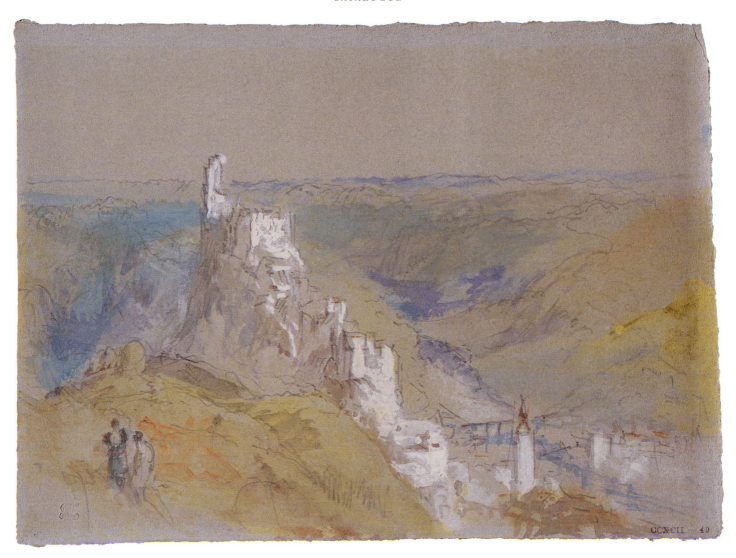

92 Burg Hals from the Hillside 1840

Pencil, watercolour and gouache on grey paper
139 × 189 (5½ × 7⁷⁄₁₆)
TB CCXCII 49 ('Ruined castle on mountain: town and river
below', *c*.1834)
D28997

Finberg's suggestion that cat.no.91 depicts Burg Eltz near
the Mosel has been followed by at least two modern com-
mentators (Wilkinson 1975, p.96, and Luxembourg 1984,
no.48). However, both cat.nos.91 and 92 actually show
Burg Hals, the church of St George and the village of
Hals which lie on the river Ilz two miles north of Passau.
These two drawings were made from high viewpoints on

the nearby hill path back over to Passau, by which Turner
must have returned. From here, he was able to see Hals at
its most spectacular, with the Ilz flowing on either side of
the ruin and the village nestling below. Burg Reschenstein
(cat.no.93) is also visible in the left distance of cat.no.91.

Turner did not often use blues and greens in his 1840
Mosel scenes (cat.nos.67–81), but the clear blue and
turquoise green in cat.no.92 are close to those found in
some of his Venetian scenes on grey paper (e.g. TB
CCCXVII 20). The resemblance is perhaps not surprising,
given that Turner visited and sketched Burg Hals soon
after leaving Venice, several weeks having elapsed since he
had completed his Mosel drawings.

93 Burg Reschenstein on the Ilz 1840

Watercolour
211 × 276 (8⁵⁄₁₆ × 10⁷⁄₈)
Watermarked: R. TURNER
TB CCCXL 1 ('Swiss scene', *c.*1841)
D33666

A mile to the north of Burg Hals is the neck of a second meander in the river Ilz which was guarded in former times by Burg Reschenstein high above it, just as Burg Hals guarded the more southerly one. The neck of this meander was cut through in 1827–9 by a tunnel containing both a water channel and a narrow walkway. The tunnel through the rock is 143 yards long and thirteen feet wide. Together with the adjacent boom, it enabled enormous amounts of driftwood from the Bavarian forest to make the passage down to the great shipbuilding centre of Passau more speedily than in previous centuries.

Turner drew Burg Reschenstein from the path along the Ilz just a few minutes' walk northwards from Burg Hals. As the walker follows the course of the little river, which bubbles prettily over numerous groups of rocks, the solitary tower of the ruined medieval castle suddenly comes into view above the trees. With its delicate colouring Turner's drawing captures all the charm and freshness of this scene, and he even indicates the entrance to the tunnel by the inclusion of what seems at first sight to be simply a misty gorge between two parts of the steep hillside to the right. The river itself contains a quantity of driftwood while the angle of some of the trees on the right hints at their future destiny.

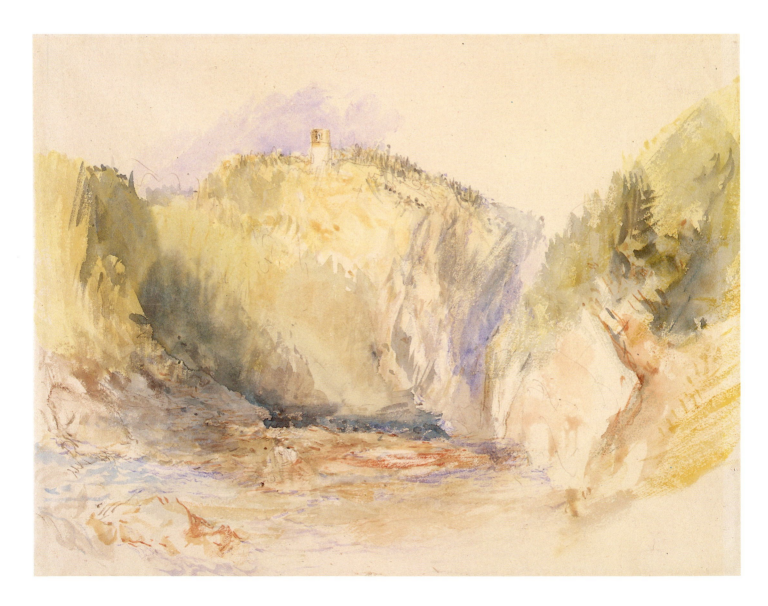

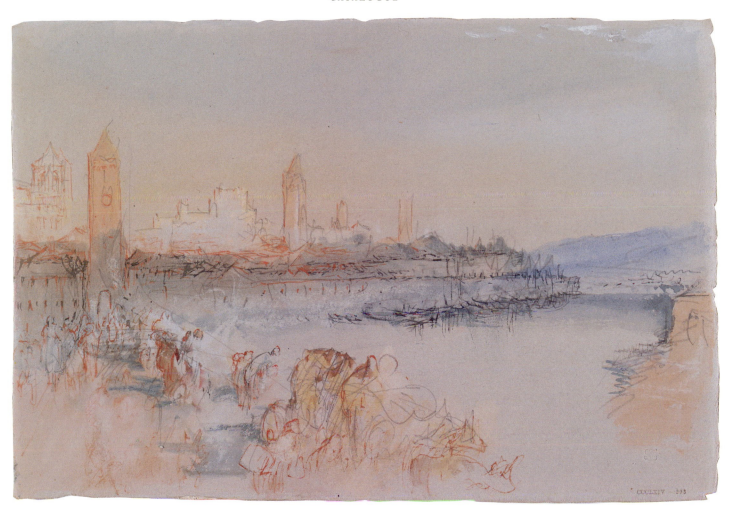

94 Regensburg from the Bridge 1840

Pencil, watercolour and gouache, with ink, on grey paper
191 × 283 (7½ × 11⅛)
Watermarked: ...E & S/...829
TB CCCLXIV 293 ('Seaside fort, with towers. Perhaps in
North Italy, near Venice', after *c.*1830); Wilton (1982), pl.77
('Mainz')
D36150

This view of Regensburg shows the city from the north-
ern end of the bridge over the Danube in the very early
morning when the sun has caught the tops of the build-
ings but not yet illuminated anything below roof level.
Turner must have seen Regensburg thus when leaving it
to walk to the Walhalla via the viewpoints of cat.nos.94–6.
On the left are the west towers of Regensburg cathedral
(the open-work caps crowning them today were not built

until 1859–69), the massive Salzstadel (salt barn) and – at
the end of the bridge itself – the tall Brückturm or bridge
tower. To its right Turner shows many further towers of
the city, above an array of old houses and numerous boats.
These include the Goliath House, the Golden Tower and
the town hall. Despite the early hour, many people are
already on the move on the bridge, going about their daily
tasks. Turner's viewpoint for this drawing was quite close
to that of cat.no.95; between them they show all the major
features of Regensburg's Danube front in an economic
fashion typical of the artist at this date.

This sheet originally formed part of the same sheet as
cat.no.96 (q.v. for details). The other half of the water-
mark occurs on TB CCCXLI 364, a distant view of the
Walhalla.

95 Regensburg from across the Danube 1840

Pencil, watercolour and gouache, with ink, on grey paper
189 × 277 (7⁷⁄₁₆ × 10⁷⁄₈)
TB CCCLXIV 294 ('Tours', after c.1830)
D36151

This drawing shows a view that was popular with visitors to Regensburg in Turner's day, since it includes two of the city's most famous features: its Gothic cathedral (on the left, with its two west towers) and the long stone bridge over the Danube. The bridge dates back to the twelfth century when the achievement involved in spanning the 330-yard river with fifteen barrel-vaulted stone arches, supported by piles of oak driven deep into the river bed, was regarded as the eighth wonder of the world. In the nineteenth century: 'Of the three principal bridges of Germany, that of Dresden is said to be the most elegant; that of Prague, the longest; and that of Ratisbon [i.e. Regensburg], the strongest' (Planché 1828, p.12). On the right-hand part of the bridge Turner has shown clearly the wedge-shaped buttresses between the arches, intended to protect them from ice-floes. However, he has expended little care on the details of Regensburg itself which is seen more clearly in cat.no.94.

The colouring, style and technique of this drawing and cat.no.94 have much in common with those of Turner's grey paper drawings of Venice of a fortnight or so earlier: the juxtaposition of different blues, purples and muted reds and the use of vigorous penwork in a variety of inks for foreground details are especially noteworthy (compare TB CCCXVII 28, 29).

96 Distant View of Regensburg from the Dreifaltigkeitsberg 1840

Pencil, watercolour and gouache on grey paper
190 × 280 (7½ × 11)
TB CCCLXIV 296 ('Metz', after c.1830)
D36153

Continuing on his early morning walk to the Walhalla (see cat.nos.94–5), Turner climbed the Steinweg to the church

95

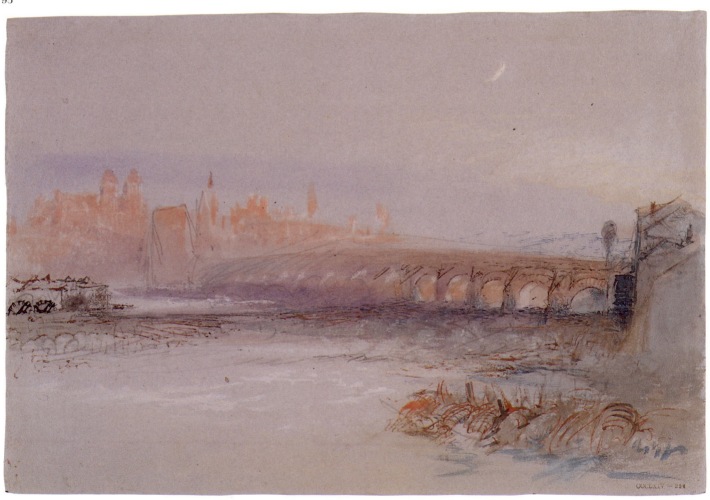

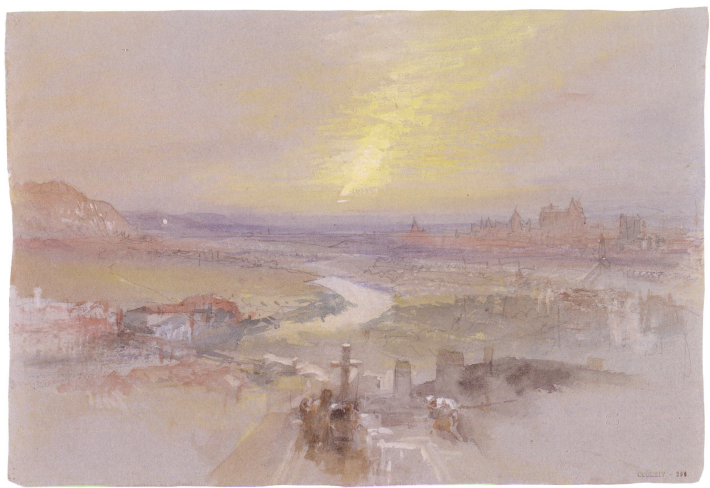

96

of the Dreifaltigkeit which crowns the hill directly to the north of Regensburg. From here and the adjacent cemetery a fine view may be obtained not only of Regensburg itself but also of the Regen, the Danube tributary that gives the city its name. In Turner's drawing Regensburg is seen on the right, the cathedral conspicuous by its bulk and two towers, the bridge over the Danube and the bridge tower just distinguishable to its right. On the left is the village of Reinhausen and the Regen, occupying the centre of the picture, flows away to join the Danube in the middle distance. The small white dot on the purple hillside above Reinhausen is the distant Walhalla (see cat.nos.97, 109), its pristine marble sparkling against its dusky hill. Turner's perennial search for good viewpoints often led him, as here, to hillsides and graveyards outside villages and towns and the praying figures observed and sketched on this occasion may well have influenced his choice of the same motif in his oil painting of the Walhalla itself.

This drawing was made on part of a much larger sheet of paper which was folded and torn into eight. Six of the other seven drawings have also been newly identified as showing Regensburg or the Walhalla. Regensburg is depicted in TB CCCXLI 360, drawn close to cat.no.96 and showing the church of the Dreifaltigkeit with the cemetery entrance arch on the left; TB CCCXVII 6, a very swift

Regensburg from the Dreifaltigkeitsberg (TB CCCXLI 360)

coloured drawing taken from Turner's hotel, the Drei Helmen, and recording a brilliant yellow sky which evidently reminded him of those of Aelbert Cuyp for it is inscribed 'Cyp'; and TB CCCLXIV 293 (cat.no.94). The Walhalla is shown in TB CCCXLI 363, 364 and 371 (see fig.54 on p.71).

97

97 The Walhalla, near Regensburg on the Danube *c.*1840–2

Pencil and watercolour
244 × 306 (9⅝ × 12)
Inscribed on the verso, in pencil: '19 Va'
TB CCCLXIV 316 ('River and bridge. Query Ratisbon', after *c.*1830; Wilton 1982, pl.73, as the Walhalla)
D36174

Although much of this view is indistinctly seen through a misty veil of colour, there can be no mistaking the dominant feature on the right: the huge temple of the Walhalla on its hill, rising above a white marble substructure of many tiers and over three hundred steps. Below it lies the Danube with the wooden bridge at Donaustauf, the ruined castle of which looms out of the haze just to the left of the Walhalla. Regensburg lies a few miles upstream, out of sight.

When Turner visited the Walhalla in September 1840 he made many quick pencil sketches recording it from every direction, both in a sketchbook (TB CCCX) and on loose sheets of grey paper (TB CCCXLI 363, 364, 371). None of these corresponds exactly to this, Turner's only known watercolour of the Walhalla, though one sketch (TB CCCX 33v) shows Donaustauf and its bridge from a similar but closer viewpoint.

This watercolour is probably a composition study, made after the artist's return when he had decided to produce an oil painting of the Walhalla (see cat.no.109). It thus corresponds in function to cat.nos.102–4 depicting Coburg and is, indeed, identical in size to two of those works.

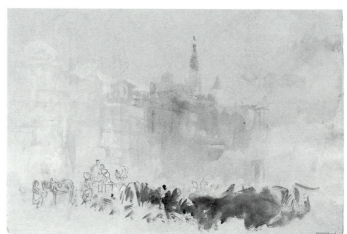

98

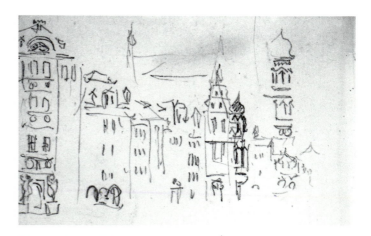

The Spitalgasse, Coburg (TB CCCX IV)

98 The Spitalgasse, Coburg, from the Weisser Schwan 1840

Pencil, watercolour and gouache on grey paper
190 × 280 (7½ × 11)
Watermarked: …E & S/…829
TB CCCXVII 7 ('A market place', c.1839)
D32186

Unlike Passau and Regensburg, Coburg did not lie directly on Turner's route home from Venice. However, he gladly made a special detour to visit it, attracted by its status as the home town of Prince Albert who had married Queen Victoria just seven months earlier.

This view is very similar to that in a small pencil sketch in the *Venice; Passau to Würzburg* sketchbook (TB CCCX IV). Both show the view from an upper window of Turner's hotel in Coburg, the Weisser Schwan in Spitalgasse which runs north from the market place. The largest house shown in Spitalgasse (on the extreme left) is the very ornate Lucchesehaus with a curved pedimental roofline and giant figures supporting its entrance porch. Above the gabled houses further to the right looms the dark spire of St Moriz's church which Turner could have seen only from an upstairs window in the hotel. The view terminates in the town hall on the south side of the mar-ket square, a building with a large pitched roof and central turret, which is also shown in cat.no.99. As in that drawing, the foreground of the present work is alive with bustle and activity. Passengers are obviously arriving or departing by carriage in front of the hotel itself, while their horse thankfully accepts a nosebag from the coachman. This drawing can best be studied from close to and from slightly to its right so that a raking light reveals its fine tonal details which are largely shown in the palest of gouache washes.

As with Turner's drawings on grey paper depicting Regensburg (cat.nos.94–5), there is a close relationship between his Coburg drawings and those of Venice in the same medium. Although he did not recognise their subject matter, cat.nos.98–101 were classified by Finberg as part of *Venice: Miscellaneous (b) Grey Paper* (TB CCCXVII) and there are, indeed, strong resemblances of both palette and expression between the four Coburg drawings and the much larger Venetian group (see, for example, TB CCCXVII 2, 4, 15, 22–5). The sheet of paper on which cat.no.98 was drawn originally formed part of a larger sheet which was divided into eight by Turner. Five of these were used for German subjects – cat.nos.98–101 and 106 – and the remaining three probably for Venetian ones.

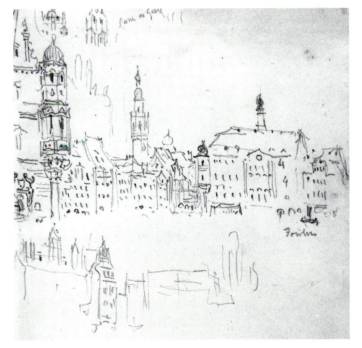

The market place, Coburg (TB CCCX IV)

99 The Market Place at Coburg 1840

Watercolour and gouache on grey paper
192 × 279 (7⁹⁄₁₆ × 10¹⁵⁄₁₆)
TB CCCXVII 8 ('Market place', c.1839)
D32187

In this view from the west, Coburg's town hall is on the right and the Stadthaus, another municipal building, which dates back to 1597, on the left, while the dark spire of the church of St Moriz can be seen towering above the east side of the square. All these are shown very impressionistically, though Turner has clearly indicated the historic oriels which project at the corners of both municipal buildings and has emphasised the horizontal divisions which are such a prominent feature of the eighteenth-century façade of the town hall. Turner drew the same buildings from a position much closer to the Stadthaus in a small pencil sketch (TB CCCX IV). There again, both oriels are very prominent as are, too, the round-headed pediments over some of the windows on the town hall. In

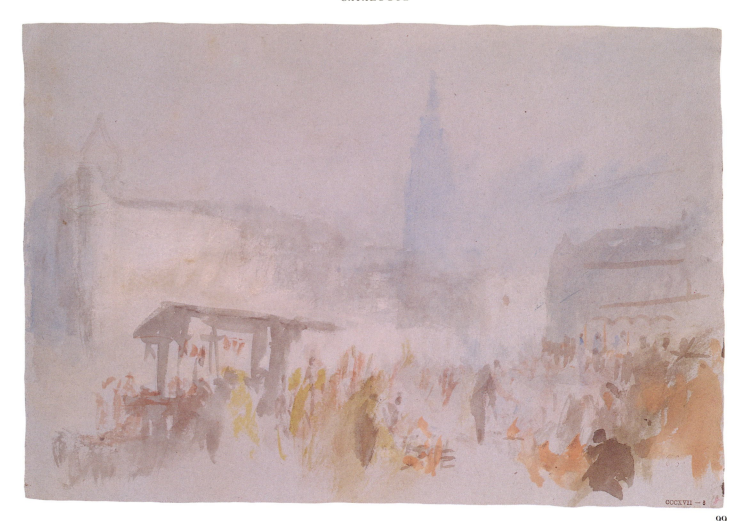

99

cat.no.99 the square itself is teeming with activity and a covered stall occupies a prominent place on the left. Shadowy figures are clustered round fires, evidently cooking bratwurst in exactly the same spot as is used today for this very purpose. A watercolour in the Royal Collection, by Heinrich Brückner (1805–92) and dating from the 1840s, shows a broadly similar scene.

Twenty-five years after Turner's visit, a statue of Prince Albert (1819–61) was unveiled in this square in the presence of Queen Victoria. It was the work of the British sculptor William Theed (1804–91), with whom Turner had been familiar, and was unveiled on the anniversary of the Prince Consort's birth, 26 August 1865.

This sheet of paper originally formed part of the same large sheet as several others bearing German drawings of 1840, including cat.no.98 (q.v. for details).

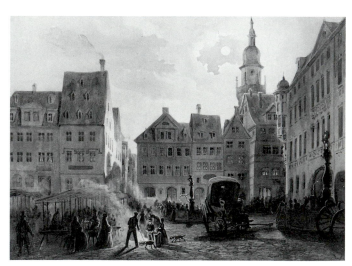

H. Brückner, 'The Market Place, Coburg'. Watercolour, 1840s. *The Royal Collection, Her Majesty The Queen*

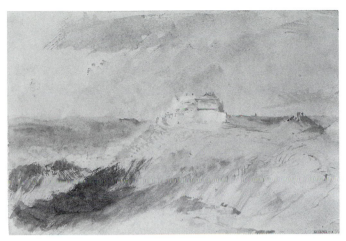

100

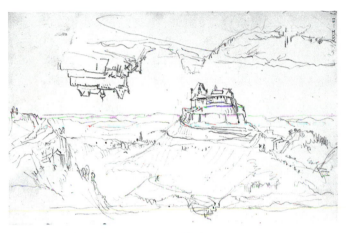

Veste Coburg from the east (TB CCCX 61r)

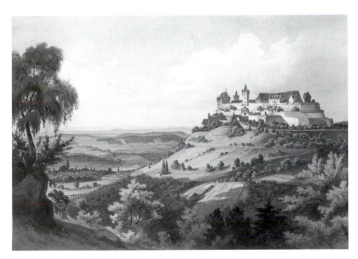

T.J.L. Rothbarth, 'Veste Coburg', watercolour, *c.*1860–5.
The Royal Collection, Her Majesty The Queen

100 Veste Coburg from the East 1840

Watercolour and gouache on grey paper
190 × 280 (7½ × 11)
TB CCCXVII 9 ('Castle on hill', *c.*1839)
D32188

The castle of Veste Coburg ('Veste' is an alternative form of 'Festung' or fortress) dates back to the fifteenth century. It was the home of the Saxon dukes until 1547 when they moved their court down to the newly built Schloss Ehrenburg in the centre of Coburg itself. Veste Coburg has many historical associations (Luther resided here for three months in 1530, during the Diet of Augsburg; as an outlaw he could not attend the Diet itself and this was the nearest to Augsburg he could approach). However, Turner was chiefly interested in it as the property, for so many centuries, of Prince Albert's forbears.

Veste Coburg is here seen very much as in Turner's largest pencil sketch on f.61r of the *Venice; Passau to Würzburg* sketchbook (cat.no.65), though in the coloured scene Coburg itself is indicated only by the light, mostly unpainted, patch to the left of the hill on which Veste Coburg stands, and the small hill on the left of the pencil sketch lies beyond the left-hand edge of the paper. From this direction the viewer has a very powerful impression of the way in which Veste Coburg seems to grow out of the conical hill on which it stands (compare the slightly later watercolour painted by Theodor Johann Lorenz Rothbarth, 1823–91). Walls and bastions rise tier upon tier from the steeply rising ground, the diagonal thrust ending in the gables of the castle buildings themselves. The entrance way shown by Turner in cat.no.101 is situated just below the most prominent gable in the pencil sketch, that of the Hohes Haus. In the watercolour Turner distinguishes clearly between the light stone of some parts of the fortress and its red roofs, but the entrance is indicated by no more than a few strokes of mauve wash.

This sheet originally formed part of the same large sheet as cat.no.98 (q.v. for details).

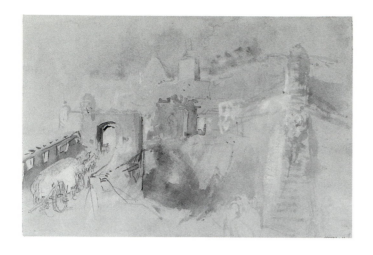

101 The Entrance to Veste Coburg 1840

Pencil, watercolour and gouache on grey paper
190 × 278 (7½ × 10¹⁵⁄₁₆)
TB CCCXVII 11 ('Fortress, with drawbridge', c.1839)
D32190

This drawing, which shows a similar view to that recorded in one of Turner's pencil sketches (TB CCCX 63r), gives a good impression of the very steep ascent by which Veste Coburg is reached and the vast size of its walls and bastions. The 'Bunter Löwe' bastion, surmounted by a turret and adorned with a huge stone cartouche depicting a lion flanked by griffons, dominates the whole of the right-hand side of the scene; a heavily laden wagon slowly crawls up the steep path on the left. The buildings within the walls are only roughly washed in, as if Turner was scarcely interested in them at all, by contrast to the grandeur and strength of Veste Coburg as a whole.

This sheet originally formed part of the same large sheet as cat.no.98 (q.v. for details).

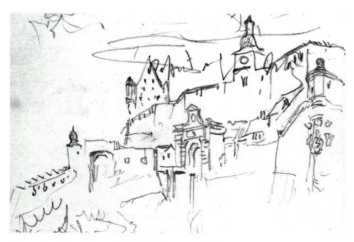

The entrance to Veste Coburg (TB CCCX 63r)

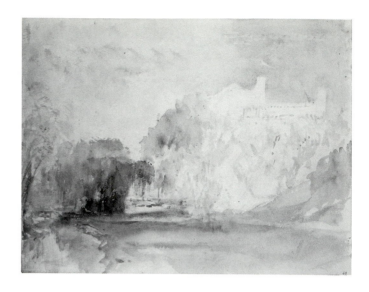

102 Schloss Rosenau, near Coburg: The Birthplace of H.R.H. Prince Albert c.1840–1

Watercolour
244 × 306 (9⅝ × 12)
TB CCCLXIV 49 ('River, with trees and castle on hill (?Rosenau)', after c.1830; Wilton (1982), pl.74, as 'Rosenau', 1840)
D35889

It was not Turner's usual practice to make watercolour studies as intermediate preparatory works, helping to transform pencil sketches into oil paintings. However, this work provides a rare example of him doing just this: the watercolour was based on his small pencil sketch on f.22r of his *Venice; Passau to Würzburg* sketchbook of 1840 (see p.177) and it looks forward to the oil painting exhibited in 1841 (cat.no.107). It testifies to the great care with which Turner planned the painting of Prince Albert's birthplace which was intended to catch the Prince's eye.

In the coloured sketch Turner has already relieved his scene of the rather congested area of trees and architecture to the right of the Schloss which his pencil sketch had faithfully recorded on the spot. The left-hand part, however, relies closely on the pencil sketch and does not include the tall tree with the silver trunk that adds such grandeur to the final painting. The stream is still confined to the middle distance and left-hand foreground and none of the human participants has yet made an appearance.

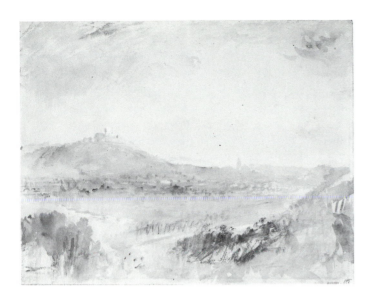

Cat.no.103 is stylistically very close to cat.no.102, depicting Prince Albert's birthplace, Schloss Rosenau. The pencil sketches on which they are based are on adjacent pages of the same sketchbook, so it is very likely that Turner developed both into watercolours simultaneously. The page bearing the sketch of Schloss Rosenau (f.22r) is disfigured by two large dog-ears. These must surely have been made by Turner himself so as to be able to flick it to and fro while consulting f.22r and f.23r at the same time. The view of Coburg on f.21v received a splash of crimson paint, obviously at the same time.

103 Veste Coburg and Coburg from the North-west *c.*1840–1

Watercolour
244 × 307 (9⅝ × 12¹⁄₁₆)
Inscribed on the verso: (in pencil) '10 C'; (in ink) '16'
TB CCCLXIV 105 ('Valley, with river and distant town and hills', after *c.*1830)
D35948

This watercolour shows a view very similar to that of the pencil sketch drawn in the grounds of Schloss Ernsthöhe (TB CCCX 23r); the palace itself is depicted on the same page. Veste Coburg is seen majestically situated on its hill to the left, while the town of Coburg appears as a dark mass on the right, dominated by the spire of St Moriz's church. At the artist's feet lie the rich fields, dotted with bushes and trees, that surround Coburg, the road through the fields making a strong diagonal in both pencil sketch and watercolour.

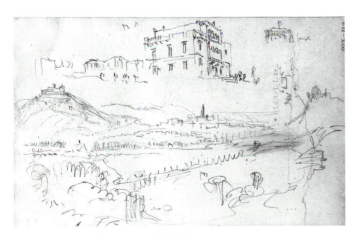

Veste Coburg and Coburg, with Schloss Ernsthöhe sketched above (TB CCCX 23r)

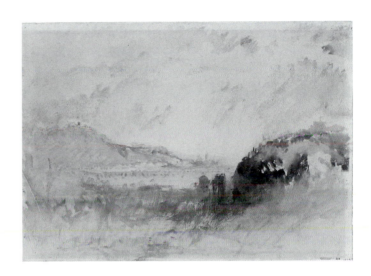

104 Veste Coburg and Coburg with Schloss Ernsthöhe *c.*1840–1

Watercolour
233 × 326 (9³⁄₁₆ × 12¹³⁄₁₆)
Inscribed on the verso: (in pencil) '11 C'; (in ink) '15'
TB CCCLXIV 329 ('A distant city', after *c.*1830)
D36187

Like cat.nos.102 and 103, this drawing is based on a pencil sketch of 1840 (TB CCCX 22v). The viewpoint is very similar to that of cat.no.103, but Turner is now further away from the town so that Schloss Ernsthöhe is clearly seen on its hill to the right, its flagpole arising from the dark block representing the main part of the palace.

Schloss Ernsthöhe was built for Duke Ernst von Württemberg, a cousin of Prince Albert, and it was completed in the very year of Turner's visit, 1840. He recorded it from its grounds in his sketchbook (see under cat.no.103), but in this watercolour he was interested in

its landscape setting, not its architecture. Like the blue in the middle distance of cat.no.102, the blue in the foreground is an indication of the river Itz (thus named in a note on Turner's pencil sketch), and blue is the keynote of the entire work, giving it a mysterious beauty very different from the freshness of cat.no.103.

Cat.nos.102–4 were all executed entirely in watercolour, directly following pencil sketches in a sketchbook. This fact, taken with the inscriptions on the versos of cat.nos.103–4 discovered during remounting for the present exhibition, seems to indicate that in the winter of 1840–1 Turner was initially uncertain as to which Coburg subject he should work up for the following year's Royal Academy exhibition (see cat.no.107). Alternatively, he may have contemplated a whole series of Coburg subjects, possibly to be engraved in a book on that town, since the royal marriage led to an outburst of books and prints as well as paintings, for example Douglas Morison's *Views of the Ducal Palaces and Hunting Seats of Saxe Coburg and Gotha* (1846); Turner would naturally have been keen to participate in the new fashion.

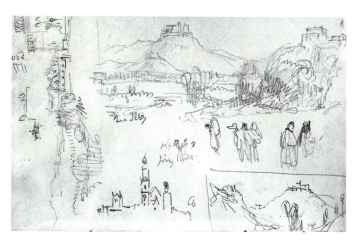

Veste Coburg, Coburg and Schloss Ernsthöhe (TB CCCX 22v)

105 Distant View of Würzburg from the South

*c.*1840–1

Watercolour, with pen and ink
231 × 288 (9⅛ × 11⁵⁄₁₆)
National Museum and Gallery, Cardiff
W 1322

Turner made many small pencil sketches of Würzburg in a sketchbook (see cat.no.66), coloured sketches on both blue and grey paper (TB CCCLXIV 300 and cat.no.106) and two larger pencil studies on loose sheets of white paper (TB CCCXLIV 151, 152), but his finest and most ambitious drawings of the city are two watercolours, the present work and W 1321. These are similar in size to TB CCCXLIV 151 and 152 and were probably painted over pencil sketches drawn on the spot. In all the larger drawings Turner shows the city from the south with the horizon dominated by the great fortress of the Marienberg with its corner towers. Below it flows the Main and the spires and towers of the city fill the middle distance. The hill to the left of the Marienberg is crowned by the Käppele, an ornate pilgrimage church designed by Balthasar Neumann.

For many years this work was known as 'Ehrenbreitstein and Coblenz' and is thus referred to even in recent publications. However, it was exhibited under its correct title in Cologne in 1980. Turner's second watercolour of Würzburg (W 1321) was also originally catalogued as an 'Ehrenbreitstein and Coblenz' but this was identified in the early 1980s (see Muth 1983). The composition is very similar but several important topographical features (the Käppele, the bridge over the Main, and the distant hills) are represented far more distinctly.

In cat.no.105 the river Main and Würzburg's famous eighteenth-century stone bridge are indicated in the most summary fashion and Turner's viewpoint seems rather an eccentric one, compared to the earlier views taken from the riverside by Prout and Robert Batty. Turner's broader vision of Würzburg is, however, typical of his work inspired by the 1840 tour (see, e.g., cat.nos.96, 103–4).

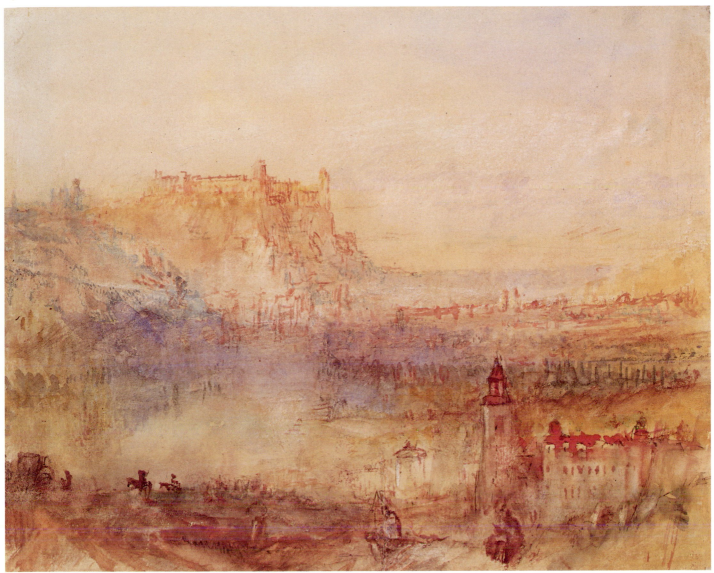

105

Würzburg from the south (TB CCCXLIV 151)

Würzburg from the south (TB CCCXLIV 152)

106 Würzburg from the Path to the Käppele

1840

Pencil, watercolour and gouache on grey paper
190 × 277 (7½ × 10⅞)
TB CCCLXIV 301
D36158
[Exhibited in Germany only]

The sheet of paper on which Turner drew this view of Würzburg was originally attached to those on which he drew his four coloured sketches of Coburg (cat.nos. 98–101). Those of Coburg were drawn around 17–20 September 1840, that of Würzburg around 22 September. Not surprisingly, there are marked similarities of style and palette.

Turner's view of Würzburg is here much closer to the fortress of the Marienberg than that in cat.no.105, so that its constituent parts are far more clearly seen. His position was, in fact, on the pathway leading up to the pilgrimage church of the Käppele, designed by the renowned baroque architect Balthasar Neumann and built between 1748 and 1750. Steps, balustrades and volutes belonging to one of the chapels over the Stations of the Cross are all sketchily indicated on the left, but the church itself with its three onion domes lies beyond the edge of the paper.

107 Schloss Rosenau, Seat of H.R.H. Prince Albert of Coburg, near Coburg, Germany

RA 1841

Oil on canvas
972 × 1248 (38¼ × 49⅛)
Board of Trustees of the National Museums and Galleries on Merseyside. Walker Art Gallery, Liverpool
B&J 392
[Exhibited in London only]

Turner was always a strong supporter of the British monarchy but his art found little favour with the royal family. His one commission from George IV, 'The Battle of Trafalgar' (B&J 252), was soon despatched from Carlton House to Greenwich Hospital, and he was not among the artists honoured by the young Queen Victoria on her accession in 1837. After the Queen married her German cousin, Albert of Saxe-Coburg-Gotha, in February 1840, Turner decided to make a bid for their patronage. He therefore made a detour to Coburg, one of the capitals of the Duchy of Saxe-Coburg-Gotha, on his way home through Germany from Venice in 1840. Here he made sketches both of the main ducal palace, Schloss Ehrenburg, in the centre of the town and of the much smaller Schloss Rosenau just to the north. Schloss Rosenau dates back to the fifteenth century but it was restored in the English neo-Gothic style in the early nineteenth century in order to become a summer residence for the ducal family. It was here that Queen Victoria's future husband was born on 26 August 1819, the second child of Ernst and Louise, the Duke and Duchess of Saxe-Coburg-Gotha. Victoria's own parents, the Duke of Kent and Ernst's younger sister, Victoria, had been married in the Riesensaal (Hall of the Giants) of Schloss Ehrenburg on 27 May 1818.

As a child Albert spent many happy summers at Schloss Rosenau which is surrounded by a large park, laid out in the early nineteenth century in the style of English landscape gardens with lakes, woods and winding paths. He pursued such country occupations as riding, hunting and gardening and he revelled in the forests and streams. However, his childhood was not without its darker side. His parents separated in 1824 and were divorced in 1826, so he was deprived of his mother at a very early age, a wound that not even his close relationships with his father and elder brother could entirely assuage.

This painting is closely based on a pencil sketch on f.22r of the *Venice; Passau to Würzburg* sketchbook (TB CCCX). Turner stood on the bank of the river Itz looking, left, towards a dark grove of trees (annotated 'Alders')

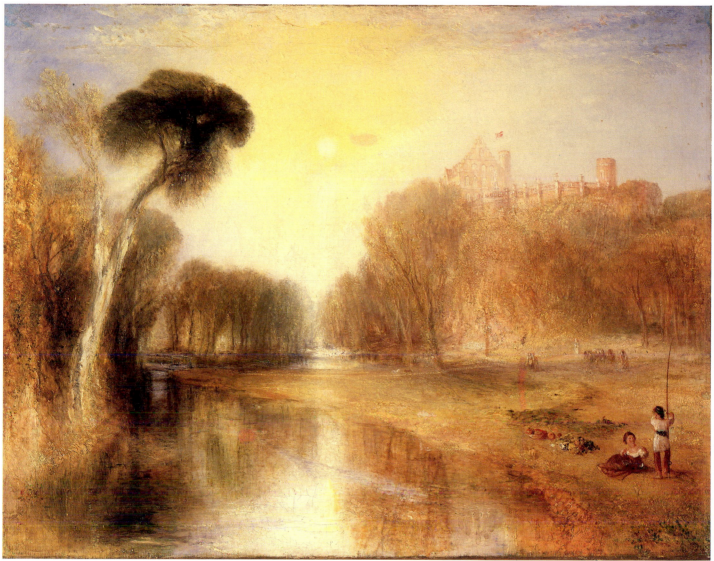

107

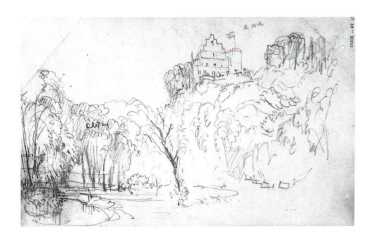

Schloss Rosenau (TB CCCX 22r)

and, right, up at the garden façade of Schloss Rosenau itself, with the ducal flag of red and white (annotated 'R W R') flying from its castellated tower. Between the house and the large garden tower further to the right (shown among trees in the sketch but more clearly in the painting) lies a small formal garden enclosed by a balustraded wall which is surmounted at regular intervals by stone urns. Turner recorded many of these features in the garden itself on f.63v of his sketchbook, into a corner of which he tucked a sketch of the main façade of the house which looks out in the other direction over sloping parkland with trees and deer. In the painting Turner gave the garden façade the larger, more elaborate and more numerous Gothic windows of the principal façade rather than the narrow slits which he himself had recorded on f.22r. Presumably he did this deliberately in order to raise the

status of the Schloss, rather than in error. Such conflations of material are a common feature of Turner's art.

Since the little boy's fishing rod points towards the castle and echoes its ducal flag, he may be seen as a depiction of the young Albert but the children on the bank could equally well be regarded as symbolic figures, reminding viewers of the innocent pleasures of childhood. It would have been typical of Turner to intend such dual interpretations.

At the Royal Academy exhibition of 1841, 'Schloss Rosenau' completely failed to attract the attention of the Prince Consort as Turner had intended. It was roundly abused by the critics for its extravagance, two of the insults hurled at it being classics of the genre ('the fruits of a diseased eye and a reckless hand' and 'eggs and spinach … the art of cookery is more predominant than the art of painting'). Nevertheless, Turner succeeded in selling it within a very few years to one of his major patrons of the time, the industrialist Joseph Gillott of Birmingham (1799–1872) who had been appointed 'Steel Pen Manufacturer in Ordinary to Her Majesty' on 13 April 1840. Gillott sold other Turner paintings from his collection but he resisted numerous offers from potential purchasers of this one over the next thirty years, perhaps through sheer love of the painting, perhaps through pride in owning a work connected with the royal family. Turner's sense of frustration with his own lack of recognition by the royal family must have been considerable. Four of his close friends – Soane, Chantrey, Wilkie and Callcott – received knighthoods in the 1830s and a fifth, Eastlake, in 1850, but this honour eluded Turner to the end.

It is hard today to have much sympathy with the critics of 1841, since 'Schloss Rosenau' is a hauntingly beautiful work. The trees and reflections in the water are painted with airiness and subtlety. Its depiction of children living a life of their own among meadows, streams and woods is entirely lacking in Victorian sentimentality, looking forward instead to the robuster qualities of Frances Hodgson Burnett's *The Secret Garden* (1911). Another version belongs to the Yale Center for British Art (B&J 442) but its authenticity is extremely doubtful.

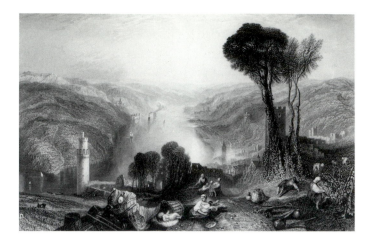

J.T. WILLMORE AFTER J.M.W. TURNER

108 Oberwesel 1842

Line engraving on steel
222 × 343 (8¾ × 13½)
Trustees of the British Museum, London
R 660

The engraving of 'Oberwesel' is based on an unusually large and very fine watercolour that Turner painted in 1840 (w 1380; see Powell 1991, cat.no.30). It is possible that the watercolour was deliberately made for the purpose of engraving (see Herrmann 1990, p.233), as had been the case with another Rhineland subject 'Ehrenbreitstein' (cat.no.110) shortly before. At all events, it was engraved very soon after its appearance, being published in the *Royal Gallery of British Art*, a publishing venture of William Finden which had been inaugurated in 1838.

Turner's scene provides a quintessential view of the Rhineland, with its magnificent river, fertile hills and unending succession of ancient walls, castles and towers. It is a vision of peace and plenty which Turner has chosen to locate on the hillside above Oberwesel which he himself had discovered for the first time on his visit to this area in 1839. The high viewpoint enabled him to demonstrate his virtuosity in distant views and aerial perspective, while the broad foreground provided a stage on which to present a glimpse of Rhineland life: country people harvesting the vintage or resting from their labours, accompanied by their children. It has been suggested (Piggott 1993, p.68 n.23) that the figures in the foreground were intended by Turner as a pun on the Rhenish wine known as Liebfraumilch and a reference to Byron's 'maternal Rhine' in *Childe Harold's Pilgrimage*. However, family groups are very common in Turner's foregrounds, regardless of the locality he is depicting, and

it must be doubted whether his German was actually good enough for him to make such a pun.

The Mummery collection of prints at the Victoria and Albert Museum contains an interesting, though foxed, proof of 'Oberwesel', touched and annotated by Turner himself (E.4966-1946). He marked nine crosses on the part of the Rhine between the Ochsturm on the left and the small clump of trees in the centre and wrote a note in the lower margin: 'Water and Land too much distinguished owing to the Horizontal Line of the Water and all XX too dark and all [word cropped] will continue so I fear while the Horizontal Line remains so evident.' By its very nature, a line engraving could not reproduce all the infinite subtleties of Turner's watercolour technique and his almost indistinguishable transitions from earth to water, but cat.no.108 comes very close to achieving this.

109 The Opening of the Wallhalla, 1842

RA 1843

Oil on mahogany panel
1125 × 2005 (44⁵⁄₁₆ × 79)
Turner Bequest; B&J 401
N00533
[Exhibited in London only]

The Walhalla (in Turner's spelling 'Wallhalla') is a huge Doric temple closely based on the Parthenon at Athens and situated high above the Danube about six miles from the city of Regensburg. It was designed by the German neo-classical architect Leo von Klenze and built between 1830 and 1842. It was the brain-child of King Ludwig I of Bavaria, conceived during the early years of the century when he was still Crown Prince and Napoleon's armies were sweeping through Europe, conquering one country after another. In 1806 many defeated German states were forced to join the Confederation of the Rhine, which gave Napoleon control of over eight million Germans. During the humiliating years that followed, the young Ludwig had the idea of a monumental building which would honour the most distinguished German men and women of history and give those of the present a sense of unity and pride and of the greatness of their country. Its name was suggested to him by his adviser, the historian Johannes von Müller: Walhalla, the home of the gods in ancient

109

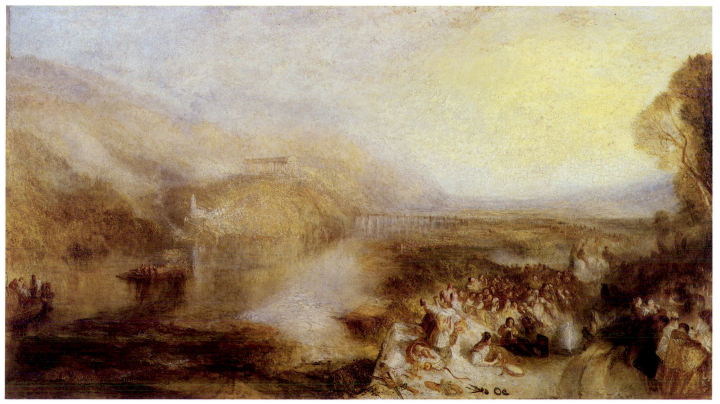

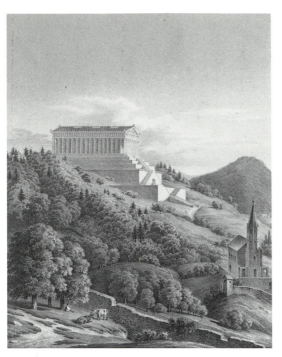

The Walhalla in its landscape setting, from a mid-nineteenth-century print

German mythology. After Napoleon had been defeated, the temple was finally built and it was opened, with due pomp and ceremony, on 18 October 1842.

Turner based this painting on some of the many pencil sketches he had drawn of the Walhalla and its setting when he visited it from Regensburg on 12 or 13 September 1840. At that date it was still unfinished but he was able to make swift records of all its essential features including its interior (see figs.54–5, p.71). When it was opened it contained ninety-six busts together with sixty-four commemorative tablets to heroes and heroines of such antiquity that no likenesses could be attempted (e.g. Charlemagne, the Venerable Bede and St Boniface). Since its opening, many more busts have been added, so that visitors of today are confronted not only with images of historical rulers and poets, painters and philosophers, musicians and generals, scientists and inventors but also with twentieth-century notables as well.

When Turner exhibited his painting at the Royal Academy in London in 1843, he accompanied it with lines from his own unpublished *Fallacies of Hope*. These begin by saluting King Ludwig and then look back at

Napoleon's conquest of Bavaria, likening 'the tide of war' to 'the swollen Danube'. In 1809 Napoleon had inflicted a crushing defeat on the Austrians at Regensburg (Ratisbon), though himself receiving a wound in the foot, and went on to take Vienna after defeating them again at Wagram. Turner's last three lines stress the new dawn of science and the arts brought by the return of peace. Both sentiments are echoed by the composition of the painting itself, which looks eastwards down the Danube, away from Regensburg towards Vienna:

> *'L'honneur au Roi de Bavière'*:
> 'Who rode on thy relentless car, fallacious Hope?
> He, though scathed at Ratisbon, poured on
> The tide of war o'er all thy plain, Bavare,
> Like the swollen Danube to the gates of Wien.
> But peace returns – the morning ray
> Beams on the Wallhalla, reared to science, and the arts,
> For men renowned, of German fatherland.'
> —*Fallacies of Hope*, M.S.

Although cat.no.109 depicts the Walhalla itself in its wooded setting above the Danube, near the village and bridge of Donaustauf, it does not really show the actual opening of the building as its title claims. This event was attended with much ceremony, including the firing of artillery, speeches, presentations, choral renderings of special songs and ultimately red, white and blue illuminations, all of which, naturally, centred on the temple itself (the events were minutely described in the *Illustrated London News* of 12 November 1842). Turner was not in a position to depict the major events of the day but his painting is true to reality in two respects. The roads were indeed crowded with 'thousands of eager and expectant spectators', and, after a threatening start to the day, the sun suddenly broke through the clouds and the Walhalla became visible to all the pilgrims who were hastening there. Turner's crowd is very much a crowd of pilgrims – though the cavalry in the background are a reminder of the years of war. In the distant building King Ludwig must be imagined, expressing the hope that his new Walhalla may promote German sentiments and make Germans feel they have one common country; in Turner's foreground the Bavarians are feeling all the blessings of peace and are thankful.

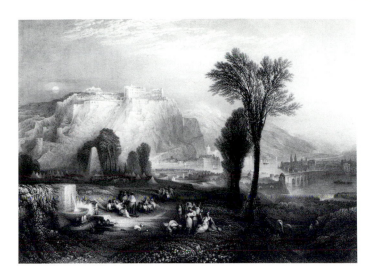

JOHN PYE AFTER J.M.W. TURNER

110 Ehrenbreitstein 1846

Line engraving on copper, first published state
280 × 387 (11 × 15¼)
Trustees of the British Museum, London
R 662

Although Turner depicted Coblenz and Ehrenbreitstein many times in both pencil and watercolours between 1817 and the early 1840s, he produced only one oil painting of this subject: 'The Bright Stone of Honour (Ehrenbreitstein), and Tomb of Marceau, from Byron's *Childe Harold*', exhibited at the Royal Academy in 1835. This is one of Turner's most important depictions of Germany, with a quintessentially Turnerian and Byronic mingling of beauty and sadness. The young French general Marceau had been noted equally for his bravery and his humanity and his early death made him, for Byron, a perfect example of the Romantic hero. In 1795 and 1796 he had participated in the unsuccessful attempts on Ehrenbreitstein and later in 1796 he was caught by an Austrian bullet while protecting the retreat of his division of the Sambre-et-Meuse army at the battle of Altenkirchen. His body was escorted back to the Rhine by a convoy of some two thousand soldiers and he was buried at the headquarters of the Sambre-et-Meuse army just north of the confluence at Coblenz, the Austrians themselves taking part in the ceremonies in his honour. Here a stone pyramid was built over his tomb, and it was this monument that inspired the lines in canto III of *Childe Harold's Pilgrimage* (stanzas lvi–lviii) that Turner adapted for the Royal Academy catalogue in 1835:

> By Coblentz, on a rise of gentle ground,
> There is a small and simple pyramid,
> Crowning the summit of the verdant mound;
> Beneath its base are heroes' ashes hid,
> Our enemy's – but let that not forbid
> Honour to Marceau——————————
> ——————————He was freedom's champion!
> Here Ehrenbreitstein, with her shattered wall,
> Yet shows of what she was …

In the 1830s Turner issued large prints after several of his paintings. 'The Bright Stone of Honour' was specifically painted for the engraver John Pye who planned to work on the plate whilst he was abroad educating his daughter. This proposal, however, proved unworkable, since the painting was too large for Pye to take with him, so it was not engraved until after his return. The entire endeavour took almost eleven years.

Some of the details of the arrangements between Pye and Turner and the events of these years are provided by the Pye manuscripts in the Victoria and Albert Museum and other correspondence. According to the engraver's own draft, on 19 August 1835 Pye wrote to Turner:

> Dear Sir
>
> I beg to subjoin a brief memorandum of the terms on which you were led to paint the picture of Ehrenbreitstein; and to assure you that I am fully prepared to carry my part of it into effect –
>
> I have carefully looked at the different propositions made since the picture has been painted, for Engraving the plate on a large scale, for you to pay half the price of Engraving it &c.; but they all appear objectionable, and throw me back to the original one in which we started, and which led you to offer to paint the picture instead of making a Drawing
>
> I am Dear Sir
> Yours respectfully
> John Pye
> turn over

Memo:
The picture of Ehrenbreitstein was painted to be lent to Mr. Pye for the purpose of a plate being Engraved from it about the size of a work Box, <pointed to by Mr. Pye in his back parlour> i.e. the size of Mr. G. Cookes plate of Rotterdam, on the following conditions – The plate to be Engraved free of all cost to Mr. Turner

Mr. Turner to aid Mr. Pye in its progress by his suggestions and by touching proofs

Mr. Pye to be paid out of the publication of the plate the price of Engraving it; after which the plate

and stock of prints (Mr. Turner paying half the price of printing) to become the joint property of Mr. Turner and Mr. Pye – Mr. Pye further agrees that Mr. <Pye> Turner shall be entitled to 100 print<s> impressions of the plate beyond an equal division

The price of Engraving the plate the size of the plate of Rotterdam Mr. Pye estimates at £400

The division of the property not to exceed two years from the completion of the plate or earlier if possible – Mr. Turner to have Twelve unlettered proofs, Mr. Pye to have Six –

Mr. Pye engages to deliver up the picture so soon as the plate is completed; or, in the event of the death of Mr. Pye the picture to be delivered up so soon as demanded, – the picture to be returned to Mr. Turner within the space of five years from its delivery to Mr. Pye and as much earlier as can be effected consistently with Mr. Pye's other professional engagements

(V&A Pye MSS 86.FF.73, f.7)

At the beginning of 1842, however, the print was still not ready and Turner wrote to Pye (Gage, 1986, no.248a):

> My dear Sir
> Year after year rolls on and no proof of Ehrenbreitstein appears – I do request you to proceed (pray state your own time) or let me have the Picture
> Yours truly
> JMW Turner

In March 1844 Turner sold the painting to his friend Elhanan Bicknell but would not actually hand it over, since the engraving was not completed. On 23 June 1845 it was Bicknell's turn to put pressure on Pye (V&A Pye MSS 86.FF.73, f.8):

> My getting the painting *appears* as distant now as it was in March 1844. I thought I had only to send to Queen Ann St to have it – but the grim master of the Castle Giant Grimbo shakes his head & says he & you must first agree that all is done to the plate that is nec-

111

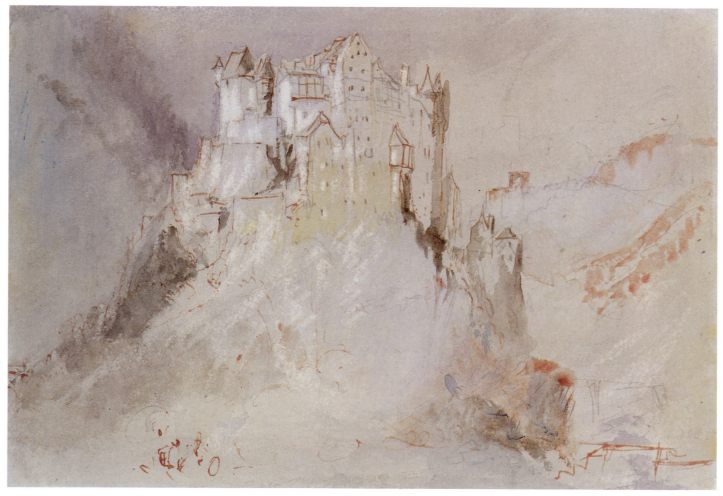

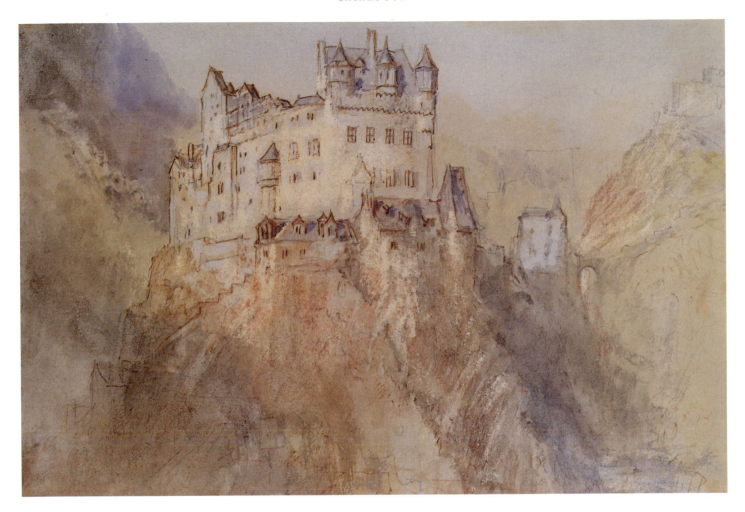

essary, & the picture will be wanted to refer to. Now as I know he goes out a good deal fishing at this season – & then leaves town for some months tour in the Autumn I hope you will do what is required while he is in town.

The engraving was finally published on 2 March 1846, with a dedication to Bicknell. Its title was now simply 'Ehrenbreitstein', with a brief reference to *Childe Harold*, canto III and no specific mention of Marceau or his tomb. The mistranslation of 'Ehrenbreitstein', using 'bright' instead of 'broad', had also disappeared.

111 Burg Eltz from the South *?c.*1841–2

Pencil, watercolour, and pen and red ink with scratching out on paper prepared with a grey wash
158 × 231 (6¼ × 9¹⁄₁₆)
Private Collection

W 1333
[Exhibited in London only]

112 Burg Eltz from the South-east *?c.*1841–2

Pencil, watercolour, gouache, and pen and ink with scratching out on paper prepared with a grey wash
158 × 228 (6¼ × 9)
Private Collection, UK
W 1334

These two works come from a group of at least five watercolours of Burg Eltz which have a distinctive character and probably date from a year or two later than cat.nos.76–7. Three have long been known (w 1333–5) and two have recently appeared in salerooms (both Sotheby's, New York: 21 Nov. 1980 and 22 May 1986).

Turner's earlier watercolours of Burg Eltz are not only on smaller pieces of paper than these works and painted in a different style but were drawn looking down on the castle from the viewing station near Trutz Eltz or higher still. For four of these later works, Turner has dropped down to the valley floor and approached much nearer to the castle in order to explore it thoroughly by walking right round the rock on which it stands. In cat.no.111 figures are seen in the foreground on the river bank and an indication is given of the bridge over the Eltz which

[183]

Turner must have crossed to arrive at his viewpoint. Trutz Eltz is seen crowning the far valley side on the right in both cat.nos.111 and 112 and on the left in w 1335. The valley is now a thickly wooded nature reserve and access to all of Turner's viewpoints is not permitted, but it is nevertheless still possible to appreciate, as Turner did, the extraordinary set of buildings constituting the castle.

The Eltz family divided into three separate lines in the thirteenth century, with the branches continuing to live together as joint heirs in the castle. The building of their various houses took place over many centuries and it has been estimated that up to a hundred members of the family used to live in almost the same number of rooms. Since Burg Eltz is built on an elliptical rock with access only from the pointed end to the north, it is views from the east (cat.no.112) and the west (w 1335) which show the buildings in their full complexity. Because of the contours of the rock itself, the Kempenich and Rodendorf Houses on the east façade are composed of many facets, while the west façade is largely built in a single plane, with the Rübenach House at its centre.

Turner's colouring faithfully shows the pale golden stone, grey roofs and red woodwork of Burg Eltz itself, his very fine penwork deftly articulating the complexities of its many profiles.

113 Burg Ehrenfels on the Rhine, looking towards Bingen c.1841

Pencil, watercolour and gouache, with scratching out
184 × 241 (7¼ × 9½)
Royal Institution of Cornwall, Royal Cornwall Museum, Truro
Not in Wilton
[Exhibited in London only]

Turner used the Rhine as his highway to and from Switzerland many times betweeen 1841 and 1844. Sometimes he recorded its familiar sights in tiny notebooks (e.g. *Dover, Rhine and Innsbruck*, TB CCCIX); sometimes in large 'roll' sketchbooks (e.g. *Rhine and Rhine Castles*, TB CCCLI, cat.no.133); sometimes, as here, on loose sheets of paper. Year after year he recorded the same sights that had enchanted him in 1817, sketching them from his boat or carriage and, whenever this was possible, climbing the same hills and exploring the same castles.

It was, however, extremely rare for Turner to visit the east bank of the Rhine at precisely the point where he drew cat.no.113, since the ruins of Burg Ehrenfels occupy an isolated site on the hillside. Usually he found himself at Bingen on the opposite shore (its church can be clearly seen in the distance). Here he would change carriages or boats and sometimes explore a little way up the Nahe valley (see cat.nos.134–7). The present work must probably belong to the same tour as several related sketches. These are the group of pencil drawings made above Rüdesheim (TB CCCXLIV 21, 22, 54, 55, 348, 349), some of which were evidently made during the long climb to Burg Ehrenfels; the small watercolour looking down on Rüdesheim from the hillside of the Niederwald (not in Wilton; Sotheby's sale, London, 19 Nov. 1992, lot 61); and the sketchbook

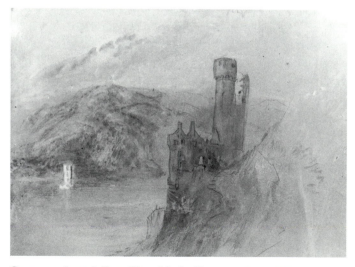

Cat.no.113 (verso): Burg Ehrenfels, looking towards the Mäuseturm

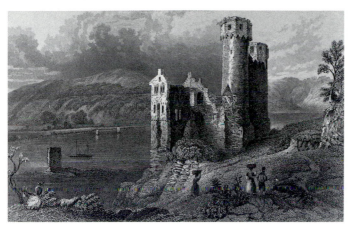

'Ruins of Ehrenfels', engraving from *Tombleson's Views of the Rhine* (1832)

with the rough sketch annotated 'Waiting for the Ferry Bingen' (TB CCXCI(a) 50v).

As with many other sketches made on the Rhine at about this time, Turner has worked both sides of the sheet almost equally. The view on the recto looks south-eastwards towards Bingen from the west side of Burg Ehrenfels and the island of the Mäuseturm is immediately below. The drawing on the verso was made just to the east of Burg Ehrenfels, looking across at the Mäuseturm, and Bingen is now out of sight on the left. In the Middle Ages Burg Ehrenfels and the Mäuseturm were used to raise tolls for the Archbishops of Mainz from all the river craft which had to pass through the narrow channel between them (the Binger Loch). The castle was wrecked by the French in 1689 and remains a ruin though the Mäuseturm was rebuilt in neo-Gothic style in 1855. Both Turner's viewpoints provide very fine views and his two sketches can be matched with innumerable reproductions.

113

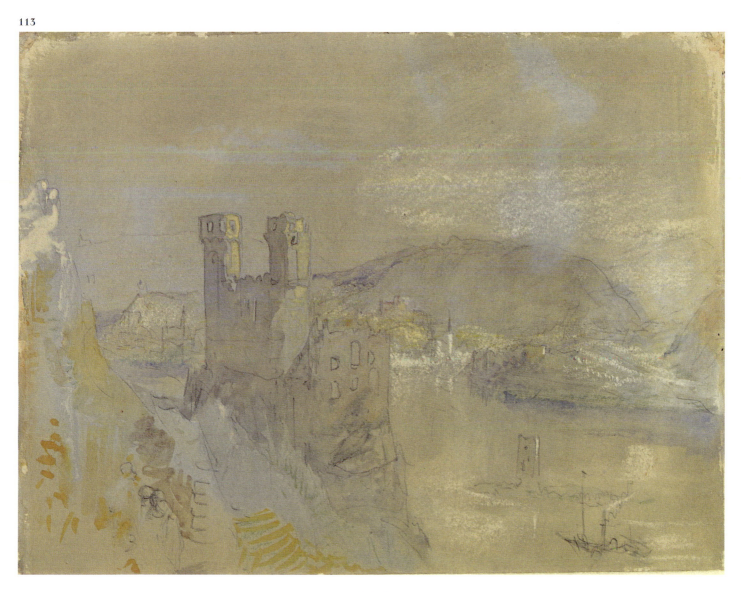

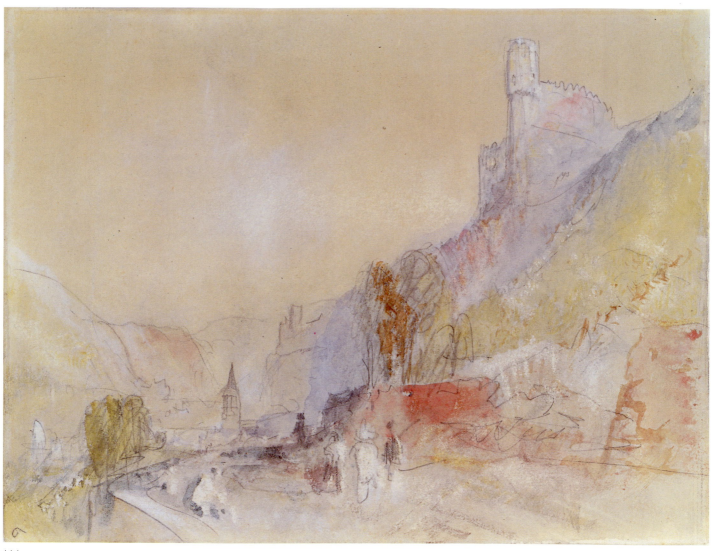

114

114 The Klemenskapelle with Burg Rheinstein and Burg Reichenstein *c.*1841

Pencil, watercolour and gouache on a lightweight white
paper prepared with a grey wash
185 × 242 (7¼ × 9½)
PROV: ... P. Graham; ... Mrs Donald Nicoll, Winchester; ...
Galerie Jan Krugier, Geneva
Not in Wilton

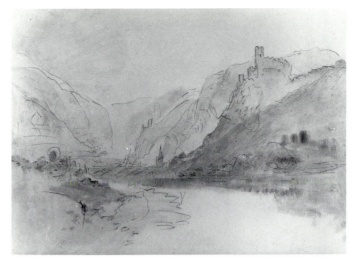

'The Klemenskapelle with Burg Rheinstein and Burg Reichenstein'
(formerly known as 'Cochem on the Moselle') (W 1337). Watercolour,
*?c.*1841. *Birmingham Museums and Art Gallery*

This work was recently sold at Sotheby's in London from
a private collection (8 Nov. 1994, lot 173). Its frame then
carried the legend 'Prague'. It is, however, a Rhine scene
and the paper, which bears no watermark, shows signs of
stitch-holes, pointing to its originally being a page in a
sketchbook. The size is not that of any sketchbook of the
relevant period in the Turner Bequest, but it has long
been known that at least one Turner sketchbook of the
1840s was dismembered at an early date and its contents
dispersed through sales. Many of these late German
sketches (e.g. W 1324, 1327, 1328, 1332) are of identical
size to the present work.

Cat.no.114 looks south towards the thirteenth-century
Klemenskapelle, one of the oldest churches along the
Rhine, which lies close to the shore beneath Burg
Reichenstein about half way between Bacharach and
Bingen. In the distance can be seen a second castle, Burg
Rheinstein, while the sketchy outlines of buildings on the
opposite bank indicate Assmannshausen. The view is
broadly similar to one of Turner's fifty Rhine scenes of
1817, 'The Bautsburg' (W 640/683; see Powell 1991,
cat.no.10). Travellers are depicted on the road in both
works, but in 'The Bautsburg', the ruins of Burg Reichen-
stein are excluded by the edge of the paper.

This stretch of the Rhine is so rich in ruined castles
that Murray's *Handbook* declared it to be truly 'the castel-
lated Rhine' referred to by Byron (see cat.no.24). Guide-
books themselves often lost track of exactly how many
castles there were, confused not only by the multiplicity
of ruins but by their plethora of names. Burg Reichen-
stein, sometimes referred to as Falkenburg, is notable for
its massive outer wall and octagonal tower, both swiftly
but surely captured by Turner's pencil. It was still a ruin
at this date, not being restored until the turn of the centu-
ry. This made it a far more attractive subject for Turner
than Burg Rheinstein (the former Bautsburg) which had
been restored and renamed in 1825–9 by Prince Friedrich
Wilhelm Ludwig, nephew of King Friedrich Wilhelm III
of Prussia. Cat.no.114 is notable for its limpid freshness of
colouring which looks back to that of his Rhineland
sketches on grey paper of 1840.

Turner drew a third watercolour of this scene (W 1337)
which has, for years, mistakenly been referred to as a
depiction of Cochem. Its composition is broadly similar
but the artist is much further away.

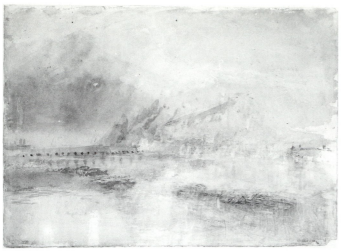

115

115 Ehrenbreitstein 1841

Watercolour on white wove paper
249 × 340 (9^{13}⁄$_{16}$ × 13^3⁄$_8$)
Watermarked: J WHATMAN/TURKEY MILL/1825
Inscribed in pencil on the verso, with a poem of six lines
TB CCCLXIV 26
D35863
[Exhibited in Germany only]

116 Ehrenbreitstein 1841

Watercolour with pen on white wove paper
250 × 315 (9^{13}⁄$_{16}$ × 12^7⁄$_{16}$)
TB CCCLXIV 285
D36138

116

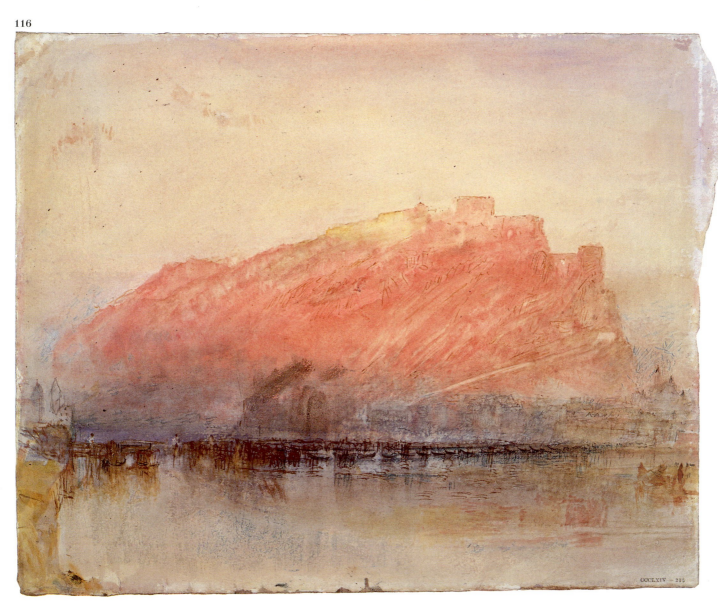

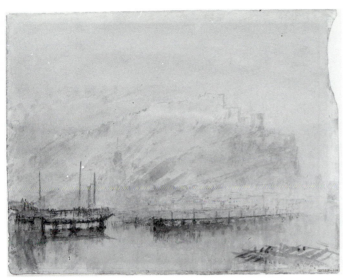

117

117 Ehrenbreitstein 1841

Watercolour on cream wove paper
245 × 305 (9⅝ × 12)
Watermarked: C. ANSELL / 1828
TB CCCLXIV 309
D36166
[Exhibited in Germany only]

118 Ehrenbreitstein 1841

Watercolour on white wove paper
242 × 302 (9½ × 11⅞)
Watermarked: J WHATMAN / TURKEY MILL / 1822
TB CCCLXIV 319
D36177

118

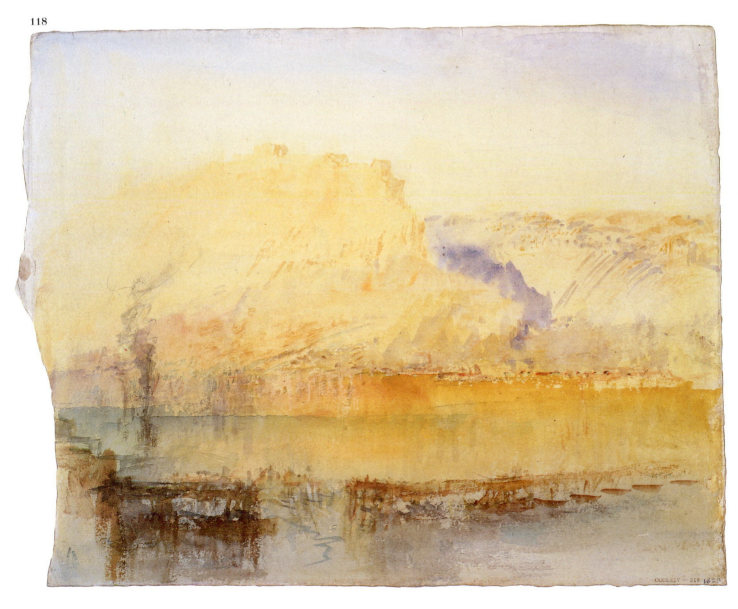

119 Ehrenbreitstein 1841

Watercolour on white wove paper
240 × 305 (9⁷⁄₁₆ × 12)
TB CCCLXIV 328
D36186
[Exhibited in Germany only]

120 Ehrenbreitstein 1841

Gouache and watercolour on white wove paper
243 × 300 (9⁹⁄₁₆ × 11¹³⁄₁₆)
TB CCCLXIV 328a
D40181
[Exhibited in Germany only]

121 Ehrenbreitstein 1841

Watercolour and pen and ink on white wove paper
237 × 300 (9⁵⁄₁₆ × 11¹³⁄₁₆)
TB CCCLXIV 346
D36206

Turner's series of coloured sketches showing Ehrenbreitstein caught by the evening sun are among his most poetical Rhineland views. They are bold in their handling, yet infinitely subtle in the gradations and contrasts of their colours. The light sources include the setting sun, the rising moon, and flares along the riverside beneath the fortress itself. All these cast their magic over the wide smooth surface of the river, transforming it into a golden or silvery stream shimmering with reflected colours. In the 1830s the art critic Mrs Jameson had contrasted Turner with his famous German contemporary, Friedrich, remarking that the genius of the latter 'revels in gloom, as that of Turner revels in light' (*Visits and Sketches at Home and Abroad*, 1834, I, p.144). Nothing could illustrate this point better than a comparison between Turner's sketches of Ehrenbreitstein and Friedrich's paintings of the Baltic or the Elbe. Turner's sketches also provide a perfect illustration of what Victor Hugo meant when he declared the Rhine to be as 'swift as the Rhône, broad as the Loire … historic as the Tiber, royal as the Danube, mysterious as the Nile, sparkling with gold as a river of America, clothed in fables and phantoms as a river of Asia' (*Le Rhin*, 1842, letter xiv).

Turner must have made these sketches when staying in Coblenz on his way to or from Switzerland in 1841. The *Berne, Heidelberg and Rhine* sketchbook (TB CCCXXVI) used on the same tour shows a similar interest in the Rhine front at Coblenz with sketches of the many hotel buildings there, in one of which Turner must surely have stayed. His viewpoints in the coloured sketches are surprisingly varied: cat.no.121 was taken from the furthest downstream, cat.no.115 from the furthest upstream. He probably sketched them very lightly in pencil on the riverside, and then added his colouring back in his hotel.

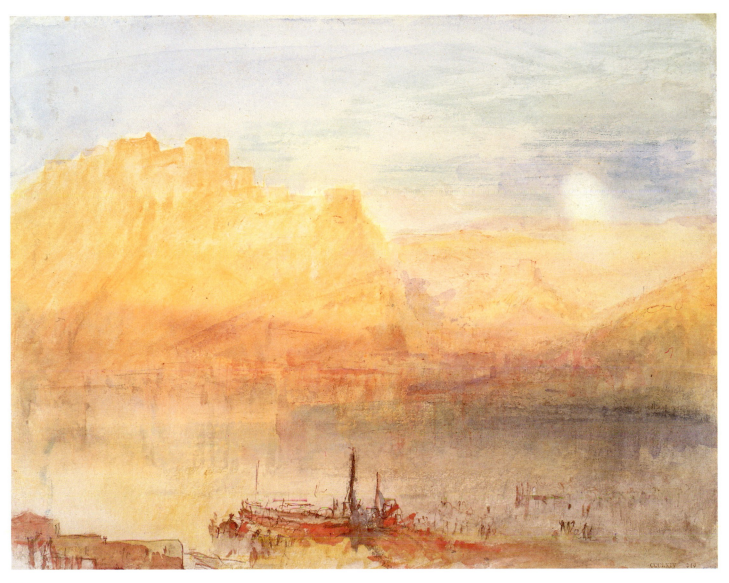

121

122 The Mosel Bridge at Coblenz: Colour Study

*c.*1841–2

Gouache and watercolour on white wove paper
246 × 348 (9¹¹⁄₁₆ × 13¾)
Watermarked: J WHATMAN/TURKEY MILL/1825
Inscribed in pencil, at lower right, 'Coblenz'
TB CCCLXIV 336
D36194

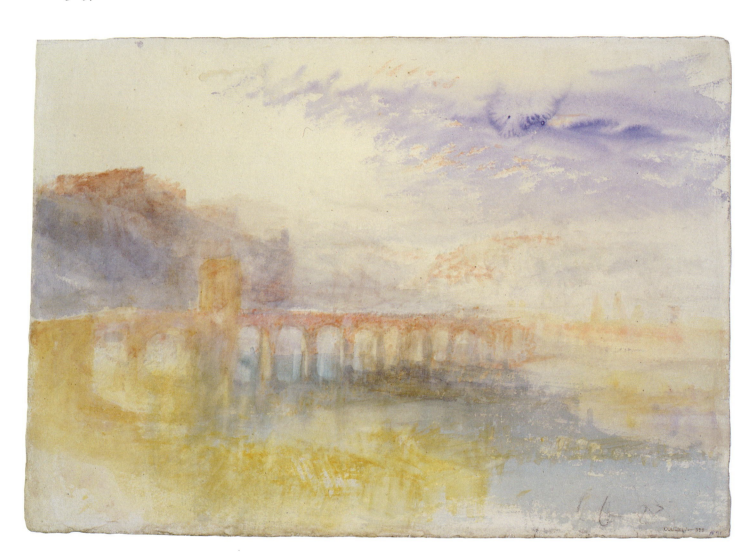

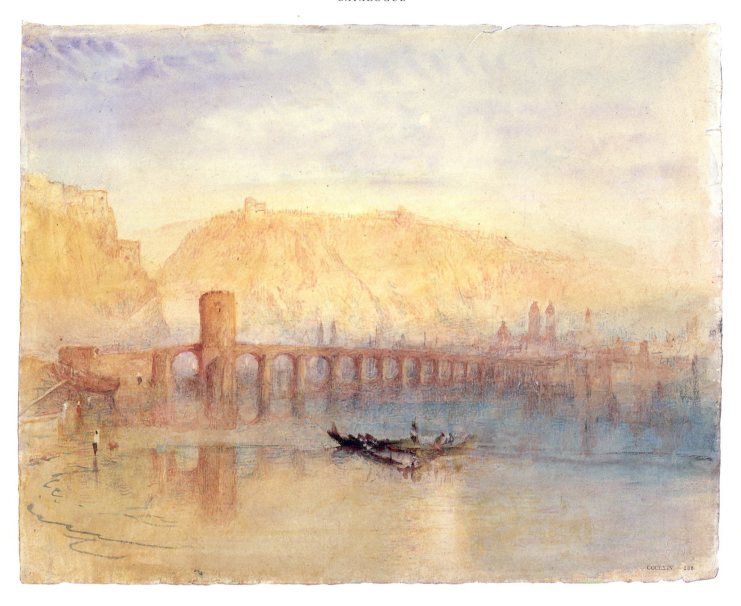

123 The Mosel Bridge at Coblenz: Sample Study *c.*1841–2

Watercolour on white wove paper
236 × 295 (9¼ × 11⅝)
Watermarked: J WHATMAN/TURKEY MILL/1822
Inscribed in pencil, on the verso: '<u>J. Ruskin, Junr, Esq</u>'; '9'
TB CCCLXIV 286
D36139

During the 1840s Turner produced around forty to fifty 'sample studies' for his agent, Thomas Griffith, to show to potential patrons in order to attract commissions for watercolours (see Warrell 1995, pp.149–55). Cat.no.123 belongs to the first group of 'sample studies', painted in 1841–2, which led to the execution of ten magnificent watercolours, chiefly of Swiss subjects and including both 'The Blue Rigi' and 'The Red Rigi' (w 1523–7 and 1529–33). It was preceded by the more private study,

cat.no.122, in which Turner's first compositional ideas were tried out with the same range of colours used in a much freer and more spontaneous fashion. Here the colours are used very sparingly, painted wet on wet, so that pools of brilliant blue, turquoise and gold seem to float over the white page. In the 'sample study', however, Turner's technique is far more refined, with numerous tiny strokes building up intricate patterns of relief and volume. Its composition, too, is more complex and balanced: Ehrenbreitstein and the neighbouring hill beyond the Rhine provide a golden backdrop; the Mosel bridge appears to span the page just as it does the river itself; the many towers of Coblenz echo the supports of the bridge; figures on the shore provide a sense of scale; and the dark boat is placed just where the blue surface of the water starts to shimmer with golden light.

The finished watercolour itself (1842; w 1530) was

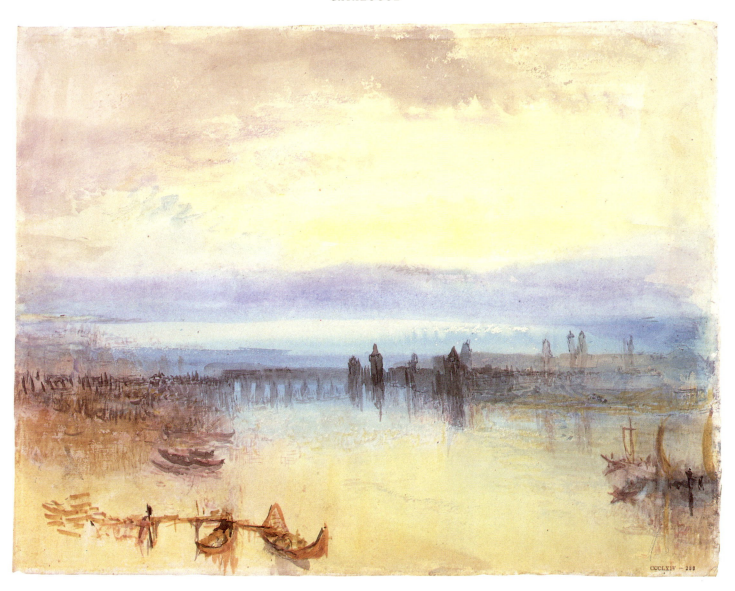

bought by Ruskin; hence the inscription on the verso of cat.no.123. Its present whereabouts is unknown; it was last recorded as on loan to the Victoria and Albert Museum from the collection of R.E. Tatham, *c.*1912–13 (see Warrell 1995, cat.no.8). It was illustrated and discussed by Ruskin in his *Elements of Drawing* (1857) and several copies exist, made by Ruskin's pupils under his supervision, including one by William Ward in the Art Museum, Cincinnati.

124 Constance: Sample Study *c.*1841–2

Watercolour
242 × 311 (9⁹⁄₁₆ × 12¼)
Inscribed on the verso: (in pencil) '8'; (in red chalk) '12'
TB CCCLXIV 288
D36142

125 Constance 1842

Watercolour
307 × 464 (12¹/₁₆ × 18¹/₄)
York City Art Gallery (Purchased with the aid of the Victoria and Albert Museum and the National Art Collections Fund)
W 1531

Cat.no.124 belongs to the same group of 'sample studies', painted in 1841–2, as cat.no.123 showing the Mosel bridge at Coblenz. The finished watercolour (cat.no.125) was in this case also bought by Ruskin, though he acquired it only when no other purchaser was forthcoming. As Ruskin himself later recorded, the 'sample study' of 'Constance' failed to attract a commission at all but Turner executed his planned watercolour regardless, determined to produce the round number of ten scenes and envisaging it as a remuneration for Griffith for acting as his agent. However, shortly afterwards Griffith sold it to Ruskin who noted that the day on which he brought it home was 'one of the happiest in my life'. He made a squared-up copy of its boats and buildings, probably intending to use this in his drawing lessons (see Warrell 1995, cat.no.20).

The town of Constance (Konstanz) is situated near the west end of Lake Constance (the Bodensee) where the Rhine leaves the lake, flowing on through the subsidiary lake of the Untersee and then on westwards towards Schaffhausen and Basel. Although the southern shore of Lake Constance lies in Switzerland, the town itself is part of Germany. Turner's view is taken from the north-west. The Rhine forms the foreground, spanned in the distance by the old wooden bridge at Constance with its huge protective towers, the Rheintorturm and nearby Pulverturm. The town lies to the right, its cathedral not yet crowned by its perforated spire built in the 1850s. On the left bank lies the village of Petershausen.

Cat.no.125 is, not surprisingly, a far more complex scene than its 'sample study'. The colours are rich and deep, the handling immensely detailed and the light effects a *tour de force* of brilliance and variety. Turner suggests the grandeur of the town by paying less attention to individual buildings than in the study, concentrating instead on strength and bulk. The Rhine, too, is given enhanced splendour with shimmering reflections and numerous tiny figures dotted all over its banks. In the left

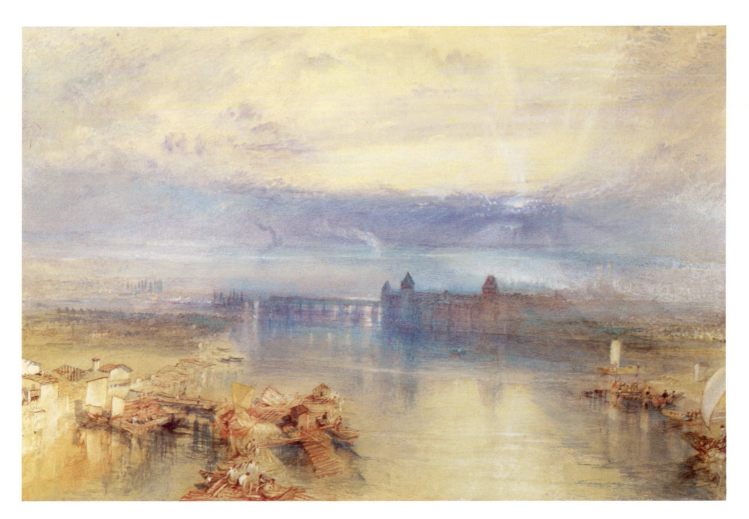

foreground men are at work on a landing-stage consisting of the rafts of logs that were such a feature of the river in the nineteenth century; a ferry is evidently in operation at this point also, with boatloads of people assembled on either shore. A broad expanse of blue water is now clearly shown in the middle distance, punctuated by spirals of smoke from steamers on the lake. Above this the Alps rise proudly like a wall of purple touched with silver. The sun is just rising over their snowy peaks, flooding the sky with golden light and transforming both lake and river into shimmering pools of colour.

126

126 Heidelberg: Large Colour Study *c.*1841

Pencil and watercolour
486 × 693 (19⅛ × 27⁵⁄₁₆)
Watermarked: 1794 / J WHATMAN
Inscribed with numerous calculations and the date '10 Mar 1841'
TB CCCLXV 34
D36325
[Exhibited in Germany only]

The unusually large size of this drawing, its viewpoint and the date, casually jotted down on the edge of the paper, all demonstrate that it is related to Turner's two large watercolours of Heidelberg executed in the early 1840s: 'Heidelberg, with a Rainbow' (cat.no.127) and 'Heidelberg, Sunset' (cat.no.129). The first of these was painted for the purpose of a large engraving by T.A. Prior (cat.no.128). Turner's viewpoint here is not identical to that used in either of his finished watercolours, but it is broadly similar. For cat.no.127 Turner based his scene on a sketch by Prior himself and he may well have made this drawing in order to help in the process of enlargement

and development. Some of the key contrasts between light and dark are already present, as are some of the motifs in the foreground.

Heidelberg is here seen from the Neuenheim shore, looking up the Neckar to the eighteenth-century stone bridge and the castle on its hill. This was one of the most popular viewpoints of Heidelberg in the nineteenth century with artists of many nationalities, featuring in paintings, prints and as a frontispiece to books on the town.

Turner himself discovered the fine views from the Neuenheim shore on his first visit to Heidelberg in 1833 (TB CCXCVIII 14r, 14v, 15v, 16r). He also made several very rough pencil sketches from similar viewpoints on a much later tour (*Berne, Heidelberg and Rhine* sketchbook, TB CCCXXVI 39v–42r, 44r). This sketchbook is probably datable to 1841, by which time Turner was engaged on his two large watercolours. However, the sketches are far too vague to have made any contribution to them and Turner would have walked and sketched on the shore simply for his own enjoyment.

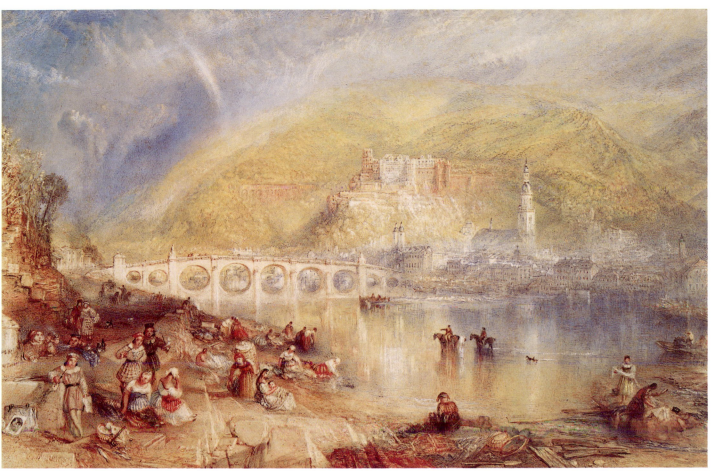

127

127 Heidelberg, with a Rainbow *c.*1841

Watercolour
311 × 521 (12¼ × 20½)
Private Collection on loan to the National Gallery of Scotland, Edinburgh
W 1377

THOMAS ABEL PRIOR AFTER J.M.W. TURNER

128 Heidelberg from the Opposite Bank of the Neckar 1846

Line engraving on steel, first published state
370 × 543 (14⁹⁄₁₆ × 21¼)
T05190
R 663

Turner's exceptionally fine watercolour was made for the purpose of engraving, as was the case with at least one other large German subject (see cat.nos.108, 110). The engraving was published on 1 June 1846 and the drawing is thought to have been made a few years earlier. Although

Turner visited Heidelberg on at least four occasions, the idea of the engraving was not his own, nor was the composition of his own devising. As W.G. Rawlinson recounted (1913, p.343), 'The late Mr. Prior told me that in 1840 he applied to Turner for a commission for engraving, and having been attracted by Heidelberg on a recent visit, he suggested that subject to Turner. The painter at first discouraged him, as his large engravings had not latterly been selling well, but on reflection he yielded and promptly made the Heidelberg Drawing from a sketch of Prior's, charging the latter 100 gs. for it. This Drawing Prior afterwards sold to Mr. Windus.' Turner's hesitation may also reflect the fact that British engravings in general were not selling as well in Germany as French ones or the very much cheaper Italian ones, so that continental sales could not be relied on. As the 'Heidelberg' plate proceeded, it appears that Turner was pleased with Prior, with whom he had not worked previously, and only touched the proof of it once, which was very unusual for him.

It is often said that the figures in this scene are in medieval costume, but this is only true of the young men, who are evidently students of Heidelberg university in festive mood. The spectacular buildings of Heidelberg – the Renaissance castle and Heiliggeistkirche and the late eighteenth-century bridge over the Neckar are much as Turner and Prior must have seen them, the castle clearly showing the damage it had sustained in the wars of the late seventeenth century. The foreground is replete with contrasting incidents including pipe-smoking students, a courting couple, women attending to their laundry, horsemen and a dog refreshing themselves in the river and a solitary reader on the shore. The pensive standing figure on the left, close to the palette, portfolio and lady's portrait in a roundel, is clearly an artist and is reminiscent of the figure of Raphael in Turner's oil painting 'Rome, from the Vatican' of 1820 (B&J 228; Tate Gallery). Above them all is one of Turner's most splendid skies, partially veiling the richly wooded hill against which Heidelberg is built. Both landscape and sky are gloriously painted and were, indeed, well engraved by Prior.

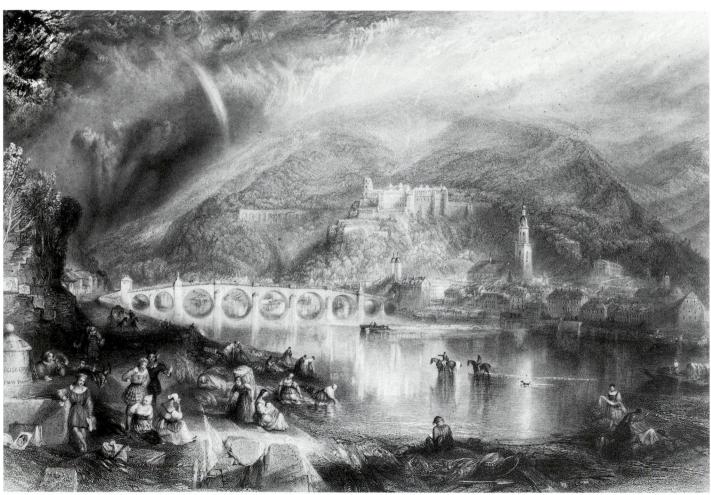

128

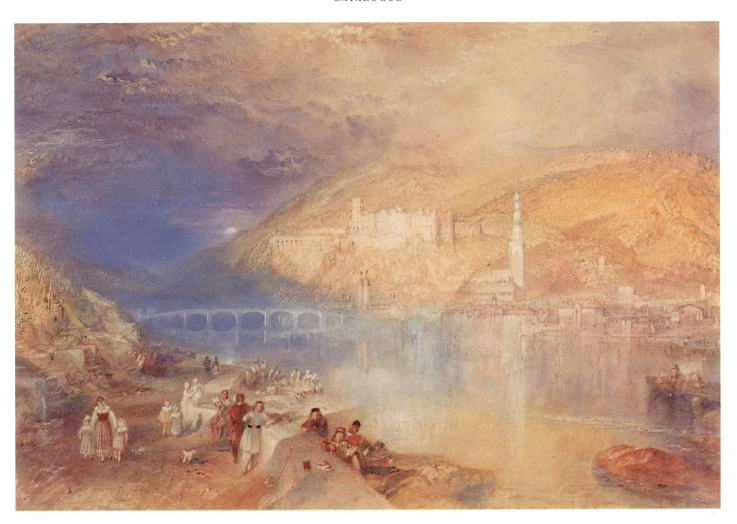

129 Heidelberg, Sunset ?c.1842–3

Pencil, watercolour and gouache with scratching out
380 × 552 (15 × 21¾)
Manchester City Art Galleries
w 1376
[Exhibited in London only]

This watercolour is close to cat.no.127 in its composition but exceeds it somewhat in size. It was presumably a commissioned repeat of that view for a collector who had seen the earlier work whilst Prior was engaged on his engraving.

There is far less concentration on narrative incident here than was necessary in the work intended for engraving. In place of this, Turner created magnificent atmospheric effects which transform the prosaic reality of hills, river and town into a fairyland of light and colour. On the left the moon rises over the brow of the hill on which Heidelberg castle is situated, but most of the scene is bathed in the light of the sun which is setting beyond the right-hand edge of the picture. Such contrasts of light, warmth and colour with shade, coolness and darkness were a recurring motif in Turner's art, both in oils and watercolours. On more than one occasion around 1840 he appended Byron's lines, 'The moon is up and yet it is not night / The sun as yet divides the day with her', from *Childe Harold's Pilgrimage*, canto IV, to one of his exhibited paintings and they would have provided a perfect accompaniment to cat.no.129. Like the Roman Forum, the vast ruin of Heidelberg castle was a powerful symbol of vanished glory: for centuries it had housed the court of the Electors Palatine before being wrecked by Louis XIV's troops in 1689. As in many of Turner's Italian paintings, so here in his 'Heidelberg' the citizens of his own day pursue their mundane daily tasks as if unaware of the splendour and antiquity that surround them, making a poignant contrast between past and present.

130 Heidelberg, Moonlight: Sample Study

c.1841–2

Watercolour
241 × 300 (9½ × 11¹³⁄₁₆)
TB CCCLXIV 325
D36183

This work is stylistically very similar to other 'sample studies' of the early 1840s, all depicting Switzerland. No finished watercolour was apparently developed from this scene, either because Turner chose, in the end, not to circulate it, or because no commission for it was forthcoming (see Warrell 1995, pp.149–51, for the group of works to which it surely belongs).

The topography here is far less easy to understand than that in Turner's other watercolour depictions of Heidelberg from the early 1840s (cat.nos.127, 129), owing to the apparent absence of the bridge. This, however, should be understood as being on the left. Beneath the castle terrace (the horizontal in the light patch on the hillside to the left of the castle itself) can clearly be seen the light-coloured bridge towers and further to the left another light horizontal area indicates the start of the bridge itself. The youths in Turner's foreground are thus enjoying themselves along the popular Neuenheim shore – the perfect place for some moonlight mischief.

Turner produced his 'sample studies' from the sketchbook material of his very recent tours. He drew many rough pencil sketches of Heidelberg from the Neuenheim shore in the *Berne, Heidelberg and Rhine* book (TB CCCXXVI 39v–42r, 44r). That on f.40r shows the bridge, terrace, castle and town in the same schematic way

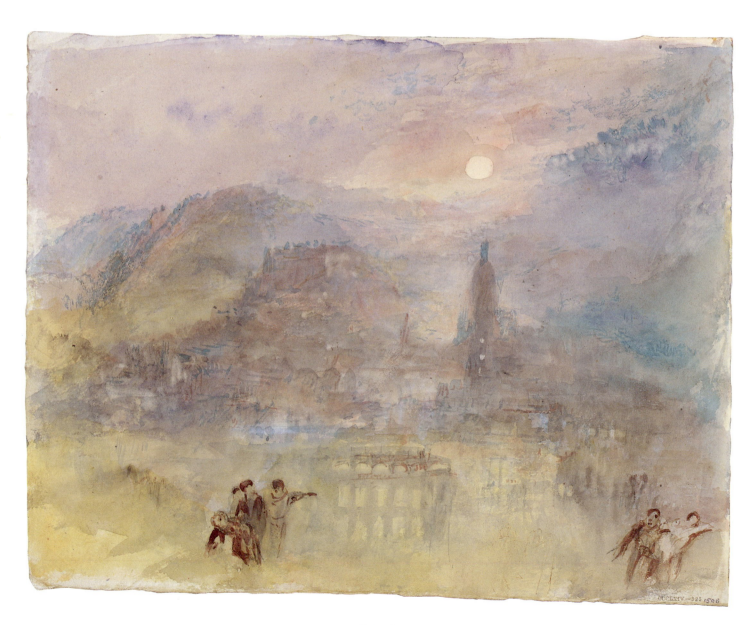

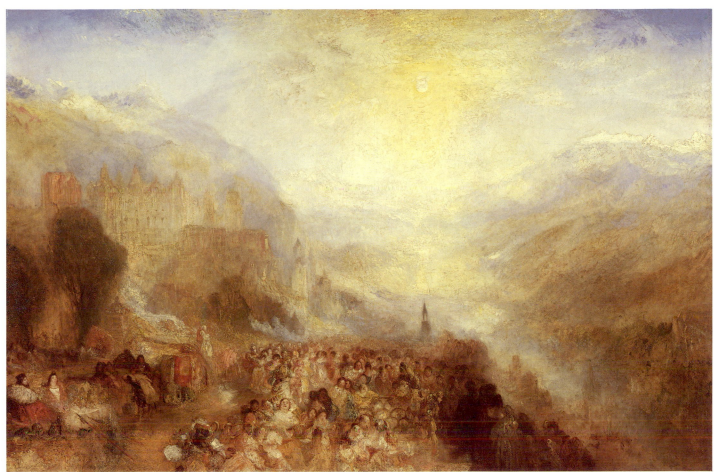

131

as cat.no.130. However, in the 'sample study' Turner decided to move the Heiliggeistkirche further to the right so as to separate it further from the castle and give it greater prominence.

The *Berne, Heidelberg and Rhine* sketchbook may be dated to 1841 partly through its inclusion of a sketch of the Place Gutenberg at Strasbourg with the statue of Gutenberg himself by the French sculptor David d'Angers, erected in 1840 (f.43r).

131 Heidelberg *c.*1844–5

Oil on canvas
1320 × 2010 (52 × 79½)
Turner Bequest; B&J 440
N00518
[Exhibited in London and Mannheim only]

This painting, never exhibited by Turner himself and evidently unfinished, is of very similar size to 'The Opening of the Wallhalla, 1842' (cat.no.109) and it may perhaps have been intended as a pendant to it. It may well have

been inspired by Turner's last visit to Heidelberg, which can now be precisely dated to 24–7 August 1844. During this visit he made many watercolour sketches of Heidelberg itself, several from the hillside around the castle (see cat.nos.138–44, especially 139).

Whereas 'The Opening of the Wallhalla' takes very recent history for its subject, 'Heidelberg' is definitely a semi-allegorical depiction of events in an earlier century. It looks back to the golden age of the court of the Elector Palatine Friedrich V who married Princess Elizabeth, the eldest daughter of the English king James I and his queen, Anne of Denmark, in 1613. As in the case of the marriage of Queen Victoria and Prince Albert in 1840, it was a carefully arranged marriage between Protestant kingdoms, combined with genuine love between the young people themselves. In honour of his wife Friedrich added the 'English Building' to Heidelberg Castle and laid out the 'English Garden' behind it with the Elizabeth Gate, a triumphal arch marking his wife's nineteenth birthday in 1615. Their court at Heidelberg was famous for its festivities and extravagant entertainments, banquets and masques, but their gay life did not last for long. In 1619

Friedrich accepted the throne of Bohemia and moved to Prague but he was driven out the following year and, having lost control of the Palatinate also, the family lived thereafter as exiles in Holland. Of the couple's numerous children, the youngest daughter, Sophia, married into the electoral family of Hanover and became the mother of the future king of England, George I.

Turner's painting shows the view westwards down the Neckar valley towards its junction with the Rhine at Mannheim. The castle, built by successive generations of the Electors Palatine, stands completed on the hillside and in the left foreground a courtier bows low before the seated figures of Friedrich V and Elizabeth. Close to them a great gathering of their court is in festive mood – embracing, dancing, conversing or simply reclining on the grass. This hillside was laid out by Friedrich V as the 'Hortus Palatinus', a formal garden designed by the French architect Salomon de Caus, with terraces, ponds, statues, grottoes, fountains, an artificially heated orangery, bathhouses and over-life-size statues of Friedrich and Elizabeth. Sadly, the gardens soon suffered severe damage in the Thirty Years' War. However, Turner must certainly have seen some of the many engravings of them whilst he was in Heidelberg, showing similar views to that of this painting and with the figures of Friedrich and Elizabeth in the foreground.

Turner may have intended 'Heidelberg' and 'The Opening of the Wallhalla' as an 'ancient' and 'modern' pair, as in his earlier oil paintings of Rome and Italy on this theme in 1838 and 1839; and he perhaps lost interest in completing 'Heidelberg' after the unsuccessful showing of 'The Opening of the Wallhalla' in Munich in 1845.

132

On the Neckar sketchbook 1844

132 Two Views of Hirschhorn from the East

Pencil
Page size: 155 × 100 (6⅛ × 3¹⁵⁄₁₆)
White wove writing paper, machine-made and of continental origin
Inscribed: 'R Rock' (f.28)
TB CCCII ff.27 verso, 28
D30424, D30425
[Exhibited in Germany only]

Turner noted inside this sketchbook that it was 'Bought at Heidelbergh' and it contains sketches of the Neckar valley from Heidelberg up to Heilbronn. These must certainly have been drawn on the same tour as the watercolour sketches of several of the same places (cat.nos.145–50). Often in the book Turner's sketching style is loose and hasty, probably reflecting not only his age but also the bad weather that marred this tour. A contributory factor may have been the poor quality of the paper.

Some fifteen miles from Heidelberg the Neckar curves in a spectacular double bend similar to those of the Mosel. Hirschhorn lies to the north of this curve with the medieval Ersheimer Kapelle nearly opposite, on the lower land around which the river flows. The two sketches on ff.27v–28r were drawn from slightly further upstream than Turner's coloured sketch (cat.no.148), so that both the chapel and its picturesque situation are recorded far more explicitly.

Rhine and Rhine Castles sketchbook 1844

133 Burg Reichenberg

Watercolour
Page size: 229 × 327 (9 × 12⅞)
White wove drawing paper
Watermarked: J WHATMAN/1844
This sketchbook also contains one sheet (ff.3/22 and 9/16)
of a cream wove drawing paper
Watermarked: J WHATMAN/TURKEY MILL/1839
TB CCCLI f.4
D35178
[Exhibited in Germany only]

On Turner's late continental tours he habitually used small notebooks, such as cat.no.132, in conjunction with 'roll' sketchbooks such as this one. The former could be used for brief memoranda, the latter for more expansive sketching and work in colours. Turner's coloured sketches in these roll sketchbooks were frequently of such high quality that after his death the books were unbound and the pages separately mounted so that most of them could be exhibited (see cat.nos.134–50). The *Rhine and Rhine Castles* sketchbook, however, escaped this fate, owing to the more summary style of its contents. It is exhibited here to show both a contrast in sketching styles with cat.nos.134–50 and also the context in which those much finer drawings were actually created by Turner's hand.

The sketchbook contains pencil sketches of Cologne and of St Goar and St Goarshausen with their castles of Burg Rheinfels and Burg Katz, but many sketches show Burg Reichenberg behind St Goarshausen. This may well be the subject of the sketch on f.4, an isolated castle painted in a free and highly expressive style reminiscent of Turner's preparatory watercolour sketches for his vignettes of the 1830s. It is this economy of means that makes Turner's later watercolour work so poetical and evocative and, at the same time, so modern.

134 Bingen and Burg Klopp from the Nahe
1844

Pencil, watercolour and gouache, with pen
228 × 326 (9 × 12⅞)
TB CCCLII 19 ('Coblentz')
D35239

Because of its compositional similarity to cat.nos.122–3, this drawing has always been regarded as a depiction of Coblenz and Ehrenbreitstein, but it in fact shows the bridge over the Nahe at Bingen, with Burg Klopp on the hill in the distance. Bingen itself is shown as a grey cluster of buildings at the water's edge, the houses and their reflections merging in a flurry of grey and mauve dabs of paint and the spires of its church providing a naturally picturesque ending. The Nahe flows into the Rhine between the church and the group of buildings roughly sketched in red on the left.

This is one of the classic views of Bingen: Turner himself painted it thus in 1817 (w 682), it was drawn by Clarkson Stanfield for *Heath's Picturesque Annual for 1832*, and it is embossed on a Prussian sketchbook used by Turner in 1835 (cat.no.31). However, cat.no.134 is especially significant in that it inaugurated Turner's exploration of the Nahe valley much further than was usual with British travellers (see cat.nos.135–7).

Cat.nos.134–50 all come from two identical roll sketchbooks of Whatman paper watermarked 1844, which were taken apart for exhibition purposes soon after Turner's death. These two, along with other sketchbooks, were used in both Germany and Switzerland on Turner's last major continental tour which has, in the past, hindered the identification of their contents. But even if it is no longer possible to be sure which pages came from which book, it is at least possible to give them their correct topographical titles.

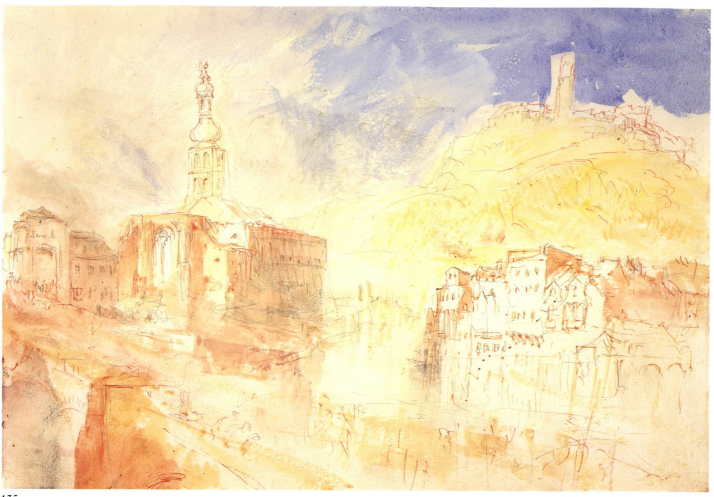

135

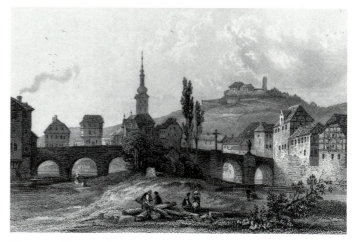

'Creutznach', engraving from K. Simrock, *Das Rheinland* (*c*.1840).
By permission of The British Library

135 Kreuznach on the Nahe 1844

Pencil and watercolour, with pen
228 × 328 (9 × 12^{15}/$_{16}$)
Watermarked: J WHATMAN/1844
TB CCCLII 10 ('Heidelberg')
D35230

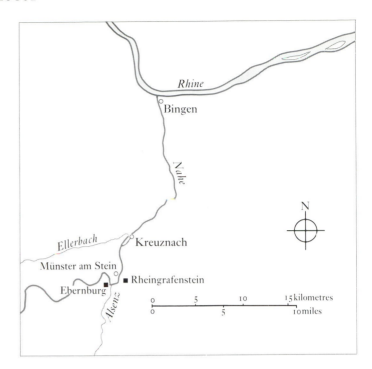

Kreuznach lies ten miles south of Bingen on the river
Nahe where it is joined by its tributary the Ellerbach.
Below the ruined medieval castle of the Counts of
Sponheim, on the hill of the Kauzenberg between the two
rivers, an important spa town developed during the
second quarter of the nineteenth century, with a Kurhaus
being built in 1840 and other amenities thereafter. It is
now called 'Bad Kreuznach'.

Turner's view is taken from the old stone bridge over
the Nahe, looking west towards the castle, and is dominat-
ed by the Protestant Pauluskirche. This dates back to the
fourteenth century but it was wrecked in 1689. Some of
the medieval ruins were incorporated by Philipp Heller-
mann into a new hall-church in 1768–81. The picturesque
ruined Gothic east choir depicted by Turner was the sub-
ject of many prints and drawings (see W. Reiniger, *Stadt
und Ortsansichten des Kreises Bad Kreuznach 1523–1899*,
Bad Kreuznach 1990). It remained in ruins until 1863
when it was restored with the help of contributions from
the many English visitors to the Kurhaus, after which it
was both known and used as 'the English church'. Just a
year before Turner's visit, the young Karl Marx, a native
of Trier, was married in the Pauluskirche, on 19 June
1843.

Both the Pauluskirche and the Kurhaus are situated on
an island in the Nahe, the Badewörth. On the left of his
scene Turner includes some of the Brückenhäuser, a
series of small medieval houses built upon the wider por-
tions of the bridge itself. On the right he shows some of
the houses of Klappergasse. The same ingredients can be
seen, more straightforwardly composed, in the engraving
of the town published in Karl Simrock's *Das Rheinland*,
issued as volume IX of the twelve-volume work *Das
malerische und romantische Deutschland* (Leipzig 1836 et
seq.).

Although unaware of their subject matter, Ruskin
greatly admired Turner's Nahe drawings (see his com-
ments quoted in Warrell 1995, pp.53, 126, 128).

136 Rheingrafenstein and Ebernburg on the Nahe 1844

Pencil and watercolour, with pen
229 × 327 (9 × 12⅞)
TB CCCXLIX 21 ('Fortress and torrent')
D35145

About three miles south of Kreuznach (cat.no.135), the Nahe valley becomes truly spectacular, with rearing cliffs of red porphyry that are unequalled in Germany. The river here flows round the appropriately named town of Bad Münster am Stein, which enjoys views of two vast crags surmounted by castles: Rheingrafenstein (on the left of cat.no.136) and Ebernburg (on the right). The first is perched on a pinnacle of the rock that rises almost perpendicularly from the river but it was nevertheless seized and destroyed by the French in 1689. Murray's *Handbook for Northern Germany* pointed out that tourists would find the ruins more accessible by descending from the hill above than by crossing the Nahe on the ferry and ascending via a very steep footpath. The unpleasantness of such a crossing can easily be imagined from Turner's turbulent foreground. The much larger castle of Ebernburg was the subject of a second drawing by Turner, taken from the opposite direction (cat.no.137).

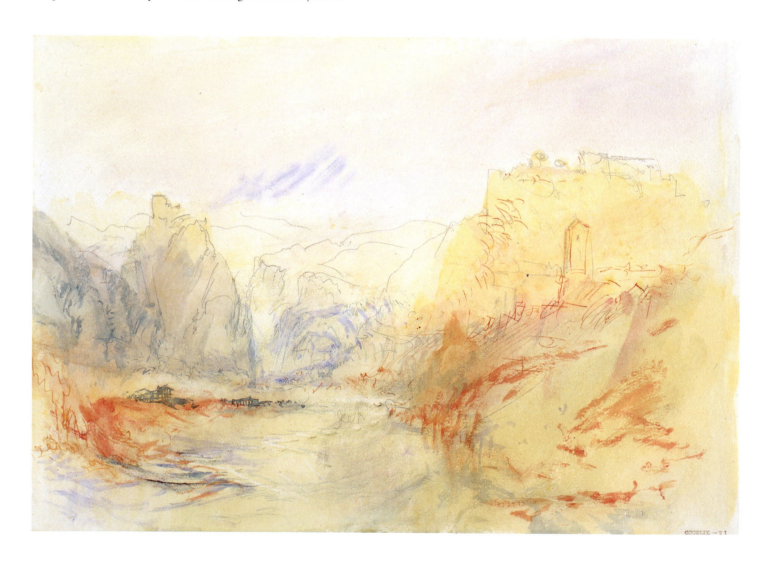

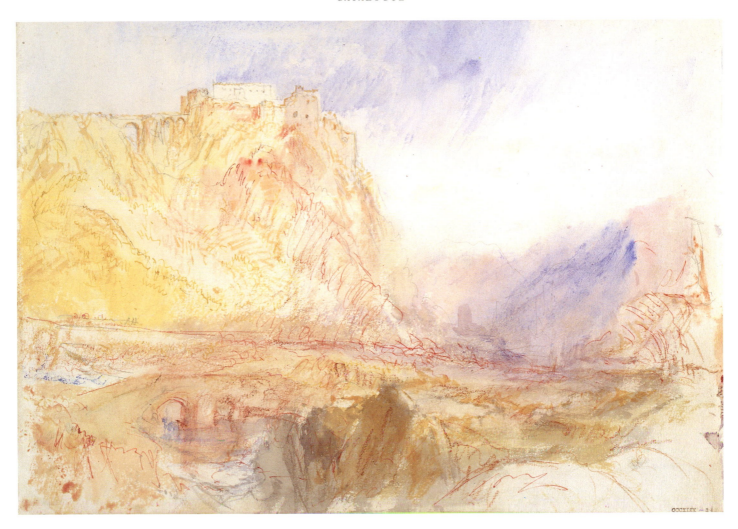

137 Ebernburg from the Valley of the Alsenz

1844

Pencil and watercolour, with pen
229 × 326 (9 × 12⁷⁄₈)
TB CCCXLIX 24 ('Castle near Meran')
D35148

Ebernburg stands high above the Nahe just where it is joined by its tributary the Alsenz, seen here in Turner's foreground. All around are the towering cliffs of porphyry for which this area is famous. These include the most precipitous rock face in Germany north of the Alps, the seven hundred foot Rotenfels, here seen curving round the Nahe valley opposite Ebernburg. Turner's dynamic pen drawing in reds and browns well conveys both the colouring and the drama of the scenery.

In the sixteenth century Ebernburg was the castle of the celebrated Franz von Sickingen who sheltered many of the early Reformers here, including Melanchthon and Ulrich von Hutten, but he was overcome by the united strength of the Elector Palatine and other rulers. The castle was destroyed by these princes soon after his death and dismantled further in 1698. It was the subject of many prints and drawings, some of which correspond closely to Turner's view (see W. Reiniger, *Stadt und Ortsansichten des Kreises Bad Kreuznach 1523–1899*, Bad Kreuznach 1990, especially pp.86–8).

138 View along the Hauptstrasse, Heidelberg
1844

Pencil and watercolour
229 × 329 (9 × 13)
TB CCCLII 12
D35232

The castle of Heidelberg dominates nearly all Turner's views of the town drawn on his last visit there in late August 1844 (cat.nos.138–44). In this one alone, his viewpoint is neither the hillside nor the banks of the Neckar, but the eastern end of the Hauptstrasse, close to the side of the Heiliggeistkirche, the buttresses of which are shown in steep perspective on the left.

Two fine old buildings are sketched on the right. Beneath – and in stark contrast to – the ethereal golden evocation of the castle is the early eighteenth-century Hofapotheke or Court Apothecary (with a pedimented top storey). The lighter grey building on the extreme right is the Gasthaus zum Ritter or Hotel Ritter. Built in 1592, it was the only Renaissance building in Heidelberg to survive the destruction wreaked on the town during the war of 1689–93 and it has functioned as a hotel since 1705. Turner's impressionistic sketch conveys the idea of its size and grandeur, its many windows separated by columns, and the progression up to its gable via a series of volutes and pinnacles. It does not, however, attempt to do justice to the hotel's immensely rich sculptural decoration of statues, coats of arms, caryatids, busts, inscriptions and arabesques, nor to its topmost ornament, the figure of a knight which gives the building its name.

By Turner's day the hotel was noted not for its comforts but for its history: according to tradition, it was the customary 'house of call' of Götz von Berlichingen (see cat.no.145). One of the many English books on Heidelberg to recommend the hotel used by Turner, the Prinz Carl (see fig.56 on p.74), remarked that those who were less particular would be content with the Ritter (R.H. Gunnell, *Picturesque Views of Heidelberg and its Environs*, 1837, p.12).

In its quiet range of colours and peaceful mood, this view is similar to Turner's urban views of Coburg made in 1840 (cat.nos.98–9).

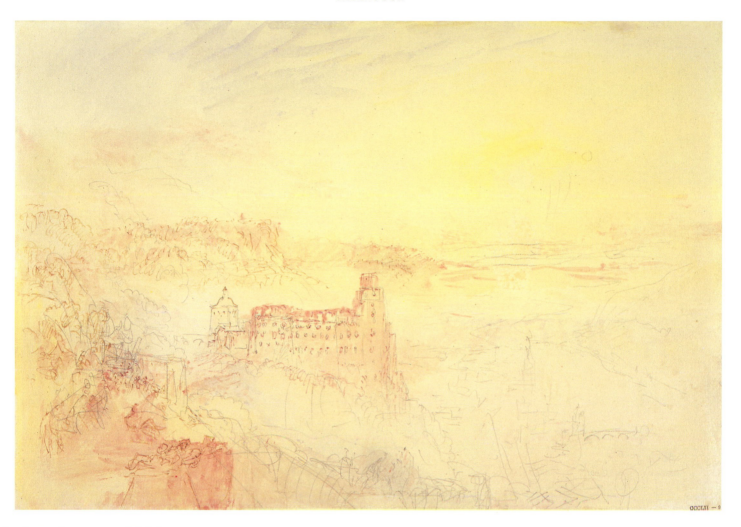

139 Heidelberg from the East 1844

Pencil and watercolour, with pen
228 × 327 (9 × 12⁷⁄₈)
TB CCCLII 9
D35229

This view of Heidelberg castle, the town and the Neckar flowing westwards to meet the Rhine is regarded as one of the finest sights in all Germany and tourists have long flocked to admire it from the specially constructed terrace in the castle grounds. Turner's viewpoint is, however, much higher than the terrace itself, indicating that he climbed up away from the other tourists to a wilder piece of hillside providing a more dramatic prospect.

Cat.no.139 shares the same brilliant warm colouring of cat.nos.143 and 144, evoking the glow of a warm August evening as well as the redness of the buildings themselves. The sun sinks to the west, setting the hillside aflame with countless tints of pale gold and pink, while the areas of paper that are scarcely touched by colour seem already enveloped in mist.

140 Heidelberg Castle from the Hirschgasse

1844

Pencil and watercolour
227 × 329 (8¹⁵⁄₁₆ × 13)
TB CCCLII 13
D35233

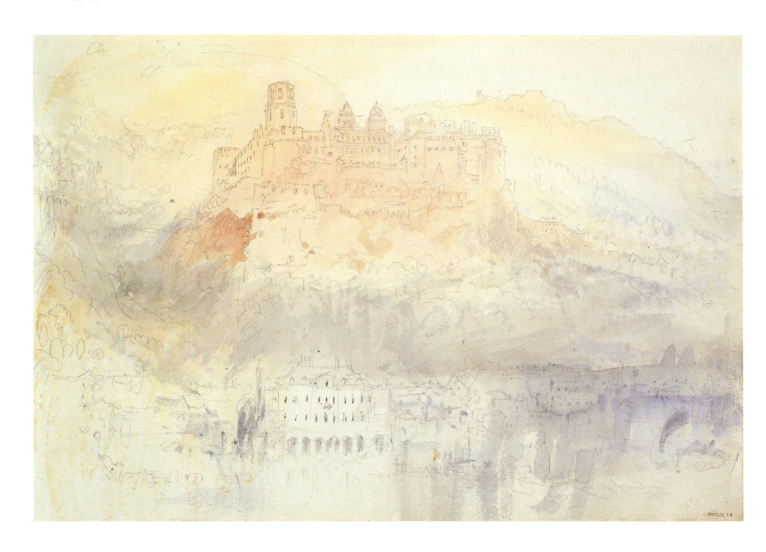

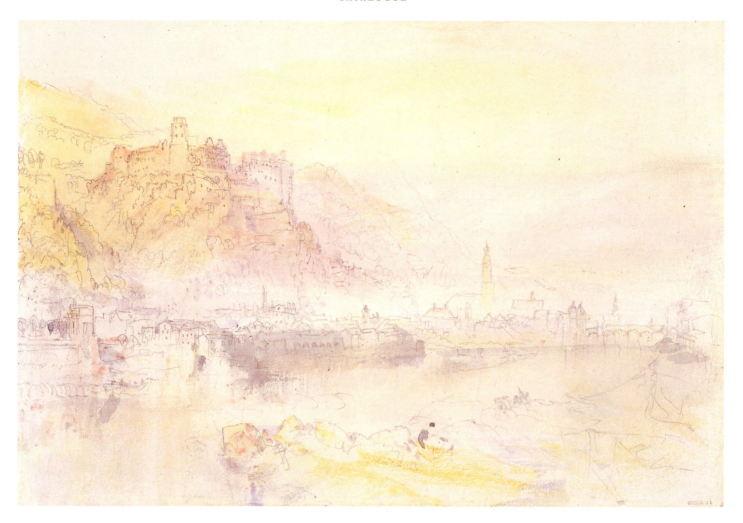

141 Heidelberg from the Hirschgasse 1844

Pencil and watercolour
228 × 330 (9 × 13)
TB CCCLII 11
D35231

These views of Heidelberg and its castle were taken from a very popular spot across the Neckar just where a path led up the hillside into a side valley. Artists came here to draw and paint, students came to fight their notorious duels, and both converged on a well-known tavern.

In cat.no.140 Turner gives a lucid portrait of the castle showing (from left to right): the Apothecary's Tower; the tall octagonal Bell Tower; the Friedrich Building with its two gables; the English Building; and finally the Great Tower (sometimes translated as Fat Tower since it is broad rather than tall). The same features appear in the same configuration in cat.no.141, but there Turner's view is much wider, extending from the Karlstor on the riverside road on the left to well beyond the bridge over the Neckar with its two bridge towers on the right. In cat.no.140 Turner's view of the castle is nicely complemented by his depiction of the eighteenth-century Palais Weimar on the Neckar shore immediately beneath; its garden terrace supported by a wall of arches echoes the design of the terrace in the garden of the castle itself, just seen on the hillside at far left.

The colours used in cat.no.140 faithfully evoke both the forceful redness of the castle and the sense of a grey mauve mist hovering over the river.

Five of Turner's 1844 drawings of Heidelberg – cat.nos.139–41, 143–4 – featured in Ruskin's first selection from the Turner Bequest in 1857 (for his comments on them, see Warrell 1995, pp.47–51).

142 Heidelberg from the Schlangenweg

Pencil, watercolour and gouache
229 × 328 (9 × 12¹⁵⁄₁₆)
TB CCCLII 17 ('Fribourg(?)')
D35237

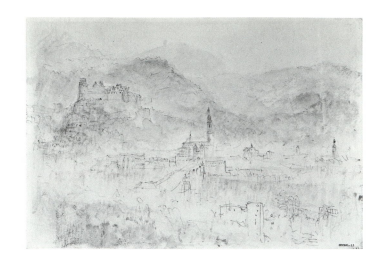

As in cat.nos.140–1 Turner's viewpoint is on the north side of the Neckar but he is now just west of the bridge which appears near the centre of the scene below the great mass of the Heiliggeistkirche. The Schlangenweg is a steep winding path up from the bridge to the Philosophenweg, a walk that provides breathtaking views of Heidelberg. Turner, like so many other nineteenth-century visitors to the town, evidently explored both the Hirschgasse and the Philosophenweg on the same exhilarating expedition.

143 Heidelberg from the South 1844

Pencil and watercolour, with pen
228 × 327 (9 × 12⁷⁄₈)
TB CCCLII 15
D35235

143

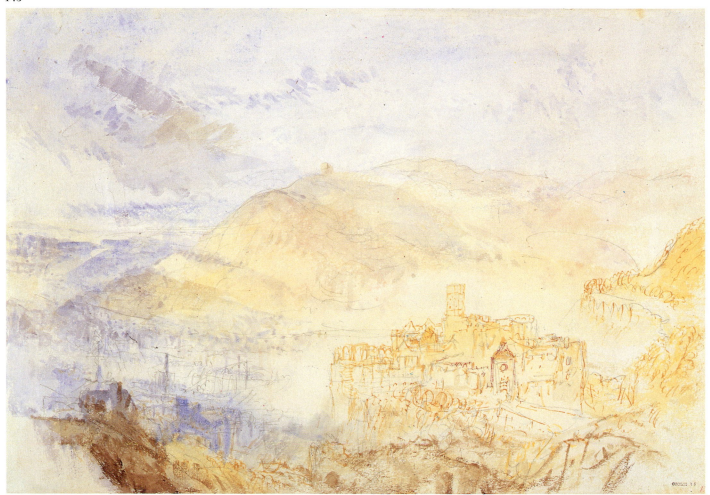

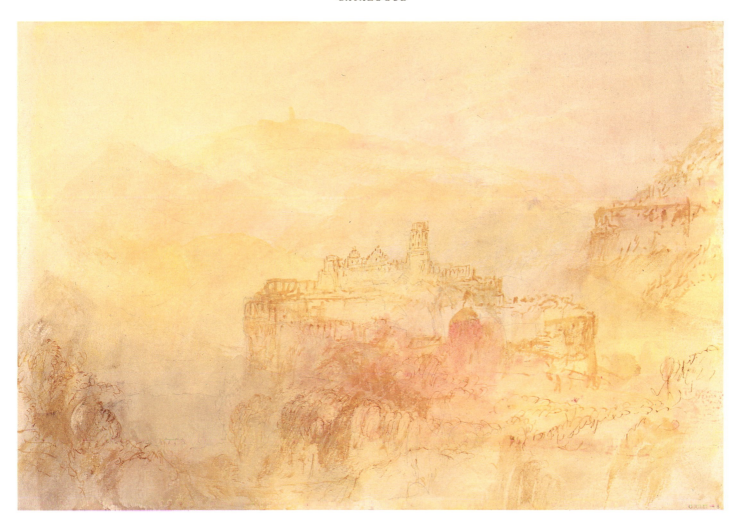

144 Heidelberg Castle from the South 1844

Pencil and watercolour, with pen
229 × 328 (9 × 12^{15}/$_{16}$)
TB CCCLII 8
D35228

In these two watercolours Turner's viewpoint is the opposite to that in cat.nos.140–2. He is standing south of the castle, probably on the road which leads to the Molkenkur, and looking down on to – indeed virtually into – parts of the complex that cannot be seen, or even guessed at, from the riverside. Nearest to him is the well-preserved Gate Tower at the south-west corner with its bell-shaped roof (in cat.no.143 swift pen lines indicate its clock and, slightly lower down, the 'gate giants'); furthest away are the Great Tower, Friedrich Building and Bell Tower, all now showing their inner façades to his gaze. On the far right of both drawings is the hillside with a terrace, supported on an arched substructure, which was near

Turner's viewpoint for cat.no.139. On the left of cat.no.143 a touch of purple indicates the spire of the Heiliggeistkirche and a pencilled whirl the arches of the bridge over the Neckar.

In cat.no.143 Turner's colour scheme of gold and lilac is characteristic of his Neckar drawings as a whole (see cat.nos.145–50) but several areas of the page are, with superlative mastery, left completely untouched by water-colour washes: the Neckar itself amid the buildings of Heidelberg enveloped in a mauve and blue mist; and the area beyond the castle, which is thus disengaged from the further hillside and appears as though floating on a sea of mist.

In cat.no.144 the town has disappeared from view entirely in a golden haze, whilst the overall colour scheme is more unified and much warmer, with the hillside trans-formed and burnished by the sun.

145 Heilbronn from the Neckar 1844

Pencil and watercolour
229 × 328 (9 × 12^{15}⁄$_{16}$)
Watermarked: J WHATMAN/1844
TB CCCLII 16 ('Town beside river')
D35236

Heilbronn was the most distant town up the Neckar valley sketched by Turner in 1844. It lies on the right bank about fifty-five miles south-east from Heidelberg and he had passed it in 1833 when he was on his way by road from that town to Stuttgart. In 1833 Turner made no attempt to explore the Neckar valley but in 1844 he made up for this oversight. The result was a far more exciting and magical group of watercolour sketches than he would have produced in 1833. Ruskin included all six of them in his first selection from the Turner Bequest in 1857, uncertain as to their subject matter but in no doubt at all as to their quality (see Warrell 1995, cat.nos.9–11, 16, 18, 82).

The subject of this work remained unknown until it was included in a British Council touring exhibition of watercolours from the Turner Bequest (then in the British Museum) which was seen in Mannheim, Munich and Nuremberg in 1950–1 (no.37, 'Stadt am Fluss'). Fritz Zink (1954) at last revealed its true identity, illustrating a similar view of Heilbronn engraved in the late 1830s and published in Gustav Schwab, *Wanderungen durch Schwaben*.

Turner shows Heilbronn from Badstrasse on the left bank of the Neckar, looking downstream to the covered wooden bridge and the distant hill of the Wartberg. Of the two church towers near the centre, the more ornate one on the left is that of St Kilian's church, built between 1513 and 1529 and the first important Renaissance building in Germany. The tower ascends in many richly decorated octagonal tiers with an external spiral staircase, clearly shown by Turner in a long rippling line, and is crowned by the figure known as the 'Heilbronner Männle'. Turner made several pencil sketches of the church and its tower from different positions in the town

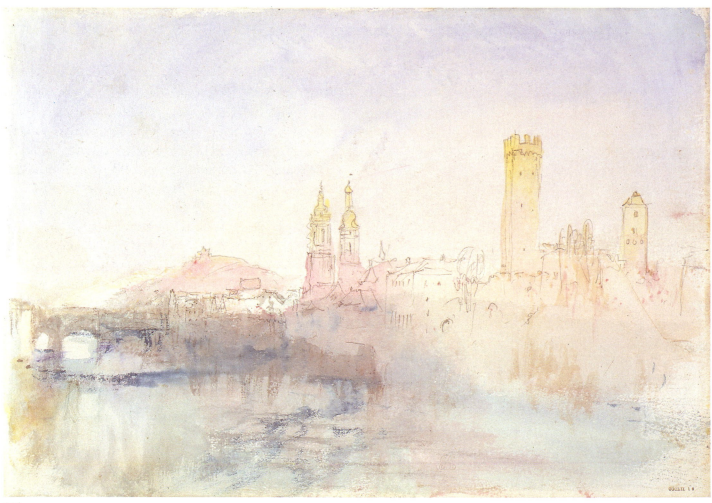

145

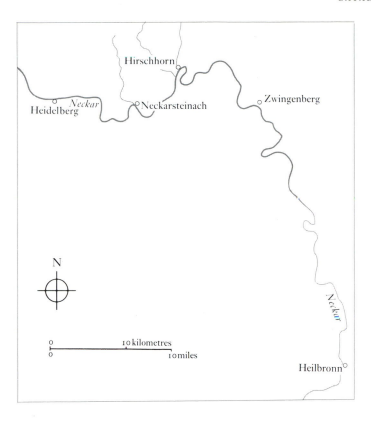

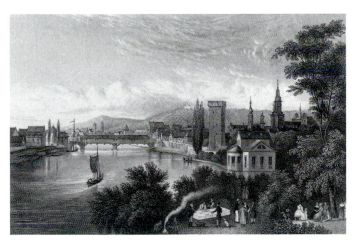

'Heilbronn', engraving from G. Schwab, *Wanderungen durch Schwaben* (c.1840). *By permission of The British Library*

(TB CCCII 2v–3r, 13v, 14v, 15r), but none of these has the same viewpoint as cat.no.145. The second church tower belonged to the Deutschordens Münster, since 1806 the Roman Catholic parish church of Heilbronn (seen also in Turner's pencil sketches in TB CCCII 13v and 15r). Like St Kilian's, this church still stands in Heilbronn, but it was rebuilt in the late 1960s after its destruction by bombing in December 1944 and it now sports a very different tower.

The scene closes with two of Heilbronn's fortified towers. The smaller one, the Butz– or Kohlenturm, was destroyed a few years after Turner's visit, in 1849, but the taller crenellated one, the Götzenturm which dates back to 1392, still stands today. This was

> formerly the prison of the celebrated Götz of the Iron Hand, who, it is said, died within its walls. The doughty champion will probably live in the remembrance of the good people of Heilbronn, only so long as the old tower which bears the name of the *Götzen Thurm* continues to stand; but the fame of Götz von Berlichingen will never die but with the extinction of German literature, handed down as it is to posterity by the master-hand of Göthe.
>
> (Tobin 1832, p.24)

In March 1799 an English translation of Goethe's play *Götz von Berlichingen* was published and was so popular that a second edition was soon called for. It was the second published work of the young Walter Scott and was of crucial importance in his career, directing him towards the tales of feuds and forays among robbers and barons in far-off times that he was to develop into a genre of his own within a Scottish setting.

Although this watercolour is much less strong in colouring, it shares the same concern with light and shadow as cat.no.150: the shadowy river is characterised by subtle shades of blue and mauve which contrast with the buildings of Heilbronn itself. The golden light of an August evening still burnishes the very tops of their spires and towers, but the lower parts of all the buildings are already in shadow (compare Turner's treatment of similar light effects, but experienced very early in the morning, at Regensburg in 1840: cat.no.94).

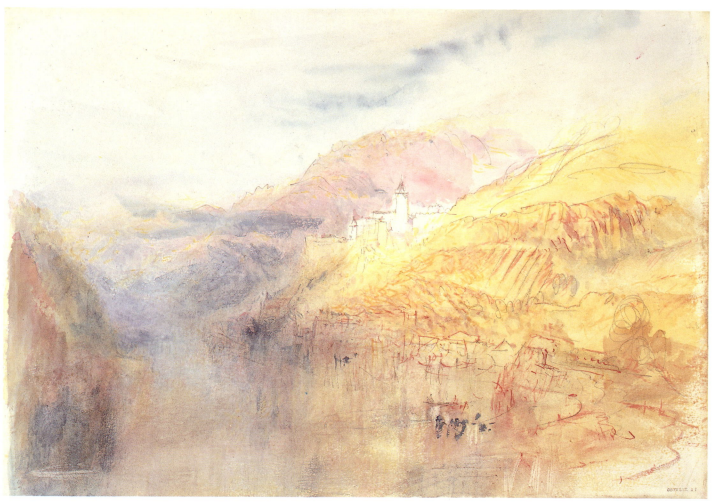

146

146 Zwingenberg on the Neckar 1844

Pencil and watercolour, with pen
229 × 328 (9 × 12¹⁵⁄₁₆)
Watermarked: J WHATMAN/1844
TB CCCXLIX 27 ('Castle on hill beside river')
D35151

147 Zwingenberg on the Neckar 1844

Pencil and watercolour, with pen
229 × 329 (9 × 13)
Watermarked: J WHATMAN/1844
TB CCCXLIX 26 ('Castle on hill beside river')
D35150

Although these sketches are listed in Finberg's *Inventory* as coming from the *Rheinfelden* sketchbook (TB CCCXLIX), it is very likely that they in fact came from the *Heidelberg* sketchbook (TB CCCLII). The books were so named not by Turner but by Finberg, according to the most recognisable subjects in each. They were of identical format, containing the same Whatman paper, and after they were broken up in the late nineteenth century for exhibition purposes, it became impossible to know where the various pages had originated. Four sketches of the Neckar (cat.nos.146–9) were assumed to be of the Rhine and were therefore allocated to the *Rheinfelden* book. Two others (cat.nos.145, 150), although not actually recognised as Neckar subjects, were allocated to the *Heidelberg* sketchbook.

Zwingenberg is situated on the right bank of the Neckar, about twenty-seven miles upstream from Heidelberg. Turner made it the subject of several hurried pencil sketches in his *On the Neckar* sketchbook (TB CCCII 24v, 25r, 25v, 26r), of which those on ff.24v and 25r share viewpoints similar to that of cat.no.147. The castle, which is built on a spur of rock, belonged to the Grand-Duke of Baden. The keep dates from the thirteenth century, other parts belonging to the fifteenth, and it was rebuilt in the 1590s. After Turner's day it was considerably restored, with extra buildings and towers being added, but even in the 1840s it was an exceptionally impressive habitation complete with roofs, rather than a ruin like so many of the German castles he depicted. The gorge behind the castle, the wild and romantic Wolfsschlucht, inspired the spine-chilling scenes of sorcery and black magic that lie at the heart of Carl Maria von Weber's opera *Der Freischütz* (1821).

Cat.nos.146 and 147 both show Zwingenberg looking downstream towards Heidelberg. The nearer view

(cat.no.147) must have been drawn from the Goldener Anker inn on the bend immediately above Zwingenberg, while the more distant one (cat.no.146) shows the prospect from near the landing-stage of the ferry. At first sight, Turner's two scenes appear to be painted in very different styles but in fact the real difference is simply that cat.no.146 has several more layers of watercolour wash, resulting in a richer, deeper colouring throughout. Both works are executed in a comparatively narrow range of colours, the balance between them being worked out to perfection in cat.no.146. The shadowy west side of the Neckar is depicted in very soft pinks, mauves and blues which are highlighted, more often than the eye at first perceives, with streaks of gold which provide shape, form and depth. Conversely, the eastern shore, which is bathed in the golden sunlight of late afternoon, is moulded and diversified by numerous streaks and stabs of pink and red of varying intensity. The castle acts as a still, quiet centre amid this kaleidoscope of light effects. The result is one of Turner's most beautiful watercolours of Germany.

147

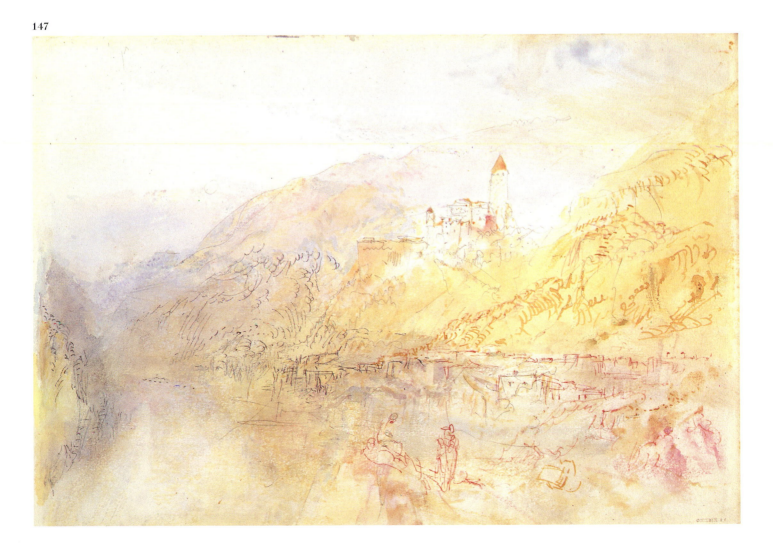

148 Hirschhorn on the Neckar from the North 1844

Pencil and watercolour, with pen
229 × 330 (9 × 13)
Watermarked: J WHATMAN/1844
Inscribed: (in sky) 'Blue'; (right of castle) '[?Tower against Light]'
TB CCCXLIX 20 ('On the Rhine'); Wilton (1982), pl.124 ('View on the Rhine: Rheinfelden?')
D35144

Hirschhorn is described in early editions of Baedeker as 'the most picturesque point in the lower valley of the Neckar'. The town, which lies some fifteen miles upstream from Heidelberg, is situated on a very grand bend in the river. Inside this loop, opposite the town, lies its cemetery chapel, the Ersheimer Kapelle, a Gothic building of *c*.1355–1517, which is clearly shown on the left of Turner's scene, outlined sharply in red. The castle which dominates both the town and Turner's drawing is that of the barons of Hirschhorn. The oldest part is the curtain wall of *c*.1200; the tower dates from 1300 while the residential parts were created between 1400 and 1586. Turner's eye was caught by the dramatic appearance of its slender dark tower seen against the light, the subject of a pencilled note immediately next to it.

In September 1822 the American writer Washington Irving dined at Hirschhorn on his way from Darmstadt to Heidelberg and did not think very highly of it, noting in his journal, 'Small town on the Neckar … Old castle above the town … A very indifferent country Inn. Landlord a redfaced potbellied little man' (*Journals and Notebooks*, III, 1819–27, ed. W.A. Reichart, Madison 1970, pp.23–4). In August 1844 Turner probably did not spend long there, since he made only two pencil sketches of it in his *On the Neckar* sketchbook (see cat.no.132). Perhaps the clue lies in what is depicted in the present work: Turner's stark colour scheme of grey, red and yellow, with only an occasional hint of blue, prepares the viewer for the approaching storm that is already ruffling the waters of the river. It gives a chill and brooding quality to the scene very different from that of Turner's other watercolours of the Neckar.

148

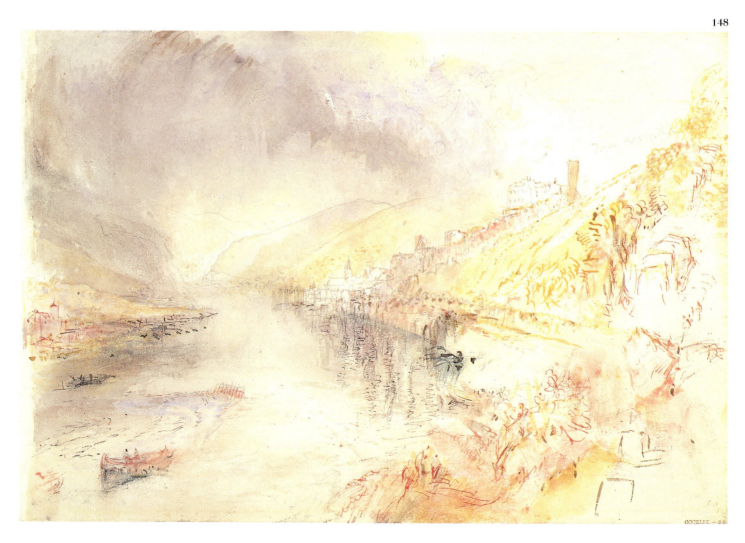

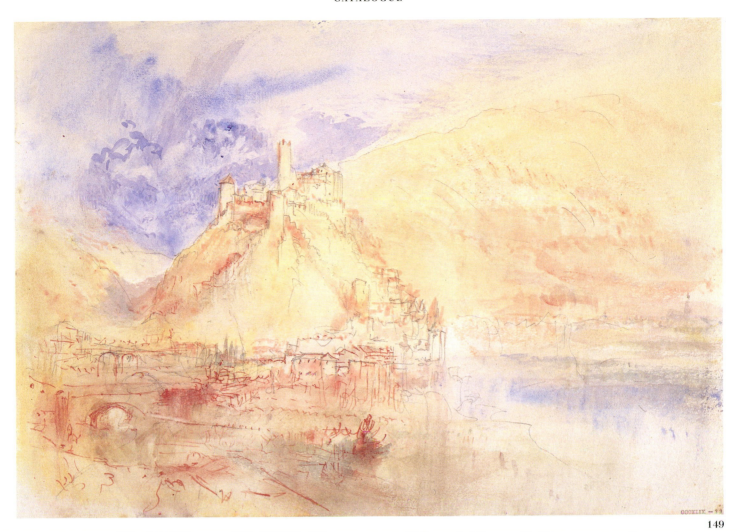

149

149 Hirschhorn on the Neckar from the South

1844

Pencil and watercolour, with pen and scratching out
229 × 326 (9 × 12⅞)
TB CCCXLIX 22 ('Village and castle on Rhine')
D35146
Verso: Small sketch of ? a valley

This view of Hirschhorn shows the town from the opposite viewpoint to cat.no.148. It was drawn from the Neckarsteinach road, beyond the Laxbach which can be seen flowing under the bridges on the left to join the Neckar in the right foreground. The Ersheimer Kapelle can just be distinguished on the far right. Whereas the bend of the Neckar on which Hirschhorn lies is best appreciated from the north, it is only from the south that the town's defensive siting can be fully appreciated: the castle is perched on a spur of the Feuerberg, here seen dominating the curve of the river to the right, and it is protected on all other sides by the twin valleys of the Ulfenbach and Finkenbach which join to form the Laxbach.

150 Neckarsteinach on the Neckar 1844

Pencil and watercolour, with pen
229 × 330 (9 × 13)
Watermarked: J WHATMAN / 1844
TB CCCLII 14 ('Bellinzona(?)')
D35234
Verso: Pencil drawing of Neckarsteinach and its four castles from further to the left than the scene on the recto, so that more of the Dilsberg is shown

As with cat.no.145, the true subject of this drawing was not recognised until it was exhibited in Germany nearly a century after Turner's death (see Zink 1954). It was subsequently discussed and reproduced by Max Schefold (1968).

Neckarsteinach lies about eight miles up the Neckar from Heidelberg just where that river is joined by a small tributary, the Steinach. In the nineteenth century the town was a favourite place of excursion with locals and tourists alike, for its charming scenery afforded many pleasing walks, prospects and interesting buildings, not to mention places of refreshment. In Turner's drawing the Neckar is on the left curving round the wooded eminence

of the Dilsberg (which lies just beyond the edge of the paper). In the centre is Neckarsteinach itself with the pointed spire of its Protestant church sharply silhouetted against the river. Like other tourists, he has climbed a high hill to the north of the town, the Eichelberg, to gain a good view of the four castles on a single long spur between the two rivers for which Neckarsteinach is famous: the Vorderburg (the nearest to the town and that shown in the greatest detail); beyond this, Burg Schadeck, also known as the 'Swallow's Nest' from its remote position; the Mittelburg (recently restored in a medieval style with an imposing crenellated tower) and finally the distant ruined Hinterburg perched over the Steinach valley. The unexpected pleasure of coming across such a view of the Steinach was remarked on by Mrs Trollope: 'we beheld a little valley deep sunk below us; so bright in verdure, and so tempting from its cool and quiet shade, that nothing prevented my immediately descending into it but a timely

recollection of the labour of returning. Through this emerald valley flowed a stream, rapid, deep, and clear' (1835, I, p.301).

Turner made numerous small pencil sketches of Neckarsteinach in his *On the Neckar* sketchbook (cat.no.132). These were drawn at immense speed, the castles being represented by the most schematic of symbols which nevertheless capture their essential shapes exactly.

In this work, as in so many of his Neckar drawings, Turner represents light and shade simply by the opposition of yellows to mauves. The two interact constantly throughout the scene so that very few parts can be regarded as wholly in light (like the bottom right-hand corner) or wholly in shadow (the roofs of the town). The work provides a striking contrast to cat.no.146: just as its topography is vastly more complex, so too, inevitably, are its light effects.

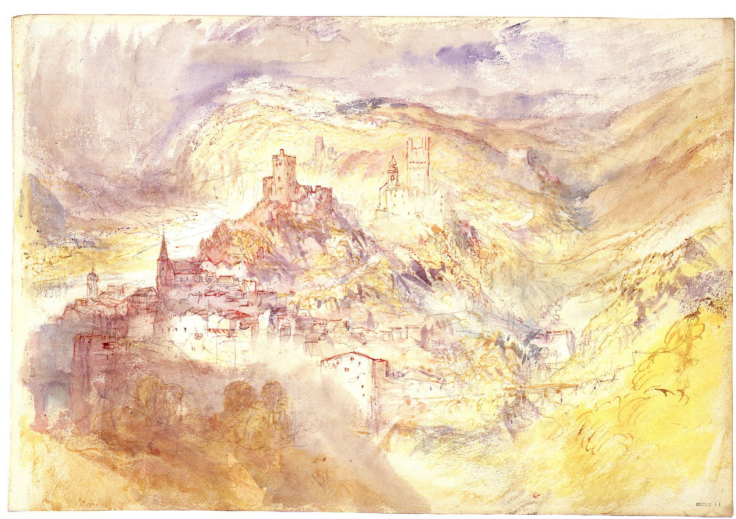

150

Appendix

The German and Austrian Sketchbooks Used on Turner's Tours
of 1833, 1835, 1840 and 1844

Notes

In the lists below, unless otherwise indicated, Turner's sketches are identified from the top of the page downwards and/or from the outer edge of the sketchbook inwards, regardless of the way in which individual sketches face. The stamped *Inventory* numbers are always treated as being at lower right, even when the sketchbooks were numbered from the wrong end.

Inscriptions are transcribed in italics, clarified where necessary by

[Yellow] editorial insertion
[? *Yellow*] uncertain reading
[…] missing or undeciphered letters or words
<*Yellow*> deleted word

Acknowledgments

Turner's German and Austrian sketches have received little attention since Finberg's *Inventory* (1909) and his later comments on them (1930, pp.168–73; at relevant places in his biography of the artist (1939; 2nd ed. 1961); and in his manuscript notes now in the Clore Gallery). In compiling the entries for certain sketchbooks below the author has also been helped by, and would like to acknowledge, the published work of Appeltshauser (1976) and (1991), Freiberg (1955), George (1984) and Schefold (1968). Full details of these appear in the Select Bibliography.

TB CCXCVI *Brussels up to Mannheim – Rhine* sketchbook 1833 (see cat.no.27)

Bound in boards, with a red leather back and a broken brass clasp. On the outside of the back cover Turner has written in pencil *Brussels up to Mannheim – Rhine*.

Inside front cover
 Inscr. *1 oz of Cinnamon* […]
 1 Gran of Epecunha
 25 Drops of Ladanum
 2 Drams of Spirit of Lavender
 2 Drams of Tinture of Rubar
 […]
 20 Grans of Carbonate of Soda
 Tartaric of Potash 8 Scruples
 N[…] *Ether* […] *W*
 for 6 or 8
 Also: hill and house
 1r (1) Three boats, the third drawn in ink

 (2) Canopied boat, with the Rheingau in the background
 Inscr. *Boat Reingard*
 (3) Schloss Biebrich, looking downstream
 Inscr. *Bibrik*
 (4) Two boats
 1v (1) Ostend? (extends across f.1r)
 (2) Ghent: the Maison des Francs Bateliers on the Quai aux Herbes, and another house
 Inscr. *1770*
 2r On the coast, near Ostend?
 2v (1) Ostend?
 (2) Bingen, the Mäuseturm and Burg Ehrenfels, looking downstream from Rüdesheim
 Inscr. *Bingen Custom House*
 (3) Bingen and the Mäuseturm from the Rhine, looking downstream
 3r–5r Views at and near Ostend
 5v Bruges: the Rue des Pierres with the Belfry and St Saviour's church
 6r Bruges: the Belfry
 6v Bruges: the church of Notre Dame, illegibly inscr.
 6B Inscr. *26R St Gal* […]
 Rest of page torn away
 6Bv Coastal scene
 7r Bruges: the Belfry, Chapel of the Holy Blood and Hôtel de Ville from the Quai du Rosaire
 7v Bruges: the Hôtel de Ville, Palais du Franc and Belfry from the Quai Vert
 Inscr. *Ston Hoven dyk*
 8r Bruges
 8v (1) Bruges: the Grand' Place looking towards the Government Buildings, Belfry and Notre Dame
 Inscr. […]; *4* (on the bays of the Halle)
 (2) Bruges: the Hôtel de Ville and Chapel of the Holy Blood from the Place du Bourg
 Inscr. *6*; *5* (on the bays of the buildings)
 9r Bruges?
 9v Ghent: St Bavon's cathedral and Belfry
 9v–10r A domed building
 10r Ghent: St Jacques' church and Collaciezolder (or Toreken) from the Marché du Vendredi
 10v Ghent: St Nicholas' church, Belfry and St Bavon's cathedral from the west
 Page inscr. (by Turner) *Pare Pore dique*; *St Michael*; (in another hand) *Predil reere paler*
 11r (1) Ghent: St Nicholas' church and houses
 (2) Ghent: St Nicholas' church from the Marché aux Grains
 Inscr. *Bridge*

11v–12r Sketches of Bruges or Ghent
 12v Namur: the citadel from the Sambre, showing the *rampe verte* (1815–30) to the Terra Nova
 13r Namur: the citadel from the Liège road
13v–14r Namur: view across the Sambre, looking to St-Aubain (f.13v) and up to the citadel (f.14r)
 Inscr. *Hill*
 14r Namur: St-Aubain and other buildings
 14v Several slight sketches, with illegible inscr.
 15r (1) (2) Mainz from the waterfront, looking downstream
 (3) (4) Rough sketches
 15v Several slight sketches, inscr. *H*[…]; *P*[…]; *St Roch*
 Also inscr., possibly not in Turner's writing: *Aselbers*; *Haselberg*
 16r Namur: the Meuse from the citadel
 16v Namur: view down the Meuse
 17r Namur: the citadel and view down the Meuse
 Inscr. *9* (by the arches of the bridge)
 17v Two views near Namur?
 18r Namur: the citadel, Hospice d'Harscamp and view up the Meuse
 18v (1) Nonnenwerth, Rolandswerth and the Drachenfels, looking down the Rhine
 (2) The Seven Hills (continuation of (1))
 (3) View down the Rhine to Neuwied
 Inscr. *Neuwied*
 (4) Neuwied and Weissenthurm, looking up the Rhine
 19r Namur: the citadel and view up the Meuse
 19v Namur: three views from the north
 20r Namur: view down the Meuse from the citadel
 20v Meuse view, probably near Namur
 21r (1) Coblenz and Ehrenbreitstein: view down the Rhine
 (2) Namur: view up the Meuse
 21v Several slight sketches, inscr. *B & W*; *Maza*; *B*[…]; *Road*
 22r Two views near Namur
 22v Namur: view from the north
 23r Namur: view from just outside the city walls to the north
 23v Namur: view up the Sambre to the citadel and bridge
 24r Three sketches of the castle of Beaufort near Huy on the Meuse
 (1) Inscr. *Boufour*
 24v (1)–(3) The castle of Beaufort
 (1) Inscr. *16*
 (2) Inscr. *Bel*; *R Meuse*
 (4) River scene with a boat
24v–25r Namur: view up the Meuse to the confluence with the Sambre

25v (1) River view with church
(2) Namur, looking upstream

26r Namur: view up the Meuse to the confluence

26v Namur and other towns, probably on the Meuse
Inscr. *20; 60; R[…]*

27r Two sketches of Namur looking up the Meuse

27v Several slight sketches, probably of the Meuse, inscr. *H[…]*; *Leife* (Lives?)

28r Five sketches of cliffs on the Meuse near Namur
Inscr. *[…]*; *10*; *Meuse*

28v (1) (2) Views on the Meuse, (2) inscr. *Muse*
(2) View down the Rhine to Schloss Stolzenfels and Oberlahnstein
Inscr. *Rhine*
(4) View up the Rhine to the Marxburg and Rhens
Inscr. *Rintz*

29r Huy: view from the south with the citadel in the distance and St Rémy and a bridge in the foreground

29v Slight sketches

30r (1) Namur: view up the Sambre with the old mill on the left
(2) Huy: the citadel from the south-east with the town walls

30v Huy: the citadel and Notre-Dame from the north-east with the town hall, old houses and bridge over the Houyoux

31r Two views in the countryside south of Huy

31v Huy: view from the south with the citadel in the distance and St Rémy and the town walls in the foreground
Inscr. *Old Wall of Huy*

32r Huy: view from the south-east with the citadel in the distance
Inscr. *H[…]*; *M[…]*

32v Many small sketches of the junction of the Lahn and the Rhine, showing Kapellen, Schloss Stolzenfels, St John's church, Niederlahnstein, Burg Lahneck and Ober-lahnstein
Inscr. *Cappelle*; *Kappele*

33r Huy: the town walls and a gateway with the citadel in the distance

33v Huy: Notre-Dame, the citadel and bridge over the Meuse from the Quai des Récollets

34r (1) Distant view of Rolandseck, Nonnen-werth and the Drachenfels from Unkel (continued in sky)
(2) Bonn, looking up the Rhine
Inscr. *Bonn*

34v Many small sketches of Coblenz and Ehrenbreitstein, the first four inscr. *1; 2; 3; 4*

35r Four sketches of Ehrenbreitstein, one inscr. *Eren*

35v Blank

36r Mannheim: view from the Rhine (in two instalments) with the observatory, Jesuits' church, Electoral Palace and bridge of boats
Inscr. *Manine*

36v (1) Cologne
Inscr. *Col.*
(2) Burg Lahneck and Oberlahnstein
Inscr. *Lahn*
(3) Schloss Stolzenfels

Inscr. *Cappelle*
(4) Burg Lahneck, Oberlahnstein and the Martinsburg

37r Several sketches of Rhine castles including the Marxburg, Martinsburg, Burg Lahneck and Burg Katz from beyond the Lorelei
Inscr. *Markburg; Lauhn; Katz*

37v Liège: the courtyard of the Episcopal Palace with figures and details of the grotesque carvings on the columns

38r (1) Liège: the Pont des Arches, looking downstream from the Quai des Pêcheurs to the citadel and church of St Barthélémy
(2) Liège: buildings along the Meuse, including (1) an enlarged detail of the spire of St Paul's cathedral

38v (1) The Seven Hills from the Rhine
Inscr. *7 Hil*
(2) Hammerstein, looking upstream
Inscr. *Hammst*
(3) Hill and castle on the Rhine

39r Mainz: the cathedral from the north-west

39v Liège: the market square, with the dome of St Andrew's church, Perron fountain and town hall; detail of fountain in sky

40r Mainz: the west tower of the cathedral, in two instalments (an extension of the sketch on 39r)

40v Blank

41r Mainz: the cathedral from the east, with the Gutenberg house on the right

41v Ehrenbreitstein and Coblenz (in three instalments)

42r Two sketches of the Marxburg?
Inscr. *C[…] Marxb*

42v Silhouettes of Ehrenbreitstein

42v–43r Cologne: the Rhine front, looking downstream with Great St Martin

43v Four sketches of houses, one inscr. *2; D*

44r Two sketches of the Seven Hills and the Drachenfels from the Rhine, and one small sketch of a cliff, inscr. *L[…]*

44v Two sketches of Linz, looking down the Rhine
(1) Inscr. *Red W Red* (for the flag on a boat); *Lintz*
(2) Inscr. *[…]*

45r (1) (2) Linz, both inscr. *Lintz*
(3) Bornhofen, Burg Sterrenberg and Burg Liebenstein, looking down the Rhine
Inscr. *Brothers*

45v Two sketches of the Drachenfels

46r Several sketches of the Drachenfels

46v Five rough Rhine sketches, facing in different directions, one inscr. *Sinzig*, another *Ham*[merstein]

47r Two views of Coblenz and Ehrenbreitstein

47v (1) View down the Rhine towards Coblenz and Ehrenbreitstein in the distance, with boat in the foreground
Inscr. *R; B; White Sail Higher than red Haze*
(2)–(4) Rhine views

48r (1) Burg Maus and Wellmich, looking upstream
(2) Burg Maus and Wellmich church, with a sailing boat
(3) View down the Rhine towards Eltville and the Rheingau
Inscr. *[…]*; *Joh*[annis]*burg*

48v Blank

49r Mainz, looking downstream

49v (1) Schloss Biebrich, from the Rhine
(2)–(4) The banks of the Rhine between Biebrich and Mainz, from the river, (4) inscr. *S*
(5) (6) The waterfront at Mainz with a blazing sun, the cathedral, Holzturm, and bridge of boats to Kastel

50r (1) Castle
Inscr. *D[…]* (twice)
(2)–(4) Eltville, from the Rhine
(2) Inscr. *Elfelt; Reingau; S[…]*
(3) Inscr. illegibly
(4) Inscr. *Elfelt*

50v Distant views of Mainz and the Rheingau

51r Slight sketches, illegibly inscr.

51v Buildings
Inscr. *Wood*

52r Mannheim: the bridge of boats, Jesuits' church, Electoral Palace and other buildings

52v Sailing boat on the Rhine with Oppenheim in the distance
Inscr. *Openh*[eim]

53r Small Rhine view

53v Several views of castles above a river (Burg Sooneck?)

54r (1) Salmon fishing boats on the Rhine
(2) Burg Stahleck and Bacharach from the Rhine
(3) View up the Steegertal at Bacharach, from the Rhine

54v (1) The Lorelei, looking upstream
(2) The Lorelei and Burg Katz, looking downstream
(3) View up the Rhine, from just upstream of the Lorelei

55r Three Rhine views, two showing 'The Brothers'

55v (1) Hammerstein
Inscr. *Ham*
(2) Buildings on the river front at Andernach
Inscr. *Belongs to X*
(3) Andernach from the Rhine
Inscr. *X* (on the blank foreground); *Andernack*
(4) View down the Rhine from Rhens towards Schloss Stolzenfels and the Martinsburg at Oberlahnstein
Inscr. *Rintz; Oberlanstein*
(5) The Marxburg from the Rhine, looking upstream
Inscr. *Markburg*

56r (1) View down the Rhine towards Rhens, Schloss Stolzenfels and Oberlahnstein
Inscr. *Rintz; Cappl*
(2)–(4) Braubach and the Marxburg, looking downstream
(3) Inscr. *Markburg*

56v Four sketches of the Marxburg and Braubach from the Rhine from viewpoints successively further upstream

57r Numerous overlapping sketches of Boppard and its buildings including the church, Burg, Sandtor and Ritter-Schwal-bach Haus
Inscr. *Boppard; Gate at Boppard*

57v (1) Boppard, looking downstream from below Bornhofen
(2) Bornhofen and Burg Sterrenberg, looking upstream

Inscr. *Sterrfields and Livsber*

(3)–(6) Burg Sterrenberg, Burg Lieben-
stein and Bornhofen

58r Several overlapping sketches of Bornhofen,
Burg Sterrenberg and Burg Liebenstein,
from viewpoints moving successively
upstream

(1) Inscr. *Lievens Stein*

58v Many sketches of St Goar and Burg Rhein-
fels, one inscr. *St G Oar*, and Burg Katz
and St Goarshausen

59r (1) Burg Rheinfels and St Goar, looking
downstream

(2) Burg Katz and St Goarshausen, looking
downstream from by the Lorelei
Inscr. *Katz*

(3) The Lorelei, looking upstream

(4) St Goar and Burg Rheinfels from the
Rhine

59v (1) Rheinfels and the northern edge of St
Goar, looking downstream

(2) Burg Katz and St Goarshausen, looking
upstream
Inscr. *1*

(3) The southern edge of St Goar, looking
upstream (a continuation of sketch (2))
Inscr. *2*

60r (1)–(3) Burg Rheinfels and St Goar, inscr.
1; *3*; *2*

(4) Burg Katz and St Goarshausen, looking
upstream

60v (1) (2) Burg Rheinfels

(3) Burg Katz and St Goarshausen, looking
upstream

(4) Burg Rheinfels, looking upstream

61r (1) St Goar, looking upstream

(2) Burg Maus and Wellmich church, look-
ing downstream

(3) St Goar and Burg Rheinfels, looking
upstream

(4) Burg Rheinfels

61v (1) Rolandseck, Nonnenwerth, the
Drachenfels and the Seven Hills (con-
tinued in the sky above), looking down-
stream
Inscr. *Rola*

(2) Burg Maus and Wellmich church, look-
ing upstream

(3) Burg Maus and Wellmich church, look-
ing downstream

62r (1) (2) The east bank of the Rhine near
Andernach?

(3) Andernach, looking upstream, with
boats

(4) (5) The Rhine near the Marxburg
(4) Inscr. *above Markbg*

62v (1) Oberwesel, looking upstream, showing
St Martin's church, the Ochsturm and
other towers and Wernerkapelle
Inscr. *1*

(2) Oberwesel, looking upstream, showing
the Schönburg, the Liebfrauenkirche
and Wernerkapelle (a continuation of
sketch (1))
Inscr. *2* (twice)

(3) Oberwesel, looking upstream, a general
view from further downstream
Inscr. *3*

63r Sketches of Oberwesel, showing the
Schönburg, Wernerkapelle,
Liebfrauenkirche and Zehnerthurm, look-
ing upstream

63v–64r Six sketches of Oberwesel, looking down-
stream
Inscr. *1*; *2*; *Tefel*; *4*; *Rock*; *3*; *6*

64v (1) Burg Gutenfels, Kaub and the Pfalz,
looking upstream (in two instalments)

(2) Burg Gutenfels and Kaub, looking
upstream

65r Two sketches of Burg Gutenfels, Kaub and
the Pfalz, looking upstream and one of
Burg Gutenfels from beneath it

65v (1) Kaub and Burg Gutenfels

(2) Kaub and the Pfalz, looking upstream (a
continuation of sketch (1))

(3) Burg Gutenfels and Kaub, looking
downstream (extends onto f.66r)
Inscr. *3*

66r (1) Kaub, looking downstream towards
Oberwesel
Inscr. *2*

(2) Kaub, looking downstream, with a boat

(3) The Pfalz, side view from Kaub

(4) The Pfalz, looking downstream

66v (1) The Pfalz, Kaub and Burg Gutenfels,
looking downstream with the Schön-
burg in the distance

(2) Bacharach and Burg Stahleck, looking
upstream

(3) Small sketch of the Schönburg
Inscr. *2*

(4) The Pfalz, Kaub and Burg Gutenfels,
looking downstream with the Schön-
burg in the distance

(5) The Pfalz, Kaub and Burg Gutenfels,
looking downstream with the Schön-
burg in the distance

67r (1) Burg Stahleck and Bacharach, looking
upstream

(2) Burg Stahleck, Bacharach and the
entrance to the Steegertal, looking
upstream from a closer viewpoint

67v (1) Distant view of Huy
Inscr. *Huy*

(2) Coblenz and Ehrenbreitstein, looking
down the Rhine to the bridge of boats

(3) The Marxburg and Braubach, looking
downstream
Inscr. *Above Markburg*

(4) Burg Fürstenberg, looking upstream
Inscr. *S[…]*

68r (1) Burg Stahleck, Bacharach and the
Steegertal

(2)–(4) View looking upstream to Burg
Fürstenberg
Inscr. *S[…]*

68v (1) Burg Fürstenberg and Rheindiebach
from the Rhine

(2) Burg Reichenstein
Inscr. *Durr*

(3) Burg Nollig and Lorch, from the Rhine
(in two instalments)

69r (1) Oberwesel: St Martin's church and the
Ochsturm, looking upstream
Inscr. *1 of Ober Vasen*

(2) The Heimburg and church of Maria
Himmelfahrt, Niederheimbach, looking
upstream

69v (1) (2) The Heimburg and church of Maria
Himmelfahrt, Niederheimbach, looking
downstream
(2) Inscr. *Reinberg*

(3) View down the Rhine towards the
Heimburg and Burg Fürstenberg (L)

and Burg Nollig and Lorch (R)

(4) View up the Rhine towards Burg Soo-
neck

70r (1) Walls and buildings

(2) Burg Reichenstein
Inscr. *Road*

(3) Burg Reichenstein
Inscr. *Dmr*

70v (1) (2) (3) (5) The Klemenskapelle and
Burg Reichenstein

(4) Burg Rheinstein, looking upstream
Inscr. *Reinstein; Road*

71r Three sketches of Burg Rheinstein, looking
downstream

71v Three sketches of Mainz, looking down-
stream towards the bridge of boats

72r Eight sketches of the Rheingau, inscr. *1*; *2*;
3; *4*; *5*; *6*; *7*; *8*; the last (of Oestrich) also
inscr. *Estrich*

72v (1)–(5) Views of the Niederwald and
Schloss Johannisberg from the Rhine
(2) Inscr. *Nede*
(3) Inscr. *[…] to Johnbg*

(6) View down the Rhine to Bingen, the
Mäuseturm and Rüdesheim (in two
instalments)
Inscr. *R* (above Rüdesheim); *1*; *2*

73r Six sketches of the Rheingau
Inscr. *1*; *Johanberg*; *G[…]*; *Johannisberg*

73v (1) (2) Rüdesheim, from the Rhine

(3) View down the Rhine towards Burg
Klopp, Bingen, the Mäuseturm and
Burg Ehrenfels

74r (1) Hills
Inscr. *Nied*[erwald?]

(2) The Mäuseturm and Burg Ehrenfels,
looking downstream

(3) St Martin's church, Bingen, and the
bridge over the river Nahe

(4) Bingen church (on a larger scale)

(5) Bingen church and the bridge over the
Nahe

(6) Rüdesheim
Inscr. *Rudeseim*

74v (1) The Mäuseturm and Burg Ehrenfels,
looking downstream

(2) The mouth of the Nahe
Inscr. *1*; *3*

(3) Burg Klopp and Bingen church
Inscr. *4*

(4) Bingen church and the bridge over the
Nahe

75r (1) Slight sketch

(2) The Mäuseturm, Burg Klopp and Bin-
gen, looking upstream

(3) Burg Ehrenfels, looking downstream,
with a detail of the Burg
Inscr. *2*

(4) The Mäuseturm, Burg Klopp and Bin-
gen, looking upstream from the Binger
Loch
Inscr. *3*

(5) The Mäuseturm and Burg Ehrenfels,
looking downstream
Inscr. *4*

75v (1) Namur: the citadel and view down the
Meuse

(2) Kastel and the entrance to the Main
from Mainz
Inscr. *Mayence*

76r (1) Oestrich
Inscr. *Estrick; Johannbg*

(2) View at Namur
Inscr. *Namur*
(3) Rüdesheim
Inscr. *Rudesheim*
(4) Bingen, the Mäuseturm and Burg
Ehrenfels
76v (1) Burg Klopp and Bingen, looking down-
stream with a boat in the foreground
(2) View down the Rhine towards the
Mäuseturm and Burg Ehrenfels
(3) The crane and custom house, Bingen,
looking upstream
Inscr. *1*; *Bingen*
(4) Rüdesheim from Bingen
Inscr. *2*
(5) The custom house, Bingen
Inscr. *Porch Custom Hse*; *4*
(6) Rüdesheim from the Rhine
Inscr. *Vines*; *Rudesheim*; *3*
77r (1) Nierstein
Inscr. *Nierstein*
(2) (3) River scenery
77v (1) Oppenheim
Inscr. *Openheim*
(2) Church and river
78r Ehrenbreitstein
78v Namur: the citadel
79r Rough sketches, including one of Namur
79v–80r Namur: the citadel and the bridge from
Jambes
80r River views
80v (1) Mainz: the waterfront, looking down-
stream towards the Holzturm
(2) A waterfront building, probably at
Mainz
81r (1) The castle of Chokier near Liège on the
Meuse
Inscr. *Chateaux Chocker Chorcher*
(2) (3) Landing-stage and buildings, possi-
bly at Mainz
81v–82r Mannheim: view across the bridge of boats
on the Rhine, showing: the bridge over the
canal linking the Rhine and the Neckar, the
Jesuits' church and the Electoral Palace
82r Oppenheim from the Rhine
Inscr. *Openheim*
82v–86r Blank
86v Distant view of Worms?
87r Nackenheim from the Rhine
Inscr. *Nacknheim*
87v Slight riverside sketch
88r Mainz: five sketches looking downstream
Inscr. *M*; [...]
88v Mainz: five sketches of parts of the cathe-
dral and other buildings
89r (1) Worms from the Rhine
Inscr. *Worms*
(2) Mainz
89v (1) (2) The Rhine, with Burg Reichenstein
and Burg Rheinstein
(3) (4) Worms, inscr. *Worms*
90r Huy: Notre Dame and the citadel from the
north
90v (1) Reclining female nude
(2) Manuscript notes

	Thrs	Sq	Fls	K		F		
Cologne to Cob	4	10	–8	10	–3	15	6	8
Cob to May	9	10	16	20	7	–	12	16
—— *Manh*	12	–	21	–	9		13	10
Scroeck	14	20	25	40	11	–	19	15
Cob to May	4	13	8	17	3	6	16	6 11

Cologne to Cobl at 6 oClock
Cob to Mayence 6
Mayence to Worms Spires – Germisheim &
from Germisheim to Schohin Carlsrhur
and Baden Baden M[orning] *at 5*
Back Schroeck
to Mayence 10 ..
Mahinn to May
afternoon at 3
91r (1) Sailing boat
(2) River scenery, illegibly inscr.
(3) Reclining female nude
91v Huy: the east end of the church of Notre
Dame and separate detail of the Bethlehem
portal
Also two slight landscape sketches
Inside back cover
(1)–(4) Hills and river scenery with castles
and a town
Inscr. *Oppenheim*
(5) (6) Buildings at Worms
Inscr. *Worms*

TB CCXCVIII *Heidelberg up to Salzburg* sketchbook 1833 (see cat.no.28)

Bound in boards covered in dark marbled paper,
with a differently patterned paper covering a paste
paper spine and an inside front pocket made from a
third paper. Four leather loops for holding a pencil,
two at each end. Four ink lines scored across the
upper fore-edge of the pages.

Inside front cover
Inscr. *Ente Duck* and with Turner's name
for this sketchbook, *Hdelberg up to
Saltzburg*
1r Faint sketches, probably of Heidelberg and
illegibly inscr.
1v Heidelberg: view from the castle (the foot
of the Great Tower)
2r Heidelberg: the castle from the south
2v (1) Heidelberg: the castle from close to the
Gate Tower
(2) Hillside at Heidelberg
3r Heidelberg: view from close to the Great
Tower and separate sketch of a ruined win-
dow in the Great Tower
3v Heidelberg: view from the Stückgarten of
the castle
Inscr. *6* (under the arches of the bridge)
4r Heidelberg: view from the Stückgarten of
the castle, with the Great Tower
4v Heidelberg: the castle from the Stück-
garten (in two instalments)
5r Heidelberg: the castle and the view up the
Neckar from the Altan
5v Heidelberg: the castle and the view down
the Neckar from the Altan (in two instal-
ments)
Inscr. *8* (for the bays of the Friedrich
Building); *B*; *B*; *Doric*
6r Heidelberg: the castle courtyard looking
towards the Friedrich Building, with one
bay of the Otto-Heinrich Building
6v Heidelberg castle: the Gate Tower and
Broken Tower from the south-east

7r (1) Heidelberg castle, the east façade
(2) Heidelberg castle: the Apothecary's
Tower and Bell Tower from the east
7v Heidelberg: the castle and town from the
hillside terrace (the southern part of the
east façade continued in the sky above)
Inscr. *6*; *3*; *6*; *12* (indicating windows)
8r Three rough sketches, two showing an
archway or small bridge, the third inscr.
Jny over the D
8v Heidelberg: the castle and town from the
east
9r Heidelberg: the castle and town from the
east
9v Heidelberg: the castle and town from the
east
10r Heidelberg: the castle and town from the
east (in two instalments)
Inscr. [*?Tower*]
10v Heidelberg: the castle from the east
Inscr. *Road*
11r Heidelberg: the castle and Neckar valley
from the east
11v Heidelberg: the castle and Neckar valley
from the east (in two instalments)
12r Heidelberg: the castle and Neckar valley
from the east
12v Heidelberg: the castle, town and Neckar
valley from the east (in two instalments)
13r Heidelberg: the castle from the south
13v Heidelberg: view from close to the castle
entrance
14r Heidelberg: the bridge and castle from the
west (extends slightly onto f.13v)
14v Heidelberg: the bridge and
Heiliggeistkirche (in two instalments) (a
continuation of the view on f.14r)
Inscr. *13* (on the bays of a building)
15r Slight sketches and illegible inscr.
15v Heidelberg: the castle and town from the
Neuenheim shore
16r Heidelberg: the castle and town from the
Neuenheim shore
16v Heidelberg: the Karlstor, Palais Weimar
and castle from the Hirschgasse
17r Heidelberg: the Heiliggeistkirche from the
Hirschgasse (a continuation of the view on
f.16v)
17v Heidelberg: the bridge from the
Hirschgasse
18r Heidelberg: the Heiliggeistkirche and
bridge from the Hirschgasse
18v Heidelberg: the Karlstor, Palais Weimar
and castle, looking down the Neckar
Inscr. *Doric*
19r Heidelberg: the Karlstor, castle and town,
looking down the Neckar
19v Heidelberg: view down the Neckar from
east of the town
20r Heidelberg: view down the Neckar from
east of the town
20v Heidelberg: view down the Neckar from
east of the town
21r Heidelberg: view down the Neckar from
east of the town
21v Heidelberg: view down the Neckar from
east of the town
22r Heidelberg: view down the Neckar from
east of the town
22v Heidelberg: view down the Neckar from
east of the town
23r Heidelberg: the castle from the

Hirschgasse

23v Heidelberg: the castle and Palais Weimar
from near the Hirschgasse

24r (1) Slight sketch of Heidelberg
(2) (3) Heidelberg: the Heiliggeistkirche
and bridge, looking downstream, one
with a group of people in the fore-
ground
Inscr. […]ing raft at Hidelberg

24v (1) Heidelberg: view down the Neckar
(2) Heidelberg: view across the Neckar
Inscr. Raft of Timber going down the
Neck[ar]

25r Heidelberg: view over the bridge to the cas-
tle and town

25v Heidelberg: the Karlstor and view down
the Neckar

26r Heidelberg: the Karlstor and view down
the Neckar

26v View up the Neckar from just outside
Heidelberg towards Neckargemünd, with
superimposed sketch of Neckargemünd
Inscr. Eremberg

27r Two sketches looking up the Neckar
towards Neckargemünd

27v The abbey of Neuburg

28r (1) Building or monument
(2) Group of figures
Inscr. Mackerheim (i.e. Meckesheim);
[…]

28v Three rough sketches of buildings, one
inscr. Wood; Zutseheim (i.e. Zuzenhausen);
Road

29r Three rough sketches of buildings probably
of Zuzenhausen, one inscr. Mill

29v Three rough sketches of buildings, one
inscr. Road; Mill; Pas qu […] say […];
Amsten

30r (1) Groups of figures, including a funeral
procession and a man on horseback
Inscr. corpse covered with flags; [? Yellow];
Red; […]
(2)–(4) Buildings, one sketch inscr. Sinsiem
(i.e. Sinsheim)

30v Rough sketches of hills, Talheim and
figures
Inscr. […]; Talhem; [?Baden] (against a
figure)

31r Distant view of Heilbronn, and details of
its towers
Inscr. Hilbron; [?Wirtberg]

31v Two rough landscape sketches, one inscr.
Neckar
Page also inscr. Gammele; Gamilde (proba-
bly an attempt at Gemälde, 'painting')

32r House and tower

32v Three rough sketches of Lauffen am
Neckar
Inscr. Laufen Nec

33r Four rough sketches (Lauffen am Neckar?)

33v Three rough sketches of towns

34r Besigheim

34v Three sketches of Besigheim
Inscr. Barstheim; […]

35r (1) Rough landscape
(2) Bridge and houses
Inscr. Isare (i.e. Isar)

35v Stuttgart from the east

36r Landscape
Inscr. Neckar

36v (1) Distant view of Bietigheim
Inscr. Beedikheim

(2) Three figures

37r (1) Distant view of Hohenasperg
Inscr. Asberg; Ludwisberg
(2) 'Ilioneus' (an antique statue in the
Glyptothek in Munich)

37v Stuttgart from the Uhlandshöhe

38r Plain and hills near Stuttgart, with detail in
the sky

38v Stuttgart: the market square with the town
hall and Stiftskirche

39r Stuttgart: the Stiftskirche and Altes
Schloss from the Karlsplatz

39v Stuttgart from the south-east
Inscr. 6; 6; 7 (against the bays of the Neues
Schloss)

40r Stuttgart from the south-east

40v Stuttgart from a hill to the south-east
Inscr. Vine; 3 [?arches]

41r Stuttgart from the north-east (in two
instalments)

41v (1) Town by a cliff
(2) Stuttgart from the north-east
Page also inscr. Liechnstein; […]; Estashy

42r Two distant views of Stuttgart, with
Schloss Rosenstein (1824–9) on the left
(one with continuation in sky)
Inscr. […] Ros[…]

42v (1) Cannstatt? (church spire extends onto
f.43r)
(2) Figures
(3) River scenery with Cannstatt?
Inscr. […] Blue […]

43r Cannstatt?
Inscr. Oben; above; Cansdat

43v (1) Schloss Rosenstein, near Stuttgart
(2) Village and hills
Also small sketches of a figure and a hill
with a castle

44r Three views on the Neckar near Stuttgart

44v (1) Schloss Rosenstein, near Stuttgart
Inscr. 9 (for its bays)
(2) Gateway, illegibly inscr.

44v–45r The church at Berg, looking towards
Cannstatt
Inscr. Weeler Berg

45v Stuttgart from the north
Inscr. […]; Vines

46r (1) Stuttgart: the tower of the Stiftskirche
(? from a window of the Altes Schloss)
(2) Studies of women's headdresses

46v (1) Landscape, illegibly inscr.
(2) Figures and a cart

47r Stuttgart from the east

47v (1) Rough sketch of Ulm
Inscr. Ulm
(2) Landscape with figures seated in the
foreground
Inscr. Ca; W; V[…]; W; […]

48r (1) The Rotenberg with its funerary chapel
Inscr. Mont Rosa; Rosenberg
(2) Standing figure

48v (1) Schlösschen Weil, near Esslingen
Inscr. Weel
(2) View on the Neckar
Inscr. Neckar; Nec; Kirchheim; Road

49r Esslingen
Inscr. Eslingen […]

49v Rough sketches at Esslingen
Inscr. Es

50r Rough sketches at Esslingen, and figure
studies, illegibly inscr.

50v (1) Castle above a river (?Stein an der

Traun)
(2) Bridge

51r Several rough sketches
Inscr. Warfel; […]rick; Ruelle; […]

51v (1) The skyline of Ulm
Inscr. Ulm
(2) Figures
(3)–(5) Three views of a castle on a hill, one
illegibly inscr.

52r (1) Church interior?
Inscr. Dark; […]; Wall
(2) 'Ilioneus' (see f.37r)
(3) Ulm from the Danube

52r (1) Ulm: the Einlassturm and Metzger-
turm
Inscr. Ulm
(2) Ulm: the town hall, illegibly inscr.

53r Rough sketches of Ulm, a figure and two
further views of the 'Ilioneus' statue
sketched on ff.37r and 52r
Page also inscr. Gab[…] Le[…]

53v (1) A marine painting?
(2) Distant view of Zusmarshausen
Inscr. Zoushmashaise

54r (1) Munich: the Angertor
Inscr. […] through the Gate; MK
(2) A marine painting?

54v Munich: the Rundturm (Scheibling) with
the Frauenkirche, Petersksirche and
Heiliggeistkirche

55r Munich from Bogenhausen with the Isar in
the foreground (in two instalments)

55v (1) Munich from Bogenhausen with the
Isar in the foreground (in two instal-
ments)
Inscr. 1; 2
(2) View down the Isar

56r Munich: Schloss Schleissheim (in two
instalments)
Inscr. 8; 9; 5; 8; 6; 15; 5 (against its bays)

56v (1) Munich: domes and towers
Inscr. Mnch
(2) Munich: view down Briennerstrasse
with the Glyptothek on the left
Inscr. 3; 4 (against distant houses)

57r Munich: the Alte Pinakothek looking
towards Karolinenplatz (plus a detail of one
window)
Inscr. 24 (against its bays); […]

57v Munich: the Marienplatz, looking towards
the town hall, Mariensäule and Peters-
kirche

57v–58r Munich: the Peterskirche and adjacent
house

58r Munich: the Mariensäule and
Frauenkirche towers

58v Munich: two views looking towards the
Frauenkirche and Mariensäule

59r (1) Augsburg: buildings, including the
tower of SS. Ulrich and Afra
(2) Landscape (near Cannstatt?) (extends
onto f.58v)
Inscr. Con statz or C[…]

59v (1) Munich: the Sendlinger Tor
Inscr. Munck
(2) Slight landscape
(3) Munich: the Karlstor
Inscr. Carle Thor MK

60r Ulm: the town hall and market place

60v Ulm: view down the Danube
Inscr. […]place

61r Ulm

61v River scenery?

62r Hills and river (two sketches or instalments)
Inscr. *S to*[...]; *Neckar*

62v Hills and towers
Inscr. *Hoanstatten Kirchstift* (i.e. 'Haunstetten', south of Augsburg, and 'Stiftskirche'?); [...]

63r Two sketches of a town with a castle
Inscr. *Konig*[...]

63v (1) Munich: the Isartor with the Frauenkirche, Peterskirche and Heiliggeistkirche in the background
(2) Slight sketch of buildings

64r Towers at Ulm

64v Ulm: view down the Danube
Inscr. *Ulm*

65r Ulm: the Glöcklertor from the west

65v Ulm: the cathedral and Münsterplatz (and detail of the Lion fountain) from an upstairs window in the Cafe Tröglen opposite the west front
Inscr. *Fountain; Lions*

66r Ulm: the cathedral from the south-east (with detail of an arch)

66v Two sketches of Ulm cathedral

67r (1) The façade of Ulm cathedral (extends onto f.66v)
(2) Bridge and tower

67v (1) (2) Rough sketches
(3) Munich: the Karlstor
Inscr. *Charl Tor Mnck*

68r Church and hills (Günzburg?)
Inscr. *Gantz*

68v Buildings, including Schloss Rosenstein and a bridge

69r (1) Buildings among hills
(2) The Reisenburg near Günzburg
Inscr. [...]; *Rusbuck; Riesben*
Page also inscr. *Com*[...]; *Th*[...]; *Th*[...]

69v (1) Figure studies, one inscr. *Silk Gloves*
(2) Hills and tower
Inscr. *Ober*[...]
(3) Hills and town
Inscr. *Eslingen*; [...]

70r (1) Distant view of Munich from the Isar
Inscr. *MK*
(2) Houses and towers at Leipheim (the Güssenschloss)
Inscr. *Laipen; Leephei*

70v (1) Church tower, illegibly inscr.
(2) Hills and tower

71r Two views of a town

71v (1) View of the Isar
(2) Part of a building
(3) Munich from across the Isar (in three instalments)

72r Many views of Munich from across the Isar

72v Two small views of Munich

73r Munich from Bogenhausen

73v Munich: the Theatine church from the north with the entrance to the Hofgarten
Inscr. *15; 14* (against the bays of adjacent houses)

74r Several sketches of the Bavarian Alps, one with Munich in the foreground

74v (1) Tower
(2) Distant view of Munich (in two instalments)

75r Munich: the Heiliggeistkirche and Peterskirche from Im Tal, possibly from the Zum Dürrbräu inn

Inscr. *Clock; F*[...]

75v (1) Munich: the town hall, with the Frauenkirche beyond
(2) Buildings, probably at Munich

76r Distant view of the Alps beyond Salzburg

76v (1) Distant view of the Alps beyond Salzburg (in three instalments)
(2) Salzburg: view down the Salzach to the bridge and Müllnerkirche
Inscr. *6* (for the supports of the bridge)

77r Two sketches of Wasserburg am Inn, and other sketches

77v Wasserburg am Inn, with the bridge, Pfarrkirche and Stadtturm

78r (1) Distant view of the Alps
(2) Reclining female, two sketches
Inscr. *Brechla*

78v–79r Salzburg: the monastery on the Kapuzinerberg from across the Salzach with the houses of the Inner Stein

79r Wasserburg am Inn
Inscr. *Wasserburg; River Inn; Road*

79v Munich: the Peterskirche from the Rindermarkt

80r Two views of the Kapuzinerberg at Salzburg
Page also inscr. *Iken Hof*; [...]

80v Rough sketches of buildings

81r Munich: the Glyptothek
Also: mountains and two inscr. *Mon^r. Thier; B*[...]

81v Hill and buildings

82r Munich, with the Frauenkirche, illegibly inscr.

82v Blank

83r Salzburg: view from the Kapuzinerberg
Inscr. *R*[oofs?] *Red*

83v Distant hills

84r Gateway and towers

84v (1) Buildings in an extensive plain
Inscr. *Mill; N*[...]
(2) Woman
Inscr. *Little Jacket or rather Bodice* [...]
(3) Man
Inscr. *Bavarian; Blue* [...]; *W and Black*

85r (1) Distant view of Ulm
Inscr. *Ulm*
(2) Buildings
Inscr. *Berkheim*
(3) Woman at a window
Page also inscr. *10 M*[...]; *2 florins, 60*[...]; *1 52*

85v–86r Rough sketches of buildings, those on f.86r inscr. *1; 2; 3*

86v St Georgen near Stein?

86v–87r Three sketches of mountains
(1) Inscr. *Stein*

87r St Georgen near Stein?

87v Blank

88r Salzburg: view along Judengasse to the fortress and dome of the cathedral from an upstairs room in the Höllbräu
Page also inscr. *Montag; Vinstadt; Mitvor; Donostag; Fristag; Samstag; Sontag*

88v–89r Blank

89v Landscape
Inscr. *Largo Vaving* (i.e. the Waginger See); [...]

90r Mountain scenery, with a church tower

90v–93v Blank

94r Stein an der Traun
Inscr. *Stein*

94v Rough sketches of a town

95r (1) Buildings and tower
Inscr. *Saltz*[...]
(2) A classical interior, with sculpture group

95v–96r Mountain scenery, illegibly inscr.

96v–97r Blank

97v–98r Three sketches of a hill and buildings with a rain storm, inscr. *R*[...]; *Steinharing*

98v Several rough sketches of buildings and a figure, with illegible inscr.

Inside back cover
Buildings, with illegible inscr.

TB CCC *Salzburg and Danube sketchbook 1833* (see cat.no.29)

Bound in boards covered in multi-coloured marbled paper (very similar to that of the inside pocket of TB CCXCVIII though using different colours), with black leather spine. Pages edge-painted in yellow. Four ink lines scored across the lower fore-edge of the pages.

Inside front cover
Many sketches: women's heads, two seated figures, a cart, two men, a boat, a spire
Inscr. *Blue and White; Boats on the Danube* [partly on f.1r]; [...]; *G*[...] *old W*[?agon]

1r View on the Danube with Göttweig abbey in the distance and a boat in the foreground
Also four small sketches of boats on the Danube, one inscr. *Horses*

1v Several sketches: two soldiers; boats on the Danube, man in a top hat
Inscr. *Method of* [?load]*ing Wine Casks*; [...]; *Red Collar; Cuffs of the same Hue; Blue; Blue; Austrians*

2r Heidelberg: the castle, bridge and Heiliggeistkirche from across the Neckar

2v Salzburg: two views of the gateway and Stations of the Cross on the Kapuzinerberg; figures of Christ and Mary in first Station

3r Salzburg: view of the Mönchsberg and part of the city from the Kapuzinerberg (continued on nearest part of f.2v)

3v Salzburg: the Mönchsberg and Müllnerkirche from the Kapuzinerberg, with the Johanniskirche in the foreground

4r Salzburg: the Sebastianskirche and view down the Salzach from the Flagellation Station of the Cross on the Kapuzinerberg; Maria Plain in the distance

4v Salzburg: view up the Salzach towards Stift Nonnberg and the Kajetanerkirche; Pass Lueg in the distance (view continued on f.5r)

5r Salzburg: the fortress from the Kapuzinerberg

5v Salzburg: view from across the Salzach (continued in the sky)
Inscr. *Bells; Red; Salzbg*

6r Three views on the Danube:
(1) Stein
(2) Probably Mautern and Stein

(3) Göttweig abbey and Mautern from Stein

6v View up the Salzach, looking south to Pass Lueg (view continued on f.7r)

7r View up the Salzach with the Hoher Göll, eastern flank of the Untersberg and the Watzmann beyond

7v Salzburg: the fortress from the east, with the Untersberg

8r Salzburg from the east, with the Kapuzinerberg wall and turrets

8v View up the Salzach in two instalments: (1) looking south to Pass Lueg; (2) looking west to Salzburg fortress, with the Stauffen beyond

9r Salzburg: view down the Salzach to the Kapuzinerberg

9v (1) View looking west to Salzburg fortress from the Salzach, with a water mill in foreground
(2) View looking up the Salzach to Salzburg fortress and Stift Nonnberg

10r View up the Salzach to Pass Lueg
Inscr. in sky *W*; *Blue*

10v (1) Salzburg: the Untersberg and Stauffen
(2) Salzburg: view from the south

11r (1) Salzburg: view looking south to Pass Lueg
(2) Salzburg: the Kapuzinerberg from the south

11v View up the Salzach to Pass Lueg, with the Hoher Göll, Watzmann and eastern flank of the Untersberg

12r View west over the Salzach towards the Watzmann and Untersberg (continued in the sky)

12v Salzburg: view down the Salzach to the city

13r View up the Salzach to Pass Lueg, with the Hoher Göll and the Untersberg

13v (1) Salzburg: view down the Salzach to the city
(2) Salzburg: closer detail showing the Kapuzinerkloster

14r View up the Salzach, with the Hoher Göll and the Untersberg

14v View up the Salzach, with the Hoher Göll and the Untersberg and ? a riverside hoist
Inscr. *H[...] G[...]*

15r (1) View up the Salzach to Schloss Goldenstein and Pass Lueg
(2) Boat on the Salzach filled with logs
Inscr. *Timber* (on f.14v)

15v View up the Salzach to Schloss Goldenstein and Pass Lueg
Inscr. *Salsack*

16r View up the Salzach to Schloss Goldenstein and Pass Lueg

16v View on the Salzach with riverside buildings

17r View up the Salzach to Schloss Goldenstein and Pass Lueg

17v View up the Salzach to the Hoher Göll, with a boat

18r View on the Salzach

18v View across the Salzach to Schloss Hellbrunn with the Untersberg beyond
Inscr. *1* (against the Untersberg); *Avenue of very fine Trees*; *Hellbrun*

19r (1)–(4) Studies of a country woman, one illegibly inscr.
(5) The Untersberg
Inscr. *2*

(6) A boat
Inscr. *Red*

19v View across the Salzach to the Hoher Göll and Untersberg; Schloss Hellbrunn in the distance
Inscr. *Road*

20r Two views of Salzburg and its fortress, one from the Kapuzinerberg

20v Salzburg: two views of the fortress
(1) Inscr. [?*Water*]; [?*White House*]

21r View near Salzburg in two instalments: (1) looking south to Pass Lueg with the Hoher Göll; (2) the Watzmann and Untersberg
(2) Inscr. *Salx*

21v Salzburg: the Kapuzinerberg and view up the Salzach from close to the Michaelstor

22r Salzburg: view up the Salzach and along the Rudolfskai from close to the Michaelstor

22v Salzburg: the fortress from the south (two views)

23r Salzburg: the fortress from the south

23v Salzburg: view northwards to the pilgrimage church of Maria Plain

23v–24r Salzburg: the fortress (two rough views)

24v Salzburg: view from the north, on the way to Maria Plain (continued in the sky)

25r Salzburg: view from near one of the Stations of the Cross on the way to Maria Plain

25v Salzburg: Maria Plain with the bridge over the Alterbach and its statue of St John Nepomuk and a Station of the Cross

26r Salzburg: the Kapuzinerberg, city and fortress from the north

26v Salzburg: two views on the way to Maria Plain, one looking north down the Salzach

27r Salzburg: view from the north, on the way to Maria Plain

27v Salzburg: view from the north, on the way to Maria Plain (in two instalments)

28r Salzburg: view from the north, on the way to Maria Plain

28v Salzburg: view from the last Station of the Cross on the Plainberg

28v–29r Salzburg: the façade of Maria Plain
Inscr. *7* (against the bays of the convent)

29r Laden carts

29v Salzburg: distant view of the city from Maria Plain

30r Valley and hills (continuation of view on f.29v)

30v Salzburg: distant view of the city from the organ loft of Maria Plain, with statue of St Peter in foreground

31r Salzburg: the city from the way to Maria Plain

31v (1) Salzburg: view down the Salzach to the Müllnerkirche and Mönchsberg
(2) Salzburg: view down the Salzach to Maria Plain

32r (1) Salzburg: the Müllnerkirche and Mönchsberg
(2) Krems on the Danube
Inscr. *Krems*
(3) Göttweig abbey, as seen from the Danube
(4) Stein on the Danube
Inscr. *Steyn*

32v Salzburg: the Kollegienkirche, with the Mönchsberg beyond, from across the Salzach

33r Salzburg: the Müllnerkirche (extends onto f.32v)

33v (1) Salzburg: view down the Salzach to the bridge and Kapuzinerberg (shown at top right in instalments) with the Michaelstor on the left
Inscr. *Michael Gate*; *Thor*; *3*; *2*
(2) Salzburg: the fortress (continued from f.34r)

34r Salzburg: the Domplatz, with the cathedral, fortress and Mariensäule
Inscr. *Angles*; *Dom Platz*; *Ionic*

34v Salzburg: view up the Salzach to the fortress, Stift Nonnberg, cathedral and bridge

35r Salzburg: the Kollegienkirche

35v Salzburg: view along the Getreidegasse, to the Blasiuskirche and the Mönchsberg

36r (1) An archway with cartouche above, probably at Salzburg
(2) The Danube at Stein and Krems
Inscr. *Stein*; *Vines*; *Krems*

36v Salzburg: a street with a church (the Franziskanerkirche?) on the right
Inscr. [?*Fountain*]

37r Salzburg: the fortress and city from the north

37v (1) Salzburg: the Stiftskirche St Peter, looking north
Inscr. *Salzburg*
(2) Salzburg: view up the Salzach to the bridge, cathedral and fortress

37v–38r Mountains
Inscr. *In Tyrol*; *going to Lintz*

38r Salzburg: view up the Salzach to the Kapuzinerberg and bridge

38v Salzburg: the fortress and bridge looking south, with detail of a gateway; gateway detail repeated, illegibly inscr.

39r (1) Salzburg: the façade of the cathedral
(2) The Untersberg

39v Two views of hills between Salzburg and Linz
Inscr. *to Lintz*

40r Salzburg: two views of the city side of the Neutor

40v Salzburg: view from across the Salzach

41r Salzburg: the Kollegienkirche with the Mönchsberg beyond, from across the Salzach

41v Salzburg: the Marstallschwemme and Neutor

42r Salzburg: view past the steeple of the Stiftskirche St Peter to the fortress

42v Salzburg: the cathedral from the Residenzplatz
Inscr. *Platz Risidentz*; *7* (against the bays of the Residenz)

43r, Panorama of Salzburg from the
43v–44r Mönchsberg. 43r: from the fortress (R) to the cathedral (L); 43v–44r: from the cathedral (R) to the Kapuzinerberg (L) with the Kollegienkirche in the left foreground

44v Salzburg: views from the Mönchsberg:
(1) Looking north down the Salzach towards Maria Plain, with the Kollegienkirche in the foreground
(2) (continuation in sky) Fortifications on the Mönchsberg, inscr. *2*
(3) (detail in sky) Pair of church towers, inscr. *3*

45r Salzburg: the fortress and city from the

Mönchsberg

45v Salzburg: the Neutor and
Marstallschwemme

46r (1) Men, women and soldiers
Inscr. [?*Gold*]; [?*Silver*] *Blue*

(2) Salzburg: the city side of the Neutor
Inscr. *Medusa Head*

46v (1) Boat with a cabin and awning
Inscr. *Painted like B*[...]; *Kitchen*; *Place
Rigged out to make Table* [...]; *Boat on
the Danube*

(2) Salzburg: the south-west side of the
Neutor

(3) The inscription on the city side of the
Neutor: *Te Sax*[a] *Loquuntur* [...] *Way*
[...] (page torn)

47r Salzburg: interior of the Franziskaner-
kirche, with figures
Inscr. *V*[...] *W*[...]; *Gold* (on the altar);
[...] *very light*; *Confes*[sion]*al* (next to
kneeling figures to right)

47v Mountain scenery

48r (1) Distant view of Salzburg looking north,
with carts

(2) The Hoher Göll
Inscr. *Salzach*

48v–50r Mountain scenery

50v Linz: view down the Landstrasse towards
the Danube, with the old cathedral, Ursu-
line church and Carmelite church on the
right

51r (1) Linz: view across the Danube to Urfahr
and the Pöstlingberg, from just down-
stream from the bridge

(2) Linz: view up the Danube, showing the
castle and Pöstlingberg

51v (1) Linz: the parish church, Ursuline
church and old cathedral

(2) Linz: the Landhaus and castle from the
bridge
Inscr. *9; 24* (against the bays of the
castle)

52r Linz: view down the Danube towards the
bridge and parish church

52v (1) Linz: view down the Danube to the
castle

(2) Linz: view up the Danube to the castle,
bridge and Pöstlingberg (detail included
in sky)
Inscr. *13 P* (against the bridge)

53r (1) Linz: view up the Danube towards the
bridge, Urfahr and Pöstlingberg

(2) Linz: view down the Danube

53v (1) Linz: view up the Danube to Buchenau

(2) Linz: view down the Danube from near
the castle

(3) Linz castle
Also: wagons, a building and a figure

54r Interior of an inn with figures seated at
tables
Inscr. *De Hooge*; *Grey B*[...]; *2*; *W*; *1*

54v (1) View up the Danube to Linz and the
Pöstlingberg (continued in sky)

(2) Steyregg
Inscr. *Steereck*

(3) Danube view
Inscr. *Beefehigberg* (i.e. Pfenningberg?)

55r Four sketches of the Danube near Linz
(3) Inscr. *Lintz*

55v Five sketches of the Danube between
Steyregg and the junction with the Enns,
three showing the town of Enns in the dis-

tance
(2) Inscr. *Eiyens*

56r (1)–(5) The ruins of Spielberg on its island,
one inscr. *Spilberg*

(6) Hills along the Danube

56v Five sketches of Spielberg

57r (1) Mauthausen from upstream

(2) The Stadtturm of Enns

(3) Enns from the Danube
Inscr. *Ince*

(4) Spielberg

(5) Mauthausen from downstream

(6) Hills along the Danube

57v (1) (2) Hills along the Danube, inscr. *Neu-
berg*; [...] *Vassee*

(3)–(5) Wallsee castle, (5) inscr. *Walsee*

(6) Hills along the Danube

58r Three closer sketches of Wallsee castle,
from successive viewpoints moving down-
stream

58v (1) (2) Wallsee castle

(3) (4) The Danube near Wallsee

59r (1) (2) Wallsee castle

(3) (4) Klam castle, as seen from the
Danube, and a detail

59v (1)–(3) The Danube between Wallsee and
Grein, from successive viewpoints
moving downstream

(4) Grein
Inscr. *Green*

60r (1)–(4) The Danube just above Grein, from
successive viewpoints moving down-
stream

(5) Grein

60v (1) The Strudel, looking downstream

(2) (3) Grein, looking upstream

61r (1) Distant view of Grein, looking
upstream
Inscr. *Grein*

(2) The Danube near Grein

(3) (4) Grein castle and church

61v Three sketches of the Strudel

62r Four sketches of the Strudel, looking
downstream
Page also inscr. *Werbel*

62v (1) The Wirbel and St Nikola, with the
Haustein, looking downstream

(2) The Haustein

(3) Struden, looking upstream

(4) The Wirbel and St Nikola, looking
downstream

63r (1) The Haustein

(2) (3) Sarmingstein, looking upstream
(2) Inscr. *S*[...]*bingsten*

63v (1) Hills along the Danube

(2) (3) Sarmingstein and the ravine of the
Sarming

64r (1)–(3) Freyenstein castle, from successive
viewpoints moving downstream

(4) Sarmingstein

64v (1) Distant view of Freyenstein, looking
upstream

(2)–(4) Persenbeug castle, from successive
viewpoints moving downstream

64v–65r View down the Danube to Persenbeug cas-
tle and Ybbs, with stormy sky
Inscr. *B* (in sky); *Paesenburg*; *Epeese*

65r (1) Persenbeug castle, looking downstream

(2) (3) A storm over the Danube
Both inscr. *X* in sky and (3) inscr. *Bl*
among dark clouds

65v The churches of Stein and its town hall

from the waterfront
Page also inscr. *Golden Traube* (i.e. an inn,
the Golden Grape)

65v–66r View from just outside the walls of Stein
across to Mautern
Inscr. *Wood*

66r Female figure and outline of buildings

66v–67r (1) Boats on the Danube

(2) The outskirts of Stein, with a wayside
shrine dedicated to St Sebastian
Inscr. *Danube*; *St Sebastian*

(3) Stein and Krems, in two instalments,
the first inscr. *Danube*; *Road*; *Vines*;
Vines; the second inscr. [...];
Gold [...]; *2*

67r (1) Distant view of Marbach?
Inscr. *Danube*; *Mahburg*

(2) Three men

67v Blank

68r Buildings

68v Buildings by the Danube

69r Rough sketch (a gateway?)
Page also inscr. *Reise auf der Donau Ulm to
Wien* (Turner's rendering of the title of a
guidebook; the British Library has an edi-
tion published in 1818 but there must have
been others)

69v–70r Blank

70v Three sketches of Säusenstein, with its
parish church and collegiate church
Inscr. *Sigelstern*

70v–71r View down the Danube to the pilgrimage
church of Maria Taferl with a cloudy sky
(plus a detail of the church)
Inscr. *Yellow* (in sky); [...]

71r View just outside Stein, with a boat and
stormy sky, illegibly inscr.

71v Three Danube views near Marbach
Inscr. [...]*estey*; *Marba*; *R* [?*Gasthaus*];
G[...]
Page also inscr. [...]*to Wien*

72r (1) Weitenegg castle and Melk abbey
(extends onto f.71v)
Inscr. *Melch Clois*

(2) (3) Weitenegg castle
Inscr. *White Neck*

(4) Weitenegg castle
Inscr. *Wterburg*

(5) Hills along the Danube

72v (1) Weitenegg castle

(2) (3) Melk abbey and several details of it
Inscr. *8; 20; 8; 8; 6* (for its bays and win-
dows)

73r (1) Weitenegg castle

(2) Melk abbey

(3) View down the Danube to Schönbühel
castle with man on raft in foreground

(4) View up the Danube, to Weitenegg
castle

73v Four sketches of Schönbühel castle and
monastery plus details, (1) inscr. [...]; (2)
inscr. *Rocks*; (4) inscr. *Reisenfels*

74r (1) Schönbühel monastery

(2) The Danube near Schönbühel

(3) Schönbühel castle and Melk abbey,
looking upstream (in two instalments,
inscr. *1; 2*)

(4) View downstream to Aggstein castle
Inscr. *Oxtein*

74v Two sketches of Aggstein, looking down-
stream, each with a separate detail

75r Five sketches of Aggstein, one inscr. *Oxten*

75v (1) Spitz and the Tausendeimerberg, look-
ing downstream
(2) The Hinterhaus and Spitz, looking
downstream
Inscr. *Spiss*
(3)–(7) The Hinterhaus, Spitz
76r Three sketches of Spitz and the Hinter-
haus, inscr. *Spiz; Spitz*
76v (1) St Michael, looking downstream, plus
detail
(2) Arnsdorf and Spitz, looking upstream
(3) (4) St Michael
(3) Inscr. *St Michal*
77r (1) View upstream to Arnsdorf, Spitz and
St Michael
Inscr. *St Miachal*
(2) Wösendorf, looking downstream
(3) The church at Weissenkirchen
Inscr. *Wiesenkirchen*
(4) (5) Distant views of Dürnstein
Inscr. *Riesenhertz; Clock*
77v Three sketches of Dürnstein, one with
detail
78r Three sketches of Dürnstein
78v–79r (1) (2) Dürnstein, looking upstream
(1) Inscr. *Herstz*
(3) Stein, looking downstream
Inscr. *Stein*
(4) View down the Danube to Stein and
Mautern
Inscr. *Bridge 21*
(5) View upstream to Dürnstein
78v Göttweig abbey, as seen from the Danube
Inscr. *Danube*
79r (1) Stormy sky
Inscr. *Yel; Or and Red B Purple Or*
(2) Göttweig abbey , as seen from the
Danube
79v (1) Krems
Inscr. *Krems*
(2) Distant view of Göttweig abbey, as seen
from the Danube, and detail (extends
onto f.8or)
(3) (4) Krems
(3) Inscr. *Krems*
(5) (6) Hollenburg
(5) Inscr. *Ulemburg*
80r (1) Hollenburg
(2) View looking upstream to Hollenburg
(3) The Leopoldsberg near Vienna, with
Klosterneuburg in the distance and sep-
arate detail of the Leopoldsberg church
itself
80v Four sketches of the Danube between
Wagram and Vienna
(1) Inscr. *Wagram; K[rems]*
(3) Inscr. *Wagram; I[s]lands in the Danube*
81r Three sketches of the Danube near Tulln,
with boats and separate detail of Tulln
itself
81v (1) Distant view of Kreuzenstein castle
from the Danube near Klosterneuburg
Inscr. *Mill*
(2) Klosterneuburg
(3) Village on the Danube
(4) The Leopoldsberg, looking downstream
Inscr. *4 Miles* (i.e. from Vienna)
82r (1)–(3) The Danube close to Vienna, two
showing Kreuzenstein castle
Inscr. *Grifenstein*
(4) (5) Village on the Danube
Inscr. *Ebburg; Ditto*

82v (1) Klosterneuburg, with separate details
(2) Distant view of Kreuzenstein
Inscr. [...]
(3) Klosterneuburg, with Kreuzenstein in
the distance
Inscr. *Grifstein*
(4) Klosterneuburg
(5) Danube view
83r Blank
83v Slight sketch in corner
84r Salzburg from the Mönchsberg, looking
northwards to Maria Plain, with the Müll-
nerkirche (Augustinian)
Inscr. *Augustan Ch; [...] Weath[?er]*
84v Fortifications at Salzburg, probably on the
Mönchsberg
Page also inscr. with Turner's name for this
sketchbook: *Saltzburg and Danube*
Inside back cover
Fortifications at Salzburg, probably on the
Mönchsberg

TB CCCXI *Vienna up to Venice* sketchbook 1833 (see cat.no.30)

Bound in boards covered in blue marbled paper, with
the back and corners in a brown marbled paper, an
inside front pocket made from a blue embossed
paper, and four leather loops for holding a pencil,
two at each end. Five ink lines scored across the
upper fore-edge of the pages. Inside the back cover is
a printed label:

Bey Anton Lehenbauer
bürgerlichen
Buchbinder
in Wien, Stadt, Rothgasse
№ 641.

Formerly known as the *Lintz, Salzburg, Inns-
bruck, Verona and Venice* sketchbook. However, the
book contains no sketches of Linz and is here
renamed in the style of Turner's other sketchbooks
of 1833. For reasons of space, the unidentified and
slight sketches drawn on Turner's journey from
Innsbruck to Venice are here listed in the briefest
possible way.

Inside front cover
Five slight sketches of figures in paintings
in the Imperial Picture Gallery in Vienna
including (1) Francesco Furini's 'Penitent
Magdalene' and (3) Rubens's 'Portrait of
Hélène Fourment in a Fur Wrap'
Several inscr. including *Frances Furini;
160[...]69; Ven[...] del [...]; Vienna; Mon-
tag Diesstum Fristag Samstadt; like Titian;
529*
1r Two slight sketches, including one of a
painting in the Imperial Picture Gallery in
Vienna: Venetian School, 'Ecce Homo'
(Kunsthistorisches Museum inv. no. 280)
Several inscr. including *Head of Christ;
A[n]drea Mantegna 1431 1506 from which
Titian has stolen his [...] or rather copied it;
Lord Egremont Palma; S[...] 1501 604;
T[...] 1607 1669; D[...] 1607 1675; Newu-
berg*
1v Vienna: view from a window in the Upper

Belvedere
2r Two views of towns, one illegibly inscr.
2v Mountains
3r Blank
3v–4r Two views near Vienna, illegibly inscr.; also
several sketches of mountain scenery with
illegible inscr.
4v Vienna: three views of the Karlskirche
(one, looking westwards, extending onto
f.5r)
5r (1) A fortified gateway
(2) (3) A walled town
(4) (5) Composition studies of river scenery
Page also inscr. *6[...]*
5v Vienna: the Upper Belvedere from close to
the fountain with sculpture figures in the
centre of the gardens
6r Blank
6v (1) Vienna: the Upper Belvedere and its
gardens from the corner of the gardens
by the East Pavilion; sphinxes in the
foreground
(2) Tower
Inscr. *E[...]*
7r Vienna: view from the Belvedere gardens
close to that used for f.6v
7v Vienna: view down Weihburggasse to the
Franciscan church
Inscr. *Carlo Theatre* (i.e. the Carl-Theater)
8r View near the Leopoldsberg?
8v Vienna: the façade of St Stephen's cathe-
dral (spire continued at top right)
Inscr. *Lion* (against one of a pair of statues)
9r (1) Vienna: view from the outskirts
(2) The Kahlenberg and Leopoldsberg
9v–10r View over Vienna from above Grinzing (in
three instalments)
Inscr. [...]; *Ginzing*
10v The Danube from the Vienna Woods
Inscr. *C[...]*
11r Three sketches of Vienna and its surround-
ings from the Leopoldsberg
Inscr. *B[...]; Vineyards; Road; Dab; 2*
11v The Kahlenberg in the Vienna Woods
Inscr. *Wood; Kalenburg*
Also another rough sketch
12r (1) Vienna: view from the Leopoldsberg
Inscr. *Dark but the Danube in Light; [...]
V; Dab*
(2) The Kahlenberg and the Leopoldsberg
Inscr. *Closter*
12v Vienna: view from the Leopoldsberg
Inscr. [...]; *Giz* (i.e. Grinzing)
13r (1) The Leopoldsberg, looking towards
Korneuburg
Inscr. *Corn[...]; Vil; V; V* (against dis-
tant villages)
(2) The Danube valley
Inscr. *2*
13v Austrian soldiers, with details of costumes
Inscr. *Red; Brown; Light G; Red; Red*
14r (1) Vienna: view from the Leopoldsberg
(2) View from the Vienna Woods
Inscr. *Grinzing [...]*
14v (1) The Leopoldsberg from the Kahlenberg
cemetery
(2) Vienna from the Kahlenberg
15r (1) The Leopoldsberg and view up the
Danube (plus more detailed sketch of
the church and bastions)
Inscr. *Leopoldsbg*
(2) Slight sketch of buildings

15v Church and mountain scenery
Inscr. *1; 2; 2; 3*

16r View up the Danube from the Leopolds-
berg
Inscr. *Gretselstn* (above Kreuzenstein);
Heuenstinn from Leopodberg

16v Three views from or near the Leopoldsberg
Inscr. *3; Genzing; Vines*

17r Two views of the Danube near Vienna
Inscr. *D*[…]

17v The Leopoldsberg and the church of
Kahlenbergerdorf looking up the Danube
(in two instalments)

18r Vienna: the cathedral and Lazanskyhaus
from the Stock-im-Eisen-Platz

18v A valley among mountains
Inscr. *Road; Valembroce*

18v–19r Vienna: the cathedral from the south-west
Inscr. *Vol*[…]

19v Mountain sketches
Inscr. *1; 2; 3; 4; 5;* […]

20r Vienna: the cathedral spire (continues the
sketch on ff.18v–19r)
Also: landscape sketches inscr. *near
Val*[…]; *Road; Road*

20v–21r Vienna: the cathedral from the south

21r Hills and church
Inscr. *Val*[…]

21v Town

22r Vienna: the skyline in silhouette (in three
instalments) and other slight sketches

22v–23r Mountain scenery, with inscr.

23v Melk abbey on the Danube, as seen from
the road

24r Three sketches with inscr., the last showing
Vöcklabruck

24v–25v Mountain scenery and buildings, with
inscr.

26r Blank

26v (1) Rough sketches of hills, one inscr. *from
Lintz to Sal*[zburg]; another *Cyp*
(2) Wayside shrines with worshippers
Inscr. *G; B; Large straw Hat*[…] *Black*

27r Eight wayside shrines of different designs

27v Two views of Frankenmarkt, one inscr.
Frankenmak

28r (1) Rough sketch of Vienna cathedral
(probably by night)
(2) Buildings, illegibly inscr.

28v Rough sketch of Vienna cathedral
Inscr. *Domo at Night; Moon* […]

29r (1) Frankenmarkt
Inscr. *Fall Water;* […]
(2) Frankenmarkt, with separate detail of
its church spire
Inscr. *Fall*
(3) (4) Mountain scenery, illegibly inscr.

29v–34r Mountain scenery and buildings, with
inscr.

34v Salzburg: view up the Salzach, from nearly
opposite the Michaelstor, to the Kajetaner-
kirche, Stift Nonnberg and fortress

35r Salzburg: view down the Salzach to the
fortress, cathedral, bridge and Kapuziner-
berg (continued in the sky)

35v Salzburg: view across the Salzach to Stift
Nonnberg, the fortress and the Kajetaner-
kirche

36r (1) Salzburg: the Franciscan church
(2) Church interior

36v–37v Mountain scenery and buildings, with
inscr.

38r Mountain scenery, buildings, figures and a
church interior, with inscr.

38v Buildings (including part of the fortress at
Salzburg) and two female nude studies,
with inscr.

39r–40r Mountains, buildings and figures, with
inscr.

40v Salzburg: Stift Nonnberg and the fortress,
looking up the Salzach

41r–51v Mountain scenery and buildings, with
inscr.

52r Venice

52v–53v Mountain scenery and buildings, with
inscr.

54r Innsbruck: view along the Maria-There-
sien-Strasse to the Triumphpforte

54v Innsbruck: view along the Maria-There-
sien-Strasse to the town hall, Goldenes
Dachl, Stadtturm and cathedral

55r (1) Innsbruck: view of the city from across
the Inn
Inscr. *Campo Sancta*
(2) Mountains at Innsbruck

55v Innsbruck: view along the Maria-There-
sien-Strasse to the town hall and Stadt-
turm, with the Annasäule on the right

56r Innsbruck: view of the city from across the
Inn

56v–57v Innsbruck: views from its outskirts

58r Innsbruck: the Stadtturm and Hofburg
from the Hofgarten
Inscr. […]; *Inspruck*

58v–59r Verona: four sketches of the Scaliger
tombs. That of Cansignorio della Scala
wrongly inscr. *Paul Veronese Resting Place;*
and that of Giovanni della Scala (d. 1359,
illegitimate and originally buried in S.
Fermo Minore) accompanied by a copy of
its inscription
[…] *AEDES FIRMIO POSITUM*
[…] *EXIMO ABSDIS PARETI*
INFIXUS SALIGERI
HUC TANDEM INTER SUAE GENTIS
TUMLOS
ANNO MDCCCXXXI
JOANNIS SCALIGERI SARCOPAGUS
TRANSLATUS EST
FRANCISCO FERRARIO PRAETORE

59v–62r Mountain scenery and buildings, with
inscr.

62v Verona: Ponte Scaligero

63r–64r Buildings (mostly at Verona) and moun-
tains

64v (1) Buildings
(2) Vienna: St Stephen's cathedral by night

65r Innsbruck: view down the Inn to the cathe-
dral and Stadtturm

65v Innsbruck?

66r–66v Mountain scenery and buildings, with
inscr.

67r (1) Verona: the Arena and adjacent build-
ings
(2) Buildings, with inscr.

67v Verona: the Arena (page smudged with
blue and red watercolour washes)

68r Verona, with S. Zeno Maggiore

68v Mountain scenery, including a view of Ala,
inscr. *Ala*

69r (1) Bolzano
Inscr. *Bolx*
(2) Verona: view down Piazza delle Erbe to
Piazza dei Signori

69v Verona: Ponte Pietra and its gate tower,
looking up the Adige

70r Verona: Castel S. Pietro and Ponte Pietra,
looking down the Adige

70v Verona
Inscr. *River*

71r (1) Verona?
Inscr. *Salita St* [?*Zena*]
(2)–(5) Rough sketches of Padua and near-
by hills, twice inscr. *Padua*

71v–72v Verona?

73r Blank

73v–74r Verona: Piazza delle Erbe, looking towards
the Torre Civica, with inscr.
Also: slight sketches of Verona

74v Verona: Piazza dei Signori, looking towards
the Tower of the Scaligeri and Palazzo del
Consiglio
Inscr. *Court;* […]; *Piazza Signore*

75r Verona

75v–76r Mountain scenery and buildings, with
inscr.

76v Female figure

77r Blank

77v–78r Mountain scenery and buildings, with
inscr.

78v–79r Blank

79v–81r Venice, with inscr.

81v–82r Blank

82v Page inscr. *Verona*

83r Verona: two views of the Ponte Scaligero,
one inscr. *1; 10; 2; 2; 10; 2; 4*

83v Verona?

84r Mountains, valley and town (Innsbruck?)

84v Venice, with inscr.

85r Blank

85v–87r Mountains and buildings, with inscr.

87v–88r Blank

88v–89v Mountains and buildings, with inscr.

90r–92r Blank

92v Vienna: slight sketch of the cathedral

93r A landscape sketch and two figures

93v Mountains and buildings, with inscr.

94r Vienna: the cathedral from Churhausgasse

94v Slight sketch of buildings and two inscr.
relating to works in the Imperial Picture
Gallery in Vienna:
(1) *Titian Venus and* […]
all but the Cupid
[…] *of* […] *Bath of Diana*
without the Black W[…]
(2) *Casper Crayer 1582*
[…] *Christ 1669*
Roger […]
S[…] *del* […]

Inside back cover
Inscr. […] *Basseti 1520;* also columns of
figures (financial calculations?)

3	—		
10	*40*	*7*	*2*
13	*40*		*8*
7	*40*		[…]
5			*23* —
12	*40*	*13*	*40*
3	*10*	*40*	
9	— *10*	*28*	
		12	
		30	

TB CCCV *Hamburg and Copenhagen sketchbook* 1835 (see cat.no.31)

Bound in dark plum boards embossed with floral decorations and with views of Bad Ems on the Lahn and Bingen on the Rhine, with two loops at one end for a pencil. Pockets inside covers made from coloured paper printed with a rococo pattern. Pages edge-painted in yellow. f.1 is occupied by a printed perpetual calendar with adjustable parts.

Formerly known as the *German (?)* sketchbook and numbered by Finberg starting at the opposite end of the book to that used by Turner. The list below follows Turner's sequence. He fitted the Copenhagen sketches into the spaces left by the Hamburg ones, sometimes on the same page.

34v Blank
34r (1) Two figures
 (2) (3) Copenhagen from the Sound, with boats
33v (1) Hamburg: houses and the Nikolaikirche from the south end of the Holzbrücke, with figures in the foreground
 (2) Copenhagen from the Sound
33r Hamburg: the Katharinenkirche and Reimersbrücke from the north end of the Holzbrücke
32v Hamburg: on the Stintfang (?), with figures in the foreground
32r Copenhagen: the interior of the Church of Our Lady
 Inscr. *St B*[artholomew]; *Thomas*; *Jacobus*; *14*; *Phi*[li]*ppus*
31v Hamburg: the Baumhaus and the Vorsetzen from the Kehrwieder, with the spire of the Michaeliskirche behind
31r Copenhagen: the Landemaerket looking towards the Trinity Church, Round Tower and Church of Our Lady
 Inscr. [...]
30v Hamburg: the Blockhaus, with the spire of the Michaeliskirche beyond
30r Hamburg: the Blockhaushafen with the Vorsetzen
 Inscr. *1*; *3*
29v Hamburg: the Blockhaushafen with the Nikolaikirche and other churches and the Baumhaus
 Inscr. *2*
29r Blank
28v Hamburg: slight sketch of gabled houses
28r Hamburg: the western prospect from the Stintfang, looking down the Elbe towards St Pauli, with gazing figures in the foreground
27v Hamburg: the western prospect from the Stintfang, looking down the Elbe towards St Pauli, with gazing figures in the foreground
27r Copenhagen: the south-west and north-west sides of Kongens Nytorv (in two instalments: the first showing the King's Theatre, Ericsens Palace, St Nicholas' Tower, and Hôtel du Grand Nord, the second the Hôtel d'Angleterre and Hovedvagten)
 Inscr. *A* (next to the Hôtel d'Angleterre)
26v Hamburg: the mill on the Muhlenberg and ?the Zeughausmarkt

26r (1) A woman in a wide-brimmed hat carrying a yoke and pails
 Inscr. *W*; *Red*
 (2) Two men
 (3) A cart
25v (1) Hamburg: view from just outside the Millernthor with the mill on the Mühlenberg, Nikolaikirche and Michaeliskirche
 (2) Sketches of two women
 Inscr. *B*; [?*Shawl*] *Red*; *Yellow D*[ress]
25r Hamburg: the eastern prospect from the Stintfang, with the spire of the Michaeliskirche
24v Hamburg: the eastern prospect from the Stintfang, with the spire of the Michaeliskirche
24r (1) Hamburg: view along the Jungfernstieg with the Jacobikirche and Petrikirche
 (2) Two women
 (3) Copenhagen: the south-east side of Kongens Nytorv with the Charlottenborg Palace and Harsdorff's Mansion
 Inscr. *5* (for the bays of Harsdorff's Mansion)
23v (1) Group of people seen at Hamburg
 Inscr. *Blue*; *Red*; [...]; *Red*
 (2) Copenhagen: the north-east side of Kongens Nytorv from an upper storey of the Hôtel d'Angleterre, with the equestrian statue of Christian V in the foreground; the Giethuset and King's Theatre (a continuation of sketch (3) on f.24r) squeezed into the sky above
 Inscr. *6*; *3*; *6* (for the bays of the Giethuset)
23r Hamburg: view along the Jungfernstieg to the Hotel Belvedere, with the Jacobikirche and Petrikirche beyond
22v Hamburg: view along the Jungfernstieg to the Hotel Belvedere with the spires of the Jacobikirche and Petrikirche beyond (the latter extends onto f.23r)
22r Hamburg: the Elbe shore, with boats
21v Hamburg: the Elbe shore west of the Niederhafen, looking towards the city
21r (1) Copenhagen: the Round Tower as seen from Store Kannikestraede, plus a detail of its doorway and one of a window, inscr. *7* (the number of windows in each bay)
 Inscr. with a copy of its rebus/inscription which translates as *Decretam et justitiam dirige Jehovah corde coronati Christiani quarti 1642*
 (2) Hamburg: the Niederhafen from the west
20v Hamburg: figures, boats and buildings on the Elbe shore
20r Copenhagen: several overlapping sketches of buildings seen in the Frue Plads area: two views of the Church of Our Lady (from the south-east and the façade); the spire of St Peter's church; the Round Tower; the main university building
 Inscr. *Fredericus Sextus Instauravit* (copied from the university doorway); [?*Fluted D*]; *Doric 8* (against the façade of Our Lady)
19v Hamburg: the Niederhafen from the west with the spire of the Michaeliskirche
 Inscr. *Al*
19r (1) Hamburg: view across the Aussenalster

from the Alsterglacis to the Georgkirche, windmill and Lombardsbrücke; early morning sun reflected in the water
 (2) Copenhagen: the apse of the Church of Our Lady?
18v Hamburg: view across the Aussenalster to the spires of the Jacobikirche, Gertrudkirche, Katharinenkirche, Petrikirche and Nikolaikirche
 Inscr. [?*Lake*] *Alsder*; *Water* [...]
18r Hamburg: view across the Binnenalster, in two instalments continuing the scene from f.17v:
 (1) From the Petrikirche to the Katharinenkirche
 Inscr. *2*
 (2) From the Nikolaikirche to the Michaeliskirche
 Inscr. *3*
17v Hamburg: view across the Binnenalster. First instalment showing the Gertrudkirche and Jacobikirche (both repeated nearby in the sky, the latter extending onto f.18r)
 Inscr. *1*; [...]
17r (1) Hamburg: view from the Alsterglacis towards the Lombardsbrücke with the Büsch monument in the foreground, the spire of the Georgkirche seen across the Aussenalster (L) and the Jacobikirche and Petrikirche seen across the Binnenalster (R)
 (2) A tiny version of a similar view
16v Hamburg: the monument to Johann Georg Büsch on Bastion David north of the Lombardsbrücke, with separate details of one of its reliefs showing figures pouring libations, and of a garland relief
 Inscr. *Von Seinen Danck Baren Mit Burgern MDCCCI*; *Geburtsiahr MDCCXXVIII* (copied from two of its inscriptions)
16r Hamburg: the Lombardsbrücke with the windmill on its right and the spires of the Jacobikirche and Petrikirche seen across the Binnenalster; the sun shown in the eastern sky
15v Hamburg: the Lombardsbrücke, windmill and spires of the city from the Alsterglacis; the sun shown in the eastern sky
15r Hamburg: view with gabled houses and trees
14v Hamburg: view on the ramparts
14r Hamburg: view in the Binnenhafen, with the Katharinenkirche
13v Hamburg: view in the Binnenhafen (extends slightly onto f.14r)
13r Hamburg: view in the Binnenhafen
12v Hamburg: the Binnenhafen (with the building that was later the Glaslager of C.E. Gätcke) (continued in the sky above)
12r Two isolated sketches of church towers at Hamburg: the Nikolaikirche and Michaeliskirche
11v Hamburg: the Elbe shore, looking towards the city
11r Kiel: the Schloss and Nikolaikirche
10v Kiel: the Schloss and Nikolaikirche
10r Kiel: the Nikolaikirche
9v Two sketches of cliffs, possibly on Moen
9r Four sketches of coastline, (1) inscr. *Waihburg*, (3) inscr. *Falster*

8v Four sketches of coastline, inscr. *1; 2; 3*

8r Five sketches of a coastline or islands
Inscr. *Steerborg R…; [?Fort]*

7v Three sketches of a coastline or islands
Inscr. *Sleger: Am[ager?]*

7r (1) Copenhagen from the Sound
(2) (3) Copenhagen: two views of Rosen-borg Palace from just inside the main entrance on Oster Voldgade,
(2) looking north, (3) looking south
(3) Inscr. *Ros*

7r–6v Copenhagen: two sketches of Rosenborg Palace from just outside the main entrance on Oster Voldgade

6v Three sketches of the cliffs of Moen, from the sea, one inscr. *Maon*

6r Two sketches of the cliffs of Moen, from the sea, one inscr. *Moen*

5v Two sketches of the cliffs of Moen, from the sea (one in two instalments)

5r (1) Copenhagen: St Nicholas' Tower from the corner of Nikolaj Plads and Store Kirkestraede
Inscr. *1591; [?Bridge]; St[…]*
(2) (3) Distant views of Copenhagen from the Sound

4v Blank

4r–3v Two rough sketches of Copenhagen from the Sound, one showing the tower of the Church of the Redeemer
Inscr. illegibly

3r Copenhagen: view from the Christian IV Bridge with the Knippelsbro, Exchange, Christiansborg Palace, Holmens church and St Nicholas' Tower

2v (1) Copenhagen: slight sketch of the Knip-pelsbro and Holmens church
(2) Copenhagen: view from the eastern end of Børsegade with the Exchange, Chris-tiansborg Palace, Christian IV Bridge and Holmens church

2r (1) Copenhagen: Christiansborg Palace from Holmens Kanal
(2) Houses and masts

1v Several sketches including two of a country girl
Inscr. *[…]; Green and Gold; Quantity of Ribbons; Green or Red*

1r A printed calendar

TB CCCVII *Copenhagen to Dresden* sketchbook 1835 (see cat.no.32)

Bound in boards covered in brown and green mar-bled paper, with dark brown leather spine with gilt decoration, dark brown leather corners and three leather loops for a pencil, two at one end and one at the other. Pocket inside one cover made from blue and brown marbled paper. Pages edge-painted in yel-low.

Formerly known as the *Dresden* sketchbook and numbered by Finberg starting at the opposite end of the book to that used by Turner. The list below fol-lows Turner's sequence. However, his vocabulary section clearly starts on f.1r, running through to f.4r, and it was this that misled Finberg.

Inside cover
Several rough sketches including one of the spire of the Church of the Redeemer, Copenhagen, and a few words including *Harfen; Fish; Speise; Tafel*

59v Two sketches of women with large head-dresses and a rough one of a line of build-ings

59r (1) Dresden: view on the bank of the Elbe near the Brühl terrace, looking down-stream to the bridge, with figures under trees
(2) Copenhagen: the equestrian statue of Frederik V in the Amalienborg
(3) Inscr. *[…] of Lippe; Amalie Palazzo* (i.e. the Amalienborg Palace, Copenhagen)
(4) Part of a female nude (a statue on the Schack Palace, Copenhagen?)

58v Copenhagen: the colonnade of the Amalienborg Palace from the Amaliegade with the equestrian statue of Frederik V seen beyond it and the side of the Schack Palace on the right
Inscr. *4 Col[umns]*

58r Copenhagen: view of the Amalienborg Palace showing the Schack Palace, equestri-an statue of Frederik V, colonnade and part of the Moltke Palace

57v Christianshavn with Nyholm's Hovedvagt, the rigging shears and a ship out of the water (in two instalments)

57r The entrance to Christianshavn and the fortifications of Copenhagen (in three instalments)
Inscr. *3; L; 4; […]* (by the Church of the Redeemer); *Brick* (on the fortifications)

56v Three sketches of fortifications near Copenhagen, a sailing ship and a rough sketch illegibly inscr.

56r Fortifications near Copenhagen, sailing ships and the Swedish flag, inscr. *Blue; yel-low; Blue*

55v Three sketches of fortifications near Copenhagen, one illegibly inscr.

55r Three sketches of sailing ships near Copen-hagen

54v Several sketches of the fortress island of Trekroner, one inscr. *[?White]*

54r Three sketches of the towers of Copen-hagen from the Sound and two of sailing ships

53v Several sketches of Trekroner and of sailing ships near Copenhagen

53r (1) Copenhagen from the Sound
(2) Copenhagen from the Sound and Trekroner
(3) Trekroner

52v Three sketches of Copenhagen from the Sound

52r Two sketches of Copenhagen from the Sound, with Trekroner, the first in two instalments, illegibly inscr.

51v (1)–(3) Three sketches of Copenhagen and the nearby coastline from the Sound, one inscr. *El[…]*
(4) Buildings
Inscr. *F[…]dsbg*

51r Copenhagen from the Sound and nearby coastline, in three instalments
Inscr. *[…]; Am[…]; Sound*

50v (1) Sailing ships
(2) Buildings

Inscr. *Poss[…]*
(3) Low sun over the sea
Inscr. *Yellow; Purple; […]; Water Light*
(4) Coastal buildings (extends onto f.51r)
Inscr. *Fragner*
(5) Ships in the Baltic
Inscr. *Swedish Coast on Left; Water Dark*

50r Three sketches of ships in the Baltic

49v Several sketches of distant coastlines, one with sunlight penetrating through clouds, two with a boat
Inscr. *[…]; 1; 2; Rugen; [?Arcona]*

49r Several sketches of distant coastline and islands, inscr. *Redish color; […]; Grasland*

48v (1) Clouds and low sun over the sea
Inscr. *Pink; Yellow Red orange; Light*
(2) Distant coastline (in two instalments)
Inscr. *Grats[…]*
(3) Distant coastline (in four instalments)
Inscr. *1; […]; 2; Water Dark the Land red; 3; 4*

48r (1) Distant coastline (in two instalments)
Inscr. *Greifswalder[…]*
(2) Sailing boat and buoys
Inscr. *Morning* [or *Mooring*] *in the B[altic]*

47v Four sketches of distant shorelines
(1) Inscr. *[?Swinemund]; Pomerania; W[…]berg; […]lenburg*

47r Three sketches of distant shorelines
(3) Inscr. *Swinemunde*

46v Three sketches of a distant shoreline with buildings, boats, lightships, etc (extending onto f.47r)

46r (1) (2) Distant shoreline with buildings
(2) Inscr. *Water very dark*
(3) Distant shoreline with masts and build-ings (an extension of the view in (2) above)

45v (1) Distant shoreline
(2) Coastal buildings

45r (1) (2) Buildings seen from the sea
(3) Distant cliffs and land
Inscr. *Odr*
(4) Distant cliffs

44v (1) Cliffs above the sea or a river
Inscr. *Daff; Volin* (probably Haff and Wollin)
(2) Two sailing ships, with cliffs in the dis-tance

44r–43v (1) Stettin from the Oder
(2) Hills along a river, with boats
(3) Hills, houses and boats on a river
Inscr. *Al[…]; D[…]*
(4) Hills and boats on a river

43r Two sketches of hills along the Oder, one inscr. *Odr*

42v Two sketches of hills along the Oder, one with a sailing boat

42r Two sketches of hills (or cliffs) along the Oder, inscr. *L[…]nberg; L[…]itz Das Hall*

41v (1) (2) Stettin from the Oder
(3) Landscape with a cart

41r (1) Stettin from the Oder
(2) Small boat with figures
Inscr. *RPP*

40v (1) Figures, inscr. *[…]; Black H[at]*
(2) Hills with windmills, and a river and boats in the foreground
(3) Stettin: the castle and St James's church from the north
(4) Coast or river landscape with figures in

a boat (extending across f.41r)

40r (1) Dresden: view across the Elbe from just downstream of the bridge, showing the Frauenkirche, bridge, Kreuzkirche, Hofkirche and Schloss (continued in sky above)

(2) Stettin: the harbour with boats, buildings and figures

39v Stettin: the harbour with buildings, masts and figures

39r (1) Stettin: view across the Oder to the castle

(2) Stettin: the castle

(3) Stettin: the octagonal tower and gateway of the castle (extends onto f.38v)

38v Stettin: the castle gateway

38r Stettin from the Oder, looking upstream to St James's church, the castle, Tower of the Seven Coats, and SS Peter and Paul's church (with two extensions in the sky)

37v Stettin: view across the Oder to St James's and St John's churches and the castle

37r (1) Stettin: St John's church

(2) Stettin: St John's and St James's churches (extends onto f.36v)

36v Stettin: two views of St James's church following that drawn on f.37r and a further detail of its tower; and another slight sketch of Stettin
Inscr. *W*; *3*; *2*; *2*; *St Peter* (not shown on this page)

36r (1) Stettin: St James's church (an extension of the view on f.35v)

(2) Stettin: view of the castle showing the octagonal tower, illegibly inscr.

35v Stettin: the Königstor, SS Peter and Paul's church and castle from the Königsplatz
Inscr. *Grosse Conicks*

35r (1) Stettin, the castle, SS Peter and Paul and St James's churches from the north, beyond the fortifications

(2) Stettin: the north façade of the castle (extends onto f.34v)
Inscr. *8*; (for its bays)

34v Stettin: the castle, SS Peter and Paul and St James's churches from the north-east; and another slight sketch of Stettin

34r Stettin: two views from the north-east, dominated by the castle and St James's church

33v (1) Stettin: St James's church

(2) Stettin: view from the Logengarten with the Oder, castle and St James's church

33r Boats, figure groups, carts, luggage and equipment
Inscr. *Boat W*[...]*ing*; [...] *and Low*; *Light Yellow Fore sail*; *not* [...]; [?*Broad Dray*]; *Red*; *Green*; *Red*; *Jack for* [?*Loading*]; *Rafi*[...]*NB*

32v Stettin: the harbour, with boats and figures
Inscr. *Pig and Calv*

32r (1) Berlin: the Oranienburg Gate
Inscr. *Doriannburger Thor*

(2) Horses drawing a laden cart

31v (1) Sketches of three women, one inscr. *Yell*; [...]; *Blue*; *Pink*, one illegibly inscr.

(2) Berlin: view westwards along the Spree to the Waisenbrücke and Waisenhauskirche

31r Berlin: the upper vestibule of the Museum with the copy of the Warwick Vase at the

top of the stairway and the Domkirche and Schloss seen on the right through the Museum colonnade and across the Lustgarten
Inscr. *Warick V*[ase]; *4* (for the columns of the vestibule); *Eingang zur GEMALDE-GALL* (from an inscription over a doorway)

30v Berlin: view down Unter den Linden and across the Lustgarten to the Zeughaus, Lustgarten, fountain, Museum and Domkirche, from the north-eastern corner of the Schloss (details of Schloss façade in sky)
Inscr. *18* (above the colonnade of the Museum)

30r Berlin: the internal courtyard of the Schloss
Inscr. *2* (on a balustrade); *Cor*[inthian] *Pilas*[ters] (above the attic storey); *Cor*[inthia]*n*; *Dor*[ic]; *Cor*[inthian] (against the ground floor)

29v Berlin: the Schlossplatz from Königstrasse with the statue of the Great Elector (L) and south façade of the Schloss (R); small detail in the sky
Inscr. *3*; *3*; *3* (above a distant building); *4*; *8* (against the bays of the Schloss); *Or*[...]

29r Berlin: the south and east façades of the Schloss, the Langebrücke and statue of the Great Elector, from Burgstrasse

28v (1) Berlin: the Museum from outside the Eosander Portal with the Schlossfreiheit (L) and Schloss (R)

(2) Berlin: the Museum and Domkirche

(3) Berlin: an improved version of the Domkirche as seen in (2)
Inscr. *Ionic*

(4) Berlin: the west front of the Schloss with the Eosander Portal from the eastern end of the Schlossbrücke, with detail of a capital inscr. *Cor*[inthian]

28r Berlin: the Schlossbrücke, Domkirche and north façade of the Schloss from south-west of the bridge
Inscr. *1* [...] *2* [...] (on the bridge); *6* (over the bays of the Schloss)

27v Berlin: view from the Schlossbrücke of the old houses of the Schlossfreiheit between the Schloss and the Spreekanal, and the Bauakademie (R)
Inscr. *Pal*[ace]

27r (1) Berlin: the Neue Wache and Zeughaus from close to the Opera House, with the statue of Blücher in the foreground. Separate details of the Zeughaus and the statues of Bülow and Scharnhorst added above
Inscr. *4 figures at* [...]; *Doric Pil*[aster]; *Helmets*; *6* (on the bays of the Zeughaus)

(2) Berlin: small sketch of the Domkirche and the Marienkirche
Inscr. [?*Fountain*]

26v Berlin: view along Unter den Linden past the university (L) and Opera (R) to the Schlossplatz
Inscr. *Platz and Opera house*; *3*; *8*; *5* (against bays of buildings)

26r Berlin: the statue of Blücher, domes of St Hedwigskirche and east side of the Opera from Unter den Linden

Inscr. *Sol*[?i]*d P*[...]; *7* (on the Opera)

25v Berlin: the back of the statue of Blücher, the Neue Wache and Zeughaus from next to the Opera House
Inscr. *B*[...]; also *MDCCCXIIII*; *4*; *5* (from the inscription on the statue's base)

25r Berlin: the Zeughaus, Neuer Packhof, Museum, Domkirche, Marienkirche and Schlossbrücke from the south
Inscr. *18* (on the columns of the Museum) Also slight sketches of figures and buildings

24v (1) Berlin: the equestrian statue of the Great Elector, by Schlüter, on the Langebrücke

(2) Berlin: the Museum, Domkirche and Schlossbrücke from the south
Inscr. *Hil*[...]

24r (1) Berlin: the east side of the Schloss from the Langebrücke

(2) Female figure carrying a child, seen from the rear

23v Berlin: the Pariser Platz with Count Redern's palace (L) and the Brandenburg Gate
Inscr. *B*; *Pariser Stratz*

23r Berlin: the Brandenburg Gate from the Pariser Platz
Inscr. *Metopes*; *Tricks* (i.e. triglyphs) Also: a female figure, inscr. *D*[...]

22v Berlin: view along Taubenstrasse with the Schauspielhaus (L) and New church (R); small sketch of urn on the church's roof

22r (1) Berlin: view eastwards along the Spree to the Waisenhauskirche and Waisenbrücke, illegibly inscr.

(2) Procession of carriages, one inscr. *Green*

(3) Berlin: the Kreuzberg and city centre from a distance, with hillside in the foreground

21v Berlin: the Gendarmenmarkt from close to the New church, with many architectural details shown separately including the pediment and quadriga of the theatre and the lower drum and south- and east-facing pediments of the French church
Inscr. *Place*[...]; *Rustic*; *6*; *7*; *Cart*; *26* (on the steps); *Ionic*; *Market*; *W on Cloud*; *C and dog*

21r (1) Part of the liberation monument on the Kreuzberg and scenery beyond it
Inscr. (deriving from three compartments on the monument commemorating separate battles) [Bar] *sur Aube*; *Katzbach*; *Bell*[e] *All*[iance]

(2) Gateway and house

(3) Figures

20v Berlin: the Gendarmenmarkt from the south, with the New church (its dome appears on f.21r), Schauspielhaus and French church
Inscr. *6* (twice, for the columns of the two visible porticoes of the New church); *L*[...] *Houses*; [...] *H*

20r (1) Berlin: the Kreuzberg and city centre from a distance (in three instalments)
Inscr. *Pal*[ace] (over the Schloss)

(2) (superimposed at right angles to the above) Berlin: the liberation monument on the Kreuzberg
Inscr. (deriving from three compartments on the monument commemorating separate battles) *Gross Goerschen 12 May*; *Gross Berlin* [sic] *23 Ags 1813*;

Donnewitz 6 S[eptember]

19v Berlin: the Kreuzberg and city centre from a distance (in two instalments)
Inscr. *Mar* (against the Marienkirche)

19r (1) Small sketch of ?a fountain
(2) Berlin: the Königskolonnaden from the Königsbrücke

18v Berlin: the Königskolonnaden and Königsbrücke from Königstrasse
Inscr. *Fausts Winter Garden* (against its entrance between the colonnade and the bridge); *All W[?omen]* (by the people in a boat)

18r Berlin: view westwards along the Spree to the Waisenbrücke, Waisenhauskirche and Marienkirche, with the New and French churches and Nikolaikirche in the distance
Inscr. *Light; Mar*

17v (1) Berlin: view westwards towards the Königskolonnaden and the Marienkirche
Inscr. [*?Cart for Hire*]
(2) Buildings, boats and figures

17r Berlin: view eastwards along the Spree to the Waisenhauskirche and the Waisenbrücke, with boats in the foreground
Inscr. *Neu*; […]; *Neu Kolln am Wasser*

16v Berlin: view on the Spree with houses, boats and figures

16r Berlin: the Münze on the Werderscher Markt
Inscr. (above it, a hasty rendering of its inscription) *Fridericus Guilelmus III Rex monetariae mineralogicae architectonicae MDCCC*; also *Lion; Lion H[ead]; Doric*

15v (1) Berlin: view southwards along the Spree towards the Museum, Schloss and Schlossbrücke
(2) Berlin: view looking eastwards along Unter den Linden, with the Zeughaus (L) and Blücher statue and Opera (R)

15r (1) (main sketch on page) Berlin: view looking eastwards along Unter den Linden with the entrance gate to the University, Zeughaus, statue of Blücher and Opera. Sketch continues as (2), (3), (4)
Inscr. *6* (for the number of columns across the façade of the Opera); and a rough version of *Fridericus 6 Apollini & Musis* (the inscription in its frieze)
(2) Berlin: the side of the Opera and part of the dome of St Hedwigskirche
Inscr. *5; 7* (for the bays of the Opera)
(3) St Hedwigskirche, with the side steps of the Opera and part of the Royal Library
Inscr. *6 Doric ½ the W[idth]* (for the church portico);
(4) Berlin: three rough sketches of domes

14v Berlin: view across the Opernplatz from the university to the Opera House, New and French churches and (in more detail) the Royal Library

14r (1) Berlin: view along Unter den Linden, looking westwards from the corner of the Zeughaus (continued in the sky above, inscr. *2*)
(2) Berlin: the Schloss and Schlossbrücke from close to the Zeughaus
Inscr. *6; 7* (for the bays of the Schloss)

13v (1) Berlin: the Lustgarten from the foot of the steps up to the Museum: the

Marienkirche, Domkirche, north façade of the Schloss and granite basin in front of the Museum
Inscr. *6; 7* (for the bays of the Schloss)
(2) Berlin: the inscription on the front of the Museum: *Fridericus Guilelmus III studio antiquitatis omnigenae et artium liberalium museum constituit MDCCCXXXIII* (a copying error for MDCCCXXVIII)
(3) Berlin: a more detailed sketch of three bays of the north façade of the Schloss (extends onto f.14r)
Inscr. […]; *Fig[ure]*

13r–12v Slight sketches of buildings seen from the carriage on the journey from Berlin to Dresden, illegibly inscr.

12r (1)–(3) Slight sketches of buildings seen between Berlin and Dresden
(2) Inscr. [*?Brandenburg*]
(3) Schloss Moritzburg?
(4) Dresden: view down the Elbe towards the Palais Brühl, Hofkirche and bridge (continues onto f.11v)

11v (1) Slight sketch of buildings
Inscr. *E[…]furt*
(2) Dresden: the Frauenkirche from the junction of Rampischegasse with Salzgasse, illegibly inscr.

11r (1) Small sketch of river scenery, presumably along the Elbe
(2) Dresden: the Neustädter Markt, looking southwards to the Hofkirche, Blockhaus and statue of Augustus the Strong (continued in the sky above)
Inscr. *Newstadt*

10v Dresden: view across the Elbe to the Frauenkirche, Kreuzkirche, Hofkirche and Schloss from the northern bank just upstream of the bridge
Also: two boats

10r Dresden: the bridge, Frauenkirche, Kreuzkirche, Hofkirche and Schloss from the northern shore of the Elbe just downstream of the bridge, with boats and figures in the foreground

9v Dresden: two sketches of the Frauenkirche, bridge, Kreuzkirche, Hofkirche and Schloss from the northern shore of the Elbe, slightly further downstream than f.10r, with boats and figures
(1) Inscr. *10* (under the arches of the bridge)

9r (1) Dresden: view from the Brühl terrace towards the Schloss, Hofkirche and bridge (continued in the sky, showing the Neustadt)
Inscr. *4½; WBY*
(2) Dresden: the monument to General Moreau at Räcknitz, looking away from Dresden, with hills in the distance

8v (1) Small sketch of river scenery with boats
Inscr. *Elbe*
(2) Dresden: view along the Brühl terrace towards the Hofkirche and bridge

8r (1) Dresden: the monument to General Moreau at Räcknitz, with the city in the background
Inscr. (copied from the monument itself) *MOREAU DER HELD FIEL HIER AN DER SEITE ALEXANDERS DEN XXVII AUGUST*

MDCCCXIII 3
(2) Small sketch of the helmet on the monument and distant hills

7v Three paintings in the Dresden Picture Gallery
(1) Aert de Gelder, 'Christ before Pilate' (inv.no. 1791)
(2) Raphael, 'The Sistine Madonna' (inv.no. 93)
Inscr. […]; *Red; Green; Green; Or; Blue*
(3) Correggio, 'The Penitent Magdalene reading' (now lost) and a detail of the flowers in its foreground

7r Two paintings in the Dresden Picture Gallery:
(1) Correggio, 'Madonna with St George' (inv.no. 153)
Inscr. *B; Or; Red; Red; L[ight] B[lue]; Red*
(2) Correggio, 'Madonna with St Francis' (inv.no. 150)
Inscr. *Blue; Red; Red*
Also
(3) Dresden: the Kreuzkirche
Inscr. *Sporer Strasse*

6v Two paintings in the Dresden Picture Gallery:
(1) Correggio, 'Madonna with St Sebastian' (inv.no. 151)
Inscr. *Yell. Glory; Red L; Blue; P[…] Gre; Gold; Or*
(2) Watteau, 'Conversation in a Park' (inv.no. 781)
Inscr. *L[ight] B[lue]; Light; Yellow; L[ight] Yel[low]; P[ink]; W[hite]; W[hite]; V[ine]; Red Yellow the Key; B[lue] Y[ellow] Stripes; […]; Lilak*

6r Four paintings in the Dresden Picture Gallery (listed in the order sketched, upside down on the page):
(1) Claude Lorrain, 'Landscape with the Flight into Egypt' (inv.no. 730)
(2) Claude Lorrain, 'Landscape with Acis and Galatea' (inv. no. 731)
(3) Govaert Flinck, 'David giving Uriah the Letter' (inv. no. 1602)
Inscr. *D Red; […]; Yell; Grey; Bright Lights*
(4) Jacob van Ruisdael, 'The Hunt' (inv. no. 1492)
Inscr. *Risdael*

5v (1) Dresden: the Frauenkirche and Neumarkt (its spire continued in three separate details)
(2) A smaller version of a similar view but from much closer to the staircase of the Johanneum
Both illegibly inscr.

5r Dresden: the Neumarkt from the end of Moritzstrasse, showing the Johanneum, Hotel Stadt Berlin, Frauenkirche and Türkenbrunnen
Inscr. *11; 7; 5* (over the bays of the hotel); *4, 4; 6* (on the bays of the houses behind the Türkenbrunnen); *Pump*; […] (by the fountain itself)

4v (1) A figure?
(2) Dresden from Räcknitz
(3) The Elbe valley near Dresden

4r–3v (1) Dresden: the Frauenkirche from Rampischegasse
(2) View in a garden, probably that north of

the Zwinger
Inscr. *Wall*

The following pages constitute a personal portable phrasebook. The English phrases are all written in Turner's handwriting, the German ones in another hand.

4r *To know where*
Wissen warum
Which place
Welche stelle
Try again
versuch es noch einmal

3v *To make*
Machen
Buy
Kaufen
Sell
Verkaufen
Lost
Verloren
My Bill to pay
Meine rechnung zu bezahlen
How much
Wie viel
All
alles
Altogether
allzusammen

3r (This page is at present located between ff.37 and 38 in the sketchbook, due to a rebinding error)
Will you come
Wollen sie kommen
Will you go
Wollen sie gehen
Will you take
Wollen sie nehmen
What do you want
Was wollen sie
What am I to do
Was muss ich thun
Baggage
Baggage
Money
Geld
Linen
Zeug
Also a small sketch: Dresden: view on the bank of the Elbe near the Brühl terrace, looking downstream to the bridge, with trees in the foreground

2v *Tell me*
Sagen sie mir
Which is the way
Was ist die weg
How far is it
Wie weit ist es
What place
War für eine stelle
What is the name
Wie heist

2r On ff.2r, 1v and 1r all the German phrases – except the first three on f.1r and last one on f.2r – are written twice: first in ordinary cursive script and then in German script ('deutsche Kurrent')
I have been
Ich bin gewesen
Thou hast been
Du bist gewesen
He has been

Er ist gewesen
We have been
Wir sind gewesen
You have been
Sie sind gewesen
They have been
Sie sind gewesen

1v *Take that*
Nehmen sie das
Will you
Wollen sie
Can you
Können sie
I was I am
Ich war Ich bin
I have
Ich habe

1r *I want to go to Berlin*
Ich will nach Berlin gehen
I wish to see
Ich wollte – sehen
How can I go
Wie kann ich nach – kommen
What can I get
Was kann ich bekommen
Give me
Geben sie mir
Take this
Nehmen sie dies

Inside cover
Inscr. 1813

TB CCCVI *Dresden and Saxon Switzerland* sketchbook 1835 (see cat.no.33)

Bound in boards covered in dark purple and black marbled paper, with black leather spine and corners and three leather loops for a pencil, two at one end and one at the other.
 Formerly known as the *Dresden and River Elbe* sketchbook and numbered by Finberg starting at the opposite end of the book to that used by Turner. The list below follows Turner's sequence.

Inside cover
Inscr. *Swinger* (i.e. Zwinger); [?*Dresden*]
68v Several rough sketches including one of a cart inscr. *Water cart*; a group of people; buildings, illegibly inscr.
68r (1) The Elbe east of Dresden near Loschwitz, with wooded hills
Inscr. *El*[...]; *W*[...]*berg*
(2) Hillside with castle
Inscr. *Pirnitz*; *P and River*
67v Three rough sketches, one showing Loschwitz from the Elbe and inscr. *Ostwitz*; *Ebe*
67r Two sketches of the Elbe, with churches (Loschwitz?)
Inscr. *Lustw*; *R*[...]
66v The Elbe east of Dresden with wooded hills
Inscr. *Wall*
66r The Elbe east of Dresden with wooded hills and the flying bridge of Loschwitz carrying carts
65v Dresden: view from next to the fountain

above the Nymphenbad in the Zwinger, looking towards the Schloss, Frauenkirche, Crown Gate and pavilions of the Zwinger (the bridge continued in the sky)
65r Schloss Pillnitz from the Elbe
64v Two rough sketches of the Elbe valley, one looking down on Pirna from the Pirna–Königstein road and inscr. *Sonnenstein*
64r (1) Schloss Pillnitz from the Elbe (with a more detailed sketch of it above)
(2) Distant view of Lilienstein from the Pillnitz–Lohmen road
63v Two rough sketches, one showing Lohmen church, looking towards Pillnitz, inscr. *Loh*[...]
63r The Elbe near Dresden with a church and a boat in the foreground
62v (1) Distant view of Lilienstein and Königstein from the Lohmen–Uttewalde road
(2) (3) (4) Rough sketches in the Uttewalder Grund
62r The Uttewalder Grund, as seen descending the steps from Uttewald
Inscr. *Atter Wald de Grundt*
61v Four sketches of the Uttewalder Grund
(1) Inscr. *W*[...] *OW*
(3) The Teufelsküche looking towards Wehlen
Inscr. *Tuforstu*[...]
(4) View looking in the opposite direction to (3) from the same viewpoint
61r Two rough sketches of the Höllergrund, the first inscr. *Heller*[...]
60v Three rough sketches, probably of the Höllergrund
60r Rocks in the Höllergrund
Inscr. *Heler rund*
59v View to Lilienstein, Pfaffenstein, Königstein and the Bärensteine from above a cleft in the hillside west of the Bastei
Inscr. *Lilis*; *Faufenstein*; *K*; *K*[...]; *Pironstein*; *Bastei*[...]; *Amsel*
59r View north-eastwards to Hohnstein from the Bastei, with the Grosse Gans, Kleine Gans and Wehlturm in the middle distance
Inscr. *Hoonstin*; *Vielstur*
58v View south-eastwards to distant mountains, from the Bastei close to the viewing platform
Inscr. *Winterberg*; *R*[...] (i.e. Rosenberg); *Shirsten* (i.e. Zschirnsteine)
58r View towards Lilienstein, Pfaffenstein and Königstein, from the Bastei, with the viewing platform in the centre foreground
Inscr. *L*; *F*; *K*; *T*[...]
57v View up the Elbe to Lilienstein, Pfaffenstein and Königstein, from the Bastei, with the viewing platform in the centre left
57r View down the Elbe from the Bastei
Inscr. (in the sky) *Nonenstein*; *Beernstein*; *St Welle* (i.e. Stadt Wehlen); *B* (on the Bärensteine); *630* (the approximate height of the Bastei, in feet)
56v View up the Elbe towards Lilienstein, Pfaffenstein and Königstein, from the Bastei, with the viewing platform on the left
56r View near the Bastei, illegibly inscr.
55v View near the Bastei
55r View from the Bastei bridge with the viewing platform on the right

Inscr. *Ell*[...]

54v View southwards to Lilienstein, Pfaffen-
stein and Königstein with the Bastei plat-
form among trees

54r View southwards to Lilienstein with the
Bastei viewing platform on the left

53v View up the Elbe with the Bastei viewing
platform on the left

53r The Bastei and its bridge, looking towards
Felsenburg Neurathen

52v The Bastei and its bridge, looking towards
Felsenburg Neurathen, with Lilienstein in
the distance
Inscr. *Burg Niralf*

52r Among the rocks of the Bastei

51v Among the rocks of the Bastei, with its
bridge

51r Among the rocks of the Bastei

50v The rocks of the Bastei and its bridge, with
Lilienstein in the distance

50r The rocks of the Bastei and its bridge, with
Lilienstein in the distance

49v The rocks of the Bastei and its bridge,
looking southwards

49r View up the Elbe from the Bastei with
Lilienstein in the distance

48v View down the Elbe from the Bastei, with
the Bärensteine

48r (1) Distant hills
(2) Lilienstein, Pfaffenstein and Königstein
(3) Rathewalde
Inscr. *Rathewald*

47v Six landscape sketches in Saxon Switzer-
land, (1)–(3) showing Lilienstein in the dis-
tance, (2)–(6) continuing onto f.48r
(1) inscr. *Bastei*

47r Hohnstein

46v Hohnstein and the viewing platform at
Hockstein across the Polenz valley

46r Hohnstein and the viewing platform at
Hockstein across the Polentz valley

45v Hohnstein

45r Hohnstein and the Polentz valley

44v Hohnstein and the Polentz valley

44r–43v Seven rough sketches of rocky landscapes
east of Schandau, one on f.43r inscr. [?*Cut
Wood*]

43r (1) The Schrammsteine
(2) Rocky landscape

42v (1) Rocky landscape near Schandau (con-
tinued in the sky)
(2) Rocks

42r–41v Six rough sketches of rocky landscapes in
Saxon Switzerland

41r Rocky landscape
Inscr. *Hurneshvall W*

40v Views near Schandau, inscr. *1; 2*

40r Two sketches of Schandau?

39v (1) (2) Schandau, (2) inscr. *Gaspar; Shan-
dau*
(3) Lilienstein from near Schandau
(4) Königstein and Lilienstein from near
Schandau (extends across f.40r)

39r Carriage sketch of Schandau?, illegibly
inscr.

39r–38v Carriage sketch of Schandau, looking
towards Lilienstein

38r Carriage sketch with Lilienstein

38r–37v Carriage sketch of Schandau and Lilien-
stein

37v Rocky cliff with arches
Inscr. *St Augst* [...]

37r (1) Gorge on the Elbe
(2) Bend on the Elbe

36v Gorge and houses on the Elbe

36r View up the Elbe with the Johanniskirche
at Schandau and the Schrammsteine

35v Schandau, seen across the Elbe

35r View up the Elbe to the Schrammsteine

35r–34v Hills near Schandau

34v Schandau from the Elbe

34r (1) View up the Elbe to Schandau and the
Schrammsteine
(2) A rougher version of the same view

33v (1) Königstein fortress and Lilienstein from
the direction of Schandau
(2) Schandau and the Schrammsteine
(3) View up the Elbe to Schandau and the
Schrammsteine
(4) Hills
Inscr. *K*[...]

33r View up the Elbe to Schandau and the
Schrammsteine
Inscr. [?*Sheep*]; [...] *Raft*

32v Königstein fortress and town and the edge
of Lilienstein, from the Schandau road

32r (1) Lilienstein
(2) Königstein town and fortress, from the
Schandau road
(3) Königstein town and fortress and
Lilienstein, from the Schandau road
Inscr. *Lilienstn & K*

31v Lilienstein and view up the Elbe from
upriver from Königstein town

31r (1) Königstein town and fortress and view
down the Elbe
(2) Slight sketch of Königstein fortress

30v Lilienstein and view up the Elbe from the
landing-stage at Königstein town

30r (1) Königstein town and fortress looking
along the Elbe, illegibly inscr.
(2) A much smaller rough version of the
same view
Inscr. (on f.29v) *Bridge*

29v Königstein fortress: view from the town

29r View up the Elbe to Lilienstein and König-
stein town, from the hillside

28v (1) View up the Elbe to Lilienstein and
Königstein, from the hillside
(2) Königstein fortress: north side

28r–27v (1) View up the Elbe to Lilienstein and
Königstein town and fortress, from the
hillside
(2) (3) Slight sketches of Königstein from
the north-west

27r View down the Elbe with Lilienstein in the
middle distance (and Königstein fortress
depicted in the sky), from the hillside

26v Königstein fortress: west side, from the
hillside

26r View down the Elbe to the Bastei with
Lilienstein in the middle distance and
Königstein fortress on the right, from the
hillside

25v Königstein fortress: west side

25r (1) The Bärensteine and Lilienstein
(2) (3) Königstein fortress
(4) The Bärensteine, Lilienstein and
Königstein fortress

24v Two sketches of Königstein fortress

24r Pirna: the fortress of Sonnenstein and view
up the Elbe

23v View on the Elbe, probably near König-
stein, with one of the post-distance

columns

23r Pirna: the fortress of Sonnenstein

22v Pirna: the fortress of Sonnenstein

22r Pirna and Sonnenstein from the Elbe
Inscr. *Mill*; [...]

21v Three sketches on the Elbe, the first two
showing Pirna and Sonnenstein

21r Pirna: the Marienkirche and town hall
from the corner of the market place
Inscr. *Fount*[ain]

20v Two sketches of Pirna, with the town hall,
Marienkirche and Sonnenstein, the first
drawn in the market place (both extend
slightly onto f.21r)

20r Three slight sketches of Pirna from the
Dresden road

19v Two slight sketches

19r Distant view of Pirna from the Dresden
road

18v Three slight sketches, the second showing
a distant view of Pirna

18r Four slight landscape sketches on the Elbe,
one showing Lilienstein and Königstein in
the distance and inscr. *L; K*

17v Two slight sketches of towers in land-
scapes, one inscr. *D*[...]

17r Slight sketch (Schloss Weesenstein?)

16v Distant view of Schloss Weesenstein
Inscr. *W*[...]

16r–15v Schloss Weesenstein from the road, with
the bridge on the left

15r Schloss Weesenstein from its gardens
(extends slightly onto f.14v)

14v Schloss Weesenstein from its gardens (plus
a more precise profile of its tower)

14r Schloss Weesenstein from its gardens

13v Schloss Weesenstein from its gardens

13r Schloss Weesenstein from its gardens

12v Schloss Weesenstein from the road

12r (1) Schloss Weesenstein
(2) Dresden: the tower and spire of the
Hofkirche (in two instalments; a contin-
uation of the sketch on f.9r)

11v Several carriage sketches of Schloss
Weesenstein from the road

11r Schloss Weesenstein: carriage sketch

11r–10v Dresden: view from the gardens on the
upper level of the Zwinger close to the
outer side of the Wall Pavilion, looking
towards the bridge, Hofkirche, Wall Pavil-
ion and Schloss

10v Schloss Weesenstein: carriage sketch

10r Schloss Weesenstein: carriage sketch

9v Schloss Weesenstein: carriage sketch

9r Dresden: the Schloss and Hofkirche from
the end of the Brühl terrace (the spire of
the Hofkirche continued on f.12r)

8v Blank

8r Dresden: view from the Brühl terrace,
looking towards the Hofkirche, Italian vil-
lage, bridge and part of the Japanese Palace
on the opposite bank

7v Dresden: view from the basin on the upper
level of the Zwinger close to the outer side
of the Wall Pavilion, looking towards the
Japanese Palace (across the Elbe) and
(through the trees) the Wall Pavilion,
Hofkirche and Schloss

7r Dresden: view from the basin on the upper
level of the Zwinger close to the outer side
of the Wall Pavilion, looking towards the
Neustadt, bridge, Wall Pavilion, Hofkirche,

Schloss and Frauenkirche (the trees and figures in the garden continued in the sky)

6v Dresden: the Zwinger gardens, looking towards the Crown Gate, Mathematical-Physical Salon, Wall Pavilion and French Pavilion from the upper balustrade in the eastern corner
Inscr. *9* (against the bays of the Mathematical-Physical Salon); *16* (against the arcade linking it and the Wall Pavilion)

6r–5v Church and hillside
Inscr. *Albrechtsburg*; *S[…]*; *M[…]*

5r–2v Blank

2r Two views in Saxon Switzerland, the second inscr. *Fa[]stein* (i.e. Pfaffenstein); *Konigs[tein]*; *Road*

1v *Nem se take care* […]
What is the Name of […]
…
131

1r *Ich Wischin in Platz in
den Ilwaggen –
Wasistes –
Whats is es fur hinnere plaze
We what ist is –
Es <hat> is langer das vier
in commen
wol volonce se future
how fist ho* […]
Enge[…] *Storm
Rangenstirm Rainstorm
Bringen me ye no Eis*

Inside cover
Carl (the *C* corrected to *K*)
Grahl auf d Bad in Schandau (not in Turner's writing)

TB CCCI *Dresden, Teplitz and Prague* sketchbook 1835 (see cat.no.34)

Bound in boards covered in brown and black marbled paper, with three leather loops for a pencil, two at one end and one at the other. Pages edge-painted in yellow.

Formerly known as the *Dresden (?)* sketchbook.

Inside front cover
The phrases marked with an asterisk are not in Turner's handwriting
I wishen in zu […]
Can ich platz neem
[…] *verda ich* […]
Can ich […] *Engang*
*Can ich dahin gehen
Dahin
[…] glass of WW […]
*Chaudeau
M*[…] *al*[…]

1r Dresden: the Frauenkirche and details of its lantern and towers
Page also inscr. *Eberf*[…]

1v Dresden: the Frauenkirche

2r Dresden: two sketches from along the Elbe
(1) looking downstream to the bridge and principal buildings
(2) looking upstream to the city from its outskirts

2v Dresden: view from the gardens of the Japanese Palace with the palace itself, bridge, Frauenkirche, Hofkirche and Schloss
Inscr. *3; 4; 3* (for the bays of the Japanese Palace)

3r Dresden: view from the gardens of the Japanese Palace (similar to that on f.2v)

3v Dresden: two views up the Elbe (from much further downstream than that on f.3r)

4r Dresden: view up the Elbe (from much further downstream than that on f.3v), with separate detail of a spire
Inscr. []

4v Dresden: view across the Elbe to the Kreuzkirche and Frauenkirche

5r Dresden: view across the Elbe to the Kreuzkirche, Frauenkirche, Schloss, Hofkirche and bridge

5v Dresden: view across the Elbe to the Frauenkirche, Schloss, Hofkirche and bridge
Inscr. *Elbe*[…]

5v–6r Dresden: the Zwinger from beyond the moat to the north-west, with the Hofkirche and Schloss seen over it

6r Dresden: the Zwinger from beyond the moat to the north-west with the Hofkirche and Schloss seen over it and the Crown Gate (in two instalments)
Inscr. *Water*

6v (1) (2) Dresden: the Zwinger from beyond the moat to the north-west with the Hofkirche and Schloss seen over it and the Crown Gate (R), the second with figures in the foreground
(2) Inscr. *19* (for the bays of the Long Gallery left of the Crown Gate)
(3) Details of the Mathematical-Physical Salon and the Crown Gate

7r Dresden: the Zwinger from across the moat with the Crown Gate, Long Gallery and bridge

7v Rough carriage sketches, one inscr. [?*Oltenburg*]

8r Rough carriage sketches of hills and buildings, one illegibly inscr.

8v Rough carriage sketches, one inscr. *Hellendorf*

9r Rough carriage sketches of hills

9v Rough carriage sketches of hills, a spire and figures on a road

10r Rough carriage sketches of indistinct buildings

10v Teplitz from the north-west with the buildings of the Schlossplatz in the foreground (R) and the Schlossberg in the distance
Also a view of hills and a standing woman

11r View of hills from Teplitz
Inscr. *Tep looking toward Prag*

11v Teplitz from the north-west, with the buildings of the Schlossplatz in the middle ground (R) and the Schlossberg and Schlackenberg in the distance

12r Teplitz from the north-west, with the buildings of the Schlossplatz in the middle ground (L), the Schlossberg and Schlackenberg in the distance
Also a standing soldier and an illegible inscr.

12v Teplitz from the Königshöhe, looking

down onto the buildings of the Schlossplatz

13r Teplitz from the Königshöhe, with the Erzgebirge in the distance

13v Teplitz: the Stefanshöhe and the Schlossberg

14r Teplitz: view down onto Schönau with the Erzgebirge in the distance and the Schlossberg (R)

14v Teplitz: view from the south-east to the Königshöhe and Stefanshöhe

15r Teplitz: view up to the Schlossberg and distant hills, with a larger version of the Schlossberg itself

15v Teplitz: view from the east (the ascent to the Schlossberg) with the Königshöhe and Stefanshöhe in the foreground

16r Teplitz: three sketches of the castle on the Schlossberg
Inscr. *Sl*[…]

16v Teplitz: four sketches of the castle on the Schlossberg

17r Teplitz: the castle on the Schlossberg

17v Teplitz: the castle on the Schlossberg and the view from it

18r Teplitz: the castle on the Schlossberg and the view from it

18v (1) Teplitz: the Schlossberg, with figures in the foreground
(2) Standing figure with a bundle on its head, illegibly inscr.

19r Teplitz: the Schlossplatz, looking towards the plague column, Dekanalkirche, Schlosskirche and Schloss

19v Three groups of figures, two against a background of arcades (probably at Teplitz), the third with colour notes including *B, R, B*

20r Distant view of Teplitz and an illegible inscr.

20v View in a town (probably Teplitz)

21r Rough carriage sketches with inscr. including *Wil*[…]; *Bilin*

21v–22r Rough carriage sketches of a rocky hill and buildings between Teplitz and Prague, including ones inscr. *Vilinbg*; *Bilin*

22v Rough carriage sketches of scenery between Teplitz and Prague, including ones inscr. *Larabgh*; *Larrn*; *Laun*; *Rein*[…]

23r Rough carriage sketches of buildings, including one of the bridge over the Eger at Laun, its arches inscr. *40*

23v Rough carriage sketches of scenery and buildings, two illegibly inscr., one inscr. *Rod*[…]

24r Rough carriage sketches of buildings, illegibly inscr.

24v Rough carriage sketches of a river valley with town

25r Prague: view across the Vltava from the Belvedere to the Old Town, with the Tyn church

25v Prague: view across the Vltava from the Belvedere to the Old Town (an extension of the view on f.25r)
Inscr. […]

26r Prague: view up the Vltava to the Charles Bridge (an extension of the prospect on f.25v but from a lower viewpoint)

26v Prague: view southwards from Hradčany to the Old Town with St Nicholas's church in the middle ground

Inscr. *C Nostitz, Nostowitz* (a palace in the middle ground)

27r Prague: the castle and cathedral (its spire continued in the sky) from the north-east with the vista up the moat and across to the castle garden (also continued in the sky)

27v Prague: the castle and cathedral from the north-east with an extensive view up the Vltava

27v–28r Prague: the castle and cathedral with an extensive view up the Vltava

28r Prague: the castle and cathedral from the north-east with the Belvedere in the castle garden on the right

28v Prague: view in the Old Town Square looking towards the town hall of the Old Town and the Tyn church
Inscr. [...] (above the town hall)

29r Prague: the castle and cathedral from the slopes of the castle hill

29v Prague: view across the Charles Bridge to the Petřín hill and Hradčany
Inscr. *All in Light*

30r Prague: view across the Charles Bridge to the Petřín hill and Hradčany (in three instalments)
Page also inscr. *Rap[...] [?bridge]*

30v Prague: view across the Charles Bridge to the Petřín hill and Hradčany, with figures next to a wayside crucifix on the right

31r Prague: the west end of the Charles Bridge looking towards St Nicholas's church and the bridge towers

31v Prague: view of the city from the forecourt in front of the castle (seen on the left) (in two instalments looking east and south)
Inscr. *2; 1*

32r Prague: Hradčany and the Little Quarter from the hill to the south-west, with an extensive prospect down the Vltava (in two instalments)

32v Prague: Hradčany and the Little Quarter from the Petřín hill

33r Prague: Hradčany and the Charles Bridge from the south-eastern edge of the bridge

33v Prague: view on the Charles Bridge looking towards St Francis's church and bridge tower

34r–35v Blank

36r Prague: view in the Old Town Square looking towards the town hall of the Old Town and the Tyn church
Inscr. [...]

36v Prague: the Petřín hill, Little Quarter and Hradčany from the north-east

37r (1) Prague: view in the Old Town Square looking towards the Kinsky Palace, Tyn church, fountain and column of the Virgin
Inscr. *Nine* (against the pinnacles of the Tyn gable); *No Roof here* (against a house-top)
(2) Prague: the Belvedere (an extension of the sketch on f.36v)

37v Prospect of hills, with the site of the battle of Kulm (1813)
Inscr. *Culm*

38r Prospect of hills, probably near Kulm

38v Prospect of hills, with the site of the battle of Nollendorf (1813)
Inscr. *Nolldorf*

39r Prospect of hills, probably near Nollendorf

39v (1) Prospect of hills
(2) Gatetower

40r (1) Trees by a stream
Inscr. [?*Ratehous*]; [...]; *Willow; Poplars; W[...]*
(2) Building among hills

40v The phrases marked with an asterisk are not in Turner's handwriting and are in German script ('deutsche Kurrent'). The sequence here follows that on the pages, which are used upside down.
Ich will ein Platz bis Toplitz
Kann ich [...] mit [...] oder [...]?
[...] den [...] Post [...] auf Prag ab.
Shorn – Handsome
Thüre Thor gate
Motte Todt Wall

Inside back cover
Ich wisin ain a platz
nach T
Can ich morgen other
[...]
Lohnkutscher
R di Prusse
[...] *gade Von*
... *post <gelegni>*
glegenhight nach Prag
Opfen open open
[...] *gasteshaus 6 to Books*
Plus [...]
[...] *theurer*
phen
[...] *vernünftig*

TB CCCIV *Prague, Nuremberg, Frankfurt and Rhine* sketchbook 1835 (see cat.no.35)

Bound in boards covered in pink and black marbled paper, with linen spine and corners and four parchment loops for a pencil, two at each end. Pages edge-painted in red.

Formerly known as the *Rhine, Frankfort, Nuremberg, and Prague (?)* sketchbook and numbered by Finberg starting at the opposite end of the book to that used by Turner. The list below follows Turner's sequence.

103r– Several rough sketches, probably of towns
102v on the lower Rhine (f.103r is stuck down so that it has become the endpaper)

102r Prague: view from the east

101v Blank

101r Prague: view from the east

100v Blank

100r Prague: view up the Vltava to Hradčany
Inscr. *D [...]*

99v Blank

99r (1) Prague: view up the Vltava to Hradčany
Inscr. *Str[...]* (above the Strahov monastery)
(2) Riverside buildings (at Düsseldorf?)
Inscr. [...]; [?*Dussel*]

98v A town square, with a tower and arcaded building
Inscr. *6* (under the arcade)

Also an illegible inscription

98r Prague: view up the Vltava to Hradčany
Inscr. *T[...]; R[...]*

98r–97v Prague: the Old Town from the Vltava with the tower of its town hall

97v Prague: view up the Vltava to Hradčany (in two instalments)
Inscr. *1; 2*

97r Prague: view up the Vltava to the Charles Bridge, Petřín hill and Hradčany (continued in the sky) with boats on the river
Inscr. *Red and W R[...]* (by the boats)

96v (1) Frankfurt: the tower of the cathedral glimpsed among other buildings
(2)–(4) Buildings and hills

96r Prague: view up the Vltava to the Charles Bridge, Petřín hill and Little Quarter, with the sun in the south-west (an extension of the prospect sketched on f.95r)

95v Prague: view along the Vltava?

95r Prague: Hradčany from across the Vltava (continued in the sky) (an extension of the prospect sketched on f.96r)

94v Blank

94r Prague: view up the Vltava to the Old Town bridge tower and Charles Bridge

93v Blank

93r Prague: view up the Vltava from the river bank, with St Francis's church, Old Town bridge tower and part of the Charles Bridge

92v (1) View up the Rhine to Ehrenbreitstein
(2) View down the Rhine to Coblenz and Ehrenbreitstein, with the bridge of boats

92r (1) Prague: view up the Vltava to the Charles Bridge, Little Quarter and St Nicholas's church
(2) River scenery with sailing boats, probably on the lower Rhine

91v Three rough sketches, one illegibly inscr., the first, a river scene with boats, probably showing the Rhine with Kaub, Burg Gutenfels and the Pfalz
Page also inscr. *Da Kleins Seite* (i.e. the Little Quarter at Prague)

91r Prague: Hradčany and fortifications from the east (in three instalments)
Inscr. (against successive bays of the castle) *20; 12; 13; 20; 3; 3; 4; 4; 4; 3; 6; 3; 1; 3*

90v Blank

90r Prague: Hradčany, St Nicholas's church, and Charles Bridge, looking down the Vltava (an extension of the prospect on f.89r)

89v Prague: Old Town Square?, illegibly inscr.

89r Prague: the Charles Bridge and Hradčany looking down the Vltava (an extension of the prospect on f.90r), and buildings south of the Old Town bridge tower

88v Several sketches of a town with a domed church, two extending onto f.89r

88r Prague

87v Prague

87r Slight sketch of buildings

86v Prague: view through the Melantrichova Passage to the town hall of the Old Town with its astronomical clock

86r–85v Prague: the town hall of the Old Town with its astronomical clock, with the Tyn church beyond

85r Prague: view across the Charles Bridge towards the Little Quarter and Hradčany

84v Views on the Rhine near the Drachenfels

84r Prague: the Vyšehrad? with a monument in the foreground
Inscr. [...] *Die Juli 1804* (evidently copied from a monument)

83v Blank

83r Prague: distant view

82v Prague: distant view

82r Three sketches of distant hills, one with an obelisk in the foreground
Inscr. *1; 2*

81v (1) Prague?
(2) Distant hills
Inscr. *4*

81r Towers
Inscr. [...]*ziger Thor*

80v (1) View in a town, with a pair of Doric buildings
Inscr. *4 Doric Col*[umns]
(2) Two slight sketches of a town
Inscr. *Z*[...]

80r Prague: Hradčany, St Nicholas's church and the Little Quarter from the south-west

79v Prague: view down the Vltava and across to the Old Town, illegibly inscr.

79r Prague: Hradčany and St Nicholas's church from the south-west

78v (1) Distant view of Düsseldorf
Inscr. *Dusseldorf*
(2) Prague?

78r Prague: view of the Little Quarter and the prospect down the Vltava
Inscr. *RC; WC*

77v Cologne from the Rhine: several sketches

77r–76v Prague: view across the Vltava to the Old Town with the Nostiz Palace in the foreground
Inscr. *Nosswitz*

76v Prague?

76r Prague: the city and the prospect down the Vltava from Petřín hill

75v Cologne: the bridge of boats and Deutz

75r Prague: the city and the prospect down the Vltava from Petřín hill

74v (1) Cologne from the Rhine
Inscr. *Leonhardt Thor*; *Holtz Thor*; *Pant*[aleons] *Thor*
(2) Prague: St Lawrence's church

74r Prague: the city and the prospect down the Vltava, from Petřín hill, with St Lawrence's church on the left

73v (1) Cologne, with the bridge of boats and cathedral
(2) Prague: view down the Vltava, from Petřín hill, with St Lawrence's church on the left

73r View down the Rhine with Rolandseck, Nonnenwerth, Drachenfels and the Seven Hills (in two instalments)

72v Slight sketch of a shrine, possibly on Petřín hill in Prague

72r Prague: Hradčany and an extensive prospect of the Little Quarter and down the Vltava, from Petřín hill
Inscr. *C*[...] *Sh*[...]

71v Three sketches of Cologne from the Rhine and one of a woman, inscr. *Bon*

71r Prague: St Vitus's cathedral from the south
Also three sketches of a tower, one inscr. *Dr*

70v Prague: slight sketch of the cathedral from the north
Also sketches of towers, inscr. *D*[...]; *Mer*[...]

70r Several small sketches of towns on the Rhine including Cologne
Also a sketch of boats on a river with clouds and a low sun

69v Several small sketches of towns on the Rhine including Cologne, one inscr. *M*[...]

69r Prague: view up the Vltava to the Old Town bridge tower, Charles Bridge, Petřín hill and Hradčany (in three instalments)
Inscr. *9* (against the arches of the bridge)

68v Three sketches (Prague?)

68r Prague: St Nicholas's church, Little Quarter, from the south-west, with a carriage in the foreground

67v Blank

67r Buchau
Inscr. *Buckhau*

66v Several sketches of Hartenstein castle, one inscr. *Harten*[...]

66r Several sketches including one inscr. *Hart*[...]

65v Landscape with Engelhaus castle near Carlsbad
Inscr. *Engelhouse*

65r Prague from the south

64v (1) Buildings
(2) Prague from the south

64r–63r Rough sketches, including one of a castle and one inscr. *Eger*

62v Buildings and monument in a town

62r Two sketches of riverside towns, one inscr. *Amreck*

61v A town

61r A town (Elbogen?)

60v Several rough sketches

60r Two sketches of Elbogen near Carlsbad
Inscr. *Elbougen*

59v Several rough sketches, probably at Elbogen
One inscr. *Elbogn*

59r Houses at Nuremberg?

58v Three slight sketches, including one probably of Sulzbach, illegibly inscr.

58r Two slight sketches, one inscr. illegibly, the other *Salzb*[...] (i.e. Sulzbach)

57v Nuremberg: view from the Trödelmarkt looking west to the Henkersteg and its towers

57r Nuremberg: view from the Maxbrücke looking north-west to the Kettensteg
Inscr. *Der Kettensteg*

56v Nuremberg: view from the Maxbrücke looking south-east to the Weinstadel, Water Tower, Henkersteg and spires of St Lorenz

56r Nuremberg: view from the Pegnitz west of the Kettensteg, looking east to the Neutor, Burg and St Sebaldus

55v Nuremberg: view southwards from Königstrasse to the Tugendbrunnen, St Lorenz and Nassauer Haus

55r Nuremberg: houses on the north side of Karolinenstrasse including the Herdegenhaus

54v (1) Slight sketch of Schloss Johannisburg at Aschaffenburg
(2) Nuremberg: the north side of St Lorenz, the Nassauer Haus and the Tugendbrunnen from the Lorenzer Platz

54r Nuremberg: the Hauptmarkt from the north-west corner, with the Schöner Brunnen and Frauenkirche

53v–53r Blank

52v Nuremberg: the apse of St Sebaldus and the town hall from the north-west corner of the Hauptmarkt, with the Burg in the distance

52r Nuremberg: the Burg and Sinwellturm from the northern end of Burgstrasse

51v–51r Slight sketches, illegibly inscr.

50v Nuremberg: the outer court of the Burg from close to the Heidenturm, with the Sinwellturm and a view southwards over the town with St Lorenz and St Sebaldus (detail of the latter in the sky)
Inscr. *En gang von de Stadt Zur Burg*

50r Nuremberg: the Kaiserstallung and its towers from the Vestnertorgraben, with the Burg on the right

49v Nuremberg: the Kaiserstallung and Burg from the north (the Vestnertorgraben) (continued in the sky above)
Inscr. *Der Ziegen* (i.e. Tiergärtner) *Thurn*; [...] *de Küserstellung*; *der Burg nordlich*

49r Blank

48v Nuremberg: the Burg and Tiergärtnertor from the north-west (the northern end of the Neutorgraben)

48r (1) Nuremberg: St Elisabeth, the Weisserturm and St Jakob from Ludwigstrasse
(2) Nuremberg: St Lorenz from Karolinenstrasse

47v Nuremberg: the Burg and Tiergärtnertor from the west (the northern end of the Neutorgraben)

47r Carriage sketch of a rainy landscape, possibly Würzburg, illegibly inscr.

46v Nuremberg: the Dürer house, Tiergärtnertor and Burg from Albrecht-Dürer-Strasse
Inscr. *Alb Dur*

46r–45v Nuremberg: the Burg and Neutor from the Neutorgraben

45v Nuremberg: the Königstor from Königstrasse

45r Nuremberg: the Burg and Neutor from the west

44v Aschaffenburg: Schloss Johannisburg
Inscr. *5* (for the number of bays not sketched)
Also: slight landscape sketch

44r Nuremberg: the Burg from the Spittlertorgraben

43v Blank

43r Blank

42v Nuremberg: St Lorenz from Karolinenstrasse

42r Part of the fortifications and Graben at Nuremberg?

41v Nuremberg: view along Königstrasse to the Königstor, St Klara and Mauthalle

41r Nuremberg: view along Königstrasse to the Mauthalle and St Lorenz
Also: slight landscape sketch, extending onto f.40v, illegibly inscr.

40v Nuremberg: city walls and Königstor from the south
Also: a sailing boat

40r Three carriage sketches of buildings

39v Frankfurt: view up the Main to the Rententurm and bridge

39r Frankfurt: view along the Main quay showing the Saalhof, cathedral and Rententurm

38v Frankfurt: view up the Main to the cathedral, bridge, Maininsel and Sachsenhausen

(shown in a separate instalment)

38r Frankfurt: view up the Main quay to the Rententurm, with the cathedral seen above houses

37v Frankfurt: the Fahrtor

37r Frankfurt: the Römerberg with the Niko-laikirche (R) and the cathedral in the dis-tance, with separate details of parts of the Nikolaikirche
Inscr. *St Niccoli*

36v Rough carriage sketch

36r Frankfurt: view across the Main with the bridge, Deutschherrnhaus and Sachsen-hausen (in two instalments)

35v Frankfurt: two sketches of the cathedral, glimpsed between houses (one extends onto f.36r)

35r Frankfurt: two sketches of the cathedral, glimpsed between houses

34v Frankfurt: the Katharinenkirche and adja-cent buildings

34r Frankfurt: the bridge and Maininsel, look-ing downstream to the cathedral (in two instalments)

33v Frankfurt: the bridge and Maininsel, look-ing downstream to the cathedral (in two instalments)

33r (1) Frankfurt: view across the Main with the Leonardskirche, Rententurm, Katharinenkirche and Nikolaikirche
(2) Frankfurt: houses on the Maininsel
(3) Frankfurt: the cathedral and bridge from across the Main (extends onto f.32v)

32v Frankfurt: the Katharinenkirche, houses and trees

32r Frankfurt: view across the Main with the Leonardskirche, Katharinenkirche and Rententurm (in several instalments, with details)

31v Frankfurt: view across the Main to the cathedral from further downstream than the sketch on f.31r

31r Frankfurt: view across the Main to the cathedral with the bridge on the right (with continuation in sky)

30v Frankfurt: the cathedral seen from a nar-row street

30r Blank

29v Frankfurt: the cathedral from the south (continued on f.26v)
Also a tiny sketch of Düsseldorf from the Rhine, inscr. *Dusseldorf*

29r Blank

28v River with a bridge of boats, illegibly inscr.

28r The Drachenfels from the Rhine

27v The Drachenfels from the Rhine

27r Blank

26v Frankfurt: the tower of the cathedral (a continuation of the sketch on f.29v)

26r Two sketches of buildings

25v Blank

25r–22v Outlines of distant hills

22r–21v Blank

21r–20v Rough carriage sketches, two inscr. [?*Long-furt*]; [...]*berg*

20r–19r Blank

18v Two sketches of Ehrenbreitstein

18r Ehrenbreitstein

17v Three sketches of Ehrenbreitstein

17r The Pfalz, Kaub and Burg Gutenfels

16v Burg Fürstenberg

16r Burg Fürstenberg
Inscr. *Furstenberg*

15v Burg Sooneck

15r Three rough sketches of the Rhine gorge

14v Distant town
Inscr. *B[...]eck*

14r–13v Rough sketches of a town

13r Burg Sooneck

12v Burg Rheinstein and Burg Reichenstein

12r Burg Reichenstein

11v Burg Rheinstein

11r (1) Town on the lower Rhine
(2) Burg Ehrenfels and the Mäuseturm, looking upstream to Bingen

10v The Rhine gorge below Bingen, looking downstream

10r Buildings
Inscr. *N[...]*

9v (1) The Mäuseturm and Burg Ehrenfels
(2) The Mäuseturm

9r (1) Town on the lower Rhine
Inscr. *Duis*
(2) Burg Klopp, Bingen church and the bridge over the Nahe

8v (1) Town
Inscr. *Wesel; not Wessil*
(2) Rüdesheim and the Rheingau
(3) Walled town on the lower Rhine

8r Burg Klopp, Bingen, the Mäuseturm and Burg Ehrenfels (in two instalments)

7v (1) View down the Rhine to Burg Klopp, Bingen, the Mäuseturm and Rüdesheim
(2) Rüdesheim

7r–6v The Drachenfels and the Seven Hills
Inscr. *Drachfels*

6v (1) Rüdesheim and the Johannisburg
(2) Eltville

6r Buildings, inscr. *3; 4*, and several sketches of boats

5v Several sketches of coastal or riverside towns, inscr. *Kidlerswade; Wesher*

5r Three sketches of towns on the Waal branch of the Rhine, one inscr. *Gorcum* (i.e. Gorinchem) and one of a sailing ship

4v Four sketches of towns on the Waal branch of the Rhine, one inscr. *Bom[...]* (i.e. Bom-mel), one inscr. *Alluvenstn* (i.e. Loevestein), some extending onto f.5r

4r–3r Blank

2v Two slight sketches

2r–1r Blank

Inside cover
Two slight sketches of towers

TB CCXCIX *Trieste, Graz and Danube sketchbook 1840 (see cat.no.64)*

Bound in boards covered in light buff paper, with three green leather loops for holding a pencil, two at one end, one at the other.

Formerly known as the *Danube and Graz* sketch-book and numbered by Finberg starting at the oppo-site end of the book to that used by Turner. The list below follows Turner's sequence.

The twelve sketches on ff.13v–10r marked below with an asterisk are Turner's copies after the litho-graphs in Adolf Kunike and Jakob Alt's *Donau-Ansichten vom Ursprunge bis zum Ausflusse ins Meer* (1819–26). The three on ff.13r and 11r marked with a dagger are copies after other prints.

For reasons of space, Turner's sketches of Trieste and those drawn on his journey from Trieste to Graz are here listed in the briefest possible way.

67r–64v The gulf of Trieste

67r Also includes sketches of shipping and two figures with baskets; also slight sketches in red chalk. This page is stuck down so as to become the endpaper

66v Also includes a sketch of towers inscr. *R; 7; 9; Thur[...] Danube*

64r–59r Trieste and its gulf, sometimes with the addition of later mountain sketches drawn between Trieste and Graz

58v–57r Trieste

56v Blank

56r (1) Distant view of Persenbeug castle, with Ybbs opposite
(2) Distant view of Freyenstein castle, look-ing upstream
Inscr. *Frensten*
Page also inscr. *Donnanwert* (i.e. Donau-dorf, a village close to Persenbeug)

56r–55v Two sketches of Persenbeug castle, (1) from across the Danube, with boat, (2) with Ybbs opposite, looking down the Danube

55r–53v Hills with castles or distant towns

53r Three sketches of hills, one inscr. *Tyrol Alps from the Danube*

52v–49v Hills and castles, with inscr.

49r Boats and hills

48v (1) Graz
Inscr. *Market D*
(2) Man sawing
Inscr. *Sawing Logs of Wood*

48r Graz: two sketches from the east

47v Graz: the Schlossberg from the north-east, and detail of the Glockenturm

47r Graz: two sketches from the east

46v Two sketches of hills

46r (1) Town buildings (Graz with the suspen-sion bridge in the distance?)
Inscr. *K[...]*
(2) Hills

46r–45v Graz: view from the north

45r Graz: five sketches of the Schlossberg from different directions

44v Graz: view across the Mur to the Schloss-berg and old houses on the riverside, with continuation in the sky
Inscr. *Red* (on a wall); *BW[...]*

44r Graz: the Schlossberg and Uhrturm from the Lendkai
Inscr. *up to Coffee H[ouse] X; Graz; [...];*

Dark Road

43v (1) Graz: view up the Mur to the suspen-
sion bridge, with continuation in the
sky
Inscr. *Bridge*
(2) Graz: view from the west

43r Graz: view up the Mur to the Schlossberg
from the Grieskai
Inscr. *W; W; Col; Pil*

42v Graz: view up the Mur to the Schlossberg
from the Grieskai, illegibly inscr.

42r (1) Graz: view up the Mur to the Schloss-
berg from the Grieskai, with continua-
tion in the sky
Inscr. *Red*
(2) Detail of a painting?
Inscr. *BR; GW; GA*

41v (1) Castle (Feistritz?)
Inscr. *Fi*
(2) Graz: view from the Schlossberg to the
Uhrturm and down the Mur

41r Several sketches of cliffs, river and build-
ings, one inscr. *Shotwin* (i.e. Schottwien)

40v (1) Church tower
(2) The top part of St Stephen's spire,
Vienna (continues sketch on f.40r)
(3) Gorge

40r (1) Vienna: St Stephen's cathedral and
Lazanskyhaus from the Stock-im-
Eisen-Platz
(2) Vienna: the cathedral glimpsed amid
houses

39v Four views of Freyenstein castle, two with
boats in the foreground
Inscr. *Frauentt*[…]; *Thursday Mg*

39r (1) (2) Two views of Sarmingstein
(2) Inscr. *Sauminstein; Samersty*
(3) (4) Two views of Freyenstein castle, (3)
extending onto f.38v
(4) Inscr. *Thursday Morning; Fraustein*

38v (1) (2) Sarmingstein, one inscr. *Sarmerents*
(3) (4) Freyenstein castle, with detail of coat
of arms, inscr. *Red; W;* […]

38r Three sketches of St Nikola
(3) Inscr. *R*[iver] *D*[anube]; *St Nicola*

37v Three sketches of the Wirbel and
Hausstein

37r (1) (3) The Wirbel and Hausstein
(2) The Strudel

36v Two sketches of Werfenstein and the
Strudel

36r Two sketches of Werfenstein and the
Strudel, each with separate details

35v Four sketches of Werfenstein and the
Strudel

35r Werfenstein and the Strudel, looking
downstream

34v Werfenstein and the Strudel, looking
downstream

34r Werfenstein and the Strudel, looking
downstream

33v Two rough sketches of a town, one inscr.
Bridge, overlapping a third sketch of the
Strudel

33r The Strudel

32v The Strudel
Inscr. *11 Horses*

32r The Strudel and Werfenstein, looking
downstream
Inscr. *[?Sand Red]*

31v (1)–(5) The Danube between the Strudel
and Grein

(6) Greinburg castle
Inscr. *Krennenburg C*

31r Passau: view across the Inn to the cathedral
and the Oberhaus beyond

30v Several rough sketches (including the
Oberhaus at Passau?)

30r Passau: view across the Inn to St Michael's
church and the Oberhaus beyond (a second
instalment of the view on f.31r)

29v–28v Blank

28r Passau: view down the Danube, with the
Oberhaus, Niederhaus and cathedral

27v Blank

27r (1)–(4) Ottensheim
(1) Inscr. […]; *Otenzheim*
(4) Inscr. […] *B Olive*
(5)–(7) Hills

26v (1) Aschach, looking downstream, with the
Traunstein in the distance
Inscr. *Achau*
(2) Distant view of Neuhaus castle, looking
upstream
(3) Neuhaus castle, looking upstream
Inscr. *Neuhaus*

26r (1) Linz, looking up the Danube to the
bridge
Inscr. *Lintz*
(2) Linz, looking down the Danube to the
bridge
Inscr. *L*
(3) Boats on the Danube
(4) (5) A castle

25v (1) Spielberg
Inscr. *R*[iver] *D*[anube]
(2) Spielberg
Inscr. *B Ottenhaus*
(3) Melk abbey
Inscr. *Milz*
(4) Castle and hills (continuation of
f.26r(5))

25r (1) The Leopoldsberg near Vienna
Inscr. *Leopolds*
(2) (3) and ?(4) Mauthausen

24v (1) Spielberg
Inscr. *S*[…]*berg*
(2) Enns
(3) Spielberg
(4) Mauthausen
Inscr. *Bahttousen*

24r Three sketches of the Danube near
Neuhaus castle
Inscr. *Blue*

23v Three sketches of the Danube with
Neuhaus castle
Inscr. *R*[iver] *D*[anube]

23r Passau: view down the Danube looking
towards the Oberhaus, with continuation in
the sky

22v Passau: view down the Danube from near
the Palkerstein-Turm, plus details

22r (1) (2) The Danube near Kerschbaum
(3) Kerschbaum, looking upstream
Inscr. *Keresburg; St Machael*

21v (1) The Danube near Marsbach castle
(2) (3) The Danube near the Schlögen
bend, with Kerschbaum, plus detail
Inscr. *R*[iver] *D*[anube]

21r (1) The Danube bend at Schlögen and the
ruins of Kerschbaum
(2) View up the Danube with Marsbach
castle and Rannariedl
Inscr. *Marxpa*

(3) (4) Marsbach castle, looking down-
stream
(5) View down the Danube with Marsbach
castle and Wesenufer
Inscr. *Weus New*

20v (1) Engelszell abbey, looking upstream
(2) Rannariedl castle, looking downstream,
plus detail
(3) Rannariedl castle, looking upstream,
plus detail
Inscr. *Rinnil Closter*

20r (1) Villagers on the river bank at Engel-
hartszell
(2) Viechtenstein, looking upstream
Inscr. *Veckenten*
(3) View down the Danube from close to
Viechenstein

19v (1) Jochenstein
Inscr. *Rock*[…]
(2) (3) Obernzell
Inscr. *Obensay*

19r (1) Krampelstein castle, looking upstream
Inscr. *L*[…]
(2) (3) The fortified church at St Michael
Inscr. *St Michaels*

18v Blank

18r Three views of Passau, looking upstream
towards the confluence from a boat, going
upriver

17v (1) The Danube near Passau
(2) Passau?
(3) Krampelstein castle, looking down-
stream

17r (1) Grein and Greinburg castle, looking
downstream
Inscr. *Shloss Grien Grinburg*
(2) (3) Krampelstein castle, (2) looking
downstream, (3) looking upstream

16v (1) Säussenstein
Inscr. *Burnt by Napoleon*
(2) Distant view of Säussenstein
(3)–(5) Grein and Greinburg castle

16r Four rough sketches of the Teufelsmauer
and the Hinterhaus at Spitz, (2) and (4)
continuing onto f.15v
Inscr. (three times) *Spitz*

15v (1) Greinburg castle
(2) (3) Spitz and Arnsdorf
(2) Inscr. *Aunstur*

15r (1) Säussenstein?
Inscr. […]; *Sisenstein*
(2)–(5) Rough sketches near Spitz, St
Michael and Arnsdorf, some continuing
onto f.14v, one inscr. *Spitz*; […]

14v Rough sketches of Arnsdorf and St
Michael
Inscr. *Begun in the Moonlight at St
Michaels; Anstour; St Michl; Ansthough*

14r (1) Wallsee castle
Inscr. *Wallshee*
(2) (3) Hollenburg
Inscr. *Holemberg*

13v (1) *Theben castle (then the Austro-Hun-
garian border, between Vienna and
Pressburg) (Alt, plate 127)
Inscr. *Theban*
(2) *Pressburg (now Bratislava) (Alt, plate
128)
(3) (4) Greifenstein castle
(4) Inscr. Greifenstein

13r (1) †Werfenstein and the Strudel
Inscr. *Struden*

(2) *Weitenegg castle (Alt, plate 82)
 Inscr. *R*; *Weidnek*
(3) *The Wirbel (Alt, plate 71)
 Inscr. *Der Wirbel*
12v (1) *Wallsee castle (Alt, plate 64)
 Inscr. *River D*; *Wallsee*
(2) *Werfenstein and the Strudel (Alt, plate 69)
(3) *Werfenstein (Alt, plate 72)
 Inscr. *Werfenstein*
12r (1) Greifenstein castle
(2) (3) Distant views of Kreuzenstein castle
(4) Greifenstein castle
11v (1) Hills on the Danube near the Leopoldsberg
(2) Kreuzenstein castle
(3) Greifenstein castle, plus separate detail
 Inscr. *Gretenstin*; *Gereelstn*
11r (1) †Steyrigg
 Inscr. *Steyerbourg*
(2) *Spielberg (Alt, plate 61)
 Inscr. *Rocks*; *River D*; *Spielburg*
(3) †Krampelstein castle
 Inscr. *Grempenstein*
10v Vienna: the Burgtor?
10r (1) *Wildenstein castle (Alt, plate 5)
 Inscr. *Wildenstein*
(2) *Sigmaringen castle (Alt, plate 6)
 Inscr. *Singmaringen*
(3) *Donaustauf, near Regensburg (Alt, plate 39)
 Inscr. *Danaustof*
(4) *Abbach (Alt, plate 34)
 Inscr. *Aback*
9v Two sketches of St Stephen's cathedral, Vienna, from the south (by the Chur Haus) and south-west, plus separate details of its western towers
9r Four sketches of Wallsee castle, (2) inscr. *Boat Mill*, (4) inscr. *Wallsee*
8v (1) (2) Wallsee castle, looking downstream, (1) inscr. *Wallsee*, (2) inscr. *Wallshee*
(3) The top part of St Stephen's spire, Vienna (continues sketch on f.9v)
8r Blank
7v The Altenburg
 Inscr. *Altenbugh*
7r (1) The Leopoldsberg and distant view of Klosterneuburg, boat in foreground
(2) Klosterneuburg
 Inscr. *Cloister Neuburg*; *6*; *Neiburg*
(3) (4) Klosterneuburg
(5) Boats on the Danube
 Inscr. *Danube*; *Horses*
6v (1) The Altenburg near Vienna
 Inscr. *Alenburgh*; *[?Closter]*
(2) Hill and church
(3) Arcaded interior
(4) Vienna: St Michael's church and the Winterreitschule from the Michaelerplatz, with detail of arcade
6r Blank
5v Vienna: houses with St Stephen's cathedral in the distance
5r Three rough sketches, one showing the suspension bridge at Graz, another a distant view of Vienna
4v Rough sketch of mountains, illegibly inscr.
4r Vienna: houses with St Stephen's cathedral in the distance
3v Three rough landscape sketches, two inscr. *W*[…]

3r Graz: view down the Mur to the suspension bridge
2v Rough sketch of city walls, probably at Vienna
 Inscr. *V*
2r (1) Slight sketch of buildings, probably at Vienna
 Inscr. *V*[…]
(2) (3) Trieste
1v Trieste?
1r Four views of hills, with distant castle
(1) Inscr. […] *Gratz* […] *WB* (or *to B*?)
(2) Inscr. *30 Hills*
Inside cover
 Hills, wagons, etc.
 Inscr. *to Gratz*

TB CCCX *Venice; Passau to Würzburg* sketchbook 1840 (see cat.no.65)

Bound in boards covered in light buff paper. One cover bears several pencil lines, the other an inscr. in ink, in Turner's writing:

 Aust[ri]*an Florin – 3 Si.*
 one Secuin – 14

Formerly known as the *Coburg, Bamberg, and Venice* sketchbook. After initially using this book in Venice (ff.1r–18r), Turner then sketched in TB CCXCIX for several days. When he resumed using TB CCCX at Passau, he started at the opposite end from his Venetian sketches. The list below retains Finberg's numerical order but Turner's own sequence was Venice, Passau and Burg Hals, Regensburg and the Walhalla, Nuremberg, Bamberg, Coburg, Würzburg. For reasons of space, all the Venetian sketches are here listed simply as 'Venice'.

Inside front cover
 Inscr. (extending onto f.1r)
 (1) *6 Florins for trunk by Route to Coburg – 17 Sep*[r] (in Turner's writing)
 (2) *f.6 – von Bamberg bis Coburg alles inbegriffen Stephan* (in a German hand)
 Also several sketches:
 (1) Rough sketch map of part of the river Main with *Frank*[furt], *Wurzb*[ur]*g*, *S*[chwe]*infurt*, *Cob*[urg] and *Bam*[berg] roughly marked; *6 or 7* […]
 (2) Diagram of an interior wall of the Walhalla
 (3) Schloss Rosenau
 (4) Two details of a classical roof
 (5) Four sketches of headdresses
 Inscr. *Aus*; *Gold* […]; *3*; *Gold*; *Ba*; *Gold*; *Bam*
1r (1) Venice
 (2) Rough sketch of tower and spire, probably at Coburg
 Page also inscr. *Wiss Swan* (with outline of swan)
1v (1) Coburg: view from an upper floor of the Weisser Schwan of Spitalgasse from the Lucchesehaus to the market place, with detail of the Stadthaus
 (2) Coburg: the Stadthaus, Zeughaus and St Moriz church
 (3) Coburg: the market place from Spital-

gasse with architectural details
 Inscr. *Same as Gabel*; *4*; *4*; *4*; *Fountain*
2r (1) (2) Coburg: the Ketschentor
 Inscr. *Ent*[rance] *to Cobg*
(3) Venice
2v Five sketches of Coburg and Veste Coburg surrounding one of Venice
(1) (2) Veste Coburg from its approach road next to the Hofgarten
(3) Coburg from the approach road to Veste Coburg
(4) (5) Veste Coburg from the north
 Both inscr. *Coburg*
 Page also inscr. *Sam*; *Co*
3r (1) Venice
(2) Coburg: the Zeughaus from Herrngasse
 Inscr. *Ga*[…] *H*[…]
(3) Coburg: the Judengasse and Judentor
3v (1) Venice
(2) Distant view of Veste Coburg, illegibly inscr.
4r (1) Venice
(2) Veste Coburg from the east
4v Venice
5r (1) Venice
(2) Veste Coburg and the Heiligkreuzkirche
5v Venice
5v–6v Coburg: St Moriz from Pfarrgasse
 Inscr. *3*; *Coburg*; *T*[…]
6r–7v Venice
8r (1) Venice
(2) Coburg: Schloss Rosenau, with pavilion in foreground
8v–10r Venice
10v (1) Coburg: Schloss Callenberg from the east
(2) Coburg: St Moriz from Neugasse
11r–16r Venice
16v Coburg: the Schlossplatz with Schloss Ehrenburg, St Moriz, the Zeughaus and the Hoftheater
 Inscr. *6*; *R*[…]; *Coburg*
17r Venice
17v Blank
18r Venice
18v Regensburg: the Neupfarrkirche from the south-west corner of the Neupfarrplatz
19r Blank
19v Bamberg: the Altenburg with the city below, with details
 Page also inscr. *Altenburg ca*[…]; *Ex*; *R*[…]; *X*
20r Blank
20v Three views of Coburg and Veste Coburg from the south-west
21r Coburg: Schloss Ehrenburg from the Schlossplatz (plus details and separate continuations), with St Moriz's church on the right
 Inscr. *7 Wind*[ows]; *5 Wind*[ows]; […]; *only two arch*[es]; *Pump*
21v (1) (2) The Itz at Schloss Rosenau
(3) Coburg and Veste Coburg from the south (with separate detail of Veste Coburg)
 This page is slightly marked with a purplish paint stain
22r Coburg: Schloss Rosenau from the Itz valley
 Inscr. *Alders*; *RWR* (by the red and white striped flag on the castle)
22v (1) Veste Coburg and Schloss Ernsthöhe

from the north-west, with enlarged version of Veste Coburg in sky above and figures in foreground
Inscr. […]*Itz*

(2) Distant view of Veste Coburg from the north-west

(3) Coburg: St Moriz's church and Schloss Ehrenburg
Inscr. […]; *Co*

22v–23r Veste Coburg and Schloss Ernsthöhe, with details of Schloss Ernsthöhe
Inscr. *B*; *W*; *Red* (for a flag)

23r (1) Coburg: Schloss Ernsthöhe, with details

(2) Veste Coburg and Coburg: view from Schloss Ernsthöhe (the same viewpoint as (1))

23v Coburg: several sketches of the town and its setting, with Veste Coburg in the distance

24r (1) Schloss Rosenau from the Itz valley

(2) Coburg: the Weisser Schwan and Spitaltor, with detail, illegibly inscr.

24v (1) Veste Coburg from Schloss Ernsthöhe (and detail of Veste Coburg)

(2) Veste Coburg, illegibly inscr.

(3) Coburg and Veste Coburg from Schloss Ernsthöhe with the Heiligkreuzkirche and continuation in sky
Inscr. *HC*; [*Holy Cross*] […]

25r Coburg: Schloss Ernsthöhe with the Heiligkreuzkirche and figures in the foreground

25v (1) Coburg: Schloss Ernsthöhe from the valley, with detail

(2) Veste Coburg and the Heiligkreuzkirche (from same viewpoint as (1))

25v–26r Veste Coburg and the Itz valley, with a bridge in the foreground
Inscr. *Fall*

26r Two sketches of Coburg and Veste Coburg from Schloss Ernsthöhe, one with detail and continuation in sky

26v Bamberg: five sketches showing the Geyserswörth, town hall, Obere Pfarrkirche and cathedral towers from different viewpoints

(3) Inscr. *Back of 3 Crowns*

27r (1) Bamberg: the Obere Pfarrkirche and Kaulberg from the east

(2) Bamberg: the town hall island from the south-west

(3) Bamberg: view down to the cathedral

(4) Landscape

27v (1) Part of Veste Coburg

(2) Coburg
Inscr. *Coburg*

(3) Bamberg, illegibly inscr.

28r (1) Bamberg: the Altenburg and view down to the city

(2) Distant view of Bamberg
Inscr. *Path* […]

(3) Church

28v Bamberg: the cathedral and Alte Hofhaltung from the north

29r (1) Nuremberg: view from the market place to St Sebaldus and the Burg, the town hall and Schöner Brunnen
Inscr. *M*[?*arket*] *Nubg*

(2) Castle and hills: Giech and Gügel near Schesslitz
Inscr. *Giech*

29v Nuremberg: street scene with fountain,

looking towards the Weisser Turm from Josefs Platz
Inscr. *Adler Str*[asse]

30r (1) Nuremberg: St Elisabeth, the Weisser Turm and St Jakob, with details

(2) Nuremberg: the Weisser Turm and Spittlertor

(3) Nuremberg: the Heiliggeistspital and Schuldturm

30v (1) Nuremberg: the Weisser Turm and St Elisabeth
Inscr. *Red*; […]*of L*[…]

(2) Nuremberg: St Jakob, the Spittlertor and St Elisabeth

(3) Nuremberg: the archway of the Spittlertor

31r (1) Nuremberg: the Spittlertor and town walls

(2) Nuremberg: St Lorenz from Karolinenstrasse

31v Nuremberg: the Spittlertor and town walls

32r (1) Regensburg: the East Gate
Inscr. […] *thro the Gateway*

(2) Outline of hills (near Lichtenfels or Staffelstein?)
Inscr. *S*[…]*berg*; *W.G*; […]; *Rd from B to Co*

(3) Nuremberg: the town walls

32v Several rough sketches drawn from the carriage, one showing Regensburg
Inscr. *Road*; *R*[…]; *Regbg*; […]

33r Three distant views of Regensburg, two from close to a wayside cross
Inscr. *Rainburg*; *Rainsbg*; *Post P*[…]; *Blue C*[…]

33v Donaustauf and its castle, with the bridge over the Danube

34r St Salvator's church and the Walhalla, with details of the hillside and the infrastructure of the Walhalla in the sky

34v View down the Danube from close to the Walhalla
Inscr. *South*

35r View up the Danube to Donaustauf and Regensburg, from close to St Salvator

35v St Salvator and view down the Danube to the Walhalla (in two instalments)
Inscr. *St Salvato*

36r Donaustauf and view up the Danube from the hillside above St Salvator

36v (1) The Walhalla from Wörtherstrasse, showing a house in that street and the Wirtshaus zur Walhalla

(2) View down the Danube (a near-continuation of (1))
Inscr. *Claude Dis*[tance]; *Gardens*; *Danube*

37r Donaustauf and view up the Danube from the same spot as the sketches on f.36v

37v View southwards to Donaustauf and the Walhalla, with a foreground figure kneeling at a shrine

38r View southwards to Donaustauf and the Walhalla

38v Regensburg with the cathedral and bridge tower

39r Distant view of Regensburg from the terrace in front of the Dreifaltigkeitskirche

39v Regensburg: view up the Danube, with buildings near the Schiegenturm

40r Regensburg: view down the Danube to the bridge from close to the Schiegenturm

40v Regensburg: the Thurn and Taxis palace with the Obermünster in the distance

41r (1) Donaustauf and the Walhalla from the Danube (in two instalments)

(2) Veste Coburg and Coburg

41v Regensburg: the Neupfarrkirche and Neupfarrplatz from Turner's room at the Drei Helmen hotel
Inscr. *Neu*; *Arch under* (on the Hauptwache)

42r Two distant views of Donaustauf, St Salvator and the Walhalla from the Danube

42v Regensburg from across the Danube (in two instalments)

43r (1) Distant view of Donaustauf and the Walhalla from the Danube, with a boat in the foreground

(2) (3) Veste Coburg

43v (1) Distant view of Donaustauf and the Walhalla from the Danube

(2) Regensburg from the Danube (in two instalments)

44r The Walhalla from the Danube (in two instalments)

44v (1) Regensburg: view across the Danube to the city, with the bridge on the left

(2) The Main, with hills and towers, near Ebing
Inscr. *Ferry over the Main* [*between*] *Bam and Coburg*

45r (1) Nuremberg: bridge over the Pegnitz with St Lorenz in the background
Inscr. *Nurmberg*

(2) Nuremberg: bridge over the Pegnitz
Inscr. *Neur*[…]

(3) Bamberg: distant view
Inscr. *Bam*

(4) Figures
Inscr. *G*; *G*

45v Regensburg: view across the Danube to the cathedral, with the bridge on the right

46r Bamberg: the town hall and spires of the cathedral from the Pegnitz close to the old crane
Inscr. *Krahn*

46v–47r Regensburg: the façade of the cathedral
Inscr. *Zalsbrg* (above the Dalberg palace)

47v (1)–(4) Sketches of hills and castles, probably made from a carriage

(5) Bamberg: the Altenburg
Inscr. *2*; *Heelenberg S*[…]

48r Bamberg: the cathedral, Obere Pfarrkirche, St Stephan and Carmelite church
Inscr. *Heelenberg*

48v Passau: the cathedral from the Domplatz

49r Rough sketch of Passau

49v Five rough sketches of a castle

50r (1)–(3) Three rough sketches of a castle

(4) Slight sketch of Vilshofen on the Danube
Inscr. *R*[iver] *D*[anube]; […]*ilzhofen*

50v Several rough sketches made while travelling

51r (1) Würzburg: the market place from Turner's hotel, the Wittelsbacher Hof

(2) Dettelbach am Main
Inscr. *Heil*[…]

51v Passau: view from the Mariahilfsberg (the prospect continues on f.52r)

52r Passau: the Oberhaus and Ilzstadt from the Mariahilfsberg, with details of Mariahilf

itself in the sky above
Inscr. *Arch*

52v Passau: rough sketches from the Ilz valley

53r Passau: the Oberhaus with view up the Ilz

53v Passau: the Oberhaus from near the mouth of the Ilz

54r Passau: the Niederhaus

54v Passau: view from the back of the Ilzstadt

55r Passau: the confluence of the three rivers from the Ilzstadt

55v Passau: the confluence from above the Ilz-stadt

56r Passau: the Oberhaus and Ilzstadt

56v Passau: the confluence from the Ilzstadt

57r Venice

57v–58r Passau: view down the Ilz to the Oberhaus
Inscr. *M and W [...]ing on W*

58v Hals from across the Ilz with St George's church on the left

59r (1) Veste Coburg and Schloss Ernsthöhe
Inscr. *Ilz R[iver]; near Coburg*
(2) Burg Hals from the Ilz
Inscr. *Haltz*
(3) Veste Coburg and Coburg (continued in sky above)
Inscr. *Coburg; 2*

59v Hals and Burg Hals from the hillside to the north

60r Veste Coburg and Coburg from Schloss Ernsthöhe
Inscr., but erased so that scarcely legible,

Lundi	*Monday*	
Mardi	*Tuesday*	[...]
Mercredi	*Wednesday*	
Jeudi	*Thursday*	
Vendredi	*Friday*	
Samedi	*Saturday*	*Sam*
Dimanche	*Sunday*	*So*
		Samsto
		Dimso

another similar list, even less legible; and the date *17 Sept*

60v Hals and Burg Hals from the north across the Ilz with St George's church

61r Three sketches of Veste Coburg from the east, one with detail

61v (1) (2) Hals and Burg Hals from the south across the Ilz, with a tiny continuation
Inscr. *1; 2*
(3) The entrance gate to Burg Hals as seen from the market place

62r (1) (2) Coburg: Schloss Callenberg
(1) Inscr. *Altenberg*
(3) Veste Coburg and Schloss Ernsthöhe from the west
Inscr. *Coburg; Sunday 20 Sept; Road*
(4) (5) Distant views of Veste Coburg
(5) Inscr. [...]; *Altenberg*

62v View southwards from Burg Hals with some of its ruins, St George's church and the Oberhaus at Passau in the distance

62v–63r Coburg: Schloss Rosenau and its garden terrace with details of fountain and façades of the house

63r (1) The entrance to Veste Coburg
(2) Rough outline of buildings
Page also inscr. *Poppendorf on the Iltz*

63v Burg Hals and the highest houses in Hals from the south-west

64r (1) Domed church
(2) Coburg: St Moriz from Rückertstrasse with the Morizbrunnen

(3) (4) Coburg: Schloss Rosenau and its setting
Page also inscr. *Kalenberg*

64v Burg Hals and the highest houses in Hals from the west

65r (1) Bamberg: the Altenburg from the south-east
(2) Part of Burg Hals
(3) An embracing couple and two seated figures

65v (1) Burg Hals and the highest houses in Hals from the path over to Passau
(2) Distant view of Bamberg
Inscr. *to West*

66r (1) The Altenburg, with Bamberg below
Inscr. *Bilenoff* (over a distant building, probably Schloss Giech near Peulendorf)
(2) Bamberg from the Altenburg (in two instalments)

66v Burg Hals and the highest houses in Hals from the path over to Passau
Inscr. *4*

67r (1) Bamberg: St Michael, the cathedral, Obere Pfarrkirche, St Stephan and St Jakob
Inscr. *Bamberg*
(2) A smaller version of the same view

67v (1) Town with bridge and figures
(2) Part of a Doric entablature, probably that of the Walhalla
(3) Veste Coburg from the north

68r (1) (2) The infrastructure of the Walhalla
(3) Castle on distant hill
Inscr. *Tom Girtin*

68v (1) Passau: view across the Danube, from close to the Oberhaus, to the cathedral and St Paul's church
(2) Dettelbach am Main

69r (1) Donaustauf from the back of the Walhalla
(2) The infrastructure of the Walhalla
(3) Several figure studies
Inscr. *G. Bonnet; Yell*

69v (1) Veste Coburg and Schloss Ernsthöhe (with outlines of town and Veste Coburg)
(2) Landscape with buildings including a domed church
(3) Veste Coburg from the south
Inscr. *Gi[...]burg*

70r (1) The façade of the Walhalla and ground plan of part of its peristyle
(2) Female figure
Inscr. *RBG*

70v (1) Part of the entablature of the Walhalla
Inscr. *35*
(2) Several studies of female figures, illegibly inscr.

Inside back cover
(1) Ground plans relating to parts of the Walhalla
Inscr. *3 Steps*
(2) Two female figures, illegibly inscr.

TB CCCXL *Passau and Burg Hals* sketchbook 1840 (see cat.nos.85, 86, 88, 93)

Roll sketchbook, with buff paper cover. Formerly known as the *Grenoble (?)* sketchbook. All versos are blank, but see note on f.9r.

1r Burg Reschenstein on the Ilz (watercolour)

2r Burg Hals on the Ilz (watercolour)

3r Passau: the confluence from above the Ilz (watercolour)

4r Hals, Burg Hals and Burg Reschenstein from the hillside to the south (pencil)

5r Hals and Burg Hals from the hillside to the south (pencil)

6r Water and sky (watercolour)

7r Sky study (watercolour)

8r Sky study (watercolour)

9r Passau: view down the Danube (this page is really f.9v; as Ruskin observed (Finberg, 1909, p.1064), its pencil drawing continues across to form the drawing on f.10r) (pencil and watercolour)

10r Passau: view up the Danube (pencil)

TB CCCIII *Würzburg, Rhine and Ostend* sketchbook 1840 (see cat.no.66)

Bound in boards covered in very dark brown marbled paper, with an inside pocket, an inside loop for a pencil and a tuck-in flap. Pages edge-painted in red.

Formerly known as the *Ostend, Rhine, and Würzburg* sketchbook and numbered by Finberg starting at the opposite end of the book to that used by Turner. The list below follows Turner's sequence.

Inside cover
Includes a few illegible inscr., *27* and a rough sketch of Würzburg cathedral (extends slightly onto f.89v)

89v Blank, except for hatching lines where Turner has tried out a pencil or pencils

89r–88v Würzburg: the Domstrasse, with the town hall, cathedral and Vierröhrenbrunnen

88r Würzburg: the Käppele, St Burkard's church and Marienberg from the Mainkai (extends slightly onto f.87v)

87v Würzburg: the Käppele, St Burkard's church and Marienberg from just below the bridge

87r Würzburg: the Marienkapelle, town hall, cathedral and Neubau church from the west bank, just above the bridge

86v Würzburg: the Marienberg and St Burkard's church from the bridge (extends slightly onto f.87r)

86r Würzburg: view across the Main to St Burkard's church, the Käppele and Marienberg

85v Würzburg: view up the Main from the bridge

85r Würzburg: the east bank of the Main below the bridge from the west bank

Inscr. *Boat load of F*[…]

84v Würzburg: the Main bridge, Marienkapelle, town hall, Neumünster and cathedral from the hillside above St Burkard's church

84r Würzburg: the Marienberg from near St Burkard's church

83v Würzburg: the Deutschhaus church from Zellerstrasse

83r Würzburg: the Marienberg, St Burkard's church, bridge, town hall, Marienkapelle, Neumünster and cathedral from the southern end of the Mainkai (in two instalments)
Inscr. *Water*; *Rubbish* […]

82v Würzburg: the Marienberg

82r Würzburg: view of the city from the Marienberg (180° view in two instalments)
Inscr. (next to the Neubau church): *C Red*

81v Würzburg: view of the Neumünster, cathedral and Marienberg from above Dreikronenstrasse (in two instalments)
Inscr. *B Washer Woman*

81r Würzburg: view across the bridge to the town hall and cathedral

80v Würzburg: the Marienkapelle from the market place, with extra details

80r Würzburg: view up the Main past the Pleichertor to the Marienkapelle, town hall and Marienberg (in two instalments)
Inscr. […] *of St* […]

79v Würzburg: the bridge and Marienberg from the landing-stage on the Kranenkai

79r (1) Wurzburg: the Marienberg with the Pleichertor in the foreground
(2) Würzburg: the Pleichertor and fortifications

78v Würzburg: the Stift Haug church, cathedral and Neumünster from across the Main

78r Würzburg: view from the banks of the Main north of the city (in two instalments)
Inscr. (on f.77v) *River in front*

77v Würzburg: view from the banks of the Main north of the city (in two instalments, inscr. *1*; *2*)
Inscr. twice *River Main*

77r Würzburg: view from the Steinberg, with the infirmary in the foreground

76v Würzburg: view from the hillside below Schloss Steinburg

76r Würzburg: view from the north west

75v Würzburg: distant view from the north

75r (1) Würzburg: distant view from the north
(2) View from the Steinberg
Inscr. *Steinberg*

74v Würzburg: view from the Steinberg

74r View down the Main from the Steinberg
Inscr. *Wall*

73v Würzburg: view up the Main from the Steinberg

73r Würzburg: view up the Main from the Steinberg

72v Würzburg: view from the west bank of the Main
Inscr. *one C and F*[*?erry*] [*?across*] *Water*

72r Würzburg: the Residenz
Inscr. *6* (for its bays)

71v Würzburg: the market place, Marienkapelle and Haus zum Falken from Schönbornstrasse

71r–70v Blank

70r Landscape with stormy sky
Inscr. […]; *Yelow*; *G*

69v (1) River valley with spires
(2) Two recumbent figures (sculptures?)

69r River valley with spires and archway

68v Hills
Inscr. *All*[…]

68r–67v Blank

67r The Mäuseturm

66v Burg Klopp and Bingen

66r Bingen and the Rochus chapel, looking upstream

65v The Mäuseturm

65r Burg Ehrenfels

64v View downstream to the Mäuseturm and Burg Rheinstein

64r View upstream to Burg Ehrenfels, Bingen and the Mäuseturm

63v View upstream to Burg Ehrenfels, the Rochus chapel above Bingen and the Mäuseturm

63r Near Burg Rheinstein

62v Burg Rheinstein

62r Burg Reichenstein

61v (1) Burg Rheinstein, Burg Reichenstein and the Klemenskapelle
(2) Burg Reichenstein

61r Rhine view near Niederheimbach

60v (1) Three views of Burg Sooneck
(2) The Heimburg and Niederheimbach
Inscr. *Rhineback*

60r The Heimburg and Niederheimbach

59v View down the Rhine with Burg Nollig and Lorch on the right

59r Burg Fürstenberg and Rheindiebach, and a separate sketch of Burg Fürstenberg

58v Blank

58r Burg Fürstenberg, looking upstream

57v Bacharach, looking downstream, and a separate sketch of Burg Stahleck

57r Bacharach, from opposite the Steegertal

56v Bacharach

56r Distant view of Bacharach, looking upstream

55v The Pfalz, Kaub and Burg Gutenfels, looking downstream

55r The Schönburg, the Pfalz, Kaub and Burg Gutenfels, looking downstream

54v The Pfalz, looking downstream

54r Kaub and Burg Gutenfels, looking downstream

53v Kaub and Burg Gutenfels, looking upstream

53r Oberwesel: the Schönburg and Liebfrauenkirche, looking downstream

52v Oberwesel: the Schönburg and Liebfrauenkirche, looking downstream

52r Oberwesel: the Schönburg and Liebfrauenkirche

51v Oberwesel

51r Oberwesel and the Schönburg, looking upstream

50v The Lorelei

50r St Goar and Burg Rheinfels

49v Slight sketch of Burg Katz

49r Slight sketch of part of Burg Rheinfels

48v St Goar and Burg Rheinfels

48r Burg Rheinfels

47v Burg Maus and Wellmich church

47r Burg Maus and Wellmich church

46v The Rhine near Burg Maus, with a steamer

46r View upstream to Burg Maus

45v The Rhine at Hirzenach, with a steamer

45r Distant view of Burg Sterrenberg and Burg

Liebenstein, looking downstream, with three figures towing a boat in the foreground

44v Bornhofen, Burg Sterrenberg and Burg Liebenstein, looking downstream

44r Bornhofen, Burg Sterrenberg and Burg Liebenstein

43v Bornhofen, Burg Sterrenberg and Burg Liebenstein

43r Two sketches of Bornhofen, Burg Sterrenberg and Burg Liebenstein

42v Bornhofen, Burg Sterrenberg and Burg Liebenstein

42r Boppard

41v Braubach and the Marxburg

41r Blank

40v Rhens and Schloss Stolzenfels, looking downstream, with detail of Rhens

40r Slight sketch of hills

39v Schloss Stolzenfels and Kapellen church, looking downstream

39r The mouth of the Lahn with Burg Lahneck

38v The mouth of the Lahn with St John's church, Niederlahnstein, and Burg Lahneck

38r (1) The junction of the Lahn and the Rhine, looking up the Rhine to Burg Lahneck, Oberlahnstein and Schloss Stolzenfels
(2) Ehrenbreitstein, looking downstream

37v Weissenthurm, looking downstream

37r Neuwied, looking upstream

36v Two sketches of the Rhine near Andernach

36r Near Andernach

35v Andernach and the Devil's House, Neuwied, looking downstream
Inscr. *Andernach*

35r Hammerstein, looking downstream from near Andernach

34v Andernach, looking downstream

34r Andernach, looking upstream

33v Hammerstein, looking downstream

33r Hammerstein, looking downstream

32v Hammerstein

32r Hammerstein, looking upstream

31v The Rhine front at Linz

31r A tower at Linz, looking upstream
Inscr. *Lintz*

30v View down the Rhine with the Erpeler Lei

30r (1) Remagen and the Apollinaris chapel, looking downstream
(2) The Erpeler Lei, looking upstream

29v Remagen and the Apollinaris chapel

29r The Apollinaris chapel

28v Distant view of Rolandseck, Nonnenwerth and the Drachenfels, looking downstream

28r Erpel, Remagen and the Apollinaris chapel, looking upstream

27v The Rhine with sailing boats in the foreground

27r Distant view of Rolandseck, Nonnenwerth and the Drachenfels, looking downstream from near Unkel
Inscr. [*?Cow*]

26v Distant view of Rolandseck, Nonnenwerth and the Drachenfels, looking downstream

26r Rolandseck, Nonnenwerth and the Drachenfels, looking downstream

25v Rolandseck, Nonnenwerth and the Drachenfels, looking downstream

25r Two sketches of Rolandseck, Nonnenwerth

and the Drachenfels, looking downstream

24v Two sketches of Rolandseck, Nonnenwerth and the Drachenfels, looking downstream

24r The Drachenfels, looking downstream

23v The Drachenfels, looking downstream

23r The Drachenfels

22v The Drachenfels

22r The Drachenfels, looking upstream to Rolandseck

21v The Godesburg and Bonn

21r Ostend (in two instalments)
Inscr. *2; 1; Ostend*

20v Cologne: the town hall and cathedral from the old market

Many of the sketches on the remaining pages of the book depict Ostend, often with several drawings or instalments per page

TB CCCLI *Rhine and Rhine Castles* sketchbook 1844 (see cat.no.133)

Roll sketchbook, with grey paper cover.

Many of the sketches in this book are extremely schematic and their subjects cannot be established with any certainty. Unless otherwise specified, all sketches are in pencil.

1r River and mountains

1v Blank

2r Town on a river

2v Blank

3r Storm over a river (watercolour)

3v Blank

4r Castle on a hill (Burg Reichenberg?) (watercolour)

4v Blank

5r Castle (watercolour)

5v Blank

6r Storm over a river (watercolour)

6v Cologne from the Rhine (in several instalments)

7r Storm over the Rhine (watercolour)

7v Castle on a hillside (Burg Katz, looking to St Goar?)

8r Cologne from the Rhine

8v St Goar and Burg Rheinfels, looking downstream to Burg Maus

9r Castle on a hillside (Burg Katz, looking to St Goar?)

9v Distant view of Burg Reichenberg

10r Burg Reichenberg

10v Hills and buildings

11r Hills and castles

11v Hills and river

12r Blank

12v Castle on a river bend?

13r Blank

13v Hills

14r Burg Reichenberg

14v River valley

15r Burg Reichenberg

15v River valley

16r Burg Reichenberg

16v Town on a hill (Patersberg?)

17r Burg Reichenberg

17v Castle on a hill (the back of Burg Katz?)

18r Hills

18v Hills

19r Burg Reichenberg

19v Hills
Inscr. *Road*

20r Burg Reichenberg

20v (1) Burg Rheinfels
(2) Burg Katz

21r Burg Reichenberg

21v St Goar and Burg Rheinfels, Burg Katz and St Goarshausen, looking downstream to Burg Maus

22r Burg Reichenberg

22v St Goar and Burg Rheinfels, Burg Katz and St Goarshausen, looking downstream to Burg Maus

23r Burg Rheinfels from close to Burg Katz?

23v St Goar and Burg Rheinfels, Burg Katz and St Goarshausen, looking downstream to Burg Maus

24r Burg Reichenberg

24v Burg Katz

25r Castle or tower by a river (the Ochsturm at Oberwesel?)

TB CCCII *On the Neckar* sketchbook 1844 (see cat.no.132)

Bound in boards covered in green paper, with maroon leather spine and the remains of three maroon leather loops, two at the back and one at the front. Glued to the front cover is a small paper label engraved with a heart, inside which a pencil sketch is faintly visible.

Inside front cover
Several sketches of Hirschhorn and one of Wimpfen
Inscr. *Bought at Heidelbergh; Hershorn; […] Wim*

1r Several sketches of castles and other buildings
Inscr. *Necker […]; Wood; Road; W; W*

1v–2r Blank, as is also an unnumbered leaf between 1 and 2

2v Heilbronn from the Neckar

2v–3r Heilbronn: the market place with the town hall (L) and St Kilian's church (R)
Inscr. *8; 3; 12* (for the bays of a building)

3v–5r Blank

5v Slight sketch of hills and tower

6r (1) Heilbronn: the town walls with three towers including the Götzenturm
(2) Slight sketch

6v–8v Blank

9r Slight sketch of hills

9v Four slight sketches, the first two inscr. *1; 2*

10r Schloss Horneck

10v (1) Burg Guttenberg from near Schloss Horneck
Inscr. *N*
(2) The Ehrenberg from near Schloss Horneck
(3) Schloss Horneck
Inscr. *Hornek*

11r Schloss Horneck
Inscr. *Hornek; Nec*

11v Four rough sketches, three showing Wimpfen on the skyline and the Benediktinenkloster, including one inscr. *Kirche*

12r (1) Distant view of Wimpfen
(2) Wimpfen, with the Benediktinenkloster

12v Heidelberg: the Mannheim Gate

13r Blank

13v (1) Heilbronn: the spires of the Deutschhauskirche and St Kilian's church
(2) Heilbronn: St Kilian's church

14r Two sketches of Wimpfen and two other Neckar subjects

14v Heilbronn

15r Heilbronn from the Neckar with the spires of St Kilian's church and the Deutschhauskirche

15v–16r Blank

16v (1) Schloss Horneck, looking upstream
(2) Distant view of Wimpfen
Inscr. *W*

17r (1) Burg Guttenberg, from close to Schloss Horneck
Inscr. *Gutenberg*
(2) Schloss Horneck, looking upstream
Inscr. *Neck*

17v (1) Gundelstein church and the Ehrenberg?
(2) A loop of the Neckar seen from a height, probably the view from the Garnberg
Inscr. *Road*
(3) Distant view of the Ehrenberg?

18r (1) Burg Hornberg
(2) Small sketch, probably of Burg Hornberg
Inscr. *R[oa]d*
(3) Distant view of the Ehrenberg?

18v (1) Gundelstein church and the Ehrenberg?
(2) Burg Guttenberg?
(3) (4) (5) Burg Hornberg, looking upstream

19r (1) Small sketch of Burg Hornberg
(2) Burg Hornberg

19v Three sketches, one inscr. *Mi[…]berg* and probably showing the Minneburg

20r The Neckar bend at Zwingenberg, with floating timber, looking downstream

20v Three sketches of castles

21r Three sketches of castles, one inscr. *Necker*

21v River scenery: wooded hills

22r River scenery: hills and a bend

22v Castle and tower
Inscr. *Necker*

23r Two river sketches, one showing the Minneburg

23v The Minneburg

24r Four slight sketches, two showing the Minneburg, one the church at Neckargerach

24v Zwingenberg, looking downstream

25r Four sketches of Schloss Zwingenberg, one inscr. *Necker*

25v (1) Slight sketch of buildings
(2) Schloss Zwingenberg

26r Schloss Zwingenberg, with separate detail of the tower

26v Five sketches of Burg Stolzeneck, two inscr. *Necker*

27r Two views of Eberbach, one inscr. *Ebach*

27v Hirschhorn and the Ersheimer Kapelle, looking downstream

28r Hirschhorn and the Ersheimer Kapelle,

looking downstream
Inscr. *R*[ed] *Rock*

28v (1) The bridge over the Steinach at
Neckarsteinach
(2) Village (Neckarsteinach?) and boats

29r Neckarsteinach with the Dilsberg

29v Neckarsteinach

30r Neckarsteinach

30v The four castles of Neckarsteinach, looking
downstream
Inscr. *Road*; [...]

31r The Dilsberg and the four castles of
Neckarsteinach, looking downstream

31v (1) The Dilsberg
(2) The Dilsberg and Neckarsteinach

32r The Dilsberg (also in separate insert) and
Neckarsteinach from the hillside to the
north-east, illegibly inscr.

32v Several sketches including one of the Dils-
berg from Neckarsteinach?; and one of the
Ehrenberg, inscr. *Erenberg*; *Neck*

33r Neckarsteinach, with the bridge over the
Steinach in the foreground

33v The Dilsberg and the Vorderburg at
Neckarsteinach and four more detailed
ones of the four castles of Neckarsteinach,
the Mittelburg inscr. *Terrace*

34r Several rough sketches including one of the
Mittelburg and Vorderburg at
Neckarsteinach

34v The castles of Neckarsteinach, with a rain-
bow

35r Neckargemünd?
Inscr. *Wood*

35v (1) Neckarsteinach: the Hinterburg, Mit-
telburg and Vorderburg
(2) Hills and distant castle
Inscr. [?*Wilneck*]

36r (1) Neckarsteinach: Burg Schadeck and the
Hinterburg, looking upstream
(2) Town

36v Neckarsteinach: Burg Schadeck, the Hin-
terburg, Mittelburg and Vorderburg, look-
ing upstream
Inscr. *Goats and kid*

37r Two slight sketches of river and hills

37v The four castles of Neckarsteinach, looking
upstream
Inscr. *Swalnest*

38r Neckarsteinach: the Mittelburg and Dils-
berg, looking upstream

38v The Dilsberg, looking upstream
Inscr. *Dillberg*; *Wood*; [...]

39r Two sketches, one inscr. *Vill*; *Neckar*

39v (1) Neckar view
(2) Neckargemünd, looking downstream

40r View near Neckargemünd

40v Neckargemünd, looking downstream from
the opposite bank

41r Neckargemünd from across the Neckar
(continued in the sky above, the two parts
inscr. *1*; *2*)
Inscr. *Ferry*

41v Neckargemünd from the Neckar with the
ferry in the foreground

42r (1) Burg Hornberg and the church at
Neckarzimmern
(2) Slight sketch

42v Neckargemünd, looking upstream from
below the mouth of the Elsenz

43r Neckargemünd, from the ferry landing-
stage on the opposite bank

43v Heidelberg from just outside the Karlstor

44r Wimpfen

44v–45r Blank

45v Heidelberg: the Karlstor, with the bridge in
the distance
Inscr. *5*
Also three slight sketches

Inside back cover
Hills and buildings, including Burg Horn-
berg, illegibly inscr.

TB CCCLII *Heidelberg* sketchbook 1844 (see cat.nos.134–5, 138–45, 150)

Roll sketchbook, with grey paper cover. The book
was dismembered at an early date after Turner's
death and some of the pages stamped CCCLII may in
fact derive from other sketchbooks.

Unless otherwise stated, all sketches are in water-
colour (sometimes with pencil) and all versos are
blank.

1r Storm over a river or lake
2r River and hills
3r Hills, river and boats
4r Ebernburg from the valley of the Alsenz
4v Heidelberg from the Neckar shore close to
the Hirschgasse, illegibly inscr. (pencil)
5r Heidelberg from the Neckar shore close to
the Hirschgasse
6r Ebernburg from the valley of the Alsenz
6v Cliffs and tower (pencil)
7r Stormy sky
8r Heidelberg castle from the south
9r Heidelberg from the east
10r Kreuznach on the Nahe
11r Heidelberg from the Hirschgasse
12r View along the Hauptstrasse, Heidelberg
13r Heidelberg castle from the Hirschgasse
14r Neckarsteinach on the Neckar
14v Neckarsteinach (pencil)
15r Heidelberg from the south
16r Heilbronn from the Neckar
17r Heidelberg from the Schlangenweg
18r Heidelberg from the Neckar shore close to
the Hirschgasse
19r Bingen and Burg Klopp from the Nahe

TB CCCXLIX *Rheinfelden* sketchbook 1844 (see cat.nos.136–7, 146–9)

Roll sketchbook, with grey paper cover. The book
was dismembered at an early date after Turner's
death and some of the pages stamped CCCXLIX may
in fact derive from other sketchbooks.

All sketches are in watercolour (sometimes with
pencil and pen). For further information on ff.13–19
see Warrell (1995), cat.nos.83, 85–90.

1r–10r Sky, sea and river sketches, sometimes with
slight indications of buildings
11r Rheinfelden

12r Baden
13r Baden from the north
14r Baden from the south-east
15r Rheinfelden from the north-east
16r Rheinfelden from the north-west
Inscr. *L*[...]
17r Rheinfelden from the north
Inscr. *Fount*[ain]
18r Rheinfelden from the north-west
19r Rheinfelden from the north
20r Hirschhorn on the Neckar from the north
Inscr. *Blue*; [?*Tower against Light*]
21r Rheingrafenstein and Ebernburg on the
Nahe
22r Hirschhorn on the Neckar from the south
22v Small sketch of a valley?
23r Baden
24r Ebernburg from the valley of the Alsenz
25r Baden
26r Zwingenberg on the Neckar
27r Zwingenberg on the Neckar
28r Rheinfelden
29r Rheinfelden

TB CCXCVII *Spires and Heidelberg* sketchbook 1844 (see p.82, n.11)

Bound in boards covered in a black and white pat-
terned paper. Page size: 169 × 108 ($6^{11}/_{16}$ × $4^{1}/_{4}$).

Finberg dated this sketchbook to *c*.1837–40, iden-
tifying only the inscribed sketch of Speyer on f.3r
and most of those showing Heidelberg. He did not
assign it to a particular tour and, not having
identified any of the views of Lucerne, did not con-
nect it with any of Turner's Swiss tours of the 1840s.

Inside front cover
Heidelberg: the castle from south-east of
the Broken Tower and other sketches
1r Lucerne
1v–3r Mountains and buildings, two inscr. *Olten*
3r Also includes a distant view of Speyer
Inscr. *Spires*
3v–6r Mountains and buildings, one inscr. *Z*[...]
6v (1) Heidelberg: the castle from the hillside
to the east, illegibly inscr.
(2) Mountains
7r–8r Mountains and buildings
8v Lucerne
9r (1) Distant view of town
Inscr. *Leopold* [?*Bridge*]
(2) A ruined tower
(3) Buildings on a river (in two instalments)
(4) Distant view of the Godesburg
9v–12r Slight mountain sketches, some illegibly
inscr.
12v Heidelberg: the castle from the east
13r Heidelberg from the east
13v–14r Lucerne
14v Heidelberg: the castle and town from the
terrace
15r Two slight sketches of buildings
15v Heidelberg: the castle from above the Bro-
ken Tower
15v–16r Slight mountain sketch
16r Slight sketches including parts of Heidel-
berg castle

16v Blank

17r (1) A building with classical façade

(2) Heidelberg: the castle from the hillside
immediately to the east

17v (1) Heidelberg: the castle from the hillside
to the east

(2) Heidelberg castle: the Gate Tower

18r Heidelberg castle: the Bell Tower,
Friedrich Building and Altan, and view
eastwards to the terrace

18v Heidelberg castle: the Friedrich Building
and Altan, and view westwards down the
Neckar

Inscr. *The Last Gleam of Sun*

19r (1) Heidelberg from the foot of the Great
Tower with a detail of the Great Tower
below

(2) Heidelberg: the bridge towers from
close to the castle

19v Blank

20r Lucerne

Inscr. *Red WB*

20v–21r Lucerne

21v Lucerne

22r Mountains

22v (1) Weggis

Inscr. *Wig*; [...]

(2) Female figures

Inside back cover

Lucerne

Lenders

Beit Collection 24
Stadt Bernkastel-Kues 23
British Museum, London 108, 110
Royal Institution of Cornwall, Royal
 Cornwall Museum, Truro 113
Courtauld Institute Galleries, London
 9, 12, 82
Galerie Jan Krugier, Geneva 114
Landesmuseum Mainz 18
Manchester City Art Galleries 15, 129
Private Collections 1, 2, 3, 4, 10, 13,
 17, 111, 112

Private Collection courtesy of Agnew's
 11, 14
Private Collection on loan to the
 National Gallery of Scotland,
 Edinburgh 127
Rheinisches Landesmuseum Bonn 8
National Museum and Gallery, Cardiff
 16, 105
National Museums and Galleries on
 Merseyside, Walker Art Gallery,
 Liverpool 107
York City Art Gallery 125

Photographic Credits

Agnew's, London
Beaverbrook Art Gallery, Fredericton
The Alfred Beit Foundation,
 Russborough
Birmingham Museum and Art Gallery
British Library, London
British Museum, London
Christie's Images, London
A.C. Cooper Ltd
Courtauld Institute Galleries, London
The Frick Collection, New York
Patrick Goetelen
Galerie Jan Krugier, Geneva
H. Lilienthal
Landesmuseum Mainz
Manchester City Art Galleries

National Galleries of Scotland,
 Edinburgh
National Museums and Galleries on
 Merseyside
National Museum and Gallery, Cardiff
Rheinisches Landesmuseum Bonn
S.J. Roberton
The Royal Collection
The Royal Cornwall Museum, Truro
Sotheby's, London
Staatsarchiv Hamburg
Steve Tanner
Tate Gallery, London
Rodney Todd-White & Son
John Webb
York City Art Gallery

Index